D0139226

Representing the Nation: A Reader

Representing the Nation brings together key writings on how the nation and its past are constructed and represented. Despite assertions that we are living in a period of globalisation, there has been a startling resurgence of nationalism, regionalism, and other assertions of local identity. The contributors to this Reader, who include leading thinkers in cultural studies, museum studies, sociology and cultural history, explore how our sense of national identity and of belonging to a nation come about, and what part museums, exhibitions and heritage play in this process.

The articles are grouped into thematic parts, each with an introduction by the editors. The opening part addresses how national cultures are invented and sustained through such strategies as the standardisation of language and the sidelining of regional cultures. In the second part, contributors examine the growth of 'heritage culture', and the ways in which the past is preserved, represented and consumed as 'heritage'.

The third part looks at the historical development of the public museum, examining conventions of classification and display, and stressing the link between the emergence of museums and the development of the modern nation state. The final part focuses on issues facing museums today, such as the difficulties they encounter in responding to the competing demands and interests of public funding bodies and local and ethnically specific communities, and argues that museums cannot continue to operate as if they are the repositories of objective and universal knowledge.

Editors: David Boswell is Senior Lecturer in Sociology and Jessica Evans is Lecturer in Media and Cultural Studies at the Open University.

REPRESENTING THE NATION: A READER

This Reader provides some of the set readings for a 16-week module (D851 *Representing the Nation*) which is offered by The Open University Masters in Social Sciences Programme.

The Open University Masters in Social Sciences

The MA Programme enables students to select from a range of modules, to create a programme to suit their own professional or personal development. Students can choose from a range of social science modules to obtain an MA in Social Sciences, or may specialise in a particular subject area. Thus, D851 *Representing the Nation* is one of the modules leading to an MA in Cultural and Media Studies.

At present there are three study lines leading to:

- an MA in Cultural and Media Studies;
- an MA in Environmental Policy and Society;
- an MA in Psychological Research Methods.

Other study lines being planned include a MSc in Psychology and an MA in Social Policy/MA in Social Policy and Criminology.

OU Supported Learning

The Open University's unique, supported open ('distance') learning Masters Programme in Social Sciences is designed to introduce the concepts, approaches, theories and techniques associated with a number of academic areas of study. The MA in Social Sciences programme provides great flexibility. Students study in their own environments, in their own time, anywhere in the European Union. They receive specially prepared course materials, benefit from structured tutorial support throughout all the coursework and assessment assignments, and have the chance to work with other students.

How to apply

If you would like to register for this programme, or simply find out more information, please write for the Masters in Social Sciences prospectus to the Course Reservations Centre, PO Box 724, The Open University, Walton Hall, Milton Keynes, MK7 6ZW, UK (Telephone 0 (0 44) 1908 653232).

Representing the Nation:
A Reader

Histories, heritage and museums

Edited by

David Boswell and Jessica Evans

London and New York

in association with

The Open
University

First published 1999
by Routledge
11 New Fetter Lane, London EC4P 4EE

Simultaneously published in the USA and Canada
by Routledge
29 West 35th Street, New York, NY 10001

Routledge is an imprint of the Taylor & Francis Group

In editorial matter and selection © The Open University
In individual contributions © 1999 the contributors

Typeset in Perpetua and Bell Gothic by The Florence Group, Stoodleigh, Devon
Printed and bound in Great Britain by TJ International Ltd, Padstow, Cornwall

All rights reserved. No part of this book may be reprinted or reproduced or utilised in any
form or by any electronic, mechanical, or other means, now known or hereafter invented,
including photocopying and recording, or in any information storage or retrieval system,
without permission in writing from the publishers.

British Library Cataloguing in Publication Data
A catalogue record for this book is available from the British Library

Library of Congress Cataloging in Publication Data
A catalogue record for this book has been requested

ISBN 0-415-20869-6 (hbk)
ISBN 0-415-20870-X (pbk)

Contents

CONTENTS

Illustrations

Figures

Tables

Acknowledgements

Permission given by the following copyright holders and authors is gratefully acknowledged.

Kevin Robins, 'Tradition and translation: national culture in its global context' from Corner, J. and Harvey, S. (eds) *Enterprise and Heritage – Cross-currents of National Culture*, (London, Routledge, 1991), pp. 21–44.

Stuart Hall, 'Culture, Community, Nation', *Cultural Studies*, vol. 1, no. 3 (1993), pp. 349–363.

Anthony D. Smith, 'History and modernity: reflections of the theory of nationalism' from Hall, J. A. and Jarvie, I. (eds) *The Social Philosophy of Ernest Gellner*, (Amsterdam, Rodopi, 1996), pp. 129–146.

Eric Hobsbawm, 'Mass-producing traditions: Europe, 1870–1914' from Hobsbawm, E. and Ranger, T. (eds) *The Invention of Tradition*, (London, Cambridge University Press, 1983) pp. 263–307. Courtesy of Cambridge University Press and The Past and Present Society.

Philip Dodd, 'Englishness and the national culture' from Colls, R. and Dodd, P. (eds) *Englishness: Politics and Culture 1880–1920*, (London, Croom Helm, 1986) pp. 1–28. © Routledge.

Patrick Wright, 'Trafficking in History' from *On Living in an Old Country*, (London, Verso, 1985), pp. 33–93. © Patrick Wright.

Robert Hewison, 'The climate of decline' from *The Heritage Industry: Britain in a Climate of Decline*, (London, Methuen, 1987), pp. 35–47.

Raphael Samuel, 'Resurrectionism' from *Theatres of Memory, Vol. 1. Past and Present in Contemporary Culture*, (London, Routledge, 1994), pp. 139–167.

Chris Rojek, 'Fatal attractions', from *Ways of Escape: Modern Transformations in Leisure and Travel*, (London, Macmillan, 1993), pp. 136–172. Courtesy of Macmillan Ltd.

John Urry, 'Gazing on history', from *The Tourist Gaze: Leisure and Travel in Contemporary Society*, (London, Sage, 1990) pp. 104–134. Courtesy of Sage Publications.

Richard Altick, 'National monuments' reprinted by permission of the publisher from *The Shows of London* by Richard D. Altick, (Cambridge, Mass.: Harvard University Press), pp. 434–54. Copyright © 1978 by the President and Fellows of Harvard College.

David Goodman, 'Fear of circuses: founding the national museum of Victoria', *Continuum*, vol. 3, no. 1 (1990), pp. 18–34. Courtesy of Continuum.

Robert W. Rydell, 'The Chicago world's Columbian exposition of 1893: "And was Jerusalem builded here?"', from *All the World's a Fair. Visions of Empire at American International Expositions, 1876–1916*, (University of Chicago Press, 1984), pp. 39–69.

Carol Duncan, 'From the princely gallery to the public art museum: the Louvre Museum and the National Gallery, London', from *Civilising Rituals – Inside Public Art Museums*, (London, Routledge, 1995), pp. 21–47. © 1995 Routledge.

Tony Bennett, 'The exhibitionary complex', *New formations*, no. 4 (1988), pp. 73–102. © 1988 Tony Bennett.

Kenneth Hudson, 'Attempts to define "museum"', from *Museums for the 1980s: A Survey of World Trends*, (London, Macmillan/UNESCO, 1977), pp. 1–7. Courtesy of Macmillan Ltd.

Tony Bennett, 'Useful culture', *Cultural Studies*, vol. 6, no. 3 (1992). pp. 395–408. © 1992 Routledge.

Colin Mercer, 'Cultural policy: research and the governmental imperative', *Media information Australia*, no. 73, Aug (1994). pp. 16–22.

Arjun Appadurai and Carol A. Breckenbridge, 'Museums are good to think: heritage on view in India', from *Museums and Communities: The Politics of Public Culture*, edited by Ivan Karp, *et al.*, (Washington DC: Smithsonian Institution, 1992), pp. 34–55. Copyright © 1992 by the Smithsonian Institution. Used by permission of the publisher.

Sharon Macdonald and Roger Silverstone, 'Rewriting the Museums: Fictions, Taxonomies, Stories and Readers', *Cultural Studies*, vol. 4, no. 2, May (1990) pp. 176–91.

James Clifford, 'Museums as contact zones' reprinted by permission of the publisher from *Routes: Travel and Translation in the Late Twentieth Century* by James Clifford, (Cambridge, Mass.: Harvard University Press, 1997), pp. 188–219. Copyright © 1997 by the President and Fellows of Harvard College.

Illustration acknowledgements

All illustrations are by the author of the chapter concerned, with the exception of the following. We are indebted to the people and archives below for permission to reproduce these photographs. Every effort has been made to trace copyright holders, but in a few cases this has not been possible. Any omissions brought to our attention will be remedied in future editions.

6.1 Drawing by Andrzej Krauze.
6.2 Drawing by Andrzej Krauze.
6.3 Drawing by Andrzej Krauze.
6.4 Drawing by Andrzej Krauze.

6.5	Drawing by Andrzej Krauze.
7.1	Chris Orr, "Heritage Gifts" shop front.
7.2	Photo by Alan Titmus.
7.3	Photo by Alan Titmus.
8.1	Photo by John James.
8.2	Photo by John James.
8.3	Photo by John James.
8.4	Photo by John James.
9.1	Thomas Hardy's map of Wessex.
10.1	Wigan Pier Heritage Centre. Photo: author.
10.2	Sainsbury's supermarket, Camden Town. Photo: author.
10.3	Museum of the former Gestapo cells in Berlin. Photo: author.
11.1	George Scharf the Elder, entrance hall of old Montague House, 1845. Courtesy of the British Museum.
11.2	The Easter Monday crowd in the Great Zoological gallery of the British Museum, 1845. *Illustrated London News*, 29 March 1845. Courtesy of the *Illustrated London News*.
11.3	The Egyptian room of the British Museum. *Illustrated London News*, 13 February 1847. Courtesy of the *Illustrated London News*.
11.4	The Coral Room of the British Museum. *Illustrated London News*, 3 April 1847. Courtesy of the *Illustrated London News*.
11.5	*Punch*, 17 April 1847 and 25 October 1845. © Punch Ltd.
11.6	*Punch*, 15 September 1846. © Punch Ltd.
11.7	*Punch*, 11 May 1844, 28 February 1846, and 31 May 1846. © Punch Ltd.
12.1	The Victorian Museum of Natural History, from *The Illustrated Journal of Australasia*, 1857. Source: La Trobe University Library, Melbourne.
13.1	Court of Honour. Courtesy of Smithsonian Institution Archives, Record Unit 95, Photograph Collection.
13.2	World's Columbian Exposition. Courtesy of Prints and Photographs Division, Library of Congress.
13.3	"Darkies' Day at the Fair" from World's Fair Puck. Courtesy of Prints and Photographs Division, Library of Congress.
13.4	Ferris Wheel. Courtesy of Prints and Photographs Division, Library of Congress.
14.1	Louvre Museum, Paris; entrance to the Apollo gallery. Photo: author.
14.2	The old Louvre palace. Photo: author.
14.3	Creating a genius ceiling in the central dome of the Louvre's Daru staircase; from *L'Illustration*; 27 August, 1887.
14.4	Louvre Museum, the Salle des Etats, 1886; from *L'Illustration*, 30 October 1886.
14.5	Ceiling in the Hall of Seven Chimneys, Louvre Museum. Photo: author.
14.6	The dining room of Landsdowne House, London, installed in the Metropolitan Museum of Art, New York. Photo: author.
14.7	The Barry Rooms, National Gallery, London. Courtesy of the Trustees, the National Gallery, London.
15.1	The *Metallotheca* of Michelle Mercati in the Vatican, 1719.

ACKNOWLEDGEMENTS

15.2 H. Owen and M. Ferrier, the Great Exhibition, 1851. Courtesy of the Board of Trustees of the Victoria and Albert Museum.

15.3 The Paris Exhibition, 1855. Courtesy of the Board of Trustees of the Victoria and Albert Museum.

15.4 John Watkins, the South Kensington Museum, circa 1876. Courtesy of the Board of Trustees of the Victoria and Albert Museum.

15.5 Colossus of Abu Simbel, 1852/3. Photo: Philip Henry Delamotte.

15.6 Ferrante Imperato's museum in Naples, 1599.

15.7 Stuffed animals and ethnographic figures. Photo: Philip Henry Delamotte.

15.8 H. Owen and M. Ferrier, the Great Exhibition, 1851. Courtesy of the Board of Trustees of the Victoria and Albert Museum.

15.9 The Chicago Columbian Exposition, 1893. Courtesy of the Chicago Historical Society.

19.1 Bombay, 1989. Photo: authors.

19.2 Madras, 1989. Photo: authors.

19.3 Madras, 1989. Photo: authors.

19.4 Madras, 1989. Photo: authors.

19.5 Madras, 1989. Photo: authors.

19.6 Madras, 1989. Photo: authors.

19.7 Madras, 1989. Photo: authors.

19.8 Madras, 1989. Photo: authors.

Jessica Evans

INTRODUCTION
Nation and representation

IN RECENT YEARS 'THE NATION' has come to be seen not merely as the object of political, geographical or economic analysis, but as one of *cultural* analysis. This is not just about the application of a new method. Conducting a cultural analysis enables us to conceptualize the object with a specific and characteristic set of emphases. People are not merely legal citizens of a nation; in an important sense a nation is also a symbolic community which creates powerful – and often pathological – allegiances to a cultural ideal; for example, 'the British way of life'. Most often, as Ernest Gellner argued in his *Nations and Nationalism* (1983), this cultural ideal is expressed in the motivation to unify, to create a congruence between membership of the political nation-state and identification with a national culture, a way of life.

Accordingly, a central theme shared by the articles in this volume is the ways in which the concept of the nation is called upon and activated across a range of cultural – i.e. meaning-making – forms and practices. How is the very idea of the nation created and re-created in symbolic forms that seek not only to gain rhetorical success but to impact upon social and cultural life? The distinctiveness of this emphasis should not go unrecognized. The central question is not whether 'the nation' is at heart a 'real' or a 'fictional' entity. To be concerned with the symbolic, historically produced practices that construct nationhood and national culture is not meant, therefore, to imply that the nation is *per se* a 'false' community to which might be juxtaposed the real or more authentic communities of a region or community with a more reliable, less ideological past. Here, we follow Benedict Anderson's argument that nations are best viewed as particular ways of 'imagining' bonds of human solidarity. In contrast to religious communities or dynastic realms, the modern nation-state creates its identity through imagining that its people are bound to the same territory, as, in the words of Tony Bennett, 'occupants

of a territory that has been historicized and subjects of a history that has been territorialized' (Bennett, 1995: 141). The point about 'imagining' is that nations have to be imagined in a particular and selective style, which, as our readings show, achieves tangible and symbolic form in the traditions, museums, monuments and ceremonies in which it is constructed.

The subject of this volume is the ways in which particular ideas of the nation are created and embedded in the exhibitionary forms of a range of cultural practices and institutions, such as tourism, museums, expositions and heritage displays. The first two groups of readings have been selected to introduce the concept of the nation and national culture and the cultural forms in which its appeal is manifested, and to present the wide range of reactions to the expansion of interest in, and use of, the past and its artefacts that are exemplified in the heritage debate. The second two groups of readings take as their object the historical emergence of the museum form and the articulation of its collecting and display practices with a range of national and local cultural policies.

Thus our emphasis is upon the cultural aspects of the nation – the ways in which our sense of nationhood and of national identity arises from arrangements of meaning-making, from symbolic practices. What it means to be and *feel* Australian, American, Jamaican or English, for example, is bound up with the ways those nations and regions are made tangible through repeated and recognizable symbolic forms, narratives and communicative styles – in short, the sum of cultural representations that go to make up the achievement of a national identity. Our knowledge and sense of *what Englishness is*, for example, are a function of the images and narratives that constitute it, that provide it with its identity as English rather than, say, Scottish.

Much of what goes to make up our sense that we belong to a unified 'nation', as Eric Hobsbawm and Terence Ranger point out in their influential book *The Invention of Tradition* (1983), consists of constructs in the form of public ceremonies, symbols, institutions and discourses invented no more than a century ago (see Chapter 4 in this volume). It is a paradox that the very appeal to *tradition* is a particular feature of modern nations, which seek to justify present social arrangements through a reference back to ways of life the origins of which are so remote that they apparently need no justification – they have always simply 'been there'. For example, in the early 1990s former British Prime Minister, John Major, favoured speeches that embodied a typical 'one-nation' *conservative* emphasis upon origins, traditions and continuity. His pictorial language – the cricket bat being swung on the village green, the warm beer, the women cycling back from church – evoked a time when everyone knew their place and no one sought to disrupt the harmony of existing social relations. Major selected a fictional, vaguely pre-war, rural community rather than the densely populated urban environments characteristic of modern industrialized nations. British life, implicitly whites only, is projected as a moment of organic racial unity before 'foreigners' arrived, as if historical development is then a 'completing' process designed to accomplish its ends in 'our' present. Simultaneously, however, the past is evoked as a period of difference from the present, in order to protect history's glorious culmination in the present from being

sabotaged (see Patrick Wright for an imaginative discussion of this contradictory amalgam of public philosophies of history in his *On Living in an Old Country*, 1985: 148). Hence, Raphael Samuel speaks of the regressive agenda hidden in the invocation of Tradition: the 'sleeping images which spring to life in times of crisis – the fear, for instance, of being "swamped" by foreign invasion – testify to its continuing force' (Samuel, 1989: xxxii; quoted in Chapter 1 (p. 15) of this volume).

It would be wrong, however, to associate the idea of a single culture simply with a moribund Toryism; the solidarity of the war effort and its effect upon the post-war welfare-state settlement which brought the state into new areas of intervention was a defining moment for mid-century labour patriotism. Thus, it was George Orwell's wartime descriptions of the English character – set in rural *and* urban contexts – in his essay 'England, your England' (originally published in his book *The Lion and the Unicorn*, 1941: 36) which John Major plundered for his evocation of England as a domestic and rural community. And the proto-communitarian socialism of Raymond Williams was rooted in an implicitly racially exclusive form of social identity. In his 'Culture, community, nation' Stuart Hall notes – citing another important critic of Williams, Paul Gilroy – that in rejecting legalistic definitions of identity because they smack of compromise with the bourgeois state, Williams preferred to find the roots of national identity in temporally continuous and socially integrated 'settled communities'. This contrast is underpinned by a fundamental dichotomy in Williams's work between the 'abstractions' of modern national cultural identities with their 'imposed artificial orders' against the 'rooted settlements' of actual and sustained social relationships' (all quotes from Hall, in Chapter 2 of this volume, pp. 33–44). As Hall points out, this attachment to a mythical organic community seems to be Williams's version of the Tebbit cricket test. He argues that 'formal legal definitions of citizenship matter profoundly' and 'cannot be made conditional upon cultural assimilation' (ibid., p. 42).

The administrations of Margaret Thatcher will be remembered for having fundamentally broken with the post-war welfare state settlement, a consensus based upon a widely regarded attribution of a direct relationship between 'winning the war' and 'winning the peace'. Many people born in the 1960s will remember when, as school children in the early 1970s, their free milk was withdrawn chanting the popular rhyme 'Maggie Thatcher, Milk Snatcher': a prescient sign of things to come from the future Prime Minister during her stint as Education Secretary. The destruction of the central principle governing the welfare state, that of universality, was precisely the legacy of the neo-liberal, free-market Thatcher and Reagan administrations of the 1980s. Progressively throughout the 1980s and 1990s, European and US governments have sought to downplay the potential leverage of individual national governments in the economic life of the nation, citing inexorable global forces and the necessity for deregulated markets as their *raison d'être*. However, in the case of the UK, this has been conjoined with conservative social and cultural values about the arts, culture and national heritage, which can be regarded as one manifestation of a general social policy centred on a moral authoritarianism that seeks to regulate the family form, crime and sexuality,

amongst others, in the name of overturning the 'permissive society'. Conservative values, as we have seen, are rooted variously in the idea that the national past is an Edenic point of origin from which we derive our present identities as members of a homogeneous nation, and in the claim that certain cultural activities represent edifying values that need protecting against the debasements of vulgar popular culture.

However, the changes in every sphere which the Thatcher administrations inaugurated brought into focus the tensions within the Conservative Party between the Tory tradition of paternalism and the New Right economic and moral libertarians. Thus, as Patrick Wright observed with reference to the National Trust in his *On Living in an Old Country*, the conflict between the motivation of *laissez-faire* economic modernizers, whose *modus operandi* is to root out static conceptions of order and hierarchy, and that of the cultural preservation lobby, whose guiding principle is conservation, is not easily resolved. As Wright pointed out some years later, the ideology of conservative modernization was encapsulated by the passionate debates aroused by the threatened abolition of the red telephone boxes when the nationally owned telephone service was about to be sold off, as the flagship of Thatcher's privatization programme, to British Telecom (Wright, 1991, 1996). For many Conservative MPs and intellectuals associated with the New Right such as Roger Scruton, the accordant visual landscape provided by the GPO telephone boxes, the same up and down the land, was precisely one of the symbolic trademarks that held Britain Inc. together. They railed against what they saw as the destruction of national homogeneity by the abandonment of this icon of a single culture. It was obvious although allegiance to the general principle of de-nationalization and deregulation prevented them from stating it as such, that their concern with the descent of the telephone service into a privatized company was that it would not achieve a similar power to represent *all* of the British people. Charles Moore, editor of the *Daily Telegraph*, referred to the 'civilizing influence' of the red telephone box, even in desolate urban areas dominated by high-rise blocks (see Wright, 1991, 1996). Thus, the Tory hand-wringers were caught in an ideological conflict: at one and the same time, privatization was understood as a development that could not itself be opposed *and* the loss of the standard telephone box was bemoaned – surely a piece of magical thinking in which the hope was expressed that privatization might leave some things the same!

It is significant, from the point of view of our *cultural* interest in these matters, that the reason this material artefact could be widely held to represent the nation was that it made tangible and visible the ideal of public service. The ethos of public service is based on a national consensus about the importance of equality of access and standardization of delivery. The privatization of telephones and now trains – with the immediate consequence of visual chaos and a hacked-about appearance to the landscape – was seen then by many Conservatives as widely inhibiting the power to represent ourselves to ourselves in the continuous narrative of nationhood.

Red telephone boxes were, indeed, removed from most areas but some were retained in places where it was felt their presence would enhance or maintain

'historical value'. The 1930s Society and the Victorian Society, aided in partic-
ular by the historical research of Gavin Stamp, retrieved them from the public
domain as part of the nation's design heritage. Different models were identified
and an originating creator found in the architect Sir Giles Gilbert Scott (see Stamp,
1989; Wright, 1991, 1996). How soon these telephone boxes passed into the arena
of the historical document! The fact that they were eagerly bought up by such
organizations as garden centres and museums for a high price both here and in
other countries as a sign of quintessential British culture is a testament to their
place in public affection, albeit now as an aestheticized icon of 'Britain'.

In contrast to the Conservative Party's ideology of 'conservative moderniza-
tion' the post-1997 Labour government of Tony Blair has, in the main, hitched
its political project to a rebranding of Britain as a vital modern nation of entre-
preneurs in which 'people' and 'nation' are brought into a new alignment. Hence,
we are enticed with an image of 'Cool' Britannia, and meetings at No. 10 Downing
Street between the Prime Minister and pop stars or public relations company direc-
tors sipping champagne, rather than the TUC with beer and sandwiches. In part,
this reflects the fundamentally altered affiliations in Britain between national
parties and the class structure since the mid-1980s. But more specifically it is an
indication that the engine house of economic change and thus of a new sense
of national identity is now assumed to be post-industrial *cultural* producers and
image managers. This process of redefinition had its apogee in September 1997,
in the week following the death of Diana, Princess of Wales. Blair, adept at the
copywriter's trade, was able to buttress the project of Labour's New Nation with
the already existing myths of the Diana phenomenon. Labour's New Nation is
represented as a fundamentally modern one in which focus groups and other direct,
and apparently unmediated, means of expressing citizens' points of view bypass
the normal processes and institutions of representative democracy. Similarly,
'the People's Princess' was seen as having a magical capacity to witness and
respond to people's suffering in a way that traditional royals could not. Thus, 'the
People' were homologous with 'the nation', but carefully defined as a nation at
war with the nation-as-establishment, the latter being not just the Tory traditions
of a sovereign state but clearly the paternalist, interventionist state associated with
'old Labour'.

In recent years there has been a tremendous interest in 'representing the past'
through preservation and presentation of material artefacts – either in their own
settings or in the museums and exhibitions that house them. These displays and
collections have a diversity of purposes – for public education, tourism, enter-
tainment, as well as for memorabilia and oral and social history projects. The
main lines of conflict over the terms and implications of heritage are the subject
of Part Two. What is, at the least, implied by the vexed term 'heritage industry'
is the instrumental (commercially and/or state-funded) use of representations and
activities centred upon memorializing, preserving or re-enacting the past in order
to protect and project a nation's inheritance. A key question that one would want
to ask here is, precisely *whose* inheritance is claimed to be in need of protection?
Does not the rhetoric of 'a nation's inheritance' precisely reproduce the mythical

idea that Britain is composed of a single culture, in which the narratives of those others who do not fit into this culture (be they the chambermaids of the country house, or the slaves who underpinned the British shipping trade and are absent from most maritime museums), and whose very presence is testament to a history of conflict, are either romanticized or sanitized as a discrete moment of error in the past? Is the still rapacious drive for heritage projects to be interpreted as a reactionary mission to preserve − backed up by an attachment to the values of a fading aristocratic class and a conservative view of culture as a civilizing instrument − with the intent to demonstrate a continuity with the past? Does it present reactionary spectacles for a passive form of consumption in which tourism is held up as an adequate replacement for a declining industrial nation? Or, is it the case that although in the form of 'heritage' the past has been commodified and made to pay its way, it has also been the spur for a proliferation of more accessible and diversified representations that have arisen from a grass-roots demand for the expression, exploration and representation of local and distinctive ways of life?

What we now recognize as the modern public museum − the subject of the readings in Parts Three and Four − was invented, in the period from the mid-eighteenth to the late nineteenth centuries in Europe, Australia and North America, for the purposes of celebrating and dramatizing the unity of the nation-state and to make visible to its public the prevailing ideals embodied by the concept of national culture. However, any discussion of the 'invention' of the museum form should not assume that it has a pristine historical moment of conception unrelated to other modes of public exhibition. Nor should we project more recent dualisms between popular and high culture into the past and assume that the museum form was securely placed on the side of the latter. There were, in fact, a diverse range of other sites and institutional spaces in which objects were brought together and preserved for the purposes of display, and the histories of museums intersect with those of these other forms and practices of collections. These include art galleries, international expositions of the type inaugurated by the Great Exhibition of 1851, zoos, fairgrounds, waxworks, panoramas, and exhibitions of freaks and monstrosities and displays of scientific wonders, to name but a few.

It is the purpose of the readings in Part Three, which treat a range of national cultures to aid comparative work, to tease out some of the central historical moments that were formative for the invention of the museum form. It is important that, in these readings, the pre-history of the form is understood not so much as an historical backdrop, but as the very ground of contestation and conflict upon which strategies, at both national and local level, to develop the museum arose. Part Four then goes on to consider, in a group of articles concerned with contemporary curating practices and dilemmas, how specific policy frameworks, developed within the museum, incorporate, directly or indirectly, practical and ethical components which are often the object of broader governmental prerogatives and policies. This section is framed by an introduction to the important debate on cultural policy and cultural studies that has recently taken place, particularly in Australia, from a Foucauldian perspective. Some of the readings in Parts Three and Four deploy

a Foucauldian schema, but it is in Part Four that the theoretical framework of a 'governmental' approach is more explicitly developed.

It is generally agreed that the pre-twentieth-century history of the museum form can be divided into two main stages. The first, broadly speaking, spans the late seventeenth and eighteenth centuries and is characterized by the transformation of earlier practices of collection and exhibition, based on the sensational and the unique artefact, to yield, by the beginning of the nineteenth century, museums which were recognizably if unevenly modern in terms of their scientific thematics and 'rational' principles of classification and representation. However, they were still limited, in terms of access, to the aristocratic classes under the model of secularized private patronage. The nineteenth-century history of the museum is one of consolidation and extension of these emergent principles of classification, often based on a desire to distance itself *qua* museum from contemporary popular exhibitions. As Tony Bennett has shown, the birth of the museum is coincident with, and supplied the institutional environment for, the emergence of a new set of disciplinary knowledges – geology, anthropology, history and art history, 'each of which, in its museological deployment, arranged objects as parts of evolutionary sequences (the history of the earth, of life, of man, and of civilization) which, in their interrelations, formed a totalizing order of things and peoples that was historicized through and through' (Bennett, 1995: 96; and see Carol Duncan's elucidation of this in terms of art history in Chapter 14 of this volume). Moreover, a defining feature of this period was the new pressures leading museums to grant unrestricted access to a public citizenry, often as a part of a series of strategies aimed at the moral and cultural regulation of the popular and working classes (see Altick, 1978, which is Chapter 11 in this volume and Goodman, 1990 which is Chapter 12).

More broadly, developments in the latter half of the eighteenth century – for example, in post-Revolutionary France – are fundamentally bound up with the process of redefining the concept of 'the public' according to new democratic and often republican principles concomitant with the rise of the modern nation-state. What gained ground everywhere in the latter half of the nineteenth century was the idea of the museum as an institution administered by the state for the instruction and edification of an undifferentiated public. As Carol Duncan and Alan Wallach have shown, for example, the public art collection is built upon a set of social relations entirely different from those of the princely gallery: 'The princely gallery spoke for and about the prince. The visitor was meant to be impressed by the prince's virtue, taste and wealth. . . . But now the state, as an abstract entity replaces the king as host. This change redefines the visitor. He is no longer the subordinate of a prince or lord. Now is he addressed as a citizen and therefore a shareholder in the state' (Duncan and Wallach, 1980: 456). At the same time that the museum was becoming a public institution, the realm, in its turn, increasingly became a nation-state. The territories of nations, rather than the sub- or transnational territories of royal dynasties, increasingly came to constitute the major political and administrative units of Europe as well as supplying the language of historical continuities and cultural unities governing the terms in which communities were typically 'imagined' (Anderson, 1983). The development of the museum form was thus closely associated with a

broader set of interacting developments, which, in extending and democratizing the public, also nationalized it.

The majority of these articles and extracts have been abbreviated as appropriate to the overall theme and purpose of this collection. Original illustrations and footnotes have been included only where the editors consider them necessary for reference. David Boswell and I are grateful both to the authors and to the original publishers for permission to publish their writings. We hope this use of their work in a new setting will both extend its familiarity and its use and form a valuable starting-point for students of the nation as represented by the international diversity of its histories, cultures and museums.

Editor's acknowledgement

Many of the readings in Parts Three and Four were originally selected for a course in the Master's Programme in Cultural Policy at Griffith University in Queensland, Australia. We would like to express our gratitude to Tony Bennett and Colin Mercer, who devised the course, and to Griffith University for permitting us to reuse their selection here.

References

Altick, Richard D. (1978) *The Shows of London*, Cambridge, MA and London: Belknap Press of Harvard University Press.

Anderson, Benedict (1983) *Imagined Communities: reflections on the origin and spread of nationalism*, London: Verso.

Bennett, Tony (1995) *The Birth of the Museum: history, theory, politics*, London: Routledge.

Duncan, Carol and Wallach, Alan (1980) 'The universal survey museum', in *Art History* 3(4) (December): 447–69.

Gellner, Ernest (1983) *Nations and Nationalism*, Oxford: Blackwell.

Hobsbawm, Eric and Ranger, Terence (eds) (1983) *The Invention of Tradition*, London: Cambridge University Press.

Orwell, George (1941) 'England, your England', *The Lion and the Unicorn*, London: Searchlight Books, Secker and Warburg.

Samuel, Raphael (1989) 'Introduction: exciting to be English', in R. Samuel (ed.) *Patriotism: the making and unmaking of British national identity*, Vol. 1, London: Routledge.

Stamp, Gavin (1989) *Telephone Boxes*, London: Chatto & Windus.

Wright, Patrick (1985) *On Living in an Old Country*, London: Verso.

Wright, Patrick (1991) *A Journey through Ruins*, London: Radius.

Wright, Patrick (1996) 'Threadbare England', a lecture in the series *You're just as English as you feel*, BBC Radio 3, June.

Culture, community and nation

Introduction to part one

■ David Boswell

T HE NATION-STATE is said to have passed its day but nationalism, espe-
 cially in the reassertion of its ethnically based regional form, seems particularly
vociferous. It is one of the great paradoxes of current affairs. During a period of
apparently intensive standardization through a remarkably monopolistic global-
ization of information technology and manufactured goods for sale in a few private
hands, there has been a resurgence of national, regional and other forms of localism.
One major contributor has been and will continue to be the effects of the economic
collapse and political disintegration of the greatest power-bloc based on a different
mode of planned economy, the Soviet Union and Comecon. But another is the
reaction to the integration of the European Union by both its constituent nation-
states and also within those countries by some regions that assert their own claims
to popular and territorial separatism. A third contributor, which may but need not
be found in the other two, takes the particular form of an appeal to local culture,
often through alternative structures of religious organization, which has notably
been expressed in Islamic states in a rejection of modernization as alien western-
ization. But there are many active movements throughout the world seeking to
change the geo-political status of their followers by force or other means. In his
article on national culture in its global context, with which this Reader begins,
Kevin Robins outlines this apparent paradox and the relationship between exten-
sive globalization and intense localism.
 Any conception of and claim to community can entail a sense of belonging,
a set of shared values, cultural or biological traits and, perhaps fundamentally,
the perception of difference from others. But the concept of a common culture
has been challenged by those questioning the status and ownership of its
dominant forms. Stuart Hall, in his review of the contribution of Raymond Williams
to the analysis of the relationship between culture and community in a nation,

summarizes Williams's reaction to the dominant, self-satisfied and ignorantly exclusive upper middle-class culture that he encountered as a scholarship boy at Cambridge. Not only was there a Welsh culture but a working-class Welsh culture too. But Hall draws attention to another inevitable exclusiveness within Williams's account, also noted by other authors in this reader. Where do the black British find a place in Williams's emphasis upon the integrated and long-settled communities he thinks of as typical of a community? Quite how locally rooted and specific the perceptions of national belonging may be is outlined by Anthony Cohen in his introduction to a collection of essays based on anthropological research in British rural communities. He argues that these stem from local economic and social practicalities that may follow, but are not seen as deriving from, broader and more abstract generalities such as class and systems of social relations. As he puts it, 'local experience mediates national identity' (Cohen, 1982: 13).

Some such debate underlies the attempt to postulate a general theory for the origins of nationalism in the modern world. This requires the interplay of history, economics, and political as well as social theory. Linda Colley (1992) has argued that British national consciousness and its characteristic emblems and cultural features were forged from competition and war to acquire trading and imperial advantages. The expression of common characteristics arose, therefore, from those differences of interest. Earlier than this, in an attempt to salvage a materialist theory of nationalism from the Marxist critique of this phenomenon as a manipulated false consciousness, Tom Nairn (1977) had argued that the anti-imperial nationalism, which was seen as 'progressive', originated from the same conditions as the usually earlier forms of European nationalism. They could almost all be seen as the reactions of people who had perceived their lack of economic development and power compared with the dominant nation-states and who sought a collective identity to lay claim to similar benefits. The exceptions, which appeared 'reactionary' were those that had already achieved that international, or more local, dominant position of which Britain, or Cardiff and Ulster, were examples – i.e. more economically developed areas with an interest in maintaining their advantages. But these arguments fit within the more general theory of nationalism as a feature of modernization proposed by Ernest Gellner in several books from 1964. Nation-states, industrialization (usually capitalism) and a nationally shared culture produced by state, or nationwide, education increasingly formed the global mode, notwithstanding the continued existence of other forms of polity and religious hegemony. The basic components of Gellner's argument were clearly summarized by Anthony Smith in his contribution to a symposium convened to review the work of this philosopher, anthropologist and social theorist and to give Gellner the chance of publishing his responses, shortly before he died in 1995. Smith goes on to argue his own case that the contents of these nationalisms were not just drawn from any differences that came to hand, but from particular traditions and histories of peoples who could appeal to some previous distinctiveness, although they had not taken the modern form of nationalism. There is an obvious parallel between Smith's conception of historic roots, Cohen's sense of local belonging, and Williams's conception of several cultures within a nation.

Reference has already been made to the wide range of academic disciplines with an interest in nations and nationalism. This Reader cannot attempt to exemplify all these as well as achieve the objections outlined in the introduction. Smith noted some examples of the historical writing that has most appealed to students of cultural studies. One is Benedict Anderson's (1983) concept of an 'imagined community', which arose from his research into the reactions to imperialism and the establishment of new nations in south-east Asia. He was concerned to conceptualize how a sense of unity could be felt between people who could not interact personally, and might not even share more than certain geo-political and administrative boundaries. Another historical thesis of great influence has been the one promulgated in Eric Hobsbawm and Terence Ranger's (1983) edition of articles on the invention of tradition. Some assume such traditions to be the creation of false consciousness by those in power to manipulate the rest in their hegemonic interests. But from a cultural studies point of view the most interesting conclusion is that there can be several histories, several different traditions to appeal to, and that the process of creating them is a social one irrespective of the verifiable evidence for the events taken up by any particular tradition/history. With specific reference to national traditions, Hobsbawm's article from this *Past and Present* collection includes many examples from Europe, at its most competitive after the creation of the new nation-states in Germany and Italy, and in the challenge to continental empires like Austria/Hungary as well as in competition for the expansion of global empires. But the process of invention was a general one in that other traditions were established that promoted socialist solidarity or catholicized festivities. And some failed because the myths never caught the general public's imagination or could not be sustained as circumstances changed. In his article on the foundation of various English cultural institutions during the same period, Philip Dodd outlines the significance of this desire to form a national culture in English which is represented by the *New English Dictionary*, a *Dictionary of National Biography*, a National Portrait Gallery, and a National Theatre. He also suggests how what was essentially an English cultural elite sought to incorporate both the rest of the English population and the increasingly assertive Celtic fringe in this process. It is this conception of a common national culture that underlies much of the discussion in subsequent sections of this Reader, which assumes that there are different histories and cultures in the process of formation or to which appeals may be made.

References

Anderson, B. (1983, revised 1991) *Imagined Communities: reflections on the origin and spread of nationalism*, London: Verso.

Cohen, A. P. (1982) *Belonging: identity and social organisation in British rural communities*, Manchester: Manchester University Press.

Colley, L. (1992) *Britons: forging the nation 1707–1837*, London: Yale University Press.

Hobsbawm, Eric and Ranger, Terence (eds) (1983) *The Invention of Tradition*, London: Cambridge University Press.

Nairn, T. (1977) *The Break-up of Britain: crisis and nationalism*, London: New Left Books.

Kevin Robins

TRADITION AND TRANSLATION
National culture in its global context

> Where once we could believe in the comforts and continuities of Tradition, today we must face the responsibilities of cultural Translation.
>
> (Homi Bhabha)

Tradition and translation

RECENT DEBATE ON THE STATE of British culture and society has tended to concentrate on the power of Tradition. Accounts of the crisis of British (or English) national traditions and cultures have described the cultural survivalism and mutation that come in the aftermath of an exploded empire. As Raphael Samuel argues in his account of the pathology of Tradition, the idea of nationality continues to have a powerful, if regressive, afterlife, and 'the sleeping images which spring to life in times of crisis – the fear, for instance, of being "swamped" by foreign invasion – testify to its continuing force'.[1] It is a concern with the past and future of British Tradition that has been central to Prince Charles's recent declamations on both enterprise and heritage. A 'new Renaissance for Britain' can be built, he suggests, upon a new culture of enterprise; a new business ethos, characterized by responsibility and vision, can rebuild the historical sense of community and once again make Britain a world actor. What is also called for, according to the Prince's 'personal vision', is the revival and re-enchantment of our rich national heritage. As Patrick Wright argues, the Prince of Wales has been sensitive to 'the deepest disruptions and disappointments in the nation's post-war experience',[2] and his invocation of so-called traditional and spiritual values is again intended to restore the sense of British community and confidence that has collapsed in these modern or maybe postmodern times.

This prevailing concern with the comforts and continuities of historical tradition and identity reflects an insular and narcissistic response to the breakdowns of Britain.

[. . .]

Protective illusion, I am going to suggest, has also been central to the obsessive construction of both enterprise and heritage cultures in these post-imperial days. The real challenge that I want to consider is about confronting imperial illusion (in both fantasy and literal senses). It is about recognizing the overwhelming anxieties and catastrophic fears that have been born out of empire and the imperial encounter. If, in psychoanalytic terms, 'a stable disillusionment' is only achieved 'through many bruising encounters with the other-ness of external reality'[3] then in the broader political and cultural sphere what is called for is our recognition of other worlds, the dis-illusioned acknowledgement of other cultures, other identities and ways of life.

This is what I take Homi Bhabha to mean by the responsibility of cultural Translation. It is about taking seriously 'the deep, the profoundly perturbed and perturbing question of our relationship to others – other cultures, other states, other histories, other experiences, traditions, peoples, and destinies'.[4] This responsibility demands that we come to terms with the 'geographical disposition' that has been so significant for what Edward Said calls the 'cultural structures of the West'. 'We could not have had empire itself,' he argues, 'as well as many forms of historiography, anthropology, sociology, and modern legal structures, without important philosophical and imaginative processes at work in the production as well as the acquisition, subordination, and settlement of space.'[5] Empire has long been at the heart of British culture and imagination, manifesting itself in more or less virulent forms, through insular nationalism and through racist paranoia. The relation of Britain to its 'Other' is one profoundly important context in which to consider the emergence of both enterprise and heritage cultures. The question is whether, in these supposedly post-imperial times, it is possible for Britain to accept the world as a sufficiently benign place for its weakness not to be catastrophic. The challenge is not easy, as the Rushdie affair has made clear, for 'in the attempt to mediate between different cultures, languages and societies, there is always the threat of mis-translation, confusion and fear'.[6] There is also, and even more tragically, the danger of a fearful refusal to translate: the threat of a retreat into cultural autism and of a rearguard reinforcement of imperial illusions.

The making of geography

Geography has always mattered. For many, it matters now more than ever. Edward Soja, for example, suggests that we are now seeing the formation of new postmodern geographies, and argues that today 'it may be space more than time that hides consequences from us, the "making of geography" more than the "making of history" that provides the most revealing tactical and theoretical world'.[7] I want, in the following sections, to explore the spatial context in which enterprise and heritage cultures have been taking shape.

Geographical reconfigurations are clearly central to contemporary economic and cultural transformation. If, however, there is such a phenomenon as the post-modernization of geography, then what is its organizing principle? How are we to make sense of these complex spatial dynamics? What is needed is an understanding of the competing centrifugal and centripetal forces that characterize the new geographical arena. On this basis we can then begin to explore the implications for cultures and identities. More particularly, we can consider the significance of these developments for the geographical disposition that Edward Said sees as so much at the heart of western dominion. Are they likely to reinforce, to recompose, or perhaps even to deconstruct, the geographical disposition or empire? My central concern is whether the 'making of geography' can be about the 'remaking of geography'.

It is clear that geographical transformations are now being brought about through the international restructuring of capitalist economies. This has been associated with a changing role for the nation-state (though in precisely what sense it is being transformed remains to be clarified). At the same time there has been a consolidation of supra-national blocs (such as the European Community) and a new salience for sub-national territories (regions and localities). The reorganization of the international economic order has also changed the nature and role of cities, bringing about new and direct confrontations between city administrations and transnational corporations, and stimulating global competition between cities to attract ever more mobile investors. It has created new centres and peripheries, and also new territorial hierarchies. It has produced new rational contexts and configurations. Regions, for example, are now assuming a whole new significance in the context of a 'Europe of the regions'.[8] And, beyond this, there is the over-arching global context: 'regional differentiation becomes increasingly organised at the international rather than national level; sub-national regions increasingly give way to regions of the global economy.'[9]

This process of international restructuration is bringing change not only to the space economy, but to imaginary spaces as well. As territories are transformed, so too are the spaces of identity.[10] National cultures and identities have become more troublesome (though they have a long and potent half-life). For many, European culture has offered a more challenging and cosmopolitan alternative, even if there are real difficulties here, too, in exorcizing the legacy of colonialism, and even if recent events in Central and Eastern Europe raise questions about what Europe really means.[11] Local and regional cultures have also come to be revalued (as is apparent in the growth of the heritage industry), and there is now a renewed emphasis on territorial locations as poles of identity, community and continuity.[12]

The organizing principle behind these complex transformations, both economic and cultural, as I shall argue in the following sections, is the escalating logic of *globalization*.[13] More precisely, as I shall then go on to make clear, the so-called postmodernization of geography is about the emergence of a new *global–local nexus*. Historical capitalism has, of course, always strained to become a world system. The perpetual quest to maximise accumulation has always compelled geographical expansion in search of new markets, raw materials, sources of cheap labour, and so on. The histories of trade and migration, of missionary and military conquest, of imperialism and neo-imperialism, mark the various strategies and stages that

have, by the late twentieth century, made capitalism a truly global force. If this process has brought about the organization of production and the control of markets on a world scale, it has also, of course, had profound political and cultural consequences. For all that it has projected itself as transhistorical and transnational, as the transcendent and universalizing force of modernization and modernity, global capitalism has in reality been about westernization – the export of western commodities, values, priorities, ways of life.[14] In a process of unequal cultural encounter, 'foreign' populations have been compelled to be the subjects and subalterns of western empire, while, no less significantly, the west has come face to face with the 'alien' and 'exotic' culture of its 'Other'. Globalization, as it dissolves the barriers of distance, makes the encounter of colonial centre and colonized periphery immediate and intense.

Global accumulation

Enterprise and heritage cultures must both be seen in the context of what has become a globally integrated economic system. What is new and distinctive about global accumulation, and what differentiates it from earlier forms of economic internationalization? Globalization is about the organization of production and the exploitation of markets on a world scale. This, of course, has long historical roots. Since at least the time of the East India Company, it has been at the heart of entrepreneurial dreams and aspirations. What we are seeing is no more than the greater realization of long historical trends towards the global concentration of industrial and financial capital. Transnational corporations remain the key shapers and shakers of the international economy, and it is the ever more extensive and intensive integration of their activities that is the primary dynamic of the globalization process: it remains the case, more than ever, that 'size is power'.[15] What we are seeing is the continuation of a constant striving to overcome national boundaries, to capture and co-ordinate critical inputs, and to achieve world-scale advantages.

But if this process is clearly about the consolidation of corporate command and control, it is none the less the case that, to this end, we are now seeing significant transformations and innovations in corporate strategy and organization. The limitations of nationally centred multinationals are now becoming clear, and the world's leading-edge companies are seeking to restructure themselves as 'flexible transnationals' on the basis of a philosophy and practice of globalization. These companies must now operate and compete in the world arena in terms of quality, efficiency, product variety, and the close understanding of markets. And they must operate in all markets simultaneously, rather than sequentially. Global corporations are increasingly involved in time-based competition: they must shorten the innovation cycle; cut seconds from process time in the factory; accelerate distribution and consumption times. Global competition pushes towards time-space compression. Globalization is also about the emergence of the decentred or polycentric corporation.

[. . .]

This whole process has been associated with a corporate philosophy centred around the 'global product'. A universalizing idea of consumer sovereignty suggests that

as people gain access to global information, so they develop global needs and demand global commodities, thereby becoming 'global citizens'. In his influential book *The Marketing Imagination*, the pioneer of this approach, Theodore Levitt, forcefully argues that the new reality is all about global markets and world-standard products. This is, of course, no more than a continuation of mass production strategies which always sought economies of scale on the basis of expanding markets. However, whilst the old multinational corporation did this by operating in a number of countries and by adapting its products to different national preferences, today's global corporation operates 'as if the entire world (or major regions of it) were a single, largely identical entity; it does and sells the same things in the same single way everywhere'. Transcending vestigial national differences, the global corporation 'strives to treat the world as fewer standardised markets rather than as many customised markets'.[16]

Of course, there is both hype and hyperbole in this.[17] There has been a tendency to overemphasize the standardization of products and the homogenization of tastes. None the less, it would be a mistake to dismiss this globalizing vision as simply another empty fad or fashion of the advertising industry. Levitt's position is, in fact, more complex and nuanced than is generally understood. What he recognizes is that global corporations do, indeed, acknowledge differentiated markets and customize for specific market segments. The point, however, is that this is combined with the search for opportunities to sell to similar segments throughout the globe. These same insights have been taken up in Saatchi & Saatchi's strategies for pan-regional and world marketing. Their well-known maxim that there are more social differences between midtown Manhattan and the Bronx than between Manhattan and the 7th arrondissement of Paris, suggests the increasing importance of targeting consumers on the basis of demography and habits rather than on the basis of geographical proximity; marketing strategies are 'consumer-driven' instead of 'geography-driven'.[18] What is at the heart of this economic logic of world brands remains the overriding need to achieve economies of scale, or, more accurately, to achieve both scale and scope economies – that is, to combine volume and variety production – at the global level.

Globalization also demands considerable changes in corporate behaviour; the flexible transnational must compete in ways that are significantly different from the older multinational firm. In a world of permanent and continuous innovation, a world in which costs must be amortized over a much larger market base, a world in which global span must be combined with rapid, even instantaneous, response, the global corporation must be lean and resourceful. In order to ensure its competitive position it must ensure a global presence: it must be 'everywhere at once'. This is bringing about significant changes in corporate strategy, with a huge burst of activity centred around mergers, acquisitions, joint ventures, alliances, inter-firm agreements and collaborative activities of various kinds. The objective is to combine mobility and flexibility with the control and integration of activities on a world scale. The global corporation seeks to position itself within a 'tight-loose' network: tight enough to ensure predictability and stability in dealings with external collaborators; loose enough to ensure manoeuvrability and even reversibility, to permit the redirection of activities and the redrawing of organizational boundaries when that becomes necessary.

Truly global operations imply a quantum reduction in time-space distanciation. Global production and marketing depend upon a massively enhanced 'presence-availability', and this has been made possible by new computer-communications systems. On the basis of an electronic communications network, the global corporation organizes its activities around a new space of information flows. [. . .] Globalization is realized through the creation of a new spatial stratum, a network topography, an electronic geography.[19] The strategic nodes of these electronic grids are the financial centres and skyscraper fortresses of 'global cities' like New York, Tokyo and London. These world cities are the command and control centres of the global economy.[20]

Global culture

The historical development of capitalist economies has always had profound implications for cultures, identities and ways of life. The globalization of economic activity is now associated with a further wave of cultural transformation, with a process of cultural globalization. At one level, this is about the manufacture of universal cultural products – a process which has, of course, been developing for a long time. In the new cultural industries, there is a belief – to use Saatchi terminology – in 'world cultural convergence'; a belief in the convergence of life-style, culture and behaviour among consumer segments across the world. This faith in the emergence of a 'shared culture' and a common 'world awareness' appears to be vindicated by the success of products like *Dallas* or *Batman* and by attractions like Disneyland. According to the president of the new Euro Disneyland, 'Disney's characters are universal'. 'You try and convince an Italian child', he challenges, 'that Topolino – the Italian name for Mickey Mouse – is American.'[21]

[. . .]

What is being created is a new electronic cultural space, a 'placeless' geography of image and simulation. The formation of this global hyperspace is reflected in that strand of postmodernist thinking associated particularly with writers like Baudrillard and Virilio. Baudrillard, for example, invokes the vertigo, the disorientation, the delirium created by a world of flows and images and screens. This new global arena of culture is a world of instantaneous and depthless communication, a world in which space and time horizons have become compressed and collapsed.

The creators of this universal cultural space are the new global cultural corporations. In an environment of enormous opportunities and escalating costs, what is clearer than ever before is the relation between size and power. [. . .] The most prominent example of conglomerate activity is, no doubt, Rupert Murdoch's News Corporation, which has rapidly moved from its base in newspapers into the audio-visual sector. Through the acquisition of Fox Broadcasting, 20th Century Fox and Sky Channel, an (eventually unsuccessful) attempt at a joint venture with Disney, and now a renewed interest in the acquisition of MGM/UA, Murdoch is striving to become involved at all levels of the value chain. The most symbolic example of a global media conglomerate, however, is Sony, which is now 'buying a part of

America's soul'. From its original involvement in consumer electronic hardware, Sony has diversified into cultural software through the recent acquisitions of CBS and Columbia Pictures. The Sony–Columbia–CBS combination creates a communications giant, a 'total entertainment business', whose long-term strategy is to use this control over both hardware and software industries to dominate markets for the next generation of audio-visual products.[22] What is prefigurative about both News International and Sony, is not simply their scale and reach, but also the fact that they aspire to be stateless, 'headless', decentred corporations. These global cultural industries understand the importance of achieving a real equidistance, or equipresence, of perspective in relation to the whole world of their audiences and consumers.

If the origination of world-standardized cultural products is one key strategy, the process of globalization is, in fact, more complex and diverse. In reality, it is not possible to eradicate or transcend difference. Here, too, the principle of equidistance prevails: the resourceful global conglomerate exploits local difference and particularity. Cultural products are assembled from all over the world and turned into commodities for a new 'cosmopolitan' market-place: world music and tourism; ethnic arts, fashion, and cuisine; Third World writing and cinema. The local and 'exotic' are torn out of place and time to be repackaged for the world bazaar. So-called world culture may reflect a new valuation of difference and particularity, but it is also very much about making a profit from it. Theodore Levitt explains this globalization of ethnicity. The global growth of ethnic markets, he suggests, is an example of the global standardization of segments:

> Everywhere there is Chinese food, pitta bread, country and western music, pizza, and jazz. The global pervasiveness of ethnic forms represents the cosmopolitanisation of speciality. Again, globalisation does not mean the end of segments. It means, instead, their expansion to worldwide proportions.[23]

Now it is the turn of African music, Thai cuisine, Aboriginal painting, and so on, to be absorbed into the world market and to become cosmopolitan specialities.

[. . .]

If the global collection and circulation of artistic products has been responsible for new kinds of encounter and collision between cultures, there have also been more direct and immediate exchanges and confrontations. The long history of colonialism and imperialism has brought large populations of migrants and refugees from the Third to the First World. Whereas Europe once addressed African and Asian cultures across vast distances, now that 'Other' has installed itself within the very heart of the western metropolis. Through a kind of reverse invasion, the periphery has infiltrated the colonial core. The protective filters of time and space have disappeared, and the encounter with the 'alien' and 'exotic' is now instantaneous and immediate. The western city has become a crucible in which world cultures are brought into direct contact. As Neil Ascherson argues:

> the history of immigration into Europe over the past quarter century may seem like the history of increasing restrictions and smaller quotas.

> Seen in fast forward, though, it is the opposite: the beginning of a historic migration from the South into Europe which has gained its first decisive bridgehead.

It is a migration that is shaking up the 'little white "christian" Europe' of the past.[24] Through this irruption of empire, the certain and centred perspective of the old colonial order is confronted and confused.

Time and distance no longer mediate the encounter with 'other' cultures. This drama of globalization is symbolized perfectly in the collision between western 'liberalism' and Islamic 'fundamentalism' centred around the Rushdie affair. How do we cope with the shock of confrontation? This is perhaps the key political agenda in this era of space-time compression. One danger is that we retreat into fortress identities. Another is that, in the anxious search for secure and stable identities, we politicize those activities – religion, literature, philosophy – that should not be *directly* political. The responsibility of Translation means learning to listen to 'others' and learning to speak to, rather than for or about, 'others'. That is easily said, of course, but not so easy to accomplish. Hierarchical orders of identity will not quickly disappear. Indeed, the very celebration and recognition of 'difference' and 'otherness' may itself conceal more subtle and insidious relations of power. [. . .]

Global–local nexus

Globalization is about the compression of time and space horizons and the creation of a world of instantaneity and depthlessness. Global space is a space of flows, an electronic space, a decentred space, a space in which frontiers and boundaries have become permeable. Within this global arena, economies and cultures are thrown into intense and immediate contact with each other – with each 'Other' (an 'Other' that is no longer simply 'out there', but also within).

I have argued that this is the force shaping our times. Many commentators, however, suggest that something quite different is happening: that the new geographies are, in fact, about the renaissance of locality and region.[25] There has been a great surge of interest recently in local economies and local economic strategies. The case for the local or regional economy as the key unit of production has been forcefully made by the 'flexible specialization' thesis. Basing its arguments on the economic success of the 'Third Italy', this perspective stresses the central and prefigurative importance of localized production complexes. Crucial to their success, it is suggested, are strong local institutions and infrastructures: relations of trust based on face-to-face contact; a 'productive community' historically rooted in a particular place; a strong sense of local pride and attachment.[26] In Britain this localizing ethos, often directly influenced by the 'flexible specialization' thesis, was manifest in a number of local economic development strategies undertaken by local authorities (notably the Greater London Council, Sheffield City Council and West Midlands County Council).[27]

In the cultural sphere too, localism has come to play an important role. The 'struggle for place' is at the heart of much contemporary concern with urban

regeneration and the built environment. Prince Charles's crusade on behalf of community architecture and classical revivalism is the most prominent and influential example. There is a strong sense that modernist planning was associated with universalizing and abstract tendencies, whilst postmodernism is about drawing upon the sense of place, about revalidating and revitalizing the local and the particular. A neo-Romantic fascination with traditional and vernacular motifs is supposedly about the re-enchantment of the city.[28] This cultural localism reflects, in turn, deeper feelings about the inscription of human lives and identities in space and time. There is a growing interest in the embeddedness of life-histories within the boundaries of place, and with the continuities of identity and community through local memory and heritage. Witness the enormous popularity of the Catherine Cookson heritage trail in South Tyneside, of 'a whole day of nostalgia' at Beamish in County Durham, or of Wigan Pier's evocation of 'the way we were'. If modernity created an abstract and universal sense of self, then postmodernity will be about a sense of identity rooted in the particularity of place: 'it contains the possibility of a revived and creative human geography built around a newly informed synthesis of people and place'.[29]

Whilst globalization may be the prevailing force of our times, this does not mean that localism is without significance. If I have emphasized processes of de-localization, associated especially with the development of new information and communications networks, this should not be seen as an absolute tendency. The particularity of place and culture can never be done away with, can never be absolutely transcended.[30] Globalization is, in fact, also associated with new dynamics of *re*-localization. It is about the achievement of a new global–local nexus, about new and intricate relations between global space and local space.[31] Globalization is like putting together a jigsaw puzzle: it is a matter of inserting a multiplicity of localities into the overall picture of a new global system.

We should not idealize the local, however. We should not invest our hopes for the future in the redemptive qualities of local economies, local cultures, local identities. It is important to see the local as a relational, and relative, concept. If once it was significant in relation to the national sphere, now its meaning is being recast in the context of globalization. For the global corporation, the global–local nexus is of key and strategic importance. According to Olivetti's Carlo de Benedetti, in the face of ever-higher development costs, '*globalisation* is the only possible answer'. 'Marketers', he continues, 'must sell the latest product everywhere at once – and that means producing *locally*.'[32] Similarly, the mighty Sony describes its operational strategy as 'global localisation'.[33] NBC's vice-president, J. B. Holston III, is also resolutely 'for localism', and recognizes that globalization is 'not just about putting factories into countries, it's being part of that culture too'.[34]

What is being acknowledged is that globalization entails a corporate presence in, and understanding of, the 'local' arena. But the 'local' in this sense does not correspond to any specific territorial configuration. The global–local nexus is about the relation between globalizing and particularizing dynamics in the strategy of the global corporation, and the 'local' should be seen as a fluid and relational space, constituted only in and through its relation to the global. For the global corporation, the local might, in fact, correspond to a regional, national or even pan-regional sphere of activity.

This is to say that the 'local' should not be mistaken for the 'locality'. It is to emphasize that the global–local nexus does not create a privileged new role for the locality in the world economic arena. Of course local economies continue to matter. That is not the issue. We should, however, treat claims about new capacities for local autonomy and proactivity with scepticism. If it is, indeed, the case that localities do now increasingly bypass the national state to deal directly with global corporations, world bodies or foreign governments, they do not do so on equal terms. Whether it is to attract a new car factory or the Olympic Games, they go as supplicants. And, even as supplicants, they go in competition with each other: cities and localities are now fiercely struggling against each other to attract footloose and predatory investors to their particular patch. Of course, some localities are able successfully to 'switch' themselves into the global networks, but others will remain 'unswitched' or even 'unplugged'. And, in a world characterized by the increasing mobility of capital and the rapid recycling of space, even those that manage to become connected into the global system are always vulnerable to the abrupt withdrawal of investment and to disconnection from the global system.

The global–local nexus is also not straightforwardly about a renaissance of local cultures. There are those who argue that the old and rigid hegemony of national cultures is now being eroded from below by burgeoning local and regional cultures. Modern times are characterized, it is suggested, by a process of cultural decentralization and by the sudden resurgence of place-bound traditions, languages and ways of life. It is important not to devalue the perceived and felt vitality of local cultures and identities. But again, their significance can only be understood in the context of a broader and encompassing process. Local cultures are overshadowed by an emerging 'world culture' – and still, of course, by resilient national and nationalist cultures.

It may well be that, in some cases, the new global context is re-creating sense of place and sense of community in very positive ways, giving rise to an energetic cosmopolitanism in certain localities. In others, however, local fragmentation – remember the Saatchi point about the relationship between populations in midtown Manhattan and the Bronx – may inspire a nostalgic, introverted and parochial sense of local attachment and identity. If globalization recontextualizes and reinterprets cultural localism, it does so in ways that are equivocal and ambiguous.

It is in the context of this global–local nexus that we can begin to understand the nature and significance of the enterprise and heritage cultures that have been developing in Britain over the past decade or so. I want now to explore two particular aspects of contemporary cultural transformation (each in its different way centred around the relationship between Tradition and Translation).

On not needing and needing Andy Capp

Why discuss enterprise and heritage together? Is there really any connection between the modernizing ambitions of enterprise culture and the retrospective nostalgia of heritage culture? The argument put forward in this section is that there is in fact a close and *necessary* relation between them. The nature of this relation-

ship becomes clear, I suggest, when we see that each has developed as a response to the forces of globalization. Insight into this relational logic then helps us to understand the neurotic ambivalence that is, I think, at the heart of contemporary cultural transformation.

Enterprise culture is about responding to the new global conditions of accumulation. British capital must adapt to the new terms of global competition and learn to function in world markets. It must pursue strategic alliances and joint ventures with leading firms in Europe, North America, and Japan. In all key sectors – from pharmaceuticals to telecommunications, from automobiles to financial services – 'national champions' are being replaced by new flexible transnationals. In the cause of global efficiency, it is necessary to repudiate the old 'geography-driven' and home-centred ethos, and to conform to the new logic of placelessness and equidistance of perspective. The broadcasting industries are a good example. In the new climate, it is no longer viable to make programmes for British audiences alone. One way of understanding the debate around 'public service versus the market' is in terms of the displacement of nationally centred broadcasting services by a new generation of audio-visual corporations, like Crown Communications and Carlton Communications, operating in European and global markets. As the recent White Paper on broadcasting makes clear, television is 'becoming an increasingly international medium' centred around 'international trade in ideas, cultures and experiences'.[35] The consequence of these developments, across all sectors, is that the particularity of British identity is de-emphasized. In a world in which it is necessary to be 'local' everywhere – to be 'multidomestic' – certain older forms of national identity can actually be a liability. The logic of enterprise culture essentially pushes towards the 'modernization' of national culture. Indeed it is frequently driven by an explicit and virulent disdain for particular aspects of British culture and traditions. This scorn is directed against what the self-styled 'department for Enterprise' calls 'the past anti-enterprise bias of British culture'.[36] The spirit of enterprise is about eradicating what has been called the 'British disease': the 'pseudo-aristocratic' snobbery that has allegedly devalued entrepreneurial skills and technological prowess, and which has always undermined Britain's competitive position in world trade.[37]

If enterprise culture aims to refurbish and refine national culture and identity, there are, however, countervailing forces at work. Globalization is also underpinned by a quite contrary logic of development. As Scott Lash and John Urry argue, the enhanced mobility of transnational corporations across the world is, in fact, associated with an increased sensitivity to even quite small differences in the endowments of particular locations. 'The effect of heightened spatial difference', they suggest, 'has profound effects upon particular places . . . contemporary developments may well be heightening the salience of localities.'[38] As global corporations scan the world for preferential locations, so are particular places forced into a competitive race to attract inward investors. Cities and localities must actively promote and advertise their attractions. What has been called the 'new urbanity'[39] is very much about enhancing the profile and image of places in a new global context. It is necessary to emphasize the national or regional distinctiveness of a location. [. . .] In this process, local, regional or national cultures and heritage will be exploited to enhance the distinctive qualities of a city or locality.[40]

Tradition and heritage are factors that enhance the 'quality of life' of particular places and make them attractive locations for investment. An emphasis on tradition and heritage is also, of course, important in the development of tourism as a major industry. Here, too, there is a premium on difference and particularity. In a world where differences are being erased, the commodification of place is about creating distinct place-identities in the eyes of global tourists. Even in the most disadvantaged places, heritage, or the simulacrum of heritage, can be mobilized to gain competitive advantage in the race between places. When Bradford's tourist officer, for example, talks about 'creating a product' – weekend holidays based around the themes of 'Industrial Heritage' and 'In the Steps of the Brontës',[41] he is underlining the importance of place-making in placeless times, the heightened importance of distinction in a world where differences are being effaced.

In the new global arena, it is necessary, then, simultaneously to minimize and maximize traditional cultural forms. The north-east of England provides a good example of how these contradictory dynamics of enterprise and heritage are developing. In this part of the country, it is over the symbolic body of Andy Capp that the two logics contest. 'Andy Capp is dead – Newcastle is alive'[42] – that is the message of enterprise. The region no longer has a place for Andy or for other cloth-capped local heroes like the late Tyneside comedian, Bobby Thompson. 'The real Northerner is no relation to Bobby or Andy', local celebrity Brendan Foster tells us.[43] The 'Great North' promotional campaign puts great emphasis on 'enterprise' and 'opportunity' and tries to play down the heritage of the region's old industrial, and later de-industrialized, past.[44] Newcastle City Council has recently employed J. Walter Thompson to change the city's image and to get rid of the old cloth-cap image once and for all. [. . .] Japan is the key to constructing the new model Geordie. The region's history is now being reassessed to emphasize the special relationship between Japan and the north-east. 'The North-East aided Japan's progress towards modernisation in the late nineteenth and early twentieth centuries', we are told, whilst 'today Japanese investment is contributing to the revitalisation of a region that followed a very different course in the post-war period.' We must, it is stressed, 'adapt to changing times'.[45]

If the spirit of enterprise wants to kill off Andy Capp, there is, however, a counter-spirit that keeps him alive. The region's industrial past is its burden, but it is also its inheritance. It is clear that history can be made to pay. Beamish, the Land of the Prince Bishops, Roman Northumberland and Catherine Cookson Country are all heritage assets that can be exploited to attract tourists and investors alike. But if heritage is to be marketed, it becomes difficult to avoid the reality that the north-east was once a region of heavy engineering, shipbuilding and coal mining. And around these industries there developed a rich working-class culture. For many in the region, the conservation of local culture and traditions is extremely important. [. . .] And it is also in many ways an affirmative image. The gritty and anarchic humour of Andy and Bobby distinguishes the region, gives it a positive sense of difference.

My objective is not to enter into a detailed account of enterprise and heritage cultures in the north-east, but rather to emphasize how the region's new global orientation is pulling its cultural identity in quite contradictory directions: it

involves at once the devaluation and the valorization of tradition and heritage. There is an extreme ambivalence about the past. Working-class traditions are seen, just like 'pseudo-aristocratic values', as symptoms of the 'British disease', and as inimical to a 'post-industrial' enterprise ethos. But tradition and heritage are also things that entrepreneurs can exploit: they are 'products'. And they also have human meaning and significance that cannot easily be erased. At the heart of contemporary British culture is the problem of articulating national past and global future.

The burden of identity

I want, finally, to return to the question of what postmodern geographies might imply for the question of empire. Postmodernism, as Todd Gitlin argues, should be understood as 'a general orientation, as a way of apprehending or experiencing the world and our place, or placelessness, in it'.[46] Globalization is profoundly transforming our apprehension of the world: it is provoking a new experience of orientation and disorientation, new senses of placed and placeless identity. The global–local nexus is associated with new relations between space and place, fixity and mobility, centre and periphery, 'real' and 'virtual' space, 'inside' and 'outside', frontier and territory. This, inevitably, has implications for both individual and collective identities and for the meaning of coherence of community. Peter Emberley describes a momentous shift from a world of stable and continuous reference points to one where 'the notions of space as enclosure and time as duration are unsettled and redesigned as a field of infinitely experimental configurations of space-time'. In this new 'hyperreality', he suggests, 'the old order of prescriptive and exclusive places and meaning-endowed durations is dissolving' and we are consequently faced with the challenge of elaborating 'a new self-interpretation'.[47]

It is in this context that both enterprise and heritage cultures assume their significance. Older certainties and hierarchies of British identity have been called into question in a world of dissolving boundaries and disrupted continuities. In a country that is now a container of African and Asian cultures, the sense of what it is to be British can never again have the old confidence and surety. Other sources of identity are no less fragile. What does it mean to be European in a continent coloured not only by the cultures of its former colonies, but also by American and now Japanese cultures? Is not the very category of identity itself problematical? Is it at all possible, in global times, to regain a coherent and integral sense of identity? Continuity and historicity of identity are challenged by the immediacy and intensity of global cultural confrontations. The comforts of Tradition are fundamentally challenged by the imperative to forge a new self-interpretation based upon the responsibilities of cultural Translation.

Neither enterprise nor heritage culture really confronts these responsibilities. Both represent protective strategies of response to global forces, centred around the conservation, rather than reinterpretation, of identities. The driving imperative is to salvage centred, bounded and coherent identities – placed identities for placeless times. This may take the form of the resuscitated patriotism and jingoism that we are now seeing in a resurgent Little Englandism. Alternatively, as I have

already suggested, it may take a more progressive form in the cultivation of local and regional identities or in the project to construct a continental European identity. In each case, however, it is about the maintenance of protective illusion, about the struggle for wholeness and coherence through continuity. At the heart of this romantic aspiration is what Richard Sennett, in another context, calls the search for purity and purified identity. 'The effect of this defensive pattern', he argues, 'is to create in people a desire for a purification of the terms in which they see themselves in relation to others. The enterprise involved is an attempt to build an image or identity that coheres, is unified, and filters out threats in social experience.'[48] Purified identities are constructed through the purification of space, through the maintenance of territorial boundaries and frontiers. We can talk of 'a geography of rejection which appears to correspond to the purity of antagonistic communities'.[49] Purified identities are also at the heart of empire. Purification aims to secure both protection from, and positional superiority over, the external other. Anxiety and power feed off each other.

[. . .]

To question empire, then, is to call into question the very logic of identity itself. In this context, it is not difficult to understand the anxious and defensive efforts now being devoted to reinforce and buttress 'traditional' cultural identities.

Is it, then, possible to break this logic of identity? How do we begin to confront the challenge of postmodern geographies and the urgent question of cultural Translation? British enterprise and heritage cultures are inscribed in what Ian Baruma has called the 'antipolitical world of *Heimat*-seeking'.[50] Against this ideal of *Heimat*, however, another powerful motif of the contemporary world should be counterposed. It is in the experience of *diaspora* that we may begin to understand the way beyond empire.

[. . .]

The experience of diaspora and exile is extreme, but, in the context of increasing cultural globalization, it is prefigurative, whilst the quest for *Heimat* is now regressive and restrictive. The notion of distinct, separate, and 'authentic' cultures is increasingly problematical. A culture, as Eric Wolf argues, is 'better seen as a series of processes that construct, reconstruct, and dismantle cultural materials'; 'the concept of a fixed, unitary, and counted culture must give way to a sense of the fluidity and permeability of cultural sets'.[51] Out of this context are emerging new forms of global culture. There is, to take one example, a new cosmopolitanism in the field of literature. Writers like Isabel Allende, Salman Rushdie or Mario Vargas Llosa are recording 'the global juxtapositions that have begun to force their way even into private experience', 'capturing a new world reality that has a definite social basis in immigration and international communications'.[52] For Rushdie, these literary exiles, migrants or expatriates are 'at one and the same time insiders and outsiders', offering 'stereoscopic vision' in place of 'whole sight'.[53]

The point is not at all to idealize this new cosmopolitanism (the Rushdie affair is eloquent testimony to its limits and to the real and profound difficulties of cultural Translation). It is, rather, to emphasize the profound insularity of enterprise and heritage cultures and to question the relevance of their different strategies

to re-enchant the nation. As Dick Hebdige emphasizes, everybody is now 'more or less cosmopolitan; "mundane" cosmopolitanism is part of "ordinary" experience'.[54] If it is possible, then it is no longer meaningful, to hold on to older senses of identity and continuity. In these rapidly changing times, Hanif Kureishi writes, the British have to change: 'It is the British, the white British, who have to learn that being British isn't what it was. Now it is a more complex thing, involving new elements'.[55]

The argument of this chapter has been that the emergence of enterprise and heritage cultures has not been a matter of the purely endogenous evolution of British culture, but rather a response to the forces of globalization. If, however, over the past decade or so, both of these cultural developments have been provoked and shaped by those forces, neither has been open to them. The question for the 1990s is whether we will continue to insulate ourselves with protective and narcissistic illusions, or whether, in the new global arena, we can really find 'a new way of being British'.

Notes

1 R. Samuel, 'Introduction: exciting to be English', in R. Samuel (ed.), *Patriotism: The Making and Unmaking of British National Identity*, Vol. 1 (London: Routledge, 1989) p. xxxii.

2 P. Wright, 'Re-enchanting the nation: Prince Charles and architecture', *Modern Painters* 2(3) (1989): 27. On Prince Charles's ideas about business in the community, see, for example, his article, 'Future of business in Britain', *Financial Times*, 20 November 1989.

3 B. Richards, *Images of Freud: Cultural Responses to Psychoanalysis* (London: Dent, 1989), pp. 38–9.

4 E. W. Said, 'Representing the colonised: anthropology's interlocutors', *Critical Inquiry* 15(2) (1989): 216.

5 ibid: 218.

6 H. Bhabha, 'Beyond fundamentalism and liberalism', *New Statesman and Society*, 3 March 1989, p. 35. On the Rushdie affair, see L. Appignanesi and S. Maitland (eds), *The Rushdie File* (London: Fourth Estate, 1989).

7 E. W. Soja, *Postmodern Geographies: The Reassertion of Space in Critical Social Theory* (London: Verso, 1989). See also M. Dear, 'The postmodern challenge: reconstructing human geography', *Transactions of the Institute of British Geographers* 13 (1988): 262–74; D. Gregory, 'Areal differentiation and post-modern human geography', in D. Gregory and R. Walford (eds), *Horizons in Human Geography* (London: Macmillan, 1989). On the importance of geography, D. Massey and J. Allen (eds), *Geography Matters!: A Reader* (Cambridge: Cambridge University Press, 1984).

8 See M. Hebbert, 'Britain in a Europe of the regions', in P. L. Garside and M. Hebbert (eds), *British Regionalism 1900–2000* (London: Mansell, 1989).

9 N. Smith, 'The region is dead! Long live the region!' *Political Geography Quarterly* 7(2) (1988): 150.

10 See K. Robins, 'Reimagined communities: European image spaces, beyond Fordism', *Cultural Studies* 3(2) (1989): 145–65; D. Morley and K. Robins,

'Non-tariff barriers: identity, diversity, difference', in G. Locksley (ed.), *Information and Communications Technologies and the Single European Market* (London: Belhaven, 1990), pp. 44–56; D. Morley and K. Robins, 'Spaces of identity: communications technologies and the reconfiguration of Europe', *Screen* 30(4) (1989): 10–34; I. Paillart, 'De la production des territoires', *Mediaspouvoirs* 16 (1989) 58–64.

11 See S. Sontag, 'L'Idée d'Europe (une élégie de plus)', *Les Temps modernes* 510 (1989): 77–82.

12 M. Rustin, 'Place and time in socialist theory', *Radical Philosophy* 4 (1987) 30–6; J. A. Agnew and J. S. Duncan (eds), *The Power of Place* (Boston: Unwin Hyman, 1989).

13 On globalization, see J. Chesneaux, 'Désastre de la mondialisation', *Terminal* 45 (1989): 9–14; J. Chesneaux, *Modernité-Monde*, (Paris: La Découverte, 1989).

14 See Serge Latouche, *L'Occidentalisation du monde* (Paris: La Découverte, 1988).

15 See B. Harrison, 'The big firms are coming out of the corner: the resurgence of economic scale and industrial power in the age of "flexibility"', paper presented to the International Conference of Industrial Transformation and Regional Development in an Age of Global Interdependence, United Nations Centre for Regional Development, Nagoya, Japan, 18–21 September 1989.

16 T. Levitt, *The Marketing Imagination* (London: Collier Macmillan, 1983).

17 For discussion and critiques of Levitt, see the special issue of *Journal of Consumer Marketing* 3(2) (1986); the special issue of *Revue française du marketing* 114 (1987); A. Mattelart, *L'Internationale publicitaire* (Paris: La Découverte, 1989) Ch. 3.

18 S. Winram, 'The opportunity for world brands', *International Journal of Advertising* 3(1) (1984): 17–26.

19 K. Robins and M. Hepworth, 'Electronic spaces: new technologies and the future of cities', *Futures* 20(2) (1988): 155–76.

20 On world cities, see J. Friedmann and G. Wolff, 'World city formation: an agenda for research and action', *International Journal of Urban and Regional Research* 6(3) (1982): 309–43; J. Friedmann, 'The world city hypothesis', *Development and Change* 17(1) (1986): 69–83.

21 S. Shamoon, 'Mickey the Euro mouse', *Observer*, 17 September 1989.

22 S. Wagstyl, 'Chief of Sony tells why it bought a part of America's soul', *Financial Times*, 4 October 1989; G de Jonquieres and H. Dixon, 'The emergence of a global company', *Financial Times*, 2 October 1989.

23 Levitt, op. cit., pp. 30–1.

24 N. Ascherson, 'Europe 2000', *Marxism Today* (January 1990): 17.

25 On locality and localism, see A. Jonas, 'A new regional geography of localities?', *Area* 20(2) (1988): 101–10; on regionalism, A. Gilbert, 'The new regional geography in English and French-speaking countries', *Progress in Human Geography* 12(2) (1988): 208–28.

26 On the 'flexible specialization' thesis, M. Piore and C. Sabel, *The Second Industrial Divide: Possibilities for Prosperity* (New York: Basic Books, 1984); P. Hirst and J. Zeitlin (eds), *Reversing Industrial Decline? Industrial Structure and Policy in Britain and her Competitors* (Oxford: Berg, 1989); P. Hirst and J. Zeitlin, 'Flexible special-isation and the competitive failure of UK manufacturing', *Political Quarterly* 60(2) (1989): 164–78; the special issue on 'Local industrial strategies' of *Economy and Society* 18(4) (1989). For discussion and critique, see A. Amin and K. Robins, 'The re-emergence of regional economies? The mythical geography of flexible

accumulation', *Environment and Planning D: Society and Space* 8(1) (1990): 7–34; A. Amin and K. Robins, 'Jeux sans frontières: verso un'Europa delle regioni?', *Il Ponte* 46 (1990).

27 See A. Cochrane (ed.), *Developing Local Economic Strategies* (Milton Keynes: Open University Press, 1987), A. Cochrane, 'In and against the market? The development of socialist economic strategies in Britain, 1981–1986', *Policy and Politics* 16(3) (1988): 159–68.

28 Wright, op. cit.; Prince of Wales, *A Vision of Britain: A Personal View of Architecture* (London: Doubleday, 1989); C. Jencks, *The Prince, the Architects, and New Wave Monarchy* (London: Academy Editions, 1988).

29 D. Ley, 'Modernism, post-modernism, and the struggle for place', in Agnew and Duncan, op. cit., p. 60.

30 A. Pred, 'The locally spoken word and local struggles', *Environment and Planning D: Society and Space* 7(2) (1989): 211–33.

31 C. F. Alger, 'Perceiving, analysing and coping with the local–global nexus', *International Social Science Journal* 117 (1988): 321–40.

32 Quoted in W. Scobie, 'Carlo, suitor to La Grande Dame', *Observer*, 14 February 1988.

33 Wagstyl, op. cit.

34 C. Brown, 'Holston exports', *Broadcast*, 13 October 1989, p. 44.

35 Home Office, *Broadcasting in the '90s: Competition, Choice and Quality*, Cm. 517 (London: HMSO, 1988), p. 42.

36 Department of Trade and Industry, *DTI – the Department of Enterprise*, Cm. 278 (London: HMSO, 1988), p. 3. See also M. J. Wiener, *English Culture and the Decline of the Industrial Spirit 1850–1980* (Cambridge: Cambridge University Press, 1981).

37 For an extended discussion of the 'British disease' and of the counter-offensive being waged by the protagonists of enterprise culture, see K. Robins and F. Webster, *The Technical Fix: Education, Computers and Industry* (London: Macmillan, 1989), Ch. 5.

38 S. Lash and J. Urry, *The End of Organised Capitalism* (Cambridge: Polity Press, 1987), pp. 86, 101–2.

39 H. Häussermann and W. Siebel, *Neue Urbanität* (Frankfurt: Suhrkamp, 1987). See also *An Urban Renaissance: The Role of the Arts in Inner City Regeneration and the Case for Increased Public/Private Sector Cooperation* (London: Arts Council of Great Britain, 1987).

40 Even if it is the case that 'the serial reproduction of the same solution generates monotony in the name of diversity', D. Harvey, 'Down towns', *Marxism Today* (January 1989): 21.

41 I. Page, 'Tourism promotion in Bradford', *The Planner* (February 1986): 73.

42 J. Whelan, 'Destination Newcastle', *Intercity* (November 1989): 26.

43 B. Foster and D. Williams, 'Farewell to Andy Capp', *Observer*, 4 June 1989. See also, P. Young, 'Let's drive out Andy Capp!', *Evening Chronicle* (Newcastle), 22 November 1989; R. Baxter, 'Comment Thatcher a tué Andy Capp', *Politis* 60 (1989): 46–9.

44 See P. Hetherington and F. Robinson, 'Tyneside life', in F. Robinson (ed.), *Post-Industrial Tyneside: An Economic and Social Survey of Tyneside in the 1980s* (Newcastle upon Tyne: Newcastle upon Tyne City Libraries and Arts, 1989), pp. 189–210

45 M. Conte-Helm, *Japan and the North East of England: From 1862 to the Present Day* (London: Athlone Press, 1989).

46 T. Gitlin, 'Postmodernism: roots and politics', *Dissent* (Winter 1989): 101.

47 P. Emberley, 'Places and stories: the challenge of technology', *Social Research* 56(3) (1989): 755–6, 748.

48 R. Sennett, *The Uses of Disorder* (Harmondsworth: Penguin, 1971), p. 15.

49 D. Sibley, 'Purification of space', *Environment and Planning D: Society and Space* 6(4) (1988): 410.

50 I. Baruma, 'From Hirohito to Heimat', *New York Review of Books*, 26 October 1989, p. 43.

51 E. Wolf, *Europe and the People Without History* (Berkeley: University of California Press, 1982), p. 387. See also T. Mitchell, 'Culture across borders', *Middle East Report* (July–August 1989): 4–6.

52 T. Brennan, 'Cosmopolitans and celebrities', *Race and Class* 31(1) (1989): 4, 9.

53 S. Rushdie, 'Imaginary homelands', *London Review of Books* (7–20 October 1982); p. 19.

54 D. Hebdige, 'Fax to the future' *Marxism Today* (January 1990): 20.

55 H. Kureishi, 'England, your England', *New Statesman and Society* (21 July 1989); p. 29.

Stuart Hall

CULTURE, COMMUNITY, NATION

[. . .]

I STILL RECALL THE SHOCK of recognition which I experienced on reading Raymond Williams's response to his interviewers' questions in *Politics and Letters*, about the impact of Cambridge on him when he first went 'up' in October 1939: 'I was', he said, 'wholly unprepared for it. I knew nothing about it' (1979: 40). [. . .]

What was striking was the confidence with which Raymond Williams was able to measure the so-called 'civilization' of Cambridge against another civility, another set of standards, drawn from his experience of an alternative, and different, 'knowable community' – his Welsh 'Border Country' – against which he found Cambridge sadly wanting:

> I was reminded of a conversation my father had reported to me from his advance visit [to Trinity]. The porter had asked him, rather haughtily, whether my name was already down, 'Yes, since last autumn'. 'Last autumn? Many of them, you know, are put down at birth.' I try to be charitable and find it easier now. But I remember sitting on the benches in hall surrounded by these people and wishing they *had* been put down at birth. . . . The myth of the working-class boy arriving at Cambridge . . . is that he is an awkward misfit and has to learn new manners. It may depend on where you come from. Out of rural Wales it didn't feel like that. The class which has dominated Cambridge is given to describing itself as well-mannered and polite, sensitive. It continually contrasts itself favourably with the rougher and coarser others. When it turns to the arts it congratulates itself overtly on its taste and its sensibility; speaks of its poise and tone. If I then say that what I found was an extraordinarily coarse, pushing, name-ridden group, I shall be told I am showing class-feeling, class envy,

> class resentment. That I showed class feeling is not in any doubt. All
> I would insist on is that nobody fortunate enough to grow up in a good
> home in a genuinely well-mannered and sensitive community, could
> for a moment envy these loud, competitive, deprived people. All I did
> not know then was how cold that class is. That comes with experience.
>
> (1989b: 7–8)

What made Raymond Williams capable of, as he put it later, 'hitting Cambridge and being extraordinarily unafraid of it'? It was his 'placing' within another culture; his access to a different, 'knowable' community, indeed another national culture, a different 'structure of feeling'. Though subordinated to and displaced in its peripheral relationship to the dominant English culture, and with the culture of the educated, metropolitan, upper middle classes, this other 'knowable community' provided him with certain cultural resources, which enabled him to live and feel, and later to write and think, according to a different grain from that of 'Cambridge'. It was this, in turn, which influenced the way he thought about, and gave an experiential, 'lived', dimension to, such 'key ideas' as 'culture' and 'community', and indeed Wales as a nation and 'being Welsh' as a cultural identity, when later he came to reflect on this cluster of concepts. [. . .]

In his discussion of 'culture', in the famous chapter on 'The analysis of culture' in *The Long Revolution*, his pathbreaking attempt to break with the literary-moral discourse of *Culture and Society* into a more sustained effort of general theorizing, the key conceptual move he makes is from an 'abstract' definition of culture – a state or process of human perfection – to culture as 'a description of a particular way of life which expresses certain meanings and values, not only in art and learning, but in institutions and ordinary behaviour'. Culture, he insisted, with his characteristic inflection on 'our common life', is 'ordinary'. The analysis of culture, from such a definition, he argued, 'is the clarification of the meanings and values implicit and explicit in a particular way of life, a particular culture'. [. . .]

Later he was to insist that the more specialized forms and conventions of what Cambridge knew as 'literature' were most valuably to be understood as different kinds of 'writing', all related in different ways and forms to wider 'structures of feeling', the way meanings and values were *lived* in real lives, in actual communities. 'The most difficult thing to get hold of, in studying any past period, is this felt sense of the quality of life at any particular place and time; a sense of the ways in which the particular activities combined into a way of thinking and living. . . . I think we can best understand this if we think of any similar analysis of a way of life that we ourselves share' (1961: 80). He called this 'most delicate and least tangible' of structures the 'structure of feeling' of a period. Edward Said, the 1989 Williams Memorial lecturer, thought this concept, which enabled him to move beyond 'the ideological capture of the text into the life of the communities beyond it', his 'most famous contribution to literary study' (1990).

Incidentally, few people know that one of the first, considered formulations of this central idea in Williams's work first appeared in a little book entitled *Preface to Film*, which he wrote and published (in 1954) with Michael Orrom, a film director who worked with Paul Rotha and whom Raymond met at Cambridge:

All the products of a community in a given period are, we now commonly believe, essentially related, although in practice and in detail this is not always easy to see. In the study of a period, we may be able to reconstruct with more or less accuracy the material life, the general social organization and, to a larger extent, the dominant ideas. It is not necessary to discuss here which, if any, of these aspects is, in the whole complex, determining. . . . But while we may, in the study of a past period, separate out particular aspects of life, and treat them as if they were self-contained, it is obvious that this is only how they may be studied, not how they are experienced.

(1954: 9)

Even when, in *The Long Revolution,* his rather 'organicist' stress on culture as 'a whole way of life' moves in a more dialogic direction, to an emphasis on the giving and taking of meanings within a set of lived relations, this new emphasis on 'communication' is immediately linked back to and informs the idea of 'community':

Human community grows by the discovery of common meanings and common means of communication. . . . Thus our descriptions of our experience come to compose a network of relationships, and all our communication systems, including the arts, are literally parts of our social organization. The selection and interpretation involved in our descriptions embody our attitudes, needs and interests, which we seek to validate by making them clear to others. At the same time the descriptions we receive from others embody their attitudes, needs and interests, and the long process of comparison and interaction is our vital associative life. Since our way of seeing things is literally our ways of living, the process of communication is in fact the process of community: the sharing of common meanings, and thence common activities and purposes; the offering, reception and comparison of new meanings, leading to the tensions and achievements of growth and change.

(1961: 10)

Theoretically, Williams's formulations grew over the years in both complexity and confidence – *Marxism and Literature* is a powerfully condensed statement of his more mature reflections on these topics. But the emphases we have identified in the early work remain active to the end.

What does his difficult wrestling with these questions of culture, community, shared experience and national identity have to tell us now in the more highly charged era of revived nationalisms in big and small societies, and the aspirations of marginalized peoples to nationhood, which have become so unexpectedly a feature of the late-modern world of the 1990s and are transforming the cultural life of modernity? How useful are they in helping us to decipher the unpredicted 'return' of nationalism as a major historical force, and the efforts to restore national cultures as the primordial source of cultural identity as these tendencies are manifesting themselves today, well beyond the limits of the national-liberation struggles that marked the decolonizing moment of the immediate post-war decades?

How much can we learn from him in negotiating the shoals and currents of these confusing and dangerous waters?

We have, first, to set the context by trying, however sketchily, to characterize this 'new' situation. The great discourses of modernity – in this respect Marxism no less than liberalism, both in their different ways, Enlightenment 'grand narratives' – led us to expect, not the revival but the gradual disappearance of the nationalist passion. Attachments to nation, like those to tribe, region, place, religion, were thought to be archaic particularisms which capitalist modernity would, gradually or violently, dissolve or supersede. Socialism, the 'counter-culture of modernity' in Zygmunt Bauman's phrase, was equally predicated on the subsumption of these particularisms into a more cosmopolitan or internationalist consciousness. Globalization, drawing more and more of the globe into the net of the global capitalist market, is, of course, no recent, post-'Big Bang' phenomenon. It has been going on since the Spanish and the Portuguese initiated the West's 'encounter' with the Rest at the end of the fifteenth century. The recent integration of financial systems, the internationalization of production and consumption, the spread of global communications networks, is only the latest – albeit distinctive – phase in a long, historical process.

However, this latest phase of capitalist globalization, with its brutal compressions and reorderings across time and space, has not necessarily resulted in the destruction of those specific structures and particularistic attachments and identifications which go with the more localized communities which a homogenizing modernity was supposed to replace. Of course, the forces of capitalist modernity, in their combined and uneven development, have radically dislocated the societies into which they penetrated (though this distinctive history of capitalist development has, classically, been subordinated in its narrativization to the quite different story of how capitalism peacefully 'evolved' from the womb of feudal Europe). But the so-called 'logic of capital' has operated as much *through* difference – preserving and transforming difference (including sexual difference) – not by undermining it.

The engine of this expansionist history was the European nation-state, with its well-defined territorial boundaries, national economies and increasingly national cultures. Of course, side by side with this, were the flows – of capital, goods, labour – *between and across* national frontiers. As Immanuel Wallerstein has observed, 'At the very moment that one has been creating national cultures, each distinct from the other, these flows have been breaking down national distinctions' (1991: 19). This tension between the tendency of capitalism to develop the nation-state and national cultures and its transnational imperatives is a contradiction at the heart of modernity which has tended to give nationalism and its particularisms a peculiar significance and force at the heart of the so-called new transnational global order. Negotiating this tension was one of the key conjuring tricks of Thatcherism; and it was its failure to resolve this tension – the illusion that Britain could snatch the goodies of a 'single market' without sacrificing an inch of national sovereignty or 'Englishness' as a cultural identity to the European idea – which finally destroyed Mrs Thatcher and which brought her successors [. . .] to the brink of the post-Maastricht abyss.

Nevertheless, the present intensified phase of globalization has favoured the tendencies pushing nation-states towards supranational integration – economic,

and, more reluctantly, political and cultural: weakening without destroying the nation-state and thereby opening up local and regional economies both to new dislocations and to new relationships. Paradoxically, globalization seems also to have led to a strengthening of 'local' allegiances and identities *within* nation-states; though this may be deceptive, since the strengthening of 'the local' is probably less the revival of the stable identities of 'locally settled communities' of the past, and more that tricky version of 'the local' which operates within, and has been thoroughly reshaped by, 'the global' and operates largely within its logic.

One result has been a slow, if uneven, erosion of the 'centred' nationalisms of the Western European nation-state and the strengthening of both transnational relations and local identities – as it were, simultaneously 'above' and 'below' the level of the nation-state. Two features of this very uneven process have been the re-valorization of smaller, subordinate nationalisms and movements for national and regional autonomy by precisely those groups whose identities were swallowed up by or subsumed under what Ernest Gellner calls the 'political roof' of the big nation-states, and the parallel growth of a defensive reaction by those national cultures which see themselves threatened from their peripheries. We can see this not only in the strengthening of regional and national identities within the UK (or, as Raymond Williams calls it, 'The Yookay') but also in the growing efforts of local centres attempting to by-pass blockages of various kinds at the national level – Scotland's dream of breaking the English connection and restoring its Enlightenment links with Europe; the possibility of subsuming Northern Ireland's intractable problems in some sort of 'European' solution. Williams himself reflects the ambivalence of identification produced by these two tendencies when he referred to himself as feeling like a 'Welsh-European'. But there are similar signs elsewhere in Europe, the growth of the Northern League in Italy, as a way of dissociating the industrial (and, as it turns out, corrupt) Milan from the 'backward' (and, of course, equally corrupt) South, being only the most recent example.

At the same time as this has been going on in Western Europe, we have seen the break-up of the Soviet Union and Eastern Europe and the revival of ethnic nationalisms amongst peoples submerged for decades within the supernationalism of the Soviet sphere of influence. This seems to reflect a complicated double-movement – the attempt to reconstitute themselves as a nation representing both the reaction against the Soviet and state-socialist past and the hope for the future – which may turn out to be illusory – that 'nationhood' is the only passport or entry-ticket left for backward East Europeans to the new Western European prosperity.

Hence the confusing spectacle of what we may call ascending and descending nationalisms, locked in a sort of combined-and-uneven double helix. It seems clear that, despite the often over-rationalist expectations favoured by the internationalist perspectives of the left, nationalism is not only *not* a spent force; it isn't *necessarily* either a reactionary or a progressive force, politically. We have seen plenty of both varieties in recent years – even supposing that it is easy to establish the criteria by which they can be easily distinguished (is Iraqi nationalism progressive because it opposes the West or reactionary because it holds its people in a crude and violent dictatorial grip?). [. . .]

The nation-state was never simply a political entity. It was always also a symbolic formation — a 'system of representation' — which produced an 'idea' of the nation as an 'imagined community', with whose meanings we could identify and which, through this imaginary identification, constituted its citizens as 'subjects' (in both of Foucault's senses of 'subjection' — subject of and subjected to the nation). There is no question, then, that the relative decline of the centralized nation-states, with their incorporating cultures and national identities, implanted and secured by strong cultural institutions, which claimed to be able to subsume all differences and diversity into their imagined unity, opens up profound ambivalences and fissures within the discourse of the nation-state and thus presents unprecedented opportunities for smaller nationalisms to realize their aspirations for autonomy in new, more effectively self-governing arrangements. This is the perspective which Raymond Williams addressed, with increasing frequency and urgency, in his writing about Wales and other struggles for 'actual social identities', especially in *Towards 2000*, but of course also, in a different register, in his fiction.

Nevertheless, it is important to acknowledge that the drive to nationhood in many of the 'ascending' small nationalisms can often take the form of trying to construct ethnically (or culturally, religiously or racially) closed or 'pure' formations in the place of the older, corporate nation-states or imperial formations; a closure which comes, in Gellner's terms, from trying to realize the aspiration, which they see as the secret of success of the great, modernizing nation-states of Western modernity, of gathering *one* people, *one* ethnicity, gathered under *one* political roof.

But the history of the nation-states of the West has *never* been of this ethnically pure kind. Without exception, as Daffyd Ellis Thomas, the former Plaid Cymru MP, pointed out again recently, they are without exception ethnically hybrid — the product of conquests, absorptions of one people by another. It has been the main function of national cultures which, as we argued, are systems of representation, to *represent* what is in fact the ethnic hotch-potch of modern nationality as the primordial unity of 'one people'; and of their invented traditions to project the ruptures and conquests, which are their real history, backwards in an apparently seamless and unbroken continuity towards pure, mythic time. What's more, this 'hybridity' of the modern nation-state is now, in the present phase of globalization, being compounded by one of the largest forced and unforced mass migrations of recent times. So that, one after another, Western nation-states, already 'diaspora-ized' beyond repair, are becoming inextricably 'multicultural' — 'mixed' ethnically, religiously, culturally, linguistically, etc.

Despite this, many of the new nationalisms are busy trying, often on the basis of extremely dubious myths of origin and other spurious claims, to produce a purified 'folk' and to play the highly dangerous game of 'ethnic cleansing' — to use the charming phrase which the Serbs have returned to the postmodern European vocabulary. Here, real dislocated histories and hybridized ethnicities of Europe, which been made and remade across the tortured and violent history of Europe's march to modernity, are subsumed by some essentialist conception of national identity, by the surreptitious return to 'tradition' — often of the 'invented' kind, as Hobsbawm and Ranger define it — which recasts cultural identity as an unfolding essence, moving apparently without change, from past to future.

Lest we think that this kind of ethnic absolutism is restricted to the Balkans – which Western Europeans have always thought unfit to govern themselves – we must remember that versions of it are alive and well in the old 'modern' nation-states, especially in the wake of the multicultural diversity which the dislocations of globalization are pushing along. We can now see Thatcherism's question – 'Are you one of us?' – not only as a search for true converts to the Gospel of Market Forces, but as only the latest effort, still continuing, to resurrect that rapidly vanishing species, the late-twentieth-century 'true born Englishman' (the gendered form is deliberate) and to rediscover, by a virulent form of regressive modernization (an attempt to capture the future by a determined long detour through the past), those discursive forms of manly and entrepreneurial 'greatness' which could restore 'Englishness' as a beleaguered national identity: that cultural identity into which all the other diverse cultures of the British Isles and, at its peripheries, the colonized societies, were so often and so brutally collapsed.

In the face of the proliferation of cultural difference 'at home', and the multi-ethnic character of the 'new Britain', and threatened on the other side by the encroaching trauma of an emerging 'European' identity, we have seen in Britain, over the past decade, the construction of a particularly defensive, closed and exclusive definition of 'Englishness' being advanced as a way of warding off or refusing to live with difference – a retreat from modernity which no exercise in managerial newspeak or 'the new entrepreneurialism' can disguise or deflect. [. . .] 'Cultural belongingness' (redefined as an old, exclusive form of ethnicity) has replaced genetic purity and functions as the coded language for race and colour. As Paul Gilroy observed in *There Ain't No Black in the Union Jack*:

> A form of cultural racism which has taken a necessary distance from crude ideas of biological inferiority now seeks to present an imaginary definition of the nation as a unified *cultural* community. It constructs and defends an image of national-culture, homogeneous in its whiteness yet precarious and perpetually vulnerable to attack from enemies within and without.
>
> (1987: 49–50)

Something of the same fear of difference and diversity can be seen, in different forms, everywhere in the 'New Europe', as the most heterogeneous peoples hastily cobble together some new unitary cultural identity as a shield, not only against neighbours with whom they have peacefully dwelled for centuries, but also against Muslim, North African, Turkish and other migrants drawn to Europe from its peripheries. We can see it reflected in the consciously 'Little England' schemes drawn up for teaching literature and history – the key discourses in the construction of national identity – in the new English National Curriculum for schools.

[. . .]

The responses to massive unplanned movements of populations from the declining 'South' to the overfed 'North' under the impact of globalization, powered as they are by polite and other forms of ethnic absolutism, are a species of *fundamentalism*

every bit as backward-looking as those to be found in some sections of the Islamic world. These have replaced Communism in the demonology of the West and are superficially portrayed as the sign of a retreat from modernity by backward peoples, when they are often ambiguous responses by those either left out of 'modernity' or ambiguously and partially incorporated in one of its many forms, whereas the fundamentalisms which are afflicting 'modern' national cultures not only are arising from the very heart of modernity but are a continuing reminder of the dark shadow which has persistently accompanied modernity and the European Enlightenment from its inception.

In the face of these dislocations, it is easy to understand why Raymond Williams again and again affirms what he calls the 'rooted settlements', 'lived, worked and placeable social identities', to set off against what he persistently characterizes as the 'abstractions' of modern national cultural identities. With unerring accuracy, he places who or what is responsible for these dislocations, against which national identity has so frequently in the past been summoned as a reliable defence: 'It is, in the modern epoch, capitalism which has disrupted and over-ridden natural communities and imposed artificial orders. It is then a savage irony that capitalist states have again and again succeeded in mobilizing patriotic feelings in their own forms and interests' (1983: 184).

The persistent emphasis in Williams on 'actual lives' in 'knowable communities' is salutary in the current post-Maastricht confusion. For, much as one may support the shift from a narrow little Englandism to a broader European perspective, welcoming this enlarging and diversification of 'English' perspectives, one has also to acknowledge that the idea that, overnight, something called a 'European identity' or culture could be willed into being at the behest of a single market or the requirements of the European banking system, represents a conception of culture and an understanding of the mechanisms of social identification so shallow and 'abstract', in Raymond Williams's terms, that it deserves the comeuppance which the Danish so tellingly delivered to the European Community in their 1992 referendum. The more one 'believes in Europe' or, to put it more accurately, the more the question of Europe appears to be a contested concept worth struggling over and around, the more important are the questions of 'which Europe?', and of 'what is European culture?' and 'whose European identity?' and 'which version of European modernity?' and indeed of how and whether it might ever be possible to be both 'Black *and* European'.

Williams certainly appreciated the complexities of trying to restore an already unified Welsh identity around any single notion of Wales as a national community. Despite the wonderful work he did in his novels in imaginatively re-creating it as an 'imagined community', he often acknowledged his problematic relationship to Wales. His family, after all, were not Welsh-speaking, though they learned Welsh poems and songs for special occasions. His early 'hostility to the norms of Welsh nonconformist community' resulted initially in 'a rejection of my Welshness which I did not work through until well into my thirties, when I began to read the history and understand it'. Again and again, as we might expect, he insists that 'I have to emphasize great complexity in Wales and England'. Welshmen are always asking what Wales actually was, 'The problematic element is characteristic' (1989c: 68).

He fully understood the essentially mythic and constructed discourse of 'essential cultural continuity' with which the Welsh sometimes console themselves for what has happened to them. [. . .] The Welsh national cultural revival, he insists, requires 'the working through of a history among now radically dislocated and subordinated people, rather than the fortunate resurgence of a subdued essence' (1989c: 68).

Nevertheless, the emphasis on 'actual and sustained social relationships' as the principal basis of identification and cultural 'belongingness' presents many real difficulties which take us back to that original stress, in Williams's work, on culture and community as a 'whole way of life'. Whose *way*? Which *life*? One way or several? Isn't it the case that, in the modern world, the more we examine 'whole ways of life', the more internally diversified, the more cut through by complex patterns of similarity and difference, they appear to be? Modern people of all sorts and conditions, it seems, have had, increasingly, as a condition of survival, to be members, simultaneously, of several, overlapping 'imagined communities'; and the negotiations between and across these complex 'borderlines' are characteristic of modernity itself. Lest one think that this capacity to live in and negotiate several 'worlds' at once is a sign of the modern alienated condition, a burden laid on the postmodern, Western nomadic subject alone, it is worth recalling that the burden of 'double consciousness' which W. E. B. DuBois identified, was the burden of consciousness, not of the Master but the Slave, and his/her descendants, who – as C. L. R. James observed – are 'in western civilization, who have grown up in it but yet are not completely a part of it'.[1]

In *Towards 2000*, Williams discusses the response of the white working-class man to what he calls – too euphemistically by half – 'the most recent immigrations of more visibly different peoples' and the angry confusions and prejudices which are triggered when, as he puts it, the blacks (for it is them – us – who are the 'visibly different peoples') 'intersect with the most selective forms of identity'. He acknowledges that the reaction to the presence of foreigners easily slides into specifying this 'otherness' as black. But he objects to this always being labelled 'racism' and especially to what he calls the 'standard liberal reply', 'But they are as British as you are', which, he argues, is to employ 'a merely legal definition of what it is to be British'.

> It is a serious misunderstanding when full social relations are in question to suppose that the problems of social identity are resolved by formal definitions. For unevenly and at times precariously but always through long experience substantially, an effective awareness of social identity depends on actual and sustained social relationships. To reduce social identity to formal legal definitions at the level of the state, is to collude with the alienated superficialities of 'the nation' . . . which are the limited functional terms of the modern ruling class.
>
> (1983: 195)

This passage seems to me to contain a series of powerful truncations and ellipses and it is therefore no surprise that, in a now famous exchange in *There Ain't No Black in the Union Jack*, Paul Gilroy, quite correctly, fastened on it as representing

in its implications a racially exclusive form of social identity, and a sign of the degree to which Williams's work, like so much other thinking on the left, remains both blind to questions of race and framed by certain unexamined 'national' cultural assumptions. As Gilroy asked, How 'full' must 'full social relations' be? How 'actual' are the social relationships between blacks and whites in many inner-city communities and how 'sustained' do they have to be to include equality of respect? It is true that social identity cannot be reduced to formal legal definitions. But it is a serious misjudgement to ascribe it exclusively to 'the alienated superficialities of "the nation" and the functional terms of the modern ruling class'. If you are a black woman trying to secure rights of citizenship from the local DHS office or an Asian family with British residence running the gauntlet of the immigration authorities at Heathrow, 'formal legal definitions' matter profoundly. They cannot be made conditional on cultural assimilation.

It should not be necessary to look, walk, feel, think, speak exactly like a paid-up member of the buttoned-up, stiff-upper-lipped, fully corsetted 'free-born Englishman' *culturally* to be accorded either the informal courtesy and respect of civilized social intercourse or the rights of entitlement and citizenship. This is to apply the Tebbit cricket test (i.e. which cricket team do Afro-Caribbeans support when the West Indies is touring Britain?) with a vengeance – subsuming cultural allegiance to the vagaries of the batting form of the England cricket team (a slender reed indeed), as the price of drawing the family allowance. [. . .] We need to be able to insist that rights of citizenship and the incommensurabilities of cultural difference are respected and that *the one is not made a condition of the other*. In this sense, unless the universalistic language of citizenship, derived from the Enlightenment and the French Revolution (but long denied both women in Europe and black slaves in Hispaniola) is transformed in the light of the proliferation of cultural difference, the idea cannot and does not deserve to survive in the transformed conditions of late-modernity in which it is required to become substantively operable.

Since cultural diversity is, increasingly, the fat of the modern world, and ethnic absolutism a regressive feature of late-modernity, the greatest danger now arises from forms of national and cultural identity – new or old – which attempt to secure *their* identity by adopting closed versions of culture or community and by the refusal to engage – in the name of an 'oppressed white minority' (*sic*) – with the difficult problems that arise from trying to live with difference. The capacity to *live with difference* is, in my view, the coming question of the twenty-first century. New national movements that, in their struggle against old closures, reach for too closed, unitary, homogeneous and essentialist a reading of 'culture' and 'community' will have succeeded in overcoming one terrible historical hurdle only to fall at the second.

[. . .]

I feel compelled to close, as it were, from another place. From the place of the millions of displaced peoples and dislocated cultures and fractured communities of the 'South', who have been moved from their 'settled communities', their 'actual lived relations', their 'placeable feelings', their 'whole ways of life'. They have had to learn other skills, other lessons. They are the products of the new

diasporas which are forming across the world. They are obliged to inhabit at least two identities, to speak at least two cultural languages, to negotiate and 'translate' between them. In this way, though they are struggling in one sense at the margins of modernity, they are at the leading edge of what is destined to become the truly representative 'late-modern' experience. They are the products of the cultures of hybridity. This notion of hybridity is very different from the old internationalist grand narrative, from the superficiality of old-style pluralism where no boundaries are crossed, and from the trendy nomadic voyaging of the postmodern or simplistic versions of global homogenization – one damn thing after another or the difference that doesn't make a difference. These 'hybrids' retain strong links to and identifications with the traditions and places of their 'origin'. But they are without the illusion of any actual 'return' to the past. Either they will never, in any literal sense, return or the places to which they return will have been transformed out of all recognition by the remorseless processes of modern transformation. In that sense, there is no going 'home' again. That is why they speak and sing and write so eloquently within the metaphorical languages of 'voyaging', travelling and 'return'.

[. . .] They are the product of a diasporic consciousness. They have come to terms with the fact that in the modern world, and I believe irrevocably, identity is always an open, complex, unfinished game – always under construction. As I remarked elsewhere, it always moved into the future through a symbolic detour through the past (Hall, 1990). It produces new subjects who bear the traces of the specific discourses which not only formed them but enable them to *produce themselves anew and differently*. [. . .]

Notes

1 The idea of 'Double consciousness' is from W. E. B. Dubois (1989).

References

DuBois, W. E. B. (1989) *The Souls of Black Folks*, Harmondsworth: Penguin.

Gilroy, Paul (1987) *There Ain't No Black in the Union Jack*, London: Hutchinson.

Hall, Stuart (1990) 'Cultural identity and diaspora', in Jonathan Rutherford (ed.), *Identity*, London: Lawrence & Wishart.

Hall, Stuart (1993) 'The Raymond Williams interviews', *Screen Education* 34. Reprinted in Alverado, M., Buscombe, E. and Collins, R. (eds), *The Screen Education Reader*, London: Macmillan.

Rushdie, Salman (1992) *Imaginary Homelands*, London: Granta Books.

Said, Edward (1990) 'Narrative, geography and interpretation', *New Left Review*, 180.

Wallerstein, Immanuel (1991) 'The national and the universal', in A. King (ed.), *Culture, Globalization and the World System*, London: Macmillan.

Williams, Raymond (1961) *The Long Revolution*, Harmondsworth: Penguin.

Williams, Raymond (1979) *Politics and Letters*, London: New Left Books.

Williams, Raymond (1983) *Towards 2000*, London: Chatto & Windus.

Williams, Raymond (1989a) *What I Came to Say*, London: Radius.

Williams, Raymond (1989b) 'My Cambridge', in Williams (1989a)

Williams, Raymond (1989c) 'Wales and England', in Williams (1989a).

Williams, Raymond and Orrom, Michael (1954) *Preface to Film*, London: Film Drama Limited.

Anthony D. Smith

HISTORY AND MODERNITY
Reflections on the theory of nationalism

PHENOMENA AS COMPLEX as the nation and nationalism may be examined from many angles: for their ubiquity and variety, their scope and salience, their social and cultural background, their political influence and geopolitical impact, and their significance for social theory.

None of these, however, provides the main focus for this essay, though all are involved in some way. Here I want to return to a fundamental debate, or set of debates, in the theory of nationalism: the question of the nation's role in history, and more specifically, of the modernity of nationalism.

Today, the 'theory of nationalism' is predominantly 'modernist'. That is to say, the majority of scholars, while acknowledging the existence of ethnic ties prior to the modern era, locate the nation and nationalism in the modern era, variously dated to the period after the French Revolution, or perhaps the Reformation. This is particularly, and quite explicitly the case, in the most elaborated and probably best-known of the modernist theories, that of Ernest Gellner. It is to his theory that I wish to return as the fullest, most original and most forthright statement of the modernist approach.

The modernist approach

For Ernest Gellner, nationalism, the 'political principle, which holds that the political and the national unit should be congruent', is modern in the double sense that it is a fundamental feature of the modern world, and a product and producer of that world. The idea that all nations should have their own political roofs may be an outgrowth of Enlightenment ideas, but it accords with the fundamental ordering of modern, industrial society. So, while nationalism is obviously logically contingent, it is *sociologically necessary* in the modern world. His theory attempts to explain why this should be so (Gellner, 1965: 150–1; Gellner, 1983b: 1).

Gellner starts by distinguishing three epochs of human history: that of the hunter-gatherer, the agro-literate and the modern, industrial societies. In the first, largely acephalous type, there is not enough centralised power to conjoin to culture, hence nations and nationalism are inconceivable. In the agro-literate societies, however, which are often also centralised states, power and culture are united according to rank: there is a set of horizontal strata, aristocratic, military, bureaucratic, priestly, who form the elites and who use culture to mark out their separate status from the rest of the population. The vast majority of that population consists of food-producers, organised in small local communities, and 'Small peasant communities generally live inward-turned lives, tied to the locality by economic need if not by political prescription.' Moreover 'local culture is almost invisible', with the self-enclosed community communicating in terms of *contextual* meaning. So: 'Culture tends to be branded either horizontally (by social caste), or vertically, to define very small local communities.' The upshot is that, in sharply stratified agro-literate societies, there can be no cultural homogenisation of larger populations, and hence no nations. Even the clerisy in such societies, the only stratum which might have an interest in cultural imperialism, either has no interest in seeing its norms and rituals imitated (as with the Brahmins) or simply has not the resources to spread its norms to all the members of a wider society (Gellner 1983b: 12, 16–17; cf. Gellner 1983a).

Industrial societies, in contrast, require nations and nationalism. The reason is simple:

> In an age of universalised clerisy and Mamluk-dom, the relationship of culture and polity changes radically. A high culture pervades the whole of society, defines it and needs to be sustained by the polity. *That* is the secret of nationalism.
>
> (Gellner 1983b: 18)

The central idea of modern society is that of progress, because modern, industrial society lives on and is sustained by perpetual growth. Ours is a society of endless discovery. It is also a fluid society, one whose productivity depends on a rapidly changing division of labour. In contrast to the hierarchical and relatively stable pre-modern societies, modern society 'is egalitarian because it is mobile'. That, at least, is its ideal and goal, if not always its practice (ibid.: 24–5).

Public education and political fission

It is also a highly specialised society. At the same time, its specialisms are more closely related to each other than those of pre-industrial societies. That is why they require a much more rigorous common or *generic* training, which precedes a specialist training on and for the job. It follows that the education systems of industrial societies are much more public, homogenous, standardised and diploma-dependent. They also have a far more important role in modern societies than the earlier contextual and often familial education of pre-modern societies. Exo-education systems provide a thorough training for the whole population in

the uses of precise, context-free and explicit meanings in a standard idiom and often in writing. Only large and complex exo-socialisation systems can train whole populations to be 'clerks', and hence literate, numerate and effective citizens of modern states. Consequently, the size of these systems provides the lower limit for the size of modern political units (Gellner, 1983b: 27–9, 33–4; Gellner, 1973: 6–9).[2]

Today it is education, and education in a particular language and culture, that confers identity, security and self-respect. "Modern man is not loyal to a monarch or a land or a faith, whatever he may say, but to a culture" (Gellner, 1983b: 36).

But only the state is large and powerful enough to sustain and control the public system of mass education, which in turn is the sole mechanism for training people in the shared, literate 'high' culture required for a modern, industrial society. Hence,

> the imperative of exo-socialisation is the main clue to why state and culture *must* now be linked, whereas in the past their connection was thin, fortuitous, varied, loose and often minimal. Now it is unavoidable. That is what nationalism is about, and why we live in an age of nationalism.
>
> (Gellner, 1983b: 38)

In short 'nationalism is indeed an effect of industrial social organisation', though other purely historical factors (the Reformation, colonialism) may have contributed to its spread. Hence both the weakness and the strength of nationalism. It is weak in its *own* terms, because only a small proportion of the potential cultural candidates for the status of nation actually make the claim; most of these linguistic cultures remain 'determined slumberers', in nationalist terms. They are the 'wild' cultures, spontaneous, undirected, without special nutrition, as opposed to the 'garden' or specially cultivated, literate cultures of the modern era. On the other hand, nationalism is strong in the modern world because practically every state today must legitimate itself in terms of the national principle, and because cultural homogeneity is imposed by the requirements of industrialism (Gellner, 1983b: 40, 48, 50).

For Gellner, cultures are often overlapping, subtly grouped and intertwined, yet have always constituted an important reality. Political units too have been a significant, if variable, factor in history. Nations and nationalism, on the other hand, have only become important in the modern, industrial era:

> Nations as a natural God-given way of classifying men, as an inherent though long-delayed political destiny, are a myth; nationalism, which sometimes takes pre-existing cultures and turns them into nations, sometimes invents them, and often obliterates pre-existing cultures: *that* is a reality, for better or worse, and in general an inescapable one.
>
> (Gellner 1983b: 48–9, italics in original)

The modern, industrial world can be likened to a series of structurally similar giant aquaria, sporting superficial cultural differences. The water and atmosphere in these 'breathing chambers' are specially serviced to breed the new species of

industrial person, and the specialised plant that provides this service is a national state-protected education system. This is what we mean by the new political community, the nation.

This is the basis for Gellner's contention that 'nations can be defined only in terms of the age of nationalism'. To define them in terms of 'will' or 'culture' alone would include a far larger set of human groupings than the political nations we generally recognise. Nations can only be defined in terms of the conjunction of will and culture with political units when

> general social conditions make for standardised, homogeneous, centrally sustained high cultures, pervading entire populations and not just elite minorities, [and] a situation arises in which well-defined educationally sanctioned and unified cultures constitute very nearly the only kind of unit with which men willingly and often ardently identify.
>
> (Gellner, 1983b: 55)

It follows that

> It is nationalism which engenders nations, and not the other way round. Admittedly, nationalism uses the pre-existing, historically inherited proliferation of cultures or cultural wealth, though it uses them very selectively, and it most often transforms them radically. Dead languages can be revived, traditions invented, quite fictitious pristine purities restored. But this culturally creative, fanciful, positively inventive aspect of nationalist ardour ought not to allow anyone to conclude, erroneously, that nationalism is a contingent, artificial, ideological invention . . . concocted by a few European thinkers and foisted on unwitting populations all round the world. The nationalist principle has deep roots in the modern shared cultural condition, even if 'the cultures it claims to defend and revive are often its own inventions, or modified out of all recognition'.
>
> (Gellner, 1983b: 55–6)

Nationalism, then, contrary to its *volkisch* idiom and self-image,

> is, essentially, the general imposition of a high culture on society, where previously low cultures had taken up the lives of the majority, and in some cases the totality, of the population. . . . It is the establishment of an anonymous, impersonal society, with mutually substitutable atomized individuals, held together above all by a shared culture of this kind, in place of a previous complex structure of local groups, sustained by folk cultures reproduced locally and idiosyncratically by the microgroups themselves. That is what *really* happens.
>
> (Gellner, 1983b: 57, italics in original)

Why do the local groups, the Ruritanians, become conscious of their own 'low' culture and seek to turn it into a literate 'high' culture? Not out of any conscious

self-interest, nor as a result of manipulation by a calculative intelligentsia. Rather, labour migration and bureaucratic employment soon taught the Ruritanian locals the difference between dealing with a co-national, 'one understanding and sympathising with their culture, and someone hostile to it. This very concrete experience taught them to be aware of their culture, and to love it (or, indeed, to wish to be rid of it)'. So, in circumstances of mobility and context-free communication, 'the culture in which one has been *taught* to communicate becomes the core of one's identity' (Gellner, 1983b: 61, italics in original).

This is the first of two principles of fission in industrial society: the principle of barriers to communication, inherited from the cultures of the pre-industrial world. The other is the principle of inhibitors of social entropy, traits which resist even dispersion throughout industrial society, even after the passage of time. In the latter case, assimilation of those possessing the entropy-resistant trait proves impossible. This is true of populations defined by genetic traits like colour, or 'deeply engrained religious-cultural habits' which 'frequently have a limpet-like persistence', especially groups with a high religion 'fortified by a script and sustained by specialised personnel'. In the later stages of industrialisation, when inequality is reduced and communication between people is easier, 'moral chasms' will open up between groups with counter-entropic traits and the host society, giving rise to new nationalisms and perhaps nations (Gellner, 1983b: 70–2, 74–5).

Dying for a 'high culture'

I have highlighted Gellner's theory, and cited passages from it at some length, because it remains the most cogent, powerful and influential of the modernist theories of nationalism. It is instructive to compare it with its most frequently cited successor, Benedict Anderson's *Imagined Communities* (Anderson, 1983). For Anderson, too, the nation and nationalism are powerful forces in the modern world. They are also modern constructs, the product of an interplay between a technological revolution (printing), an economic revolution (capitalism) and the fatality of linguistic diversity. Following a decline in earlier sacred realms (monarchies) and sacred communities (churches) and a revolution in our conceptions of time, these factors converged to form mass reading publics in vernacular administrative languages (a kind of 'high culture'); with the result that these publics were enabled to imagine themselves as sovereign, but finite, political communities,.i.e. as nations, through the products of 'print languages'. In other words, the boundaries of the nation came to coincide with those of a 'print-community'.[3]

At first sight, Anderson's conception is quite different to Gellner's and to other modernist theories. In some ways, it could be labelled 'post-modernist', particularly in his use of deconstructive techniques of the literary devices which enable people who will never know or see each other, to imagine and identify themselves with a wider 'print-community'. In other respects, of course, Anderson is a modernist of a Marxian variety, with the economics of cultural change replacing the economics of social and political change as the locus of causation. Here he moves closer to Gellner, not only in his emphasis upon the printed word and literary culture in explaining the nation and nationalism, but also in the

underlying materialism of his conception. But, even here, there is an important difference. Gellner emphasises the consequences of industrialism as opposed to capitalism; he also grounds the literary culture which is so vital a part of the nation's lifeblood in a large-scale public, mass institution: the national system of mass education. There is no institutional equivalent in Anderson's account, and this gives it a rarefied, elitist air. One is left wondering why so many people (the 'masses') should be impressed by, let alone, ardently identify with, the literary musings of an intelligentsia.[4]

But, we may ask: do the people ardently identify with even an educationally sanctioned and sustained high culture? Is it this that they are really defending? Particularly when Gellner so often emphasises the invented, often artificial quality of so much of the new 'high' culture, the question arises: why should people be willing to lay down their lives for an invention?

There is a further difficulty. Far more than Anderson, or Hobsbawm, Gellner roots his high cultures in real social and institutional circumstances, that is, in the consequences of the new division of labour in industrial society. But these 'high' cultures are rarely continuations of the old 'low' cultures. For Gellner, the latter are selected, adapted, modified out of all recognition, radically transformed, invented, imposed from above, or simply obliterated. In other words, these new cultures are rooted in modern, not pre-modern, conditions; they answer to present social and economic needs.

Now, for Gellner, the great majority of people embrace these new cultures with conviction and passion. Yet they are described as largely artificial and even invented. This places an enormous weight on the role of mass, public education in forging loyal, even ardent, citizens around the new high cultures. For it is difficult to see how, otherwise, large numbers of people, in a matter of a few generations, should forsake their old, familiar cultures and embrace a new, relatively artificial, 'tamed' garden culture – and even be prepared to die for it!

There is, indeed, much to commend itself in Gellner's emphasis on the power of modern systems of mass, public education. It is well known how the Third Republic and its successors in France, for example, were able to forge a national curriculum, notably in the teaching of history, geography and literature, and through the dissemination of standard textbooks, such as the Lavisse history textbook, to inculcate a conventional and standardised understanding and hence loyalty in successive generations of French schoolchildren. And there are imitations of this pattern in Japan, Turkey and other developing states.[5]

But can such systems bear the weight ascribed to them in the modernist theory of nationalism? There are several questions here. To begin with, the ardour of the early nationalists, those who propose the category and cause of the nation, cannot be the product of a national public, mass education system which has not at that date come into being. *Their* ardour is either the 'product' of an 'alien' education system, or of travel to and socialisation in a distant (usually western) country and its educational institutions, or both. *Their* ardour creates the possibility of the community obtaining an education system of its own, which will then nurture and sustain the new high culture of the newly independent nation.

By the same token, the mass of the followers of the early nationalists, Hroch's agitator intelligenstia of phase B, will not be the product of national education

system and a new high culture which they are in process of creating *de novo*. Nationalism – the nationalist movement – largely precedes both the new high culture and the new public, mass education system, until the moment of independence. Hence the ardour and self-sacrifice of nationalism cannot be explained in terms of exo-socialisation and attachment to a high culture. Rather, these are the products of nationalist zeal.[6]

There is a third problem. The communist experiment in Eastern Europe and the former Soviet Union has surely taught us to be wary of assertions about the power of public, state-controlled mass education systems. In fact, we do not have to look so far. The relative failure of many western public, mass education systems to inculcate the relevant knowledge, skills, values and loyalties into so many of their 'products' suggests that, however much states may take mass education seriously, their expectations greatly outrun the reality, and it is doubtful whether the Rousseauan and Fichtean belief in the efficacy of mass education for nation-building was ever justified.[7]

There is a more fundamental issue: the extent to which most people become attached to a high culture and how far that attachment may influence their political conduct and loyalties. For Anderson, it is the disinterested nobility of the fraternal community that commands mass loyalty and mass self-sacrifice. For Gellner, it is the necessity and uses of a 'garden' high culture that has such widespread appeal and evokes such ardent sentiments. If Anderson's account sounds detached from the everyday realities of ordinary (unheroic) people and almost unconstrained, Gellner's view suggests a degree of necessity and determination, of functionality for industrialism, that fails to account for apathy and even resistance to the demands of nationalism. Gellner is not arguing that we embrace our high cultures so fervently because we realise the 'needs of industrialism' (whose benefits we all desire); nothing so calculative as this. He does seem to be suggesting that most of us fail to perceive the real situation, and that in this matter our sentiments and actions are predetermined by social forces outside our control, forces that emanate from the very nature of industrial society itself. In the interesting passage cited earlier, he argues that labour migration and bureaucratic employment brought home to the peasants 'the difference between dealing with a co-national, one understanding and sympathising with their culture, and someone hostile to it. This very concrete experience taught them to be aware of their culture, and to love it (or, indeed, to wish to be rid of it) without any conscious calculation of advantages and prospects of social mobility' (Gellner 1983b: 61).

The uses of history

So the 'uses of adversity', if not exactly sweet, are turned into virtue and industrialism forces us to realise our kinship with 'a co-national', who understands and sympathises with 'our' culture.

This is an interesting concept. Not only does it suggest once again that the nation (in the form of understanding co-nationals) pre-exists the dislocations of industrialism. It also elides the difference, and route, between the two kinds and stages of culture marked out elsewhere by Gellner. For those who at the moment

of labour migration 'understand' and 'sympathise with' the culture of the peasants, have not yet created the new 'high culture'. They, like the peasants, are adherents and lovers of the old 'low' culture. They may of course aspire to modernise it, to transform it into a 'high' culture. But it is the pre-modern 'low' culture, the wild and spontaneous variety, that provides the basis of their affinity with the Ruritanian peasants, and the hostility of those who do not share it.

Could it be that *this* is the culture that peoples and nations so ardently embrace? Not the cultivated kind of modern 'high' culture, but the wild pre-modern varieties which spring up spontaneously, in which the people have been 'taught', but taught at their mother's knee and in the village school, among their peers, not the garden culture which forms the staple diet of the state academies and gymnasia. Particularly when those academics and gymnasia imposed ethnic quotas, taught in alien languages and propagated values, traditions and memories which had little or no connection with the traditions, values and memories of many of the youth aspiring (or forced) to attend them.

For modernists, the culture of the modern nation is a mass, public, standardised culture. It is the culture of state schooling and citizenship. The question, however, is to what extent that public culture is infused with, is indeed coterminous with, the pre-modern historic culture of the dominant *ethnie*, and how far oral 'low' cultures provide the basis for literate 'high' cultures. That such older historic cultures are modernised, their vocabularies extended, their concepts revised, their forms enlarged, is not in dispute. The point at issue is how far that modern public culture is a modern version of the pre-modern ethnic culture, or how far it simply 'uses' elements ('materials') from an older cultural repertoire for its own, quite novel, purposes.

The latter would appear to be Gellner's solution to the question of the relationship between pre-modern 'low' and modern 'high' cultures. Yet the fact that he keeps returning to the question, and stresses the ways in which modern industrial cultures continually hark back to, and need, elements of pre-modern ethnic culture, suggests that the 'uses of history' model is not entirely satisfactory.

According to this model, 'history' fulfils various social and political purposes. These include serving as a quarry of cultural materials for didactic and illustrative goals, as a series of moral *exempla virtutis*, as an arena for the rhetoric of nationalist politicians, and especially of *narodniks* [intellectuals identifying with populist agrarian socialism], and as legitimation for the often painful innovations demanded by the needs of industrialism. For Gellner as for other modernists, these are all uses to which nationalists may put the past or pasts which they seek to appropriate for their specific purposes, and we should not take their protestations too seriously. This is most evident in territorial claims like those in the Middle East, the former Yugoslavia and the Caucasus today. In each case, the modernists argue, the 'past' serves the perceived needs of the present and the interests of current participants. Indeed, our vision of 'the past' is shaped by present needs and circumstances.[8]

But can 'the past' be ransacked in this way? Is it a matter of moral tableaux for emulation or legitimation? We know that both neo-classical and romantic European intellectuals selected such tableaux and heroes as public moralities in the later eighteenth and early nineteenth centuries, for the instruction of the educated classes in the West. Yet, by the early nineteenth century such cavalier 'historical

mobility' was overtaken by the quest for archaeological verisimilitude and histor-
ical authenticity. Was this just a quirk of romantic intellectuals?[9]

The fact is that a much more systematic and 'ethnically authentic' approach
to history came into favour throughout the world, because of the concomitant
movement of mass emancipation and because of the constraints imposed by ethnic
history on the self-understanding of each community. It is not enough to see the
past or pasts being shaped by the needs and interests of the present; the latter are
in turn shaped by both the traditions and past experiences of each community or
area, and by the growing knowledge of these traditions and experiences. Hence,
'ethno-historical' understanding was always changing, as newly emancipated strata
and groups added their experiences and traditions to the communal heritage and
as these were woven into the received frameworks.

But equally important were the distinctive qualities of the community and the
limits imposed by its historical experiences and traditions on their ethno-historical
understandings. Such a view of 'ethno-history' presupposes the presence of ethnic
ties antedating the formation of nations in a given cultural unit of population and
area. These ties may be of various kinds. In some cases, they will be little more
than customary cultural characteristics or life-styles such as those of nomadic tribes.
In others, it may be sets of common or replicated customs and institutions like
those embodied in the early Swiss cantons or Sumerian city-states. In yet others,
a common language or religion, or both, will set up barriers against outsiders and
unify the members through common activities into a clearcut ethnic community,
or *ethnie*.

While it is possible for nationalists to select from the rich motley of ethnic
ties present in a given polity those that appear to offer the best basis for political
mobilisation, the range and strength of such ties impose definite limits on the
process of selection. At one extreme are pure inventions. As the fate of Esperanto
suggests, inventions of this kind have difficulty in finding any following. At the
other extreme are well-formed *ethnies*, with a host of traditions, myths and symbols
that provide a clear basis for the future nation. In between, fall various kinds of
degrees of pre-existing ethnic relationships, many of which, provided they possess
popular resonance, can furnish bases for political mobilisation for nationalist goals,
as occurred among Arab elites in Lebanon and Iraq and among Hindu intellectuals
in India.[10]

All of this suggests that the pre-modern 'wild' or spontaneous cultures are a
good deal more important, and less malleable, than modernists would have us
believe. To be sure, there are cases of the attempt to form nations, as in Trinidad
or Mauritius, which do not appear to depend on pre-existing ethnic ties and
cultures. Even here, the picture is quite complicated. Though there may be no
Ur-Kultur on these islands, the component *ethnies* have cultures and traditions of
their own, and these have to be incorporated and reinterpreted into the emergent
new national culture, and this is always a matter of trial and error, of hard polit-
ical effort which may go fearfully wrong. It is by no means a foregone conclusion
of capitalism or industrialism.[11]

The doubtful fate of many polyethnic and multinational states in the late twen-
tieth century should put us on our guard against underestimating the power of
ethnic ties and the imperatives of ethnic history. Because some nationalists have

tried to use history as a sweetshop in which to 'pick and mix', that is no reason why we should commit the same error in our analyses of the rise of nations. Despite their attempts at interpreting the past to suit their own interests, the nationalists were limited by that past in at least three ways. First by the state of scientific knowledge of the relevant past that existed at the time, and by the ability of historical research to validate or cast doubt on received traditions. Second, by the popular resonance of that past, or aspects of it, i.e. by the degree to which events and personages in the ethnic past, as well as certain symbols and values, commanded a popular following and lived in the memories and myths of the desig-nated population in the towns and in the countryside. And third, by the patterning and recurrence of motifs in a particular communal history, i.e. by the limits and boundaries set up by events and conditions in the past of the designated popula-tion, and by the frameworks, symbolic and institutional, which were established in that past and which influenced and conditioned the present.

There is another factor which has militated against the 'uses of history' model and encouraged a more 'holist' and authentic approach to ethno-history. This, of course, is the doctrine of nationalism itself. As an evolutionist salvation drama, the doctrine envisions a world of nations, each with its own origin, character and destiny. Each nation possesses, according to the doctrine, its own inner laws of development and must be treated as a unique whole, even when it is manifestly composed of several parts (successive cultures, traditions, strata, etc.). While such a doctrine has not prevented a highly selective use (and amnesia) of the ethnic past by nationalists, it has always contained within itself the potential for 'self-correc-tion', i.e. for further interpretations and emendations to any official line of the moment, as is occurring in present-day Russia. Nor is it true that nationalists always embellish the past, filter out embarrassing episodes or heroise 'the people'. There are many different kinds of nationalists, of all ideological hues, in succes-sive periods, as the history of nationalism in late nineteenth-century France or twentieth-century Iran or India reveals; the amnesia of one is grist to the mill of another.

The history of modernity

This suggests that the *narodnik* appeals of nationalism are not simple rhetoric. They are an essential component of the way in which nationalism acts as a 'bridge' between past and future, between the specific heritage of 'irreplaceable culture values' (Weber) of each community or cultural unit of population, and the growing exigencies of a modern and increasingly industrialised nation, forced to survive in a world of competing nations. Nationalism is the means by which these two worlds are brought together, and the prism through which the continuities of the past are preserved amid the changes of the present.

This brings us back to the central tenets of modernism. For the modernist, 'history' is a series of plateaux with sharp step-like 'transitions'. The steepest and most radical of these transitions leads from the stable plateau of traditional, agro-literate societies to that of modern, industrial societies. It follows that once that divide has been safely negotiated, societies in the modern, industrial category come

to resemble each other much more closely in most spheres than each of them does its agro-literate progenitor or counterpart.[12]

There is a growing body of evidence to support this view. As the debates over Maastricht and 'ever closer union' of the European Community states have revealed, those states and societies that have achieved a high degree of capitalist industrial growth and educational skills, as well as democratic institutions, have come to share values, institutions, experiences and outlooks that distinguish them from other less industrialised and non-democratic states; and this enables them to pool their resources and skills in a common fund, and build a common political framework for their further exploitation. In this way, each state can devalue the importance of its separate national past for present and future collective action, while retaining its cultural trappings. Their spokesmen may, of course, speak like *narodniks*, but they 'all act as westernisers' (Gellner, 1965: 171).

But, the same Maastricht debates also revealed that popular doubts and resistance in France, Britain and Denmark, and perhaps elsewhere, continue to trouble the Brussels and national elites. This suggests that we should not overlook the continuing importance of national traditions and experiences that often draw on long histories of ethnic memories, myths, symbols and values. There are still many people in the Community for whom their ethnic heritages and national traditions retain a powerful hold. In this respect, the 'before-and-after model' of a sharply dichotomised modernisation theory is likely to mislead us into underestimating the tenacity of ethnic and cultural forms across the divide and the ways in which these historic cultures are often rejuvenated by modernity. The history of modernity is likely to be more complex and less straightforward than the modernists would have us believe.[13]

This last point is most vividly illustrated by Gellner's puzzlement over the 'limpet-like' persistence of certain cultural traits and habits like scripturally-based ethnic religion. To view these as (counter-entropic) 'traits' unevenly distributed in a population is to miss their binding and communal quality, the way in which they have continued to define and hold together certain populations through a common religious and ethnic heritage which remained more important to many members of the designated group than the attractions (or miseries) of modernity. In fact, the heritage has often experienced a new lease (or leases) of life. Many of its adherents reinterpreted it as an ethnic charter for collective political action in the modern world. Among Arabs, Persians, Jews, Greeks, Armenians, Sikhs, Sinhalese and Hindus, ethno-religious nationalism has revitalised the ancient faith by giving (or restoring to) it new political and social dimensions.

These are not the only cases to cast doubt on the more general hypothesis of modernism: that nations are the product of the transition of modernisation and its uneven, violent tidal wave of dislocation. The history of modernity is neither so uniform nor so separable from its pre-modern base, and nowhere is this more forcibly illustrated than in the rise of nationalism. While it is indisputable that there have been clusters of changes since the sixteenth century which we can sum up as 'revolutions of modernisation', these have taken different forms in different parts of the world not just because of their differential timing and intensity, but as a consequence of the pre-existing social structures and cultures in each area. These cultures and structures are largely responsible for the emergence of *particular* nations, not just for their shape and 'local colour', but for the very fact of

their emergence among this population in that place. If the timing of a nationalism is contingent on some of the new forces of 'modernity', the emergence and character of that nationalism are the result of pre-existing cultures and ethnic ties in a given cultural unit of population. Culture, then, links the pre-modern 'agro-literate' society of a given population and its modern counterpart, just as the social and economic changes divide the two. The strain created by this radical juxta-position accounts for many familiar contemporary social and political phenomena, including the gulf between generations and the often violent movements of youth and intellectual alienation.

In the history of modernity, then, nations and nationalisms assume a prominent and ambiguous role. On the one hand, their very definitions as named territorialised communities of shared memories, public culture and common economy and legal rights, and as ideological movements for autonomy, identity and unity for populations deemed to constitute such 'nations', marks nations and nationalisms out as quintessentially modern phenomena. Nations *in that form,* i.e. 'mass nations', could only have emerged during or after the revolutions of modernisation. Similarly, nationalism, the ideological movement, is inconceivable as a global doctrine and movement before the eighteenth century, despite previous intimations in Holland, England and elsewhere.[14]

On the other hand, these same definitions encompass elements drawn from pre-modern epochs – names, memories, territories, cultures, identities – which amount to far more than 'pre-existing cultural materials' to be quarried by latterday nationalists. These components form the foundations and plans on which the national edifice is constructed, and without which it would lack political definition and social depth. They also provide cultural models for social and political mobilisation, exactly because they can be so effectively linked to the living memories and traditions of many groups within the designated national population. These memories, myths, symbols and traditions are not only alive in sections of the population, they are ancestral and distinctive. Thus, though the *Kalevala* was a modern – one could say, overtly modernist and nationalist – compilation by a modern professional, the doctor Elias Lonnrot, it could never have had the extraordinary resonance and hold that it has exerted over modern Finns if it had not embodied ancient legends, memories and symbols that, through the ballads of the Karelian peasants, still permeated sections of the Finnish population. Similarly, the revival of pre-Columbian Indian styles and cultures, though conceived in a revolutionary nationalist and modernist (and anti-Hispanic) spirit, could only provide a framework and inspiration for a distinctive modern, if culturally divided, Mexican nation because it was linked to the living memories of the ethnic pasts of Mexico's Indian (Maya, Zapotec, Nahua, etc.) minorities.[15]

Conclusion

The modernist paradigm of nations and nationalisms has undoubtedly proved to be a salutary and fruitful approach in a field that was dominated by nationalist-inspired perspectives. In countering the uncritical assumptions of the perennialists who hold that nations are immemorial, or at least of great antiquity, modernism

has moved the debate on to new ground and opened up new ways of linking the 'building' of nations to the needs of modern industrial societies and the interests of modern professional elites. There is a considerable body of evidence to document these connections, and especially the vital role of professionals and intellectuals in generating and disseminating nationalism.[16]

At the same time, the modernist paradigm is a flawed account. It fails to grasp that at the centre of the nationalist enterprise, and neither by accident nor by manipulation nor by some kind of false consciousness, stands the return to ethno-history and the necessity to locate the modern community in its own authentic past. This is not simply a restatement of the nationalist ideology; it springs from those same 'needs of modernity' that Gellner and the other modernists are concerned to uncover. At the same time, the return to ethno-history is dictated not just by modern conditions, but also by the shape and force of that ethno-history. This is partly because to create the modern 'mass nation', one has to 'invoke the masses', at least in name. This in turn, as Tom Nairn and others have realised, means it is necessary to take the masses' cultures seriously. What he and other modernists miss is the price that must be paid, namely, that the distinctive qualities of the cultures and ethno-histories invoked cast a spell, as it were, on subsequent 'nation-building' by forcing the modern nation to adhere as much to its own distinctive past (whatever the protestations of elites to the contrary) as to the requirements of the modern world. We are all doomed to build socialism, or whatever, in one country, and it is always a special country.

There are other reasons why distinctive ethno-histories continue to inform the life and shape of modern nations. One is the problem of territory. Nationalism may not be reducible to a question of boundaries, but the idea of a homeland, and often a sacred one, is a powerful force in its own right, and one that is frequently bound up with pre-modern myths of ethnic election. Subsequently, it became confused with the geo-politics of modern states, and the concept of a balance of power between competing centres. Not surprisingly, these power centres often turn out to be the homelands of former 'chosen peoples', now secularised as political and cultural exemplars of national modernity.

Another reason is the problem of cohesion in modern societies. Neither language nor even public, mass education can provide a sense of cohesion in highly differentiated societies, though each may be an instrument for its dissemination. Rather, we must look to the fund of ethnic myths, symbols and values, and to the corpus of ethno-historical traditions, to inspire a sense of cohesion among the very different groups and often conflicting classes in a modern industrial society. While the mass media, mass education and political socialisation may all help to spread the ideas and beliefs of citizenship and democracy, only ethnic history and national traditions can unite the body of individual citizens and furnish a sense of belonging for groups with often disparate interests. Despite the familiar problems of selecting and cultivating ethnic history and traditions, particularly in polyethnic states, the creation of nations with a minimum sense of cohesion requires some set of ethnic memories and traditions, and to have some resonance, they must be drawn from the ethnic past of the majority or dominant *ethnie*.

What all this suggests is not simply the persistence of ethnic ties from the past which must be taken seriously by theorists of nationalism, but also the continuities

between pre-modern ethnic communities and identities and their modern national counterparts. I am not claiming that there are 'nations before nationalism', certainly not in the sense in which we understand and characterise contemporary nations. There is a world of difference between contemporary England, Poland and Mexico and their counterparts in the medieval era. At the same time, there are powerful links between them, and not simply because they occupy the same approximate geographical space. The ethnic communities that occupied (parts of) those spaces in the medieval era were also characterised by incipient processes of nation forma-tion, and because of this they bequeathed traditions, symbols, values, myths and and the like to the nations that succeeded them, even when those nations were ethnically mixed and based on conquest, as in Mexico. These processes and the heritage they bequeathed are as much part of the modern nation as the technical, economic and political institutions required by a modern civilisation.

Notes

1 This contribution does not aspire to range over the many issues raised by Gellner's theory of nationalism. I am only concerned with one substantive, albeit crucial, aspect of that theory. I have also concentrated most of my attention on Gellner's fullest exposition of his theory, i.e. on *Nations and Nationalism* (1983b), but have alluded to the earlier chapter in *Thought and* Change (1965: Ch. 7), where appropriate. There are differences between Gellner's earlier and later statements of his theory, notably less attention to the role of language and more to mass education, a more overtly materialist explanation, and a much fuller account of the absence of nationalism in premodern societies, in the later work. But from the standpoint adopted here, they are all secondary.

2 Again, Gellner's discussion of generic and specialist education in this article, though it marks a transition from a more linguistic-cultural to a more educa-tional-industrial version of his theory, is not central to the issues raised here, though I come back to it briefly in discussing social cohesion in the conclusion.

3 Anderson's approach has had particular appeal in more literary circles such as cul-tural studies, but also in history and in international relations. This is especially true of the concept of an imagined political community, in which the nation becomes a construct of the literary imagination, an artefact and re-presented image. Some of this approach is also found in the essays in Hobsbawm and Ranger (1983). In con-trast, Gellner's approach, like that of Tom Nairn (1977) and Michael Hechter (1975), has had most appeal among sociologists and anthropologists.

4 It is difficult to pin down the 'postmodernist' elements in Anderson's account, or to gauge how far they mesh with the more traditional Marxian parts of the theory. This is even more the case with Hobsbawm's (1990) analysis, where the historical Marxist analysis is uppermost.

5 On the Third Republic and its education system, see Weber (1979) and Citron (1988).

6 For Hroch's three-phase scheme of the rise of nationalist movements in Eastern Europe, see Hroch (1985)

7 The classic analysis of Fichte's contribution is Kedourie (1960); for Rousseau and nationalism, see Cohler (1970).

8 Vivid examples of the uses of history in the Middle East can be found in the anthology by Haim (1962). For more general discussions, see Matossian (1962), Breuilly (1982) and Tonkin, McDonald and Chapman (1989).

9 For these *exempla virtutis* and public moralities, see Rosenblum (1967: Ch. 2) and A. D. Smith (1986: Ch. 8).

10 For several examples in the Middle East, India and Africa of the role of intellectuals in revitalizing ethnic ties, see Kedourie (1971: Introduction)

11 These two cases are discussed, in terms of a distinction between a more official, formal, state nationalism and a more popular, informal ethnic nationalism, in Eriksen (1993).

12 Modernists tend to be vague about ethnic filiation. For Nairn, ethnic groups certainly existed before 1800, but he sees their relationship to modern nationalism as secondary; they can be used by nationalist elites. Similarly for Hobsbawm, 'proto-national' ties and communities are rarely relevant to the essentially political doctrine of nationalism. See Nairn (1977: Ch. 2); Hobsbawm (1990: Ch. 2)

13 For the wider debate about a 'European' identity, see Wallace (1990: Ch. 4) and A. D. Smith (1991: Ch. 7).

14 For the contention that the nation can only be said to exist when most of the designated population are imbued with national sentiment, i.e. the nation is a mass nation, see Connor (1990). For a contrary view, see Grosby (1991); also A. D. Smith (1994).

15 For the circumstances of the compilation of the *Kalevala*, see Branch (1985: Introduction). On the uses of pre-Columbian cultures by the revolutionary Mexican governments, see Franco (1970).

16 There is a large literature on the role of the intelligentsia; see, *inter alia*, J. H. Kautsky (1962); Kedourie (1971); Pinard and Hamilton (1984); Hutchinson (1987).

References

Anderson, B. (1983) *Imagined Communities: Reflections on the Origin and Spread of Nationalism*, London: Verso Books.

Armstrong, J. (1982) *Nations before Nationalism*, Chapel Hill: University of North Carolina Press.

Breuilly, J. (1982) *Nationalism and the State*, Manchester: Manchester University Press.

Branch, M. (ed.) (1985) *Kalevala: the Land of Heroes*, trans. W. F. Kirby, London: Athlone Press and New Hampshire: Dover.

Citron, S. (1988) *Le Mythe National*, Paris: Presses Ouvriers.

Cohler, A. (1970) *Rousseau and Nationalism*, New York: Basic Books.

Connor, W. (1990) 'When is a nation?' *Ethnic and Racial Studies* 13(1); 92–103.

Eriksen, T. H. (1993) 'Formal and informal nationalism', *Ethnic and Racial Studies* 16(1): 1–25.

Franco, J. (1970) *The Modern Culture of Latin America*, Harmondsworth: Penguin.

Gellner, E. (1965) *Thoughts and Change*, London: Weidenfeld & Nicolson.

Gellner, E. (1973) 'Scale and nation', *Philosophy of the Social Sciences* 3 (1) (March): 1–17.

Gellner, E. (1983a) 'Nationalism and the two forms of cohesion in complex societies', *The Radcliffe-Brown Memorial Lecture: Proceedings of the British Academy* 58: 165–87.

Gellner, E. (1983b) *Nations and Nationalism*, Oxford: Blackwell.

Grosby, S. (1991) 'Religion and nationality in antiquity: the worship of Yahweh and ancient Israel', *European Journal of Sociology* XXXII: 229–65.

Haim, S. (ed.) (1962) *Arab Nationalism, An Anthology*, Berkeley and Los Angeles: University of California Press.

Hechter, M. (1975) *Internal Colonialism: The Celtic Fringe in British National Development, 1536–1966*, London: Routledge & Kegan Paul.

Hobsbawm, E. (1990) *Nations and Nationalism since 1780*, Cambridge: Cambridge University Press.

Hobsbawm, E. and Ranger, T. (eds) (1983) *The Invention of Tradition*, Cambridge: Cambridge University Press.

Hroch, M. (1985) *Social Preconditions of National Revival in Europe*, Cambridge: Cambridge University Press.

Hutchinson, J. (1987) *The Dynamics of Cultural Nationalism. The Gaelic Revival and the Creation of the Irish Nation State*, London: Allen & Unwin.

Kautsky, J. H. (ed.) (1962) *Political Change in Underdeveloped Countries*, New York: John Wiley.

Kedourie, E. (1960) *Nationalism*, London: Hutchinson.

Kedourie, E. (ed.) (1971) *Nationalism in Asia and Africa*, London: Weidenfeld & Nicolson.

Matossian, M. (1962) 'Ideologies of "delayed industrialisation". Some tensions and ambiguities', in Kautsky (1962).

Nairn, T. (1977) *The Break-up of Britain*, London: New Left Books.

Pinard, M. and Hamilton, R. (1984) 'The class bases of the Quebec independence-movement. Conjectures and evidence'. *Ethnic and Racial Studies* 7 (1): 19–54.

Rosenblum, R. (1967) *Transformations in late Eighteenth Century Art*, Princeton: Princeton University Press.

Smith, A. D. (1986) *The Ethnic Origins of Nations*, Oxford: Blackwell.

Smith, A. D. (1991) *National Identity*, Harmondsworth: Penguin.

Smith, A. D. (1994) 'The problem of national identity. Ancient, medieval and modern?', *Ethnic and Racial Studies* 17: 375–99.

Tonkin, E., McDonald, M. and Chapman, M. (eds) (1989) *History and Ethnicity*, London: Routledge.

Wallace, W. (1990) *The Transformation of Western Europe*, London: Pinter, publishers for RIIA.

Weber, E. (1979) *Peasants into Frenchmen. The Modernisation of Rural France, 1870–1914*, London: Chatto & Windus.

Eric Hobsbawm

MASS-PRODUCING TRADITIONS
Europe, 1870–1914

ONCE WE ARE AWARE how commonly traditions are invented, it can easily be discovered that one period which saw them spring up with particular assiduity was in the thirty or forty years before the First World War. One hesitates to say 'with greater assiduity' than at other times, since there is no way of making realistic quantitative comparisons. Nevertheless, the creation of traditions was enthusiastically practised in numerous countries and for various purposes, and this mass-generation of traditions is the subject of this chapter. It was both practised officially and unofficially, the former – we may loosely call it 'political' – primarily in or by states or organized social and political movements, the latter – we may loosely call it 'social' – mainly by social groups not formally organized as such, or those whose objects were not specifically or consciously political, such as clubs and fraternities, whether or not these also had political functions. The distinction is one of convenience rather than principle. It is designed to draw attention to two main forms of the creation of tradition in the nineteenth century, both of which reflect the profound and rapid social transformations of the period. Quite new, or old but dramatically transformed, social groups, environments and social contexts called for new devices to ensure or express social cohesion and identity and to structure social relations. At the same time a changing society made the traditional forms of ruling by states and social or political hierarchies more difficult or even impracticable. This required new methods of ruling or establishing bonds of loyalty. In the nature of things, the consequent invention of 'political' traditions was more conscious and deliberate, since it was largely undertaken by institutions with political purposes in mind. Yet we may as well note immediately that conscious invention succeeded mainly in proportion to its success in broadcasting on a wavelength to which the public was ready to tune in. Official new public holidays, ceremonies, heroes or symbols, which commanded the growing armies of the state's employees and the growing captive public of schoolchildren,

might still fail to mobilize the citizen volunteers if they lacked genuine popular resonance. The German Empire did not succeed in its efforts to turn the Emperor William I into a popularly accepted founding father of a united Germany, nor in turning his birthday into a genuine national anniversary. (Who, by the way, now remembers the attempt to call him 'William the Great'?) Official encouragement did secure the building of 327 monuments to him by 1902, but within *one* year of Bismarck's death in 1898, 470 municipalities had decided to erect 'Bismarck columns'.[1]

Nevertheless, the state linked both formal and informal, official and unofficial, political and social inventions of tradition, at least in those countries where the need for it arose. Seen from below, the state increasingly defined the largest stage on which the crucial activities determining human lives as subjects and citizens were played out. Indeed, it increasingly defined as well as registered their civil existence (*état civil*). It may not have been the only such stage, but its existence, frontiers and increasingly regular and probing interventions in the citizen's life were in the last analysis decisive. In developed countries the 'national economy', its area defined by the territory of some state or its subdivisions, was the basic unit of economic development. A change in the frontiers of the state or in its policy had substantial and continuous material consequences for its citizens. The standardization of administration and law within it, and, in particular, state education, transformed people into citizens of a specific country: 'peasants into Frenchmen', to cite the title of an apposite book.[2] The state was the framework of the citizens' collective actions, insofar as these were officially recognized. To influence or change the government of the state, or its policy, was plainly the main objective of domestic politics, and the common man was increasingly entitled to take part in it. Indeed, politics in the new nineteenth-century sense was essentially nation-wide politics. In short, for practical purposes, society ('civil society') and the state within which it operated became increasingly inseparable.

It was thus natural that the classes within society, and in particular the working class, should tend to identify themselves through nation-wide political movements or organizations ('parties'), and equally natural that de facto these should operate essentially within the confines of the nation.[3] Nor is it surprising that movements seeking to represent an entire society or 'people' should envisage its existence essentially in terms of that of an independent or at least an autonomous state. State, nation and society converged.

For the same reason, the state, seen from above in the perspective of its formal rulers or dominant groups, raised unprecedented problems of how to maintain or even establish the obedience, loyalty and co-operation of its subjects or members, or its own legitimacy in their eyes. The very fact that its direct and increasingly intrusive and regular relations with the subjects or citizens as individuals (or at most, heads of families) became increasingly central to its operations, tended to weaken the older devices by means of which social subordination had largely been maintained: relatively autonomous collectivities or corporations under the ruler, but controlling their own members, pyramids of authority linked to higher authorities at their apexes, stratified social hierarchies in which each stratum recognized its place, and so on. In any case social transformations such as those which replaced ranks by classes undermined them. The problems of states and rulers were evidently

much more acute where their subjects had become citizens, that is people whose political activities were institutionally recognized as something that had to be taken note of – if only in the form of elections. They became even more acute when the political movements of citizens as masses deliberately challenged the legitimacy of the systems of political or social rule, and/or threatened to prove incompatible with the state's order by setting the obligations to some other human collectivity – most usually class, church or nationality – above it.

The problem appeared to be most manageable where social structure had changed least, where men's fates appeared to be subject to no other forces than those which an inscrutable divinity had always unleashed among the human race, and where the ancient ways of hierarchical superiority and stratified, multiform and relatively autonomous subordination remained in force. If anything could mobilize the peasantry of south Italy beyond their localities, it was church and king. And indeed the traditionalism of peasants (which must not be confused with passivity, though there are not many cases where they challenged the actual existence of the lords, so long as these belonged to the same faith and people) was constantly praised by nineteenth-century conservatives as the ideal model of the subject's political comportment. Unfortunately, the states in which this model worked were by definition 'backward' and therefore feeble and any attempt to 'modernize' them was likely to make it less workable. A 'modernization' which maintained the old ordering of social subordination (possibly with some well-judged invention of tradition) was not theoretically inconceivable, but apart from Japan it is difficult to think of an example of practical success. And it may be suggested that such attempts to update the social bonds of a traditional order implied a demotion of social hierarchy, a strengthening of the subject's direct bonds to the central ruler who, whether this was intended to or not, increasingly came to represent a new kind of state. [. . .]

Conversely the problem was most intractable in states which were completely new, where the rulers were unable to make effective use of already existing bonds of political obedience and loyalty, and in states whose legitimacy (or that of the social order they represented) was effectively no longer accepted. In the period 1870–1914 there were, as it happened, unusually few 'new states'. Most European states, as well as the American republics, had by then acquired the basic official institutions, symbols and practices which Mongolia, establishing a sort of independence from China in 1912, quite rightly regarded as novel and necessary. They had capitals, flags, national anthems, military uniforms and similar paraphernalia, based largely on the model of the British, whose national anthem (datable *c.* 1740) is probably the first, and of the French, whose tricolour flag was very generally imitated. Several new states and regimes could either, like the French Third Republic, reach back into the store of earlier French republican symbolism or, like the Bismarckian German Empire, combine appeals to an earlier German Empire, with the myths and symbols of a liberal nationalism popular among the middle classes, and the dynastic continuity of the Prussian monarchy, of which by the 1860s half of the inhabitants of Bismarckian Germany were subjects. Among the major states only Italy had to start from scratch in solving the problem summarized by d'Azeglio in the phrase: 'We have made Italy: now we must make Italians'. The tradition of the kingdom of Savoy was no political asset outside the

north-western corner of the country, and the church opposed the new Italian state. It is perhaps not surprising that the new kingdom of Italy, however enthusiastic about 'making Italians', was notably unenthusiastic about giving the vote to more than 1 or 2 per cent of them until this seemed quite unavoidable.

Yet if the establishment of the legitimacy of new states and regimes was relatively uncommon, its assertion against the challenge of popular politics was not. As noted above, that challenge was chiefly represented, singly or in combination, by the sometimes linked, sometimes competing, political mobilization of masses through religion (mainly Roman Catholicism), class consciousness (social democracy), and nationalism, or at least xenophobia. Politically these challenges found their most visible expression in the vote, and were at this period inextricably linked with either the existence of, or struggle for, a mass suffrage, waged against opponents who were mainly by now resigned to fighting a delaying rearguard action. By 1914 some form of extensive if not universal manhood suffrage was operating in Australia (1901), Austria (1907), Belgium (1894), Denmark (1849), Finland (1905), France (1875), Germany (1871), Italy (1913), Norway (1898), Sweden (1907), Switzerland (1848–79), the United Kingdom (1867–84) and the USA, though it was still only occasionally combined with political democracy. Yet even where constitutions were not democratic, the very existence of a mass electorate dramatized the problem of maintaining its loyalty. The unbroken rise of the Social Democratic vote in imperial Germany was no less worrying to its rulers because the Reichstag in fact had very little power.

The widespread progress of electoral democracy and the consequent emergence of mass politics therefore dominated the invention of official traditions in the period 1870–1914. What made it particularly urgent was the dominance both of the model of liberal constitutional institutions and of liberal ideology. The former provided no theoretical, but only at best empirical barriers against electoral democracy. Indeed, it was difficult for the liberal not to expect an extension of civic rights to all citizens – or at least to male ones – sooner or later. The latter had achieved its most spectacular economic triumphs and social transformations by systematically opting for the individual against the institutionalized collectivity, for market transactions (the 'cash nexus') against human ties, for class against rank hierarchy, for *Gesellschaft* against *Gemeinschaft*. It had thus systematically failed to provide for those social bonds and ties of authority taken for granted in earlier societies, and had indeed set out to weaken and had succeeded in weakening them. So long as the masses remained outside politics, or were prepared to follow the liberal bourgeoisie, this created no major political difficulties. Yet from the 1870s onwards it became increasingly obvious that the masses were becoming involved in politics and could not be relied upon to follow their masters.

After the 1870s, therefore, and almost certainly in connection with the emergence of mass politics, rulers and middle-class observers rediscovered the importance of 'irrational' elements in the maintenance of the social fabric and the social order. As Graham Wallas was to observe in *Human Nature in Politics* (1908): 'Whoever sets himself to base his political thinking on a re-examination of the working of human nature, must begin by trying to overcome his own tendency to exaggerate the intellectuality of mankind.'[4] A new generation of thinkers had no difficulty in overcoming this tendency. They rediscovered irrational elements

in the individual psyche (Janet, William James, Freud), in social psychology (Le Bon, Tarde, Trotter), through anthropology in primitive peoples whose practices no longer seemed to preserve merely the childhood traits of modern humanity (did not Durkheim see the elements of all religion in the rites of the Australian aborigines?[5]), even in that quintessential fortress of ideal human reason, classical Hellenism (Frazer, Cornford).[6] The intellectual study of politics and society was transformed by the recognition that whatever held human collectivities together it was not the rational calculation of their individual members.

[. . .]

It was plainly not enough to regret the disappearance of that ancient social cement, church and monarchy, as the post-Communard Taine did, giving no sympathy for either.[7] [. . .] An alternative 'civic religion' had to be constructed. The need for it was the core of Durkheim's sociology, the work of a devoted non-socialist republican. Yet it had to be instituted by less eminent thinkers, if more practical politicians.

It would be foolish to suggest that the men who ruled the Third Republic relied mainly on inventing new traditions in order to achieve social stability. Rather, they relied on the hard political fact that the right was in a permanent electoral minority, that the social-revolutionary proletariat and the inflammable Parisians could be permanently outvoted by the over-represented villages and small towns, and that the Republican rural voters' genuine passion for the French Revolution and hatred of the moneyed interest could usually be assuaged by roads suitably distributed around the arrondissements, by the defence of high farm-prices and, almost certainly, by keeping taxes low. [. . .]

Nevertheless, the invention of tradition played an essential role in maintaining the Republic, if only by safeguarding it against both socialism and the right. By deliberately annexing the revolutionary tradition, the Third Republic either domesticated social revolutionaries (like most socialists) or isolated them (like the anarcho-syndicalists). [. . .] Yet the basic fact was that those who controlled the imagery, the symbolism, the traditions of the Republic were the men of the centre masquerading as men of the extreme left: the Radical Socialists, proverbially 'like the radish, red outside, white inside, and always on the side the bread is buttered'. Once they ceased to control the Republic's fortunes – from the days of the Popular Front onwards – the days of the Third Republic were numbered.

There is considerable evidence that the moderate Republican bourgeoisie recognized the nature of its main political problem ('no enemies on the left') from the late 1860s onwards, and set about solving it as soon as the Republic was firmly in power.[8] In terms of the invention of tradition, three major innovations are particularly relevant. The first was the development of a secular equivalent of the church – primary education, imbued with revolutionary and republican principles and content, and conducted by the secular equivalent of the priesthood – or perhaps, given their poverty, the friars – the *instituteurs*.[9] There is no doubt that this was a deliberate construction of the early Third Republic, and, given the proverbial centralization of French government, that the content of the manuals which were to turn not only peasants into Frenchmen but all Frenchmen into good Republicans, was not left to chance. Indeed the 'institutionalization'

of the French Revolution itself in and by the Republic has been studied in some detail.[10]

The second was the invention of public ceremonies.[11] The most important of these, Bastille Day, can be exactly dated in 1880. It combined official and unofficial demonstrations and popular festivities – fireworks, dancing in the streets – in an annual assertion of France as the nation of 1789, in which every French man, woman and child could take part. Yet while it left scope for, and could hardly avoid, more militant, popular manifestations, its general tendency was to transform the heritage of the Revolution into a combined expression of state pomp and power and the citizens' pleasure. A less permanent form of public celebration were the occasional world expositions which gave the republic the legitimacy of prosperity, technical progress – the Eiffel Tower – and the global colonial conquest they took care to emphasize.[12]

The third was the mass production of public monuments already noted. It may be observed that the Third Republic did not – unlike other countries – favour massive public buildings, of which France already had a large supply – though the great expositions left some of these behind them in Paris – nor gigantic statuary. The major characteristic of French 'statuomania'[13] was its democracy, anticipating that of the war memorials after 1914–18. It spread two kinds of monuments throughout the cities and rural communes of the country: the image of the Republic itself (in the form of Marianne which now became universally familiar), and the bearded civilian figures of whomever local patriotism chose to regard as its notables, past and present. Indeed, while the construction of Republican monuments was evidently encouraged, the initiative, and the costs of, such enterprises were undertaken at a local level. [. . .] Such monuments traced the grass-roots of the Republic – particularly in its rural strongholds – and may be regarded as the visible links between the voters and the nation.

[. . .]

The Second German Empire provides an interesting contrast, especially since several of the general themes of French Republican invented tradition are recognizable in its own. Its major political problem was twofold: how to provide historical legitimacy for the Bismarckian (Prusso-Little German) version of unification which had none; and how to deal with that large part of the democratic electorate which would have preferred another solution (Great Germans, anti-Prussian particularists, Catholics and, above all, Social Democrats). Bismarck himself does not seem to have bothered much about symbolism, except for personally devising a tricolour flag which combined the Prussian black–white with the nationalist and liberal black–red–gold which he wished to annex (1866). There was no historical precedent whatever for the Empire's black–white–red national banner. His recipe for political stability was simpler: to win the support of the (predominantly liberal) bourgeoisie by carrying out as much of its programme as would not jeopardize the predominance of the Prussian monarchy, army and aristocracy, to utilize the potential divisions among the various kinds of opposition and to exclude political democracy as far as possible from affecting the decisions of government. Apparently irreconcilable groups which could not be divided – notably the Catholics and especially the post-Lassallean Social Democrats – left him somewhat at a loss. In

fact, he was defeated in his head-on confrontations with both. One has the impression that this old-fashioned conservative rationalist, however brilliant in the arts of political manoeuvre, never satisfactorily solved the difficulties of political democracy, as distinct from the politics of notables.

The invention of the traditions of the German Empire is therefore primarily associated with the era of William II. Its objects were mainly twofold: to establish the continuity between the Second and First German Empires, or, more generally, to establish the new Empire as the realization of the secular national aspirations of the German people; and to stress the specific historical experiences which linked Prussia and the rest of Germany in the construction of the new Empire in 1871. Both, in turn, required the merger of Prussian and German history, to which patriotic imperial historians (notably Treitschke) had for some time devoted themselves. [. . .]

Buildings and monuments were the most visible form of establishing a new interpretation of German history, or rather a fusion between the older romantic 'invented tradition' of pre-1848 German nationalism and the new regime: the most powerful symbols being those where the fusion was achieved. Thus, the mass movement of German gymnasts, liberal and Great German until the 1860s, Bismarckian after 1866 and eventually pan-German and antisemitic, took to its heart three monuments whose inspiration was basically not official: the monument to Arminius the Cheruscan in the Teutoburg Forest (much of it constructed as early as 1838–46, and inaugurated in 1875); the Niederwald monument above the Rhine, commemorating the unification of Germany in 1871 (1877–83); and the centenary memorial of the battle of Leipzig, initiated in 1894 by a 'German patriotic League for the Erection of a Monument to the Battle of the Peoples at Leipzig', and inaugurated in 1913. On the other hand, they appear to have showed no enthusiasm for the proposal to turn the monument to William I on the Kyffhäuser mountain, on the spot where folk myth claimed the Emperor Frederick Barbarossa would appear again, into a national symbol (1890–6), and no special reaction to the construction of the monument to William I and Germany at the confluence of the Rhine and the Moselle (the 'Deutsches Eck' or German Corner), directed against French claims to the left bank of the Rhine.[14]

Leaving such variations aside, the mass of masonry and statuary which went up in Germany in this period was remarkably large, and made the fortunes of sufficiently pliable and competent architects and sculptors.[15] Among those constructed or planned in the 1890s alone, we may mention the new Reichstag building (1884–94) with elaborate historical imagery on its façade, the Kyffhäuser monument already mentioned (1890–6), the national monument to William I – clearly intended as the official father of the country (1890–7), the monument to William I at the Porta Westfalica (1892), the William I monument at the Deutsches Eck (1894–7), the extraordinary Valhalla of Hohenzollern princes in the 'Avenue of Victory' (Siegesallee) in Berlin (1896–1901), a variety of statues to William I in German cities (Dortmund 1894, Wiesbaden 1894, Prenzlau 1898, Hamburg 1903, Halle 1901) and, a little later, a spate of Bismarck monuments, which enjoyed a more genuine support among nationalists.[16] The inauguration of one of these monuments provided the first occasion for the use of historical themes on the postage stamps of the Empire (1899).

This accumulation of masonry and statuary suggests two comments. The first concerns the choice of a national symbol. Two of these were available: a vague but adequately military 'Germania', who played no notable role in sculpture, though she figured extensively on postage stamps from the start, since no single dynastic image could as yet symbolize Germany as a whole; and the figure of the 'Deutsche Michel' who actually appears in a subordinate role on the Bismarck monument. He belongs to the curious representations of the nation, not as a country or state, but as 'the people', which came to animate the demotic political language of the nineteenth-century cartoonists, and was intended (as in John Bull and the goateed Yankee – but *not* in Marianne, image of the Republic) to express national character, as seen by the members of the nation itself.[17] . . . 'Michel' seems to have been essentially an anti-foreign image.

The second concerns the crucial significance of the Bismarckian unification of Germany as the *only* national historical experience which the citizens of the new Empire had in common, given that all earlier conceptions of Germany and German unification were in one way or another 'Great German'. And within this experience, the Franco-German war was central. Insofar as Germany had a (brief) 'national' tradition, it was symbolized in the three names: Bismarck, William I and Sedan.

This is clearly exemplified by the ceremonials and rituals invented (also mainly under William II). Thus the chronicles of one Gymnasium record no less than ten ceremonies between August 1895 and March 1896 recalling the twenty-fifth anniversary of the Franco-Prussian war, including ample commemorations of battles in the war, celebrations of the emperor's birthday, the official handing-over of the portrait of an imperial prince, illuminations and public addresses on the war of 1870–1, on the development of the imperial idea (*Kaiseridee*) during the war, on the character of the Hohenzollern dynasty, and so on.[18]

[. . .]

In the same year an imperial decree was to announce the construction of the Siegesallee, linking with the twenty-fifth anniversary of the Franco-Prussian war, which was presented as the rising of the German people 'as one man', though 'following the call of its princes' to 'repel foreign aggression and achieve the unity of the fatherland and the *restoration* of the Reich in glorious victories' (my italics).[19] The Siegesallee, it will be recalled, represented exclusively the Hohenzollern princes back to the days of the Margraves of Brandenburg.

A comparison of the French and German innovations is instructive. Both stress the founding acts of the new regime – the French Revolution in its least precise and controversial episode (the Bastille) and the Franco-Prussian war. Except for this one point of historic reference, the French Republic abstained from historical retrospect as strikingly as the German Empire indulged in it. Since the Revolution had established the fact, the nature and the boundaries of the French nation and its patriotism, the Republic could confine itself to recalling these to its citizens by means of a few obvious symbols – Marianne, the tricolour, the 'Marseillaise', and so on – supplementing them with a little ideological exegesis elaborating on the (to its poorer citizens) obvious if sometimes theoretical benefits of Liberty, Equality and Fraternity. Since the 'German people' before 1871 had no political definition

or unity, and its relation to the new Empire (which excluded large parts of it) was vague, symbolic or ideological, identification had to be more complex and – with the exception of the role of the Hohenzollern dynasty, army and state – less precise. Hence the multiplicity of reference, ranging from mythology and folklore (German oaks, the Emperor Frederick Barbarossa) through the shorthand cartoon stereotypes to definition of the nation in terms of its enemies. Like many another liberated 'people', 'Germany' was more easily defined by what it was against than in any other way.

This may explain the most obvious gap in the 'invented traditions' of the German empire: its failure to conciliate the Social Democrats. [. . .]

Yet in a nation relying for its self-definition to so great an extent on its *enemies*, external and internal, this was not wholly unexpected;[20] all the more so, since the by definition anti-democratic military élite formed so powerful a device for assimilating the middle class to the status of a ruling class. Yet the choice of Social Democrats and, less formally, of Jews as internal enemies had an additional advantage, though the nationalism of the Empire was unable to exploit it fully. It provided a demagogic appeal against both capitalist liberalism and proletarian socialism which could mobilize the great masses of the lower middle class, handicraftsmen and peasants who felt threatened by both, under the banner of 'the nation'.

Paradoxically, the most democratic and, both territorially and constitutionally, one of the most clearly defined nations faced a problem of national identity in some respects similar to imperial Germany. The basic political problem of the USA, once secession had been eliminated, was how to assimilate a heterogeneous mass – towards the end of our period, an almost unmanageable influx – of people who were Americans not by birth but by immigration. Americans had to be made. The invented traditions of the USA in this period were primarily designed to achieve this object. On the one hand the immigrants were encouraged to accept rituals commemorating the history of the nation – the Revolution and its founding fathers (the 4th of July) and the Protestant Anglo-Saxon tradition (Thanksgiving Day) – as indeed they did, since these now became holidays and occasions for public and private festivity.[21] (Conversely, the 'nation' absorbed the collective rituals of immigrants – St Patrick's Day and later Columbus Day – into the fabric of American life, mainly through the powerful assimilating mechanism of municipal and state politics.) On the other hand, the educational system was transformed into a machine for political socialization by such devices as the worship of the American flag, which, as a daily ritual in the country's schools, spread from the 1880s onwards.[22] The concept of Americanism as an act of *choice* – the decision to learn English, to apply for citizenship – and a choice of specific beliefs, acts and modes of behaviour implied the corresponding concept of 'un-Americanism'. In countries defining nationality existentially there could be unpatriotic Englishmen or Frenchmen, but their status as Englishmen and Frenchmen could not be in doubt, unless they could also be defined as strangers (*metèques*). Yet in the USA, as in Germany, the 'un-American' or '*vaterlandslose*' person threw doubt on his or her actual status as member of the nation.

As might be expected, the working class provided the largest and most visible body of such doubtful members of the national community; all the more doubtful because in the USA they could actually be classified as foreigners. The mass of

new immigrants were workers; conversely, since at least the 1860s, the majority of workers in virtually all the large cities of the land appear to have been foreign-born. Whether the concept of 'un-Americanism', which can be traced back to at least the 1870s,[23] was more a reaction of the native-born against the strangers or of Anglo-Saxon Protestant middle classes against foreign-born workers is unclear. At all events it provided an internal enemy against whom the good American could assert his or her Americanism, not least by the punctilious performance of all the formal and informal rituals, the assertion of all the beliefs conventionally and institutionally established as characteristic of good Americans.

Table 4.1 First use of historical stamps before 1914[24]

Country	First stamp	First historical stamp	Jubilee or special occasion
Austro-Hungary	1850	1908	60 years Franz Joseph
Belgium	1849	1914	War (Red Cross)
Bulgaria	1879	1901	Anniversary of revolt
Germany	1872	1899	Unveiling of monument
Greece	1861	1896	Olympic Games
Italy	1862	1910–11	Anniversaries
Netherlands	1852	1906	De Ruyter tercentenary
Portugal	1852	1894	500th anniversary of Henry the Navigator
Romania	1865	1906	40 years rule
Russia	1858	1905, 1913	War charity, tercentenary
Serbia	1866	1904	Centenary of dynasty
Spain	1850	1905	*Don Quixote* tercentenary
Switzerland	1850	1907	–

We may deal more cursorily with the invention of state traditions in other countries of the period. Monarchies, for obvious reasons, tended to link them to the crown, and this period saw the initiation of the now familiar public relations exercises centred on royal or imperial rituals, greatly facilitated by the happy discovery – or perhaps it would be better to say invention – of the jubilee or ceremonial anniversary. Its novelty is actually remarked upon in the *New English Dictionary*.[25] The publicity value of anniversaries is clearly shown by the occasion they so often provided for the first issue of historical or similar images on postage stamps, that most universal form of public imagery other than money, as Table 4.1 demonstrates.

Almost certainly Queen Victoria's jubilee of 1887, repeated ten years later in view of its notable success, inspired subsequent royal or imperial occasions in Britain and elsewhere. Even the most traditionalist dynasties – the Habsburgs in 1908, the Romanovs in 1913 – discovered the merits of this form of publicity. It was new insofar as it was directed at the public, unlike traditional royal ceremonials designed to symbolize the rulers' relation to the divinity and their position

at the apex of a hierarchy of grandees. After the French Revolution every monarch had, sooner or later, to learn to change from the national equivalent of 'King of France' to 'King of the French', that is, to establish a direct relation to the collectivity of his or her subjects, however lowly. Though the stylistic option of a 'bourgeois monarchy' (pioneered by Louis Philippe) was available, it seems to have been taken only by the kings of modest countries wishing to maintain a low profile – the Netherlands, Scandinavia – though even some of the most divinely ordained rulers – notably the Emperor Francis Joseph – appear to have fancied the role of the hard-working functionary living in spartan comfort.

Technically there was no significant difference between the political use of monarchy for the purpose of strengthening effective rulers (as in the Habsburg, Romanov, but also perhaps in the Indian empires) and building the symbolic function of crowned heads in parliamentary states. Both relied on exploiting the royal person, with or without dynastic ancestors, on elaborate ritual occasions with associated propagandist activities and a wide participation of the people, not least through the captive audiences available for official indoctrination in the educational system. Both made the ruler the focus of his people's or peoples' unity, the symbolic representative of the country's greatness and glory, of its entire past and continuity with a changing present. Yet the innovations were perhaps more deliberate and systematic where, as in Britain, the revival of royal ritualism was seen as a necessary counterweight to the dangers of popular democracy. Bagehot had already recognized the value of political deference and the 'dignified', as distinct from the 'efficient', parts of the constitution in the days of the Second Reform Act. The old Disraeli, unlike the young, learned to use 'reverence for the throne and its occupant' as 'a mighty instrument of power and influence' and by the end of Victoria's reign the nature of the device was well understood. J. E. C. Bodley wrote about the coronation of Edward VII:

> The usage by an ardent yet practical people of an ancient rite to signalise the modern splendours of their empire, the recognition by a free democracy of a hereditary crown, as a symbol of the world-wide domination of their race, constitute no mere pageant, but an event of the highest historical interest.[26]

Glory and greatness, wealth and power, could be symbolically shared by the poor through royalty and its rituals. The greater the power, the less attractive, one may suggest, was the bourgeois option for monarchy. And we may recall that in Europe monarchy remained the universal state form between 1870 and 1914, except for France and Switzerland.

II

The most universal political traditions invented in this period were the achievement of states. However, the rise of organized mass movements claiming separate or even alternative status to states, led to similar developments. Some of these movements, notably political Catholicism and various kinds of nationalism, were

keenly aware of the importance of ritual, ceremonial and myth, including, normally, a mythological past. The significance of invented traditions is all the more striking when they arose among rationalist movements which were, if anything, rather hostile to them and lacked prefabricated symbolical and ritual equipment. Hence the best way to study their emergence is in one such case – that of the socialist labour movements.

The major international ritual of such movements, May Day (1890), was spontaneously evolved within a surprisingly short period. Initially it was designed as a single simultaneous one-day strike and demonstration for the eight-hour day, fixed on a date already associated for some years with this demand in the USA. The choice of this date was certainly quite pragmatic in Europe. It probably had no ritual significance in the USA, where 'Labor Day' had already been established at the end of summer. It has been suggested, not implausibly, that it was fixed to coincide with 'Moving Day', the traditional date for ending hiring contracts in New York and Pennsylvania.[27] Though this, like similar contractual periods in parts of traditional European agriculture, had originally formed part of the symbolically charged annual cycle of the pre-industrial labouring year, its connection with the industrial proletariat was clearly fortuitous. No particular form of demonstration was envisaged by the new Labour and Socialist International. The concept of a workers' festival not only was not mentioned in the original (1889) resolution of that body, but was actively rejected on ideological grounds by various revolutionary militants.

Yet the choice of a date so heavily charged with symbolism by ancient tradition proved significant, even though – as Van Gennep suggests – in France the anticlericalism of the labour movement resisted the inclusion of traditional folklore practices in its May Day.[28] From the start the occasion attracted and absorbed ritual and symbolic elements, notably that of a quasi-religious or numinous celebration ('*Maifeier*'), a holiday in both senses of the word. (Engels, after referring to it as a 'demonstration', uses the term '*Feier*' from 1893.[29] Adler recognized this element in Austria from 1892, Vandervelde in Belgium from 1893.) Andrea Costa expressed it succinctly for Italy (1893): 'Catholics have Easter; henceforth the workers will have their own Easter';[30] there are rarer references to Whitsun also. A curiously syncretic 'May Day sermon' from Charleroi (Belgium) survives for 1898 under the joint epigraphs 'Proletarians of all lands, unite' and 'Love one another'.[31]

Red flags, the only universal symbols of the movement, were present from the start, but so, in several countries, were flowers: the carnation in Austria, the red (paper) rose in Germany, sweet briar and poppy in France, and the may, symbol of renewal, increasingly infiltrated, and from the mid-1900s replaced, by the lily-of-the-valley, whose associations were unpolitical. Little is known about this language of flowers which, to judge by the May Day poems in socialist literature also, was spontaneously associated with the occasion. [. . .]

As it happened, the First of May was initiated at a time of extraordinary growth and expansion in the labour and socialist movements of numerous countries, and might well not have established itself in a less hopeful political atmosphere. The ancient symbolism of spring, so fortuitously associated with it, suited the occasion perfectly in the early 1890s.

It thus became rapidly transformed into a highly charged annual festival and rite. The annual repetition was introduced to meet a demand from the ranks. [. . .] And

indeed, the public parade of the workers *as a class* formed the core of the ritual. It was, as commentators noted, the *only* holiday, even among radical and revolutionary anniversaries, to be associated with the industrial working class and no other; though – in Britain at least – specific communities of industrial workers had already shown signs of inventing general collective presentations of themselves as part of their labour movement. (The Durham miners' gala was first held in 1871.[32]) Like all such ceremonials, it was, or became, a basically good-humoured family occasion. [. . .] Most crucially, it asserted the working-class presence by that most fundamental assertion of working-class power: the abstention from work. For, paradoxically, the success of May Day tended to be proportionate to its remoteness from the concrete every-day activities of the movement. It was greatest where socialist aspiration prevailed over the political realism and trade union calculation which, as in Britain and Germany,[33] tended to favour a demonstration on the first Sunday of the month over the annual one-day strike on the first of May. Victor Adler, sensitive to the mood of the Austrian workers, had insisted on the demonstrative strike against the advice of Kautsky,[34] and the Austrian May Day consequently acquired unusual strength and resonance. Thus, as we have seen, May Day was not so much formally invented by the leaders of the movement, as accepted and institutionalized by them on the initiative of their followers.

The strength of the new tradition was clearly appreciated by its enemies. Hitler, with his acute sense of symbolism, found it desirable not only to annex the red of the workers' flag but also May Day, by turning it into an official 'national day of labour' in 1933, and subsequently attenuating its proletarian associations.[35] We may, incidentally, observe that it has now been turned into a general holiday of labour in the EEC.

May Day and similar labour rituals are halfway between 'political' and 'social' traditions, belonging to the first through their association with mass organizations and parties which could – and indeed aimed to – become regimes and states, to the second because they genuinely expressed the workers' consciousness of their existence as a separate class, inasmuch as this was inseparable from the organizations of that class. While in many cases – such as Austrian Social Democracy, or the British miners – class and organization became inseparable, it is not suggested that they were identical. 'The movement' developed its own traditions, shared by leaders and militants but not necessarily by voters and followers, and conversely the class might develop its own 'invented traditions' which were either independent of the organized movements, or even suspect in the eyes of the activists. Two of these, both clearly the product of our period, are worth a brief glance. The first is the emergence – notably in Britain, but probably also in other countries – of costume as a demonstration of class. The second is linked with mass sports.

It is no accident that the comic strip which gently satirized the traditional male working-class culture of the old industrial area of Britain (notably the North East) should choose as its title and symbol the headgear which virtually formed the badge of class membership of the British proletarian when not at work: 'Andy Capp'. A similar equation between class and cap existed in France to some extent[36] and possibly also in parts of Germany. In Britain, at least, iconographic evidence suggests that proletarian and cap were not universally identified before the 1890s, but that by the end of the Edwardian period – as photographs of crowds leaving football matches or mass meetings will confirm – that identification was almost complete.

[. . .] Keir Hardie's demonstrative entry into parliament in a cap (1892) indicates that the element of class assertion was recognized.[37] It is not unreasonable to suppose that the masses were not unaware of it. In some obscure fashion they acquired the habit of wearing it fairly rapidly in the last decades of the nineteenth and the first decade of the twentieth century as part of the characteristic syndrome of 'working-class culture' which then took shape.

[. . .]

The adoption of sports, and particularly football, as a mass proletarian cult is equally obscure, but without doubt equally rapid.[38] Here the timing is easier to establish. Between the middle 1870s, at the earliest, and the middle or late 1880s football acquired all the institutional and ritual characteristics with which we are still familiar: professionalism, the League, the Cup, with its annual pilgrimage of the faithful for demonstrations of proletarian triumph in the capital, the regular attendance at the Saturday match, the 'supporters' and their culture, the ritual rivalry, normally between moieties of an industrial city or conurbation (Manchester City and United, Notts County and Forest, Liverpool and Everton). Moreover, unlike other sports with regional or local proletarian bases – such as rugby union in South Wales,[39] cricket in parts of northern England – football operated both on a local and on a national scale, so that the topic of the day's matches would provide common ground for conversation between virtually any two male workers in England or Scotland, and a few score celebrated players provided a point of common reference for all.

The nature of the football culture at this period – before it had penetrated far into the urban and industrial cultures of other countries[40] – is not yet well understood. Its socio-economic structure is less obscure. Originally developed as an amateur and character-building sport by the public-school middle classes, it was rapidly (by 1885) proletarianized and therefore professionalized. [. . .] The structure of British football professionalism was quite different from that of professionalism in sports with aristocratic or middle-class participation (cricket) or control (racing), or from that of the demotic entertainment business, that other means of escape from the working-class fate, which also provided the model for some sports of the poor (boxing).[41]

[. . .]

Unlike Central European Social Democracy, the British labour movement did not develop its own sporting organizations, with the possible exception of cycling clubs in the 1890s, whose links with progressive thought were marked.[42]

[. . .]

III

To establish the class presence of a national middle-class élite and the membership of the much larger middle class was a far more difficult matter, and yet rather urgent at a time when occupations claiming middle-class status, or the numbers of those who aspired to them, were increasing with some rapidity in industrializing countries.

[. . .]

For the upper middle classes or 'haute bourgeoisie' the criteria and institutions which had formerly served to set apart an aristocratic ruling class provided the obvious model: they merely had to be widened and adapted. A fusion of the two classes in which the new components ceased to be recognizable as new was the ideal, though it was probably not completely attainable even in Britain, where it was quite possible for a family of Nottingham bankers to achieve, over several generations, intermarriage with royalty. What made the attempts at such assimilation possible (insofar as they were institutionally permitted) was that element of stability which, as a French observer noted of Britain, distinguished the established and arrived upper bourgeois generations from the first-generation climbers.[43] The rapid acquisition of really enormous wealth could also enable first-generation plutocrats to buy themselves into an aristocratic milieu which in bourgeois countries rested not only on title and descent but also on enough money to carry on a suitably profligate lifestyle.[44] In Edwardian Britain the plutocrats seized such opportunities eagerly.[45] Yet individual assimilation could serve only a tiny minority.

The basic aristocratic criterion of descent could, however, be adapted to define a relatively large new upper-middle-class élite. Thus a passion for genealogy developed in the USA in the 1890s. It was primarily a female interest: the 'Daughters of the American Revolution' (1890) survived and flourished, whereas the slightly earlier 'Sons of the American Revolution' faded away. Though the ostensible object was to distinguish native white and Protestant Americans from the mass of new immigrants, in fact their object was to establish an exclusive upper stratum among the white middle class. The D.A.R. had no more than 30,000 members in 1900, mostly in the strongholds of 'old' money – Connecticut, New York, Pennsylvania – though also among the booming millionaires of Chicago.[46] Organizations such as these differed from the much more restrictive attempts to set up a group of families as a quasi-aristocratic élite (by inclusion in a *Social Register* or the like), inasmuch as they provided nation-wide linkages. The less exclusive D.A.R. was more likely to discover suitable members in such cities as Omaha than a very élitist *Social Register*. The history of the middle-class search for genealogy remains to be written, but the systematic American concentration on this pursuit was probably, at this period, somewhat exceptional.

Far more significant was schooling, supplemented in certain respects by amateur sports, which were closely linked to it in the Anglo-Saxon countries. For schooling provided not only a convenient means of social comparability between individuals or families lacking initial personal relations and, on a nation-wide scale, a means of establishing common patterns of behaviour and values, but also a set of interlinked networks between the products of comparable institutions and, indirectly, through the institutionalization of the 'old boy', 'alumnus' or '*Alte Herren*', a strong web of intergenerational stability and continuity. Furthermore it provided, within limits for the possibility of expanding an upper-middle-class élite socialized in some suitably acceptable manner. [. . .]

Secondary schooling provided a broad criterion of middle-class membership, but one too broad to define or select the rapidly growing, but nevertheless numerically rather small, élites which, whether we call them ruling class or 'establishment', actually ran the national affairs of countries. Even in Britain, where no national secondary system existed before the present century, a special sub-class of 'public schools' had

to be formed within secondary education. They were first officially defined in the 1860s, and grew both by the enlargement of the nine schools then recognized as such (from 2,741 boys in 1860, to 4,553 in 1906) and also by the addition of further schools recognized as belonging to the élite class. Before 1868, two dozen schools at most had a serious claim to this status, but by 1902, according to Honey's calculations, they consisted of a minimum 'short list' of up to 64 schools and a maximum 'long list' of up to 104 schools, with a fringe of perhaps 60 of more doubtful standing.[47] Universities expanded at this period by rising admissions rather than by new foundations, but this growth was sufficiently dramatic to produce serious worries about the overproduction of graduates, at least in Germany. Between the mid-1870s and the mid-1880s student numbers approximately doubled in Germany, Austria, France and Norway and more than doubled in Belgium and Denmark.[48] The expansion in the USA was even more spectacular. By 1913 there were 38.6 students per 10,000 population in that country, compared with the usual continental figure of 9–11.5 (and less than 8 in Britain and Italy).[49] The problem of defining the effective élite within the growing body of those who possessed the required educational membership card was real.

In the broadest sense it was attacked by institutionalization. The *Public Schools Yearbook* (published from 1889) established the member schools of the so-called Headmasters' Conference as a recognizable national or even international community, if not of equals, then at least of comparables; and Baird's *American College Fraternities* (seven editions between 1879 and 1914) did the same for the 'Greek Letter Fraternities', membership of which indicated the élite among the mass of American university students. Yet the tendency of the aspiring to imitate the institutions of the arrived made it desirable to draw a line between the genuine 'upper middle classes' or élites and those equals who were less equal than the rest.[50] The reason for this was not purely snobbish. A growing national élite also required the construction of genuinely effective networks of interaction.

Here, it may be suggested, lies the significance of the institution of the 'old boys', 'alumni' or '*Alte Herren*' which now developed, and without which 'old boy networks' cannot exist as such. In Britain 'old boy dinners' appear to have started in the 1870s, 'old boy associations' at about the same time – they multiplied particularly in the 1890s, being followed shortly after by the invention of a suitable 'old school tie'.[51] Indeed it was not before the end of the century that the practice of sending sons to the father's old school appears to have become usual: only 5 per cent of Arnold's pupils had sent their sons to Rugby.[52] In the USA the establishment of 'alumni chapters' also began in the 1870s, 'forming circles of cultivated men who would not otherwise know each other',[53] and so, a little later, did the construction of elaborate fraternity houses in the colleges, financed by the alumni who thus demonstrated not only their wealth, and the intergenerational links but also – as in similar developments in the German student 'Korps'[54] – their influence over the younger generation. Thus Beta Theta Pi had 16 alumni chapters in 1889 but 110 in 1913; only a single fraternity house in 1889 (though some were being built), but 47 in 1913. Phi Delta Theta had its first alumni association in 1876 but by 1913 the number had grown to about one hundred.

[. . .]

In Britain, it is safe to say, the informal networks, created by school and college, reinforced by family continuity, business sociability and clubs were more effective than formal associations. How effective may be judged by the record of such institutions as the code-breaking establishment at Bletchley and the Special Operations Executive in the Second World War.[55] Formal associations, unless deliberately restricted to an élite – like the German 'Kösener Korps' which between them comprised 8 per cent of German students in 1887, 5 per cent in 1914[56] – served largely, it may be suggested, to provide general criteria of social 'recognizability'. Membership of *any* Greek Letter Fraternity – even the vocational ones which multiplied from the end of the 1890s[57] – and possession of *any* tie with diagonal stripes in some combination of colours served the purpose.

However, the crucial informal device for stratifying a theoretically open and expanding system was the self-selection of acceptable social partners, and this was achieved above all through the ancient aristocratic pursuit of sport, transformed into a system of formal contests against antagonists selected as worthy on social grounds. It is significant that the best criterion for the 'public-school community' discovered is by the study of which schools were ready to play games against each other,[58] and that in the USA the élite universities (the 'Ivy League') were defined, at least in the dominant north-east, by the selection of colleges choosing to play each other at football, in that country essentially a college sport in origin. Nor is it an accident that the formal sporting contests between Oxford and Cambridge developed essentially after 1870, and especially between 1890 and 1914 (see Table 4.2).

Table 4.2 Regular Oxford–Cambridge contests by date of institutions[59]

Date	No. of contests	Sport
Before 1860	4	Cricket, rowing, rackets. real tennis
1860s	4	Athletics, shooting, billiards, steeple-chasing
1870s	4	Golf, soccer, rugby, polo
1880s	2	Cross-country, tennis
1890s	5	Boxing, hockey, skating, swimming, water-polo
1900–13	8	Gymnastics, ice-hockey, lacrosse, motor-cycle racing, tug-of-war, fencing, car-racing, motor-cycle hill climbing (some of these were later abandoned)

In Germany this social criterion was specifically recognized:

> The characteristic which singles out academic youth as a special social group (*Stand*) from the rest of society, is the concept of '*Satisfaktionsfähigkeit*' [the acceptability as a challenger in duels], i.e. the claim to a specific socially defined standard of honour (*Standesehre*).[60]

Elsewhere de facto segregation was concealed in a nominally open system.

This brings us back to one of the most significant of the new social practices of our period: sport. The social history of upper- and middle-class sports remains to be written[61], but three things may be suggested. First, the last three decades of the nineteenth century mark a decisive transformation in the spread of old, the invention of new, and the institutionalization of most sports on a national and even an international scale. Second, this institutionalization provided both a public show-case for sport, which one may (with tongue in cheek) compare to the fashion for public building and statuary in politics, and a mechanism for extending activities hitherto confined to the aristocracy and the rich bourgeoisie able to assimilate its life-styles to a widening range of the 'middle classes'. That, on the continent, it remained confined to a fairly restricted élite before 1914 is another matter. Third, it provided a mechanism for bringing together persons of an equivalent social status otherwise lacking organic social or economic links, and perhaps above all for providing a new role for bourgeois *women*.

[. . .]

It is hardly necessary to document the fact that the institutionalization of sport took place in the last decades of the century. Even in Britain it was hardly estab-lished before the 1870s – the Association football cup dates back to 1871, the county cricket championship to 1873 – and thereafter several new sports were invented (tennis, badminton, hockey, water-polo, and so on), or de facto intro-duced on a national scale (golf), or systematized (boxing). Elsewhere in Europe sport in the modern form was a conscious import of social values and life-styles from Britain, largely by those influenced by the educational system of the British upper class, such as Baron de Coubertin, an admirer of Dr Arnold.[62] What is significant is the speed with which these transfers were made, though actual insti-tutionalization took somewhat longer.

Middle-class sport thus combined two elements of the invention of tradition: the political and the social. On the one hand it represented a conscious, though not usually official, effort to form a ruling élite on the British model supplementing, competing with or seeking to replace the older aristocratic–military continental models, and this, depending on the local situation, associated with conservative or liberal elements in the local upper and middle classes.[63] On the other it repre-sented a more spontaneous attempt to draw class lines against the masses, mainly by the systematic emphasis on amateurism as the criterion of upper- and middle-class sport (as notably in tennis, rugby union football as against association football and rugby league and in the Olympic Games). However, it also represented an attempt to develop both a specific new bourgeois pattern of leisure activity and a life-style – both bisexual and suburban or ex-urban[64] – and a flexible and expand-able criterion of group membership.

Both mass and middle-class sport combined the invention of political and social traditions in yet another way: by providing a medium for national identification and factitious community. This was not new in itself, for mass physical exercises had long been linked with liberal–nationalist movements (the German *Turner*, the Czech *Sokols*) or with national identification (rifle-shooting in Switzerland). Indeed the resistance of the German gymnastic movement, on nationalist grounds in general and anti-British ones in particular, distinctly slowed down the progress of

mass sport in Germany.[65] The rise of sport provided new expressions of nation-alism through the choice or invention of nationally specific sports — Welsh rugby as distinct from English soccer, and Gaelic football in Ireland (1884), which acquired genuine mass support some twenty years later.[66] However, although the specific linking of physical exercises with nationalism as part of nationalist move-ments remained important — as in Bengal[67] — it was by now certainly less significant than two other phenomena.

The first of these was the concrete demonstration of the links which bound all inhabitants of the national state together, irrespective of local and regional dif-ferences, as in the all-English football culture or, more literally, in such sporting institutions as the cyclists' Tour de France (1903), followed by the Giro d'Italia (1909). These phenomena were all the more significant as they evolved spontaneously or by commercial mechanisms. The second consisted of the international sporting contests which very soon supplemented national ones, and reached their typical expression in the revival of the Olympics in 1896. While we are today only too aware of the scope for vicarious national identification which such contests provide, it is important to recall that before 1914 they had barely begun to acquire their modern character. [. . .] International sport, with few exceptions, remained dominated by amateurism — that is by middle-class sport — even in football, where the international association (F.I.F.A.) was formed by countries with little mass support for the game in 1904 (France, Belgium, Denmark, the Netherlands, Spain, Sweden, Switzerland). The Olympics remained the main international arena for this sport. To this extent national identification through sport against foreigners in this period seems to have been primarily a middle-class phenomenon.

This may itself be significant. For, as we have seen, the middle classes in the broadest sense found subjective group identification unusually difficult, since they were not in fact a sufficiently small minority to establish the sort of virtual member-ship of a nation-wide club which united, for example, most of those who had passed through Oxford and Cambridge, nor sufficiently united by a common destiny and potential solidarity, like the workers.[68] Negatively the middle classes found it easy to segregate themselves from their inferiors by such devices as rigid insistence on amateurism in sport, as well as by the life-style and values of 'respectability', not to mention residential segregation. Positively, it may be suggested, they found it easier to establish a sense of belonging together through external symbols, among which those of nationalism (patriotism, imperialism) were perhaps the most signif-icant. It is, one might suggest, as the quintessential patriotic class that the new or aspiring middle class found it easiest to recognize itself collectively. [. . .]

The nationalism which gained ground was overwhelmingly identified with the political right. In the 1890s the originally liberal–nationalist German gymnasts abandoned the old national colours en masse to adopt the new black–white–red banner: in 1898 only 100 out of 6,501 *Turnervereine* still maintained the old black–red–gold.[69]

What is clear is that nationalism became a substitute for social cohesion through a national church, a royal family or other cohesive traditions, or collective group self-presentations, a new secular religion, and that the class which required such a mode of cohesion most was the growing new middle class, or rather that large intermediate mass which so signally lacked other forms of cohesion.

At this point, once again, the invention of political traditions coincides with that of social ones.

IV

To establish the clustering of 'invented traditions' in western countries between 1870 and 1914 is relatively easy. Enough examples of such innovations have been given in this chapter, from old school ties and royal jubilees, Bastille Day and the Daughters of the American Revolution, May Day, the Internationale and the Olympic Games to the Cup Final and Tour de France as popular rites, and the institution of flag worship in the USA. The political developments and the social transformations which may account for this clustering have also been discussed, though the latter more briefly and speculatively than the former. For it is unfortunately easier to document the motives and intentions of those who are in a position formally to institute such innovations, and even their consequences, than new practices which spring up spontaneously at the grass-roots. British historians of the future, anxious to pursue similar inquiries for the late twentieth century, will have far less difficulty with the analysis of, say, the ceremonial consequences of the assassination of Earl Mountbatten than with such novel practices as the purchase (often at great expense) of individually distinctive number-plates for motor cars. [. . .]

However, there remain three aspects of the 'invention of tradition' in this period which call for some brief comment in conclusion.

The first is the distinction between those new practices of the period which proved lasting, and those which did not. In retrospect it would seem that the period which straddles the First World War marks a divide between languages of symbolic discourse. As in military uniforms what might be called the operatic mode gave way to the prosaic mode. The uniforms invented for the interwar mass movements, which could hardly claim the excuse of operational camouflage, eschewed bright colours, preferring duller hues such as the black and brown of Fascists and National Socialists.[70] No doubt fancy dress for ritual occasions was still invented for men in the period 1870–1914, though examples hardly come to mind – except perhaps by way of the extension of older styles to new institutions of the same type and, hopefully, status, such as academic gowns and hoods for new colleges and degrees. The old costumes were certainly still maintained. However one has the distinct impression that in this respect the period lived on accumulated capital. In another respect, however, it clearly developed an old idiom with particular enthusiasm. The mania for statuary and allegorically decorated or symbolic public buildings has already been mentioned, and there is little doubt that it reached a peak between 1870 and 1914. Yet this idiom of symbolic discourse was destined to decline with dramatic suddenness between the wars. Its extraordinary vogue was to prove almost as short-lived as the contemporary outburst of another kind of symbolism, 'art nouveau'. [. . .]

On the other hand, it may be suggested that another idiom of public symbolic discourse, the theatrical, proved more lasting. Public ceremonies, parades and ritualized mass gatherings were far from new. Yet their extension for official purposes

and for unofficial secular purposes (mass demonstrations, football matches, and the like) in this period is rather striking. Some examples have been mentioned above. Moreover, the construction of formal ritual spaces, already consciously allowed for in German nationalism, appears to have been systematically undertaken even in countries which had hitherto paid little attention to it – one thinks of Edwardian London – and neither should we overlook the invention in this period of substantially new constructions for spectacle and de facto mass ritual such as sports stadia, outdoor and indoor.[71] The royal attendance at the Wembley Cup Final (from 1914), and the use of such buildings as the Sportspalast in Berlin or the Vélodrome d'Hiver in Paris by the interwar mass movements of their respective countries, anticipate the development of formal spaces for public mass ritual (the Red Square from 1918) which was to be systematically fostered by Fascist regimes. We may note in passing that, in line with the exhaustion of the old language of public symbolism, the new settings for such public ritual were to stress simplicity and monumentality rather than the allegorical decoration of the nineteenth-century Ringstrasse in Vienna or the Victor Emmanuel monument in Rome;[72] a tendency already anticipated in our period.[73]

On the stage of public life emphasis therefore shifted from the design of elaborate and varied stage-sets, capable of being 'read' in the manner of a strip cartoon or tapestry, to the movement of the actors themselves – either, as in military or royal parades, a ritual minority acting for the benefit of a watching mass public, or, as anticipated in the political mass movements of the period (such as May Day demonstrations) and the great mass sporting occasions, a merger of actors and public. These were the tendencies which were destined for further development after 1914. Without speculating further about this form of public ritualization, it does not seem unreasonable to relate it to the decline of old tradition and the democratization of politics.

The second aspect of invented tradition in this period concerns the practices identified with specific social classes or strata as distinct from members of wider inter-class collectivities such as states or 'nations'. While some such practices were formally designed as badges of class consciousness – the May Day practices among workers, the revival or invention of 'traditional' peasant costume among (de facto the richer) peasants – a larger number were not so identified in theory and many indeed were adaptations, specializations or conquests of practices originally initiated by the higher social strata. Sport is the obvious example. From above, the class line was here drawn in three ways: by maintaining aristocratic or middle-class control of the governing institutions, by social exclusiveness or, more commonly, by the high cost or scarcity of the necessary capital equipment (real-tennis courts or grouse-moors), but above all by the rigid separation between amateurism, the criterion of sport among the upper strata, and professionalism, its logical corollary among the lower urban and working classes.[74] Class-specific sport among plebeians rarely developed consciously as such. Where it did, it was usually by taking over upper-class exercises, pushing out their former practitioners, and then developing a specific set of practices on a new social basis (the football culture).

Practices thus filtering socially downwards – from aristocracy to bourgeoisie, from bourgeoisie to working class – were probably predominant in this period,

not only in sport, but in costume and material culture in general, given the force of snobbery among the middle classes and of the values of bourgeois self-improvement and achievement among the working class élites.[75] They were transformed, but their historical origins remained visible. The opposite movement was not absent, but in this period less visible. Minorities (aristocrats, intellectuals, deviants) might admire certain urban plebeian sub-cultures and activities – such as music-hall art – but the major assimilation of cultural practices developed among the lower classes or for a mass popular public was to come later. Some signs of it were visible before 1914, mainly mediated through entertainment and perhaps above all the social dance, which may be linked to the growing emancipation of women: the vogue for ragtime or the tango. However, any survey of cultural inventions in this period cannot but note the development of autochthonous lower-class sub-cultures and practices which owed nothing to models from higher social classes – almost certainly as a by-product of urbanization and mass migration. The tango culture in Buenos Aires is an example.[76] How far they enter into a discussion of the invention of tradition must remain a matter of debate.

The final aspect is the relation between 'invention' and 'spontaneous generation', planning and growth. This is something which constantly puzzles observers in modern mass societies. 'Invented traditions' have significant social and political functions, and would neither come into existence nor establish themselves if they could not acquire them. Yet how far are they manipulable? The intention to use, indeed often to invent, them for manipulation is evident; both appear in politics, the first mainly (in capitalist societies) in business. To this extent conspiracy theorists opposed to such manipulation have not only plausibility but evidence on their side. Yet it also seems clear that the most successful examples of manipulation are those which exploit practices which clearly meet a felt – not necessarily a clearly understood – need among particular bodies of people. The politics of German nationalism in the Second Empire cannot be understood only from above. It has been suggested that to some extent nationalism escaped from the control of those who found it advantageous to manipulate it – at all events in this period.[77] Tastes and fashions, notably in popular entertainment, can be 'created' only within very narrow limits; they have to be discovered before being exploited and shaped. It is the historian's business to discover them retrospectively – but also to try to understand why, in terms of changing societies in changing historical situations, such needs came to be felt.

Notes

1 G. L. Mosse, 'Caesarism, circuses and movements', *Journal of Contemporary History* vi(2) (1971): 167–82; G. L. Mosse, *The Nationalisation of the Masses: Political Symbolism and Mass Movements in Germany from the Napoleonic Wars through the 3rd Reich* (New York: 1975); T. Nipperdey, 'Nationalidee und Nationaldenkmal in Deutschland im 19. Jahrundert', *Historische Zeitschrift* (June 1968): 529–85, esp. 543n, 579n.

2 Eugen Weber, *Peasants into Frenchmen: The Modernization of Rural France, 1870–1914* (Stanford: 1976).

3 This was conclusively demonstrated in 1914 by the socialist parties of the Second International, which not only claimed to be essentially international in scope, but actually sometimes regarded themselves officially as no more than national sections of a global movement ('Section Française de l'Internationale Ouvrière').

4 Graham Wallas, *Human Nature in Politics* (London: 1908), p. 21.

5 Emile Durkheim, *The Elementary Forms of the Religious Life* (London: 1976). First French publication 1912.

6 J. G. Frazer, *The Golden Bough*, 3rd edn (London: 1907–30); F. M. Cornford, *From Religion to Philosophy: A Study of the Origins of Western Speculation* (London: 1912).

7 J. P. Mayer, *Political Thought in France from the Revolution to the 5th Republic* (London: 1961), pp. 84–8.

8 Sanford H. Elwitt, *The Making of the 3rd Republic: Class and Politics in France, 1868–84* (Baton Rouge: 1975).

9 Georges Duveau, *Les Instituteurs* (Paris: 1957); J. Ozouf (ed.), *Nous les Maîtres d'Ecole: Autobiographies d'Instituteurs de la Belle Epoque* (Paris: 1967).

10 Alice Gérard, *La Révolution Française: Mythes et Interprétations, 1789–1970* (Paris: 1970), Ch. 4.

11 Charles Rearick, 'Festivals in modern France: the experience of the 3rd Republic', Journal of Contemporary History xii(3) (July 1977): 435–60; Rosemonde Sanson, *Les 14 Juillet, Fête et Conscience Nationale, 1789–1975* (Paris: 1976), with bibliography.

12 For the political intentions of the 1889 one, cf. Debora L. Silverman. 'The 1889 exhibition: the crisis of bourgeois individualism', *Oppositions, A Journal for Ideas and Criticism in Architecture* (Spring, 1977): 71–91.

13 M. Agulhon, 'La Statuomanie et l'Histoire', Ethnologie Française 3–4 (1978): 3–4.

14 Hans-Georg John, *Politik und Turnen: die deutsche Turnerschaft als nationale Bewegung im deutschen Kaiserrich von 1871–1914* (Ahrensberg bei Hamburg: 1976), pp. 41ff.

15 'Fate determined that, against his nature he should become a monumental sculptor, who was to celebrate the imperial idea of William II in giant monuments of bronze and stone, in a language of imagery and over-emphatic pathos.' Ulrich Thieme and Felix Becker, *Allgemeines Lexikon der bildenden Künstler von der Antike bis zur Gegenwart* (Leipzig: 1907–50), III, p. 185.

16 John, op. cit., Nipperdey, 'Nationalidee', pp. 577 ff.

17 J. Surel, 'La Première Image de John Bull, Bourgeois Radical, Anglais Loyaliste (1779–1815)', *Le Mouvement Social*, cvi (Jan.–Mar. 1979): 65–84; Herbert M. Atherton, *Political Prints in the Age of Hogarth* (Oxford: 1974), pp. 97–100.

18 Heinz Stallmann, *Das Prinz-Heinrichs-Gymnasium zu Schöneberg, 1890–1945. Geschichte einer Schule* (Berlin: n.d.[1965]).

19 R.E. Hardt, *Dir Beine der Hohenzollern* (E. Berlin: 1968).

20 H.-U. Wehler, *Das deutsche Kaiserreich 1871–1918* (Göttingen: 1973), pp. 107–10.

21 The history of these festivities remains to be written, but it seems clear that they became much more institutionalized on a national scale in the last third of the nineteenth century. G. W. Douglas, *American Book of Days* (New York: 1937); Elizabeth Hough Sechrist, *Red Letter Days: A Book of Holiday Customs* (Philadelphia: 1940).

22 R. Firth, *Symbols, Public and Private* (London: 1973), pp. 358–9; W. E. Davies, *Patriotism on Parade: The Story of Veterans and Hereditary Organisations in America 1783–1900* (Cambridge, MA: 1955), pp. 218–22; Douglas, op. cit., pp. 326–7.

23 I am obliged to Prof. Herbert Gutman for this observation.

24 Source: *Stamps of the World 1972: A Stanley Gibbons Catalogue* (London: 1972).

25 The 'jubilee', except in its biblical sense, had previously been simply the fiftieth anniversary. There is no sign before the later nineteenth century that centenaries, single or multiple, still less anniversaries of less than fifty years, were the occasion for public celebration. The *New English Dictionary* (1901) observes under 'jubilee' 'especially frequent in the last two decades of the nineteenth century in reference to the two "jubilees" of Queen Victoria in 1887 and 1897, the Swiss jubilee of the Postal Union in 1900 and other celebrations': see p. 615.

26 J. E. C. Bodley, *The Coronation of Edward VII: A Chapter of European and Imperial History* (London: 1903), pp. 153, 201.

27 Maurice Dommanget, *Histoire du Premier Mai* (Paris: 1953), pp. 36–7.

28 A. Van Gennep, *Manuel de Folklore Français I*. Vol. IV, *Les Cérémonies Périodiques Cycliques et Saisonnières*, 2: Cycle de Mai (Paris: 1949), p. 1719.

29 Engels to Sorge 17 May 1893, in *Briefe und Auszüge aus Briefen an F.A. Sorge u.A.* (Stuttgart: 1906), p. 397. See also Victor Adler, *Aufsätze, Reden und Briefe* (Vienna: 1922), I, p. 69.

30 Dommanget, op. cit., p. 343.

31 E. Vandervelde and J. Destrée, *Le Socialisme en Belgique* (Paris: 1903), pp. 417–18.

32 Edward Welbourne, *The Miners' Unions of Northumberland and Durham* (Cambridge: 1923), p. 155; John Wilson, *A History of the Durham Miners' Association 1870–1904* (Durham: 1907), pp. 31, 34, 59; W.A. Moyes, *The Banner Book* (Gateshead: 1974). These annual demonstrations appear to have originated in Yorkshire in 1866.

33 Carl Schorske, *German Social Democracy, 1905–17: The Development of the Great Schism* (New York: 1965 edn), pp. 91–7.

34 M. Ermers, *Victor Adler: Aufstieg u. Grösse einer sozialistischen Partei* (Vienna and Leipzig: 1932), p. 195.

35 Helmut Hartwig, 'Plaketten zum 1. Mai 1934–39', *Aesthetik und Kommunikation* 7(26) (1976): 56–9.

36 'L'ouvrier même ne porte pas ici la casquette et la blouse' observed Jules Vallès contemptuously in London in 1872 – unlike the class-conscious Parisians. Paul Martinez, 'The French Communard refugees in Britain, 1871–1880' (University of Sussex, PhD thesis, 1981), p. 341.

37 Hardie's own deerstalker-like cap represents a transitional stage to the eventually universal 'Andy Capp' headgear.

38 Tony Mason, *Association Football and English Society, 1863–1915* (Brighton: 1980).

39 Cf. David B. Smith and Gareth W. Williams, *Field of Praise: Official History of the Welsh Rugby Union, 1881–1981* (Cardiff: 1981).

40 Abroad it was often pioneered by British expatriates and the teams of local British-managed factories, but though it clearly had been to some extent naturalized by 1914 in some capital cities and industrial towns of the continent, it had hardly yet become a mass sport.

41 W.F. Mandle, 'The professional cricketer in England in the nineteenth century', *Labour History* (Journal of the Australian Society for the Study of Labour History) xxiii (Nov. 1972): 1–16; Wray Vamplew, *The Turf: A Social and Economic History of Horse Racing* (London: 1976).

42 The Clarion Cycling Clubs come to mind, but also the foundation of the Oadby
 Cycling Club by a local radical poacher, labour activist and parish councillor.
 The nature of this sport – in Britain typically practised by youthful amateurs –
 was quite different from mass proletarian sport. David Prynn, 'The Clarion
 Clubs, rambling and holiday associations in Britain since the 1890s', *Journal of
 Contemporary History* (2–3) (July 1976): 65–77; anon., 'The Clarion Fellowship',
 Marx Memorial Library Quarterly Bulletin lxxvii (Jan–Mar 1976): 6–9; James
 Hawker, *A Victorian Poacher*, ed. G. Christian (London: 1961), pp. 35–6.

43 Paul Descamps, *L'Education dans les Ecoles Anglaises*, Bib. de la Science Sociale
 (Paris: January 1911), pp. 11, 67.

44 ibid.: 11.

45 Jamie Camplin, *The Rise of the Plutocrats: Wealth and Power in Edwardian England*
 (London: 1978).

46 Davies, *Patriotism on Parade*, pp. 47, 77.

47 J. R. de S. Honey, *Tom Brown's Universe: The Development of the Victorian Public
 School* (London: 1977), p. 273.

48 J. Conrad, 'Die Frequenzverhältnisse der Universitäten der hauptsächlichsten
 Kulturländer auf dem Europäischen Kontinent', *Jahrbücher f. N. O K u. Statistik*,
 3rd series, I (1891): 376–94.

49 Joseph Ben-David, 'Professions in the class system of present-day societies',
 Current Sociology xii(3) (1963–4): 63–4.

50 'In consequence of the general snobbery of the English, above all of the English
 rising in the social scale, the education of the Middle Classes tend to model itself
 upon that of the Upper Middle Class, though with less expenditure of time and
 money.' Descamps, *L'Education dans les Ecoles Anglaises*, p. 67. The phenomenon
 was far from purely British.

51 *The Book of Public School, Old Boys, University, Navy, Army, Air Force and Club Ties*,
 intro. by James Laver (London: 1968), p. 31; see also Honey, op. cit.

52 Honey, op. cit., p. 153.

53 W. Raimond Baird, *American College Fraternities: A Descriptive Analysis of the Society
 System of the Colleges of the US with a Detailed Account of each Fraternity*, 4th edn
 (New York: 1980), pp. 20–1.

54 Bernard Oudin, *Les Corporations Allemandes d'Etudiants* (Paris: 1962), p. 19; Detlef
 Grieswelle, 'Die Soziologie der Kösener Korps 1870–1914', in *Student und
 Hochschule im 19 Jahrhundert: Studien und Materialien* (Göttingen: 1975).

55 R. Lewin, *Ultra Goes to War* (London, 1980 edn), pp. 55–6.

56 Grieswelle, op. cit., pp. 349–53.

57 Baird lists forty-one fraternities in 1914 unmentioned in 1890. Twenty-eight of
 them formed after 1900, ten founded before 1890, twenty-eight of these were
 confined to lawyers, doctors, engineers, dentists and other career specializations.

58 Honey, op. cit., pp. 253 ff.

59 Calculated from Royal Insurance Company, *Record of Sports*, 9th edn (1914).

60 Günter Botzert, *Sozialer Wandel der studentischen Korporationen* (Münster: 1971),
 p. 123.

61 For some relevant data, see Carl Diem, *Weltgeschichte des Sports und der
 leibeserziehung* (Stuttgart: 1960); Kl. C. Wildt, *Daten zur Sportgeschichte* Teil 2,
 Europa von 1750 bis 1894 (Schorndorf bei Stuttgart: 1972).

62 Pierre de Coubertin, *L'Ecole en Angleterre* (Paris: 1888); Diem, op. cit.,
 pp. 1130 f.

63 Marcel Spivak, 'Le Développement de l'Education Physique et du Sport Français de 1852 à 1914', *Revue d'Histoire Moderne et Contemporaine* xxiv (1977): 28–48; D. Lejeune, 'Histoire Sociale et Alpinisme en France, XIX–XX s.', Revue d'Histoire Moderne et Contemporaire xxv (1978): 111–28.

64 This must be distinguished from the patterns of sports and outdoor pastimes of the old aristocracy and military, even if they sometimes took to the new sports or forms of sport.

65 John, op. cit., pp. 107 ff.

66 W. F. Mandle, 'Sport as politics. The Gaelic Athletic Association 1884–1916', in R. Cashman and M. McKernan (eds), *Sport in History* (St Lucia: Queensland University Press, 1979).

67 John Rosselli, 'The self-image of effeteness: physical education and nationalism in 19th century Bengal', *Past and Present* 86 (1980): 121–48.

68 It would be interesting, in countries whose language permits this distinction, to inquire into the changes in the mutual social use of the second person singular, symbol of social brotherhood as well as of personal intimacy. Among the higher classes its use between fellow-students (and, as with French polytechnicians, ex-students), brother-officers and the like is familiar. Workers, even when they did not know one another, used it habitually. Leo Uhen, *Gruppenbewusstsein und informelle Gruppenbildung bei deutschen Arbeitern im Jahrhundert der Industrialisierung* (Berlin: 1964), pp. 106–7. Labour movements institutionalized it among their members ('Dear Sir and Brother').

69 John, op. cit., p. 37.

70 The brightest such uniforms appear to have been the blue shirts and red ties of socialist youth movements. I know of no case of red, orange or yellow shirts and none of genuinely multicoloured ceremonial clothing.

71 Cf. *Wasmuth's Lexikon der Baukunst* (Berlin: 1932), IV: 'Stadthalle'; W. Scharau-Wils, *Gebäude und Gelände für Gymnastik, Spiel und Sport* (Berlin: 1925); D.R. Knight, *The Exhibitions: Great, White City, Shepherds Bush* (London: 1978).

72 Carl Schorske, *Fin de Siècle Vienna: Politics and Culture* (New York: 1980), Ch. 2.

73 Cf. Alastair Service, *Edwardian Architecture: A Handbook to Building Design in Britain 1890–1914* (London: 1977).

74 Professionalism implies a degree of occupational specialization and a 'market' barely if at all available among the settled rural population. Professional sportsmen there were either servants or suppliers of the upper classes (jockeys, alpine guides) or appendages to amateur upper-class competitions (cricket professionals). The distinction between the upper- and lower-class killing of game was not economic, though some poachers relied on it for a living, but legal. It was expressed in the Game Laws.

75 A Weberian correlation of sport and Protestantism has been observed in Germany up to 1960. G. Lüschen, 'The interdependence of sport and culture', in M. Hart (ed.), *Sport in the Sociocultural Process* (Dubuque: 1976).

76 Cf. Blas Matamoro, *La Ciudad del Tango (Tango Histórico y Sociedad)* (Buenos Aires: 1969).

77 Geoffrey Eley, *Re-shaping the German Right* (London and New Haven: Yale University Press, 1980).

Philip Dodd

ENGLISHNESS AND THE NATIONAL CULTURE

> The characteristic 'Englishness' of English culture was made then very much what it is now. The quip that all the oldest English traditions were invented in the last quarter of the nineteenth century has great point.[1]
>
> (Richard Shannon, *The Crisis of Imperialism*)

RICHARD SHANNON'S JUDGEMENT IS CENTRAL to the argument of this essay, even if 'invented' does not adequately register the complex and overlapping processes of invention, transformation and recovery which characterised the remaking of English identity and the national culture in the later years of the nineteenth century. [. . .] This essay argues that Englishness and the 'English spirit' were the preoccupation not only of the political culture, but also of what we might now call the institutions and practices of a cultural politics. Indeed an Englishness sited exclusively – or even primarily – in political institutions would hardly have established itself as the centre and circumference of our thinking about ourselves and our history. Certainly one does not have to think for long to acknowledge that many of our educational and, more generally, cultural traditions and institutions were forged in the later part of the nineteenth century. For instance, the tools without which this study is unimaginable – *The New English Dictionary* (1884–1928) and the *Dictionary of National Biography* (1885–1900) – are also among its objects of study; and the academic disciplines, English Literature and History, were fashioned in their present forms during this period.

I

To understand *whose* account of Englishness and the national culture was authorised during this period, and *how* it was authorised, some words from Edward Said's

impressive study of the colonisation and representation by Europe of the Orient are helpful. Said's argument is that

> without examining Orientalism as a discourse one cannot possibly understand the enormously systematic discipline by which European culture was able to manage – and even produce – the Orient politically, sociologically, militarily, ideologically, scientifically and imaginatively during the post-Enlightenment period.[2]

To translate Said's argument for our purposes: a great deal of the power of the dominant version of Englishness during the last years of the nineteenth century and the early years of the twentieth century lay in its ability to represent both itself to others and those others to themselves. Such representation worked by a process of inclusion, exclusion and transformation of elements of the cultural life of these islands. What constituted knowledge, the control and dissemination of that knowledge to different groups, the legitimate spheres and identity of those groups, their repertoire of appropriate actions, idioms and convictions – all were the subject, *within the framework of the national culture and its needs*, of scrutiny, licence and control.

But before we embark on a mapping of this English national culture and its constituent parts, one thing needs to be said. Although there is certainly evidence to support the thesis that Englishness and the national culture were reconstituted *in order* to incorporate and neuter various social groups – for example, the working class, women, the Irish – who threatened the dominant social order, it is unhelpful for two reasons to see the reconstitution as a simple matter of the imposition of an identity by the dominant on the subordinate. First, the remaking of class, gender and national identity was undertaken at such a variety of social locations and by such various groups that it is difficult to talk of a common intention. It was, for instance, undertaken not only within the new state schools and within the new public schools and ancient (and new) universities, but also by quite a remarkable number of groups, professional and otherwise, who took it upon themselves for various reasons to explore and 'colonise' others. What these groups shared was not necessarily a common intention, but (often) an interlocking membership and an overlapping vocabulary of evaluation. The other reason why 'imposition' is too simple is that the establishment of hegemony involves negotiation and 'active consent' on the part of the subordinated.[3] Take, for instance, the case of women who, as Virginia Woolf said, 'are, perhaps the most discussed animal in the universe'.[4] It is undoubtedly true that a separate spheres ideology was elaborated by professional males during the last quarter of the nineteenth century; but it is also true that at least some of the groups of women most opposed to male domi-nation often proclaimed women's moral superiority: 'while they challenged women's traditional roles, they adopted much of the traditional conception of womanhood, which they, like the anti-feminists, saw as rooted in women's domestic situation and above all in her political if not her actual maternity.'[5] Not any identity can be imposed, then; it must at least be consented to. And even to acknowledge this is still to ignore completely oppositional identities and practices forged by the subordinated groups – or at least, and this is what my argument

does, to note such identities and practices only when they were forged within and against those offered to them from above.

What I propose to do is to build a general argument about the national culture and the English around particular instances. The essay is in two parts. First, I examine the identity and 'place' within the national culture of a number of social groups, during a period when 'class loyalties and conflicts [were] set in a genuinely national framework for the first time'.[6] The groups chosen for scrutiny are the working class and the Celts. (Needless to say, other groups have powerful claims for attention.)[7] Second, I trace, through the examples of the English language and the National Theatre (with sideway glances at the *Dictionary of National Biography* and the National Portrait Gallery), how the cultural history and contemporary life of the English were stabilised and articulated anew.

II

First, a brief sketch of the dominant English. The centrality of educational institutions for the control and dissemination of a national identity hardly needs stressing, and was especially clear during the later years of the nineteenth century with the dramatic reorganisation and extension of state education. But what is interesting is that, as the new 'national system of education' began to be held responsible for the (ill-)health of the national culture,[8] the 'English spirit' was seen *not* to reside in such institutions – as one might expect – but to be incarnate elsewhere. Compare two comments, one from the end, one from the beginning, of the period. In 1929, Bernard Darwin, in one of a large number of books around that time about the public school system, said that, whatever one's views of it, 'it is really to a great extent the English character that we are criticising.'[9] And in 1869, Matthew Arnold argued in *Culture and Anarchy* that to belong to the national life one had to belong or to affiliate to certain English institutions: the Anglican Church and Oxford or Cambridge University. Arnold's definition was sufficiently flexible to accommodate John Milton, sufficiently definite to exclude the culture of the nonconformists.[10] The argument that the history of the working class, and of women, as well as certain bourgeois data have often been buried out of sight of the 'national mind' may seem to attest to the power of Arnold's and his successors' equation of Englishness with certain institutions.[11]

The establishment of those educational institutions identified by Matthew Arnold and Bernard Darwin as custodians and transmitters of English culture entailed substantial change on the part of each of the institutions. First, the ancient universities. During the late nineteenth century, their constituency changed from landed and clerical families to professional and rich business ones, and their graduates increasingly selected careers in the secular professions – including the academic one.[12] Certainly the responsibility of the ancient universities to the nation was an important matter for debate. When criticisms were made of their curriculum by scientists, the frame of reference was not those institutions' inadequate sense of what constituted knowledge, but the nation: 'That the ancient universities are keeping the nation back there cannot be a doubt.' Or when their serviceableness

was called into question it was, according to James Bryce, who was later to be a Liberal Minister, a matter of 'how to make the universities serviceable to the whole nation, instead of only to the upper classes.'[13] Needless to say, such service did not mean they had to acknowledge responsibility for the educational needs of *all* men and women; although one ought to add that the rhetoric of national service was, to a degree, coercive and successful . . . for instance, in the University Extension Movement). It could also lead Mark Pattison, Rector of Lincoln College, Oxford, to say that a National University should be 'co-extensive with the nation; it should be the common source of the whole of the higher (or secondary) education for the country'.[14] The price exacted by Pattison for Oxford's acknowledgement of its national responsibilities was high: the agreement that it was *the* source of all higher instruction, a centre of, and authority on, the national culture. In *Oxford and Working-Class Education* (1908), it was stated that 'The Trade Union Secretary and the "Labour Member" need an Oxford education as much . . . as the Civil Servant or the barrister'.[15]

The shift of national authority to the (ancient) universities – their establishment as custodians of the national culture – may be encapsulated in the example of the school subject History which was made compulsory in 1900 in secondary schools. What is interesting in this context is that the authorship of history textbooks moved from upper middle-class amateurs to schoolteachers and finally to academics. Almost all the texts written to respond to the education codes at the end of the century were produced by academics. Not only is what counts as History important, but also who controls what, who is representing whom and in what circumstances.[16] In short what was authorised as History for the new national education constituency was under the control of a particular specialised group. As we shall see, all geographical locations in England are equal but some are more equal than others. For instance, the 'essential' England may have been represented as 'rural', but it is noteworthy how many of the figures who represented it as such derived their authority from metropolitan centres such as Oxford.[17]

In order to join Oxford and Cambridge as the guardians of English cultural life, the public schools also had to undergo change. For instance, the 'old boy' consciousness was inculcated in the later nineteenth century – fewer than 5 per cent of Thomas Arnold's 'old boys' sent their sons to Rugby[18] – and the relationship of the schools to Oxford and Cambridge was intensified: between 1855 and 1899 four fifths of Oxford and Cambridge students were public schoolboys, a greater percentage than ever before. Perhaps the most important change was the one that prised the schools from their local attachments. As Brian Simon has shown, the most significant condition for the 'transformation of an endowed grammar school into a public school was the exclusion of local foundationers – the sons of tradesmen, farmers or workers'. Alienated from their locality, and 'transformed into residential schools, servicing a single class', the schools were fit to play their role as the guardians of English cultural life.[19]

But these schools did not, of course, select only in terms of class but also – like Oxford and Cambridge – in terms of gender. (The cornerstone of the curriculum, Classics, was seen as unsuitable for women.) A great deal has usefully been written about the public school system, but what is important to this argument is its construction of masculinity, and its exclusion of women – within the

terms of the argument, the exclusion of certain qualities which had been ceded to the female. Indeed one might go so far to argue that the core of the curriculum *was* masculinity.

[. . .]

But before discussing masculinity it is worth noting that the absence of women – of 'female' qualities – was remedied by reconstituting male relationships within the institution. Fagging, which acted in this way, involved 'wholly domestic chores, considered totally "feminine", in a period when no male would ever in other circumstances make toast and tea or lay and light a fire'.[21] Such reconstituted male relationships were also at the core of what has been called the homoerotic writing of the First World War, which was organised around the simultaneous exclusion of women and inclusion of those qualities which were seen as female: 'The other ranks [during the war] were equivalent to the younger boys, and as at school, one generally admired them from a distance'; 'What inspired such passion was . . . good looks, innocence, vulnerability, protection and admiration. The object was mutual affection, protection and admiration.'[22]

Masculinity itself, which was best articulated in the public schools in the recently institutionalised games (which had themselves by 1929 become part of the 'English [educational] tradition'), is as interesting for what it excludes as what it includes. In 1872, W. Turley in the journal *The Dark Blue* urged support for masculinity, relating nationhood, gender and appropriate activity in his argument that 'a nation of effeminate enfeebled bookworms scarcely forms the most effective bulwark of a nation's liberties.'[23] 'Vigorous, manly and English' was the popular collocation. The identification of the English with the masculine could even determine matters of literary style. Given that males had at least to read and write (but not too much), they must cultivate a 'masculine' style, as many of the books on style made clear. For instance, Arthur Quiller Couch could say in one of a series of lectures at the University of Cambridge: 'Generally use transitive verbs, that strike their objects and use them in the active voice. . . . For as a rough law, by his use of the straight verb and by economy of adjectives, you can tell a man's style, if it be masculine or neuter, writing or composition.'[24] [. . .] Such a climate may help to clarify the significance of the condemnations which, say, Lawrence's *The Rainbow* (1915) suffered when attention was given to its 'morbidly perverted ingenuity of style.'[25] What such a judgement did was to link the (un-English) 'ingenious' style of *The Rainbow* with the conviction that Lawrence was 'unmanly' . . . the *OED* notes that the first occurrence of 'perverted' in a sexual sense is 1906. [. . .] The dominant English licensed to other groups and to other nationalities those 'female' qualities which it did not acknowledge itself to possess. As recently as 1973 Professor William Walsh could write in his book *Commonwealth Literature* that Indians do not write in a 'direct, masculine way,' but with 'Indian tenderness'.[26]

It is not surprising that one response of female writers during 1800–1920 to the masculine norm was to recognise it and to devalue it, and to go on to identify a superior *female* form of writing. Summarising such a view, Elaine Showalter argues that its proponents saw women as disadvantaged – 'not as a deprived sub-culture forced to use the dominant tongue, but as a superior race, forced to operate on a lower level'.[27] As we shall see elsewhere, a subordinated group often gained

a degree of autonomy at the cost of accepting the terms of the argument set by the dominant group.

Men, then, that is, gentlemen, recognised each other through a shared repertoire of activity, gesture and idiom, including pronunciation, 'for whose standardisation in the late nineteenth century (at the expense of regional accents) the public school system was largely responsible'.[28] Mark Girouard's *The Return of Camelot: Chivalry and the English Gentleman* has traced the establishment of a code for gentlemen, one which structured their interpretation of their behaviour if not the behaviour itself. For instance, Captain Scott in his expedition – which had been named the National Antarctic Expedition – was described by *The Times* as 'chivalrous in his conduct'; and Roland Huntford's *Scott and Amundsen* has argued persuasively that Scott's representation of his group's behaviour was organised in terms of the chivalric code.[29] [. . .] The power of the code might be judged by noting how even its opponents paid it the compliment of using its vocabulary to influence their audience. For instance, Edward Carpenter argued that the habits of the gentleman and lady must be left behind if there was any desire to 'win the honorable title of man or woman in the world's Modern Chivalry'.[30]

The dominant English cultural ideal of the late nineteenth century was then sited in certain institutions which underwent transformation, served 'national' not local needs, gained authority to define themselves and others, and inculcated appropriate (male) behaviour defining its function in and to the national culture: 'Yet some who tried/In vain to earn a colour while at Eton,/Have found a place upon an English side/That can't be beaten.'[31]

III

But, of course, an Englishness centred exclusively on such institutions could hardly hope to mobilise the people in its defence. What about the others? The quotation from J.A. Mangan above on masculinity, which refers to Herbert Spencer and functionalism, gives us a clue. Certainly there was little dispute about the adequacy of society-as-organism analogies during the periods:[32]

> From each member in a biological organism are demanded certain functional activities for the support of the life of the organism. . . . In a body which is in health and functions economically, every one contributes to the life of the organism according to its powers. . . . Each limb, each cell has a 'right' to its due supply of blood. (1909)

> . . . to consider that phenomenon in the life of the national organism which in Nature is known as disease . . . the second step in the establishment of scientific politics is the application of society as an organism. (1904)

The provenance of the analogy is not of primary concern here. What is important is that the analogy offered to resolve the tension between a hierarchical educational and social order and the concept of a horizontal community (Benedict

Anderson's recent description of the self-perception of a national community),[33] by positing that social groups had different not unequal responsibilities and functions: 'Each limb, each cell has a "right" to its *due supply* of blood' (my emphasis). I want to trace the identity and place two groups were offered within the national culture: the working class and the 'Celts'.

First, the working class, its identity, its educational needs and its appropriate sphere of action. Study of that class took on epidemic proportions during this period, drawing on old representations for new purposes. Indeed, concern with that class often translated itself into observation and study. One of the major forms of that study was the 'Into Unknown England' writing of the late nineteenth century and early twentieth century, in which the older traditions of personal exploration blended 'into the newer techniques of sociological analysis',[34] and which included works such as Charles Booth's *Life and Labour of the People in London* (1889–1903), Rider Haggard's *Rural England* (1902) and Robert Sherard's *The White Slaves of England* (1897). Central to such works and others was the construction of class as a *cultural* formation. As Gareth Stedman Jones has said, 'it was only at the beginning of the twentieth century – in London at least – that middle-class observers began to realize that the working class was not simply without culture or morality, but in fact possessed a "culture" of its own.'[35] Even the East End – that den of 'mystery' – *began* to be seen in new terms: 'Its real people labour, they do not loaf; they toil, they do not thieve. Labour here is very laborious.'[36]

The people who were seen and studied were, as the quotation suggests, construed predominantly in terms of their (manual) labour. And, with women increasingly consigned to the home, the working class as a class was identified as male. When female labour was glimpsed, the maleness of the observer was put into question: 'Indeed no part of this work is work for women, and his manhood is ashamed who sees these poor females swinging their heavy hammers.'[37] The illegitimate deduction that what was the essential characteristic of the (male) working class was its *physicality* – articulated in its work and pleasures – was drawn from the fact that the majority of the class worked as manual labourers. Workingmens' bodies – the suffering inscribed upon them by their work or their wonderful vigour and strength – carried positive meaning, and continued to do so in that extension of the 'Unknown England' tradition, the British documentary film movement of the 1920s and 1930s, which celebrated the worker as 'a heroic figure' and 'the ardour and bravery of common labour'.[38] The noun Labour, in the sense of 'the general body of labourers and operatives . . . with regard to its political interests and claims', made its first appearance in 1880, according to the *OED*.

For the travellers into unknown England, the working class led lives which were congruent with their physical nature. This is Charles Booth, drawing on a vocabulary whose oppositions (natural/artificial) were traditional by the late nineteenth century: 'I see nothing improbable in the general view that the simple natural lives of working-class people tend to their own and their children's happiness more than the artificial complicated existence of the rich.'[39] But the meaning of such a vocabulary is not exhausted by identifying its etymology. Consider the translation of Booth's vocabulary by his co-worker, Beatrice Webb. Writing about Bacup, which she visited in disguise in 1883, Beatrice Webb shared Booth's vocabulary: Bacup 'knows nothing of the complexities of modern life'; it has no place

for 'complicated motives'. She went on to elaborate the implications for its inhab-
itants: they lack 'the far-stretching imagination of cosmopolitanism, don't realise
the existence of a larger world'.[40] And in such a judgement the working class were
fixed; their strengths were inseparable from what they were constitutionally
unsuited for. Their way of life was simple (not complex), their mode of address
direct (not sophisticated), their skills practical (not theoretical), their appropriate
sphere of activity, local (not national). What, in short, such a vocabulary as Booth's
and Webb's did was to fix working-class concerns and competence and ratify the
mental/manual distinction. Compare Sylvia Pankhurst on Annie Kenney, a cotton
operative, and a recruit to the Women's Social and Political Union: 'Her lack of
perspective, her very intellectual limitations, lent her a certain directness of purpose
– when she became an instrument of a more powerful mind.'[41] [. . .]

The contours of the identity of the (male) working class sketched above, and
the vocabulary which articulated it, can be seen in other accounts of that class
during the period. I want to look briefly at two of them. First, the University
Extension Movement. Although the University Extension Movement failed to pene-
trate seriously the working class, what it did do was to confirm a particular account
of what constituted working-class identity. If the social explorers and 'settlers'
used the language of *terra incognita* to describe their journeys into working-class
lives, so too did working-class people, when they wished to describe the educa-
tion they were offered by the Extension Movement: 'I have lived in Cleveland
about eighteen years of my life, but find it true that I am now in a strange country.
I mean however to know it'; or, 'I was always buying books, picking them up
here and there and everywhere . . . but of course I couldn't have found my way
alone. I should have got lost in the wilderness or stuck in a bog.' What these
metaphors suggest is that the cost exacted of the working class for the granting to
them their own culture was the ceding of knowledge and learning to their masters.
Such a surrender must have been particularly easy, given the interpenetration of
knowledge and certain class habits – for instance, of demeanour and pronuncia-
tion. (This is not to deny that matters of skill and practice – which the best will
in the world will not wish away – were involved.) The consequence was that
teachers and students granted to each other and claimed for themselves a partic-
ular terrain of experience and knowledge. What is striking is the overlap of
vocabulary with that sketched above. Students would sometimes oppose book
knowledge to their own 'ingenuity with practical work'; and teachers and observers
would oppose the 'dumb insight and sensibility' of the working-class male and his
ability 'to think in the concrete' to the academic's ability to 'think in abstract and
general terms of culture'.[42]

Such vocabulary extended to formal educational institutions. A practising
schools inspector as well as one of those lobbying on behalf of State intervention
in education, Matthew Arnold articulated clearly his conviction that educational
needs had to be weighed in relation to the 'evident proximate destination' of
a particular social group: 'To the middle class the grand aim of education
should be to give largeness of soul and personal dignity; to the lower class, feeling,
gentleness, humanity.' Arnold's assignment of certain needs to the working class
led him to propose a curriculum which stressed *affective* materials: 'Good poetry
. . . implies the evolution so helpful in making principles operative. Hence its

extreme importance to all of us; but in our elementary schools its importance seems to me at present extraordinary.'[43] . . . Of course, the meaning of 'appropriate education' could always be inflected differently, as it was during and after the 1909 strike at Ruskin College, Oxford, by working-class students who also wanted an education for their class: 'the establishment of a network of labour Colleges through the country . . . a huge educational structure entirely devoted to the interests of the working class.'[44]

But the interest of this argument is in the nature of the invitation to the working class to take its place in the national culture. Across the practices surveyed, the continuity of vocabulary and thinking is impressive; the working class was acknowledged and its essential identity and nature fixed. Slowly such a way of thinking would become simple common sense.

[. . .]

IV

But it was one thing to invite into the national culture an *English* working class, it was quite another to invite the marginalised peoples – the Irish, Scots and Welsh – to rejoice in such a national culture. Unambiguous solutions were, of course, on offer. Here is a judgement about the language and culture of Wales, simply a 'geographical expression', according to one bishop:

> The Welsh language is the curse of Wales. Its prevalence and the ignorance of English have excluded and even now exclude the Welsh people from the civilization, the improvement, and the material prosperity of their English neighbours . . . we can only observe as a matter of fact that Welsh music and poetry have not had the slightest effect in civilizing the Welsh people.[45]

That is a third leader in *The Times* in response to correspondence on Matthew Arnold's rejection of an invitation to address the Eisteddfod, and, more generally, on Arnold's Oxford lectures published in *The Cornhill Magazine* (1866) and collected as *On the Study of Celtic Literature* (1867). These lectures were delivered and published at around the same time as *Culture and Anarchy,* which centred on Englishness. Arnold's complementary series of lectures of the 1860s are a reminder that the definition of the English is inseparable from that of the non-English; Englishness is not so much a category as a relationship. Delivered at Oxford, the home in the 1860s of the Saxonism of Freeman, Arnold's lectures aimed to establish the contribution of the Celt to English culture. Why these lectures are useful is that they contain the substance of the Celticism argument of the following years, and were seen as seminal contributions to the debate. In reference to *The Times's* damnation of the Welsh quoted above, Alfred Nutt, who edited Arnold's essays in 1910, said: 'If it is impossible [now] for such stuff as this to appear in any self-respecting newspaper, it is chiefly thanks to the spirit induced by Arnold's work.'[46]

Arnold fixed the essential character of a people in its literature, and 'read off' the national character of the Welsh and Irish from Celtic literature, his designation

for the writing of the Welsh and Irish. After the initial opposition which seemed to favour the Celts – the 'impassive dullness' of the English, the 'lively Celtic nature' – Arnold described the cost of such a nature, the absence of 'steadiness, patience, sanity'. The shift to the political followed immediately: 'The skilful and resolute appliance of means to ends which is needed both to make progress in material civilisation, and also to *form powerful States*, is just what the Celt has least turn for' (my emphasis).

Given that the Celts were not capable of governing themselves what was their place within the national life? Arnold's answer was to claim that the matter of the minority nation's cultural identity was separable from the matter of the minority nation's political control of its cultural institutions. He proposed that the 'provincial nationalisms' had to be swallowed up at the level of the political and licensed as cultural contributions to English culture.[47] And with such an argument Arnold laid, at the very least, the groundwork for the assimilation of Irish, Scots and Welsh writers into the emergent discipline of English literature.

What Arnold did was to offer the core/periphery relationship as the appropriate one between the 'metropolitan' English culture and the 'provincial' cultures of the other nations.[48] Citing Arnold, the *OED* offers as one of the meanings of 'provincial', 'wanting the culture and polish of the capital'. (One might suggest that Joyce's refusal to exile himself in England was a rejection of his fate as a 'provincial' writer, to play jester at the court of the English, his description of Wilde's fate.) The cultural life of Scotland or Wales or Ireland could have no meaning other than in its satellite relationship with the cultural life of England. [. . .]

The autonomous contribution of the Celts to civilisation was confined to the past. According to Arnold: 'Wales, where the past still lives, where every place has its tradition, every name its poetry and where the people, the genuine people, still knows this past, this tradition, this poetry, and lives with it, and clings to it.' The 'genuine' Celts 'cling' to the past. In short, they could not face the present.[49] Their contribution to the present fixed, and their identity secured in the past, the Celts were rewarded by Arnold with his recommendation that they deserved to become the object of study of the English, in the form of a Chair of Celtic languages at Oxford or Cambridge. And within ten years of Arnold's lectures – and this is not to attribute to them simple causal significance – the first Chair of Celtic literature *was* established at Oxford University, in 1877. Like other ways of life which were fixed as objects of study – the School for Modern Oriental Studies was established in London in 1916 – Welsh became a subject of and for the English (even in the Welsh colleges, Welsh was taught in *English* until after the First World War).[50] Although such a bad judgement ignores the enterprises instituted by Welsh cultural nationalists during this period – e.g. the University Colleges of Bangor and Cardiff were established in the early 1880s, and in 1907 a National Library and a National Museum were opened – what is important to stress is that at least a number of the premises of the cultural nationalists ratified rather than challenged Arnold's terms of reference. [. . .] Gwyn A. Williams's *When Was Wales?* brilliantly shows how the Welsh Wales of the cultural nationalists neither could nor can accommodate or articulate the experiences of industrial (often South) Wales: 'the more arrogant, extreme or paranoid exponents of Welshness simply refuse to see any "culture" at all in English-speaking Wales, or else they dismiss it as "British" or even "English".'[51]

Or take the example of Ireland. After the failure of 'politics' with Parnell – politics defined in exclusively parliamentary terms; the replacement in 1881 of the Land League by the Irish National League was the 'complete eclipse by a purely parliamentary substitute of what had been a semi-revolutionary organization'[52] – the search for an Irish cultural identity was pursued. Through such institutions as the Gaelic League (1893), the Gaelic Athletics Association (1884), and the National Literary Society (1892) what was sought was an Irish cultural identity unsullied by, and morally superior to, English culture: 'Let us put our shoulder to the wheel, one and all, to make the National Literary Society strong and useful. . . . We may not, so, bring Ireland freedom, but assuredly with God's help, *let politics sink or swim*, so we shall make ourselves worthy of it.' The search for a 'pure' or essential Ireland – which legitimised and was in turn legitimised by an essential England – often led the nationalists away from weighing the complex relationship (subordination) of Ireland to England and towards a Gaelic Ireland. 'The Necessity of De-Anglicising Ireland' was the title of the Protestant Douglas Hyde's 1892 lecture to the National Literary Society.[53] The cultural nationalists' pursuit of an 'Irish' Ireland also meant that they were unable to recognise the actual diverse cultural identities within Ireland itself. In short, it is extraordinary how far some of the terms of Arnold's arguments about Celticism – language, the primacy of the cultural, the siting of value in the past – were replicated in the arguments of at least some of the cultural nationalists of Wales and of arguments of at least some of the cultural nationalists of Wales and of Ireland. Both sides sought an *essential* identity for the Celts.

The extensiveness of the colonisation by the English of the Celts – of the bestowal of identity by the core on the periphery – can be measured by a very brief mention of what may seem far removed from Celticism, the artistic colonies which were established in the 1880s and 1890s, particularly the Newlyn School, and (later) the St Ives colony. (Given the argument of this essay, the word 'colony' – their own description – is unsurprising.) The general orientation of these colonists might lead one to assume they are part of that penetration of working-class England, which has been described above. It is certainly true that they often celebrated the 'immemorial' customs of communities and the dignity of certain kinds of manual labour – for instance, of the fisherman, 'a heroic figure'.[54] But what was more determining was their construction of Cornwall as Celtic. Inspired by the example of those artistic colonies in Celtic Brittany, the colonists – 'we cannot claim to have been the discoverers of this artistic Klondyke' (Stanhope Forbes) – stabilised and fixed the identity of the Cornish as that of ancient communities, closer to nature than was metropolitan England.[55] Absent was the recent experience of the Cornish – of mass emigration, of a declining tin-mining industry, of the decimation of the fishing industry by European competition.[56] Newlyn was a 'primitive' place; and Cornwall was full of a 'simple and harmless folk'. Like Arnold for whom the 'genuine' Celt 'clings' to the past, for the colonists the genuine Cornwall was to be found in the past. The writings of Stanhope Forbes – the founder of the Newlyn School – were full 'of fear that [the traditional attire of the fisherman] was passing away with other old-fashioned and paintable things,' and that 'quaint old houses' were to be replaced by cottages that 'ape the pretentiousness of modern villadom'.[57]

But what is crucial is that this desire to fix the life of the periphery, of those whom they painted, coexisted with – or was the necessary complement of – the artists' affiliation to metropolitan institutions, especially the Royal Academy, one of those 'national' centres of authority. (The National Trust for Places of Historic and Natural Beauty, founded in 1895, gained part of its authority from the fact that three out of four Vice-Presidents of the National Trust were members of the Royal Academy.) The Newlyn paintings 'were conceived in Royal Academy terms' – and were painted for exhibition there. As early as 1888, Forbes wrote that 'the RA this year may best be described as the "triumph of Newlyn".'[58] The lasting power of this metropolitan representation is attested to in Dennis Farr's 1978 contribution to *The Oxford History of English Art*, *English Art 1870–1940*: 'Cornwall in the 1880s must have been still quite primitive, unspoilt, and akin to Brittany in both its terrain and peasant life.'[59] The fate of Cornwall at the hands of the colonists may be taken as a metaphor for the general relationship between the Celts and English. The Celts are licensed in their unique contribution to and place in the national culture: the cost is that they know their peripheral place as the subject of the metropolitan centre.

V

The colonisation of 'others' – two instances of which have been mapped – was the necessary complement of the definition of the dominant English. What was common to both these colonisations was the recognition that identity must be secured at the cultural as well as – or indeed as an alternative to – the political level. But what was the national culture in which these groups found their present place? What was the cultural heritage to which the English were heirs? How was a single heritage to accommodate the experiences of the distinct groups? The pattern again was that of inclusion, simple exclusion, and transformation – of the stabilisation of the present and past across a range of institutions and practices. As we suggested earlier, this section will focus on two matters: one taken from the field of scholarship, the other from the arts.

Consider the English language, spoken and written, and how its meanings, past and present, were made and remade. First, the present. The Society of Pure English (founded in 1913) was instituted with the conviction that the imperial duties of English taxed its strength:

> It would seem that no other language can ever have had its central force so dissipated – and even this does not exhaust the description of our special peril, because there is furthermore this most obnoxious condition, namely, that wherever our countrymen are settled abroad there are alongside of them communities of other-speaking races, who, maintaining amongst themselves their native speech, learn yet enough of ours to imitate it, and establishing among themselves all kinds of blundering corruptions, through habitual intercourse infect therewith the neighbouring English.[60]

(It is perhaps important to mention that American English was among the mongrel tongues.) The horror of such contamination, of such intercourse is clear. What is also evident is that such celebration of the English language – it was the touchstone of all other languages – co-existed with a sense of its vulnerability. If the language was threatened without, it was also threatened within. The Society was happy with compulsory state education since it 'provides a machinery which can be and is used to counteract the uncontrollable [sic] natural trend and growth of language'.[61] The title of the Society for Pure English encapsulates its limitations. Committed to pure English and simply refusing to acknowledge the varieties of English, the Society allowed the excluded elements to remain undefined and thus free to be made into centres of opposition and resistance. Dialect (as much a class as a regional matter) could and did act to emphasise the solidarity of subordinated groups, provided the idiom for cultural initiatives (e.g., Cockney in the musichall), and generated large bodies of writing.

The elements of language which were excluded by the Society were found some useful work by other strands of language scholarship which developed in the period immediately prior to 1880–1920, and in the period itself. The Philological Society founded in 1842, which originated the plan for the *New English Dictionary* (to which this argument will return), gave prominent attention to dialect. And in 1873 Walter Skeat – who three years later was to be given the Bosworth Chair of Anglo-Saxon at Oxford – undertook the secretaryship of the newly founded Dialect Society, which had the objective of collecting lists of dialect words from published books and from field work – material which was eventually used for the *English Dialect Dictionary* edited by Joseph Wright. Like many other projects initiated during this period, the *Dialect Dictionary's* importance was voiced in terms of service to the nation: 'a work of great national importance', announced the advertisement appealing for material for the *EDD*.[62] It was organised by county, and the *Dictionary* and other publications stressed the rural character of 'pure' dialects. Dialect needed to be 'preserved'; that is, it was of the *past*, not an acceptable medium of present communication.[63] Certain urban dialects (such as Cockney which was at the centre of the London music hall – 'an indigenous entertainment by Cockneys largely for Cockneys') were not accorded the status of a dialect.[64] [. . .] Wyld, who was later to become Merton Professor of English Language at Oxford, was clear that the dominant English language was to be identified with certain English institutions – the Court, the Church, the Bar, the older universities and the great public schools – but, as with Arnold, Wyld was eager to offer a place to the subordinated:

> When one dialect obtains the dignity of becoming the channel of all that is worthiest in the national literature and the national civilisation, the other less favoured dialects shrink into obscurity and insignificance. The latter preserve, however, this advantage, considered as types of linguistic development, that the primitive conditions under which language exists and changes are more faithfully represented in them than in the cultivated dialect.[65]

The analogy with the Celts is sustained. Dialect had the virtues of the 'primitive', and its contribution to the past which had made the present was acknowledged. But dialect had to recognise its subordinate position and give way to the standard. Indeed the one function of the 'pure' dialects of the past was the judging and disciplining of present mongrel dialects.

Interest in the history of English, as the quotation from Wyld suggests, is never far from concern with the present state of language. And nowhere is this more evident than in the debate around the *New English Dictionary*. General reading in nineteenth-century works on the language very quickly makes it clear that the renewed interest was in part the result of the recognition of the 'vastly increased distribution of English in the last hundred years . . . English may become the most widely spoken language on earth'.[66] Richard Trench, author of two seminal books on language, claimed that language is a 'moral barometer, which indicates and permanently marks the rise and fall of a nation's life'; 'it is the collective work of the whole nation, the result of the united contribution of all'.[67] It was within such assumptions, and with the societies which helped to found those assumptions – such as the Early English Text Society (1864), and the Wyclif Society (1881) – that the debate around the *NED* was prosecuted.

When James Murray, the editor of the *NED*, entered into negotiations with Oxford University Press, he found himself under pressure from the Delegates, and especially Benjamin Jowett, Master of Balliol College, Oxford, to make the Dictionary a source of cultural authority. This could not have been welcome advice to a man who identified himself as a Whig, Dissenter and Scotsman and claimed that his own interest in language was initiated by his realisation that 'the constructions he had been scolded for at school . . . as 'bad grammar' by English standards were in fact 'good grammar' in Scotch'.[68] From the Delegates Murray had to contend with the insistence that the function of the Dictionary was to establish a standard of right and wrong; that quotations should be as far as possible drawn from great writers; that slang terms and scientific words should be limited to such as were found in literature; and that its title should be 'A New Dictionary showing the history of the language from the earliest times', with the stress on language and not on words.[69] One of the matters of interest which arise from these arguments is the tension between the historical scholarship upon which Englishness was in part reconstructed in the last quarter of the nineteenth century and the uses to which others wished to put it. As Murray said, the Delegates 'could not grasp that this [the setting of a standard of good literary usage] is not the province of an historical dictionary'.[70] The other relevant matter to note from Murray's skirmishes with Oxford and the Press is that what has come down to us as the *Oxford English Dictionary* met initial indifference or downright hostility in Oxford. One might generalise the case. So many of the scholarly initiatives of the late nineteenth century – the *NED*, the *DNB*, the discipline of English literature – which are now seen as 'Oxford' or 'Cambridge' projects and which have helped to bestow on those universities their reputation as centres of cultural authority – were initiated and sustained elsewhere.

That the *New English Dictionary* was subject to the pressures outlined above should not lead us to assume that the project itself – as conceived and sustained – was

ideologically neutral. . . . But what the *NED* enshrined was not the vision of a number of autonomous and equally valued histories but a national Whig history of the language, whose starting-point was '1150 and its early history'. For Murray, the 'English Dictionary, like the English Constitution, was the creation of no one man, and of no one age; it is a growth that has slowly developed down the ages'. . . .[71]

What the *NED* did was to offer to establish its 'evolution' and continuity, eliding the complex history of the language. It is at least arguable that the establishment of a 'single' language was the necessary prerequisite for the institution of a national literary tradition which in turn became the 'true' bearer of the language. The study of literature was all the language study that was necessary. As a recent commentator has said: the *NED* gives the impression 'that it was the giants of literature who formed our language'. Also its 'normal limitations of one or two quotations per sense per century is inadequate to account for the regional and stylistic variety of usage at any stage in the history of the language'.[72]

Before we turn away from language and briefly towards other institutions which offered to hold the English to a single and continuous history, it is worth noting that in *Imagined Communities*, Benedict Anderson argues that 'Language is not an instrument of exclusion: in principle, anyone can learn a language.'[73] At one level this may be true (an English person can learn French), but at another level the statement begs the question of what it is to learn a language. Not all ways of speaking and writing the language are equally acceptable or authorised. James Joyce's *Ulysses* was as much denigrated for its violation of the norms of the English language as for its obscenity: 'All the conventions of organised prose which have grown with our race and out of our racial consciousness which have been reverently handed on by the masters . . . have been cast aside as so much dross.'[74]

By the time he died, in 1941, Joyce had become an honorary Englishman, The English ambassador – not the Irish one – attended his funeral. One way such an outstanding representative from the 'periphery' as Joyce could gain English status was through his incorporation into English literature. For outstanding representatives in other spheres, there was always the *Dictionary of National Biography* or the National Portrait Gallery (which gained a permanent home in 1896). Although both enterprises declared that they wished to honour *British* subjects (the *DNB* added 'foreigners' eminent in British life and important figures from the colonies), both were in fact dominated by the English and simply recognised outstanding contributions from the 'peripheries'. It is, of course, important to add that neither enterprise, despite the explicit claim of the NPG 'to aid . . . the study of national history',[75] actually registered the diverse contributions of the English to English life. As one recent commentator has noted, there was an over-attachment to politicians, civil servants and the military and a neglect of the business world. A marginalisation of a different order was that of women. Their presence was negligible and, according to Sidney Lee, the second editor of the *DNB*, was unlikely to increase: 'Women will not, I regret, have much claim on the attention of the national biographer for a very long time to come.'[76]

VI

The new initiatives in learning and scholarship without which the reconstruction of Englishness was inconceivable were complemented by new institutions and patterns of production and consumption in the field of the arts. . . . I propose . . . to examine a single element of the arts, the theatre, in terms of the general argument of this essay, and show how the various theatrical sectors were offered a place in the national culture and fixed in relationship to a metropolitan core — the projected national theatre.

Serious agitation for a National Theatre began again in the 1870s, at a time when new work was produced which could not be accommodated within the commercial theatre. [. . .] What is common to [the claims then made for it] is the conviction that a certain metropolitan institution should define and bear (the drama of) the national culture and be the core from which what is of value should be disseminated to the rest of the country.

The debates continued through the last decades of the nineteenth century, especially through the writings and agitation of William Archer, defender and translator of Ibsen. Archer's conviction that the general public could not be immediately converted to the 'new' drama led him to advocate, in the words of the critic John Stokes, 'the establishment of a cadre of little theatres which would cater for the discriminating minority alone'. Archer asked, have not playwrights 'again and again found themselves continuously sacrificing artistic considerations to the necessity of conciliating the masses'?[77] When he published in 1907 (in conjunction with Granville Barker, a Fabian and member of the executive committee between 1907 and 1912) A National Theatre: Schemes and Estimates, he was at pains to stress the character of the institution. While it would break 'completely and unequivocally, from the ideals and traditions of the profit-making stage', the National Theatre 'IS NOT AN ADVANCED THEATRE . . . but forms part, and an indispensable part, of the main army of progress. It will neither compete with the outpost theatres nor relieve them of their function.'[78]

Two issues central to my general argument about the national culture arise out of the debate about the role of theatres. First, as has been mentioned, the stress on the establishment of a centre of authority which would license what constituted great drama; second, the renunciation by such an institution of engagement with new drama (G. B. Shaw declared that Archer and Granville Barker's selection of plays was obsolete)[79]; and third, implicit in the first two, the definition of the function of the National Theatre and that of others. The National Theatre would not deprive the 'advanced' theatre of its place; avant-gardism was licensed. . . . The various sectors of the artistic life of the period — like education and scholarship, and the larger national culture of which they were all part — were stabilised and fixed (always precariously) in terms of their different functions and related audiences. Elite/mass and avant-garde/commercial were not pairs of oppositional terms but pairs of complementary ones. Each ratified the sphere and responsibilities of the other. Disengaged from the contemporary culture, the artistic institutions of the national culture simply gathered up and acted as custodians of the best of the national past.[80]

This argument has tried to do two things. First, it has traced how the cultural identities of the dominant English and of the subordinated groups were articulated during this period; and second, it has showed how the diverse cultural histories and contemporary cultural life of these islands were organised and stabilised as a national culture. Englishness was appropriated by and became the responsibility of certain narrowly defined groups and their institutions, and yet meaning and function were (con)ceded to subordinated groups and institutions. But the places offered to the subordinated groups were, it is clear, no simple gift. For instance, the acknowledgement that women had their own 'culture', their own sphere of activity became, as is clear in the history of the suffragette movement, a demand that they knew their place:

> Passion ran high on both sides: that was the meaning of the 'Cat and Mouse' Act, above all of its retention of forcible feeding. The House of Commons was almost hysterical in its susceptibility to its prestige. . . . The long inequality of the sexes had bitten deeply into them, they had grown up with it in every relation of life. What from men might have been received as a commonplace of political controversy, from women was an intolerable impertinence, an unpardonable offence.[81]

One might say that the suffragette movement resisted, to use the vocabulary of my argument, the representations offered of them; they wished to represent themselves, *to make themselves present*.[82]

Inseparable from their power to represent themselves and others, the dominant English had the power, I have also argued, to say what the national culture had been and *was*. The past tense is important, for what is clear is that during 1880–1920 the conviction that English culture was to be found in the past was stabilised. The *past* cultural activities and attributes of the people were edited and then acknowledged, as contributions to the evolution of the English national culture which had produced the present. Nowhere was this more evident than through the establishment of a national literary tradition within the emergent discipline of English literature. Professor Sidney Lee, second editor of the *DNB* and Professor of English at London University, made the matter plain in his inaugural lecture.

> Current writing which awaits the final verdict does not claim the attention of the lecture room. The student may well be advised if in his leisure he attempts to appraise current writing by the standard of the old literature which has stood time's test.[83]

Everyone had a place in the national culture, and had contributed to the past which had become a settled present. The people of these islands with their diverse cultural identities were invited to take their place, and become spectators of a culture already complete and represented for them by its trustees. In the face of such an invitation it may well be appropriate to reply that 'only those directly concerned can speak in a practical way on their own behalf'.[84]

Notes

1 Richard Shannon, *The Crisis of Imperialism 1865–1915* (St Albans: Paladin, 1976), pp. 12–13.

2 Edward Said, *Orientalism* (London and Henley: Routledge & Kegan Paul, 1978), p. 3.

3 A. Gramsci, *Selections from the Prison Notebooks*, ed. Q. Hoare and Geoffrey Nowell Smith (London: Lawrence & Wishart, 1971), p. 244. The trajectory of my argument is generally indebted to Gramsci.

4 Virginia Woolf, *A Room of One's Own* (1929) in '*A Room of One's Own' and 'Three Guineas'*, intro. Hermione Lee (London: Hogarth Press, 1984), p. 25.

5 Olive Banks, *Faces of Feminism: A Study of Feminism as a Social Movement* (Oxford: Martin Robertson, 1981), p. 96.

6 David Cannadine, 'The context, performance and meaning of ritual: the British monarchy and the invention of tradition', c. 1820–1977', in *The Invention of Tradition* ed. Eric Hobsbawm and Terence Ranger (Cambridge: Cambridge University Press, 1983), p. 122.

7 'Youth', which was seen during this period as a universal grouping which included everyone of a certain age-range, is the most important group not to be given an essay in this volume.

8 'The economic, political, social and moral welfare of the community depend mainly on the development of a national system of education', *Report of the Committee . . . (to inquire into the position of the Classics* (1921), quoted in Richard Jenkyns, *The Victorians and Ancient Greece* (Oxford: Basil Blackwell, 1980), p. 345. It is important to acknowledge that there was fierce resistance, in some quarters, to national state educations, from for example, the National Education League.

9 Bernard Darwin, *The English School* (1929), quoted in Martin J. Wiener, *English Culture and the Decline of the Industrial Spirit* (Cambridge: Cambridge University Press, 1981), p. 21.

10 Matthew Arnold, *Culture and Anarchy,* in *The Complete Prose Works of Matthew Arnold*, ed. R. H. Super (Ann Arbor: University of Michigan Press, 1965), V, Preface.

11 See Tom Nairn, *The Break-up of Britain: Crisis and Neo-Nationalism*, 2nd expanded edn (London: Verso, 1981), p. 46, on the bourgeois data.

12 T. W. Heyck, *The Transformation of Intellectual Life in Victorian England* (London and Canberra: Croom Helm, 1982), p. 183.

13 H. W. Armstrong, 'The place that chemistry must take in public esteem', an address to Manchester University Chemical Society, 1906 quoted in Michael Sanderson, *The University and British Industry 1850–1970* (London: Routledge & Kegan Paul, 1972), p. 31; James Bryce, 'The future of the English universities', quoted in Heyck, *The Transformation of Intellectual Life,* p. 185.

14 Quoted in Brian Simon, *Education and the Labour Movement 1870–1920* (London: Lawrence & Wishart, 1974), p. 187.

15 Quoted in Simon, *Education and the Labour Movement*, p. 314.

16 John M. Mackenzie, *Propaganda and Empire: The Manipulation of British Public Opinion, 1880–1960* (Manchester: Manchester University Press, 1984), pp. 175–6. Although not all of the books would have been produced by Oxford or Cambridge academics, one should not underestimate the power of these

institutions to define for other universities what instituted knowledge. Jack Simmons records the incredulity of some people in Leicester that the city should consider a university: Oxford and Cambridge and London were the *real* universities: *Leicester Past and Present* (London: Methuen, 1974), Il, 73. On the continuing power of Oxford after the First World War, see Francis Mulhearn's introduction to Regis Debray, *Teachers, Writers, Celebrities: The Intellectuals of Modern France*, trans. David Macey (London: Verso, 1981), pp. xvii–xviii.

17 See the essay by P. Brooker and P. Widdowson in R. Colls and P. Dodd (eds), *Englishness: Politics and Culture 1880–1920*, (London: Croom Helm), pp.116–63.

18 J. R. de S. Honey, 'Tom Brown's Universe: the nature and limits of the Victorian public schools community', *The Victorian Public School: Studies on the Development of an education Institution*, ed. Brian Simon and Ian Bradley (Dublin: Gill & MacMillan, 1975), p. 20.

19 Simon, *Education and the Labour Movement*, pp. 101–2.

20 J. A. Mangan, *Athleticism in the Victorian and Edwardian Public School: The Emergence and Consolidation of an Educational Ideology* (Cambridge: Cambridge University Press, 1981), p. 135.

21 Isabel Quigley, *The Heirs of Tom Brown* (London: Chatto & Windus, 1982), p. 7.

22 Paul Fussell, *The Great War and Modern Memory* (Oxford: Oxford University Press, 1975), pp. 272–3.

23 Cyril Norwood, quoted in Mangan, *Athleticism*, p. 7; W. Turley, quoted in Mangan, *Athleticism*, p. 189.

24 *On the Art of Writing* (1916), quoted in Ken Worpole, *Dockers and Detectives: Popular Reading: Popular Writing* (London: Verso, 1983), p. 40.

25 E. A. Freeman, in J. W Burrow, *A Liberal Descent: Victorian Historians and the English Past* (Cambridge: Cambridge University Press, 1981), pp. 209–12; *Quarterly Review* is quoted in C. K. Stead, *The New Poetic* (Harmondsworth: Penguin, 1967), p. 75; James Douglas, *The Star*, is quoted in *D. H. Lawrence: The Critical Heritage*, ed. R. P. Draper (London: Routledge & Kegan Paul, 1970), p. 93.

26 William Walsh, *Commonwealth Literature* (Oxford: Oxford University Press, 1973), p. 1, p. 10. I am indebted to Aleid Fokkema for the reference.

27 Elaine Showalter, *A Literature of their Own: British Women Novelists from Brontë to Lessing*, rev. edn (London: Virago, 1982), p. 259.

28 Honey, 'Tom Brown's universe', p. 21.

29 Mark Girouard, *the Return to Camelot: Chivalry and the English Gentleman* (New Haven and London: Yale University Press, 1981), p. 6; Roland Huntford, *Scott and Amundsen* (London: Hodder & Stoughton, 1979).

30 Edward carpenter, *Women and her Place in a Free Society* (Manchester: Labour Press Society, 1894), p. 28.

31 E. W. Hornung, 'Lord's Leave 1915', quoted in Mangan, *Athleticism* p. 193.

32 J. A. Hobson, *The Crisis of Liberalism: New Issues of Democracy* (London: King & Son, 1909), pp. 80–1; Charles H. Harvey, *The Biology of British Politics* (London: Swan Sonnenschein, 1904), p. 95.

33 Benedict Anderson, *Imagined Communities: Reflections on the Origin and Spread of Nationalism* (London: Verso, 1983), p. 16.

34 *Into Unknown England: Sections from the Social Explorers*, ed. Peter Keating (London: Fontana, 1976), p. 10.

35 Gareth Stedman Jones, 'Working class culture and working class politics in London, 1870–1900: notes on the remaking of a working class', in *Languages of Class: Studies in English Working Class History 1832–1982* (Cambridge: Cambridge University Press, 1983), pp. 183, 219. Another 'residual' tradition – of seeing the working class as animals, as cultureless – was still active. For its roots, see F.S. Schwarzbach, 'Terra incognita – an image of the city in English literature, 1820–55', in *The Art of Travel*, ed. Philip Dodd (London: Frank Vass, 1982).

36 George Haw, 'Weekly Sun Literary Supplement' (1896) quoted in Peter Keating, 'Fact and fiction in the East End', in *The Victorian City: Images and Realities*, ed. H. J. Dyos and Michael Wolff (London and Boston: Routledge & Kegan Paul, 1973), II, 600.

37 Sherard, 'The chainmakers of Cradley Heath', quoted in Keating, *Intro Unknown England*, p. 180.

38 See Robert Colls and Philip Dodd, 'Representing the nation: documentary film, 1930–45', *Screen* 26 (1985): 21–33.

39 Charles Booth, *Life and Labour of the people in London*, quoted in Keating, *Into Unknown England*, p. 127.

40 *Glitter Around and Darkness Within: The Diary of Beatrice Webb*, Vol. 1, *1873–1892*, ed. Norman and Jeanne Mackenzie (London: Virago, 1982), pp. 183–4. The diary entry is for 31 October 1886.

41 E. Sylvia Pankhurst, *The Suffrage Movement: An Intimate Account of Persons and Ideals* (1931) (London: Virago, 1977), p. 186.

42 'Travellers in a strange country: responses of working-class student to the university extension movement 1873–1910', *History Workshop Journal* 12, repr. Sheila Rowbotham, in *Dreams and Dilemmas: Collected Writings* (London: Virago, 1983), pp. 267–305. All quotations in the paragraph are taken from this essay.

43 Matthew Arnold, *A French Eton* (1863–4) and *What Her Majesty's Inspectors Say 1880–81,* both quoted by Brian Hollingsworth in 'The mother tongue and the public schools in the 1860s', *British Journal of Educational Studied* 22 (1974): 319–20.

44 Simon, *Education and the Labour Movement*, p. 324.

45 The bishop is quoted in Gwyn A. Williams, *When Was Wales? A History of the Welsh* (Harmondsworth: Penguin, 1985), p. 229; Arnold quotes the leader in his 'introduction', *On the Study of Celtic Literature, Lectures and Essays in Criticism,* in *The Complete Works of Matthew Arnold*, III, pp. 391. The relative neglect of Scotland by Arnold and others may be due to the fact that nationalism in Scotland reappeared only later in this period. See Nairn, *The Break-up of Britain*, p. 95.

46 Quoted by Rachel Bromwich in *Matthew Arnold and Celtic Literature: A Retrospect 1865–1965* (Oxford: Clarendon Press 1965), p. 38.

47 Arnold, *Complete Prose Works*, III, pp. 295, 344, 345, 296.

48 For this phrase I am indebted to Michael Hechter, *Internal Colonialism: The Celtic Fringe in British National Development 1536–1966* (London: Routledge & Kegan Paul, 1975).

49 Arnold, *Complete Prose Works*, III, p. 291.

50 Ned Thomas, 'Renan, Arnold, Unamuno: philology and the minority languages', *Bradford Occasional Papers* 4 (1984): 8.

51 Williams, *When Was Wales?* p. 236.

52 Michael Davitt, quoted in John S. Kelly, '"The fall of Parnell of the rise of Irish Literature: an investigation", *Anglo-Irish Studies* 2 (1976): 6.

53 That the Irish Republican Brotherhood demanded political as well as cultural free-dom marked them out as different from some of the cultural nationalists – but the IRB did want, with other nationalists, an Ireland 'not merely free but Gaelic as well'. Tim Pat Coogan, *The IRA*, rev. ed. (London: Fontana, 1980), p. 35.

54 Caroline Fox and Francis Greenacre, *Artists of the Newlyn School (1880–1900)*, exhibition catalogue of Newlyn Orion galleries, 1979. The description is Norman Garstin's, quoted p. 31.

55 Mrs Lionel Birch, *Stanhope Forbes ARA and Elizabeth Stanhope, ARWS* (London: Cassell, n.d.), p. 26.

56 See, for example, F. E. Halliday, *A History of Cornwall* (London: Duckworth, 1959).

57 Such sentiments are commonplace in the writings of the painters. See, for the quoted phrases, Birch, *Stanhope Forbes ARA* p. 27 and Fox and Greenacre, *Artists of the Newlyn School*, p. 66.

58 Fox and Greenacre, *Artists of the Newlyn School*, pp. 28, 60–1.

59 Dennis Farr, *English Art 1870–1940* (Oxford: Clarendon Press, 1978), p. 40.

60 Society for Pure English, *Tract XXI*, partly repr. in *The English Language*, Vol. 2, *Essays by Linguists and Men of Letters 1858–1964*, selected and edited W. F. Bolton and D. Crystal (Cambridge: 1969), pp. 88, 93.

61 Society for Pure English, repr. Bolton and Crystal, *The English Language*, Vol. 2, p. 93.

62 From Joseph Wright's letter to newspapers appealing for material for the *EDD*, quoted Elizabeth Mary Wright, *The Life of Joseph Wright* (London: Oxford University Press, 1932), Il, 357.

63 The *preservation* of *pure* dialects is everywhere recommended. See, for example, Wright's piece in *Notes and Queries* (1870) and Elizabeth Mary Wright, *Rustic Speech and Folk-Lore* (London: Oxford University Press, 1913), p. 1.

64 William Matthews, *Cockney Past and Present: A Short History of the Dialect of London* (London and Boston: Routledge & Kegan Paul, 1938), p. 83.

65 Henry Cecil Wyld, *The Historical Study of the Mother Tongue: An Introduction to Philological Method* (London: John Murray, 1920), p. 358. First pub. 1906.

66 Thomas Watts, 'On the probable future position of the English language' (1850), quoted by Hans Aarsleff in *The Study of Language in England 1780–1860* (London: Athlone Press 1983), p. 222.

67 Trench, quoted Aarsleff, *Study of Language in England*, pp. 241–1.

68 K. M. Elisabeth Murray, *Caught in the Web of Words: James A. H. Murray and the Oxford English Dictionary* (Oxford: Oxford University Press, 1979), pp. 181, 51.

69 Murray, *Caught in the Web of Words*, Chs 8–13.

70 Murray, *Caught in the Web of Words*, p. 223.

71 Murray, *Caught in the Web of Words*, p. 187.

72 *TLS*, 13 October 1972, pp. 1211–12.

73 Anderson, *Imagined Communities*, p. 122.

74 Harold Jackson in *Today*, quoted in *James Joyce: Critical Heritage*, ed. Robert H. Denning (London: Routledge & Kegan Paul, 1970), I, 48.

75 *The National Portrait Gallery*, ed. Lionel Cast (London: Cassell, 1901); Philological Society is quoted in Murray, *Caught in the Web of Words*, p. 137.

76 Sidney Lee quoted in 'George Smith and the *DNB*', *TLS*, 24 December 1971, pp. 1593–5. The recent commentator is David Cannadine in a review of the *DNB 1961–1970*, *London Review of Books*, 3–16 December 1981, pp. 3–6.

The *DNB* was bequeathed to Oxford University press by Smith's family in 1917.

77 John Stokes, *Resistible Theatres: Enterprise and Experiment in the Late Nineteenth Century* (London: Elek, 1972), p. 9.

78 Quoted in James Woodfield, *English Theatre in Transition 1889–1914* (London: Croom Helm, 1984), p. 99. Only recently have historians begun to be interested in the popular and/or political theatre which Archer and Granville Barker would not acknowledge. See, *Theatres of the Left 1880–1935: Workers Theatre in Britain and America*, ed. Raphael Samuel, Ewan MacColl and Stuart Cosgrave (London: Routledge & Kegan Paul, 1985).

79 Quoted in Woodfield, *English Theatre in Transition*, p. 100.

80 That the National Theatre was not established during the period of this volume does not materially affect the argument which is centred on the dominant ways of conceiving the national culture and its constituent parts. An account of a later institution such as the Arts Council would confirm my argument. Robert Hutchison has shown how the concern during the Second World War with taking the arts to the people and with supporting the arts produced by the people evaporates in the 1950s, and is replaced with a policy of supporting certain metropolitan centres of excellence: *The Politics of the Arts Council* (London: Sinclair Browne, 1982), p. 100.

81 Pankhurst, *The Suffragette Movement*, p. 454.

82 Raymond Williams, *Towards 2000* (London: Chatto & Windus, 1983), pp. 114–19 discusses the various meanings of 'representation'.

83 Sidney Lee, 'The place of English literature in the modern university', in *Elizabethan and Other Essays by Sir Sidney Lee*, ed. Frederick Boas (Oxford: Clarendon Press, 1929), p. 4.

84 Gilles Deleuze in conversation with Michel Foucault, *L'Arc* (1972) quoted in Alan Sheridan, *Michel Foucault: The Will to Truth* (London: Tavistock, 1980), p. 114.

Representing the past as heritage and its consumption

Introduction to part two

■ David Boswell

ANYONE ENCOUNTERING the heritage debate, and in particular the critique of the heritage industry in the 1980s, might suppose that the British had suddenly woken up to their past and become obsessed with it to the exclusion of current conditions and remodelling for the future. But the situation is more complicated and has a far longer history than this suggests. English gentlemen and travellers had contributed both the extensive landscaped garden and then the concept of the picturesque in nature to European culture during the major agrarian revolution that accompanied the early years of the industrial revolution. But it was the latter and the speed and scale of urbanization that transformed the life of the British population in the nineteenth century. Peter Mandler (1997) has shown how the Victorian idea of heritage developed as an aspect of popular culture encouraged by mass-produced literature and a conception of a past that could be valued as progressive by the populace. They discerned in it the origins of the social and political institutions which they had made more democratic by removing the entrenched privileges of the aristocracy and other self-perpetuating oligarchies. Their evaluation of the buildings and the past culture they associated with these institutions had much to do with their notion of the founding of modern England, their England, and did not reflect a fawning adulation of the great estates of the aristocracy from whom they had wrested a share in governing the country.

The Tudor and Jacobean manor houses of 'the olden time' which appealed to this industrial generation formed the core of the culture subsequently taken up by the critics of industrialization, and the arts-and-crafts movement which formed the cultural wing of the radical and socialist movement in Britain. The preservationist movement took a long time to achieve anything like power in Westminster because of its challenge to private property rights but when it did so this was on a broad front. The preservation of natural beauty and historic buildings with access to

them were the founding purposes of the National Trust in 1895. The protection of ancient buildings, rather than their insensitive remodelling to suit current fashions, was the aim of the eponymous society of 1876. And the Ancient Monuments Acts eventually established both a private duty to care and a public agency to hold and maintain the ruins of the prehistoric and mediaeval past. In the subsequent half-century a variety of amenity societies, preservationist associations, quasi-governmental boards and fiscal measures have been set up and introduced. These were consolidated in the National Heritage Acts of the 1980s which gave rise to the debate already noted.

But there were other features of this concern for the past which were remarkable. One was the phenomenal growth in the number of private and public collections and museums, and the virtually totally inclusive range of objects now considered worth preserving and displaying. Another was the parallel growth in the visiting public itself and the leisure, rather than primarily educative, functions of this multi-faceted heritage. A third was the apparent commercial cachet that accrued to areas associated with conservation and prestigious public or private museums and buildings.

The heritage debate, as exemplified by the critique emanating from writers on national cultural priorities, is therefore a critique of the Thatcher years. Patrick Wright, returning from Canada, was astounded by the museumification of Britain, and by the prominence given to the fate of the very different notions of culture represented by Mentmore Towers, a château of the Rothschilds and Roseberys, and Calke Abbey, a country-house backwater of unknown English squires. In another essay included in his *On Living in an Old Country* (1985), he coupled this nostalgia with the drum-beating throwback to winning the Second World War through the Falklands campaign, which the Conservative government used to win another general election despite massive economic dislocation and civil unrest. He was concerned that this backward look deflected attention from the necessary debate about Britain's future. Two years later Robert Hewison took the matter up more stridently in his attack on *The Heritage Industry* (1987). We have selected his chapter on 'The climate of decline' because the thrust of his argument is that it was the response to this that generated first a middle-class nostalgic reaction to the past as better times, second the sanitization of the past and extirpation of cultural reputations and criticism concomitant on the commercialization and redevelopment of run-down industrial areas like Wigan Pier and a heritage centre that virtually ignores George Orwell whose writing gave it national significance, and third the desperate race by once-industrial local authorities to make anything out of the relics of their past for the crumbs that tourism may bring in. Hewison (1991) elsewhere argued the need for a new message to emanate from the nation's museums but expected this to come from the scholarship and educational role that museums could perform rather than an uncritical display of bygones that purveyed a quiescent, satisfied and unproblematic view of past life and times.

Of those who responded to this criticism, the most outraged was Raphael Samuel, a devoted socialist who dedicated his life to the encouragement of making history from below. In his capacious book *Theatres of Memory* (1994), he not only documented and dated the many moments of contemporary interest in the

past, but also the social transformation of that interest. This is well represented in his chapter 'Resurrectionism'. Samuel located the beginnings of popular enthusiasm for industrial archaeology and other aspects of the past to at least the 1960s. He argued that, far from its being the force for Thatcherite reaction which was always a risk for nostalgia, this took the form of a fundamental break from the previous devotion to the monarchy, Parliament and the Constitution, and instead the development of a multi-focused, often much more plebeian and even domestic, and democratic interest in all sorts of people's pasts. If the photographs of working-class families showed them at their smartest, and industrial museums focused on technological processes not drudgery, this reflected their subjects' self-respect and their concept of the dignity of labour. Essentially, the scale of popular interest was its own message. One feels Samuel could have taken his argument even further. Like Andrew Higson (1993), he thought that in a significant area of heritage production, the acclaimed British literary costume films since the 1980s, such as *Little Dorrit, Nicholas Nickleby, The Go-between* and *Howard's End*, the liberal-humanist critique of affluent materialism and the decadence of the old order were undermined by their gorgeous and nostalgic props. But surely one could interpret the popularity of not only these but so many other aspects of the representation of a material past as a severe rejoinder to the crude utilitarianism and philistine self-interestedness of a Thatcherite rhetoric – one that had no use for so many of the British institutions and ways of life, common or elite?

Chris Rojek's point of departure is quite different from that of Samuel. In *Ways of Escape* (1993), he argues for the deregulation of leisure and most particularly for a departure from the secular morality of those, like Hewison, who want the use of leisure time to be useful and educational. We have selected his chapter 'Fatal attractions' because it indicates the sort of uses to which the very recent as well as the distant local past may be put for popular entertainment. In the postmodern scenarios he outlines, the representation of the past is a means of immersing subjects in direct sensory experience. No critical message need be carried in these simulations of historical reality, and Rojek takes issue with those who continue the rational recreationist critique of capitalist amusements. He argues that they are based on distinctions that have no basis in contemporary society, such as those between work and leisure, or between high and low culture.

In the chapter 'Gazing on history' taken from his book *The Tourist Gaze* (1990), John Urry responded like Samuel and Rojek to Hewison's critique. But Urry's criticism was more extensive because he is also interested in the social movements represented in conservation and heritage presentation as well as the practicalities of museums, national parks and urban conservation. What is the 'other' that the 'heritage baiters' (Samuel's term) advocate? If not put to those new uses, would they demolish the obsolete mills of industrial Britain? Nothing else seems to be proposed. And what is vehemently condemned as bourgeois seems extremely popular with the general population. Nowhere, one may add, is this more apparent than in the popular response to the death of Diana, Princess of Wales, where newly empowered politicians succeeded, with the press, in forming a new national image of 'the people's princess'.

References

Hewison, R. (1991) 'Commerce and culture', in J. Corner and S. Harvey (eds), *Enterprise and Heritage: cross-currents of national culture*, London: Routledge.

Higson, A. (1993) 'Re-presenting the National Past: nostalgia and pastiche in the heritage film', in L. Friedman (ed.), *Fires Were Started: British Cinema and Thatcherism*, Minneapolis: University of Minnesota Press.

Mandler, P. (1997) *The Fall and Rise of the Stately Home*, London: Yale University Press.

Patrick Wright

TRAFFICKING IN HISTORY

> According to traditional practice, the spoils are carried along in the procession.
>
> (Walter Benjamin, from 'Theses on the philosophy of history'
> in *Illuminations* [London: Jonathan Cape, 1970] p. 257)

I The national heritage lost and found

> The content of cultural conservatism has undergone fundamental changes as well. It can no longer find a circumscribable social *topos* whose morality and especially whose taste could be conserved as an unimpaired paradigm. Its essence lies rather in the protective gesture itself.
>
> (Ferenc Fehér and Agnes Heller, from 'Class, democracy,
> modernity', *Theory and Society* 12 (1983): 211)

Mentmore Towers

In May 1974 the sixth Earl of Rosebery died. Millions of pounds in death duties promptly fell due, and the future of the Rosebery estate therefore came into question just as quickly. At the centre of this estate stood Mentmore Towers, a florid country house near Aylesbury in Buckinghamshire. Mentmore was built for Baron Meyer Amschel de Rothschild in the mid-nineteenth century and designed by Sir Joseph Paxton – an architect then at the height of his controversial eminence as designer of the Crystal Palace. There was also a massive collection of furnishings and works of art (French eighteenth-century and Italian sixteenth-century pieces

from the old Rothschild connection, while a formidable clutch of English paintings had been gathered under Rosebery ownership). Here, as Marcus Binney put it in 1977, was 'one of Europe's greatest treasure houses' – 'the only outstanding High Victorian house to survive intact' – under threat of dispersal and liquidation.

[. . .]

By January 1977 Sotheby's (where, incidentally, a real live Rothschild was hidden among the directors) had announced what they hoped would be 'the most important sale of the century', and for the rest of the year Mentmore was in the news.

[. . .]

On the eve of destruction there was parliamentary discussion which did not follow simply along party lines. Michael English, Labour MP for Notts West, took the parochial view that Mentmore was merely a nineteenth-century copy of sixteenth-century Wollaton Hall, which stood in his constituency, and that priorities were evidently wrong: 'if there is any public money to spend on a building of architectural merit it should be spent on the original and not on the copy.' Andrew Faulds, also Labour and a prominent advocate of heritage legislation, dismissed English as a 'lower browed twit'. The Conservative Norman St John Stevas, who was of a mind with Patrick Cormack on this matter as on so many others, warned not only of 'a grave loss to the national heritage' but of how the government stood to lose 'the bargain of the century'. Peter Shore muttered on about priorities and how there were many claims on scant resources, while Stanley Newens (Labour MP for Harlow) stressed that 'it would be a bad thing to allow the temporary situation to cause us to lose this national asset'. Nobody even dreamed of Céline's point that 'you don't lose anything much when your landlord's house is burnt down'.[1]

[. . .]

The hammer was eventually raised at Sotheby's and it didn't stop falling through April, except at those moments when the loot which had been sold had to be cleared out of the auction room so that more could be shovelled in. Prices rose above all estimates, and by the end of the month £6 million had changed hands – three times what the government had refused for all this and the house as well. Recriminations were immediate and bitter. Lady Birk confessed from her Ministerial position that there were lessons to be learned from this 'agonizing affair'. A Drouais portrait which was bought by the National Gallery for £380,000 had apparently been offered to the Treasury at a fraction of this price in lieu of estate duty and turned down. John Hale, Chairman of the National Gallery trustees, came out against the Treasury, and Denzil Davis (Minister of State at the Treasury) was publicly grilled – accused of lying as well as of general incompetence, with many of the questions coming from members of his own party. By December, Lord Penarth (Tory Chairman of an all-party reviewing committee on the Export of Works of Art) had announced what was clear to many: 'the Mentmore sale should never have taken place, and the Government and the Treasury must bear the blame.'

Mentmore was the Callaghan government's stately home, and there was nothing remotely modest about it. The house 'glittered with gold', as one anonymous

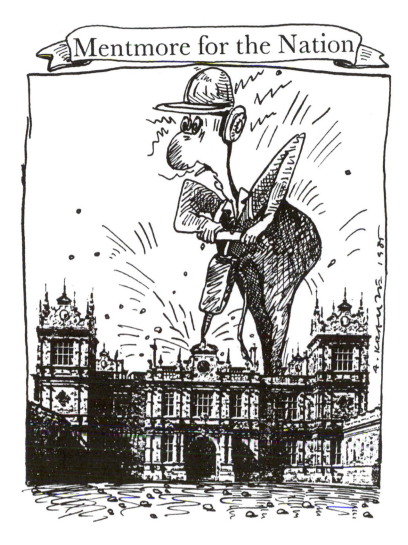

Figure 6.1 'Mentmore for the Nation': drawing by Andrzej Krauze

'expert' put it in 'Save Mentmore for the Nation', and its collection had been gathered from the rarest heights of cultural tradition.[2] If details of the contents had not been published before 1974, this was only because Lord Rosebery was already spending thousands of pounds a year on burglar alarms. Similarly, there was nothing peripheral or of merely particular interest about the position of either the Rothschild or the Rosebery family in British history – both were dynastic. Here indeed was the national heritage, and it was lost to a bungling and bureaucratic government which could have 'saved' the heritage *and* made a handsome profit at the same time (and in this Binney was proved right). Here also was Lord Rosebery, the good and patriotic aristocrat, who even withdrew a few items from the sale in order to present them as gifts to faithful but now sadly departing servants, doing everything he possibly could to ameliorate a situation which was – as he was careful to

stress – completely beyond his control. And here was a ruinous Labour government refusing to act and – at least for much of the public – finding yet another sphere in which to call the question of its own adequacy to the nation. Two years later this last question would return in a general election. By that time the Mentmore story was complete, shifted irreversibly into the past tense. In December 1978 the empty house was bought for £240,000 by the Maharishi International College, an organization concerned with transcendental meditation. G. K. Chesterton could not have done better: there were the traditional glories of an imperial nation; there was decline and betrayal; there was the empty shell of a building occupied by acolytes of an alien creed. Transcendental 'bliss' can hardly have been the happiness which Disraeli [had once said he] hoped would 'hover over the Towers of Mentmore'.

Calke Abbey

Charles Harpur-Crewe died a few years later, in 1981. Since the eighteenth century his family had occupied Calke Abbey, a country house in Derbyshire, but with Charles's demise £8 million in Capital Transfer tax fell due, and son Henry found himself offering the house (together with its contents, the park and enough agricultural land to endow the place for the National Trust) to the government in lieu of payment. Once again there were lengthy negotiations, with the Treasury eventually agreeing everything but the essential endowment. The National Trust couldn't accept the house without endowment, so destruction and dispersal loomed in their familiar way. The pattern of response was also repeated. In November 1983 Save Britain's Heritage published a 'lightning leaflet' called 'This magical house must be saved intact. Now!' and . . . the National Trust communicated its interest in the house through the correspondence page of *The Times*.[3] [. . .] On 13 March, however, and as the last hours approached, rescue was announced by Nigel Lawson in his first budget speech as Chancellor. Extra money had been made available for the National Heritage Memorial Fund to make the endowment possible. So Calke was 'saved' for the nation, represented as so often in such cases by the National Trust.

If Mentmore was Callaghan's country house, Calke is certainly one of Margaret Thatcher's. Of course there have been many other rescues and losses under both governments, but political symbolism doesn't worry over details like this when it comes to designating the representative case. Calke is significantly different from Mentmore, and not just because it was 'saved' so dramatically. By any orthodox assessment Calke was a lesser establishment than Mentmore – nobody would have called it one of Europe's greatest collections, for example. There were indeed some valuable paintings (Landseer, Linnell, Ruysdale, etc.) among other traditionally precious items, but both house and contents lacked the massive distinction and opulence of Mentmore. As for the Harpur-Crewes, who beyond a handful of cousins had ever heard of them?

[. . .]

Along with their reluctance to face historical change, it is the Harpur-Crewes's anachronistic irrelevance to the modern world that makes them so deeply 'histor-

ical' in the approach to 1984. In the 1980s the Harpur-Crewe family was distinguished precisely because it lacked any distinction, and Calke Abbey was of historical value because it too was sufficiently unremarkable to have survived unnoticed. The attraction of the house was only peripherally related to the value of its artefacts or to its architectural merit. [Lord Vaizey had suggested its contents were little more than junk.] The point instead was that Calke had not been cleaned up (by, say, the 'new wife' who Lord Vaizey thought might have helped reduce those 'skiploads of junk') and that its continued existence had gone unknown. Unlike Mentmore it was not for security reasons that this country house had never been written up and displayed, but rather for lack of sufficient interest. Like the family's want of historical distinction, it was only the house's oblivion which made contemporary rediscovery possible. The Harpur-Crewes, it was said, had not thrown anything away and Calke as a result became 'the house where time stood still' – just draw back the curtains, blow off the dust, and every little particular of the Harpur-Crewes's previously unregarded world is there to be found. Here was a time-capsule, a 'little piece of England' which had shown such remarkable resistance to the march of time that it seemed to *The Times* like 'the outcome of a successful experiment with time' – a phrase which could equally well be applied by the same newspaper to other aspects of the current Tory project.

The myth of historical recovery is complete. When journalists from the *Observer* went up to Calke early in 1984 they found no servants remaining and a singular Henry Harpur-Crewe living alone – indeed, camping out – in two of the house's eighty rooms. That left some seventy-eight rooms on which curtains and doors had been closed at some time over the last 150 years. There was the room of Richard Harpur-Crewe, who died in 1921 – his car manuals, model ships and copies of *Jane's Fighting Ships* still lying there to be photographed by the newly

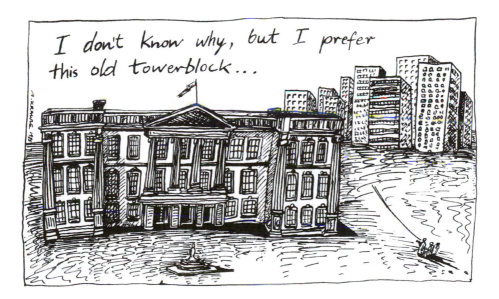

Figure 6.2 Drawing by Andrzej Krauze

admitted cameras. There was a bird lobby filled with specimen cases, while the tools and equipment in the outhouses were so well preserved that the National Trust's surveyor apparently likened the densely packed timber stores to a 'scene from Diderot's *Encyclopédie*'. And above all there was the Victorian drawing room, furnished and redecorated in 1856 and scarcely used since – the colours still brilliant after a century under wraps.

[. . .]

The brilliant and cluttered Victorian drawing room discovered at Calke was photographed and displayed widely. A remarkable survival indeed, this preserved and rediscovered room was also the somewhat ethereal realization of thousands of carefully designed historical interiors from recent television productions. Here in our midst is the world that we thought was lost; it survives only as a miraculously neglected fragment or as obsessive reconstruction in the contemporary electric theatre, or in the case of Calke as a bit of both. Far from any conventional consideration of architectural or cultural value, Calke is how one dream of old came true in the anxious climate of 1984. If the national heritage was lost at Mentmore in 1977 it was rediscovered in a different expression seven years later – still home at Calke.

II The National Heritage Act (1980) and the redeclaration of the Second World War

> It is best to have a supply of memorials to guard against accidents. I mean to have an assortment of tombstones myself.
> (Mark Twain, *Letters from the Earth,* ed. B. De Voto [Greenwich, CT: 1962])

Between Mentmore and Calke came the National Heritage Act 1980. This legislation was the culmination of considerable parliamentary discussion and agitation, much of it prompted directly by the Mentmore affair. Deliberations over the national heritage and the measures necessary to ensure its preservation occurred during Labour's term of office. A White Paper proposing legislative reform was produced in February 1979, but by this time the writing was already on the wall. A few months later Thatcher would defeat these hesitant and bureaucratic vandals in a general election and start to consolidate her project of bringing national pride and other old values back to the country at large. The national heritage was in the air during that election campaign and, while there were certainly also larger issues about, there can be little doubt that, like Dutch Elm Disease, the Mentmore fiasco played its part in forming public opinion of the Labour government.

As it happened, then, the legislative reform which was planned under Labour was modified and enacted under Tory rule. The National Heritage Bill was introduced into both Commons and Lords with considerable patriotic clamour on all sides. At its second Commons reading in December 1979 Norman St John Stevas announced that this Act alone would justify his career, claiming that the government would be remembered for this legislation long after its other achievements

were forgotten.[4] [. . .] Patrick Cormack, Conservative MP and author of *Heritage in Danger*, celebrated the fact that the Bill came forward with all-party support, announcing that 'it is vital for the preservation of our heritage that it should never become a political football'. Andrew Faulds agreed: 'it is not often – indeed in this Parliament it is exceptional, probably unique, that we in opposition can positively welcome any legislative intention from this benighted government.'

[. . .]

But if the nation was moved by these measures to protect its increasingly vaunted heritage, a far more forceful presentation of national unity was approaching and of a sort that St John Stevas is unlikely to have anticipated. With the Falklands adventure the politics of national identity and concord shifted dramatically. The sovereign heritage now needed a curiously military form of preservation as this old fox-hunting nation sailed out to be blooded once again. As for St John Stevas, by this time he himself had become a minor and indeed rather quaint piece of the past – suffering neglect if not absolute dereliction on Thatcher's back benches.

Like most of the preservation legislation preceeding it, the National Heritage Act 1980 has two main co-ordinates: it is concerned with the preservation of that range of property which it defines as 'the heritage', but it also seeks to secure public access (of an acceptable sort) to ensure that 'the heritage' is available for cultural consumption and in this case especially to see that it is *displayed* as such. In itself the National Heritage Act 1980 is a threefold measure: it eases the means whereby property can be transferred to the state in lieu of capital transfer tax and estate duty; it provides indemnity to museums which might otherwise be unable to afford the cost of insuring objects loaned to other exhibitors; and establishes the National Heritage Memorial Fund.

The National Heritage Memorial Fund was grafted onto the remains of the National Land Fund, which had itself been established in 1946 under the guidance of Labour Chancellor Hugh Dalton. The National Land Fund was set up with £50 million which came into the Exchequer from the sale of surplus war materials. Dalton's idea was for the fund to work as a 'thanks-offering and war-memorial' for the Britons killed in the Second World War: 'the beauty of England, the famous historical houses, the wonderful stretches of still unspoilt open country', surely it would be a fitting memorial that these 'might become part of the heritage of all of us'.[5] But while the words were undoubtedly fine the reality was rather less forthcoming. The National Land Fund never achieved any practical existence as an emergency or contingency fund and there was even some argument as to whether it existed at all, except as a bureaucratic accounting device within the Treasury.

[. . .]

The details may seem relatively trivial, but it should certainly be recognized that the National Heritage Memorial Fund represents one of the Thatcher government's first (and perhaps less than fully conscious) attempts to revive the spirit of the Second World War and to set up its own patriotic measure against that long drawn-out betrayal known in more polite circles as the post-war settlement. For in Conservative rhetoric the Second World War has been redeclared – not against Hitler this time, but against the kind of peace which followed it: if Spitfires and

Lancasters are in the skies again, they now fly against 'socialism' and the 'over-weening state'.

[. . .]

As it was phrased in the debates which surrounded the National Heritage Act 1980, the national past – 'our' common heritage – seems indeed to be identifiable as the historicized image of an instinctively conservative establishment. While the Great Tradition of bourgeois culture was frequently invoked in the debates, the interests of property are also more pragmatically expressed. [. . .]

But the deft manoeuvring of historic house owners cannot provide an adequate account of the National Heritage Act 1980 either – and not just because the dispossession of a few well-heeled 'guardians' of 'our' national heritage would be hopelessly inadequate as any kind of political goal. While the interests of property are undoubtedly in play, the cultural motivation for the National Heritage Act 1980 is the important issue to understand, and this as we have seen was broadly shared. The crucial questions, therefore, concern this public valuation of the national past which seems to be so widely held in common. What is this sense of nation and past which serves as cultural background to measures like the National Heritage Act 1980? What is its evidently changing interpretation of the history-to-be-saved, and how has it come to win such wide support? In order to define the character and institutional basis of this public sense of history – one in which a public is defined every bit as much as a past – I shall now give two historical sketches. The first of these is concerned with the emergence and development of preservationism from the late nineteenth century onwards, while the second deals with the ruralist advertisements which Shell has produced in Britain over the last sixty or so years.

III Preservations and the National Trust

[. . .] The impulse to preserve landscapes and buildings is an insistent cultural tendency within western modernity, but it does more than naively plea for old calm and settlement in the midst of contemporary turmoil and change. In Britain a fairly diverse preservation lobby has been working with recognizable historical continuity since the second half of the nineteenth century. The early moments are increasingly well known, often as the inaugural dates of influential voluntary organizations which were formed in the later decades of the nineteenth century. Thus in 1865 the Commons Preservation Society was formed, while 1884 saw the founding of the National Footpaths Preservation Society. Responding to the threatened 'restoration' of Tewkesbury Abbey, William Morris helped press the Society for the Protection of Ancient Buildings into existence in 1877. There were also more specifically civic initiatives, such as the London Survey Committee, which became active in the 1890s and secured the support of the London County Council in 1897. As for the more general background to these developments, a number of recently suggested factors should be acknowledged. Michael Hunter has pointed to the increasing influence of historicist values, which at this time came to be articulated against Enlightenment ideas of progress and reason, while others place more

emphasis on an aesthetic and neo-pastoral impulse which turns into a demand for preservation as it recoils from the rampant urbanity of a brutal industrial capitalism.[6] Alongside these influences, emphasis should also be placed on the consolidation of the imperial nation-state; for whatever else it may involve, preservationism has certainly played its part in a nationalization of history which enables the state to project an idealized image – never fully achieved, but there is a tendency nevertheless – of its own order against a geographical and historical background of its own selection.

Patrick Cormack, one of the many advocates who has also outlined a history of preservationism, finds the story beginning in 1854 when John Ruskin submitted a proposal to the Society of Antiquaries, suggesting that an Association be established to maintain an inventory of 'buildings of interest' threatened by demolition or the wrong kind of restoration.[7] The 1860s saw legislation to protect wildlife from the ravages of the fashion for plumage – a fashion which had numerous bourgeois women sporting half a seagull on their hats (and many others protesting) – but the first parliamentary manoeuvre on the preservation of monuments seems to have come a decade or so later, when the Liberal MP Sir John Lubbock drafted his National Monuments Preservation Bill. Influenced by Ruskin's earlier initiative, this proposed the establishment of a National Monuments Commission along with a schedule of those monuments which the Commission would protect. This Bill was rejected on its second reading in 1875, as were Lubbock's next two attempts to get preservation legislation enacted in 1878 and 1879. The opposition to preservation may have been enhanced by anti-aestheticism, but one fundamental objection was raised again and again: the enactment of any of Lubbock's Bills would introduce into 'the law of the land' a principle which elevated public interests above private property rights. This transformation was resisted heavily, and the resistance was expressed clearly by the Tory Francis Hervey, who asked: 'Are the absurd relics of our barbarian predecessors, who found time hanging heavily on their hands, and set about piling up great barrows and rings of stones, to be preserved at the cost of infringement to property rights?'[8]

In 1882, with Gladstone in power, a Bill prepared by Lubbock was enacted as the Ancient Monuments Protection Act. It was, as Cormack comments, a weak affair which established a schedule of some twenty-one monuments which the nation might take into guardianship or purchase. The 1882 Act was strengthened in 1900, but even then it was not sufficient to resolve the conflict between growing pressure for public intervention in matters of preservation and the private property rights which were so heavily represented in both Houses of Parliament. The Act provided no compulsion and it didn't apply at all to inhabited monuments. While Parliament hesitated at the brink of infringing property rights the extra-parliamentary preservation lobby continued to expand its activities. It was in the institutionalization of this lobby that a working solution to the conflict between public interest and private property was eventually negotiated. This negotiation is clearly at work in the early history of the National Trust.

The National Trust was formed in 1895, but the impetus for its formation lies in the 1880s with the experience of the Commons Preservation Society which had campaigned successfully over Hampstead Heath, Berkhamsted Common and Epping Forest. Because the Commons Preservation Society [CPS] did not have

corporate status it was legally barred from acquiring land and could consequently not purchase common rights. In 1884 Robert Hunter, solicitor with the CPS, proposed the creation of a body which would be incorporated under the Joint Stock Companies act, and therefore able to buy and hold land and buildings 'for the benefit of the nation'. As Hunter said, 'the central idea is that of a Land Company formed . . . with a view to the protection of the public interests in the open spaces of the country'. Hunter was supported by Octavia Hill who apparently suggested that the name include the word Trust rather than Company so that the benevolent side of the operation would be stressed. The third founding figure was Hardwicke Rawnsley, a friend of Ruskin's who was also Canon of Carlisle. Rawnsley had been active with the Lake District Defence Society, an organization which had been rallying the ghosts of Coleridge and Wordsworth in order to oppose the construction of railways and the closure of traditional rights of way in the Lake District. [. . .]

In 1895 the Association was registered as 'The National Trust for Places of Historic Interest and Natural Beauty'; it was registered under the Companies Act, but because it was not profit-making the Trust was not obliged to include the word 'Limited' in its title.

Especially during the first twenty years of its existence, the National Trust worked as a campaigning pressure group. This brought it into explicit conflict with private capital and government on occasion. Nevertheless, in its concern with what it has helped to define and create as at once the 'public' and the 'national' interest the Trust has also had a ground in common with government. At the institutional level, the Trust has achieved results precisely by working in close relation to both capital and state. Within two years of its formation it was advising county councils on the listing of historic buildings, and in the same early years it was attempting to unite and organize preservation groups; in 1900, for example, archaeological societies and field groups were brought into affiliation. This organization of the preservation lobby was double-edged: it brought about a more concerted and effective lobby at the same time as it produced a more corporate and therefore, under certain circumstances, a more manageable one. In 1907 an Act of Parliament made the Trust a statutory body, giving it the right to hold land 'inalienably' – that is to say, it was protected so that no one could acquire Trust property without permission from Parliament. Legally instituted in its novel way under the Companies Act, the National Trust seems to have provided the state with a way out of the conflict between public interest and private property. The two are now negotiated, if not wholly reconciled, but at a displaced level: as a registered company the National Trust holds property privately, and yet it does so in what it also works to establish as the national and public interest. Indeed in some respects this national public interest occupies a position analogous to that of the shareholder in an ordinary limited company. One doesn't have to take a completely negative view of the National Trust to see that the inalienability of the Trust's property can be regarded (and also staged) as a vindication of property relations: a spectacular enlistment of the historically defined categories 'natural beauty' and 'historic interest' which demonstrates how private property simply *is* in the national public interest.

With preservation established as a public concern within the relations of private property, the tone of Conservative thought on the matter appears to change. As

the century turned, Hervey's pompous complaints about relics and barbarians gave way to an almost opposite assertion. This can be heard in the words of the Tory Lord Curzon, who spoke against his party's previous opposition to preservation law in the debates that surrounded the extension of the Ancient Monuments Protection Act, which became law in 1913: 'This is a country in which the idea of property has always been more seriously cherished than in any other, but when you see that to get that Bill through Parliament it had to be denuded of its important features, and only after many years was it passed in an almost innocuous form into law, one feels almost ashamed of the reputation of one's countrymen.'[9]

How is one to account for this shift in emphasis? While it may not be wholly determined, the shift does accompany a change in the role of the dominant classes. In the mid-nineteenth century the bourgeoisie was transforming the whole fabric of society. By the end of the nineteenth century, and more acutely as the twentieth developed, this potion of dominance was less secure. Economic crisis, various challenges to imperial power, the rise of working-class organizations and war all threatened it. Aside from any questions of endangered landscape or monument, a growing concern with the preservation of the social order develops in this context. The endeavour to preserve landscapes and monuments is obviously not identical with this wider conservatism, but close and sometimes crudely instrumental connections have been made nevertheless. In 1929, for example, Arthur Bryant sought to identify the spirit of political Conservatism with the kind of patriotism which he associated with the preservation of rural England. For Bryant the rural scene was an 'educative influence' which needed to be preserved 'in the service of the state'. As he put it more fully:[10]

> From the plain man has been taken away the home smoke rising in the valley, the call of the hours from the belfry, the field of rooks and elms. His home is now the grey land of the coal truck and the slag heap, and 'amid these dark Satanic mills', his life is cast and his earliest memories formed. And the spirit of the past – that sweet and lovely breath of Conservatism – can scarcely touch him. It is for modern Toryism to recreate a world of genial social hours and loved places, upon which the conservative heart of Everyman can cast anchor.

Anyone choosing to glance at Patrick Cormack's *Heritage in Danger* will see that the game goes on, and that Conservative ideologues are still presenting their political project in the moving vocabulary and imagery of the national heritage. But for all the persistence there is no easy or final settlement here, and the relation between capitalist property interests and the preservation of heritage sites has remained fraught throughout the century. Capitalist property relations can only be preserved if they are reproduced through new accumulative cycles, and preservation of these relations seems in this sense to necessitate the constant transformation of life in both town and country. The preservation of capital is therefore predicated on widespread social change and, indeed, actual demolition. Summarily stated, this is the dereliction which brings capital into conflict with the preservation lobby – a conflict which, however deeply buried, still underlies the publicly maintained serenity of 'our' national heritage.

In pointing to an appeal like Bryant's I am not suggesting that the preservation movement is class-determined in a mechanical way; indeed, it should be stressed that preservation is certainly capable of internal differentiation and conflict. Thus, for example, in 1900 there was argument over Stonehenge. After peering, with understandable anxiety, into the future, two of the upright stones had fallen during the last night of the nineteenth century, and the Society for the Protection of Ancient Buildings clashed with the Commons and Footpath preservationists when the owner, Sir Edmund Antrobus, took protective measures which included the introduction of a turnstile and an admission charge. The preservation of monuments is one thing, but it is quite another to limit public access to places where, as Hardwicke Rawnsley of the National Trust put it, 'men's feet all up the ages have been as free as air to come and go'.[11] And, indeed, while preservationist idealizations of country and past certainly merged quite explicitly with Baldwinite Conservatism in the 1920s, and while they also supported massive attacks on popular 'plotland' development in the 1930s, preservationism never lies simply in the pocket of the state.[12] The contest over public access to land and traditional rights of way continued with real intensity through the 1920s and 1930s, and in organizations like the Federation of Ramblers Clubs (precursor of the Ramblers Association), the Woodcraft Folk and even perhaps the proletarian-taming Youth Hostels Association it had a recognizably working-class base. Preservationism continues to involve resistance to the inroads of state and capital on traditional towns and landscapes, and it does this in the name of a powerful national interest which can express itself in socialist as well as Tory terms.[13] Nevertheless, in the early decades of this century there does seem to have developed an increasingly stable means of negotiating the emergent conflict between preservation and property. Crucial to this is the organization of the preservation lobby in close relation to Parliament and the state.

The growing complex of extra-parliamentary pressure and amenity groups concerned with preservation, and the activities of this complex in relation to the various apparatuses of the state, has played a major part in defining the National

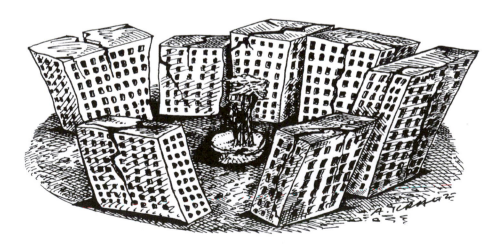

Figure 6.3 Drawing by Andrzej Krauze

Heritage. This contribution can be identified initially by indicating the conjunction of 'historic interest' and 'natural beauty' which is to be found in the full name of the National Trust. Obviously this conjunction does not originate with the National Trust, and one place where it exists before 1895 is in the academic Fine Art tradition. The National Trust may work to preserve landscapes and buildings but it is also an organization through which class-specific academic culture has been generalized and more widely disseminated. [. . .] Members of the heritage lobby sometimes speak of the country house as the 'soul' of Britain, and it is true that since the Second World War (in the years of Labour and the welfare state) the National Trust has been picking up threatened country houses at a dramatic rate. More generally, the country house is certainly the classical instance of such a coalescence: it combines its own 'historic interest' with the 'natural beauty' of what are actually heavily landscaped and aestheticized surroundings: the 'soul' of a nation or just the perfect naturalization of a hegemonic view of the nation which has needed special preservation in the years of progressive taxation and state-led social reform, or both?

In recent years all has seemed very quiet on the National Trust's many expanding fronts. Well over a million people are now members, but it has to be said that even if the National Trust is also now one of the largest landowners in the country, this is a gain which, at least when it comes to politics rather than national-historical reverie, merely snores. In 1982 it was slightly roused by those of its members who were angry at the way 'inalienable' National Trust Land in Buckinghamshire was quietly leased to the Ministry of Defence so that an anti-nuclear bunker could be built to house the Command Headquarters of the NATO air-forces. But normally the sleep is unbroken, for with its million communicant members the National Trust has become an ethereal kind of holding company for the dead spirit of the nation. Indeed, it is so busy managing its own vast and illustrious assets that other more active organizations have been formed fairly recently to campaign more noisily for threatened buildings. This is where Marcus Binney has come in, together with SAVE Britain's Heritage – the pressure group which he helped form in 1975. [. . .] This is as good a place as any to indicate how the National Heritage Act 1980 redefined questions of access and use, turning them into administrative questions of *exhibition* and display.

IV Reinstating the land (Arcadia according to Shell)

> Is there life beyond the posters? When a train takes is outside the city, we do see a green meadow – but this green meadow is only a poster which that lubricant manufacturer has concocted in league with nature in order to pay his respects to us in the country as well.
>
> (Karl Kraus, 1909)[14]

Diverse as it is, preservationism has played a forceful part in producing mass public ideas of the nation with its valued past and countryside. But if the rise of preservationism needs to be understood in its developing relationship with the state, there are also well-made connections with private capital to be taken into account.

This is evident in the advertising which has been produced in Britain by Shell — a company whose publicity has had connections with preservationism since the early 1920s at least.

[. . .]

Nature and preservation are evidently good for business, both as a direct induce-ment to consumption (on the brink of what would come to be known as the energy crisis) and also in the more general terms of public relations. But above all it is the stylized sense of paradox which is indicative of Shell's recent adver-tising strategy. It is aimed at the general public now, at the driver rather than the garage owner or tenant. One such advertisement appeared on a full page in the *Guardian* on 13 September 1979. Most of the page was occupied by a spell-binding colour photograph the quality and effect of which can usefully be described in Walter Benjamin's terms. In 'The work of art in the age of mechanical repro-duction' Benjamin discusses a photographic naturalism which is both profoundly technical and at the same time apparently free of all technical mediation. He then commented that 'the equipment-free aspect of reality here has become the height of artifice; the sight of immediate reality has become an orchid in the land of tech-nology'.[15] This says quite a lot about the image which burst into a certain area of public consciousness from that Thursday's *Guardian*.

[. . .]

It is certainly remarkable that Shell, a company whose entire operation has been premised upon that vast transformation of relations to the environment which accompanies the development of the automobile, can not only present itself as the guardian of 'nature' and 'historical sites', but also secure the assistance of the preservation lobby for the sake of this presentation. The sense of this paradox was flaunted towards the end of 1984 when Shell's new pipeline in Fife was completed. The presentation was the same in these later advertisements. Under the title 'A rambler's guide to our new pipeline', Shell showed photographs of 'ancient ritual stones' along the undisturbed castles and landscapes — £400 million sunk without trace into 'the hillsides of Mosmorran'.[16]

With the exception of a period during and after the Second World War, when petrol distribution came under state control and advertising was consequently suspended, Shell has been producing advertisements which work on the themes of 'nature' and 'history' since before the First World War. There have indeed been other themes (in the 1930s, for example, a series of advertisements likened other petrols to the restricting clothes worn by Edwardian women — 'She's a hiker, but . . .', 'She can swim, but . . .', 'It's no use William, these skirts get in the way'.). Similarly, the constraints on what can be said or suggested have obviously changed — in recent years, for example, it has not been possible openly to promote prof-ligate consumption of petrol — but the advertisements produced over the last sixty years show a remarkable consistency. The recent advertisements which I have just described draw and elaborate on a well-established repertoire which extends far beyond the well-publicized slogan 'You can be sure of Shell'. The ruralism going alongside a celebration of technology, the perspectives of the images, the almost parental claim to care for both 'nature' and 'history', the reassuring text with its

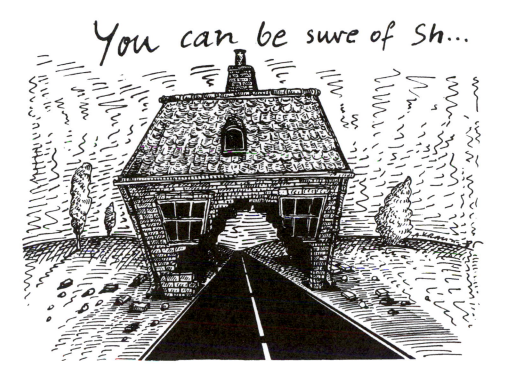

Figure 6.4 Drawing by Andrzej Krauze

mixture of comfort, expertise and good common sense, the cultivatedly pedago-
gical relation between text and image: these and other characteristics of the
advertisements can be traced through the developments of five decades.

Through the early part of the twentieth century Shell was operating in sharp
competition with other oil companies, and more than in other areas of industrial
production this competition was heavily concentrated on the control of markets.
Shell's early growth was partly due to its access to Russian oil and its ability to
subsidize one market by setting it off against another. The fundamental question
within the British market, however, seems to have been different. How does a
company strive to control a market when there is no visible difference between
its merchandise and that of rival companies? From the 1920s onwards – and along-
side a whole series of 'secret ingredients' and measures to control outlets – Shell
appears to have found a strategy to deal with this problem through advertising.
This advertising redefined the countryside in terms of tourism and leisure, and
because it did so at a time when so much of the target population was dissociated
from traditional relations to the land, it could represent the countryside in strik-
ingly abstract terms. The countryside is equated with cyclical time, with colour
and the seasons, and as such it is repossessed in bright advertising images and in
a marketing approach which differentiates 'Summer Shell' from 'Winter Shell'. In
the more homogenized space of modern communication, distance is no longer
experienced in any traditional sense: indeed, Shell restages it as 'the measured
mile' with which the motorist causes the countryside to pass in review, as so many

miles per gallon.[17] The countryside is a place of strange allure now, a utopian zone which in its 'historical' capacity still holds residues of a former world: traces of an Albion in which time is still cyclical but to which the motorist can still make his progressive way. History, progress, the time of travel all lead to a timeless *Gestalt* of earth with 'nation', and the tourist 'visit' is sublimated in advertising which makes oblique references to an earlier and less predictable kind of travel which, after Debord, can be called the 'journey'. But if the tourist is the questing hero, motorized and on wheels, 'visits' are nonetheless quantifiable for that; they can be calculated, anticipated and managed in advance. In 1974, for example, 47.6 million visits were apparently made to historic properties – 9.5 million by people from overseas. In 1983, to quote the English Tourist Board's figures, there were 174 million visits to the tourist attractions in England alone and at least £200 million was raised.[18]

It would be wrong to assert a total continuity of development in Shell's advertising, but there are noteworthy developments nevertheless. In the late 1930s, for example, the car tends to be removed, taken out of the ruralist image (the growing tension between motoring and preservation seems to encourage this).[19] Over the same period of time the road, which has always been carefully positioned in relation to landscape, becomes evident as a principle of perspective. In numerous advertisements it provides the continuity between foreground and viewed distance, and in many of the advertisements its passage through landscape is likened to that of a river: as if, as indeed is the case in one sense, the countryside takes its shape around the passage of the motor car. In a series produced in the early 1960s and called 'Explore the roads of Britain with Shell' the road itself becomes prehistoric, natural and immemorial: the series is concerned with ancient roads such as the Fosse Way or the Roman Steps in Merionethshire, and although the perspectives are identical to those of earlier images, the roads are now green or of natural stone. The tarmac has gone and the road has become a primordial pathway, 'natural' and 'historic' combined. Nothing is left of the contemplative relation to nature but a primitive and 'timeless' pact with the earth.

It is as an agency in the reproduction and elaboration of hegemonic culture that Shell is of interest in this discussion, and two aspects of this process are worth identifying more closely. The first concerns the involvement of the preservation lobby in Shell's advertising; while the second has to do with Shell's use of established 'Culture' to lend its advertising campaign substance, resonance and credibility.

Shell's involvement with the preservation lobby is some sixty years old. In 1929 an advert was formulated under the title 'Shell and the Countryside'. The text read as follows: 'Shell began removing its advertisement signs from the countryside as long ago as 1923. In 1927 they also asked their garage owners to remove Shell enamel plates from their premises. Many thousand such plates were, in consequence, abolished, and the work is still in progress. Shell's ways are different.' This piece of publicity, directly related to the start of 'lorry bills' (fairly large posters which were exhibited from the sides of Shell delivery lorries), led into a concerted advertising campaign in the early 1930s. [. . .] In the 1950s and 1960s Shell's involvement with the preservation lobby takes on a far more emphatic pedagogical aspect, involving any number of calendars and nature guides which were

taken up largely in schools. The images in these advertisements tend to follow an identifiable form: they show a collection of bits and pieces – feathers, cones, berries and suchlike – fragments of 'nature' which are singled out for pedagogical identification. These items are gathered together for the purposes of a nomenclature which forms the substance of the text, and they are displayed in the foreground of the image. A long view stretches out behind them to a landscape in the distance. The emphasis throughout is that one 'knows' nature in order better to appreciate and care for it. In these later advertisements it is knowledge and education – often the act of naming or, more generally, of what Heller describes as 'making sense' – rather than the car and the road which bridge the distance between near and far.

To a significant extent this educational approach to the countryside is continuous with earlier preservationist initiatives. Thus, for example, during the Second World War Batsford published a series of books with titles like *How to See the Country* or *How to Look at Old Buildings* – all part of an endeavour to cultivate the brutalized and (at best) indifferent senses of town-dwellers who had been displaced into the countryside by the upheavals of war.[20] As Harry Batsford wrote in the 'Introductory note' to the second edition of *How to see the Country*: 'It is hoped that all these migrations will render it possible for all but the hopeless urbanites to learn to "see" the country – to get to understand, appreciate and realise something of the message of its outward aspect, its changing seasons, its people and their life and work. . . . No-one is a true Englishman, or has lived a fully balanced life, if the country has played no part in his development.'[21] While Batsford himself didn't necessarily express all of it, an extensive demonology has been elaborated around the urban working class and its 'uneducated' relationship to the countryside. Here are people who break fences and leave litter, who play radios and shout while others are trying to commune with nature, who pick the wild flowers (even the threatened orchid) rather than appreciating them in their natural habitat, who frequent tea-shacks and lack stout shoes; who (as the century moves on) drive their vehicles way beyond the invisible boundaries where (at least according to the tacit agreement of more cultivated society) everyone should start to walk – sometimes even onto the sacred 'green roads' themselves. . . .

Shell has made extensive use of established cultural practices in developing its advertising repertoire. In terms of 'Art' this is evident in the still famous series of 'lorry bills' which were produced throughout the 1920s and 1930s. These 'lorry bills' always featured paintings, and while some of the earlier images certainly did work in terms of a conventional realism it is much more significant that the series also makes continuous appeal to what begins to look like a conventional unrealism.

Considering these images one is not, for example, dealing only with an art which seeks to efface itself, to bury all trace of its production in the view which it sets up as 'natural' and 'real'. The commissioned paintings which were reproduced as 'lorry bills' also tend to stress their character as paintings. One result of this is to lend the reproducible aura and authenticity of 'art' to those sites of 'natural' and/or 'historic' interest to which the advertisements encourage the motorist to drive. But there is something else at work here too, and this can be described as the identification of heritage sites and the countryside, not with any constructed sense of 'reality' so much as with *style*. 'Lorry bills' were produced

in the 1930s by artists such as McKnight Kauffer, Duncan Grant, Barnett Freedman, Paul Nash, Graham Sutherland and Ben Nicholson. Many of these later lorry bills, and especially those of the American expatriate McKnight Kauffer, tended to situate an assertively modernist style in the historically transforming disjunction between the urban motorist/viewer and the countryside. They use a modernist style to link the unfamiliarity with which the countryside appears to the city-dweller with the 'strangeness' of what, for all its oddity, is actually accepted as proper to 'modern art'. The invocation may still be nostalgic and pseudo-pastoral in many cases, but like motoring it is also stridently modern. The countryside is thus caught up in a tense movement in which a traditionalist and non-instrumentalist imagination of 'nature' is displayed against a stylized celebration of the machine – a movement which asserts both the cyclical time of the seasons, of the eternal return of 'nature', and also the irreversible historical time of progress, the time which has brought us the motor car. This tension, which has itself become a fairly basic figure in the image-repertoire of National Heritage, often embodies progressive time as the road while the cyclical order of time is presented as scenery, the pastoral landscape through which the road sweeps. The same tension between different conceptions of time facilitates another development which is at work in Shell's images during the 1920s: in this sequence the slightly bemused but still organic horse is lifted out of the traditional rustic field, transformed into a futuristic and metallic image, and then returned to the countryside as the abstract horse-power which gets the driver out of the city.

But it is not just a developing battery of images which Shell has used to weld ideas of countryside, the visit and the national past to the brand name. These connections are also attempted through an identification of a recognizable vocabulary and text. In the early 1930s Shell's advertising is not particularly articulate, its utterance being limited mostly to short and rather flat slogans. However, by the 1950s a characteristic language has been developed: a language full of cultural assumption, irony (even self-mockery) and display. In the early 1960s, for example, advertisements started to announce that 'here you can relive legend and history on the spot', or, in the same scene-of-the-great-even vein, to celebrate 'Glen Trool: where Bruce fled his own bloodhound'. But there is also a more evocative gibberish of authenticity, represented by the ridiculous text which accompanies a washed-out painting of Lower Lough Erne: 'Wrapped in morning mists of centuries, monks still hide.' A little bit of 'history', some 'beauty', a touch of 'artistic' and 'literary' style: these are among the basic elements of Shell's deftly constructed national archaism – an archaism which is evocative, spectacular and approachable by road.

[. . .]

In the mid-1930s Shell started to publish a series of County Guides under the general editorship of John Betjeman. The first of an immensely influential range of publications which still occupies a central place in the heritage canon, these were written, as the company announced, by authors 'who are generally poets or artists with a bump of topography'. Reminiscent, perhaps, of those 'cultured generalists' who were to be the trustees of the National Heritage Memorial Fund.

In sum, Shell draws on an asserted practice of Literature in much the same way as it draws on Art. Acceptable if not always completely soft poets of a middle class and rural inclination – figures like John Betjeman and Geoffrey Grigson – were used extensively in the 1950s, for example. The significance of this cultural connection becomes evident if one considers the shifting audience to which Shell's advertising is addressed. It is evident, for example, that the earliest advertisements mentioned in this discussion – those from the early 1920s – derive from a time when motoring was only available to a small and wealthy social fraction. It is the culture of this fraction which influences the formation of Shell's advertising repertoire: its vocabulary, its images and also what develops increasingly explicitly as a pedagogical relation between image and text. This influence takes two forms. First, it is directly at work in the formation of Shell's early images in the 1920s; but if it played this role in the initial formation of Shell's advertising repertoire, developing bourgeois culture also provided the relatively constant milieu from which later copywriters and artists were drawn, and in terms of which potential advertisements could be judged before general dissemination. [. . .]

As the automobile became available to a wider public, Shell's advertising was orientated towards a wider audience. By the 1960s and 1970s the automobile is well within the reach of members of all social classes. By this time the advertisements have become general, or rather 'national', in their appeal. They are now addressed to everyone: the citizen as motorist. In this shift of address, the repertoire certainly goes through some changes, but the overall effect is, nevertheless, the generalization as 'national' of cultural values which, in origin and also in their subsequent refinement, are specific to earlier bourgeois culture. For a consideration of public ideas of the nation then, Shell is significant as an apparatus of cultural reproduction. This can be seen very clearly in Shell's early entrance into television advertising with a series called 'Discover Britain'. As Vernon Nye recalls, 'the first advertisements were really an extension into television of the kind of advertising Shell had found so successful in the press and on posters':

> The method chosen was to invite John Betjeman to select places worth visiting and talk about them. To do this effectively required the use of three minutes of time, whereas the limit allowed by the regulations was only two minutes. However, the agents Colman, Prentis and Varley, were able to persuade the authorities to allow three minutes. Research conducted by the London Press Exchange after commercial television had been operating for a time showed that the Shell commercials helped to make TV acceptable to the public who felt that if television advertising was to be like this then it did not mind at all.

Rented Culture didn't just please 'the public'; it evidently also eased its transformation into a sphere which would be defined increasingly by the new mass media. However, if we are to draw such a conclusion, we should also register that developments of this kind also produced vehement High Cultural and neo-aristocratic rejections of the emergent mass pastoralism. [. . .]

V Taking the measure of the national past

> She went to places and shops she remembered from her young days
> sometimes merely with the curiosity of seeing whether they were still
> there.
>
> (Agatha Christie, *At Bertram's Hotel*, London, Collins, 1965)

The foregoing discussion of the National Trust and of Shell's advertising indicates
how extensively rural and 'historical' conceptions of the nation have been elabo-
rated within the changing public spheres of twentieth-century Britain. As for the
all-party rhetoric which surrounded the passage of the National Heritage Act 1980,
this displayed many of the assumptions of a public sense of history in which stately
and even academic elements find themselves aligned with the more vernacular
emphasis of everyday historical consciousness. Some of the prominent character-
istics of this sense of history can now be identified directly.

The abstraction of history

National Heritage involves the extraction of history – of the idea of historical signifi-
cance and potential – from a denigrated everyday life and its restaging or display in
certain sanctioned sites, events, images and conceptions. In this process history is
redefined as 'the historical', and it becomes the object of a similarly transformed
and generalized public attention. That 'history' can become its own justification
under these circumstances was indicated by an advertisement which the Sun Alliance
Insurance Group issued in 1980. As the text of this advertisement announced, 'Better
bring your insurance problems to us. People have since 1710.' A similar presenta-
tion of 'history' as the time of a certain kind of national test informs the memorable
Bicentennial chorus line of *Nashville*, Robert Altman's film about American populism:
'We must be doing something right to last two hundred years.' [. . .]

Abstracted and redeployed, history seems to be purged of political tension; it
becomes a unifying spectacle, the settling of all disputes. Like the guided tour as
it proceeds from site to sanctioned site, the national past occurs in a dimension
of its own – a dimension in which we appear to remember only in order to forget.
'History' is stressed to the same measure that active historicity – the possibility
of any historical development in the present which is not simply a matter of
polishing old statues with ever increasing vigour – is denied to a consequently
devalued and meaningless present-day experience.

History as entropy: the new Biedermeier

> Past inner life is turned into furniture just as, conversely, every
> Biedermeier piece was memory made wood. The interior where the
> soul accommodates its collection of memoirs and curios is derelict.
>
> (Theodor Adorno, *Minima Moralia*: *Reflections From
> Damaged Life*, London, New Left Books, 1974)

If temporary endurance stands as some sort of measure of achievement, value and quality, this sense is certainly intensified now that history is widely experienced as a process of degeneration and decline: like people, countries grow old and decrepit. In this perspective the future holds nothing in store except further decline and one can only hope that ingenious stalling measures will be contrived by necessarily Conservative governments. As that rather embittered stager of ideology Wyndham Lewis put it after the Second World War, Britain is now little better than a rabbit warren on top of a burned-out coalmine.[22] In this vision human dignity and cultural value are non-synchronous residues, sustained only by an anxious and continuously publicized nostalgia not just for 'roots' in an imperial, pre-industrial and often pre-democratic past, but also for those everyday memories of childhood which are stirred by so many contemporary invocations of this better past. In Flann O'Brien's words: 'I do not think the like of it will ever be there again'.[23]

This sense of history as entropic decline gathers momentum in the sharpening of the British crisis. National Heritage is the backward glance which is taken from the edge of a vividly imagined abyss, and it accompanies a sense that history is foreclosed. With organic history in the last stages of degeneration we enter more than just a commemorative age of dead statues. Under the entropic view of history, supported as it is by High Cultural paradigms, 'the past' is revalued and reconstructed as an irreplaceable heritage – a trust which is bestowed upon the present and must be serviced before it is passed on to posterity. In this process owners are transformed into 'custodians' or 'trustees'. The land or country-house owner, for example, emerges as the 'steward' – a public servant who does 'us' and the future a favour by living in the draughty corridors of baronial splendour and tending what he cannot simply consume. One can hear some of the key accents of this transformation in the Duke of Edinburgh's stupefying Introduction to the Department of the Environment's booklet *What is Our Heritage?*:[24]

> The great achievement of European Architectural Heritage Year has been to draw attention to the shortcomings of our generation as curators of the European Architectural collection.

The status quo becomes objective reality in a new sense. All Western Europe is now a museum of superior culture and those citizens who are not lucky enough to be 'curators' of 'the collection' shouldn't worry that they have been left out of the action, for they are still subjects of this new archaism. Their position is to look, to pay taxes, to visit, to care, to pay at the door (even when entering cathedrals these days), to 'appreciate' and to be educated into an appropriate reverence in the process. In this connection it is worth recalling that one of the objectives of the National Heritage Act 1980 was to increase the exhibition of 'the heritage'. In this age of dead statues stately display surely provides access enough.[25]

National heritage makes numerous connections with what was initially an aristocratic and high-bourgeois sense of history as decline but it also moves on into new areas. As the *Spectator*'s review of Cormack's *Heritage in Danger* announced: 'Physical decay, rather than politics, is Mr Cormack's main theme.'[26] Comparably,

during the second reading of the National Heritage Bill 1980, W. Benyon, Tory MP for Buckingham, made a curious statement in which he defined the national heritage as *that which moulders*. While this remark may have been intended to get preservation funds directed more towards property owners than towards the conservation of landscapes and wildlife, it also testifies to an expansion which has recently taken the national heritage beyond its traditional high-cultural definition. Alongside the customary valuation of artworks, country houses and landscapes, these mouldering times have – as Lord Vaizey said of Calke Abbey – seen fairly ordinary household junk included in the repertoire. Alongside the stately museum and the National Trust mansion there now comes the vernacular pleasure of the junk-shop. Here is an altogether more secular amusement in which worn-out and broken rubbish can be appreciated at the very moment of its transformation into something worth saving – a bargain, perhaps, but more significantly something resonant of an ordinary and more hand-made yesterday which is just becoming precious as yet another lost world. While the poor have always visited junk-shops in search of serviceable items with a little life in them yet, they now jostle with others who are there for more alchemical reasons. These are the ones who pick things over in order to savour the minor pleasure of deciding what shall be allowed to continue on its decline towards the rubbish heap and what will be reinstated in the light of a new attention which values, say, interwar clothes, early synthetic materials but no less newly auratic for that. This, of course, is George Orwell's territory and in due course I will have more to say about his fascination with the modest and cast-off remains of other people's everyday lives.

While the definition of the national heritage has been expanded in the recent sense of decline, this hasn't only involved the inclusion of previously secular contents in an initially sacred repertoire. For if the aura of national heritage hovers over a widening range of objects it has also been relocated, increasingly orientated towards *interiors* and their organization or design. Like the 'technostyle' interior design which became fashionable in the United States during the 1930s, this intensification of private space is occurring at a time when public life seems to be in irreversible decline and when doors are surely there to be closed behind one rather than opened onto the world.[27] In his recent suggestion that Britain is seeing the coming of a new biedermeier, Roy Strong refers to early nineteenth-century developments in the Austro-Hungarian Empire when the *ancien régime* was reinstated and the liberal middle classes, denied power, turned in on themselves and crated a style of living whose basis was the cultivation of domestic virtues in the form of all aspects of family life, the home and the garden'.[28] Along with Laura Ashley wallpapers and fabrics, Strong cites the success of a magazine called *Interiors* as evidence of this contemporary shift, and high on the list of factors which have contributed to this development we should certainly place both the continuing extension of home ownership and also the rise of television with its transformation of the relationship between 'home' and 'world'. [. . .] The same tendency is also at work in the changing world of museum technology. While the austere display of celebrated objects against an acreage of empty (if statutory) space is indeed slipping out of fashion, the most significant new displays are as much reconstructions as exhibitions; they use the interior space of the museum to construct

scenes rather than to display objects. The Yorvik Viking Centre at York, for example, uses audio-visual techniques to conjure up its recently opened Viking wharf, smells and all. For many tourists these new 'time-capsule' displays may just give boredom a mildly interesting new form, but they surely also mark a developing perception of history as a miraculous impression that can best be sensed within separate and hermetically sealed enclosures.

Heritage and danger

Given an entropic view of history, it is axiomatic that 'heritage' should be in danger. To the extent that threat defines the heritage as valuable in the first place the struggle to 'save' it can only be a losing battle. The 'stewards' struggle valiantly on behalf of their trust, but a barbarian indifference is all around. It is against this indifference that the urgent tone of the parliamentary conservationist tends to be directed: 'legislation designed to preserve the best of the past has often come too late'. . . . Of course the country house is given to decay, but there is a development of this theme which brings in the larger question of property and inheritance: 'The problems of the country house are not only fiscal, but physical. The owner has to do more and more physical work for himself, with the result that a large country house is no place for elderly people: hence the need to be able to hand on to the next generation – and the next generation will need just as much income, and probably more, than at present.'[29] Claims such as this leave no doubt that the national heritage is far more than an accumulation of threatened objects. Like Debord's spectacle, national heritage still mediates social relations through its ideas, edifices and artefacts. Quite apart from any matter of physical decay, it is also these social relations which get carried forward and secured against threat. Hence (if only in part) the curious style of presence which is so often characteristic of the national heritage – a presence in which cultural authenticity and a rather more corrupt motivation are closely (if sometimes almost discernibly) connected. [. . .]

National geography: the past which simply exists

Considering the merger of history and landscape which lies at the heart of 'our' national heritage, it is consistent that 'the past' should be treated as if it were a simple existent. This emphasis takes two forms: 'the past' is there both to be dug up and also to be visited.

The first of these two modes of presentation derives from antiquarianism and archaeology. In this presentation it is as if one only had to kick a stone in the vicinity of Ironbridge Gorge to uncover early industrial society. What might start as an (industrial) archaeological emphasis opens up a perspective in which 'the past' is defined entirely as bits and pieces which can be recovered, commodified and circulated in exchange and display. This emphasis on tangible remains tends to decontextualize the very objects through which it presents 'the past'. After all, and even though the point can't be generalized too far, it is difficult to 'recover'

social relations – to auction them off or fit them inside glass cases. Industrial archaeologists and museum staff may well appreciate this as a problem of exhibition (as the Education Officer at Ironbridge Gorge put it, 'Skills, techniques and machines, yes, but how does one exhibit social history?'), but this rendering of the past as buried and recoverable bric-à-brac or treasure is not confined to the museum. For example, with the advent of the cheap metal detector, the past has become the quarry of a bizarre field sport. The resulting protest is to be heard in the voice of 'Stop Taking Our Past', an organization which was founded in March 1980 'to prevent Britain's archaeological heritage being wiped out': 'We are appalled by the thought that one of the biggest threats to our heritage now comes not from the building of motorways, not from the building of new towns, but from hundreds and thousands of people with metal detectors.'[30] This comment is more than just the record of an existing problem (the updated barrow thief who leaves gaping holes in the verdant surface of historical sites). The hyperbole also ushers us back into that state-subsidized theatre in which middle-class images of the urban working class are played out. The passage works on the transforming theme of the great unwashed, taking it far beyond even the later image of the urban proletariat spilling back onto the land in charabancs to leave litter and broken fences to mark the incomprehension of days of leisure. The barbarians have now enlisted technology in their search for the past, and if something isn't done soon they will surely dig it all up.

This quasi-archaeological sense of the past as recoverable and talismanic bits and pieces is linked with a supposition which lies at the heart of contemporary tourism: that the past is really there to be visited. Many television presentations of history have contributed to this rendering of the past as an existent, and not just the documentaries that celebrate old remains. [. . .]

It is this imagined transformation that needs to be understood, and one needn't worry unduly that it applies equally to Texan and Londoner (there is a whole industry of genealogists giving white American and post-Commonwealth tourists access to the national heritage via 'roots'). A national heritage site must be sufficiently of this world to be accessible by car or camera, but it must also encourage access to that other 'simpler' world when the tourist or viewer finally gets there. This publicly instituted transformation between prosaic reality and the imagination of a deep past is central to the operation of the national heritage. National heritage has its sites, but like amulets to believers these sites exist only to provide that momentary experience of utopian gratification in which the grey torpor of everyday life in contemporary Britain lifts and the simpler, more radiant measures of Albion declare themselves again. This publicly instituted lapse into a kind of instinctive neo-tribalism can certainly be understood in terms of Sartre's description of the primitive community of anti-Semitism.[31] As can be seen from the following letter which was sent to the *Birmingham Evening Mail* by an expatriate now resident in Africa, the pleasure of this ideology involves the pseudo-poetry of a 'national' and implicitly racist *Gestalt*:[32]

I received a copy of the *Evening Mail*'s Our England special today. A curse on you.

I had just (after 12 months) convinced myself that I was well rid of the rotten weather, football hooligans, dirt, inflation, traffic,

double standards of politicians – and suddenly it's back to square one. The grimy facade is lifted, and the real England comes flooding back.

Long winter walks through the Wyre Forest ending at the George at Bewdley, chestnuts roasted on an open log fire and swilled down with a pint of mild, house hunting round Ludlow for the mythical half-timbered home, the joy of finding one at a price I could afford and trips to auctions to furnish it for £60. . . .

Summer evenings at the Royal Shakespeare, scents wafting across the river. . . . The sounds and scenes of England.

Thanks for helping me regain a sense of perspective.

The expatriate view has the false and wishful clarity of distance. It is from afar that the 'memory' of woodsmoke and the old counties, of thatch, live elms, three-penny bits and steam engines is most pungent, and no one should be surprised that the most rapidly nostalgic heritage publications are those like the quarterlies *This England* or *Heritage: The British Review* which incorporate an expatriate perspective and which in their reaction seem to assume that the purest Britons are those who simply couldn't stand the decline any longer – superior white subjects who finally realized that the last act of true patriotism must be to take that lucrative job in one of the old colonies.[33] Only from outside can one be the truly loyal custodian of a nation which has declined to the point where it exists only in memory and distant imagination. In these magazines the tables have turned and it seems to be the expatriate Briton who restores 'a sense of perspective' to the inevitably rather clouded residents of the perishing realm. Franco Moretti has remarked of liberal England that 'only those who saw Britain from afar were truly capable of understanding it'.[34] Further down this tumbling century, many readers of *This England* would certainly concede the point.

National heritage is visitable, but it also provides access to another world. Hence not only the British Tourist Authority slogan 'Go away to Britain', but also a saying from the Irish Tourist Board: 'Take a small step sideways and find yourself in another world.' British Rail [BR] hasn't missed out on this theme either. In 1980 BR advertised a special train of 'historical' carriages under the slogan 'In the high speed world of today it's nice to have a quick look back'. With some of the Inter-City trains now moving at 120 mph, it doesn't seem entirely facetious to suggest that this 'quick look back' is increasingly just a glance out of the window. For isn't the very look of rural Britain now publicly identified with 'the historical' itself? Isn't that the eighteenth century which can be seen flying past outside the window? Or has agribusiness won the field and landed us all in the prairies?

The accommodation of Utopia

In its historical repertoire national heritage borrows many of the trappings of the English utopia (of Arthurian legend, of Blake and Samuel Palmer, of Morris, and Pre-Raphaelitism . . .), but it stages utopia not as a vision of possibilities which

reside in the real – nor even as a prophetic if counterfactual perspective on the real – but as a dichotomous realm existing alongside the everyday. Like the utopianism from which it draws, national heritage involves positive energies which certainly can't be written off as ideology. It engages hopes, dissatisfactions, feelings of tradition and freedom, but it tends to do so in a way that diverts these potentially disruptive energies into the separate and regulated spaces of stately display. In this way, what much utopianism has alluded to or postulated as the challenge of history – something that needs to be brought about – ends up behind us already accomplished and ready for exhibition as 'the past'. Where there was active historicity there is now decoration and display; in the place of memory, amnesia swaggers out in historical fancy dress.

The 'timeless' authenticity of historical remains

Restaged and reappropriated as the past, history is often also appreciated for its 'timelessness'.[35] This paradoxical sense of timelessness existing where one could be forgiven for expecting to find a stress on historicity and change is in part a measure of endurance – the object or traditional practice which has 'come through' the trials of centuries. However, it can also reflect the immobility which descends on the present when history is eternalized and worn self-consciously as finery over the merely ageing body of society. [. . .]

'Timeless' history is often also petrified history in another sense, for what survives is usually what was made and intended to survive: the edifices and cultural symbols of the powerful, structures of stone rather than wood, the official rather than the makeshift and vernacular. However, if the survival of historical objects can mark the power of those who have been in the position to determine both history and the evidences which remain, it would certainly be wrong to reject the apparent 'authenticity' of surviving objects as emblematic of domination alone. [. . .] It should be recognized that the meaning of historical and cultural authenticity differs widely from one situation to the next. The ruins of Ancient Rome meant one thing in Mussolini's Italy but the famous ruins of Zimbabwe meant something rather different to anti-colonialists in British Rhodesia. Similarly, in some of the European countries under Soviet domination the relics even of a fairly recent old world (say, for example, the democratic First Republic of Czechoslovakia) have an aura and significance which is not generalizable – least of all in terms of museums and their conduct of exhibition.

Against Horne's suggestion that 'the very didacticism of the Communist museums makes them superior, in principle, because they do not assume that the objects tell their own story',[36] it should be insisted that there are societies in which no public evidence can exist, and in which no story of the past can be told, except in the interpretation of the state and its colluding hacks. In situations of this sort memory is bound to find mute but still evocative presences to sustain itself and 'authenticity' (whether or not it be in a museum) will communicate more than even the most rigorous exposition of 'social process'. Similarly, Horne claims that many museums have such reverence for the authenticity of objects that it is as if 'historians stopped writing history' and merely displayed their archives: 'What can

Figure 6.5 Drawing by Andrzej Krauze

these museums do that books cannot do better?' And yet people flock to see the reviled object-in-itself (far more than buy history books) and it would take massive arrogance to argue that people only do this because as tourists they are under the false spell of the past as fetishized bits and pieces. Cultural tradition does not (except in the very crudest of reductions) exist only to be explained and administered as ideology. Similarly, and for all the manipulation, the sense of the 'unique' in modernity cannot be written off as merely elitist. At the vernacular level, the 'unique gains in importance and meaning with the rationalization and disenchantment of everyday life; and despite the many problems implicit in the institutional restaging of history there is at least the possibility that real cultural creation – albeit of a kind connected to mourning – can occur in the public appropriation of historical remains. Rather than sneering at the much abused figure of the tourist (who, unlike the full-time sociologist of museums, can always go round the corner for a drink or muse, as Mark Twain did at St Paul's, on the railings rather than on the sacred edifice itself), we should instead be considering whether all those millions can really be so entirely mistaken in their enthusiasms.[37] [. . .]

Agnes Heller has written that 'in the world of conventions uniqueness is an obstacle. There one must conform.'[38] Against the rather too familiar conventions of Horne's analysis, let us remember those 'timeless' ruins of Zimbabwe as they burst through layer after layer of European and colonial false 'exposition': how, after all, could the primitive 'Kaffirs' of Mashonaland ever have built temples of this magnificence – temples, as the 'exposition' put it so clearly, which must obviously have had a whiter, more northern origin?[39] Let us also remember the enraged crowd which broke into the Cathedral Close at Lincoln in 1726, determined to prevent the reconstruction work which – as popular fear

had it – would leave the cathedral without spires.[40] A pre-touristic approach to 'authenticity', perhaps, but this story from an old world should still help to persuade us that however problematic the restaging of history may be, 'authenticity' is not to be dismissed as a universally constant confidence trick. In this case a little bit of real history may be just what we need to bring into the picture.

The vagueness of Deep England

Where the trustees of the National Heritage Memorial Fund deflected the difficulty of defining the national heritage into the pragmatics of their fund's administration, pundits and enthusiasts have long tended to plunge into a language of vague and evocative gesture. The resulting sub-lyricism is well represented by the following passage from Patrick Cormack's *Heritage in Danger*.[41]

> When I am asked to define our heritage I do not think in dictionary terms, but instead reflect on certain sights and sounds. I think of a morning mist on the Tweed at Dryburgh where the magic of Turner and the romance of Scott both come fleetingly to life; of a celebration of the Eucharist in a quiet Norfolk Church with the mediaeval glass filtering the colours, and the early noise of the harvesting coming through the open door; or of standing at any time before the Wilton Diptych. Each scene recalls aspects of an indivisible heritage, and is part of the fabric and expression of our civilisation.

In resting his case on what is self-evident to the cultivated senses of the Imaginary Briton, Cormack also writes in a well established and broadly Conservative tradition. The UR-text (and Cormack writes like a man who knows it well) seems to come from Stanley Baldwin who evoked England in this way during the 1920s – and not just when he reminisced on Bewdley, his 'native town' in Shropshire. Baldwin didn't think any more of dictionary definitions than Cormack does: for him too 'England' was to be evoked or recalled 'through my various senses – through the ear, through the eye and through certain imperishable scents'. Thus in a much cherished passage the floodgates burst open and a deeply held ancestral world pours in:[42]

> The sounds of England, the tinkle of the hammer on the anvil in the country smithy, the corncrake on a dewy morning, the sound of the scythe against the whetstone, and the sight of a plough team coming over the brow of a hill, the sight that has been seen in England since England was a land, and may be seen in England long after the Empire has perished and every works in England has ceased to function, for centuries the one eternal sight of England. The wild anemones in the woods in April, the last load at night of hay being drawn down a lane as the twilight comes on, when you can scarcely distinguish the figures of the horses as they take it home to the farm and above all, most

subtle, most penetrating and most moving, the smell of wood smoke coming up in an autumn evening, or the smell of the scutch fires: that wood smoke that our ancestors, tens of thousands of years ago, must have caught on the air when they were coming home with the result of the day's forage when they were still nomads, and when they were still roaming the forests and the plains of the continent of Europe. These things strike down into the very depths of our nature, and touch chords that go back to the beginning of time and the human race, but they are chords that with every year of our life sound a deeper note in our innermost being.

These are the things that make England, and I grieve for it that they are not the childish inheritance of the majority of the people to-day in our country.

Other interwar examples could easily be quoted from writers like G. K. Chesterton, or even Ramsay MacDonald for that matter, but illustration enough is to be found in the following passage from H. A. L. Fisher's essay on 'The beauty of England':[43]

> The unique and incommunicable beauty of the English landscape consti-
> tutes for most Englishmen the strongest of all the ties which bind them
> to their country. However far they travel, they carry the English land-
> scape in their hearts. As the scroll of memory unwinds itself, scene
> after scene returns with its complex association of sight and hearing,
> the emerald green of an English May, the carpet of primroses in the
> clearing, the pellucid trout-stream, the fat kine browsing in the park,
> the cricket matches on the village green, the church spire pointing
> upwards to the pale-blue sky, the fragrant smell of wood fires, the
> butterflies on chalk hills, the lark rising from the plough into the March
> wind, or the morning salutation of blackbird or thrush from garden
> laurels. These and many other notes blend in a harmony the elements
> of which we do not attempt to disentangle, for each part communi-
> cates its sweetness to the other.

[. . .] All three passages celebrate their 'indivisible heritage' as a kind of sacra-
ment encountered only in fleeting if well-remembered experiences which go
without saying to exactly the extent that they are taken for granted by initiates,
by true members of the ancestral nation.

There is certainly some similarity between this England and the incommuni-
cable France which Sartre traced out in his investigation of wartime anti-Semitism.
Here is another deep nation founded on an imagined participation immemorial
rather than any mere legality and demonization or exclusion can indeed be as
intrinsic to Deep England as it was to Sartre's France. If discussion of the anti-
Semitic potentials of interwar 'England' must wait until the next essay, it is certainly
worth indicating how clarifying a sense of threat is to the definition of the deep
nation. As Peter Scott, later of Slimbridge and the Wildfowl Trust, put it in a
radio broadcast on Easter Day 1943:[44]

Friday was St George's Day. St George for England. I suppose the 'England' means something slightly different to each of us. You may, for example, think of the white cliffs of Dover, or you may think of a game of bowls on Plymouth Hoe, or perhaps a game of cricket at Old Trafford or a game of rugger at Twickenham. But probably for most of us it brings a picture of a certain kind of countryside, the English countryside. If you spend much time at sea, that particular combination of fields and hedges and woods that is so essentially England seems to have a new meaning.

I remember feeling most especially strongly about it in the late Summer of 1940 when I was serving in a destroyer doing anti-invasion patrol in the Channel. About that time I think everyone had a rather special feeling about the word 'England'. I remember as dawn broke looking at the black outlines of Star Point to the northward and thinking suddenly of England in quite a new way – a threatened England that was in some way more real and more friendly because she was in trouble. I thought of the Devon countryside lying beyond that black outline of the cliffs; the wild moors and rugged tors inland and nearer the sea, the narrow winding valleys with their steep green sides; and I thought of the mallards and teal which were rearing their ducklings in the reed beds of Slapton Leigh. That was the countryside we were so passionately determined to protect from the invader.

Patriotism is obviously quickened in wartime and the results can be peculiar indeed – did Peter Scott really go to war for a duck? – as the nation is reinvented around the imperatives of the present situation. Where people like Arthur Bryant have long been deliberately renovating the history of Britain, there are also accounts of the nation's prehistory and geography which are actually contemporary projections of an endangered Deep England.

[. . .]

There was an unquestionably good cause to the Second World War (though this is far more than can be said for the redeclared version through which we are living now), and these fragile patriotic utopias should be respected to the extent that they are connected to a popular defence of democracy, perhaps even along with the claim that 'In an age of destruction there is a reawakened interest in the things that "endure"'.[45] Certainly I am not quoting these passages simply to accuse their authors of implicit anti-Semitism, or of cynically creating a mythical England out of nothing. Aside from the democratic cause of the Second World War, there is also a practical core to the patriotic fantasy – one which is real enough even though it lies at the level of everyday life rather than historiography. This can best be defined by asking what one must be to become a communicant of the essentially incommunicable deep nation. To be a subject of Deep England is above all to have *been there* – one must have had the essential experience, and one must have had it in the past to the extent that the meaningful ceremonies of Deep England are above all ceremonies of remembrance and recollection. More specifically one must have grown up in the midst of ancestral continuities and have

experienced that kindling of consciousness which the national landscape and cultural tradition prepare for the dawning national spirit. The stress on the incommunicable nature of such indivisible moments is fitting since these eulogies to England seem to celebrate both childhood amnesia (or rather the fact that conscious memory only becomes possible once a certain cultural and intersubjective formation has taken place) and also what Heller describes as the mutual *inherence* – the indivisibility – of the different constituents of everyday life. If one must have had the right experiences, therefore, the truly national subject will also have had them at the right time – at the threshold of conscious memory and self-understanding. In Sartre's language, it is not enough to have been to the wood a few times: 'one must have made notches in the trees in childhood' and one must then be in a position to go back and find them 'enlarged in ripe old age'.

The movement into racism is certainly real enough, and the normative tone – the 'ought' – has already crept into my account. However, it is vital to distinguish particularity itself from the brutal visions in which a certain particularity is elevated to the status of absolute principle. Thus while an imperialist image of British particularity has been foisted on millions of subject-peoples in the massive schoolhouse of Empire, and while the same symbolism of the British nation continues to inform the British experience of particularity, it should be recognized that particularistic experience is not *in itself* identical with imperialist experience – even though the latter, which is always normative and asserts its ruling image over others, depends so fundamentally on its imagination of the former.[46] However, if the passages quoted are not all necessarily to be treated as entirely cynical attempts to raise everyday particularity to the level of Absolute Spirit (this was, perhaps, the special gift of Baldwin and, later, Churchill), they certainly work within a select and privileged repertoire of (predominantly green) images. Deep England can indeed be deeply moving to those whose particular experience is most directly in line with its privileged imagination. [. . .]

While the particular images and ideas privileged by Deep England are of relatively narrow social provenance, there is also a celebration of particularism *in itself* in these passages, and here an extension into different social worlds becomes possible. All everyday life is situated and includes the sense of belonging to a particular culture, place and group; just as all personal consciousness accumulates within a cultural matrix which itself goes on to become the ground (both 'ours' and 'mine') of inevitably moving memory – the 'unwinding scroll' of Fisher's description. These aspects of all everyday life can find expression in a Deep England which is none the less loaded for its formal generality. The approved and dominant images of Deep England are pastoral and green, but there is also something 'green' about everyday life, whatever the situation in which it is lived. Deep England makes its appeal at the level of everyday life. In doing so it has the possibility of securing the self-understanding of the upper middle class while at the same time speaking more inclusively in connection with all everyday life, where it finds a more general resonance. The vagueness of so many of the eulogies of our 'incommunicable' and 'indivisible' national heritage is partly testimony to the inherence of everyday life and to the interrelated nature of its constitutive experiences; but vagueness is part of this other connection as well: part of what makes it possible for images to remain true to their privileged constituency at the

same time as they grant a stirring and practically based image of threatened belonging to the urban working class and even to other peripheral subjects who might choose to take it up.

Notes

Parts of this chapter first appeared in a paper by Michael Bommes and myself called '"Charms of Residence"; the public and the past', in R. Johnston *et al.* (eds), *Making Histories* (London: 1982).

1 I quote Céline from Wayne Burn's essay '*Journey to the End of the Night:* a Primer to the Novel', See James Flynn (ed.), *Understanding Céline*, (Seattle: 1984), p. 36.

2 SAVE Britain's Heritage published their leaflet 'Save Mentmore for the Nation' in February 1977. These passages are quoted from Marcus Binney's 'Introduction'. The Mentmore story is here reconstructed from its coverage in *The Times*.

3 On Calke Abbey see Marcus Binney, *Our Vanishing Heritage* (London: 1984), pp. 74–83. Here again, my account is also informed by contemporary newspaper coverage. See especially the colour supplement of the *Observer*, 25 March 1984.

4 *Hansard* (Commons), Vol. 975, No. 79, Col. 55.

5 Quoted in N. Hodgkinson, 'Alice-in-Wonderland world of the National Land Fund', *The Times*, 22 April 1977.

6 Michael Hunter, 'The preconditions of preservation: a historical perspective', in D. Lowenthal and M. Binney (eds), *Our Past Before Us: Why Do We Save It?* (London: 1981), pp. 22–32. For the more pastoral argument see John Marsh, *Back to the Land: The Pastoral Impulse in Victorian England from 1880 to 1914* (London: 1982) and also Martin J. Wiener, *English Culture and the Decline of the Industrial Spirit 1850–1980* (Cambridge: 1981).

7 See Patrick Cormack, *Heritage in Danger* (London: 1978). The general information used in this account of preservationism is largely drawn from Cormack's book. David Elliston Allen's *The Naturalist in Britain: a Social History* (Harmondsworth: 1978), Robin Fedden's official history of the National Trust, *The Coining Purpose* (London: 1968) and John Lowerson's 'Battles for the Countryside' in F. Gloversmith (ed.), *Class Culture and Social Change: a New View of the 1930's* (Brighton: 1980), pp. 258–80.

8 Quoted in Cormack, *Heritage in Danger*, p. 17.

9 Cormack, *Heritage in Danger*, p. 20.

10 Arthur Bryant, *The Spirit of Conservatism* (London: 1929), pp. 74–5.

11 Marsh, *Back to the Land*, pp. 52–3.

12 On the popular land-usage of the interwar years and the conflict between preservartionism and the makeshift plotland buildings (shacks, railway carriages, etc.) which were erected on marginal land, see Dennis Hardy and Colin Ward, *Arcadia for All: the Legacy of a Makeshift Landscape* (London: 1984).

13 For a 'socialist' argument that the people are not yet properly 'ready' for their inheritance see C. E. M. Joad, 'The people's claim', in Clough Williams-Ellis (ed.), *Britain and the Beast* (London: 1938), pp. 64–85.

14 I quote this passage from Karl Krauss, 'The world of posters', in H. Zohn (ed.), *In These Great Times: a Karl Kraus Reader* (Manchester: 1984), p. 45.

15 Walter Benjamin, 'The work of art in the age of mechanical reproduction', in his *Illuminations* (London: 1973), p. 235.

16 While Ogilvy and Mather, the advertising agency currently holding the Shell
 contract in Britain, was awarded the Creative Circle Silver award for these
 advertisements in 1985, there were contemporary conservationists who had a
 different view of the Mosmorran plant. Scottish Friends of the Earth insisted
 that 'You can't say a project is environmentally acceptable just by taking a
 picture of the nearest convenient hill' and pointed out that the gas liquids
 plant at Mosmorran exists as a massive eyesore – visible from Edinburgh and
 shooting flames 200 feet high from its chimneys. The Advertising Standards
 Authority was apparently unimpressed by the complaint (reported in *New
 Statesman*, 22 March 1985). As Ogilvy and Mather know so well, it's all a matter
 of perspective.

17 Some important remarks on the homogenization of space and 'The organisation
 of territory' are to be found in Guy Debord, *Society of the Spectacle* (Detroit:
 1970).

18 The figures for 1974 are quoted by Marcus Binney in *Save Mentmore for the Nation*;
 those for 1983 come from the English Tourist Board's *Sightseeing in 1983*
 (London: 1984).

19 The significance of the car was disputed in the interwar years. For G. K.
 Chesterton the car was an emblem of 'the mechanical forces which are laying
 waste to this country'. The fact that the modern car 'completely shuts in the
 motorist' is proof that these enclosed vehicles are really the tanks of an invading
 army:

> So the new and narrow type of trader or traveller spreads ruin
> and destruction along his essentially solitary journey, precisely
> because it is essentially solitary; and the more introspectively he
> looks inward at his speedometer or his road book, the more certainly
> and sweepingly does he in practice wither the woods on the remote
> horizon or shake the very shrines in the heart of every human
> town.
> The roads designed by this spirit are not roads to places; but
> through places. It does not entertain the old idea of reaching the
> gates of a town, but rather of shooting a town full of holes by which
> it can reach out beyond.

(From Chesterton;s 'Introduction' to Council for the Preservation of Rural
England, *The Penn Country of Buckinghamshire* [London: 1933], pp. 7–8.)
 J. B. Priestley took up the preservationist cause with comparable ardour in
the 1930s, but he tried desperately hard to see the positive side of this new
experience of 'speed':

> I shall be told that the newer generations care nothing for the beauty
> of the countryside, that all they want is to go rushing about on motor-
> cycles or in fast cars. Speed is not one of my gods; rather one of my
> devils; but we must give this devil his due. I believe that swift motion
> across a countryside does not necessarily take away all appreciation of
> its charm. It depends on the nature of the country. With some types
> of landscape there is a definite gain simply because we are moving so
> swiftly across the face of the country. There is a certain kind of

> pleasant but dullish, rolling country, not very attractive to the walker
> or slow traveller, that becomes alive if you go quickly across it, for it
> is turned into a kind of sculptured landscape. As your car rushes along
> the rolling road, it is as if you were passing a hand over a relief map.
> Here, obviously there has been a gain, not a loss, and this is worth
> remembering. The newer generations, with their passion for speed,
> are probably far more sensitive than they are thought to be. Probably
> they are all enjoying aesthetic experiences that so far they have been
> unable to communicate to the rest of us.

(Quoted from Priestley's 'Introduction' to Batsford's *The Beauty of Britain: a Pictorial Survey* [London: 1935, pp. 2–3.)

20 Harry Batsford, *How to See the Country* (London: 1940) and Edmund Vale, *How to Look at Old Buildings* (London: 1940).

21 Batsford, *How to See the Country*, p. 3.

22 Wyndham Lewis, *Rotting Hill* (London: 1951).

23 The phrase recurs as a motif in Flann O'Brien, *The Poor Mouth* (London: 1975).

24 See Department of the Environment, *What is Our Heritage? United Kingdom Achievements for European Architectural Heritage Year 1975* (London: 1975).

25 I take the phrase 'age of dead statues' from Ariel Dorfmann and Armand Mattelart, *How to Read Donald Duck: Imperialist Ideology in the Disney Comic* (New York: 1975).

26 Quoted on the front page of Cormack, *Heritage in Danger*.

27 On technostyle see John Brinckerhoff Jackson, *Discovering the Vernacular Landscape* (London: 1984), pp. 113–24.

28 Roy Strong, 'Home is where the art is', *The Times*, 10 November 1984.

29 Cormack, *Heritage in Danger*, pp. 51–2.

30 Reported in the *Guardian*, 13 March 1980.

31 Jean-Paul Sartre, *Anti-Semite and Jew* (New York: 1948), Sartre writes as follows:

> In a bourgeois society it is the constant movement of people, the
> collective currents, the styles, the customs, all these things, that in
> effect create values. The value of poems, of furniture, of houses, of
> landscapes derives in large part from the spontaneous condensations
> that fall on these objects like a light dew; they are strictly national
> and result from the normal functioning of a traditionalist and histor-
> ical society. To be a Frenchman is not merely to have been born in
> France, to vote and pay taxes; it is above all to have the use and
> sense of these values. And when a man shares in their creation, he
> is in some degree reassured about himself; he has a justification for
> existence through a sort of adhesion to the whole of society. To
> know how to appreciate a piece of Louis Seize furniture, the deli-
> cacy of a saying by Chamfort, a landscape of the Ile de France, a
> painting by Claude Lorraine, is to affirm and to feel that one belongs
> to French society; it is to renew a tacit social contract with all
> members of that society. At one stroke the vague contingency of
> our existence varnishes and gives way to the necessity of an existence
> by right. Every Frenchman who is moved by reading Villon or by

looking at the Palace of Versailles becomes a public functionary and the subject of unprescriptible rights.

Now a Jew is a man who is refused access to these values on principle. . . . He can indeed acquire all the goods he wants, lands and castles if he has the wherewithal; but at the very moment when he becomes a legal proprietor the property undergoes a subtle change in meaning and value.

Only a Frenchman, the son of a Frenchman, son or grandson of a peasant, is capable of possessing it really. To own a hut in a village, it is not enough to have bought it with hard cash. One must know all the neighbours, their parents and grandparents, the surrounding farms, the beeches and oaks of the forest; one must know how to work, fish, hunt; one must have made notches in the trees in childhood and have found them enlarged in ripe old age. You may be sure that the Jew does not fulfil these conditions. For that matter, perhaps the Frenchman doesn't either, but he is granted a certain indulgence. There is a French way and a Jewish way of confusing oats and wheat (pp. 80–3).

32 *Birmingham Evening Mail*, 6 May 1980.
33 Edited by Roy Faiers, *This England* is published from Cheltenham, Gloucester, for 'all who love our green and pleasant land'. *Heritage: the British Review* is edited for a comparable readership by Peter Shephard and published from London. Both publications testify amply to the cultural psychosis of modern English/British nationalism.
34 Franco Moretti, *Signs Taken for Wonders* (London: 1983), p. 190.
35 Raymond Williams points to the peculiarity of this sense of the 'timeless' which is ensconced where a sense of history should be, in *The English Novel from Dickens to Lawrence* (Harmondsworth: 1974), p. 89.
36 Donald Horne, *The Great Museum: the re-presentation of history* (London: 1984), p. 249.
37 See the passage on 'Old Saint Pauls' which is excerpted from Twain's English Notebook in B. DeVoto's edition of Mark Twain, *Letters from the Earth* (Greenwich, CT: 1962), pp. 140–3.
38 Quoted from Heller's essay 'George Lukács and Irma Seidler', in Agnes Heller (ed.), *Lukács Revalued* (Oxford: 1983), p. 44.
39 On Zimbabwe see E. R. Chamberlain, *Preserving the Past* (London: 1979), pp. 27–35.
40 See John Stevenson, *Popular Disturbances in England 1700–1870* (London: 1979), p. 47.
41 Cormack, *Heritage in Danger*, p. 14.
42 Stanley Baldwin, *On England* (London: 1926), p. 7. See also Bill Schwarz, 'The language of constitutionalism; Baldwinite Conservatism', in *Formation of Nation and People* (London: 1984).
43 H. A. L. Fisher, 'The beauty of England', in Council for the Preservation of Rural England, *The Penn Country of Buckinghamshire*, p. 15.
44 Peter Scott as quoted in the Foreword to Richard Harman (ed.) *Countryside Mood* (London: 1943), p. 5.
45 Harman, *Countryside Mood*, p. 5.

46 Two important essays on the elaboration of tradition within imperialism are
 Bernard S. Cohen, 'Representing authority in Victorian India' and Terence
 Ranger, 'The invention of tradition in colonial Africa', both in Eric Hobsbawm
 and Terence Ranger (eds), *The Invention of Tradition* (Cambridge: 1983), pp.
 165–264.

Robert Hewison

THE CLIMATE OF DECLINE

G EORGE ORWELL IS PART of the heritage now, his reputation safely pinned by a plaque to the wall of a house in Islington. His grimmest prophecies have been duly celebrated for not coming to pass in 1984; his politics have been consigned to 'before the war'. The year 1937 is half a century away, and if we think of the period at all we are more likely to conjure up an ambience than historical events: the Thirties of Agatha Christie series on television, or the advertisements for the Orient Express. Indeed, we can re-enter the world of Hercule Poirot by taking the train, though it only goes as far as Venice, that classic symbol of sinking European civilization.

The phrase 'before the war' needs no explanation as to which war is meant. For Britain the period 1939–45 caused a break with the past more thorough than 1914–18. Our imperial economic position was so weakened that the conversion from Empire to Commonwealth began with independence for India in 1947; domestically the war forced social and political changes that led to the creation of the Welfare State. 'After the war', the 1945 election seemed to be saying nothing was going to be the same.

Change is felt in many ways, but it is visibly expressed in the built environment, where gradual alteration to the physical patterns of everyday life registers the consequences of social change. The war meant that nearly all our cities experienced violent change: one third of the City of London was destroyed by bombing, and ports and manufacturing towns alike were damaged. Less obvious targets like Bath, Exeter and Canterbury were attacked as cultural symbols. The buildings that survived had received the minimum maintenance for six years.

The post-war period began with an emphasis – within the limits of necessary austerity measures – on reconstruction, and since some 700,000 homes had been destroyed during the war, on the building of new houses. The Conservative government which took over from Labour in 1951 outdid its predecessor in figures for

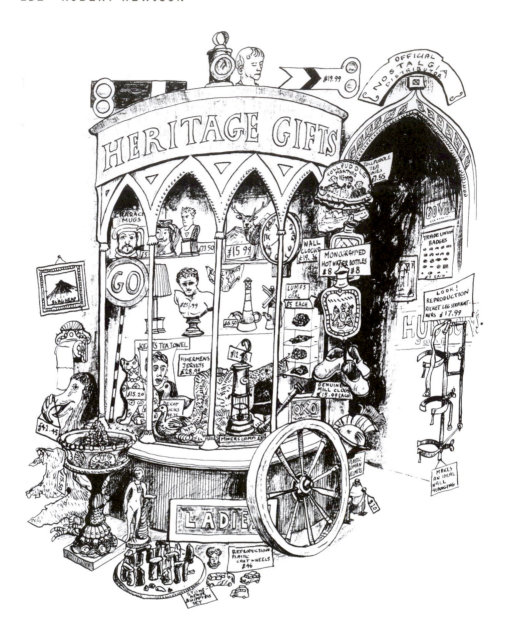

Figure 7.1 Drawing by Chris Orr

new housing: 300,000 a year in the early 1950s. Both political parties wanted not just new houses, but whole new towns. Twelve were designated by 1950, and a further ten between 1961 and 1970. In addition, planning policies continued to encourage the movement of people away from centres of big cities, over prophylactic green belts into some fifty expanded and overspill towns. By 1982 2 million people were living in urban communities that had not existed in 1945.

The result of these policies was not quite the brave new world that the drafters of the Town and Country Planning Act 1947 had intended. In 1955 the *Architectural*

Review published Ian Nairn's polemical 'Outrage', a pictorial survey of environ-mental attrition framed by a photograph of 'rural England . . . a reminder of what we are squandering with all the means at our disposal, confident that there will always be some left over'. 'Outrage' added a new word to the language: Subtopia.

> Within towns the agents of Subtopia are demolition and decay, build-ings replaced by bijou gardens, car-parks and underscale structures, reduction of density where it should be increased, reduction of vitality by false genteelism, of which Municipal Rustic is the prime agent, the transporter of Subtopian blight to town and country alike, as is the badly detailed arterial road.[1]

Although the feelings expressed in 'Outrage' had a practical outcome in the foun-dation of the Civic Trust in 1957, *Landscape in Distress*, a survey of 250 square miles of Oxfordshire carried out in 1965, demonstrated how mile by mile each small mistake – wirescape, infill, power line, road-widening and unsympathetic private and public development – continued to erode the environment.[2]

'Outrage' protested that while the planning offensive was started in a mood of idealism, the policy of dispersal was spreading Subtopia, not checking it. But already a new factor was at work that was about to bring an even more devas-tating change. In 1954 the requirement for building license, which had restricted most commercial building to the reconstruction of war-damaged offices and facto-ries, was abandoned. In London the Victorian regulation that limited the height of new buildings to 80 feet was lifted. The age of the high-rise had begun. In the next ten years an unprecedented building boom completely altered the scale and skylines of Britain's major cities. In London New Zealand House, the Shell Building, Millbank Tower, the Hilton Hotel, Campden Tower Notting Hill Gate, St Paul's Precinct, the London Wall development and the Royal Garden Hotel were all in place by 1964, when the new Labour government banned further office building. In 1963 the first property developer had been knighted.

The new architecture altered the symbolically 'national' environment of the capital (and since Labour's ban did not affect projects already started, construc-tion continued until the Conservatives lifted it again in 1970), but every major local authority in the country saw the advantage to itself in profitable partnership with property developers. Their traffic planners wanted to accommodate the ever-increasing number of motor cars, their treasurers wanted to increase the rateable value of the properties they taxed. Through their powers to deflate comprehen-sive redevelopment areas they were able to carry out wholesale demolition that wiped out old street patterns and neighbourhoods at the rate of 80,000 houses a year. Much of this was called 'slum clearance' (no compliment to the people who lived there) but many sound houses went as well.

As new towns and 'overspill' were expensive and for a time less fashionable, the logic of the commercial skyscraper was applied to homes. By 1965 there were some 27,000 flats in new buildings over ten storeys high, 6,500 in blocks of twenty storeys or more. From the alienated heights of these structures people looked down on the empty wastes where their former homes had been, and turned back to watch *Coronation Street* on the television. The architect James Stirling said recently, 'The

housing architecture of the 1960s was simply a matter of building more and more houses for less and less money until you ended up with a sort of trash.'³ The new systems-building for the blocks of flats produced damp and decay, and, in the case of the collapse of part of Ronan Point in 1968, death. The memorial to the modernizing of public housing in the 1960s was written by an anonymous resident in an overspill estate in Kirkby on Merseyside, when he told the Archbishop of Canterbury's Commission on Urban Priority Areas: 'People here have to live in a mistake.'⁴

The redevelopment of London began a fresh phase with the return of a Conservative government in 1970. In 1975, in *The Rape of Britain*, Colin Amery and Dan Cruickshank examined the damage done to thirty British towns and concluded: 'The destruction during the nineteenth century pales into insignificance alongside the licensed vandalism of the years 1950–75.'⁵ In spite of legislation to protect buildings of historical significance and architectural merit, Department of the Environment statistics showed that listed buildings were being lost at the rate of one a day; 8,000 listed buildings were destroyed between 1957 and 1977. Road schemes deadened and blighted whole areas of towns and cities. The Ancient Monuments Society has estimated that a third of all applications to demolish listed buildings came from local authorities, with some of the largest applications in connection with road proposals.

Whatever the gains there were in new houses, new schools and amenities, the clearances, demolitions and dispersal also produced loss, a loss of a sense of location and identity, as the sociologists began to notice. Marc Fried wrote of the former inhabitants of an American urban renewal scheme in Boston:

> For the majority it seems quite precise to speak of their reactions as expressions of *grief*, These are manifest in the feelings of painful loss, the continued longing, the general depressive tone, frequent symptoms of psychological or social or somatic distress, the active work required in adapting to the altered situation, the sense of helplessness, the occasional expressions of both direct and displaced anger, and the tendencies to idealise the lost place.⁶

While the urban environment of Britain became increasingly degraded and unfamiliar, the countryside suffered steady pressure from modernization. Motorways, airports, power stations and overhead transmission lines, mineral workings, reservoirs, gas holders and natural gas terminals, besides new towns and housing estates, changed the landscape. The first few miles of motorway opened in 1958; by 1974 motorways had consumed 25,000 acres of agricultural land.

The modernization of the railway system meant that following the Beeching Report of 1963 the number of passenger stations in use fell from 7,626 in 1949 to 2,364 in 1979, freight stations from 1,688 to 473.⁷ The whole architectural environment of the rail network – signal boxes, water towers, sheds and wayside halts – was radically altered, leaving over 3,000 miles of abandoned railway line. Romantic steam gave way to mundane diesel. In 1982 there were more than 20,000 acres of derelict railway land.

In both town and country, modernization seemed to produce dereliction. In 1974, 175,000 acres of land in England, Scotland and Wales were officially

recognized as derelict to which must be added other waste and 'operational' land, producing a figure of nearly 500,000 ruined, abandoned or blighted acres. Yet, even greater changes were taking place in the land reserved for agriculture. 'Britain's world-famous town and country planning system is widely considered the most sophisticated and effective mechanism in the world for curbing the inherent tendency of powerful private interests to override public interest in land', wrote Marion Shoard in *The Theft of the Countryside*. 'So what', she asks, 'has it been doing to safeguard our landscape heritage from the systematic onslaught launched by modern agriculture on the English landscape?'[8]

Her answer is 'Almost nothing'. Farming and commercial forestry are 'effectively above the law as it applies to other activities which affect the environment'.[9] Between 1947 and 1980 half the woods that had existed in England before 1600 were felled. In the 1970s Dutch Elm Disease killed 11 million trees, while farmers bulldozed small woods and cleared away single trees. In 1979 the Nature Conservancy Council warned that broadleaf woods might not survive at all outside nature reserves. New planting largely consisted of regimented belts of conifers. In an effort to maximize the efficiency of new farm machinery (which was also contributing to the decline of the rural population) fields were enlarged and familiar patterns destroyed. Between 1946 and 1975 a quarter of the hedgerows in England and Wales – 120,000 miles – were grubbed up. Roughlands were ploughed, wetlands drained, so that only just over a quarter of the lowland heaths of the nineteenth century survive. Downs, moors and clifftops disappeared beneath uniform ryegrass or plantations of fir.

The man-made features of the ancient landscape, barrows, hill forts and archaeological sites, were eroded or destroyed altogether by deep ploughing. Mechanization made old farm buildings obsolete, the amalgamation of farms into larger units caused whole groups to be abandoned. The process of change was accelerated by the Farm Capital Grants scheme operated by the Ministry of Agriculture from 1973. While the old buildings decayed, new factory-like structures rose beside them. In a survey carried out in 1977 an American architect found that out of sixty-six references to tithe barns, seven had been destroyed, eight could not be found, and of the forty-two survivors, a third were in a very bad state of repair.[10] Pre-war rural patterns crumbled in the face of the ecological asset-stripping of the agribusiness, surviving only in remote regions, or television's *All Creatures Great and Small*.

The effect of modernization was not just that everything had changed, but that everything had become more and more the same, as architectural and scenic differences were ironed out under the weight of mediocrity and uniformity. In *The Coming of Post-Industrial Society* Daniel Bell argues that technology may have brought more substantial change to individual lives in the late nineteenth and early twentieth centuries, in the shape of railways, electricity, motor cars and aviation, but the post-war development of television and computers has imposed a tighter and more uniform social network. As Marshall McLuhan has also argued, the revolutions in transport and communication have created more interdependence and therefore less isolation. 'But along with a greater degree of interdependence has come a change of scale – the spread of cities, the growth of organizational size,

Figure 7.2 Modern outrage in the countryside: photograph by Allan Titmuss

the widening of the political arena – which has made individuals feel more help-less within larger entities, and which has broadened the span of control over the activities of any organization from a centre.'[11]

In Britain until the late 1960s material change was generally regarded as the price of progress that brought full employment after the depression of the 1930s. Rising affluence compensated for loss of international status. The decade was a period of intense social as well as economic change, as new views were taken of the responsibilities of the individual and the role of the family: the Suicide Act 1961, the abolition of the death penalty in 1965, the legalization of abortion in 1967, the Sexual Offences Act in that same year, and the Divorce Act in 1969. Censorship was relaxed by the Obscene Publications Act of 1959 and the Theatres Act of 1968. By 1969 the contraceptive pill was widely available on the National Health, with lasting consequences for attitudes to sexual morality. Since 1969 the weakening hold of traditional beliefs and the shifts of population have been reflected by the redundancy of 1,053 churches.

The social revolution of the 1960s was perceived as the emergence of a new, permissive society. Its limits were defined in the 1970s, when a political reaction set in, but in spite of his sociological scepticism, Christie Davies concluded in his study that since the start of the 1960s 'people are more likely to indulge in normal and perverse sexual activities, to take drugs of varying degrees of addictiveness and to attack their fellow citizens either in order to rob them or just for the sheer pleasure of it'. But he also concluded that the loosening of traditional restraints in the 1960s seemed to have come about for no good reason. 'We have gained in tolerance, in compassion and in freedom, but not because of our belief in these

values. We are tolerant not as a matter of principle but as an expression of moral indifference.'[12]

Christie Davies's pessimism reflects the increasing disillusion of the 1970s. Whereas the economic, social and environmental change of the first post-war period took place in an atmosphere of renewal and modernization, subsequent change has taken place in a climate of decline.

The watershed between these two kinds of change, which have served to disconnect the immediate present from the perceived past, was the devaluation of the currency in 1967, at the beginning of a period of rapidly rising inflation and increasing unemployment. Emblematically, the coinage, whose traditional forms went back to the Roman introduction of £.s.d., was decimalized in 1970, a process which both disconnected the means of exchange from the past, and, it seems, further devalued 'the pound in your pocket' by stimulating inflation. The oil crisis of 1973 was a major economic blow, and demoralization was completed by Britain's submission to the dictates of the International Monetary Fund in order to avoid economic collapse in 1976. In 1987 the historian Alan Sked wrote: 'Since 1967 the British seem to have lived in an era of perpetual economic crisis, fearing that growth will never permanently return and that absolute decline may be just around the corner. That period is still continuing.'[13]

Perception of economic and social decline is relative: living standards have continued to rise, but that perception is important. Since 1960, when the United Kingdom was still the most prosperous country in Europe, our relative position has steadily fallen. In terms of *per capita* income, by 1970 we were the tenth richest nation in the Organization for Economic Co-operation and Development; by 1983 we were the thirteenth, above only Italy, Ireland, Greece and Portugal. The price of ending the profoundly unsettling rise in inflation, which in 1975 reached 24 per cent, has been recession and unemployment. In mid-1987 unemployment was officially 3 million, but effectively nearer 4. Instead of modernization, the country has undergone rationalization, redundancies, and de-industrialization.

Recession has encouraged the feeling that not only has the post-war period been one of decline, but even its innovations have been a failure. There is a belief that the Welfare State has failed in education, health and the elimination of poverty. Some 10 per cent of the population lives below the poverty line, a number being steadily added to by the long-term unemployed. The decline of industry has meant that dereliction has worsened. A 1986 study for the Department of the Environment warned that 'the vast legacy of waste land in Britain is increasing, despite greater efforts of restoration', and there is nothing to suggest that urban wasteland will not continue to increase.[14] Recession has meant that the rate of loss of agricultural land to urban use has fallen, but it continues at about 45,000 acres a year.

The failure in housing has been symbolized by the demolition of tower blocks built only twenty years ago. The estimated cost of repairing the 5 million local authority houses in England and Wales (out of some 22 million houses in the United Kingdom) is £20 billion. A million privately owned houses lack one or more basic amenity or are in need of repair. A million more are unfit for habitation. Examples of 'the boarded, tenantless flats, the fouled stairwells, the vandalised lifts, the endless graffiti' of Liverpool's 'putrescent housing', so graphically

described by the former Secretary of State for the Environment, Michael Heseltine, can be found throughout Britain's major cities.[15]

The many failures of public housing and town planning have produced a crisis of confidence within the architectural profession expressed in the bitterly contested election for the presidency of the Royal Institute of British Architects [RIBA] in 1986. The RIBA's 150th anniversary celebrations in 1984 were marred when, during a banquet at Hampton Court, the Prince of Wales attacked the plans for a proposed extension to the National Gallery as a 'monstrous carbuncle'. As a result the radically modernist design has been dropped in favour of sympathetic pastiche. Having delivered a serious blow to the reputation of modern architecture, the prince has since moved on to criticize Britain's most advanced microchip factory as a 'high-tech version of a Victorian prison'.[16]

Decline has been most bitterly experienced in the inner cities where much of the black population is clustered. Immigration, at its peak in the early 1960s, has resulted in a black and Asian population of some 2.5 million, a development that has altered the texture of urban life. Racial issues, such as an unemployment rate for blacks twice as high as for whites, have added to the social conflicts of the inner cities. The existence of an undeclared state of civil war in Northern Ireland has further damaged the United Kingdom's most depressed province, while bombing campaigns and consequently tighter security measures throughout Britain have added to the tension. Violent crime and theft are estimated to have quadrupled since the 1960s, and the police report steadily rising figures for all kinds of crime. Since the riots in Bristol in 1980 the crisis of social control has periodically led to pitched battles with the police, with race as a catalytic factor. The authorities have increased their powers of surveillance, the police are more

Figure 7.3 Inner city wreckage: photograph by Allan Titmuss

frequently armed, and the underlying menace of violence is ritually reinforced by outbreaks of football hooliganism. Throughout 1984 the miners' strike dramatized the extent of social and economic conflict.

In the face of apparent decline and disintegration, it is not surprising that the past seems a better place. Yet it is irrecoverable, for we are condemned to live perpetually in the present. What matters is not the past, but our relationship with it. As individuals, our security and identity depend largely upon the knowledge we have of our personal and family history; the language and customs which govern our social lives rely for their meaning on a continuity between past and present. Yet at times the pace of change, and its consequences, are so radical that not only is change perceived as decline, but there is the threat of total rupture with our past lives. 'We are saddened by the sight of an individual suffering amnesia', write Tamara Hareven and Randolph Langenbach in *Our Past Before Us*:

> But we are often less concerned or aware when an entire community is subjected to what amounts to social amnesia as a result of massive clearance or alteration of the physical setting. The demolition of dwellings and factory buildings wipes out a significant chapter of the history of the place. Even if it does not erase them from local memory it tends to reduce or eliminate the recall of that memory, rendering less meaningful the communication of that heritage to a new genera- tion. Such destruction deprives people of tangible manifestations of their identity.[17]

While a hold on the past is weakened, confidence in the value of the social iden- tity that comes from a secure past is also undermined: 'the condemnation and clearance of physical structures can be read as a condemnation of the way of life which had been lived there.'[18]

The effect of such clearances has been vividly described by Elspeth King, curator of the People's Palace Museum in Glasgow: 'We've had the biggest area of comprehensive redevelopment in Europe, and it was like taking a rubber to the map and just rubbing places out and rebuilding them. People socially and indeed politically were very upset, and are trying to hang on to a bit of their past, and rediscover and explore their past.'[19]

Even without the sort of environmental changes that have taken place since 1945 it would have been necessary to adapt to the process of social change. A secure sense of identity depends not only on a confident location in time and place, but also on an ability to cope with the inevitable alterations that time brings about. The sense of time passing often evokes feelings of nostalgia but, it appears, nostalgia is one of the means we use to adjust to change.

In *Yearning for Yesterday: A Sociology of Nostalgia*, Fred Davis points out that nostalgia (literally, homesickness, a seventeenth-century medical term coined to describe the melancholia of Swiss mercenaries fighting abroad) is not simply a long- ing for the past, but a response to conditions in the present. Nostalgia is felt more strongly at a time of discontent, anxiety or disappointment, yet the times for

which we feel nostalgia most keenly were often themselves periods of disturbance. Individually, it is common to experience a nostalgia for the pain and longing of late adolescence; collectively the Second World War, and most particularly the Blitz, exercises a powerful hold on the British imagination, even for people who were not yet born in 1940. A cataclysmic event, such as the assassination of President Kennedy in 1963, serves as a focus of memory, and its recollection can trigger the release of waves of nostalgia which have little relation to the impact of the event itself.

Nostalgic memory should not be confused with true recall. For the individual, nostalgia filters out unpleasant aspects of the past, and of our former selves, creating a self-esteem that helps us to rise above the anxieties of the present. Collectively, nostalgia supplies the deep links that identify a particular generation; nationally it is the source of binding social myths. It secures, and it compensates, serving, according to Davis, 'as a kind of safety valve for disappointment and frustration suffered over the loss of prized values'.[20]

As the very act of publishing a sociology of nostalgia in 1979 implies, the nostalgic impulse has become significantly stronger in recent years. For Davis, 'the nostalgia wave of the Seventies is intimately related – indeed, the other side of the psychological coin, so to speak – to the massive identity dislocations of the Sixties'.[21] Writing in 1974 Michael Wood noted that 'the disease, if it is a disease, has suddenly become universal'. He stressed the contemporary longing for the past. 'What nostalgia mainly suggests about the present is not that it is catastrophic or frightening, but that it is undistinguished, unexciting, blank. There is no life in it, no hope, no future (the important thing about the present is what sort of a future it has). It is a time going nowhere, a time that leaves nothing for our imaginations to do except plunge into the past.'[22] Nostalgia can be a denial of the future.

Yet it is also a means of coping with change, with loss, with *anomie* and with perceived social threat. It is around these unpleasant aspects of the present that our ideas of the past begin to coalesce. In 1978 Sir Roy Strong wrote:

> It is in times of danger, either from without or from within, that we become deeply conscious of our heritage. . . . within this word there mingle varied and passionate streams of ancient pride and patriotism, of a heroism in times past, of a nostalgia too for what we think of as a happier world which we have lost. In the 1940s we felt all this deeply because of the danger from without. In the 1970s we sense it because of the dangers from within. We are all aware of problems and troubles, of changes within the structure of society, of the dissolution of old values and standards. For the lucky few this may be exhilarating, even exciting, but for the majority it is confusing, threatening and dispiriting. The heritage represents some form of security, a point of reference, a refuge perhaps, something visible and tangible which, within a topsy and turvy world, seems stable and unchanged. Our environmental heritage . . . is therefore a deeply stabilising and unifying element within our society.[23]

As this passage unconsciously reveals, nostalgia is profoundly conservative. Conservatism, with its emphasis on order and tradition, relies heavily on appeals

to the authority of the past – typically in Mrs Thatcher's reference shortly before the 1983 general election to the recovery of 'Victorian values'. During the miners' strike she made much blunter political use of 'the enemy within'.

But nostalgia is a vital element in the myths of the Left as well as of the Right. There is a powerful myth of prelapsarian agricultural simplicity that has survived, even been encouraged by, three hundred years of industrialization; the emergence of an urban proletariat has led to memories of community and class solidarity which are summoned up to confront contemporary conflicts and defeat. At times the myths of the past have become more powerful than mere party politics: the Royal Jubilee in 1976 and the Royal Wedding in 1981, albeit discreetly stage-managed as a ritual enactment of tribal loyalty, tapped the most atavistic roots. The Falklands War released profound emotions derived from folk memory – the uses to which the apparent rediscovery of a national identity were put is another matter.

The impulse to preserve the past is part of the impulse to preserve the self. Without knowing where we have been, it is difficult to know where we are going. The past is the foundation of individual and collective identity, objects from the past are the source of significance as cultural symbols. Continuity between past and present creates a sense of sequence out of aleatory chaos and, since change is inevitable, a stable system of ordered meanings enables us to cope with both innovation and decay. The nostalgic impulse is an important agency in adjustment to crisis, it is a social emollient and reinforces national identity when confidence is weakened or threatened.

The paradox, however, is that one of our defences against change is change itself: through the filter of nostalgia we change the past, and through the conservative impulse we seek the change the present. The question then is not whether or not we should preserve the past, but what kind of past we have chosen to preserve, and what that has done to our present.

Notes

1 Ian Nairn, 'Outrage', *Architectural Review* 117(2) (June, 1955): lxxi.

2 Lionel Brett, *Landscapes in Distress* (London: Architectural Press, 1965).

3 Quoted in Martin Pawley, 'Johnson's journey into space', *Guardian*, 1 December 1986.

4 Quoted in Michael Heseltine, *Where There's a Will* (London: Hutchinson, 1987), p. 195.

5 Colin Amery and Dan Cruickshank, *The Rape of Britain* (London: Paul Elek, 1975), p. 10, and see Christopher Booker and Candida Lycett Green, *Goodbye London* (London: Collins/Fontana, 1973).

6 Quoted in Peter Marris, *Loss and Change* (London: Routledge, 1974), p. 43.

7 British Tourist Authority, *Britain's Historic Buildings: A Policy for their Future Use* (London: BTA, 1980), p. 19.

8 Marion Shoard, *The Theft of the Countryside* (London: Temple Smith, 1980), p. 99.

9 ibid.

10 BTA, *Britain's Historic Buildings*, p. 25.

11 Daniel Bell, *The Coming of Post-Industrial Society* (Harmondsworth: Penguin, 1976[1973]), p. 42.

12 Christie Davies, *Permissive Britain: Social Change in the Sixties and Seventies* (London: Pitman, 1975), p. 2; p. 201.

13 Alan Sked, *Britain's Decline: Problems and Perspectives* (Oxford: Blackwell, 1987), p. 28.

14 Department of the Environment, *Transforming our Waste Land: The Way Forward* (London: HMSO, 1986, p. 14.

15 Heseltine, *Where There's a Will*, pp. 142–3.

16 'Prince attacks "prison" factory', *Independent*, 6 May, 1987.

17 Tamara Hareven and Randolph Langenbach, in *Our Past Before Us: Why Do We Save It?*, ed. David Lowenthal and Marcus Binney (London: Temple Smith, 1981), p. 115.

18 ibid.

19 Interview with the author, 'A Future for the Past', BBC Radio 4, 1986.

20 Fred Davis, *Yearning for Yesterday: A Sociology of Nostalgia* (London: Macmillan, 1979), p. 105.

21 ibid.

22 Michael Wood, 'Nostalgia or Never: You Can't Go Home Again', *New Society*, 7 November 1974.

23 Roy Strong, introduction to Patrick Cormack, *Heritage in Danger*, 2nd edn (London: Quartet, 1978), p. 10.

Raphael Samuel

RESURRECTIONISM

I

THE LAST THIRTY YEARS have witnessed an extraordinary and, it seems, ever-growing enthusiasm for the recovery of the national past – both the real past of recorded history, and the timeless one of tradition. The preservation mania, which first appeared in reference to the railways in the early 1950s, has now penetrated every department of national life. In music it extends from Baroque instruments – a discovery of the early 1960s, when concerts of early music began to be performed for the *cognoscenti*[1] – to pop memorabilia, which bring in six-figure bids when they are auctioned at Christie's or Sotheby's. In numismatics it has given trade tokens the status of Roman coinage. Industrial archaeology, a term coined in 1955, has won the protective mantle of 'historic' for abandoned or salvaged plant. The number of designated ancient monuments (268 in 1882, 12,900 today) also increases in leaps and bounds: among them is that brand-new eighteenth-century industrial village – product of inspired scavengings as well as of Telford New Town's search for a historical identity – Ironbridge. Country houses, on their last legs in the 1940s and a Gothic horror in British films of the period, attract hundreds of thousands of summer visitors and have helped to make the National Trust (no more than a pressure group for the first seventy years of its existence) into the largest mass-membership organization in Britain. New museums open, it is said, at a rate of one a fortnight and miraculously contrive to flourish in face of repeated cuts in government funding: there are now some seventy-eight of them devoted to railways alone.[2]

One feature of the historicist turn in national life – as of the collecting mania – has been the progressive updating of the notion of period, and a reconstruction of history's grand narrative reference to the recent rather than the ancient past. Thus in TV documentary, the British Empire is liable to be seen through the lens of 'The Last

Days of the Raj', as it is in Paul Scott's trilogy, or the films of Merchant–Ivory. The year 1940 – replacing 1688, 1649 or 1066 as the central drama in the national past – becomes, according to taste, 'Britain's finest hour' or a privileged vantage point for studying the national decadence. Twentieth anniversaries, these days, seem to excite as much ceremony and rejoicing as for centenaries or diamond jubilees. Very pertinent here is what Fredric Jameson calls 'nostalgia for the present'[3] – the desperate desire to hold on to disappearing worlds. Hence it may be the growth of rock pilgrimages and the creation of pop shrines. Hence too, it may be – memorials to the fragility of the present rather than the past – the multiplication of commemorative occasions, such as 40th and 50th birthdays, and the explosive growth in the production of commemorative wares. The past under threat in many retrieval projects, as in the mass of 'do-it-yourself' museums, and self-made or family shrines, is often the recent past – the day before yesterday rather than as, say, in nineteenth-century revivalism, that of the Elizabethan sea-dogs, medieval chivalry or Gothic architecture.

British postage stamps, which ever since the Benn–Gentleman revolution of 1965–6,[4] have set out to represent this country pictorially rather than, as previously, regally and symbolically, seem finally to have caught up with the car-boot sales, the flea markets and the private collection of bygones and memorabilia. A recent set of greeting stamps falls firmly within the category of what is known in the auction rooms as juvenilia. Designed by Newell and Sorrell, they feature characters from children's literature, with Dan Dare, the comic superhero of the 1950s, enjoying parity of esteem with Biggles, the famous fighter pilot invented by Captain W. E. Johns. The Three Bears, who first appeared in Robert Southey's *The Doctor* (1837), are matched by Rupert Bear, from the *Daily Express* comic-strip, and Paddington Bear, who first appeared in 1958. Among the female role models, a rather vexed Alice, still bearing the traces of Tenniel's Gothic, offsets the sweetness of Little Red Riding Hood and Orlando the Marmalade Cat.

At the other end of the chronological spectrum, the New Agers and the organic farmers, proclaiming a spiritual and material kinship with the earliest inhabitants of these islands; the environmentalists, calling themselves 'Friends of the Earth'; and the ecologists, pondering the question of whether the Iron Age or the Dark Ages were the last time when Man and Nature were still in balance: [they] have each in their own way helped to make prehistory much more vividly present. Taking legend seriously, and arguing that it represents oral tradition and oral history, at many generations' remove, they set out to discover its lost and hidden landscapes. Summer solstice celebrations, such as the mass open-air festival at Glastonbury, or the 'New Age' travellers' rave-ups, resuscitate the memory of ancient shrines, and create a whole network of new ones.

Through the medium of ley-lines, or what one of New Age's more critical writers calls 'Astro-Archaeology', every old footpath is liable to be the vestige of some ancient British trackway.[5] By the same token ecologists, anyway the self-styled 'Merlin' ecologists, argue that Celtic and druidical place-names are clues to aboriginal settlement.[6] Old landmarks, under an optic like this, become the survivals of an ancient civilization, on a par with Pompeii and Herculaneum. The standing stones at Land's End, if we interpret them rightly, are the cabbala of what one writer calls 'megalithic science',[7] while Cheesewring on Bodmin Moor is 'one of the wonders of prehistoric engineering'.[8]

New Ageism has a huge cult following among the young. It finds echoes in rock music, and outer circles of influence in fringe medicine, holistic therapies and radical feminist activism. More recently it has emerged as a potent new force in environmentalist campaigning, bringing its own sacred geography into the arena; calling up a pharaoh's curse on those – like the motorway builders – who disturb the bones and the spirit of the dead; and using the occult, in the form of chants and charms, to give demonstration and protest a runic edge. [. . .] In the brilliantly successful battle for Oxleas Wood in south-east London, 'the biggest victory for environmentalists for several years,' it was the People of Dragon, 'a pagan group that brings together witches, odinists, druids, magicians and the many other elements of the neo-pagan revival now taking place in Britain', who led the way in the resistance.

[. . .]

Environmentalists, after their own fashion, can be quite as ecstatic about Neolithic times as New Agers. Thus Richard Mabey, in his interesting credo *The Common Ground*, conjures up that Arcadian time, 'about 7,000 years ago, when the wetlands were still undrained', the climate was 'agreeably warm', and about two-thirds of the land surface was thickly wooded.[9] Like the New Agers, too, though for different reasons, environmentalists, oppressed by the knowledge of disappearing or endangered species, are apt to make a fetish of relics and survivals – 'old' grasses, 'vintage' herb-rich meadows, 'semi-natural' or 'ancient' woods. Nature Conservancy officers follow suit, keeping inventories of species at risk, making a shrine of wildlife reserves – 'Nature's Heritage' is the generic title given to them in Scotland – and waymarking them with interpretive panels where their history is set out.

Under the influence of the new arboriculture, ancient woodland, which in the 1960s seemed on the point of extinction, is new treated as it if was a historic monument and promoted as one of Nature's antiquities: 'prehistoric wildwood', 'relics of the original forest'.[10] By 1989, as a result of careful management and a revival of the ancient forestry art of coppicing, as well as the formation of local and national woodland trusts, there was actually more surviving 'ancient' woodland than there had been in 1975.[11]

[. . .]

The idea of re-enacting, or establishing a living connection with, prehistoric Britain seems also to have been one of the inspirations behind the long-distance walkers' routes developed by the Countryside Commission.[12] Thus the South Downs Way, in the long stretch from Eastbourne to Petersfield, 'follows the ancient path used 5,000 years ago by early travellers'; while on the Cotswold Way, 'many hill forts are passed'.[13] The Ridgeway, 'one of the best used of all the prehistoric long-distance trade routes', was one of the models. In Wiltshire it ran round the Marlborough Downs to the Iron Age hill-fort of Barbury Castle. In Oxfordshire it became the Icknield Way. In Norfolk it ended up at Grimes Graves – 'the Neolithic flint mines which seem to have produced the principal trade commodity for the route'.[14]

More generally there is a strong historical element in the nature trails – or 'nature heritage' trails – developed, since the 1960s, as an educational device, and latterly as a tourist or visitor attraction [see also Jason's Trips on the Regent's Canal: figures 8.1–8.4]. [. . .]

Figure 8.1 A photograph from John James's student days, just before he ran the first 'Jason's Trip' on the Regent's Canal. This example of People's History as Living History was launched in 1951 for the Festival of Britain as a canal trip from Camden Town to Edgeware Road. It served to publicise the activities of the Inland Waterways Association: photograph from John James's private album

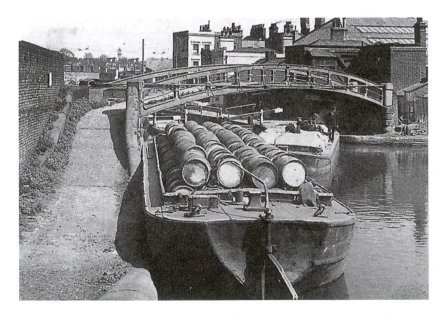

Figure 8.2 Camden Lock as it was circa 1951: photograph from John James's private album

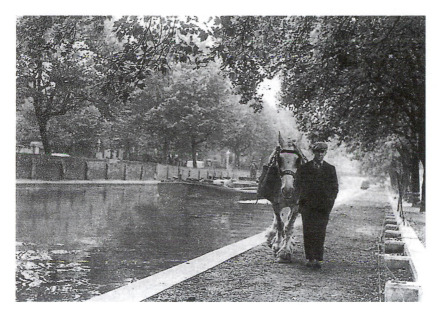

Figure 8.3 The 'Little Venice' stretch of the Regent's Canal circa 1951: photograph from John James's private album

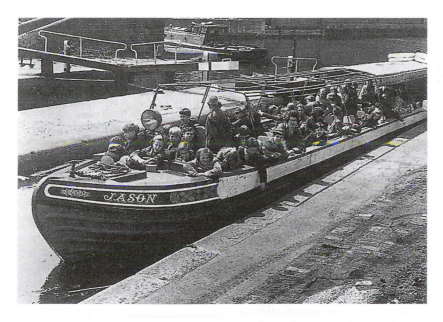

Figure 8.4 A photograph of 'Jason's Trip' on the Regent's Canal, circa 1956: photograph from John James's album

Conservation, a minority cause in the early 1960s when the term entered common currency, and restricted at the outset to the protection – or attempted protection – of well-known historic landmarks, is today the most favoured outlet for the reformist impulse in national life, mobilizing a vast amount of voluntary effort and enjoying the nominal support of politicians of all stripes. In schemes of environmental improvement, it occupies the ideological space accorded in the 1940s to modernization and planning; under the influence of ecology it has extended its activity from the built environment to bird sanctuaries and wildlife reserves. In the countryside, the Woodland Trust, which began its life in 1972, now has some 300 woods in its care. The Council for Small Industries in Rural Areas designates priority areas for the revival of traditional crafts. 'Enterprise Neptune' fights to protect the 'heritage' coast from pollution; while the National Trust, to judge by the tastefully lettered signposts which confront the modern rambler, has contrived to take every beauty spot in the country into its care.

No less symptomatic than the protection of the countryside is the 'historicization' of the towns, which has nowadays replaced streamlining and modernization as the great object of municipal idealism and civic pride. Glasgow's 'Merchant City' is an apparently successful example, the restoration and refurbishment of a run-down district of sweatshops and warehouses into one that is simultaneously pre-industrial and postmodern, exorcizing memories of the shipyards by resurrecting the commercial glories of the age of Adam Smith, while at the same time providing a showcase for modern fashion and a new business headquarters for information technology. A more macabre example would be the Rhondda Heritage Park built on the corpse of the recently closed pits, occupying a site where less than ten years ago miners were staging a sit-down strike. 'Operation Groundwork', a partnership between government, local councils and private enterprise first established in south-west Lancashire in 1981, is now generalizing such refurbishments. Landscaping and recycling old industrial plant serves to attract new investment and development, providing new office blocks with a 'heritage' core, and associating them, through museums and concert halls, with both history and the fine arts.

The historicist turn in national life may be dated to the 1960s, when it appeared as a pole of opposition to the modernizations of the time, though it also bore their impress. It was then that the museums movement got under way, and that projects for 'folk' museums, or 'industrial parks', were widely adopted by country and municipal authorities, though the newly appointed curators, painstakingly relocating and reconstructing old buildings and plant, were so thoroughly engaged in the work of site assembly that it was not until the 1970s that they began to reveal their potential. Beamish Hall, the open-air industrial museum which today attracts some 300,000 visitors a year to its 'Northern Experience' theme park, was adopted by Durham County Council in 1965, and Frank Arkinson, the curator whose inspired scavengings brought it about, was outlining the idea of it as early as 1961, in the first issue of *Industrial Archaeology*, but it was not until 1971 that it opened its gates to the public. As the admissions figures show, once opened the new museums attracted a large following. At the end of the 1970s, the *English Heritage Monitor* commented on them as follows:

[. . .] Since 1975 visits to industrial monuments, taking a constant sample of 31, have increased by 12%, compared with a 7% increase to all historic buildings. During that period the number of visitors to the Hull Town Docks Museum, Wedgwood Visitor Centre, and National Railway Museum in York has more than doubled.

Between 1975 and 1979 the number of known admissions to industrial monuments rose from 2,576,000 at 49 sites to 6,567,000 at 113 sites. [. . .] The most visited type of industrial monument is the steam railway, 34 of which attract a total of 2,880,000 passengers yearly. In addition there are at least 17 railway museums or railway centres attracting 1,717,000 visitors. Open air museums which preserve redundant industrial buildings are becoming increasingly popular. Beamish attracted as many as 316,000 visitors in 1979, an increase of 8% on 1978. The Black Country Museum and the Amberley Chalk Pits Museum are recent examples of this type. Mine works and historic ships are also attracting large numbers of visitors.[15]

Environmental education, or 'field studies', promoted by the Schools Council and progressive education officers as a species of 'discovery learning' and an ideal framework for 'project' work, took on a historical hue, and indeed in the primary schools of the 1960s and 1970s was perhaps the main agency through which a 'new-wave' social history made itself felt. In either case, there was a well-developed faith in the local and the immediate. 'Hedges and Local History' was a favourite topic.

[. . .]

Family history was one of the most striking discoveries of the 1960s. Towards the end of the decade, when the family history societies began their growth, it was giving rise to quite the most remarkable 'do-it-yourself' archive-based scholarship of our time – a movement which started literally on the doorstep and owed nothing to outside influence. In the early 1960s family history was, it seems, an unknown subject so far as university historians were concerned (Keith Thomas, addressing a *Past and Present* conference in 1962, casually remarked on its absence[16]); and it was still sailing under the aristocratic and heraldic flag of 'genealogy' when it was practised by amateurs and part-timers. Yet already Peter Laslett, a historian who had cut his teeth on the popular when working during the war in the Army Bureau for Current Affairs, and later on the BBC Third Programme, was launching the Cambridge group for the study of population, an extra-mural enterprise which made 'family reconstruction' the heart of its work, and enlisted the labour of hundreds of volunteers in transcribing parish registers.[17]

So far from wanting to construct an ideal pedigree, these new-wave genealogists can take a perverse pleasure in the transgressive. Thus Orpington, Bromley and north-west Kent family historians, maddened perhaps by the respectability which surrounds them on all sides, seem to be fastening on murder and mystery as a means of keeping their ancestry up to the mark.

[. . .]

The 1960s take-off of 'living history' and the new appetite for 'living' nature were in Marxist (or Freudian) terms, overdetermined. In the case of the museums movement, a concurrence of different causes might be hypothesized: in one aspect it can be seen as a by-product or analogue of the antiques boom of the 1960s, and the collecting mania which sent scavengers and detectorists on the trail of the humblest artefacts. In another sense, it was the beneficiary of the local govern-ment reforms of 1962, under which the county councils were empowered to appoint their own archaeologists and take charge of the museum services. In yet another – the turn to 'hands-on', interactive display, and living, working exhibits – it could be seen as a museological or historical parallel to that very 1960s excite-ment, the 'happening'.

Urban conservation was sparked into being, in the first place, as an alarmed response to the automobile revolution of the 1950s (car ownership tripled in the course of the decade) and the grandiose road-building programmes which followed in its wake. It was given a further fillip by the great rebuilding of the 1960s, and the destruction of old neighbourhoods which prepared the way for it. In quite another direction – the politics of the environment and the way it relates to changes in occupancy – reference might be made to the spread of home-ownership to 'period' properties, and the middle-class colonization of previously run-down streets. Here the rise of the amenity societies would be related to the influx of newcomers to the older Victorian suburbs, just as the spread of wildlife trusts in the same period – notoriously with 'townies' in the lead – might be explained in part by the growth of weekend-commuting and the multiplication of 'second' (i.e. country cottage) homes. The enthusiasm for voluntary associations – reflected in the membership figures, and the readiness to undertake part-time volunteer work, as well as the protective nature of the causes themselves – has evident affinities with the 'new-wave' charities of the 1960s, such as Shelter and Oxfam, while the campaigning spirit in face of threat seems of a piece with the middle-class radi-calism which, in Britain as in the United States, did so much to shape the politics of the decade.

As for the parallel rise, especially towards the end of the decade, of do-it-yourself history, a rather different set of causes might be hypothesized, one in which past–present relations were reworked as a way of taking refuge from the here-and-now. It cannot be an accident that labour history makes its appearance in the very decade which saw the start of a secular withdrawal of the working class from politics; that local history, so far as writing and often even readership was concerned, was so often in the hands of newly settled residents (the local amenity societies derived much of their energy from the same source); and that family history seems to have had a particular appeal to the geographically and socially mobile – i.e. those who, without the aid of history, were genealogical orphans. 'Feelings of rootlessness', as the family history societies themselves acknowledge, animated the new enthusiasm.[18] It gave to the territorially mobile the dignity of ancient settlement, to the limited nuclear family a far-flung kinship network, and to the urban and suburban a claim to 'country' origins.

One impetus for the historicist turn in national life, as also for the multipli-cation of retrieval projects and the growth of environmental campaigns and fears, was a vertiginous sense of disappearing worlds – or what was called in the early

1960s, when a V & A exhibition on the subject toured the country, 'Vanishing History'.[19] It was amplified in the 1970s by a whole series of separation anxieties which affected now one sector of national life, now another; by the destruction or run-down of regional economies; by threats to the living environment which put the taken-for-granted at risk; and not least by the rise of a cultural nationalism which spoke to a lost sense of the indigenous.

Many of these projects were born out of a sense of emergency, and they have been sustained by the belief that, whatever their achievements, they are fighting a losing battle against the erosions of time. From this point of view, Gordon Winter, compiling his *Country Camera* and discovering old glass slides in a cottage lettuce-bed, or John Gorman the printer-historian, rescuing old trade-union banners from the incinerator,[20] belong to the same imaginative universe as the high-level lobbyists of Save Britain's Heritage, even if there are very few other affinities between them. Retrieval projects are typically carried out, in the first place, as rescue operations, and indeed in the 1970s what was called 'Rescue' archaeology – a Houdini-like operation in which the scholars and diggers bargained for a species of time-share, snatching their findings from the very jaws of the excavators – turned every dig into a crusade and every clearance site into a potential battleground. In industrial archaeology there is a terminal sense of recording something which is crumbling into ruins; in wildlife sanctuaries and nature reserves, of protecting endangered species; in rural conservation, of defending a dwindling patrimony in which hedges are disappearing at a rate of knots and even the remotest wetlands threaten to become things of the past.

In the built environment, the working ideology of the conservationists was bleakly Malthusian, picturing an overpopulated landscape in which scarce resources were constantly being depleted and forces of destruction were on the march. There were the office developers hovering like vultures and swooping down whenever there was a vacant space. There were the lax council officials, unwilling to use the protective legislation available to them; the selfish householders who carried out alterations regardless of the building's character. There were the traffic engineers, churning up the few remaining cobblestones, and putting asphalt patches in their place. Horror stories abounded: of demolition contractors doing their destructive work by dead of night, or even, where a preservation order was immovable, setting fire to historic buildings; of country-house owners threatening to turn their properties into theme parks; of priceless panelling put out to grass in a skip; of residential houses illegally converted into offices.

II

Under influences like these, the notion of 'heritage' has been broadened and indeed transformed to take in not only the ivied church and village green but also the terraced street, the railway cottages, the covered market and even the city slum; not only the water-meadows, such as those painted by Constable, but also the steam-powered machinery lovingly assembled in the industrial museums. Historic Scotland and the Argyll and Bute Regional Council have recently voted some £200,000 for the refurbishment of a gentleman's urinal on the island of Rothesay: 'The porcelain

in the pierhead pissoir is an outstanding example of the work of Twyford Cliffevale Potteries. The urinals, called the "Adamant", are made of white porcelain with black fake marble surrounds. They are flushed via brass pipes from overhead tanks with bevelled glass panels.'[21]

Archaeology has extended the work of preservation and retrieval to objects which previous generations would have ignored or despised. A brilliant example is the application of radiocarbon dating to the analysis of waterlogged detritus. Extending their inquiries from geological remains to biological leavings, archaeologists have been able to pass from the material culture of everyday life to the intimacies of the meal-table. [. . .]

By encouraging thousands to try their hand at museology, the collecting mania has also contributed, albeit subliminally, to an enlargement of the notion of the historical. So have the inspired scavengings of the numismatists – a great source of the medieval pilgrims' badges now on display in the Museum of London. The rage for Victoriana which took off in the 1950s (and made the fortunes of Portobello Road) has raised the humblest items of household furniture to the status of antiques. Commercial ephemera are, if anything, even more highly prized. Old enamel signs are collected as 'street jewellery'.[22] Old pot-lids have their own price guide (including 'copious notes on how to distinguish modern reproductions from the genuine article').[23] At Gloucester Robert Opie has a whole museum devoted to vintage labels and decorative printed tins;[24] Buckley's Shop Museum in Battle is 'a unique collection of packaging'.

As well as enlarging the notion of the historical, and bringing within the reach of scholarship (or connoisseurship) ephemera which earlier generations would have despised, the collecting mania has also served progressively to update conventional notions of 'period'. 'Suburban style', for so long an object of ridicule to snobs, now has its cult followers with coffee-table books devoted to the inter-war semi, and exhibitions which celebrate them as 'little palaces'.[25] The Bakelite Museum in East Dulwich memorializes – along with inter-war kitchenware – the vanished glories of polystyrene; the Trerice Museum has an exhibition illustrating the history of the lawnmower. [. . .]

This updating of the idea of the past has allowed for and been encouraged by a multiplication of historical shrines. The Colman's mustard shop (with a Colman's museum attached) may not have had the accolade of being classed as a Grade I historical monument, but for many visitors to Norwich it enjoys parity of esteem, as far as sight-seeing is concerned, with the fifteenth-century cathedral.[26] Second World War memorabilia insinuate themselves in the most unlikely places – the otherwise medieval Dover Castle, for instance. They crop up as visitor attractions at some country houses and there is a whole class of newly established museums and shrines devoted to them, starting with the recently opened Cabinet War Rooms, which have joined the Houses of Parliament and the Abbey as one of the sights of Westminster. The Second World War is also a great favourite for 'living history' or 'shared experience' displays at the theme parks – partly no doubt because of the ready availability of sound recordings and film footage which can be used to animate the display of relics with 'reality effects'. Pop pilgrimages are among the more recent additions to this country's heritage trails. The museum devoted to the comics Laurel and Hardy, at their Cumbria birthplace, has recently

doubled in size. The Abbey Road zebra crossing outside the recording studio, remembered from the record sleeve of one of the Beatles' albums, is, it seems, a Mecca for Japanese tourists (Kenneth Baker, in a populist moment of his secretaryship at the Department of Education, had himself photographed there); the Cavern, Liverpool – a replica of the original musical cellar destroyed by a fire, on the other side of the road – is visited as excitedly as if it were the real thing.[27] The Granada Studios tour, opened in the summer of 1988, offers visitors 'a walk down the hallowed cobbles of Coronation Street' and the change of being photographed outside, if not having a drink in, the Rovers Return.

The most remarkable updating of the national past has been in the field of domestic architecture, where almost anything built before 1960 is liable to be labelled as 'period' – even, it seems, Second World War air-raid shelters.[28] Forty years ago the great stock of the nation's housing was regarded as obsolescent. Terraces, unless they were 'Georgian', were almost automatically designated as slums, 'unfit for human habitation'; while Victorian mansions, 'dilapidated, unsightly . . . and totally uneconomic', were either consigned to the bulldozer or converted into modern flats. As Stanley Alderson wrote in *Housing*, a Penguin special issued in 1962:

> Eighty years is a fair life for an ordinary house – even a good house. Most of the houses built before 1880 were not good ones. Not only had no minimum housing standards been laid down, until the Public Health Act of 1875 there were no effective building regulations. It is a safe assumption that there are 3,000,000 houses we ought to pull down right away. It is almost unthinkable that we should not have pulled them down before they are a hundred years old.[29]

In the modernizing hour of the 1960s, as earlier at the time of the Festival of Britain, ideas of domestic comfort were taken from abroad – central heating from the Continent; dream kitchens with their streamlined surfaces and electric gadgets, from the United States. Scandinavia set the pace in open-plan layouts and teak-handled tableware. Chianti bottles provided the artistically inclined but hard-up with their table lamps; Chinese rush matting was a modernist alternative to carpets. Simple lifeism, too, took its cues from abroad, as in the Le Creuset kitchenware and Provençal casserole dishes which launched Habitat on its brilliant career. Pine kitchens, marketed today as 'Victorian', 'Georgian' or 'farmhouse', were in their earlier version promoted as the latest Swedish thing.

Conservationism has invented an English version of the ideal home, one which draws its decorative styles from the national past, and its idea of comfort from the cluttered Victorian interior. 'Old-fashioned', so far from being a term of opprobrium, as it was in the 1950s, is here a gauge of authenticity. It may be indicative of the influence of this aesthetic that in the interiors featured in the *Observer*'s voyeuristic series, 'A Room of My Own', hardly a single one has new furnishings. The number of listed buildings (i.e. 'Buildings of Special Architectural and Historical Interest') increases by leaps and bounds: it has more than doubled since 1982, and now approaches half a million (1920s council houses in Edinburgh are among those which have recently been added).[30] Victorian buildings which quaked before the bulldozer are listed for preservation as a matter of course, and the very

features which condemned them in the 1960s as dust-traps are now advertised as 'original'. Erstwhile slums, lovingly rehabilitated, are exhibited and sold as 'period' residences – rather as mews cottages were in 1920s Mayfair and Chelsea. The terraced house – the *English* terraced house as it is called by a recent and admiring historian[31] – could be said to enjoy parity of esteem with the stately home. No less striking is the renaissance of the farm labourer's cottage – minus, of course, the farm labourer. In the 1940s these houses were thought of by many – even by country writers such as Geoffrey Grigson, and certainly by many of the inhabitants, who were only too anxious to secure a council house – as rural slums, by-words for darkness and damp.[32] For the Labour Party in particular, campaigning against 'tied' cottages, they were physical emblems of servitude. Today, expensively refurbished and emptied of their original inhabitants, they are a talisman of the Englishness projected in the tourist brochures, charming traditional homes.

It is not only individual houses which have been rehabilitated but, more pertinent to ideas of national heritage, 'townscape'. A term coined by the architectural writer Gordon Cullen and adopted by the Civic Trust in their town improvement schemes of the late 1950s and 1960s, it was given legislative recognition by the Civic Amenities Act of 1967, which empowered local authorities to designate conservation areas. The first of these to be declared, the historic centre of Stamford in Kestven, fell within a quite traditional preservationist aesthetic: the refurbishment of the late medieval and Tudor heart of an old market town, given a face-lift under the guidance of the Civic Trust.[33] But by the mid-1970s, when conservation areas began to increase by leaps and bounds (today there are some 7,000 of them), the most ordinary Victorian estate developments were being given statutory protection as a matter of course, while the planning officers of the local councils were bending over backwards to please the local amenity societies.

In the countryside, as in the town, there has been a vast metaphorical extension of the notion of 'heritage'. Under the influence of the environmental movement, as also of ecological fears, 'scenery', the great enthusiasm of the rambler of yesteryear, and 'beauty spots', the great object of picnickers and motorists, now take second place, as a focus for conservationist anxiety, to wildlife habitats and wilderness sites. Protective legislation, which under the National Parks Act of 1949 was restricted to twelve 'areas of outstanding natural beauty', has been progressively extended in scope until it can be routinely (though not always successfully) invoked in the case of the humblest bird-pecked mud-flat or orchid-bearing meadow. Otter-rich riverbanks, which the water authorities of the 1960s – like their counterparts, the traffic engineers, in the municipalities – were intent on straightening out and freeing of unsightly encumbrances, are now allowed to grow their trees again. 'Ancient woods', which in the 1960s were succumbing to the onward march of the conifer – and which so late as 1976 could still be felled at the farmer's whim – are now systemically coppiced, both to weed out intruders, and to give the hardwoods space to grow.

[. . .]

It is in relationship to the industrial landscape that the influence of archaeology in updating and enlarging the notion of the historical is most apparent. Forty years ago the industrial was a by-word for squalor, a dead weight of the past which the environmentalists of the day – as well as the planners – dreamed of grassing

over (rather as London, in the utopian dream of William Morris's *News from Nowhere*, was given over to pasture and forest). W. G. Hoskins, the pioneer of 'history on the ground', recording one of his post-war itineraries, pictured the Black Country as a dark planet, stretching out beneath a canopy of smoke and inhabited by prisoners or madmen: 'factory chimneys and cooling-towers, gasometers and pylons, naked roads with trolley-bus wires everywhere, canals and railway tracks, greyhound racecourses and gigantic cinemas; wide stretches of cindery waste-land, or a thin grass where the hawthorn blooms in May and June – the only touch of the natural world in a whole vast scene'. The Potteries, 'demonic' in their ugliness, were worse: 'hundreds of bottle-shaped kilns, black with their own dirt of generations, massed in groups mostly on or near the canal, with square miles of blackened streets of little brick houses – tall chimneys or iron and steel works, steam from innumerable railway lines that thread their way through the incredible tangle of junctions'.[34]

The discovery of industrial archaeology, a term coined by Michael Rix and quickly adopted by local historians, did not immediately change these perceptions: steam-powered factories were conspicuously absent from the major projects and initiatives of its early years, whether in the field of recording or of preservation. Windmills were the great passion of Rex Wailes, the official at the Ministry of Public Works charged with responsibility for industrial monuments in the 1960s. Canals, dating from the earliest years of the industrial revolution, were the favourite subject of early publications in the new subject. The local historians who took up industrial archaeology seem to have treated it at first as an extension of pre-industrial history, rather than as a historical and aesthetic reality in its own right. [. . .] The decline of smoke-stack industries, pit closures, and the haemorrhage of jobs in manufacturing employment changed all this. By 1971 it was possible to publish a coffee-table book with the expressive title *Our Grimy Heritage*, 'a fully illustrated study of the factory chimney in Britain'.[35] In the same year Durham County Council, which only three years before had come almost bottom of the list in the Industrial Monuments Record, opened its industrial and open-air museum dedicated to conveying 'the northern experience'. With its exciting tram-rides, lifelike Co-op stores, and pit-head winding gear, it was attracting 200,000 visitors a year by the end of the decade – more than Durham Cathedral. At the other end of the kingdom, on the western approach to London, the destruction of the Firestone factory – a brilliant example of Trading Estate Art Deco – was exciting as much outcry as if it had been the Rollright Stones or Cleopatra's Needle.

III

The past in question – the 'heritage' which conservationists fight to preserve and retrieval projects to unearth, and which the holiday public or museum visitors are invited to 'experience' – is in many ways a novel one. Though indubitably British, or at any rate English, it departs quite radically from textbook versions of 'our island story'. It has little or nothing to do with the continuities of monarchy, Parliament or British national institutions as it would have done fifty years ago, when, in the heyday of the Army Bureau of Current Affairs, Westminster was still

regarded as the mother of parliaments, and 'the British Way' was seen as the envy of the world. Overseas colonization and settlement hardly figure in it, though the family history societies, ransacking army records[36] (or convict registers[37]) for the trace of forgotten ancestors, are laying some of the foundations for the study of the British diaspora. International relations, one of the great subjects of the school histories of yesteryear are apt to appear only intermittently and in terms of their domestic repercussions – as, say, women's work in the First World War, or the experience of the evacuees in the Second. Under the influence of ecology, and of pioneering works by Keith Thomas[38] and Oliver Rackham,[39] the history of the countryside has been reconceptualized in terms of the relations of man and the natural world; the time does not seem far distant when pit ponies will figure as largely as parish apprentices in the history of the industrial revolution. The physical remains of the past enjoy a new salience, even though they are still largely ignored in higher research; and under the influence of conservationism, as also perhaps of life-style politics, there is a new interest in the record of vernacular architecture and the evolution of domestic space.

It is the little platoons, rather than the great society, which command attention in this new version of the national past; the spirit of place rather than that of the common law or the institutions of representative government. In one influential version, propagated by W. G. Hoskins and carried forward by the amateur topographers of 'history on the ground', the making of the English landscape becomes the grand subject of 'our island story'; the palimpsest on which the national past is inscribed and the genius of national life and character revealed. Archaeologists study it in terms of ancient deposits, distinguishing between scattered and nucleated settlement. Agrarian historians, identifying the pattern under the plough, ground local economies in the chalk and the clay, upland and lowland, field and forest. Local historians, conjuring villages out of suburbs, rediscover the fields beneath the streets. Family historians tracing their ancestry back to some original parish or settlement, identify locality with 'roots'. Conservationism seizes on these conceits, interpreting the built environment in terms of the spirit of place, imbuing localities with personalities which it is the duty of the planning authorities to protect.

The holiday industry follows suit – indeed, to follow the emphasis on regional difference in the tourist brochures, or on historical geography in English Heritage's guide to the properties in its care, one might imagine that England was still living in the times of the heptarchy and that the Act of Union with Scotland had never happened. The local authorities, desperate to attract investment, and turning back to the past to promote a new corporate image, amplify these effects with fancies of their own. County Durham, as motorists discover if they drive in on the A1, is 'the land of the Prince Bishops' (i.e. a palatine jurisdiction); while South Shields (more modernistically), for those who follow that town's heritage trail, is Catherine Cookson country. Middlesbrough, the home of ICI, impudently promotes itself as 'Captain Cook's country', with a heritage trail which ends up on the cliffs at Whitby; Peterborough, in the post-war years expanding on the strength of London 'overspill', is now revived as 'one of the great Roman towns', Glasgow, with its newly sandblasted warehouses and tenements, is 'the Victorian Bath'.

This new view of the national past allows for, and even builds upon, an *urban* Britishness. The terrace enjoys parity of esteem with the country house or the

cottage, the vintage tram excites as much affection as the show of shire horses. The fairground organ competes with the madrigal as the sound of national music. In the heroic moments of the national past 'the Blitz experience' – a light-show sensation at the Imperial War Museum, and a great favourite at the theme parks – seems to count for more than El Alamein or Trafalgar. Even when it comes to pastoral the city gets a look-in, with disused shunting-yards serving as bird sanctuaries, deserted railway tracks taking on the character of urban meadows, back-yard ponds supporting wildlife and suburban bee-keepers producing a better class of traditional honey than their rape-fed country rivals.[40] It is a testimony to the imaginative appeal of all this that the biggest victory for environmentalists for several years, recorded as this chapter was going to press, was the battle for a wildlife site in south-east London.

Shopping enjoys an altogether new visibility in representations of the national past. In pictorial histories (such as those reproduced from old postcards by the Hendon Publishing Company: *Bolton As It Was*; *Blackburn As It Was*) pride of place is given to the high street scene. In the mock-ups and pop-ups of the 'traditional' village, the general stores – or village post office – occupy the symbolic space once given to the parish church. 'Period' shopping is a leading attraction at the open-air museums and theme parks. At the York Castle Museum, a pioneer in this field, a cobbled Victorian street has been reconstructed, with complete shopfronts rescued as architectural salvage. 'Here are intriguing windows of a pewterer, a haberdasher, an apothecary, tobacconist, china shop and a pawnbroker. A hansom cab stands in the street and across the way is a fire establishment, a coaching house, a tallow-candle factory, a general store and a bank.' Shops of a more recent vintage are also the centrepiece of the open-air and industrial museums. [. . .]

The new version of the national past, notwithstanding the efforts of the National Trust to promote a country-house version of 'Englishness', is inconceivably more democratic than earlier ones, offering more points of access to 'ordinary people', and a wider form of belonging. Indeed even in the case of the country house, a new attention is now lavished on life 'below stairs' (the servants' kitchen) while the owners themselves (or live-in trustees) are at pains to project themselves as leading private lives – 'ordinary' people, in 'family' occupation. Family history societies, practising do-it-yourself scholarship and filling the record offices and the local history libraries with searchers, have democratized genealogy, treating apprenticeship indentures as a symbolic equivalent of the coat of arms, baptismal certificates as that of title deeds. They encourage people to look down rather than up in reconstituting their roots, 'not to establish links with the noble and great', – as in the days when blue blood ruled the roost – but, on the contrary, to celebrate humble origins.[41] To discover ancestors who were weavers or drovers, or to find oneself 'an eastender once removed', far from being a matter of shame, as it would have been when families were haunted by the fear of losing caste, is a matter of pride.[42] 'My grandfather committed a murder in the Commercial Road', an expatriate old Londoner told me after I had given a talk on London history to the West Surrey Family History Society, one of the Federation of Family History Societies: he had tears in his eyes as he spoke.

Labour, so far from being despised, as it was so often in the real historical past, is retrospectively dignified. Its artefacts are lovingly preserved at the industrial

museums, and subject to 'hands-on' interactive displays with aproned artisans plying their trades, and machinery moving on its wheels and pulleys; while at the farm museums butter is churned and horses plough a lonely furrow. It is not only labour which has been rehabilitated and given an honoured place in this new version of 'our island story', but also the shopkeeper. He is no longer the obsequious figure of nineteenth-century caricature, fawning on the carriage trade, nor yet a melancholy Mr Polly, teetering on the edge of bankruptcy and communing (or squabbling) with his fellow-failures, nor yet the vulgar commercial of Matthew Arnold's *Culture and Anarchy*, but rather, like the old-fashioned draper, an emblem of 'knowledgeable and friendly service'. In the books of sepia photographs, he is a figure of authority, flanked by respectful assistants, and backed by mountains of produce. In the trade catalogues, often reproduced in facsimile in recent years, shopkeepers figure, as in Whiteleys of Queensway, as 'universal providers'. In oral history's childhood memories they are fondly remembered as the purveyors of broken biscuits and spotted fruits.

This new version of the national past is not only more democratic than earlier ones but also more feminine and domestic. It privileges the private over the public sphere, and sees people as consumers rather than – or as well as – producers. Hearth and home, rather than sceptre and sword, become the symbols of national existence; samplers and patchwork quilts the tradition-bearers. In the hands of the historical demographers, the grand permanences of national life are no longer those of altar and throne, nor, as in the 'Whig' interpretation of history, constitutional government, but rather those of the nuclear family, as representative a feature of sixteenth-century Ealing, it seems, as of any London suburb today. Oral history, 'the spoken memory of the past', has been centrally concerned with motherhood. Starting, in the 1970s, with autobiographies of occupation – mainly male – it has increasingly come to concentrate on profiles of family life, adopting a child's-eye view of the past, and a home-centred view of sociability.

Nature has been feminized too. Wild nature is seen as a habitat, warm and life-giving rather than – as in the Wordsworthian apostrophes or Byronic tropes – rugged mountains and rocky eminences. Historical romance reinforces the feminine strain. In the hands of its most popular practitioner, Catherine Cookson, it takes the form of a family saga. Even when high politics is ostensibly the subject, as in the novels of Jean Plaidy, it is transposed into a drama of everyday life in which the most illustrious figures in national history turn out to have been made of the common clay. Costume drama, too, promotes an intimate view, making the empire-builders accessible to us by reason of their marriages and amours.

[. . .]

It is for anyone, like the present writer, who is a socialist, an unfortunate fact that these resurrectionary enthusiasms, emanating very often from do-it-yourself historical projects, popular in their sympathies and very often radical in their ancestry or provenance (even the Society for the Protection of Ancient Buildings was founded by a socialist, and the National Trust, in the early days of its existence, was a kind of Liberal front), have been subject to Conservative appropriations, and have strengthened the Right rather than the Left in British politics. Nor is this an accident. The historicist turn in British culture coincided

with the decline of Labour as a mass membership party, with the demise – in Britain as in other countries – of socialism as a workers' faith, and with the Labour Party's loss of historic confidence in the necessity and justice of its own cause – a disillusion compounded by a growing alienation from, and disenchantment with, its own electorate. At the same time the break-up of the two-camp 'us' and 'them' divisions in British society, the fragmentation of class into a thousand different splinters, the crumbling of the barrier between 'high' and 'low' culture and the growth of a two-way traffic between them, robbed the 'popular' of its subversive potential and even allowed it to be annexed to the Conservative cause. It is perhaps indicative of this that the restoration of History to the core curriculum in the schools was the work of a Conservative government, and that while, in the subsequent debate, radical voices were very much to the fore in the schools and universities, there was barely a squeak out of the Labour front bench at Westminster.

In the built environment, the turn against comprehensive clearance and high-rise flats, the rise of conservationist sentiment, and the discovery of 'heritage' in what had previously been designated slums, removed at a stroke what had been, ever since the birth of the Labour Party and in the imagination of its Fabian and ILP predecessors, the very essence of the socialist vision: a transformation of the built environment, the physical burying of what was conceived of as the nightmare legacy of Victorian industrialism and unplanned urban growth. In other countries such matters were secondary to the socialist cause; in Britain they were of its essence.

People's history may also unwittingly have prepared the way for more Conservative appropriations of the national past. Its preference for the 'human' document and the close-up view has the effect of domesticating the subject-matter of history, and making politics seem irrelevant – so much outside noise. Its very success in rescuing the poor from the 'enormous condescension' of posterity has the unintended effect of rehabilitating the past, opening the nation retrospectively to the excluded. The focus on 'domestic budgeting' and poor people's survival strategies underwrites the values of good housekeeping. The recycling of old photographs – a feature of the 'new' social history – also provides subliminal support for Conservative views of the past. It is difficult to think of the family in terms of oppression and insecurity when photographs testify to its stability and grace.

'Victorian values' were being rehabilitated in the public mind, or at any rate in the public taste, for some twenty years before Mrs Thatcher, in the run-up to the 1983 general election, annexed them to her political platform – not least through the efforts of radical historians such as Asa Briggs, who offered a positive reading of the ideas and institutions of self-help, reminding us that Samuel Smiles, so far from being an apologist for Gradgrind and Bounderby, was a radical doctor and even, in 1839 when he was editor of the *Leeds Times*, a Chartist sympathizer. Victorian slums took on a new lease of life as refurbished cottages – in an age of tower blocks, the very emblem of building to a human scale. Beam engines and pit-shafts painstakingly reassembled in the new museums of industrial archaeology served as a vivid reminder of the time when Britain had been workshop of the world. In another, more sentimental vein, the antiques boom of the 1960s

encouraged a positive revaluation of Victorian family life. Mangles, from symbols of toil, were turned into *objets d'art*; samplers and decorative fire-screens replaced Thomas Hood's 'Song of the Shirt' as emblems of Victorian stitchwork.

It seems that a comparable revaluation is now taking place in relation to the inter-war years. A time in Labour mythology, as in the collective memory of the older working class, of mass unemployment and the means test, of Colonel Blimp and 'love on the dole', it now appears as the epoch when modernity took root in British society, when progressive ideas inched forward in the schools, when the aircraft industry and precision engineering gave British technology a claim to world leadership. The inter-war semi – for so long derided as jerry-building – is now seen as a child of the Arts and Crafts movement and a pioneer of the labour-saving home. Even the sentiment which Mr Chamberlain mustered in support of Munich and Appeasement is now seen in the light of the recoil from the barbarities of the Great War.

I do not think radicals ought to press their objections to all this too closely since, as the public controversy about 'Victorian values' suggest, there are no historical propositions which are insulated from contrary readings. If radicals are fearful that resurrection domesticates the past, and by making it too familiar robs history of its terrors, there are others, at the opposite end of the political or pedagogical spectrum, who are no less convinced that the new history is turning out a nation of subversives. Here is the aggrieved letter of one of them. It appeared in a recent issue of the *Daily Telegraph*:

PUT NELSON BACK ON HIS PEDESTAL

Sir – I have recently visited HMS *Victory* in Portsmouth Dockyard, and was both perplexed and disappointed by the commentary given by the guide.

As a child I remember being fascinated by the description given by the sailor who was then our guide, not only of the function of the ship's equipment and weapons and the duties of all who sailed in her, but of the battle of Trafalgar and its place in our history.

But now *Victory* is presented simply as an ancient artefact. The guide dwells mainly on the dreadful conditions suffered by the men below deck and the punishments meted out to them by the officers, who enjoyed great comfort on the deck above.

No mention is made of that fact that all these officers, including Nelson, would have gone to sea as midshipmen, aged as young as 10; they would have lived and worked on the same decks as the men, going aloft with them to handle the sails. There was no purchase of commissions in the Royal Navy, so they would have risen to become officers only if they had mastered the skills of seamanship required to sail and fight.

Nelson's death is now presented as little more than an incident at the battle of Trafalgar. Anyone without historical knowledge might think he died just because he was standing carelessly on deck at the time. There is no explanation of why Nelson and his flagship have been held in such esteem by the nation. No reference is made to his genius,

the signalling innovations he used, or his new tactics which enabled
him to win his great battle.

 This is deplorable today, when so little history is taught in many
schools. We need our national heroes as never before.

<div align="right">Jean Gordon, Petersfield, Hants.[43]</div>

Notes

1 For some of the difficulties and excitements of this, Harry Haskell, *The Early Music Revival* (London: 1988); Tess Knighton and David Fallows (eds), *Companion to Medieval and Renaissance Music* (London: 1992), Christopher Page, *Discarding Images: Reflections on Music and Culture in Medieval France* (Oxford: 1993).

2 For the way these museums have become national monuments in their own right, see Ronald Maddox's 'Industrial Archaeology' postage stamps of 1989 – with pictures of Ironbridge; St Agnes tin mine, Cornwall; New Lanark mill; and a Clwyd viaduct. They are reproduced in *The Stanley Gibbons Books of Stamps and Stamp Collecting* (London: 1990), p. 76.

3 Fredric Jameson, *Postmodernism, or the Cultural Logic of Late Capitalism* (London: 1992).

4 The philatelic revolution, to follow the numerous diary entries Benn devotes to it, was undertaken in a modernizing spirit. He wanted to get the Queen's head off the postage stamps (an object in which he was defeated by the guile of the Palace, and the outrage of the Establishment); to democratize, or broaden, the iconography of national life; and to reflect best – practice contemporary design. David Gentleman, his fellow worker, or conspirator – 'about my age and . . . undoubtedly one of the best . . . stamp designers in this country' – shared Benn's radicalism, but artistically he was a late offspring of English neo-romanticism, having trained under Edward Bawden. In his postage designs, as in his 'Eleanor Cross' mural, which gives Charing Cross tube station a striking medieval motif, or his illustrations to the Suffolk oral histories of George Ewart Evans, he seems closer in spirit to the book of illustrations of Walter Crane or Thomas Bewick than to either Festival of Britain modernism or 1960s pop art. In any event, from Benn's time onwards postage stamps have been resolutely historical, pouncing on commemorative occasions, and giving a public platform for such historicist enthusiasms as industrial archaeology. For the struggle with Buckingham Palace, see Tony Benn, *Out of the Wilderness: Diaries 1963–7* (London: 1987), pp. 218–20, 229–32, 234, 237, 279–82, 284–5, 287–8, 296–300, 313, 316–17, 364–5, 391–3, 408–9, 411–15, 420, 428–31. For David Gentleman's historicism, see his *Britain* (1982); his *London* (1988) and the *pièce justificatif* for his design on the Northern Line platform at Charing Cross, *A Cross for Queen Eleanor: the Story of the Building of the Medieval Charing Cross* (London: London Transport, 1979). *Design in Miniature* (London: 1972) is an autobiography; and *A Special Relationship* (London: 1987), an unexpectedly fierce little portfolio of sketches directed against Mrs Thatcher and President Reagan.

5 *Early British Trackways* (1922) was the first book of Alfred Watkins, the original creator of the idea of ley-lines. Jennifer Westwood, *Albion, A Guide to Legendary Britain* (London: 1985) is a place-by-place inventory of such legends.

6 John Michel, *A Little History of Astro-Archaeology – Stages in the Transformation of a Heresy* (London: 1979).

7 John Michel, *The Old Stones of Land's End: An Enquiry into the Mysteries of Megalithic Science* (London: 1974), quoted, with suitably critical commentary, in Tom Williamson and Liz Bellamy, *Ley-lines in Question* (Tadworth: 1983).

8 Williamson and Bellamy, *Ley-lines,* p. 149 quoting Michel, *A Little History*.

9 Richard Mabey, *The Common Ground: A Place for Nature in Britain's Future* (London: 1980), pp. 69, 142. This book, written for the Nature Conservancy Council, uses photography quite brilliantly. The writer is also keenly aware of the historicity of the landscape.

10 The Arboricultural Association was formed in 1964 at the same time as a group of tree surgeons formed the Association of British Tree Surgeons and Arborists. Ten years later the two societies merged to form the Arboricultural Association. *Environment World*, (March 1992).

11 Oliver Rackham, *Trees and Woodlands in the British Landscape* (London: 1990), p. 198.

12 Hugh D. Westacott, *The Walker's Handbook* (London: 1979); *Long Distance Footpaths and Bridleways* (Countryside Commission, 1975). I am grateful to Alun Howkins for this reference.

13 Senlac Travel, 'Long Distance Walk', 1992.

14 Martin Robertson, *Exploring England's Heritage: Dorset to Gloucestershire* (London: 1992). Old packhorse bridges and drovers' tracks also seem to be favoured for these long-distance walkers' routes.

15 *English Heritage Monitor* (1980): 25. The museums explosion, though it took a decade to get under way, was greatly facilitated by the Local Government Act of 1964, which empowered county councils and town hall administrations to start their own museums, and to resource them with services and staff. This also seems to have been the Act under which county councils began to employ archaeologists, and later to form archaeological units.

16 'The Study of the Family in England has simply not begun': Keith Thomas, conference address on 'History and Anthropology', reproduced in *Past and Present* (April 1963): 15.

17 Institute of Historical Research, interviews with historians, Peter Laslett interviewed by Keith Wrightson. Also *The World We Have Gained – Essays Presented to Peter Laslett*, ed. Lloyd Bonfield (Oxford: 1986).

18 Royston Gambier, president of the Federation of Family History Societies, quoted in 'Digging Your Family Roots', *Morning Star*, 7 July 1979.

19 The 'Vanishing History' exhibition, which later went on tour, was designed 'to draw public attention to the need for the recording of old buildings due for demolition', *Amateur Historian* 5(6) (Winter 1963): 197. It is interesting that the summit of conservation ambition, in 1963, was to *record*; there was as yet no idea that the threatened buildings might be *saved* – i.e. listed and statutorily protected against clearance and vandalism.

20 Gordon Winter, *A Country Camera, 1884–1914* (Newton Abbot, Devon: 1972). John Gorman, *Banner Bright: An Illustrated History of the Banners of the British Trade Union Movement* (Harmondsworth: 1976). 'Disappearing Battlefields' is currently the focus of a great deal of campaigning, both by the recently formed Battlefields Trust and by individual causes, such as the Friends of Naseby Battlefield. 'Our Backyard', *Observer*, 10 July 1990; 'Objectors Fight to Save the Site of a Yorkist Victory' *Independent*, 6 August 1993.

21 '£300,000 Facelift for Historic Gents', *Independent*, 10 May 1993.

22 Christopher Baglee and Andrew Morley, *Street Jewellery: A History of Enamel Advertising* (London: 1978); and *More Street Jewellery* (London: 1982). Also see *The Ephemerist*, the quarterly journal of the Ephemera Society.

23 *Yesterday's Junk, Tomorrow's Antiques*, ed. James Mackay and John Bedford, (London: 1977), p. 124; A. Ball, *The Price Guide to Potlids* (London: 1970); David Griffith, *Decorative Printed Tins* (London: 1979).

24 For a description, Debra Shipley and Mary Peplow, *The Other Museum Guide* (London: 1988), p. 210.

25 The title of a splendid exhibition at the Church Farm House Museum, Hendon, 22 August–4 October 1987. It used the 'Silver' collection of inter-war furnishings, but had the wit to see that many of the pieces in an inter-war semi would have been second-hand or inherited.

26 A feature on weekend breaks in the *Wigan Evening Post*, 30 June 1993, summarizing the attractions of Norwich, features Colman's mustard shop and museum while omitting the cathedral entirely.

27 Brian Southall, *Abbey Road: The Story of the World's Most Famous Recording Studios*, (Cambridge: 1982); Granada Studios Tour brochure, 1991.

28 One of them is on display at the Brewhouse Yard Museum, Nottingham. For an example of a preservation order, *Preservation: Dawn of the Living Dead* (Cumbernauld: 1986).

29 Stanley Alderson, *Housing* (Harmondsworth: 1962), p. 43.

30 See *Traditional Homes* (May 1988), for Northfield Gardens, 'a classic inter-war council housing scheme'.

31 Stefan Muthesius, *The English Terraced House* (London: 1982).

32 'The council houses with their means of pleasanter living': Geoffrey Grigson, introduction, in George Bourne, *Change in the Village* (London: 1955), p. xv. 'The tied cottage is rightly regarded by agricultural workers as one of the most serious evils of rural life': Labour Party, *Our Land, The Future of Britain's Agriculture* (London: 1943).

33 *Amateur Historian* 7(8) (1963): 282.

34 W. G. Hoskins, *Chilterns to the Black Country* (London: 1951), pp. 26–7.

35 Walter Pickles, *Our Grimy Heritage* (Fontwell: 1971).

36 Simon Fowler, *Army Records for Family Historians* (London: Public Record Office, 1992); Michael and Christopher Watts, *My Ancestor was in the British Army: How am I to Find out about Him?* (London: Society of Genealogists, 1992); Norman Holding, *More Sources on World War One*, 2nd edn (Birmingham: 1991).

37 David T. Hawkings, *Criminal Ancestors: a Guide to Historical Criminal Records in England and Wales* (Gloucester: 1992).

38 Keith Thomas, *Man and the Natural World: Changing Attitudes in England, 1500–1800* (Harmondsworth: 1983).

39 Oliver Rackham, *The History of the Countryside* (London: 1986).

40 'Wild life in the city', *Green Magazine* (October 1989); Bob Gilbert, *The Green London Way* (London: 1991). More generally, Oliver Rackham argues that these woods – a limb of ancient royal forest – 'have almost certainly fared better under urbanisation than they would have done had they remained rural. . . . They have been loved and appreciated by a large population, and have been managed by a succession of sympathetic people . . . urbanization has brought its problems of dogs, rubbish, horses, and minor encroachment; but these are small matters compared to the destruction of replanting which have been the

fate of many rural woods.' Oliver Rackham, *The Ancient Woods of England: The Woods of South-East Essex* (Rochford: 1986), p. 108.

41 Don Steel, *Discovering Your Family History* (London: 1980); Stan Newens, 'Family History Societies', *History Workshop Journal* 2 (Spring 1981).

42 *Cockney Ancestor* (Summer 1980): 29; (Spring 1982): 3.

43 'Letters to the Editor', *Daily Telegraph*, 14 March 1994.

Chris Rojek

FATAL ATTRACTIONS

Fatality is a striking feature in the landscape of postmodernism. The excremental culture, which Kroker and Cook (1986) and Baudrillard (1990) negotiate, is choking with mass-produced commodities, simulated images and self-negating utopias. Meaning has been replaced with spectacle and sensation dominates value. What evidence is there in contemporary leisure forms to support this assertion?

The 1970s and '80s certainly witnessed gigantic capital investment in escape areas organized around spectacle and sensation. From private sector initiatives, like the Alton Towers leisure park, to local government tourist projects, like South Tyneside's 'Catherine Cookson Country' or Nottingham's 'Robin Hood Country', new leisure space was constructed around fictional and mythical themes (Urry, 1990: 144–53). The specific theming of space was often eclectic, fusing, for example, references of locale with artefacts of the culture industry. However, meta-themes can be detected which enable us to classify these new escape areas into four types:

(1) *Black Spots*: these refer to the commercial developments of grave sites and sites in which celebrities or large numbers of people have met with sudden and violent death. Examples include the recreation space constructed at the junction of Highways 466 and 41 near Cholame, California, where James Dean died in an automobile crash; Graceland where Elvis Presley died and is buried; the Grave Line Tour of Hollywood which takes in the suicide sites, assassination points and other places of death involving stars of the movie and pop worlds; Auschwitz, the Bridge over the River Kwai, and the Killing Fields of Cambodia.

(2) *Heritage Sites*: these refer to escape areas which attempt to re-create events and the ways of life of former times. Two subtypes can be identified in this

category: (i) *performance sites*, in which actors and stage sets are used to re-enact the past, e.g. the staged attractions at Beamish Open Air Museum, Newcastle; the Wigan Pier Heritage Centre; the Plimouth Plantation, New England, and the village of Waterloo, New Jersey; (ii) *tableaux*, in which models, audio-animatronics and laser systems simulate the past, e.g. the Jorvik Centre in York; the Crusades Experience, Winchester; the Oxford Story, Oxford; and the Disney Hall of Presidents.

(3) *Literary Landscapes*: these refer to escape areas which are themed around the lives of famous novelists and the characters from their fiction. Hotels, tour companies, gift shops, refreshment centres and museums all exploit these imaginary landscapes. Examples include 'Hardy Country', Dorset; 'Dickensworld', Rochester; 'James Herriot Country', Yorkshire'; 'Brontë Country', Yorkshire; 'Lorna Doone Country', Somerset; 'Land O' Burns', western Scotland; 'Steinbeck Country', the Monterey Peninsula; 'the landscape of the Beats', North Beach, San Francisco; 'Hemingway Country', Key West, Florida and Sun Valley, Idaho.

(4) *Theme Parks*: these refer to themed leisure parks organized around serialized spectacles and participant attractions. Common features include fantastic and bizarre landscapes, exotic regions and 'white knuckle' rides. Although the origins of many of today's most popular theme parks lie before the 1970s and '80s, it was during this period that many engaged in a vigorous and sustained dash for growth involving vast capital outlay and the dramatic expansion of attractions. Examples include the Alton Towers complex in the Midlands; the Chessington World of Adventures, Surrey; De Efteling Park in Eindhoven, southern Netherlands; Phantasialand, western Germany; the Disney Parks in California and Florida; and the Universal Film Lot in California.

In what follows I shall expand upon each leisure form, describing its attractions and giving examples. Although I shall comment upon how these forms relate to postmodernism in passing, my considered remarks on this subject will be postponed until the final section of the chapter. The order of my discussion will follow the listing above.

Black spots

When news of the explosion of Pan-Am Airlines Flight 103 over Lockerbie in Scotland on 21 December 1988 was broadcast, one of the immediate effects was the arrival of scores of sightseers at the scene of the catastrophe. Next day newspapers reported a six- to seven-mile traffic jam on the main road to Lockerbie; and the AA were quoted as estimating that they had received over 2,000 enquiries from people asking for the best route to the crash site.[1] The incident is not isolated. For example, in March 1987, the media reported that crowds of sightseers had flocked to the shores of Zeebrugge where the ferry *Herald of Free Enterprise* had capsized a few miles out to sea drowning 193 people. 'Some motorists', reported one newspaper,[2] 'left their cars in neighbouring towns and walked several miles

to Zeebrugge, complete with sandwiches.' Likewise, in April 1988, the press reported police criticism of sightseers who had travelled to Larnaca Airport to view the siege on board the Kuwait Airlines Boeing 747 (Flight 422). It was reported that ice-cream vans had arrived on site to supply the onlookers with snacks.[3]

The interest in catastrophes and disasters might seem to be distasteful. However, it would be foolish to deny that it is widely shared. Death sites and places of violent death involving celebrities or large numbers of people, almost immediately take on a monumental quality in our culture. One commercial expression of this is the death tours now offered by increasingly large numbers of tour operators. For example, the Dallas Tourist Board offers visitors an itinerary which explores the essential geography of the shooting of President John F. Kennedy. The visitor, the witness of the monumental scene, is taken down the route to the junction of Elm and Houston. He or she is asked to stand in the spot where the Presidential motorcade passed the Texas Book Depository, and to scrutinize the sixth-floor window where the alleged assassin, Lee Harvey Oswald, fired the fatal bullets. One is asked to project oneself into the past. Another example of a commercially successful death tour is Grave Line Tours in Hollywood, California which takes tourists on a 2½-hour trip around the 'Deathstyles of the Rich and Famous'. [. . .]

One of the most prominent examples of black spots as tourist attractions are metropolitan and national cemeteries. Here one can almost speak of a league table of the most famous cemeteries in the world: the Arlington National Cemetery in Washington where the remains of President John F. Kennedy, Senator Robert Kennedy, Joe Louis, President William Taft and Audie Murphy lie buried; Westwood Memorial Park in Los Angles, where stars including Marilyn Monroe, Natalie Wood, Donna Reed, Richard Basehart and Oscar Levant are interred; Hollywood Memorial Park where the graves of Douglas Fairbanks, Senior, Rudolph Valentino, Peter Finch, Nelson Eddy, Tyrone Power, Nelson Riddle, Bugsy Siegel and John Huston can be found; the *sepulture* of Père Lachaise in Paris where lie the remains of Apollinaire, Balzac, Sarah Bernhardt, Chopin, Doré, Eluard, Max Ernst, Ingres, La Fontaine, Nadar, Gérard de Nerval, Piaf, Pissarro, Proust, Raymond Radiguet, Seurat, Signoret, Visconti and Oscar Wilde; the Montparnasse Cemetery in Paris, where, among others, Baudelaire, Tristan Tzara, Guy de Maupassant, César Franck and Saint-Saens are interred; the San Michele Cemetery in Venice where Stravinsky, Diaghilev, Ezra Pound and Frederick 'Baron Corvo' Rolf are buried; the Protestant Cemetery in Rome where one can find the graves of Keats, Shelley and Gramsci; and, of course, Highgate Cemetery (East and West) in London where lie the remains of Karl Marx, George Eliot, Ralph Richardson, Jacob Bronowski, Michael Faraday, Radclyffe Hall, Sir Edwin Landseer and Christina Rossetti.

Bourgeois culture constructed the cemetery as a place of dignity and solemnity. Visitors were expected to show proper respect for the dead. The vast scale of Victorian mausoleums and statuary was intended to reinforce this message. However the action of Modernity operated to break down the barriers between the sacred and the profane, the closed world of the cemetery and the outside world of commerce and spectacle. With the rise of mass tourism, the metropolitan

cemetery, with its collection of illustrious corpses, became a sight to see just like any other monument. Today, the most regular visitor to the star cemeteries is in fact the tourist; and the most common accessory they bear with them is not a bunch of flowers, but a camera.

Jim Morrison's grave in Père Lachaise illustrates the extent to which the search for spectacle has replaced the respect of solemnity. Morrison, of course, was the Rimbaudesque lead singer and rock poet with the influential 1960s band, The Doors. He died suddenly and unexpectedly in Paris in 1971.[4] His grave has become a *cause célèbre* among the old-style Parisian establishment who wish to maintain the sacred aura of the city's leading cemetery. It is easy to find. Graffiti – JIM with an arrow underneath – is daubed into various tombstones *en route*. A newspaper report from 1990 described the gravesite as 'a defaced, urine stained Mecca'.[5] Certainly, empty wine bottles and beer cans are regularly deposited on the site. The surrounding crypts are scrawled with graffiti. A bust of the singer which adorned the site was stolen in the 1980s.[6] The headstone is now strewn with dead flowers and empty wine and tequila bottles. The aura of this site depends upon its distance from the conventions of the bourgeois cemetery. Benjamin proposed that distance was the indispensable requirement of the auratic object. However, in Benjamin's sociology aura tends to be associated with cultural elevation and the refinement of sensibility. Against this, the aura of the Morrison gravesite stems from the palpable degradation which it conveys. The site is socially organized precisely as the derangement of the stock bourgeois values of dignity, solemnity and respect.

One of the characteristic themes in postmodernism is that duplication and reproduction abound in contemporary culture. The simulation of objects and experiences calls into question the status of history and reality. Cinematographic and televisual technologies are crucial in bringing about the vapourization of reality. The representations which they promote are more real than reality itself (Baudrillard, 1983, 1988; Kroker and Cook, 1986: 268–79).

The leisure forms constructed around black spots certainly give signs of repetition-compulsion and seeking the duplication of experience. Three examples may be referred to at this stage in the discussion. To begin with, take the case of the James Dean fan club. James Dean died in a car crash near Cholame on 30 September 1955 at 5.59 p.m. Every year on that day a procession of 1949 Mercs and 1950 Fords, driven by fans of Dean, arrives at the spot where the crash occurred in time for the exact moment of the crash. Not only do the fans visit the black spot, but they fastidiously take the same route that Dean followed from Los Angeles on his last day. Mile for mile, and moment for moment, they try to repeat the sights, sounds and experiences that their hero experienced on the journey. Here the black spot functions not only as a monument to the dead hero, but also as the touchstone to a whole way of life which has been submerged in time. The fans take pride in the period authenticity of their automobiles and their 1950s style of dress (Beath, 1986: 10).

The second example is provided by the twenty-fifth anniversary of John F. Kennedy's assassination. Kennedy, the 36th president of the United States, was shot at approximately 1.56 p.m. Central Standard Time on 22 November 1963. He was pronounced dead about thirty minutes later. [. . .] On the occasion of

the twenty-fifth anniversary of the assassination, at precisely 1.56 p.m., a Dallas cable telephone channel replayed four full hours (uninterrupted by commercials) of NBC's original assassination coverage. The tragedy was replayed as spectacle. Viewers were invited to follow the events as they unfolded – or rather, as they unfolded again. The sign and the real were treated as equivalent. The presence of events in the contemporary-life world was not compromised by their material absence. The simulation was presented as a 'live' event.

The third example refers to Graceland, Tennessee. Elvis Presley died in Graceland on 16 August 1977. He was buried in the grounds. Every year on the anniversary of his death, thousands of people take part in a candlelight vigil. They take the journey to Graceland along the Elvis Presley Boulevard, and file past the Meditation Gardens where Elvis is buried along with his mother, father and grandmother. Hundreds linger on until the dawn breaks on the actual anniversary of his death, lighting a succession of candles. Throughout the year, tour operators present visitors with the Elvis experience. Tourists are invited to walk where he walked, sit where he sat, see what he saw. His personal cook has been employed to prepare Elvis's favourite dishes. Tourists are therefore given the chance to actually enter Elvis's bodily experience. By consuming the food that he consumed, by being catered to by the same cook that catered to him, one receives the illusion of knowing what it was like to be Elvis. [. . .] Graceland radiates with Elvis's presence, or, at least the Presley Estate's version of what Elvis actually was. And this sense of Elvis's presence in contemporary life is hardly apocryphal. Sightings of him occur constantly. [. . .] In 1989 the sightings became so persistent that the *Sun* newspaper in London offered £1 million to anyone who could prove that Elvis was still alive.[7]

Baudrillard, writing on the omnipresence of simulation in contemporary culture, submits that

> the unreal is no longer that of dream or fantasy, of a beyond or within, it is that of a *hallucinatory* resemblance of the real with itself. To exist from the crisis of representation, you have to lock the real up in pure repetition.
>
> (1983: 142)

The leisure forms described above are indeed activities of pure repetition. The commercial development of black spots encourages the tourist and the fan to project themselves into the personalities, events and ways of life which have disappeared. But this projection could not be accomplished at all unless the personalities and ways of life were not so omnipresent in our culture through audio-visual media. 'What is real', comments Tagg, 'is not just the material item but also the discursive system of which the image it bears is part' (1988: 41). Electronic audio-visual culture emphatically presses the past upon us. Through bio-pics, drama documentaries, mini-soaps, repackaged recordings and re-released movies, the past is rendered 'contemporaneous' with the present.

The cult of nostalgia was, of course, the inevitable consequence of the progress of modernity. The 'constant revolutionizing of the instruments and relations of production' (Marx and Engels, 1848: 38), which the nineteenth century established as 'normality', made the flight into the 'calmer', 'resplendent' pre-modern past

seem like a magnetic attraction for large numbers of the Victorian intelligentsia. In the Pre-Raphaelites' return to medieval England, Tennyson's popular cycle of poems organized around the Arthurian legends, and the 'classicist' photography of Francis Frith, Julia Margaret Cameron and James Craig Annan, do we not find evidence of strong aesthetic and ideological associations with the past as a place of peace and splendour? Simmel's essay on 'The ruin' (1965) recognized the prevalence and force of nostalgia in modernity. 'The ruin', he wrote, 'creates the present form of a past life, not according to the contours or remnants of that life, but according to its past as such' (1965: 265). Simmel rejects the idea that nostalgia is a cultural effect, a matter of technique, staging or re-enactment. If the ruin infuses us with a sense of nostalgia it is, he wrote, because 'where the work of art is dying, other forces and forms, those of nature have grown' (1965: 260). Nothing illustrates the contrast between human work and the remorseless effect of nature so unequivocally.

Of the black spots described in this chapter it is perhaps, only cemeteries that meet Simmel's criterion of nostalgia. They are clearly on the edge between culture and nature, and the physical decay of headstone, effigies and epitaphs only serves to make the contrast more poignant. Perhaps this is one reason why people visit cemeteries in such large numbers.[8] The other black spots described above have a staged, sensational quality which corresponds with Debord's discussion of the spectacle. Debord writes:

> The spectacle presents itself as something enormously positive, indisputable and inaccessible. It says nothing more than 'that which appears is good, and that which is good appears'. The attitude which it demands in principle is passive acceptance.
>
> (1967: 12)

Debord goes on to anticipate an argument which postmodernist authors elaborated in the 1970s and '80s. That is, contemporary society is permeated with spectacle to such an extent that modernist distinctions between real and the imaginary are no longer valid. I shall return to this argument in the final section of the chapter. However, before doing so I want to shed more light on the blurring and elimination of distinctions between the real and the imaginary by examining contemporary attempts by the leisure industry to display and re-enact the past: heritage sites.

Heritage sites

'Robin Hood is alive and well and living in Sherwood Forest,' declares the Nottinghamshire County Council's Leisure Services Department 'Special Break' brochure for the spring and summer of 1989. Robin is the lead item in the city's tourist attractions. A colour picture of his statue near the city castle appears on the cover of the complimentary Nottingham 'General Information and City Centre Map'; and a cartoon of his smiling face (evidently a simulacrum of the face of Errol Flynn who played the famous outlaw in the successful Hollywood film of Robin Hood in the 1930s), dominates the council's 'Special Breaks' brochure for

spring and summer 1989. Robin's image has also supported several private sector leisure initiatives in the city. Among the most ambitious is the 'Tales of Robin Hood' centre which opened in 1989 at the cost of £1.9 million.

[. . .]

But there is a problem with this hawking of civic pride. Historical authorities submit that Robin existed in folklore rather than fact. 'Robin's activities', declares Holt flatly, 'were not recorded by any contemporary chronicler. No one says that he knew him or had seen him. No one could point to authentic records of his activities' (1982: 40) Holt argues that Robin Hood was the mythical expression of the interweaving of numerous medieval and Tudor folktales, ballads and romances. The most powerful of these emanated from the north of England and locate Robin's activities in the Barnsdale region of Yorkshire; which is many miles from Nottingham's Sherwood Forest (Holt, 1982: 188). Even historians who are more sympathetic to the proposition that Robin did exist as a real person, insist that his relationship with Nottingham is dubious. [. . .]

However, as a myth, as a discursive system which has real effects on the way in which community and free time practice and association are organized, the legend still has enormous power in Nottingham. For example, in 1988 the city council issued a new tourist leaflet. It conceded that the legend of Robin Hood would always occupy a special place in the history and life of the city. At the same time, the leaflet pointed out that many aspects of the legend were questionable. [. . .] The leaflet was the object of ferocious criticism in the city. The Nottingham Robin Hood Society was reported as stating that 'the city has a golden egg which they should be making the most of, not trying to spoil', while the City Council Conservative group tabled members of the Tourism Committee 'to destroy the offending leaflet after world-wide protests'.[9]

Eco (1986: 7), in his inventory of hyperreality, comments upon the organization of new leisure forms based upon simulation, spectacle, impact and sensation, in which 'absolute unreality is offered as real presence'. The aim of these leisure forms, continues Eco, is to supply a 'sign' which will immediately be accepted as reality. This preoccupation is very evident in the planning and commercial development of heritage sites. 'Reality' is 'convened' by the use of two methods: (1) the employment of actors and stage sets to re-enact the past; (2) the design of tableaux in which holography, soundtracks, moving 'time cars', trick lighting and other special effects 'transport' the visitor back in time. In fact they are often mixed in heritage sites to add variety to the attractions. However, for the present purposes I will treat them in a ideal-typical way as separate categories. First, let me give some examples of 'performance sites', in which actors and stage sets operate to create a sense of historical reality.

One of the chief attractions in 'Plymouth Country', New England, where the Pilgrim Fathers landed in 1620, is the artificially constructed Plimouth Plantation heritage site. This 'outdoor museum' aims to re-create the 1627 settlement of the Pilgrims. Aboard *Mayflower II* which is docked in Plymouth harbour, 'interpreters' play the parts of the crew and passengers who made the 1620 voyage. Visitors are encouraged to pay to go on board and meet them.

[. . .]

At Wigan Pier, Lancashire, 'The Way We Were' heritage centre employs a team of seven actors to re-create life in the north-west at the turn of the century. The centre is financed and administered by Metropolitan Wigan Council and its tourist leaflet for the site invites you to

> Enter the world of 'The Way We Were' and step back into the year 1900. This is how the people of Wigan, Leigh and other local communities were at the turn of the century; how they lived, loved, worked, played and died. Start in the fantasy world of the Wigan Pier joke or join Wiganers on their all-too-brief annual Wakes Week holiday . . . experience life below ground at the coalface, see the work of the famous Lancashire pit brow lasses and feel the horrors of the Maypole colliery disaster. . . . Above all, talk to the people of 1900. In the schoolroom become a child once more and experience the rigours of a strict Victorian education. In the collier's cottage speak with the family, hear their hopes and share their sorrows. Peep into the Mayor's parlour as he tries on his ceremonial robes for the coronation of Edward VII; bargain in the markets with stall holders and talk with the young volunteer, off to South Africa and the Boer war.

Wigan Pier is presented as 'part theatre, part museum'. In common with many other heritage performance sites, for example, the Black Country Museum (Dudley) or the Beamish Open Air Museum (near Chester-le-Street), the educational role of the centre is stressed. Wigan Pier employs three full-time teachers to lead up to 200 children in project work. More generally, the exhibitions of life are designed to fulfil an educational purpose for adults. Many of the staged events focus on actors performing vanished or marginalized crafts. For example, the Black Country Museum invites you to 'witness the traditional skills of nailmaking, chainmaking, glasscutting, brass founding or boatbuilding' and to 'see how people lived in days gone by'.

I want to return to the educational purpose of heritage sites, and also to speculate on the reasons why vanished or marginalized crafts are presented as attractions, later in the section. However, before doing so it remains to consider the next main growth area in heritage sites: tableaux. 'Canterbury Pilgrims Way' is a tableau which offers 'modern pilgrims' the experience to 'tread again in steps worn 600 years ago', with Chaucer's pilgrims. In the words of the travel brochure:

> As your journey unfolds you experience authentic, unforgettable sights, sounds and smells of 14th-century life. Along the dusty stretches of road, five of your companions, the bawdy Miller, the courtly Knight, the Wife of Bath, the Nun's Priest and the Pardoner will recount their colourful stories of chivalry, romance, jealousy, pride and avarice.

The leaflet also emphasizes the educational purpose of the exhibition.

> Everything you encounter [it maintains] in The Canterbury Pilgrims Way enthrals as well as explains. Students discover a living world not

found in study programmes about Chaucer. People fascinated by the past find the textures of life that books alone cannot convey.

The Canterbury Pilgrims Way experience is far from being the only major capital investment heritage project themed around a tableau which was developed in Britain in the 1980s. For example, in Windsor, the 'Royalty and Empire' heritage centre offers tourists 'the experience of another lifetime'. The theme of the centre is the Diamond Jubilee of 1897.

[. . .]

'Postmodernism', asserts Foster, 'is marked by an eclectic historicism, in which old and new models and styles . . . are retooled and recycled' (1985: 121).[10] Eclectic historicism has certainly been the style of the performance sites and tableaux developed by the heritage industry in the 1980s. For example, the Jorvik site in York is generally regarded as one of the most successful heritage attractions developed in Britain during the 1980s. The site consists of a tableau representing the sights, sound and smells of the Viking city of Jorvik. One is 'whisked back through the centuries' by 'time cars' into 'a journey to real-life Viking Britain'. Adjacent to the tableau is a reconstruction of the archaeological dig 'exactly where it took place'.[11] The contemporary excavation and the re-erected tenth-century buildings and objects found in them are preserved together in absolute equivalence. Similarly in major performance sites in Britain, like the Beamish Open Air Museum and 'The Way We Were' exhibit in Wigan Pier, authentic historical buildings and artefacts are preserved and actors in period costume present themselves as real living people from the past. The authentic and the inauthentic are displayed as equivalent items.

The staging and display of heritage sites in the 1970s and '80s through performance sites and tableaux, involved not only the preservation of items from the past, but also simulating a context for them. Invented people were produced to personalize history. [. . .] The aim was to increase the attraction value of heritage. Design values of impact, drama and sensation were particularly important at a time in which government funding of public sector museums and heritage sites was being cut back. Self-finance was the buzz-word in the heritage industry in Britain during the 1980s. This meant not only that heritage had to be preserved, but that it had to look right (Lowenthal, 1985: 263, 293; Wright, 1985: 69; Urry, 1990: 128–34).

Some of the complexities involved in presenting inauthentic 'sights, sounds and smells' as authentic are explored by MacCannell (1973; 1976: 92–102) in his discussion of 'staged authenticity'. MacCannell uses this concept to refer to the use of dramaturgical and other presentational devices to simulate 'real life' for tourists. The concept has an obvious application to tableau and tourist sites discussed above. However, interestingly, MacCannell invests it with deeper theoretical resonance. He submits that modernity dislocates our attachment to work, neighbourhood, town and family. We become interested in 'the real lives' of others. As touristic examples, he mentions the development of tours to society's 'back regions'. That is, areas normally closed off or concealed from our view: factories, coalmines, fire-stations, farms, the stock exchange, bank vaults, ghetto

areas, etc. One ironical implication of this is that as economies de-industrialize, and more flexibility and leisure are created for people, the workplace where we can observe others at work increases its attraction value as a leisure and tourist destination. This certainly helps to explain the attraction of displaying vanished or marginalized crafts in contemporary heritage sites like the Black Country Museum, the Plimouth Plantation, the village of Waterloo and Beamish. The action of modernity, it might be said, destroys traditional crafts only to restage them as objects of display in the heritage industry. The example also illustrates the tendency of modernity to undercut the divisions and dissolve the boundaries which it initiated: back regions are turned into front regions, hidden areas of life become items of exhibition, the past which is 'lost' is 're-created' in the present.

The personalizing of leisure and tourist space, and the use of devices of staged authenticity, is not confined to heritage sites. The same methods have been used widely and intensively in the marketing and organization of literary landscapes. It is to this area that I now wish to turn.

Literary landscapes

Number 221B Baker Street in London is now a branch of a leading national building society. It was also, of course, the home of the fictional detective, Sherlock Holmes, invented by Sir Arthur Conan Doyle in 1854. One of the duties of the marketing staff employed by the building society is to answer the regular letters written to Holmes at the Baker Street address. [. . .] The marketing staff write back explaining that Holmes has retired to the Sussex countryside to pursue his hobby of bee-keeping, and that he no longer undertakes detective work.[12]

The Holmes myth shows no sign of withering away. All of the stories are still in print. Between 1900 and 1980, 60 actors played him in 175 films. Holmes is, in fact, the most frequently recurring character on the screen. Off Trafalgar Square the Sherlock Holmes restaurant features a museum including a reconstruction of Holmes's study. Sherlock Holmes societies organize mystery week-ends in the locations of his most famous stories and tours to the Reichenbach Falls in Switzerland where Holmes disappeared in his final conflict with Moriarty and where actors re-enact the drama. The Holmes myth has even received official sanction through the decision to decorate London Transport's Baker Street Underground station with reproductions of his silhouette, complete with deer-stalker and pipe.

The landscape of Atlanta, Georgia is peppered with references to fictional characters of Rhett Butler and Scarlett O'Hara created by Margaret Mitchell in her famous novel *Gone With The Wind*. Tours of the essential geography of the novel are combined with tours of the main Civil War battle-sites in the area. At the CNN Center in downtown Atlanta, the film of *Gone With The Wind*, featuring Clark Gable and Vivien Leigh, plays every day of the week. The advertisement for the center shows a colour illustration of Rhett and Scarlett locked in a passionate embrace against the backdrop of CNN TV monitors. [. . .] Thus is fiction co-opted in the service of commerce and myth mingles with reality.

Britain abounds in literary landscapes: the 'Lorna Doone Country' of Somerset; 'Daphne du Maurier Country' in Cornwall: 'Brontë Country' and 'James Herriot

Country', Yorkshire'; 'Land O' Burns', western Scotland; 'Dylan Thomas Country' in Carmarthen Bay and the Teifi Valley; 'Catherine Cookson Country' in South Tyneside; 'Shakespeare Country' in the Midlands; 'D. H. Lawrence Country' in West Nottinghamshire; 'The Lake District Country' immortalized by Wordsworth and the Lakes poets: 'Hardy Country' in Dorset; and the 'London' of Johnson, Keats, Dickens, The Bloomsbury Group, etc.

These 'countries' may be formally described as landscapes of imaginative reflection. Their authors certainly drew from the local geography, folklore and people to create fictional representations in their novels. But if this is correct it is just as true that these imaginary landscapes reflect back upon the physical spaces and folk traditions which they sprang from. For example, the 'Casterbridge' of Hardy's 'Wessex' is so real to many people that they experience a sense of anti-climax when they visit the town of Dorchester which was Hardy's model for his imaginary town. However, their sense of being in a place in which the image of Hardy's fiction is reflected is supported by numerous features in the 'real' town. Thus, Dorchester's town planners have permitted certain streets to be called after the names of characters in Hardy's novels. Similarly, a blue plaque has been authorized on the wall of a building in the town centre (now a bank), which proclaims that the building was where Michael Henchard, the eponymous hero of Hardy's *The Mayor of Casterbridge*, 'lived'.

The interweaving of fiction and reality is so strong in some landscapes that local leisure services departments have organized physical space into themed literary 'trails'. Tourists are asked to follow literary landmarks which relate to the fiction of the local novelist. For example, the Medway leisure services department issues a complimentary leaflet for the 'Dickens Trail'. It begins by asserting that Rochester, Chatham and the surrounding countryside is 'synonymous' with the novels of Charles Dickens. Local reference points are defined and their landmark status in Dickens's fiction is revealed. [. . .]

Similarly, in 1985 South Tyneside launched the 'Catherine Cookson Trail'. As with the 'Dickens Trail', physical space is organized around fictional landmark sites. For example, Gambling Man Gallery, in Wapping Street, South Shields, is identified as the setting for Cookson's novel *The Gambling Man*; the Sir William Fox Hotel, Westoe village is revealed as the setting for the events and characters in *Katie Mulholland*; and Marsden Bay, South Shields, is identified as the setting for *Mrs. Flannigan's Trumpet*. . . . Literary landscapes do not just focus on the fictional characters and settings of novelists, they also address features of the novelist's 'real' life. Tour operators are increasingly using this as a theme in the organization of literary landscapes. [. . .] In cities with strong literary associations like London, Paris, Vienna, San Francisco and New York, guided literary walks are fixed features of the local leisure and tourist industry. For example, the Streets of London Company offers weekly tours of 'The London of Sherlock Holmes', 'The London of Charles Dickens' and 'Literary London' which covers places associated with Orwell, Shaw, Pepys, Johnson, Sheridan, Goldsmith and Shakespeare.

The status of 'reality' is, of course, the crux of postmodernism. Frankfurt Marxism proposed that advanced industrial society is a world of drastically reduced meaning. Manipulation, conformity and repression dominate; dissent, diversity and irregularity are not tolerated. Postmodernism takes the opposite view. It proposes

that contemporary society is now so overloaded with meaning that our received methods and criteria of determining fact from fiction and ultimately, the real from the imaginary, have exploded. 'We are gorged with meaning', complains Baudrillard (1987: 63), 'and it is killing us'.

One corollary of this is that the legitimacy of the authorities charged with maintaining order comes under intense attack. Competing groups issue authority claims which not only challenge the legitimacy of the official power structure, but also call into question the 'order' which supports this legitimacy. Literary Landscapes illustrate the point very clearly. We may cite three examples from recent British experience.

In the autumn of 1986, the Ramblers Association held a rally in Brontë Country. The issue was the lack of free access to Stanbury Moor, an area owned by the Yorkshire Water Authority. The Authority operated a policy of barring people from roaming freely over the land which has strong associations with Brontë novels. The Ramblers Association alleged that the Authority was being negligent in its public responsibility to manage the space for recreational use as opposed to merely public utility use. The rally was one of thirty-five protests in the Ramblers 'Forbidden Britain' campaign.[13]

Another example of competing authority claims in respect of the management of a literary landscape refers to D. H. Lawrence Country in Nottinghamshire. In 1988, British Coal announced plans to develop 180 acres surrounding Lawrence's birthplace of Eastwood in Nottinghamshire for opencast mining. The announcement provoked fierce criticism. The Moorgreen and District Action Group launched a protest campaign with Lady Chatterley, the heroine of Lawrence's novel, as the spearhead of the campaign. They argued that to destroy the landscape where Lady Connie 'strolled', and where much of *Women in Love* is also set, would be an act of vandalism. British Coal is presented as an unprincipled marauder attacking an immortal order of things. Which is something of an irony, because similar criticisms were made by contemporaries of Lawrence in respect of the sexual frankness and libertarianism of his fiction. The unavailing local hostility was one factor behind Lawrence's decision to quit Britain for a more equable moral climate.[14] It was not until the 1970s that Lawrence's memory was officially rehabilitated and the local council and private leisure interests began to develop 'Lawrence Country' as a regional tourist resource.

The third example refers to Thomas Hardy Country. Hardy, we know, actively supported the transmogrification of his imaginary landscapes and characters into the 'history' of 'Wessex'. For example, he participated in Hermann Lea's *Guides to Thomas Hardy's Wessex* (first published in 1913), which included directions to, and photographs of, the 'real' places in Hardy's fiction.[15] [. . .] A recurring theme in Hardy's fiction is the annihilation of the countryside and traditional ways of life by the onslaught of modernity. Today, Thomas Hardy's literary landscape is besieged by the same threat. In 1987 and 1990 property developers attempted to reshape Hardy's Wessex by announcing major developments around Stinsford churchyard, which is literally the heart of Hardy Country.[16] [. . .] The plans were resisted by protest groups who accused the planners of attempting to commit an act of sacrilege. . . . They would obliterate the landscape which is at the centre of Hardy's novel *Under the Greenwood Tree*.[17]

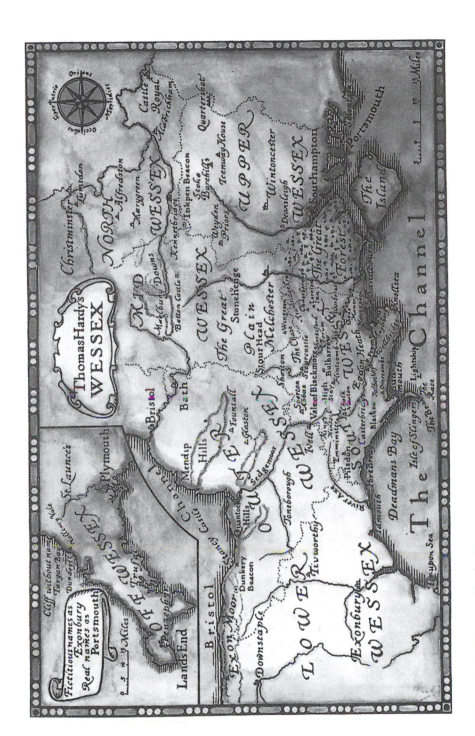

Figure 9.1 Thomas Hardy Country

What these examples show is that literary landscapes have a political signifi-cance in our culture.[18] In a society in which the commodification of physical space is the order of the day, literary landscapes are presented as escape areas which cannot be tampered with. At least, this is the position which is familiar to us in modernist discourse: that troubled discourse which sought to lay down an immortal order of things while, at the same time, recognizing the necessity of progress. However, from a postmodernist standpoint the fundamental question is not the contradictions inherent in this troubled state of things, but rather it is the ques-tion of ontology or, to put it more precisely, the question of what is meant by 'preserving' and 'escaping'.

The postmodernist argument runs like this: the mobility of things is a constant condition. The inevitable corollaries of this are ambiguity and undecidability. Preserving the past in order to escape into it is therefore seen as impossible. For merely to define something as unchangeable alters our relationship to it. Literary landscapes and, for that matter, heritage sites do not preserve the past, they represent it. If this is correct, authenticity and originality are, above all, matters of technique. The staging, design and context of the preserved object become crucial in establishing its 'reality' for us. For example, in the Catherine Cookson Trail the homes where Cookson was born and raised were demolished some time ago in the name of progress. However, their 'presence' is represented by steel street markers which locate the sites of the vanished original buildings. Similarly, the impact of the Streets of Dickens tour in London is diminished by the fact that his two main London houses have been demolished. [. . .] The 'reality' of these absent properties depends upon context. It is a conjuring trick of the tour guide using the props of the marker and the immediate locale to spellbind us.

What implications does the postmodern position have for understanding the political significance of literary landscapes? From a postmodern standpoint, the campaign to save the countryside where Lady Connie 'strolled' or Tess of the D'Urbevilles 'roamed' with Angel Clare, presents a fictional Britain and presents it as reality. The politics of preservation, on this reading, simply confirm the post-modern tenet that we live in a society in which the 'completely real' is identified with the 'completely fake' (Eco, 1986: 7).

Theme parks

The attractions developed in the theme parks of the 1970s and '80s were very varied. The two main factors causing variation were locale and the product port-folio of the managing company. Take the subject of locale first: Thorpe Park in Surrey is a water-based leisure park. It was developed from a series of disused gravel pits. Such sites are often shunned by property developers because the natural water table is exposed on excavation and often restricts building. By treating the water as an asset, the developers of Thorpe Park were able to exploit the char-acteristics of locale as themes for a range of attractions. [. . .] As for the subject of the product portfolios, the managing companies of theme parks organize attrac-tions around their corporate products as and when it is viable. For example, the Walt Disney Company ensures that its attractions at Disneyland, California, and

Disney World, Florida, feature the main Disney cartoon characters. [. . .] Attractions not only reinforce the corporate images of the companies, they also underwrite the market in on-site commodity memorabilia such as T-shirts, watches, pens, bags, stationery, key-rings, slides, etc.[19]

Although there are as many themes as there are theme parks, certain meta-themes recur. In what follows I want to concentrate on the two paramount ones: velocity and time-space compression.

(i) Velocity

[. . .] The Orient Express and Timber Wolf (roller coasters) and Typhoon (water slide) rides at the Missouri Worlds of Fun/Oceans of Fun theme park[20] [. . .] illustrate an obvious and prominent fact about theme park attractions: rides propelling bodies through great speed are a frontline attraction. [. . .]

Can we not see the preoccupation with 'endless motion' which Kroker and Cook (1986: 249) list as an identifying characteristic of postmodernism, expressed in a vivid and concentrated form in these 'white knuckle' attractions? Is there not in the desire to invert the body, to defy gravity, a parallel to be drawn with the inversion and sliding of signs which is at the heart of postmodernist vision? At least one author has thought so. Bennett (1983: 148), writing on the persistence of velocity in theme park attractions, describes the rides as 'inverting the usual rela-tions between the body and machinery and generally inscribing the body in relations different from those in which it is caught and held in everyday life'. Here mere difference and speed are identified as sources of pleasure. No functionalist or grand evolutionary narrative is attributed to them.[21] The fascination with difference for its own sake is also evident in the time-space compression attractions featured in contemporary theme parks. It is to this subject that I now wish to turn.

(ii) Time-space Compression

'This year', declares the Busch Gardens, Williamsburg, tourist leaflet for 1986, 'you can visit England, France, Germany, Italy without leaving the USA.' How is this mirac-ulous feat accomplished? The theme park contains four reconstructions of 'typical' English, French, German and Italian villages. The tour leaflet description of the English village can serve as an example of the general characteristics of the scheme:

> Enter *Banbury Cross* and find yourself surrounded by all the sights and sounds of Merrie Old England. Taste English treats, shop for fine gifts, and thrill to the Olympic style ice show in the Globe Theatre. Visit Heather Downs to see our world famous Clydesdales. Cross the castle drawbridge into Hastings and join in the fun and games of Threadneedle Faire, an authentic Renaissance Carnival.

What strikes the British reader most forcefully about this description is the reck-less eclecticism which it displays. Space and time are dissolved. One crosses a

drawbridge into 'Hastings' and finds oneself in the midst of a 'Renaissance' Carnival called 'Threadneedle Faire'. Signs and attractions obey the necessity of impact and sensation rather than nature or history. 'Merrie Old England' pulsates on the floor of the Globe Theatre in the form of an 'Olympic style ice show'.

The Busch Gardens park attempts to annihilate temporal and spatial barriers by bringing the old country of Europe into the heat of modern America. As such it reflects a common meta-theme in the organization of modern theme park attractions [. . .] In Britain the Chessington World of Adventures includes 'The Mystic East' attraction, boasting the sights and sounds of the Orient. As the tourist leaflet puts it 'Climb aboard the boat which takes you on a magical voyage up and down Dragon River – pass beneath a gigantic Japanese Buddha, through beautiful temples and pagodas, and the magnificent Golden Palace of Bangkok.' Meanwhile, just off the M1, between Derby and Nottingham, is The Great American Theme Park. It showcases simulations of the Niagara Falls, Mississippi paddleboat life, the Santa Fe Railroad, Silver City ('a real Western town') and the El Paso arena.[22]

From the standpoint of postmodernism, the development of time-space compression attractions for amusement does not anticipate a fundamental change in everyday life, it reflects it. For simultaneity and sensation are at the heart of postmodern experience. In the words of Harvey:

> Through the experience of everything from food, to culinary habits, music, television, entertainment, and cinema, it is now possible to experience the world's geography vicariously, as a simulacrum. The interweaving of simulacra in daily life brings together different worlds (of commodities) in the same space and time.
>
> (1989: 300)

Time-space compression attractions give consumer the 'experience' of stepping across continents in seconds or shedding the centuries in minutes. However, as exciting as this may be for us, it could not be accomplished so easily, unless the same principles of compression were operating in the outside world. Psychologically speaking, our resistance to the notion that we 'arrive' in Europe when we enter Busch Gardens, Williamsburg, is disarmed by the circulation of disjointed signs representing remote objects which bombard us as part of the small change of daily life.

I shall return to the implications of the last observation in the closing pages of the next section. However, before doing so I want to try to draw some of the themes in this chapter together by considering the question of the novelty of the attractions considered in the foregoing pages. I want to start with what may, at first sight, seem to be an unusual resource: the sociology of Erving Goffman.

Conclusion: emigrating from the present

Goffman's sociology is essentially concerned with the problem of boundaries. It explores the spatial and cultural settings, the 'frames of interaction', in which social routines, ground rules, excusable infractions, bypassings and tolerated violations are exploited and developed. Goffman (1967) argued that modern society includes

institutionalized 'action places' in which the individual can let off steam and engage in licensed revelry. Examples include casinos, cinemas, sport arenas, strip clubs, amusement parks, race tracks and pool halls. Goffman viewed action places as frames of controlled excitement.[23] They are described as escape centres in which the rules of everyday life are relaxed and the boundaries of social behaviour are rolled back. For example, touching, shouting and frank observing, which are restricted at work and in other places, are tolerated and even encouraged in action places. Goffman writes as if action places offered the individual the opportunity to become a momentary *émigré* from the pressures of work and the prescriptions of 'Society'.

Goffman's concept of action places would *appear* to fit the four leisure forms described in this chapter. For example, theme parks and heritage sites are certainly places in which the rules of everyday life are relaxed and the rules of 'normality' are bypassed in tolerated ways. One sees this not only in the rides and time-space compression attractions, but also the re-enactments of the past using costumed actors or tableaux. Similarly, one of the common denominators behind all four leisure forms is that they seem to offer the experience of momentary escape from the encumbrances and pressures of everyday life.

On the other hand, it is important not to lose a sense of historical perspective. One of the criticisms regularly made of Goffman's sociology is that it is over-absorbed with the present. Because of this it mistakenly implies that social practices and institutions are new, whereas in fact they have a long history behind them. The point is certainly also applicable to the leisure forms described in this chapter. For example, 'white knuckle' rides were a common attraction in nineteenth-century fairs and amusement parks. So were time-space compression attractions and simulations of impossible journeys.[24] [. . .]

A similar general point can be made about the social criticism of the attractions described in this chapter. Contemporary critics fume that history has been replaced with simulations of the past (Horne, 1984; Samuel, 1988). Neil MacGregor, the director of the National Galley in London, bemoaned the introduction of themes in heritage sites on the grounds that they imply that 'the exploration of the past need not be a serious endeavour, requiring time and commitment, but should be in essence undemanding and diverting'.[25] While Hewison (1987), in a widely read study, lamented the development of an amusement industry which, he submits, is intent upon turning the British Isles into an enormous theme park. Is there not a parallel to be drawn here with the argument used by rational recreationists that many popular 'amusements today are inane . . . stupid or aimless' (Cutten, 1926: 75)? And can we not find here an echo of Kracauer's (1975: 67) scornful dismissal of the 'undemanding' and 'diverting' entertainments staged by the capitalist 'distraction factories'?[26] Here then, it might be argued, is evidence of palpable and irrefutable continuity. The popular action places of today are condemned in the same terms as the popular action places of Modernity. That is, they reproduce mere distraction; they fail to elevate the people'; they are not serious enough. In Kracauer's critical commentary there is also the argument that the distraction factories represent a distinct order of things, that is, they exert a determinate ideological effect. The argument is mirrored in the work of contemporary critics like Marin (1977: 54), who castigates the Disneyland theme park on the grounds that it is

a fantasmatic projection of the history of the American nation, of the way in which this history was conceived with regard to other peoples and the natural world. Disneyland is an immense and displaced metaphor of the system of representations and values unique to American society.

From a postmodernist standpoint such criticism betrays a disabling sense of nostalgia. Two points must be made. In the first place, such criticism assumes that society and action places can be managed to produce moral elevation and improvement. The assumption recalls the moral economy of bourgeois society which fetishized the principle of 'a necessary balance' between work and leisure, action and rest, private and public life. For postmodernists the economic, aesthetic, technological and cultural forces unleashed by Modernity have changed our life-world unutterably. The principle of 'a necessary balance' in life has been swept away, like a bridge before a flood, leaving behind a residue of disjointed fragments. The second point is that social criticism of the type at issue, is permeated by the belief that a viable distinction can be made between high and low culture. In refuting this belief, postmodern authors maintain that a series of related modernist beliefs have also collapsed, e.g. progress vs reaction, present vs past, left vs right, modernism vs realism, abstraction vs representation (Huyssen, 1986: 217).

Goffman (1974: 560) criticized William James and Alfred Schutz for holding on to a notion of 'paramount reality' against which the 'multiple lifeworlds' which they drew attention to, can 'finally' be measured. In Goffman's view, 'paramount reality' is simply a contrast term. 'When we decide that something is unreal,' he remarked, 'the reality it isn't need not itself be very real' (1974: 560). Although he exploited this observation to explore specific strips of activity, his sociology stopped well short of claiming that the 'primary frameworks' which society has evolved to help us make sense of 'what is going on' have disintegrated. But this is precisely the claim made by postmodernist authors. For example, Baudrillard, writing on Disneyland, contends:

> Disneyland is presented as imaginary in order to make us believe that the rest is real, when in fact all of Los Angeles and America surrounding it are no longer real, but of the order of the hyperreal and of simulation. It is no longer a question of a false representation (ideology), but of concealing the fact that the real is no longer real.
>
> (1983: 25)

Under postmodernity, it might be said, everyone is a permanent *émigré* from the present. For the present is acknowledged to be a sign system in which images and stereotypes from the past and the future, from the locale and the globe, are implacably intermingled, admitting no principle of determinacy.

One implication of this is that attractions which simply rely on spectacle eventually generate a sense of anticlimax. [. . .] At any rate, the four leisure developments described in this chapter cannot be understood simply as action places or escape centres. The reproduction of attractions designed to stimulate

excitement as an end in itself, is balanced with attractions that aim to provide education and opportunities for sociation. Black spots, heritage sites and literary landscapes are designed not merely to distract us, but also to inform us. What they inform us about may be open to a large number of objections regarding accuracy and relevance. However, there is no mistaking the objective of making these attractions learning experiences and opportunities for wholesome interaction. Theme parks exhibit similar characteristics.

[. . .]

Although it would be unwise to be cynical about the idealistic motive of staging themes in leisure attractions as learning experiences, it would also be rash to ignore the commercial appeal of this strategy for businesses intent on maximizing revenue. For learning is predicted in the idea of development, the idea of adding to one's knowledge and understanding. It involves building on learning experiences, and repeating specific experiences is a necessary part of the process. By developing the theme of attractions as learning experiences, leisure managers and marketing staff create the basis for return visits. In the two Disney parks return visits are estimated to account for 80 per cent of attendance.[27]

The leisure forms described in this chapter support the general proposition that the distinctions between work and leisure, the distinctions between the world of duty and the world of freedom, have lost much of their force experientially, and are therefore of dubious analytic value.[28] In a society in which personal prosperity and security depend so much upon an openness to new channels of communication and receptivity to new information, rather than obedient loyalty to caste or community, it is obvious that leisure forms must change. The way in which they are changing points to the de-differentiation of spaces and signs – an observation which connects with Lash's argument that 'the fundamental structuring trait' of postmodernism is 'de-differentiation' (1990: 11). Bourgeois culture invested certain spaces and signs with an 'auratic' quality. The individual was required to relate to them with gravity, respect and sobriety. If the cemetery provides us with the ideal example it is because of its physical size in the landscape of modernity and its elective affinity with the sacred in bourgeois culture. Who, in bourgeois society, would have dreamt of allowing the cemetery to become a tourist attraction? Yet today, Jim Morrison's grave in Père Lachaise is the fourth biggest tourist attraction in Paris.[29] Who in bourgeois society, would have suggested that the cemetery should be classified as a spectacle or exhibition? Yet today, the National Federation of Cemetery Friends in Britain, ask us to regard cemeteries as 'outdoor museums'.[30] The gravity and solemnity of black spots have been reduced by moves to make them more colourful and more spectacular than other sights on the tourist trail. For example, in 1987 the government of Thailand unveiled plans to restore the famous Death Railway as part of a programme of investment in tourism. An estimated 16,000 Allied prisoners of war and 100,000 Asian labourers died in the process of laying the track connecting Burma to Thailand. Suggested accessories in the investment programme included hotels, eating areas, gift shops and display areas. 'It is as if', protested a spokesman for Burma Reunion, A Death Railway veterans' association, 'Auschwitz was to be reopened as an amusement park.'[31]

Black spots, then, provide a powerful example of the relabelling of signs to convey a more 'leisurely' significance and the redeployment of land use for the purpose of recreation. But one might just as easily refer to the development of heritage sites to illustrate the same principle of de-differentiation. For example, in post-industrial Pittsburgh, redundant steel mills are being renovated as museums and heritage centres;[32] Albert Dock in Liverpool, a former working dock, has been redeveloped as a recreation resource for the north-west, featuring 'The Tate Gallery of the North', 'The Merseyside Maritime Museum' and a variety of shopping malls; in Lothian, near Edinburgh, the Prestongrange and Lady Victoria mining collieries have been closed and repackaged as 'The Scottish Mining Museum'. In the general context of the de-industrialization of the American and British economies, and the switch towards investment in services and the new technology, old work sites are being transformed into centres of leisure and recreation.

[. . .]

Leisureliness is now a generalized quality of our social order. Our lives may be burdened by responsibilities, and we may sweat and hurry to fulfil our daily obligations, but, despite all of this, our existence is surrounded by images of lives of pleasure and lives of charm. The tourist industry is undoubtedly one of the principal conductors of these images. Hoardings, advertisements, television commercials and holiday brochures remind us in arresting and sometimes in aggressive ways, of a life of contrast which is just an airline ticket or railway journey away. If much leisure practice can be criticized for capitulating to the chained activities of everyday life, can we not see the holiday as a genuine form of escape, an example of real emigration, from the obligations of the present in a totally different world?

[. . .]

Notes

1 *Daily Mirror*, 22 December 1988; *Guardian*, 24 December 1988.
2 *Guardian*, 9 March 1987.
3 *Guardian*, 11 April 1988.
4 Mystery still surrounds his death. The official version maintains that he died of a heart attack in his apartment. Another version submits that he died of a drug overdose in a club called 'The Rock 'n' Roll Circus' on rue de Seine. Inevitably, there are also rumours that he never died at all. He just retreated from the glare of the media spotlight to write poetry on a secret island hideaway.
5 Sean O'Hagan: 'With the Pilgrims at Rock's Stinking Shrine', *Sunday Correspondent*, 1 July 1990.
6 When I first visited the site in 1984 the bust was still *in situ*. Someone had placed an imitation joint in its mouth.
7 See 'From the Grave', editorial, *Evening Standard*, 15 February 1989; and Martin Walker, 'The King is Dead, or Long Live the King', *Guardian*, 21 January 1990.
8 In 1989, 600,000 people visited Graceland; 400 miles away in Pilgrim Forge, near Knoxville, Tennessee, there is 'The Elvis Presley Museum' which boasts a collection of authentic Elvis memorabilia – the first dollar bill Elvis ever gave to God

(authenticated by the pastor, who sold it for £4,700); the last sunglasses he ever wore; his pyjamas; his nasal spray applicator; his Flexamatic razor; his bathroom scales; a few pairs of his underpants; and X-rays of his left hand and sinuses.

9 Both quotes are from the *Nottingham Trader*, 16 March 1988 and 30 March 1988.

10 The remark recalls Lyotard's observation on the eclecticism of postmodern style (1984: 129).

11 All quotations come from the complimentary tourist leaflet supplied at the site.

12 All quotations from C. Thatcher, 'Dear Sherlock Holmes', British Airways *High Life* magazine, May 1986.

13 *Guardian*, 6 October 1986.

14 Other important factors were, of course, his health and the public disapproval of his relationship with Frieda.

15 The *Guides* were repackaged by Penguin in 1986.

16 Hardy's heart was buried in Stinsford Churchyard; his ashes are interred in Westminster Abbey.

17 The plans were reported in the *Guardian*, 30 April 1987 and 14 April 1990; and the *Observer* colour magazine, 17 December 1989.

18 And this is a useful corrective to those fallacious views in leisure studies which invite us to view leisure as an 'escape' from the 'paramount reality' of the real world.

19 It is estimated that each visitor to Disneyland spends $25.30, including admission; 47 shops and 31 restaurants and snack bars sell Disney-related products (Gray, 1986: 18).

20 'Coasting and Sliding at 12 of America's Amusement Parks', *New York Times*, 13 August 1989, pp. 14–17.

21 However, elsewhere in his discussion Bennett (1983: 148) changes tack and maintains that 'in releasing the body for pleasure rather than harnessing it for work, part of their [the rides'] appeal may be that they invert the normal relations between people and machinery prevailing in an industrial context'. This makes a distinctly functionalist proposition and carries with it all of the old false dichotomies which have bedevilled thought and research in the study of leisure and culture: the dichotomy between leisure and work, normality and abnormality, private and public life, etc.

22 There is no gainsaying the popularity of theme parks as leisure attractions. The *New York Times* (13 August 1989) reported that 400 million people per year visit the US theme parks. In Europe the most popular theme parks are De Eftling (Netherlands – 2.5 million visitors per year); Alton Towers (UK – 2.3 million); and Phantasialand (Germany – 2 million). In the UK the most popular theme parks after Alton Towers are Thorpe Park (1.3 million); Chessington World of Adventures (1.2 million). Sources: Company Reports, *Leisure Management*, 7(5) (1987): 29; 7(9) (1987): 29; 10(10) (1990): 52.

23 Although the approach of Elias and Dunning to the study of leisure contrasts sharply with that of Goffman, there is a parallel here, i.e. their concept of 'mimetic leisure' indicates that many contemporary leisure forms let off aggressive emotions through mock combat and controlled contests.

24 As Kasson (1978: 18–27) points out, the inspiration for many of these pioneering time-space attractions came from the great nineteenth-century expositions of Science, Industry, Culture and the Arts. . . . The Exposition aimed to combine fun with the instruction and edification of the people. However, the moral

attitude that the Expositions should never be permitted to become too much fun was never far from the surface. For example, Ogden's *Penny Guide to the International Exhibition in Glasgow* (1901) solemnly observed that leisure and recreation have 'no place in the ordinary scope of the Exhibition'. . . .

25 N. MacGregor, 'Museums for their own sake', the *Guardian*, 12 October 1990.
26 Kracauer writes:

> Everyone goes through the necessary motions at the conveyor belt, performing a partial function without knowing the entirety. Similar to the pattern in the stadium, the organization hovers above the masses as a monstrous figure whose originator withdraws it from the eyes of its bearers, and who himself hardly reflects upon it. It is conceived according to the rational principles which the Taylor system takes to its final conclusion. The hands in the factory correspond to the legs of the Tiller Girls.
>
> (1975: 70)

Advanced capitalism hides the owner of capital from the view of the workers behind managerial representatives so that the monotony of the production system seems depersonalized and unalterable. In much the same way, distraction factories are here alleged to present the masses with synchronized shows in which the authorship of the audience is neutralized and responses are calculated by the manipulation of spectacle and melodrama. Adorno and Horkheimer (1944) develop the same general line of argument in their ferocious indictment of 'the culture industry' and its role in 'mass deception'.

27 Gray (1986: 19).
28 Given the degree to which a taken-for-granted assumption in the field (rarely examined and rarely questioned) is that there is a dichotomy between work and leisure, this point needs to be emphasized.
29 See Jones (1990: 23).
30 *Guardian*, 19 November 1986.
31 *Guardian*, 25 February 1987.
32 'Changed City is Trying to Save Steel Heritage', *New York Times*, 22 August 1989.

Bibliography

Adorno, T. and Horkheimer, M. (1944) *Dialectic of Enlightenment*, London: Verso.
Baudrillard, J. (1983) *Simulations*, New York: Semiotext.
Baudrillard, J. (1987) *The Ecstasy of Communication*, New York: Semiotext.
Baudrillard, J. (1988) *The Evil Demon of Images*, Sydney: Power Institute.
Baudrillard, J. (1990) *Fatal Strategies*, New York: Semiotext.
Beath, N. H. (1986) *The Death of James Dean*, London: New England Library.
Bennett, T. (1983) 'A thousand and one troubles: Blackpool Pleasure Beach', in *Formations of Pleasure*, London: Routledge & Kegan Paul, pp. 138–55.
Cutten, G. (1926) *The Threat of Leisure*, New York: Yale University Press.
Debord, G. (1967) *Society of the Spectacle*, London: Rebel Press.
Eco, U. (1986) *Faith in Fakes*, London: Secker & Warburg.

Elias, N. And Dunning, E. (1986) *Quest for Excitement: Sport and Leisure in the Civilizing Process*, Oxford: Blackwell.

Foster, H. (1985) *Recodings*, Washington DC: Bay Press.

Goffman, E. (1967) 'Where the action is', in E. Goffman, *Interaction Ritual*, New York: Pantheon, pp. 149–270.

Goffman, E. (1974) *Frame Analysis*, New York: Harper & Row.

Gray, E. (1986) 'Theme Park, USA', *Leisure Management* (5): 17–20.

Harvey, D. (1989) *The Condition of Postmodernity*, Oxford: Blackwell.

Hewison, R. (1987) *The Heritage Industry*, London: Methuen.

Holt, J. L. (1982) *Robin Hood*, London: Thames & Hudson.

Horne, D. (1984) *The Great Museum*, London: Pluto.

Huyssen, A. (1986) *After the Great Divide*, Bloomington: Indiana University Press.

Jones, D. (1990) *Dark Star*, London: Bloomsbury.

Kasson, J. E. (1978) *Amusing the Millions: Coney Island at the Turn of the Century*, New York: Hill & Wang.

Kracauer, S. (1975) 'The mass ornament', trans. B. Cowell and J. Zipes, *New German Critique* 2: 67–76.

Kroker, A. and Cook, D. (1986) *The Postmodern Scene: Excremental Culture and Hyper Aesthetics*, New York: St Martin's Press.

Lash, S. (1990) *Sociology of Postmodernism*, London: Routledge.

Lefebvre, H. (1976) *The Survival of Capitalism*, London: Allen & Unwin.

Lowenthal, D. (1985) *The Past is a Foreign Country*, Cambridge: Cambridge University Press.

Lyotard, J.-F. (1984) *The Postmodern Condition: A Report on Knowledge*, Manchester: Manchester University Press.

MacCannell, D. (1973) 'Staged authenticity: arrangements of social space in tourist settings', *American Sociological Review* 79: 589–603.

MacCannell, D. (1976) *The Tourist: A New Theory of the Leisure Class*, New York: Schocken.

Marin, L. (1977) 'Disneyland: a degenerative Utopia', *Glyph* 1: 50–66.

Marx, K. and Engels, F. (1848) 'The Communist Manifesto', in K. Marx and F. Engels (1968) *Selected Works*, London: Lawrence & Wishart, pp. 31–63.

Samuel, R. (ed.) (1988) *Patriotism*, 3 vols, London: Routledge & Kegan Paul.

Simmel, G. (1965) 'The ruin', in G. Simmel, *Essays on Sociology, Philosophy and Aesthetics*, New York: Harper & Row, pp. 259–66.

Tagg, J. (1988) *The Burden of Representation: Essays on Photographies and Histories*, London: Macmillan.

Urry, J. (1990) *The Tourist Gaze: Leisure and Travel in Contemporary Societies*, London: Sage.

Wright, P. (1985) *On Living in an Old Country*, London: Verso.

John Urry

GAZING ON HISTORY

The heritage industry

TOURIST SITES CAN BE CLASSIFIED in terms of three dichotomies: whether they are an object of the romantic or collective tourist gaze; whether they are historical or modern; and whether they are authentic or inauthentic. Characterising sites in such terms is obviously not straightforward and the third dichotomy, authentic/inauthentic, raises many difficulties. Nevertheless it is useful to summarise the differences between such sites by employing these dichotomies.

For example, the Lake District in the north-west of England can be characterised as predominantly the object of the romantic gaze; it is historical and it is apparently authentic. By contrast, Alton Towers leisure park, again in the north-west, is the object of the collective gaze; it is mainly modern and it is predominantly inauthentic. These are fairly straightforward characterisations. But more complex are places like the refurbished Albert Dock in Liverpool, the Wigan Pier Heritage Centre in Lancashire (see Figure 10.1) and the restored mills in Lowell, Massachusetts, the first industrial town in the USA. These are all examples of the heritage industry, a development which has generated a great deal of debate. Although they are the object of the collective gaze, it is more controversial whether such sites are really 'historical' and 'authentic', as is claimed. There is also much debate as to the causes of this contemporary fascination with gazing upon the historical or what is now known as heritage (generally here see Lowenthal, 1985, especially Chapter 1 on 'nostalgia' as a physical affliction dating from the late seventeenth century).

There are indicators of this phenomenon in Britain, where it seems that a new museum opens every week or so. Of the 1,750 museums responding to a 1987 questionnaire, half had been started since 1971. There are now at least 41 heritage centres, including Ironbridge Gorge near Telford, the Wigan Pier Heritage Centre, Black Country World near Dudley, the Beamish Open Air Museum near Newcastle,

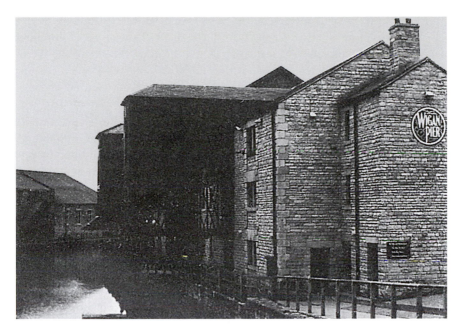

Figure 10.1 The Wigan Pier Heritage Centre, Lancashire

and the Jorvik Viking Centre in York. In Britain there are now 464 museums possessing industrial material and 817 with collections relating to rural history. The director of the Science Museum has said of this growth in heritage that: 'You can't project that sort of rate of growth much further before the whole country becomes one big open air museum, and you just join it as you get off at Heathrow' (quoted in Hewison, 1987: 24).

Some of the most unlikely of places have become centres of a heritage-based tourist development. Bradford, which once sent most of its holiday-makers to Morecambe, has now become a major tourist attraction in its own right. In the Rhondda valley in South Wales it is planned to locate a museum in the Lewis Merthyr coalmine and to establish a Rhondda Heritage Park (see Halsall, 1986) Almost everywhere and everything from the past may be conserved. In Lancashire environmentalists have sought to preserve the largest slag heap in Britain, which British Coal had wanted to remove. There are now 500,000 listed buildings in Britain, as well as over 5,500 conservation areas. The broadcaster Michael Wood writes: 'Now that the present seems so full of woe . . . the profusion and frankness of our nostalgia . . . suggest not merely a sense of loss . . . but a general abdication, an actual desertion from the present' (1974: 346). The seventeenth-century disease of nostalgia seems to have become an epidemic.

Some museums and heritage centres are, moreover, major developments. For example, in the period January–June 1988, £127.2 million was invested in heritage and museums in Britain. This investment was in a wide variety of sites and activities: such as a chemicals museum in Widnes, the restoration of the West Pier in Brighton, a 'Living Dockyard' attraction in Chatham, a Museum of Nursing in Lambeth, the reconstruction of Coronation Street in the Granada studios in

Manchester, a new themed attraction of 'waterfront Poole' in Dorset, and a 'Norfolk bygone village' in East Anglia. Until about 1970 or so most museums were publicly owned, normally by local councils. At the same time central government expenditure is considerable. It spends over £100 million a year on conserving the built environment, much of it through increasingly entrepreneurial agencies like English heritage. One striking feature of these recent developments has been the increased privatisation of the heritage/museum industry, with 56 per cent of recently opened museums being in the private sector (on these various points see Hewison, 1987: Ch. 4; White, 1987; Urry, 1988; Thrift, 1989). And these private initiatives have inspired particularly new ways of representing history, as commodifying the past.

Enormous numbers of people visit such places. In 1983–4 more people visited museums and galleries in Britain than visited the cinema, while many more visited heritage buildings than the live theatre (Myerscough, 1986: 292). The proportion of the service class visiting museum and heritage centres in any year is about three times that of manual workers. About two-thirds of the visitors to such places have white-collar occupations (Myerscough, 1986: 303–4). Seventy-five per cent of overseas visitors to Britain visited a museum/gallery during their stay in Britain. By contrast, only 40 per cent went to the theatre/concert and fewer than 20 per cent saw a film at the cinema (Myerscough, 1986: 311).

There is little doubt that similar developments are taking place in many industrial countries (see Lumley, 1988). Lowenthal says of the USA that 'the trappings of history now festoon the whole country' (1985: xv). The number of properties listed in the US National Register of Historic Places rose from 1,200 in 1968 to 37,000 in 1985 (Frieden and Sagalyn, 1989: 201). However, various critics of heritage, such as Hewison or Wright, argue that these developments are more extensive in Britain than elsewhere, although the empirical testing of such a hypothesis is clearly fraught with methodological difficulties (Hewison, 1987; Wright, 1985). What is fair to claim is the following argument.

Since the late nineteenth century in Britain there has certainly been a tradition of visiting/conserving the countryside. This is reflected in the appreciation both of certain kinds of landscape (including villagescapes) and of the grand country houses set in attractive rural settings. On the first of these Raban talks of a recent willingness of people to present a particular impression of village England: 'nowhere outside Africa . . . were the tribespeople so willing to dress up in "traditional" costumes and cater for the entertainment of their visitors. . . . The thing had become a national industry. Year by year, England was being made more picturesquely merrie' (1986: 194–5).

Some of these events are now organised as 'costume dramas' by English Heritage, the main body concerned with the protection of heritage sites. The tendency to visit grand country houses also remains immensely popular, with 4.2 million people visiting National Trust houses in 1986 (Thrift, 1989: 29).

There has been a further interest in visiting the countryside, stemming from a widespread interest in the equipment and machinery that was used in farming, and in the patterns of life that developed in agriculture. [. . .]

There has been an even more remarkable increase in interest in the real lives of industrial/mining workers. MacCannell points out the irony of these changes: 'Modern Man [sic] is losing his attachments to the work bench, the neighbour-

hood, the town, the family, which he once called "his own" but, at the same time, he is developing an interest in the "real lives" of others' (1976: 91). This interest is particularly marked in the north of England, where much heavy industry had been located. It seems that it is such industries which are of most interest to visitors, particularly because of the apparently heroic quality of much of the work, as in a coalmine or steel works. However, this should not be overemphasised, since people also appear to find interesting the backbreaking but unheroic household tasks undertaken by women. This fascination with other people's work is bound up with the postmodern breaking-down of boundaries, particularly between the front- and the back-stage of people's lives. Such a development is also part of what I will discuss later, namely, a postmodern museum culture in which almost anything can become an object of curiosity for visitors.

The remarkably rapid de-industrialisation of Britain in the late 1970s and early 1980s had two important effects. On the one hand, it created a profound sense of loss, both of certain kinds of technology (steam engines, blast furnaces, pit workings) and of the social life that had developed around those technologies. The rapidity of such change was greater in Britain than elsewhere and was probably more geographically concentrated in the north of England, South Wales and central Scotland. On the other hand, much of this industry had historically been based in inner-city Victorian premises, large numbers of which became available for alternative uses. Such buildings were either immensely attractive in their own right (such as Central Station that is now the G-Mex Centre in Manchester), or could be refurbished in a suitable heritage style for housing, offices, museums or restaurants. Such a style is normally picturesque, with sandblasted walls, replaced windows and attractive street furniture.

This process of de-industrialisation occurred in Britain at a time when many local authorities were developing more of a strategic role with regard to economic development and saw in tourism a way of generating jobs directly and through more general publicity about their area. A good example is Wigan: this is well represented in a publicity booklet called *I've Never Been to Wigan, but I Know What It's Like* (Wigan: Economic Development, undated). The first five pictures in black and white are of back-to-back terraced housing, mines and elderly residents walking along narrow alleyways. But we are then asked if we are sure this is really what Wigan is now like. The following twelve photos, all in colour, demonstrate the contemporary Wigan, which is revealed as possessing countless tourist sites, Wigan Pier, a colourful market and elegant shops, excellent sports facilities, attractive pubs and restaurants, and delightful canalside walkways. Selling Wigan to tourists is part of the process of selling Wigan to potential investors, who are going to be particularly concerned about the availability of various kinds of services for their employees.

Yet this was also a period in which the proportion of smaller enterprises was beginning to grow for the first time for many years (see Lash and Urry, 1987: Ch. 7). Much emphasis was also placed on small firms in central government policy and in the encouragement provided by local authority economic development programmes. Developing new enterprises in the tourist field, many of which are relatively small, became commonplace in Britain in the 1980s.

With the tendencies to globalisation, different countries have come to specialise in different sectors of the holiday market for overseas visitors: Spain for cheaper

packaged holidays, Thailand for 'exotic' holidays, Switzerland for skiing and mountaineering holidays, and so on. Britain has come to specialise in holidays that emphasise the historical and the quaint (North Americans often refer to Britain as that 'quaint country' or that 'old country'). This emphasis can be seen in the way that overseas visitors tend to remain inland in Britain, rarely visiting either the coast or much of the countryside. [. . .] This location within the global division of tourism has further reinforced the particular strength of the heritage phenomenon in Britain.

The preservation of heritage has been particularly marked in Britain because of the mostly unattractive character of the modern architecture produced in the UK. The characteristic modern buildings of the postwar period have been undistinguished office blocks and public housing towers, many with concrete as the most visible building material. Such buildings have proved to be remarkably disliked by most of the population, which has seen modern architecture as 'American'. Yet the contrast with the often striking and elegant North American skyscrapers located in the downstream areas is particularly noticeable. In addition Britain had a very large stock of pre-1914 houses and public buildings for conservation, once the fashion for the modern had begun to dissolve in the early 1970s. An interesting example of this can be seen in the changing attitude towards conservation, particularly of the Regency façades in Cheltenham, which is now one of the prime townscapes being strenuously preserved even though much of it had been scheduled for 'redevelopment' (Cowen, 1990).

So for a number of reasons heritage is playing a particularly important role in British tourism, and it is somehow more central to the gaze in Britain than in many other countries. But what is meant by heritage, particularly in relationship to notions of history and authenticity (see Uzzell, 1989, on the recent professional literature on heritage)? A lively public debate has been raging in Britain concerned with evaluating the causes and consequences of heritage.

This debate was stimulated by Hewison's book on the heritage industry, which was subtitled *Britain in a Climate of Decline* (1987). He begins with the provocative comment that increasingly, instead of manufacturing goods, Britain is manufacturing heritage. This has come about because of the perception that Britain is in some kind of terminal decline. And the development of heritage involves not only the reassertion of values which are anti-democratic, but the heightening of decline through a stifling of the culture of the present. A critical culture based on the understanding of history is what is needed, not a set of heritage fantasies.

Hewison is concerned with analysing the conditions in which nostalgia is generated. He argues that it is felt most strongly at a time of discontent, anxiety or disappointment. And yet the times for which we feel most nostalgia were themselves periods of considerable disturbance. Furthermore, nostalgic memory is quite different from total recall; it is a socially organised construction. The question is not whether we should or should not preserve the past, but what kind of past we have chosen to preserve.

[. . .]

Hewison notes something distinctive about some contemporary developments. Much contemporary nostalgia is for the industrial past. The first major battle in Britain was fought – and lost – in 1962 over the elegant neoclassical arch at the

entrance to Euston station. But this gave rise to a survey of industrial monuments by the Council for British Archaeology and a major conference in 1969. Four years later the Association for Industrial Archaeology was founded and by the 1980s industrial museums were developing almost everywhere in the northern half of Britain. Hewison makes much of the contrasts between the development of the industrial museum at Beamish and the devastation brought about by the closure of the steel works at Consett, just 10 miles away. The protection of the past conceals the destruction of the present. There is an absolute distinction between authentic history (continuing and therefore dangerous) and heritage (past, dead and safe). The latter, in short, conceals social and spatial inequalities, masks a shallow commercialism and consumerism, and may in part at least destroy elements of the buildings or artefacts supposedly being conserved. Hewison argues that 'If we really are interested in our history, then we may have to preserve if from the conservationists' (1987: 98). Heritage is bogus history.

Obviously there is much value in many of Hewison's comments. It seems that one commentator has even suggested that Britain will 'soon be appointing a Curator instead of a Prime Minister' (quoted in Lowenthal, 1985: 4). Similarly Tom Wolfe has recently proposed that the entire British population service a national Disneyland for foreign tourists. Most of the buildings would be fibreglass replicas designed by Quinlan Terry and made in Taiwan (see Stamp, 1987). There are, however, some serious difficulties raised by Hewison's argument.

These criticisms of heritage bear a remarkable similarity to the critique of the so-called mass society thesis. Indeed social scientists may well be prone to a kind of nostalgia themselves, that is, for a Golden Age when the mass of the population were supposedly not taken in by the new distorting cultural forms (see Stauth and Turner, 1988; and more generally here Bagguley et al., 1990: Ch. 5). There has, of course, never been such a period.

Hewison ignores the enormously important popular bases of the conservation movement. For example, like Patrick Wright he sees the National Trust as a gigantic system of outdoor relief for the old upper classes to maintain their stately homes. But this is to ignore the widespread support for such conservation. Indeed Samuel points out that the National Trust with nearly 1.5 million members is the largest mass organisation in Britain (1987a). Moreover, much of the early conservation movement was plebeian in character – for example, railway preservation, industrial archaeology, steam traction rallies and the like in the 1960s, well before more obvious indicators of economic decline materialised in Britain. Even Covent Garden, which might be thought of as the ultimate 'yuppified heritage playground', was only transformed into a tourist site because of a major conservation campaign by local residents (see Januszczak, 1987, who also misses this point). Likewise the preservation of some derelict coalmines in Wales has resulted from pressure by local groups of miners and their families who have sought to hold on to aspects of 'their' history; indeed visitors to Big Pit in South Wales, for example, are said to be pleased that it has not been made pretty for visitors. Oral history also has played a role in preservation, not just of artefacts, but of memories. Generally Hewison and his fellow critics fail to link the pressure for conservation with the much broader development of environmental politics in the 1980s. In Britain Marcus Binney is a key figure here, as reflected in his book *Our Vanishing Heritage* (1984; see Stamp, 1987). One might also ask whether Hewison is actually

suggesting that most of the unused industrial buildings should in fact have been demolished over the last decade or two.

Hewison links nostalgia for our industrial past with the growth of postmodernism. But although they are undoubtedly connected one needs to make some distinctions. This can be seen in Chester, where the expansion of a Roman centre ('Diva') will involve the demolition of a listed Georgian house. Local conservationists wish to save the house and to prevent the development of what will be a Roman theme park (with Roman coins, Roman food, etc.: see Stamp, 1987). Hewison conflates the two sides. Mainly, however, he concentrates his critique on scholarly museums and heritage centres, which often employ academic historians to research the background to the site (see Rose, 1978, for an official history of the Gregs who developed the Quarry Bank Mill, now an industrial museum in Cheshire). Hewison's case could have been made much more easily against the Camelot theme park, the proposed Roman theme park in Chester, or the possible construction of Clegg Hall heritage park near Rochdale which will involve the compulsory purchase of some of the existing terraced houses. In the USA there is a similar distinction between the scholarly representation of Lowell as part of the National Park and the construction of Main St. in Disneyland. Another distinction that might be made is between 'crafts' and 'trades'. The former is clearly part of the constructed heritage industry, even to the extent that the craftspeople become part of the exhibit. But this kind of construction can be distinguished from various 'trades' and the historical reconstruction of the authentic methods and techniques used by, say, harness-makers or wheelwrights (see discussion in Vidal, 1988). Hewison's critique is more apposite to the former than the latter. An interesting example here is the Jewellery Quarter in Birmingham and the attempt to transform a 'trade' area into a 'crafts' area.

Hewison presumes a rather simple model by which certain meanings, such as nostalgia for times past, are unambiguously transferred to the visitor. There is no sense of the complexity by which different visitors can gaze upon the same set of objects and read them in a quite different way. There is ultimately something condescending about Hewison's view that such a presentation of heritage cannot be interpreted in different ways, or that the fact that the experience may be enjoyable means that it cannot also be educational. It is also not very clear that the examples Hewison discusses are unambiguous in their meaning anyway. The Wigan Pier Centre is, after all, scholarly and educational; it presents a history of intense popular struggle; it identifies the bosses as partly to blame for mining disasters; it celebrates a non-elite popular culture; and it is organised by a council with the objective of glorifying 'heroic labour'. Compared with most people's understanding of history it surely conveys something of the social processes involved, even if it is hard to see how to build on that history in the future. Indeed, it is not at all clear just what understanding of history most people have. In the absence of the heritage industry just how is the past normally appropriated? It certainly is not through the academic study of 'history' as such (see Lowenthal, 1985: 411). For many people it will be acquired at best through reading biographies and historical novels. It is not obvious that the heritage industry's account is any more misleading.

What does need to be emphasised is that heritage history is distorted because of the predominant emphasis on visualisation, on presenting visitors with an array

of artefacts, including buildings (either 'real' or 'manufactured'), and then trying to visualise the patterns of life that would have emerged around them. This is an essentially 'artefactual' history, in which a whole variety of social experiences are necessarily ignored or trivilised, such as war, exploitation, hunger, disease, the law, and so on (see Jordanova, 1989).

Overall Lowenthal's judgement on history seems right: 'We must concede the ancients their place. . . . But their place is not simply back there, in a separate and foreign country; it is assimilated in ourselves, and resurrected into an ever-changing present' (1985: 412).

The following three sections explore certain aspects of heritage in more detail: in relation to its use as part of a local strategy for economic regeneration; in its interconnections with recent trends in design and postmodern architecture; and its role in the development of what I shall term the postmodern museum.

Tourism and the local state

In the previous discussion of the heritage industry it was noted that there is often considerable local support for conservation. I shall consider more fully here the relationship between local areas and tourism development. In that relationship there are three key elements. First, there are local people who are often concerned to conserve features of the environment which seem in some ways to stand for or signify the locality in which they live. Second, there are a variety of private sector owners and potential owners of tourist-related services. And third, there is the local state, which is comprised of local authorities as well as the local/regional representatives of various national-level bodies, including tourist boards.

An interesting example which illustrates this complexity of elements is the Winter Gardens theatre in Morecambe, which has recently been debated in the national press (see Binney, 1988). This theatre closed in the late 1970s and will cost £2–5 million to repair (there is galloping dry rot). It is widely agreed that the theatre, built in 1897, is architecturally superb. English Heritage describes it as 'outstanding', while John Earl of the Theatres Trust has characterised it as the Albert Hall of the north. It may be conserved, although this is by no means certain. If it is, there is little doubt that amongst other uses will be the staging of old-time music-hall (as well as pop/classical concerts), hence conveying nostalgic memories of a somewhat imprecise golden age of pre-TV entertainment.

Clearly such a refurbishment would be subject to criticism as yet another example of the heritage industry. However, it should be noted that without a great deal of local support for conservation the theatre might already have been demolished. There is an extremely energetic action group convinced that this currently semi-derelict building symbolises Morecambe – that if it is allowed to be demolished, that would be the end of the town itself. It is certain that there is widespread popular support for increasing the attractiveness of Morecambe, to make it more congested and more subject to the tourist gaze. Indeed potential tourists to any site cannot contribute to environmental concern: that has to be expressed by local residents. Although the building is currently privately owned, it is quite clear that it will only be refurbished with much support from public bodies including English Heritage, the European Community, Lancashire City

Council and Lancaster City Council. The last of these will almost certainly be involved in putting together an appropriate funding package. The role of the local state may well be crucial.

The example demonstrates two important points about contemporary tourist development: the impact of local conservation groups whose heritage-preserving actions will often increase tourism in an area sometimes as an unintended consequence; and the central organising role of the local state. On the first of these, it is important to note that at the strength of conservation groups varies very considerably between different places. For example, in 1980 while there were 5.1 members of 'amenity societies' per 1,000 population in the UK as a whole, the ratio was over 20 per 1,000 in Hampshire and over 10 per 1,000 in most of the counties around London, in Devon, in North Yorkshire and in Cumbria (see Lowe and Goyder, 1983: 28–30 for more detail). Clearly part of the rationale of such groups is to prevent new development taking place that will harm the supposed 'character' of the locality (in the south-east especially through low-cost housing schemes). The role of the service and middle classes in such groups is crucial – and is a major means by which those possessing positional goods, such as a nice house in a nice village, seek to preserve their advantages. However, conservation movements can often have fairly broad objectives: not merely to prevent development, but to bring about the refurbishment of existing public buildings and more generally to 'museumify' the villagescape or townscape. Moreover, even if the objectives of the movement have nothing to do with tourism, the effect will almost certainly be to increase the attractiveness of the locality to tourists.

[. . .]

A factor which has helped to strengthen conservation movements is the apparently lower rate of geographical mobility of at least the male members of the service class (see Savage, 1988). As a result such people are likely to develop more of an attachment to place than previously. One can talk therefore of the 'localisation of the service class' and this will have its impact, through the forming of amenity groups, on the level of conservation (see Bagguley et al., 1989: 151–2). To the extent that such groups are successful, this will make the place more attractive to tourists. Thus the preservation of the quaint villagescape or townscape in particular, through middle-class collective action, is almost certain to increase the number of tourists and the resulting degree of congestion experienced by residents. One place where this has been particularly marked is Cheltenham. Because of concerted conservation pressure in the late 1960s the formal development policy was dropped in 1974. Since then a conservation policy has been adopted and there has been wholesale rehabilitation of the Regency housing stock for both housing and prestige office accommodation (see Cowen, 1990).

Before considering the various ways in which local states have responded to such pressures, and more generally how they have in recent years attempted to reconstruct the objects of the tourist gaze, I will note some reasons why local states have recently become centrally involved in both developing and promoting tourism.

As many local authorities moved into local economic intervention during a period of rapid de-industrialisation, so it seemed that tourism presented one of the only opportunities available for generating employment. Indeed it has been

estimated that the cost of one new job in tourism is £4,000, compared with £32,000 in manufacturing industry and £300,000 in mechanical engineering (see Lumley, 1988: 22). [. . .] It was also noted that many such authorities have found themselves with a particular legacy of derelict buildings, such as the Albert Dock in Liverpool, and/or derelict land, such as that which now comprises the Salford Quays development in Manchester. Converting such derelict property into sites which would have a tourist aspect directly or indirectly has been almost the only alternative available.

[. . .]

Local authorities also play an important role because of the structure of ownership in tourist towns. This is often fragmented and it is difficult to get local capital to agree on appropriate actions from the viewpoint of the locality as a whole. The council is often the only agent with the capacity to invest in new infrastructure (such as sea defences, conference centres, harbours), or to provide the sort of facilities which must be found in any such centre (entertainments, museums, swimming pools). This has led in some of the older resorts, such as those on the Isle of Thanet, to the development of 'municipal Conservatism', a combination of small-scale entrepreneurialism and council intervention (see Buck *et al.*, 1989: 188–9). In the last few years in Britain many Labour councils have enthusiastically embraced local tourist initiatives, having once dismissed tourism as providing only 'candy-floss jobs' (again see Landry *et al.*, 1989), for an example of this argument; Glasgow would be a good illustration).

Finally, local councils have been willing to engage in promoting tourism because in a period of central government constraint this has been one area where there are sources of funding to initiate projects which may also benefit local residents. [. . .] Furthermore, such facilities are important since they may attract prospective employees and employers and then keep them satisfied. This seems to have happened in Wigan following the establishment of the Wigan Pier Centre. The chairman of the North-West Tourist Board argues that:

> The growth of the tourism industry has a great deal to do with the growth of every other industry or business: the opening up of the regions as fine places to visit means they're better places to live in – and thus better places to work . . . a higher quality of life benefits employees.
> (quoted in Reynolds, 1988)

It is problematic to assess the economic impact of any particular tourism initiative. This results from the difficulty of assessing the so-called multiplier. If we consider the question of income generation, the impact of the expansion of tourism cannot be assessed simply in terms of how much income is spent by 'tourists' in hotels, camp sites, restaurants, pubs, and so on. It also depends upon what and where the recipients of that income, such as suppliers to the hotel or bar staff in the pubs, spend it, and in turn where those recipients spend it, and so on. [. . .] For all these difficulties it does seem that tourist expenditure has a fairly high local multiplier compared with other kinds of expenditure that might occur locally. Most studies show that something like half of tourism expenditure will remain in the locality, from its direct and indirect effects (see Williams and Shaw,

1988: 88). However, such income remains highly unequally distributed since tourism areas are notable for their low wages level, even amongst those not even employed in the tourism industry as such (see Taylor, 1988, on the effects in tourist-rich Blackpool).

Local states in the UK have undertaken initiatives concerned to reconstruct and re-present whole places as objects of the tourist gaze. A useful summary of the actual agencies involved, and the complex conflicts and contradictions between them, is to be found in Houston (1986); on the USA see Frieden and Sagalyn (1989).

By no means all local authorities have been concerned to develop their local-ities as tourist centres. It has probably been most marked in the Midlands, the north of England, and Wales, rather less so in Scotland, Northern Ireland and the south-east. Moreover, the reorganisation of local government in the mid-1970s had the effect in some cases of merging resorts with other areas, which is believed to have reduced the support for specifically tourist initiatives, at least within the resorts themselves. [. . .]

A number of local authorities, especially in England, have recently been successful in the tourism field. An interesting example in the north is Hebden Bridge, a small west Yorkshire town (see Waterhouse, 1989). Its nadir was in the mid-1960s, when half the native population had left in the previous ten years following the closure of thirty-three clothing works. A strategy came to be formu-lated to break with the industrial past, to promote Hebden as a place to visit and to convert some of the visitors into new residents. There had been plans for a major development scheme but this was thrown out in 1967. A heritage-led growth strategy was devised instead, a strategy influenced by an early environmental move-ment in the town. The place is now booming, with a considerable shortage of housing. There are now twice as many newcomers as original residents.

Some other places that have pursued a similar strategy have been assisted by the English Tourist Board scheme to establish Tourism Development Action Programmes (TDAPs). These are integrated programmes, lasting between one and three years, which involve research, development and marketing (see Davies, 1987). The English Tourist Board serves as a catalyst, forming a partnership between the local authority, the private sector and often other agencies (such as the Training Commission). The emphasis is on taking action. Some of the places that have experienced such a programme are cities, such as Bradford, Tyne and Wear, Lancaster, Gosport and Portsmouth, rural areas such as Exmoor and Kielder Water, and seaside resorts such as Bridlington and Torbay.

[. . .]

One considerable advantage of a TADP is that it is likely to stimulate an overall strategy for the area concerned and to make it more likely that there is some consistency in the image being constructed . . . [something] that was important in the recent successful development of Bradford's tourism. The contrasting example of Manchester illustrates what can happen without co-ordination. A high redevel-opment programme is currently taking place in Manchester, which many consider to be the most promising tourism site in Britain. But with the abolition of the Greater Manchester County Council there is no co-ordinating authority. Current and competing players involved in tourist development in Manchester include: Salford, Trafford and Manchester Councils, Central Manchester and Trafford Park

Development Corporations, the English Tourist Board, the consultants Land Design and Research, and property developers Merlin Properties, Rosehaugh, and the Manchester Ship Canal Company (Pearman, 1989).

One way in which a number of cities have been more successful in constructing a relatively coherent tourist image is through so-called cultural tourism. It is calculated that about £2 billion of tourist expenditure in the US is specifically attributable to the arts. In London, for example, 44 per cent of museum attendance is made up of tourists, compared with 21 per cent outside London. Tourists form 40 per cent of the audience at London's theatres and concerts, while an incredible 37 per cent of those at West End theatres are overseas tourists. It is calculated that overall 25 per cent of all tourist-spending is arts-related (although there are immense problems of definition here; see Myerscough, 1988: Ch. 5 for more detail).

In addition to Glasgow, [. . .] Liverpool is another city which has successfully capitalised on its particular cultural heritage. Strongly featured in the *Discover Merseyside 1988* brochure is the daily 'Beatles Magical History Tour'. The brochure talks of 'Beatleland', which includes the 'Cavern Walks' shopping centre, the John Lennon Memorial Club, the Beatles Shop, Tommy Steele's statue of Eleanor Rigby, and so on. Details are also included of the annual Beatles Convention. Another cultural advantage of Merseyside increasingly featuring in its tourism literature is soccer, something which again illustrates how the boundaries between different activities are dissolving, the de-differentiation referred to earlier. Liverpool describes itself as '*The Football Capital of the World*' and there are well-organised 'Soccer City Weekend' packages where Goodison Park and Anfield constitute important objects of the tourist gaze.

Two other features of Liverpool's recent tourism strategy are of more general relevance: the garden festival and waterfront development. On the former, Liverpool's festival in 1984 was the first in Britain, to be followed by Stoke and Glasgow. The Liverpool site is now derelict and although popular at the time it has not had much long-term effect. Elsewhere, though, such festivals have helped to reinforce a conservative pastoral image, to declare that manufacturing industry has gone for good. Roberts suggests that the festivals represent an attempt to impose a predominantly southern conception on the north: 'The image of the South as predominantly green is imported into the North as a collective vision of a United Green and Pleasant Kingdom' (1989).

[. . .]

The inspiration for development in Britain has arisen from the striking ways in which the downtown areas of American cities have been transformed, mainly by private developers but with a fair degree of public co-ordination. The main features found in the USA are the 'festival marketplace', particularly by the developer James Rouse as in Fanueil Hall in Boston; historical preservation, as in Lowell, Massachusetts; the development of new open spaces or plazas, such as Harborplace in Baltimore; waterfront developments, such as Battery City Park in New York; cultural centres, such as a performing arts centre in Los Angeles; renovation of old hotels, such as the Willard Inter-Continental in Washington DC; refurbished housing, as on Beacon Hill, Boston; and new public transportation systems, even in Los Angeles, the ultimate automobile city (see Fondersmith, 1988; Frieden and Sagalyn, 1989: 210–12).

In the next section I shall consider in more detail the design and architecture of these various developments. Tourism is about finding certain sorts of place pleasant and interesting to gaze upon, and that necessarily comes up against the design of the buildings and their relationship to natural phenomena. Without the right design no amount of local state involvement will attract tourists. It will be seen that much of the architecture of these developments is in different senses *post*modern.

Designing for the gaze

Given the emphasis on tourist consumption as visual, and the significance of buildings as objects upon which the gaze is directed, it is essential to consider changing patterns and forms that those buildings might take. Moreover, it is of course impossible to consider postmodernisation without consideration of the built environment, surely the sphere which many would say best demonstrates such a cultural paradigm.

I shall argue, first, that there are a number of postmodern architectures; second, that the impact of these different architectures depends upon whether we are considering private or public buildings; third, that architects and architectural practices are of major importance in shaping the contemporary tourist gaze; fourth, that tourist practices have to be taken much more seriously by commentators on building design; and fifth, that tourists are socially differentiated and hence gaze selectively upon these different architectural styles.

The first point can be approached by considering what is meant by *post* in postmodern. There are three senses: *after* the modern; *return* to the pre-modern; and *anti* the modern. I shall now briefly summarise the architectural style associated with each of these (see Harris and Lipman, 1986, for an alternative classification).

After the modern is what one could also term 'consumerist postmodernism'. This takes its cue from Venturi's famous cry to 'learn from Las Vegas' (1972; Jencks, 1977; Frampton, 1988). Caesar's Palace at Las Vegas or Disneyland are the icons of this architecture, which proudly celebrates commercial vulgarity (see Harris and Lipman, 1986: 844–5).[. . .] In Britain Ian Pollard is one of the best-known postmodernists. A particularly striking building of his is the *Observer*'s Marco Polo House in Battersea, with its massive porticoes, broken pediments and banded ceramic towers (see Jenkins, 1987). An illustrative controversy has recently occurred over one of his other designs, a do-it-yourself store in West London built for Sainsbury (see Pearman, 1988). At the entrance to this store Pollard had playfully designed a massive Corinthian arch. Sainsbury, however, even before the store was open, found the design, with its abundance of Egyptian motifs and postmodern ornamentation, far too jokey for a serious retailer. A spokesman for the company condemned it as 'this pastiche of a design' and the arch was demolished before the store was opened.

After this débâcle Sainsbury is reassessing its design practices, since the company takes the architecture of its stores seriously, more so than other retailers. In general it favours two styles: certain kinds of modernism, as found in Norman Foster's plans for a hypermarket in Eastleigh or Nick Grimshaw's cantilevered supermarket in Camden Town (see Figure 10.2); and local vernacular styles, such as Sainsbury's Lancaster store which is built around the façade of the old public baths, or its Wolverhampton shop which is built around an old church, or its new Grimsby shop which is to be part of a fishing heritage centre. The vernacular styles

Figure 10.2 Sainsbury's supermarket in Camden Town, designed by Nick Grimshaw.

are more common in the north, modernism in the south. However, the extension to the National Gallery that the Sainsburys are funding is being designed by Robert Venturi, and although it is less colourful than expected it is nevertheless thoroughly postmodern, that is *after* the modern (see Pawley, 1987).

Much of the debate about postmodernism has tended to concentrate on significant public buildings, such as Terry Farrell's TV-AM headquarters, Philip Johnson's AT-&-T building, and James Stirling's Stuttgart gallery. There is less investigation of the impact of such a style on the everyday architecture of particular towns and cities. This is an important issue, since historically most architecture has been partly eclectic, drawing on earlier traditions, such as the gothic style favoured by the Victorians, or the Egyptian motifs popular with the Art Deco movement (on the latter see Bagguley, 1990: Ch. 5; more generally, see Lowenthal, 1985: 309–21). The one exception was the modern movement and its perhaps unique rejection of all previous architectural mannerisms. Interestingly, even during the heyday of modernism (say 1930–70 in Britain) two other styles were common: red-brick neo-Georgian shopping parades, and neo-Tudor half-timbered suburban housing.

[. . .]

Patrician postmodernism involves a *return* to the pre-modern. Here what is celebrated is the classical form, the architecture of an elite. Leon Krier summaries its attraction: 'People never protested against the tradition of classical architecture. . . . Architecture has reached its highest possible form in the classical principles and orders . . . [which] have the same inexhaustible capacities as the principles which govern nature and the universe itself' (1984: 87, 119).

This reconstructed classicism springs from individuals who believe they have distinct powers of insight, who will be able to return to the aura of the fine building. Architecture here is a self-determining practice, an autonomous discipline able to reproduce the three classical orders. This is linked to the belief that such classicism is really what people want if only their choices were not distorted by modernism. In Britain, Prince Charles in part demonstrates this position, of appearing to speak on behalf of the people who know they do not like modernism and who really want only to gaze on nothing but uninterrupted classical buildings. Roger Scruton's position is somewhat similar (and as we will see less ambiguous than the prince's; see Scruton, 1979). As Wright says: 'While Scruton certainly approaches everyday life, he does so in such a way as to freeze it over. What emerges is an aestheticized, and indeed severely "classical" definition of *appropriate* everyday life' (1985: 30–1). It is no accident that it is Krier who has been commissioned by the prince to devise the site plan for the western expansion of Dorchester, a proposal in effect to put Prince Charles's theories into practice. One interesting feature is the rejection of the idea of zoning activities. In Poundbury shops will be found in arcades under flats, and workshops will be located next to housing.

The British architect who has become best known for his implementation of the classical tradition is Quinlan Terry, particularly in a series of elegant private houses, which are usually located in pleasant countryside. More recently he has been responsible for the extensive and controversial Richmond development, which consists of fifteen separate buildings built in a variety of classical styles.[. . .]

Certainly, to the extent to which such contemporary classical buildings mirror in particular the Georgian style, they will be immensely popular objects of the tourist gaze. If there is a single style of house which tourists in Britain want to gaze upon it is the classical country house (see Hewison, 1987: Ch. 3). There is even now a handbook instructing people how to furnish and entertain in such Georgian houses, *The Official New Georgians Handbook* (Artley and Robinson, 1985).

A considerable amount of such building is preserved in many towns and cities in Britain. The most striking Georgian townscape is Bath, where the housing stock is a positional good. One could describe many of the residents as living in a museum and simultaneously surrounded by museums. The city is almost definitive of good taste and a setting in which part of the cultural capital possessed by its residents is the knowledge of such housing and of the skills necessary to improve it while at the same time appearing to conserve it. The contemporary renaissance of Bath is just as important an icon of the postmodern (in the return to the pre-modern sense) as is the latest jokey theme park or shopping mall.

There is a third variant of postmodern architecture. This is not simply after the modern, or involving a return to the pre-modern – it is *against* the modern. It has much in common with Frampton's concept of 'critical regionalism' (1988) and Foster's notion of a 'critical postmodernism' (1985). The latter defines the critique of modernism as a Eurocentric and phallocentric set of discourses (see Hebdige, 1986–7: 8–9). It is argued that modernism (like of course pre-modern classicism) privileges the metropolitan centre over provincial towns and cities, the developed world over developing countries, the North Atlantic rim over the Pacific rim, western art forms over those from the 'east' and the 'south', men's art over women's art, the professional over the people, and so on. There is one variant of the postmodern which involves challenging these dominant discourses: in architecture it can be characterised as vernacular postmodernism. Hebdige well characterises the spatial correlates of this shift. He says that there is 'not so much a lowering of expectations as a shift towards a total transformation in historical time . . . to the piecemeal habitation of finite space – the space in which we live' (1986–7: 12).

Space in vernacular postmodernism is localised, specific, context-dependent, and particularistic – by contrast with modernist space which is absolute, generalised, and independent of context (see Harvey, 1989, more generally here). Leon Krier talks of the need to create 'localities of human dignity' (1984: 87). In Britain one of the clearest examples of this has been the 'community architecture' movement which Prince Charles has also done much to foster. This movement began with the restoration of Black Road in Macclesfield designed by Rod Hackney. The main principle of such a movement is 'that the environment works better if the people who live, work and play in it are actively involved in its creation and maintenance' (Wates and Krevitt, 1987: 18). This involves much emphasis on the process of design rather than on the end product, on reducing the power of the architecture vis-à-vis clients, on channelling resources to local residents and communities, and on restoration, or, where new building is involved, ensuring it is appropriate to local historical context (see Hutchinson, 1989, for a critique of this movement).

The locality is central to such an architecture. And there are important resistances in contemporary societies which have made local vernacular architecture

particularly popular, at least outside the metropolitan centres. There is the apparent desire of people living in particular places to conserve or to develop buildings, at least in their public spaces, which express the particular locality in which they live. Such old buildings appear to have a number of characteristics: solidity, since they have survived wars, erosions, developers, town planning, etc.; continuity, since they provide links between past generations and the present; authority, since they signify that age and tradition are worthy of preservation; and craft, since they were mostly built using otherwise underrated pre-modern techniques and materials (see Lowenthal, 1985: 52–63).

And because of the universalisation of the tourist gaze, all sorts of places (indeed almost everywhere) have come to construct themselves as objects of the tourist gaze; in other words, not as centres of production or symbols of power but as sites of pleasure. Once people visit places outside capital cities and other major centres, what they find pleasurable are buildings which seem appropriate to a place and which mark that place off from others. One of the very strong objections to modernism was that it generated uniformity, or placelessness, and was therefore unlikely to generate large numbers of buildings attractive to potential tourists who want to gaze upon the district. The only exceptions are to be found in major cities, such as Richard Rogers's Lloyds building in London, or his high-tech Pompidou Centre in Paris, which now attracts more visitors than the Louvre.[. . .]

It should not be forgotten that each such place will be viewed from a variety of perspectives. There will be differences between what visitors and locals 'see' in a place, and between the viewpoints of old and new residents: 'People live in different worlds even though they share the same locality: *there is no single community or quarter*. What is pleasantly old for one person is decayed and broken for another' (Wright, 1985: 237).

[. . .]

I will conclude by making some points about architects, developers and the changing objects of the tourist gaze. Partly influenced by some of these locally based architects, a more participatory and activist-influenced planning developed, 'aimed not only at halting renewal schemes but also at preserving and enhancing the neighbourhood lifeworld' (Knox, 1988: 5). The effectiveness has of course varied enormously and quite often schemes for the desired conservation of an area turn out to have quite different consequences. The renewal of Covent Garden as a result of a planning decision influenced by activists concerned to conserve the buildings has had the consequence of generating an immensely successful tourist site (with resulting congestion, inflated prices and piles of un-collected rubbish).

According to Raphael Samuel a similar fate might befall Spitalfields in East London. Samuel argues that what is being planned in Spitalfields is an alliance of conservationists and developers working together. One effect of the proposed scheme would be to turn much of Spitalfields into a tourist site, which it is not at present. Samuel writes dismissively:

> Conservation here is typically pastiche in which, as in a costume drama, items are treasured for their period effect. . . . 'Georgianised'

Spitalfields, with its immaculate brickwork, restored lintels and tasteful interiors. . . . What meaning does conservation have . . . when a building is frozen in historical limbo?

(1987b)

A sustained attack was mounted in Britain in the 1980s on the systems of planning control that had been established since the war. A crucial Circular 22/80 from the Department of the Environment asserted the superiority of developer 'patronage' over the democratic system of planning control. Design was to be left to developers, except in certain areas, such as National Parks, Areas of Outstanding Natural Beauty, Conservation Areas and so on (see Punter, 1986–7). What came to be established was a two-tier system. Punter summarises the way this met the apparently conflicting objectives of Conservative policy:

> to retain those escapist elements of aesthetic control which protect the interests and property values [and we may add the tourist sites] of their supporters – the gentrified Georgian, Victorian and Edwardian suburbs, the picture postcard villages and 'unspoilt' countryside so sought after by long distance commuters. . . . In crude terms the remainder of the country is to be left to the mercies of the developers.
>
> (1986–7: 10)

The policy tries to overcome contradictions in Conservative attitudes to development. One way of effecting this will be to compensate farmers in rural areas for not damaging areas or features of acknowledged environmental significance (see Cloke, 1989: 44). But the most significant test of this policy is in the London Docklands. So far it seems that there is an extraordinary clutter of diverse and conflicting architectural styles, what has been referred to as an architectural zoo (see Wolmar, 1989). There had also been a lack of consultation with the local boroughs and communities and a failure to implement various social objectives. Sir Andrew Derbyshire, former chairman of the London Docklands Planning Committee, has been particularly critical of the architectural consequences: 'We have learnt from Docklands that the free play of market forces is not going to produce the best results in terms of quality. The good architects have lost out' (quoted in Wolmar, 1989: 5). It should be noted that the Docklands has nevertheless already become a major tourist site.

[. . .]

But it should not be assumed that all these developments will be financially successful. Some, such as the Metrocentre at Gateshead and Alton Towers in the Midlands, have been but others, like the London Docklands and the Battersea, were in serious financial difficulties in 1989. In the USA there has been over-investment in shopping malls in Texas and hotels in Atlanta, while Virginia's waterfront development is a financial failure. Harvey provocatively asks: 'How many museums, cultural centres, convention and exhibition halls, hotels, marinas, shopping malls, waterfront developments can we stand? (1988).

Here I have thus shown how the universalisation of the tourist gaze is reaping its postmodern harvest in almost every village, town and city in Britain and in

many other western countries as well. I will now turn to one particular kind of building – the museum.

Postmodern museums

We have seen a spectacular growth in the number of museums in western countries. This is clearly part of the process by which the past has come to be much more highly valued by comparison with both the present and the future. Also, the past has become particularly valued in the UK because of the way in which international tourism in this country has come to specialise in the construction of historical quaintness. And the attraction of museums increases as people get older – thus the 'greying' of the population in the west is also adding to the number and range of museums.

I have strongly argued for the significance of the gaze to tourist activities. This is not to say that all the other senses are insignificant in the tourist experience. But I have tried to establish that there has to be something distinctive to gaze upon, otherwise a particular experience will not function as a tourist experience. There has to be something extraordinary about the gaze.

On the face of it this seems a relatively straightforward thesis. But it is not – because of the complex nature of visual perception. We do not literally 'see' things. Particularly as tourists we see objects which are constituted as signs. They stand for something else. When we gaze as tourists what we see are various signs or tourist clichés. Some such signs function metaphorically. A pretty English village can be read as representing the continuities and traditions of England from the Middle Ages to the present day. By contrast the use of the term 'fun' in the advertising for a Club-Med holiday is a metaphor for sex. Other signs, such as lovers in Paris, function metonymically. Here what happens is the substitution of some feature or effect or cause of the phenomenon for the phenomenon itself. The ex-miner, now employed at the former coalmine to show tourists around, is a metonym for the structural change in the economy from one based on heavy industry to one based on services. The development of the industrial museum in an old mill is a metonymic sign of the development of a post-industrial society.

There have of course been museums open to the public since the early nineteenth century, beginning with the Louvre in Paris, the Prado in Madrid and the Altes Museum in Berlin. And since the *Michelin Guides* first appeared museums have been central to the tourist experience. Horne describes the contemporary tourist as a modern pilgrim, carrying guidebooks as devotional texts (1984). What matters, he says, is what people are told they are seeing. The fame of the object becomes its meaning. There is thus a ceremonial agenda, in which is established what we should see and sometimes even the order in which they should be seen.

Such museums were based on a very special sense of aura. Horne summarises the typical tourist experience, in which the museum has functioned as a metaphor for the power of the state, the learning of the scholar and the genius of the artist:

> tourists with little or no knowledge of painting are expected to pay
> their respects solely to the fame, costliness and authenticity of these

sacred objects, remote in their frames. As 'works of art' from which tourists must keep their distance, the value of paintings can depend not on their nature, but on their authenticated scarcity. The gap between 'art' and the tourist's own environment is thereby maintained.

(1984: 16)

Museums have thus been premised upon the aura of the authentic historical arte-fact, and particularly upon those which are immensely scarce because of the supposed genius of their creator. Horne argues that what can be especially prob-lematic about museums is their attribution of reverence to objects simply because of their aura of authenticity (1984: 249). How we gaze within museums has changed in three central ways. The sense of aura that Horne describes has been under-mined through the development of the postmodern museum. This involves quite different modes of representation and signification. What we 'see' in the museum has been transformed.

First, there has been a marked broadening of the objects deemed worthy of being preserved. This stems from a changed conception of history. There has been a decline in the strength of a given national history, which the national museums then exemplify. Instead a proliferation of alternative or vernacular histories has developed – social, economic, populist, feminist, ethnic, industrial and so on. There is a pluralisation and indeed a contemporarisation of history. This has produced in Britain a 150 per cent increase in the number of museums over the past twenty years (see White, 1987). The British Tourist Authority has calculated that there could be up to 12,000 museum-type venues in Britain (see Baxter, 1989). Museums are concerned with 'representations' of history, and what has happened is a remarkable increase in the range of histories worthy of being repre-sented. I have already noted some of these, especially the development of rural and industrial museums. It is now almost as though the worse the previous histor-ical experience, the more authentic and appealing the resulting tourist attraction (see Urry, 1988: 50). No longer are people only interested in seeing either great works of art or artefacts from very distant historical periods. People increasingly seem attracted by representations of the 'ordinary', of modest houses and of mundane forms of work. [. . .] There has been quite stunning fascination with the popular and a tendency to treat all kinds of object, whether it is the *Mona Lisa* or the old cake tin of a Lancashire cotton worker, as almost equally interesting. One could summarise this shift as being 'from aura to nostalgia', and it reflects the anti-elitism of postmodernism (see Edgar, 1987). It should also be noted that all sorts of other phenomena are now preserved in museums, including moving images, radio, television, photographs, cinemas, the environment and even the sets of TV soap operas (Lumley, 1988; and see Goodwin, 1989, on the Granada museum of the *Coronation Street* set).

There has also been a marked change in the nature of museums themselves. No longer are visitors expected to stand in awe of the exhibits. More emphasis is being placed on a degree of participation by visitors in the exhibits themselves. 'Living' museums replace 'dead' museums, open-air museums replace those under cover, sound replaces hushed silence, and visitors are not separated from the exhibits by glass.

[. . .]

Hooper-Greenhill notes a number of further attitudinal changes taking place in Britain's museums which are making them much more aware of the public and of how to improve the experience of visiting the particular museum (1988). In Leicester, for example, some acknowledgement is now made that visitors will come from different ethnic groups and that the museum staff must concern themselves with the various ways in which such visitors may interact with the displays and with the different accounts of histories they present (Hooper-Greenhill, 1988: 228–30).

There are further ways in which the museum display is now far less auratic. It is now quite common for it to be revealed how a particular exhibit was prepared for exhibition, and in some cases even how it was made to appear 'authentic', there are also now a number of museums where actors play various historical roles and interact with the visitors, even to the extent of participating in various historical sketches. [. . .] Lumley summarises these changes overall by arguing that they involve replacing the notion that the museum is a collection for scholarly use with the idea that it is a means of communication (1988: 15).

In addition there is a changed relationship between what is considered a museum and various other social institutions. Those other institutions have now become more like museums. Some shops, for example, now look like museums with elaborate displays of high-quality goods where people will be attracted into the shop in order to wander and to gaze. In places like the Albert Dock in Liverpool, which contains the Tate Gallery of the North, a maritime museum and many stylish shops, it is difficult to see quite what is distinctive about the shops as such since people seem to regard their contents as 'exhibits'. Stephen Bayley, from the new Museum of Design in the London Docklands, has remarked:

> the old nineteenth-century museum was somewhat like a shop . . . a place where you go and look at values and ideas, and I think shopping really is becoming one of the great cultural experiences of the late twentieth century. . . . The two things are merging. So you have museums becoming more commercial, shops becoming more intelligent and more cultural.
>
> (Quoted in Hewison, 1987: 139)

It has also been suggested recently that 'factory tourism' should be developed in Britain, that factories should in effect be viewed as museum-like. [. . .] The English Tourist Board calculates that up to 6 million people visit a factory each year and that this figure will soon rise to 10 million. What is happening is that the factory is becoming more like a museum. This poses particular difficulties for museum staff, who should be trying to fashion an identity for museums different from that of commercial enterprises. [. . .] The new-style heritage centres, such as the Jorvik Viking Centre in York or the Pilgrims Way in Canterbury, are competitors with existing museums and challenge given notions of authenticity. In such centres there is a curious mixing of the museum and the theatre. Everything is meant to be authentic, even down to the smells, but nothing actually *is* authentic. These centres are the product of a York-based company, Heritage Projects, whose work is perhaps the most challenging to existing museums who will be forced to adapt even further (see Davenport, 1987).

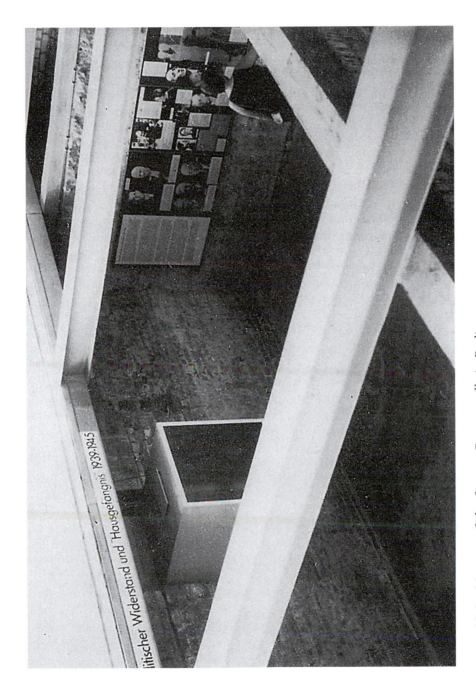

Figure 10.3 Museum of the former Gestapo cells in Berlin

The sovereignty of the consumer and trends in popular taste are colluding to transform the museum's social role. It is much less the embodiment of a single unambiguous high culture from which the overwhelming mass of the population is excluded. Museums have become more accessible, especially to the service and middle classes (see Merriman, 1989, for a recent UK survey, and Heinich, 1988, on the Pompidou Centre). In the leisure of such classes, Merriman (1989) suggests, museum-visiting, with its previously high cultural associations, enables the acquisition of a certain cultural capital, an acquisition made possible by the increased degree to which people are now able to 'read' museums. This has helped museums to become important in defining good taste, particularly, as we saw earlier, the 'heritage' look. A rural version of this is the 'country decor' look, the parameters of which are partly defined in terms of rural museums and the 'charming' manner in which the various quaint rooms are set out.

It is worth asking whether it is now possible to construct a museum or heritage centre preserving just any set of objects. It certainly seems possible. Some apparently unlikely museums which nevertheless succeed are a pencil museum in Keswick, a museum of the chemical industry in Widnes, a former Gestapo prison cells museum in Berlin (see Figure 10.3), a Japanese prisoner-of-war museum in Singapore, a dental museum in London, and a shoe museum in Street. However, such museums appear to work because some connections between the past and the present are usually provided by place. It may sometimes be provided by occupation, industry, famous person or event. However, some museums/heritage centres do not work, such as a Wild West heritage park which was located in the Rhondda Valley in South Wales; it seems that potential visitors did not view this as an appropriate location.

So it is clear that museums cannot be created about anything anywhere. But a museum on almost any topic can be created somewhere. A lot more museums will emerge in the next few years although whether we should still refer to them as 'museums' is increasingly doubtful. The very term 'museum' stems from a period of high art and aurartic culture well before 'heritage' had been invented.

Bibliography

Atley, A. and Robinson, J. (1985) *The Official New Georgians Handbook*, London: Ebury Press.

Bagguley, P. (1990) 'Gender and labour flexibility in hotel and catering', *Service Industries Journal* 10: 737–47.

Bagguley, P., Mark-Lawson, J., Shapiro, D., Urry, J., Walby, S. and Warde, A. (1989) 'Restructuring Lancaster', in P. Cooke (ed.), *Localities*, London: Unwin Hyman, pp. 129–65

Bagguley, P., Mark-Lawson, J., Shapiro, D., Urry, J., Walby, S. and Warde, A. (1990) *Restructuring: Place, Class and Gender*, London: Sage.

Baxter, L. (1989) 'Nostalgia's booming future', *Daily Telegraph*, 21 July.

Binney, M. (1984) *Our Vanishing Heritage*, London: Arlington Books.

Binney, M. (1988) 'Will Morecombe be wise?, *Sunday Telegraph*, 30 October.

Buck, N., Gordon, I., Pickvance, C. and Taylor-Gooby, P. (1989) 'The Isle of Thanet:

restructuring and municipal conservatism', in P. Cooke (ed.), *Localities*, London: Unwin Hyman, pp. 166–97.

Cloke, P. (1989) 'Land-use planning in rural Britain', in P. Cloke (ed.), *Rural Land-use Planning in Developed Nations*, London: Unwin Hyman, pp. 18–46.

Cowen, H. (1990) 'Regency icons: marketing Cheltenham's built environment', in M. Harloe, C. Pickvance and J. Urry (eds), *Place, Politics and Policy. Do Localities Matter?*, London: Unwin Hyman, pp. 128–45.

Davenport, P. (1987) 'A fine future behind us', *The Times*, 3 November.

Davies, L. (1987) 'If you've got it, flaunt it', *Employment Gazette* (April): 167–71.

Economic Development (n.d.) *I've Never Been to Wigan, but I Know What It's Like*, Wigan: Economic Development.

Edgar, D. (1987) 'The new nostalgia', *Marxism Today* (March): 30–5.

English Tourist Board (n.d.) *Tourism Enterprise by Local Authorities*, London: English Tourist Board.

Fondersmith, J. (1988) 'Downtown 2040: making cities fun', *The Futurist* (March/April): 9–17.

Foster, H. (ed.) (1985) *Postmodern Culture*, London: Pluto.

Frampton, K. (1988) 'Place-form and cultural identity', in J. Thackara (ed.) *Design after Postmodernism*, London: Thames & Hudson, pp. 51–66.

Frieden, B. and Sagalyn, L. (1989) *Downtown, Inc. How America Rebuilds Cities*, Cambridge, MA: MIT Press.

Goodwin, A. (1989) 'Nothing like the real thing', *New Statesman and Society*, 12 August.

Halsall, M. (1986) 'Through the valley of the shadow', *Guardian*, 27 December.

Harris, H. and Lipman, A. (1986) 'Viewpoint: a culture and despair: reflections on "postmodern" architecture', *Sociological Review* 34: 837–54.

Harvey, D. (1988) 'Voodoo cities', *New Statesman and Society*, 30 September: 33–5.

Harvey, D. (1989) *The Condition of Postmodernity*, Oxford: Blackwell.

Hebdige, D. (1986–7) 'A report from the Western Front', *Block* 12: 4–26.

Heinich, N. (1988) 'The Pompidou Centre and its public: the limits of a utopian site', in R. Lumley (ed.), *The Museum Time-Machine*, London: Routledge, pp. 199–212.

Hewison, R. (1987) *The Heritage Industry*, London: Methuen.

Hooper-Greenhill, E. (1988) 'Counting visitors or visitors who count', in R. Lumley (ed.), *The Museum Time-Machine*, London: Routledge, pp. 213–32.

Horne, D. (1984) *The Great Museum*, London: Pluto.

Houston, L. (1986) *Strategy and Opportunities for Tourism Development*, Glasgow: Planning Exchange.

Hutchinson, M. (1989) *The Prince of Wales: Right or Wrong?*, London: Faber & Faber.

Januszczak, W. (1987) 'Romancing the grime', *Guardian*, 2 September.

Jencks, C. (1977) *The Language of Post-Modern Architecture*, New York: Academy.

Jenkins, S. (1987) 'Art makes a return to architecture', *Sunday Times*, 15 November.

Jordanova, L. (1989) 'Objects of knowledge: a historical perspective on museums', in P. Vergo, *The New Museology*, London: Reaktion, pp. 21–40.

Knox, P. (1988) 'The design professions and the built environment in a postmodern epoch', in P. Knox, (ed.) *The Design Professions and the Built Environment*, London: Croom Helm, pp. 1–11.

Krier, L. (1984) 'Berlin-Tagel' and 'Building and architecture', *Architectural Design* 54: 87, 119.

Landry, C., Montgomery, J., Worpole, K., Gratton, C. and Murray, R. (1989) *The Last Resort*, London: Comedia Consultancy/SEEDS (South East Economic Development Strategy).

Lash, S. and Urry, J. (1987) *The End of Organized Capitalism*, Cambridge: Polity.

Lowe, P. and Goyder, J. (1983) *Environmental Groups in Politics*, London: Allen & Unwin.

Lowenthal, D. (1985) *The Past is a Foreign Country*, Cambridge: Cambridge University Press.

Lumley, R. (ed.) (1988) *The Museum Time-Machine*, London: Routledge.

MacCannell, D. (1976) *The Tourist: A New Theory of the Leisure Class*, London: Macmillan.

Merriman, N. (1989) 'Museum visiting as a cultural phenomenon', in P. Vergo, *The New Museology*, London: Reaktion, pp. 149–71.

Myerscough, J. (1986) *Facts about the Arts*, London: Policy Studies Institute.

Myerscough, J. (1988) *The Economic Importance of the Arts in Britain*, London: Policy Studies Institute.

Pawley, M. (1987) 'The man who learned', *Intercity* (November/December).

Pearman, H. (1988) 'Setting store by its designs', *Sunday Times*, 3 August.

Pearman, H. (1989) 'Manchester gets a mix 'n' match revival', *Sunday Times*, 16 April.

Punter, J. (1986–7) 'The contradictions of aesthetic control under the Conservatives', *Planning Practice and Research* 1: 8–13.

Raban, J. (1986) *Coasting*, London: Picador.

Reynolds, H. (1988) '"Leisure revolution" prime engines of regional recovery', *Daily Telegraph*, 2 December.

Roberts, J. (1989) 'Green mantle', *Guardian*, 17–18 June.

Rose, M. (1978) *The Gregs of Styal*, Cheshire: Quarry Bank Mill Development Trust.

Samuel, R. (1987a) 'History that's over', *Guardian*, 9 October.

Samuel, R. (1987b) 'A plaque on all your houses', *Guardian*, 17 October.

Savage, M. (1988) 'The missing link? The relationship between spatial mobility and social mobility', *British Journal of Sociology* 39: 554–77.

Scruton, R. (1979) *The Aesthetics of Architecture*, Princeton, NJ: Princeton University Press.

Stamp, G. (1987) 'A right old Roman carry-on', *Daily Telegraph*, 28 December.

Stauth, G. and Turner, B. (1988) 'Nostalgia, postmodernism and the critique of mass culture', *Theory, Culture and Society* 2/3: 509–26.

Taylor, I. (1988) 'Down beside the seaside', *Marxism Today* (October): 43.

Thrift, N. (1989) 'Images of social change', in C. Hamnett, L. McDowell and P. Sarre (eds), *The Changing Social Structure*, London: Sage, pp. 12–42.

Urry, J. (1988) 'Cultural change and contemporary holiday-making', *Theory, Culture and Society* 5: 35–55.

Uzzell, D. (1989) *Heritage Interpretation*, Vol 2, London: Belhaven Press.

Venturi, R. (1972) *Learning from Las Vegas*, Cambridge, MA: MIT Press.

Vidal, J. (1988) 'No room here for Mickey Mouse', *Guardian*, 19 March.

Waterhouse, R. (1989) 'Town abandons trousers for sake of tourism', *Financial Times*, 8 July.

Wates, N. and Krevitt, C. (1987) *Community Architecture*, Harmondsworth: Penguin.

White, D. (1987) 'The born-again museum', *New Society*, 1 May: 10–14.

Williams, A. and Shaw, G. (1988c) 'Tourism: candyfloss industry or job creator?', *Town Planning Review* 59: 81–103.

Wolmar, C. (1989) 'The new East Enders', *Guardian*, 8–9 April.

Wood, M. (1974) 'Nostalgia or never: you can't go home again', *New Society*, 7 November: 343–6.

Wright, P. (1985) *On Living in an Old Country*, London: Verso.

Museums as classificatory systems and their prehistories

Introduction to part three

■ Jessica Evans

T HE SHIFT FROM DISPLAYING artefacts in private collections to their
housing in national institutions was, as was pointed out in the Introduction,
uneven. It is true that there was, increasingly throughout the eighteenth century,
a tendency for private collections to pass into public forms of ownership and admin-
istration. However, this meant that museums were open not to the 'general public'
as that term came to be understood in the nineteenth century, but to the more
limited public of the educated and aristocratic society. By the end of the eigh-
teenth century those museums that were public were only so in a limited sense of
the word with regard both to the persons admitted and to the level of funding they
received. No impetus for major reform existed until the 1832 Reform Bill which,
in extending the franchise for Parliament, brought in a Whig government which
mounted a series of enquiries into a wide range of public institutions, including,
in 1835–6, the British Museum. Richard Altick in 'National monuments', a chapter
from his richly detailed book *The Shows of London* (1978) examines the back-
ground to this inquiry, relating it to contemporary dissatisfaction with the
administration of London's other major public monuments: the Tower of London,
Westminster Abbey and St Paul's Cathedral. In spite of appearances to the contrary,
both advocates and opponents of the view that the museum should be made more
readily accessible to the general public share common ground. Conservatives and
rational recreationists both saw their position as a means to another end – the
regulation and curbing of working-class radicalism and protest. Indeed, as Tony
Bennett points out in his 'The exhibitionary complex', fear of the crowd haunted
debates on the museum's policy for over a century' (in this volume, p. 332–362).
It is Bennett's contention that the impetus for allowing unrestricted universal access
to museums should be read not in terms of a manifestation of the onward march
of liberal progress, but rather as a new form of regulating mechanism which sought

to expose working-class people to the pedagogic mores of middle-class culture. This was a culture that was seen as fundamentally civilizing. So one move by museums, as they began to be used as instruments of state regulation, was quite literally to bring the popular classes into their orbit. One can see from Altick's chapter the anxious and fascinated obsession of Enquiry Commission members with the culture of the working classes – their uncouth habits of drink and sexual misdemeanours. However, it also needs to be remembered that the development, at the end of the eighteenth century, of clearer lines of separation between the newly founded public museums and popular cultural forms did not prevent the still popular exhibitions of freaks, monstrosities and assorted curiosities from informing the classificatory schemes of museums. Altick's book *The Shows of London* is an important corrective to the standard view that the practices of prestigious museums had relations only with other, equally prestigious, institutions.

Until the first half of the nineteenth century, then, respectable and popular practices of collection continued to inform each other. It is David Goodman's task in 'Fear of circuses: founding the National Museum of Victoria' to relate how, in the latter half of the nineteenth century, the founding of the National Museum of Victoria in Australia was characterized by the desire to distinguish itself from popular menageries and circuses together with the forms of coarse behaviour associated with these places of popular assembly. The logic of this need for distinction manifested itself in the claims that the museums made for the scientific and instructional value of their displays, as opposed to the exotic and the showy. Thus the museum becomes a 'house of classification' and natural specimens are arranged according to the new biological taxonomies of naming species and family; typification is the guiding principle here, rather than that of rarity and singularity. It is useful here to remember, as Goodman notes at the end of his article (Chapter 12 in this volume), that this was at a time when the relationship between the natural world and the discipline of science was not firmly secured. The Foucauldian framework that Goodman adopts allows him to interpret the object of his immediate study – the National Museum of Victoria – as the legacy of the classical period in which, Foucault argues, attachment to the classificatory table and the subordination of other senses to sight was achieved by a rejection of theatricality and the experience of immediate sensation.

The distinctions between popular culture and prestigious culture were, however, less sharp in the United States where there were important and direct connections between museums and international expositions in the latter half of the nineteenth century, the latter providing the stimulus and finance for the former. Robert Rydell, in 'The Chicago World's Columbian Exposition of 1893', looks at this six-month exhibition – of fairs, theatre, pulp fiction and so on – in terms of the way it organized the relations between the exhibition of persons and the exhibition of things. He shows how the discipline of anthropology, under the sway of eugenics, elaborated an ideology that dominant American culture is, and ought to be, *the* civilized and successful culture. It seemed that the representations and displays of the members of non-western cultures and societies, based on an evolutionary hierarchy from primitives to civilized white racial types, could reveal the integral relation-

ship between the stages of a people and the stages of national cultural achievement. The ideology of progress manifested in the Chicago exposition was, he shows, conducive to the interests of America's bourgeois classes in the sense that they could 'present Americans with visions of progress and cultural unity' (Rydell in this volume, p. 296).

The emphasis upon the evolutionary and the linear, as indicated in Rydell's article, can again be fruitfully contextualized with reference to Foucault's concept of historical *episteme*. This draws attention to the conceptual conditions of knowledge within which particular organized knowledges (such as 'anthropology' or 'biology') are structured, and which provide the background assumptions governing the perception of the relationships between 'words' and 'things'. Tony Bennett has argued that the epistemic shift that matters most for the emergence of the public museum is not that from the Renaissance to the classical episteme, as implied by many writers on the subject, but that from the latter to the modern episteme. As a consequence of this shift, he points out, artefacts came to be 'inserted within the flow of time, to be differentiated in terms of the positions accorded them within evolutionary series . . . [which] formed a totalizing order of things and peoples that was historicized through and through' (Bennett, 1995: 96). Bennett goes on to support Foucault's thesis of the emergence of the new sciences of man in the modern episteme; the birth of the museum, he argues, supplied the institutional framework in which a set of specialized and distinct disciplinary knowledges could flourish – biology, geology, archaeology, anthropology, history and art history.

Art history is the discipline implicated in Carol Duncan's seminal work on the public art museum. It is important that art history and art museums are brought into the sphere of museum studies since to ignore them would be to reinforce the myth that there are simply in existence art objects which require aesthetic appreciation and that museums evolved inevitably as the best place in which to contemplate them. Moreover, the inception of the art museum in late eighteenth-century and nineteenth-century Europe was closely linked to that of a wider set of institutions and disciplines which, representing a diversity of popular, commercial and high cultural forms, centred upon the invention of new discourses of display (see Tony Bennett's 'The exhibitionary complex' in this volume, p. 232–62). As Carol Duncan has indicated, the distinction between 'art' and 'artefact' is one that has been riven by a hierarchical set of relations in which the discipline of anthropology and that of art history have carved out separate fields, specialist lexicons and objects of study and been imbued with quite different values. Thus, we have the familiar division between western and non-western objects being, respectively, those that merit the status of art and are philosophically rich enough to merit isolated aesthetic contemplation, and those that are artefacts deriving from less evolved societies, which are seen as providing us with instructional information about the customs and social relations of a culture (see Duncan, 1995: 5). It is Duncan's project to cross these boundaries with the intention of seeing European and American museums as 'a species of ritual artefact' (ibid.: 5).

We have selected a chapter from Duncan's book *Civilising Rituals: inside public art museums* (1995) which builds closely upon the influential essay she wrote with

Alan Wallach, 'The universal survey museum' (1980). Duncan and Wallach argued then that, viewed historically, 'art history appears as a necessary and inevitable component of the public museum' (Duncan and Wallach, 1980: 456). They continued, 'In the museum, whatever meaning a work of art owed to its original context was lost. Now a part of the museum's programme, it could only appear as a moment of art history' (ibid.: 456). The point has been well made by André Malraux. 'A Romanesque crucifix', he reminds us, 'was not regarded by its contemporaries as a work of sculpture, nor Cimabue's "Madonna" as a picture. Even Pheidias' "Pallas Athene" was not, primarily, a statue' (Malraux, 1967: 9). In her first case-study, Duncan shows how these principles governed the display practices of the Louvre, once it was turned into a public art museum by the French revolutionary government in the 1790s. Collections were reorganized into art-historical schools, outstanding geniuses were highlighted and the evolutionary narrative ensured that 'by walking through the history of art, visitors would live the spiritual development of civilization' (Duncan, 1995: 49). The Italian Renaissance and Roman classicism were accorded privileged places in the museum's iconographical programme and these are seen as the natural forebears of French Classicism. In this way, the new state of the French republic is represented as the authentic heir of classical civilization. As another scholar of the Louvre has recently pointed out, Napoleon's military conquests and looting of hundreds of paintings and objects in Jena, Vienna and Italy, to name but a few, in the early 1800s made possible the expansions of the collections (see McClellan, 1994: 198). In this manner did the Louvre, not only deploying new modes of display of objects but housing these in a new building type, triumphally celebrate the French Empire as the envy of Europe. In contrast with the Louvre, the events surrounding the founding of the National Gallery, Duncan explains, lack a sharp defining moment, due to the unique situation in Britain of an dominant eighteenth-century patrician culture in which the public ownership of property was not a serviceable concept. Duncan shows how the creation of the National Gallery derived from an alignment between entrepreneurial values and the growing pressure for a conception of national institutions which could represent all its citizens, not just those who were franchised.

This brings us to the final reading in this section. In 'The exhibitionary complex', Tony Bennett refers to 'the exhibitionary disciplines' of history, art history, geology, biology and anthropology and shows how they interacted to construct an evolutionary order of things and people. He makes a contrast between institutions of exhibition and Foucault's institutions of confinement and incarceration, rather than seeing an alignment between them. This allows him to theorize the exhibitionary complex as conterminous with an 'opening up of objects to more public contexts of inspection and visibility', a regime in which everyone should be able to see (Bennett in this volume, p. 322). Thus the decisive force which creates the museum in Europe and North America is the passing of property from private to public ownership and the simultaneous management of these by the state for the benefit and education of the national citizenry. Underpinning this was a principle of classification based upon the construction of national characteristics and hierarchies of racial categories and underwritten by a story of human progress

which was fundamentally temporal. As Bennett concludes, in the case of the exhibitionary complex, the unity of the present, under the auspices of a singular national and imperial culture, derives ignominiously from the construction of a 'we' conceived as the beneficiaries of the process of evolution.

Together, the readings in this section build the case that the advent of the modern public museum is inextricably tied to the emergence of the modern nation-state. Through its historicist schema it made tangible the state's claim to be the guardian of a universalized civilization. The question of whether and to what extent these discourses and modes of classification are challenged, modified and transformed in the last decades of the twentieth century is addressed in Part four.

References

Bennett, Tony (1995) *The Birth of the Museum: history, theory, politics*, London: Routledge.

Duncan, Carol and Wallach, Alan (1980) 'The universal survey museum', *Art History* 34 (December).

Duncan, Carol (1995) *Civilising Rituals: inside public art museums*, London and New York: Routledge.

Malraux, André (1967) *A Museum without Walls*, trans. S. Gilbert and F. Price, Garden City, NY: Doubleday.

McClellan, Andrew (1994) *Inventing the Louvre: art, politics, and the origins of the modern museum in eighteenth-century Paris*, Cambridge: Cambridge University Press.

Richard D. Altick

NATIONAL MONUMENTS

UNTIL THE POST-REFORM BILL ERA, except for appropriating money to the British Museum and the National Gallery, the British government had played no part in the London exhibition world. The old and still prevailing philosophy of government's proper sphere simply excluded such aspects of the people's life from official concern. In fact, however, four of the most famous London shows belonged to the nation: two obliquely, as the property of the established Church of England (Westminster Abbey and St. Paul's Cathedral) and the others (the Tower of London and the British Museum) as outright public property. In the absence of any official solicitude respecting their management, three of these were operated as mercenary places of public resort. No such extortionate atmosphere distinguished the fourth, the British Museum, but its studied policy of excluding as many members of the general public as possible was equally at odds with the new social thought that began to make itself felt in the 1830s and 1840s. The story of the controversy involving these well-known London sights in the first half of the century is an exemplary instance of the conflict between conservative tradition and liberalism as the first faint outlines of the so-called interventionist state began to appear. By the early 1840s, when exhibitions, broadly conceived, were coming to be looked upon as a possible instrument of social reform, and their provision and regulation as a proper concern of national policy, there were signs that the government would soon actively involve itself in an aspect of London life which until then had been monopolized by private and vested interests.

The monument-showplace most often complained of was Westminster Abbey. Beginning in 1801, when the building ceased to be a public thoroughfare, a fee was levied for admittance at all times except during divine service, at the conclusion of which the vergers brusquely showed non-paying worshipers the door. The old practice of farming out particular portions of the building for the benefit of the minor canons, lay clerks, and organists persisted. By 1807, the aggregate charge

to see the Abbey was two shillings, on top of which tips were expected at numerous points, though nominally forbidden.

[. . .]

Although the entrance charge was subsequently reduced to ninepence, once inside visitors were still at the mercy of the enclosure system. Visiting London in 1835, the historiographer Frederick von Raumer complained that the building was "a labyrinth of wooden partitions, doors, screens, railings, and corners. . . . It seemed as if all these nooks and swallows' nests were contrived merely to increase the number of showmen and key-bearers who lurk in them."[1]

[. . .]

But the Abbey . . . had lost its once considerable advantage over St. Paul's. This developing branch pantheon now became a London attraction coequal with the original, and its own century-old entrance fee as much of a public issue as the price scale at Westminster.

[. . .]

The Tower of London received less criticism in the first third of the century than it appears to have deserved. Perhaps because it was not under clerical management. Its fee structure was as complex as those at the two great churches, and making the complete round cost considerably more — no less than twelve shillings in the 1830s — with the usual gratuities in addition.

[. . .]

The British Museum entered the nineteenth century in a practically comatose condition so far as service to the public was concerned. Of the £120,000 allocated to it between its establishment in 1759 and 1816, half had gone for books and manuscripts and half for two large collections of antiquities, the Towneley and the Elgin. Virtually nothing had been spent for zoological, botanical, mineralogical, or paleontological materials, so that its exhibits in these fields of growing interest, beyond the original Sloane collection, were as yet confined to what it received by gift or bequest. Beginning in 1816 modest grants were made for such purchases, but the museum's holdings only began to expand in a major way four years later, with Sir Joseph Banks's bequest of his great scientific collection.

Unsuitable from the beginning as a museum, the building now became more and more congested as the flow of acquisitions, stimulated by the Banks bequest, swelled in the late 1820s and the 1830s. Under the begrimed painted ceilings the "admired disorder" increased, the unlabeled and uncared-for exhibits being thrown together without regard for logical relationships or effective display. Much material decayed to the point of uselessness, and periodic bonfires consumed the "rubbish" from the several scientific departments. In a losing effort to bring space abreast of content, ill-matched, damp, and otherwise unsatisfactory annexes were added from time to time as part of the long-drawn-out process (1823–52) by which old Montague House was replaced by a new structure. For two decades, therefore, visitors wandered through the premises distracted by the dirt and noise of a seemingly permanent construction project.[2]

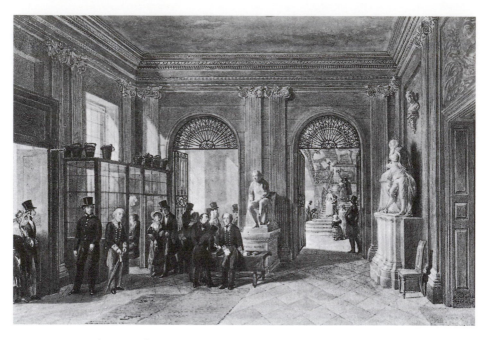

Figure 11.1 The British Museum: entrance hall of old Montagu House, from a watercolor by George Scharf the elder, made in 1845, shortly before this portion of the building was demolished

The administration was in the hands of a few sinecurist officials, chiefly clergymen, who invoked the pressures of their research, which was desultory at best, to justify their extreme reluctance to welcome casual visitors or even, in some cases, those with a serious professional interest in the collections. In the entire year 1805 only 2,500 persons, mostly foreigners, braved the obstacles thrust in their way. Among these was Benjamin Silliman, who, after having been repeatedly disappointed in his attempts to get inside, finally succeeded [. . .]: "It is really distressing," he wrote, "to be surrounded by a host of things which are full of information, and then to be hurried away from them just as one is beginning to single out particular objects."[3] A small improvement occurred two years later, when the ticket requirement was dropped in favour of admitting "any person of decent appearance" up to a limit of about 120 a day.[4] As a consequence, 13,000 persons entered during the first year under the new policy (May 1807–April 1808).[5]

[. . .]

This, then, was the condition of the four major public monuments in London when the reformist Whigs came to power in 1832. Hitherto, unlike the closely related movements on behalf of free elementary education and scientific education for the adult masses, which had behind them the powerful lobbying and propagandizing force of organizations like the Useful Knowledge Society, the spreading dissatisfaction with the operation of these institutions had been unfocused and

unorganized. Now, however, the sentiment for converting three of the monuments into freely accessible places for public enjoyment rather than personal (ecclesiastical) gain or comfort was adopted as a part of the reform bloc's program, not only for its own sake, but to help energize the program as a whole. It proved very useful.

The liberal Whigs were strongly, though selectively, anti-establishment, in harmony with the movement that had recently seen London University founded to challenge the Oxbridge monopoly on English higher education and, in another sphere, with Haydon's (and later Martin's) campaign against the autocratic Royal Academy. The impending attack on the British Museum would be fueled by the not unrelated facts that its trustees, a self-perpetuating body, were drawn from the most conservative elements in contemporary society, and most of its officials were clergymen well paid to do little work. The most powerful vested interest of all was the Church of England, whose lush privileges and unbecoming wealth the secularist politicians in particular were determined to trim. Although the actual sums of money involved at the Abbey and St. Paul's were of little consequence, the assault on the ecclesiastical proprietorship of the shows there neatly dovetailed with the grand scheme to cleanse the Established Church of its manifold corruptions of nepotism, pluralism, and luxury. What the liberals took to be the people's active desire to enjoy the public sights of London unhindered by entrance charges, the importunities of attendants, and obstructive officialdom provided them with a most attractive ground on which to assert the people's interests over the parsons', to challenge the dead hand of outworn, self-serving custom.

The reformers, however, were not so heavily committed to the democratic principle that they failed to share the upper class's long-standing fear of the people as a social and political force with great, though unmeasured, potential for trouble. The Luddite disturbances of 1811–12 and 1816 and the more recent crisis over the Reform Bill were vivid in memory, and from the mid-1830s the ominous clouds of "physical force" Chartism were gathering. An implicit end which giving the people free access to public monuments might serve, therefore, was to provide them, as popularized science might also do, with a peaceable and perhaps even rewarding alternative to talking and thinking subversion and forming militant radical organizations.

Yet beneath these immediate pragmatic objectives resided a substantial layer of idealism which was genuine enough, no matter how glibly it often was invoked – degenerating sometimes into the worst kind of pious cant – in order to conceal less altruistic purposes. A certain influential, if relatively small, body of public men had begun to believe that the intellectual curiosity and constructive mental energy to which exhibitions typified by the British Museum and the Abbey might appeal was a valuable cultural resource. In their view the government was obligated to oversee, if not actually support and manage, such institutions in behalf of the people's moral and social improvement. In the 1830s and 1840s, when the popular education movement reached its peak, there were innumerable expressions of this faith that the ordinary man was capable of participating in the nation's cultural life and should be encouraged to do so. One such statement appeared in *Blackwood's Magazine* in 1842:

> Exhibitions, galleries, and museums, are part and parcel of popular
> education in the young and the adult: they stimulate that principle of
> inquisitiveness natural to man, and with the right sort of food: they
> instil knowledge, drop by drop, through the eye into the mind, and
> create a healthy appetite, growing with what it feeds on: they make
> the libraries of those who have no money to expend on books, and are
> the travels of those that have no time to bestow on travel: they are
> schools in which the best and only true politeness may be taught —
> politeness that refines the manners by ennobling the heart: they are the
> best allies of despots, beguiling even slavery of its bitterness; and the
> surest aids to freemen, since they inculcate tastes and habits that render
> even freemen still more free.[6]

Among the evidences of the people's presumed interest in visiting the great
national monuments was the wide circulation of cheap papers describing and
picturing them. Amidst all its other "general information" articles the *Penny
Magazine*, for example, ran illustrated descriptions of England's abbeys and churches
and the Tower of London. The result of this burst of attention to architecture and
native antiquities in the didactic section of the popular press was, according to
more than one witness before parliamentary committees, "a laudable curiosity in
the hitherto misinformed mind, as well as a greater respect for works of art and
antiquity".[7] So wholesome a development should be officially encouraged by
enabling the public to visit, without cost or hindrance, the places they read about.

There was also the appeal to patriotism. As travel to the continent increased,
some Englishmen were disturbed by what they regarded as their own nation's clear
inferiority to France, Italy, and Germany in respect to the accessibility of public
buildings. The *Blackwood's* writer just quoted was unequivocal on the point:

> If there is one thing in which we fall below foreign nations, it is in the
> circumscribed and limited utility of our purely national, which should
> be purely gratuitous, exhibitions. In this we are positively shabby and
> more than shabby — we are unwise. From our public exhibitions, we
> must be estimated by the great mass of foreigners who may not have
> opportunities of gaining access to select society, and who can see nothing
> of us but our streets, and the outsides of our houses. The courteous
> liberality with which they fling open to us their churches, halls, and
> galleries, we do by no means reciprocate; and whatever estimate they
> may form of our power, grandeur, and wealth, they have but little to
> say in favour of our generosity.

The most elevated note of this campaign, however, was struck by those who
envisaged the aesthetic, and eventually the moral and religious, benefits that would
accrue to a public enjoying free access to places like the Abbey and St. Paul's. A
member of Parliament who admitted that he seldom found himself agreeing with
the reformist party declared that the difficulties impecunious people had in entering
those venerable houses of worship meant that they were being deprived of "the
finest works of art in the world". Alluding to Burke's definition of the sublime

and its tendency to call forth noble feelings, he expressed the opinion that "fine paintings on religious subjects, good sculpture, and striking architecture, influence and improve the religious sentiments of the lower classes".[8] One of the parliamentary committees involved in the movement took the same line in its report. Free admission, it asserted, "may be made conducive not merely to the gratification of curiosity and the acquirement of historical knowledge, but to the growth and progress of religious impressions, by leading the mind of the spectator from the contemplation of the building to a consideration of the views with which, and the purposes for which, it was originally erected and is still maintained".[9]

Opposing this idea that every man had an inherent right to enjoy and benefit from the national treasures were, for the most part, the old-line Tories who at the same time were fighting proposals for state-aided elementary education on the ground that teaching working people to read would tempt them into unproductive idleness and, in the extreme view, foment rebellion. They pointed to the menace that the democratization of privilege in such matters as museum-going exercised over taste. The familiar application of Gresham's law to culture in general in an emerging democracy – that low standards of necessity supersede high ones – was invoked in respect to museums in particular. James Fenimore Cooper, who shared some of the deepest prejudices of his English Tory cousins, doubtless spoke for many when he remarked of the Abbey waxworks that they exemplified the "crude and coarse tastes" which the purchasing power of the people had made a norm for the whole nation; they had "an influence on all public exhibitions that is unfelt on the continent, where the spectacle being intended solely for the intellectual, is better adapted to their habits".[10]

The doughty populist-journalist William Cobbett, sitting in the reformed Parliament as member for Oldham, vociferously opposed grants for the British Museum's annual expenses and a new building for other reasons.

> He would ask [reported Hansard] of what use, in the wide world, was this British Museum, and to whom, to what class of persons, it was useful? He found that 1,000 *l.* had been laid out in insects; and surely hon. Members would not assert that these insects were of any use to the ploughboys of Hampshire and of Surrey, and to the weavers of Lancashire! It did a great deal of good to the majority of those who went to it, but to nobody else. The ploughman and the weavers – the shopkeepers and the farmers – never went near it; they paid for it though, whilst the idle loungers enjoyed it, and scarcely paid anything. Let those who lounged in it, and made it a place of amusement, contribute to its support. Why should tradesmen and farmers be called upon to pay for the support of a place which was intended only for the amusement of the curious and the rich, and not for the benefit or for the instruction of the poor? If the aristocracy wanted the Museum as a lounging place, let them pay for it. For his own part he did not know where this British Museum was, nor did he know much of the contents of it, but from the little he had heard of it, even if he knew where it was, he would not take the trouble of going to see it".[11]

This same Cobbett, a few days earlier, had categorically declared that education was useless and that he was completely opposed to the "higher branches" of science. Rebuked though he was by some of his conservative fellow members, his views were not peculiar to him; expressed in more temperate language, they were held by a significant portion of Parliament. Nevertheless, the burden of sentiment lay elsewhere. The prevailing, if not necessarily most realistic, note in this hopeful era of cultural dissemination was that struck by one Whig member in opposition to Cobbett, Thomas Spring Rice:

> Let the hon. Member go to the Museum on any public day, and he would find it crowded . . . with members of the poorer classes, who went there to see the works of art and science, which they had read of in the works of information which they had read on the previous Saturday. He would see that the pleasure derivable from the *chefs d'oeuvres* of arts and science was not confined to the higher classes, but was extended even to those whom we were accustomed to consider as the lower classes of the community.[12]

Clearly, Spring Rice was exaggerating in a good cause: the attendance figures for these years do not permit us to believe that any substantial numbers of "the poorer classes" found their way into the British Museum. But it was on behalf of this body of the population, to which some public men attributed a genuine hunger for knowledge, that several select committees of Commons were appointed to look into the alleged malfeasance, corruption, and anti-democratic management of the noncommercial institutions most familiar to London sightseers. These inquiries constituted forums in which the complaints hitherto aired in the press, with little result, could now be authoritatively restated, amplified, and augmented. The principal subjects of the investigations were the British Museum (1835–6), "national monuments and works of art" (1841), and the National Gallery (1850). Although most of the impetus came from liberals, these were not wholly partisan undertakings. Supporting the inquiry into the British Museum, for instance, was an influential portion of the scientific community whose spokesman was Sir Humphry Davy, well known to be no "Radical Reformer" but a thoroughgoing Tory. The questioning, however, was ordinarily led by a chairman whose purposes were unmistakable, Joseph Hume, a veteran leader of liberal causes. Indispensable though the voluminous record of evidence is, it must be read with caution. The issues were emotional ones, engaging the witnesses' deepest social convictions and prejudices, and both the vividness and the hyperbole of some of the testimony distort the reality.

The tenor of the examination of hostile witnesses as well as an important line of questioning is typified by this passage in the record of the 1835 British Museum inquiry, when the crusty principal librarian (director) of the institution, Sir Henry Ellis, was giving evidence. The issue at the moment was the museum's practice of closing at Easter and Whitsuntide for annual cleaning and the receipt of a year's accumulation of newspapers from the Stamp Office. "Do you think", Ellis was asked, "that is a sufficient reason for excluding the public at a time when so large a portion of the people are at leisure?" "I think", he replied, "the most mischievous portion of the population is abroad and about at such a time."

Q Do you think that any mischief would arise to the Museum provided sufficient attendants were present?

A Yes, I think the most vulgar class would crowd into the Museum.

Q Do you not think that one object of the Museum is to improve the vulgar class?

A I think the mere gazing at our curiosities is not one of the greatest objects of the Museum.

Q Do you think there would be any difficulty, supposing the Committee thought that the Museum should be open during the Easter and Whitsun weeks, in accomplishing such a wish?

A I think the exclusion of the public is very material, inasmuch as the place otherwise would really be unwholesome. The great extent of cleansing which they enable us to undertake, renders those weeks very necessary to us. . . .

Q Would it not be desirable, with reference to the great mass of the people, that that cleansing should take place at some other part of the year, and that the Museum should be open during the great public holidays?

A I think that the inconvenience, generally speaking, is less on those great public holidays than it would be at any other time.

Q Are there not more people about whom you should be anxious to instruct and amuse during those holidays than at any other portion of the year?

A I think the more important class of the population (as far as we are concerned) would be discontented at such a change as the former question contemplates.

Q Will you describe what you mean by the more important part of the population?

A People of a higher grade would hardly wish to come to the Museum at the same time with sailors from the dock-yards and girls whom they might bring with them. I do not think such people would gain any improvement from the sight of our collections.

Q Did you ever know of an instance of a sailor bringing a girl from the dock-yards?

A I never traced them to the dock-yards, but the class of people who would come at such times would be of a very low description.[13]

The eventual consequence of this asperity-laden exchange, and of other lively passages of questioning during the same committee's hearings, was that in 1837 the British Museum was open, for the first time, on holidays. On the first Easter Monday under the new policy, 23,000 persons jammed the building.[14] Despite Sir

Henry's black misgivings, no slightest breach of the peace occurred; but this did not soften his and most of his colleagues' resistance to the further proposal that the museum and the other national monuments be opened on Sundays as well. The pressure to provide free places of recreation on Sundays and holidays was growing as city dwellers, deprived of their former easy access to the countryside, were forced to depend on the resources of central London to fill their leisure. On Sundays the Abbey and St. Paul's were open only for services, after which everyone was unceremoniously evicted. Brought back to testify before the National Monuments Committee in 1841, Ellis was as implacably opposed to opening the museum on Sunday as he had been to moving the "closed for cleaning" weeks to non-holiday periods. "The servants of the museum", he declared, "are as much entitled to the quiet of the Sabbath as any others of Her Majesty's subjects." Although Sunday labor was required of some British subjects, in general it was a peculiarity of "catholic countries" and therefore not a precedent to be followed in Britain. One of Sir Henry's colleagues offered another argument against Sunday opening: it would not do to rely on attendants who were willing to take Sunday duty. "I should have less confidence in a man who would be willing to have his Sunday occupied in that way than in one who had scruples upon the subject." A third official, however, John Edward Gray, the keeper of the zoological collection, broke ranks on the issue. Having formerly practiced medicine in Spitalfields, he knew that the residents there were "very fond of works of natural history" and spent their Sundays working in their gardens and botanizing in the country. They would assuredly come to the British Museum if it were open on Sunday afternoons.[15] (The example was as loaded as the reasoning was imperfect, because residents of Spitalfields, the descendants of silk weavers who had come there as Huguenot refugees, were regarded as the aristocrats of London labor, with a markedly superior interest in things of the mind. They constituted a negligible minority of the total population.)

It was a reformist tenet that, as a Fellow of the Antiquarian Society told the 1836 British Museum Committee, opening the museum on Sunday "would be one of the very best modes of counteracting the effect of gin palaces", which were then open all day Sunday and, after 1839, would be allowed to do business after 1 p.m. *Q:* "It would tend to give them a taste for objects of natural history, rather than a taste for gin?"[16] *A:* "Unquestionably, it would be one of the best modes of improving the morals of the people."[17] Sir Henry Ellis bluntly disagreed: "I do not think that the Museum would be an attraction to any party who might be inclined to go into a public-house on the Sunday."[18]

<div align="center">[. . .]</div>

Ellis's opposition to opening the British Museum at holiday seasons and [the Duke of] Wellington's limitation on the number of persons allowed inside the Tower [of which he was Chief Constable] at a given time exemplified the most deep-seated prejudice that haunted all discussion of free access to public monuments: the fear of the crowd that has already been mentioned. At base it was a political fear, a virtual conviction that large gatherings of lower-class people, if not strictly controlled, always posed a threat to order. The liberals, recognizing the power of such apprehensions in this nervous age of the Chartists, sought to

quiet them by arguing that "the million's" capacity for mischief could deftly be diverted into healthy channels by sending them to places like the Abbey and the British Museum. This was another assumption, less explicit than the one having to do with temperance, that lay behind the advocacy of public monuments as alternatives to public houses, because it was at one tavern or another that numerous reform or revolutionary movements in the past two centuries had been launched or had their headquarters.

But in these parliamentary inquiries, as in the surrounding climate of press comment, despite the lowering Chartist threat there was little overt hint of a bread-and-circuses motive. The specifically political desirability of moving crowds from unruly taverns to the calmer environs of churches and museums went largely undiscussed. Instead, attention was centered on the personal and group behavior of the masses, on their capacity for disorder unrelated to political agitation, and how it could be transformed into personal decency, decorum, and responsibility. The extensive testimony received by the committees must be read with an awareness that in the earliest Victorian years the public behavior of the urban population was less restrained than at any time since. "Riotous" conduct, often accompanied by drunkenness, was commonplace, and, in the thickening atmosphere of middle-class propriety, disgusting.

The prevalence of public drunkenness gave pause to even the best-intentioned friends of the people. Not many chose to contemplate the possibility that working-class men and women, failing to appreciate that the British Museum, for example, was a wholesome alternative to the public house, would seize the best of both worlds by stopping in at the latter on their way to the former. Some who were in a good position to know, however, were not unmindful of this contingency. One of the witnesses before the 1835 British Museum Committee was a minor official who was better disposed than most of his colleagues toward the common people who came to the building. "The ignorant", he said, "are brought into awe by what they see about them, and the better informed know how to conduct themselves. We have common policemen, soldiers, sailors, artillery-men, livery-servants, and, of course, occasionally, mechanics; but their good conduct I am very pleased to see." Yet even he was opposed to opening the museum on such holidays as Boxing Day, Easter Monday, and Whit Monday. "We find", he explained, "that the lowest of the low on those days are set at liberty, and get intoxicated, and I would not answer for their conduct." The obvious fear was that if the museums-for-the-people movement succeeded, the tumultuous scenes which marked the Cockney rites of spring down the river at Greenwich Fair would be moved indoors in Bloomsbury.[19]

[. . .]

It appears from [contemporary accounts] that a Sunday afternoon open house in the nave of St. Paul's was virtually indistinguishable from a weekday afternoon in an Oxford Street or Regent Street bazaar, one difference being that the cathedral lacked cosmoramas. But the moral tone at St. Paul's was in much greater peril than at those secular meeting-places. When the Select Committee on National Monuments sat in 1841, Joseph Hume produced a letter [Canon Sydney] Smith had written to Lord John Russell, reporting the failure of the experiment and

warning, "If the doors of St. Paul's were flung open, the church would become, as it has been in times past, a place of assignation for all the worst characters, male and female;" [. . .] "beggars, men with burthens, women knitting, parties eating luncheon, dogs, children playing, loud laughing and talking, and every kind of scene incompatible with the solemnity of worship. . . . On one side of a line the congregation are praying; on the other is all the levity, indecorum and tumult of a London mob, squabbling with the police, looking upon St. Paul's as a gallery of sculpture, not a house of prayer, and vindicating their right to be merry and gay, if they abstain from crime."[20] [. . .]

One other acute problem laid before the National Monuments Committee was vandalism. Smith testified that at St. Paul's "the monuments are scribbled all over, and often with the grossest indecency", and he was backed up by his senior verger, an employee of upward of forty years' service, who said that "a man went round only last week to take the writing off the walls in different parts of the church, where there has been gross and vulgar lines, not fit for any person to see".[21]

[. . .]

At Westminster Abbey, however, outright destructiveness remained a problem. In his *Letters from England* (1807) Robert Southey, in the character of a Spanish visitor, had observed: "from the mischief which is even now committed, it is evident that, were the public indiscriminately admitted, every thing valuable would soon be destroyed." The English, he said, have a "barbarous habit . . . of seeing by the sight of touch".[22]

[. . .]

John Edward Gray, the British Museum official quoted earlier, came to the defense of his compatriots. [. . .] He maintained that if the English did, perhaps, write on walls more than people did on the continent, it was because "they have not the constant dread of the surveillance of the police, which the French appear always to have before their eyes". This "remnant of barbarism" was the price – a small one, to be sure – that the nation had to pay for the precious freedom of the individual.[23]

As ill luck would have it, two separate incidents soon confirmed the bleakest fears of those who saw the unrestrained public as a threat to the nation's artistic treasures. In January 1844, a lame visitor to the National Gallery suddenly raised one crutch and thrust it through Mola's *Jupiter and Leda*.[24] [. . .] Understandably embarrassed, both Hume and Sir Robert Peel hastened to assure the House of Commons that the incident was an isolated one and that there was now "no tendency among the people in general to do that wanton mischief which once been apprehended from them".[25] But a year later an even more serious incident gave fresh cause for apprehension. On 7 February 1845 a youth identifying himself as William Lloyd, a student at Dublin University, picked up a large Babylonian sculptured stone in a room at the British Museum and hurled it at the case containing the famous Portland vase, the finest surviving example of Roman cameo glass. The vase was shattered into more than two hundred pieces. Since it was not the museum's property, having been lent by the Duke of Portland, the authorities could prosecute Lloyd only for breaking the case, which was valued at £3. [. . .]

[F]riends of the people had to work harder than ever to persuade public opinion that when ordinary men and women visited national showplaces they were, as a class, devoid of mischievous intent.

Implicit in much of the discussion was the belief that many of officialdom's worries could be resolved by the provision of adequate police. At St. Paul's, officers were on duty only on Sunday, and then mainly to see that the worshipers left as soon as service was over; otherwise vergers would, as one of them said, be deprived of their "refreshment; we could not all stop there, and it would not do to leave the public by themselves; we do not know what injury they might do".[26] The trouble was that little of what "the public" did actually broke the law.

[. . .]

Still, as Colonel Rowan, one of the two original chief commissioners of the Metropolitan Police, testified in 1841, he could do the job if he had enough men. He had sent as many as a dozen constables to the British Museum on holidays, and they had kept perfect order. [. . .] When the Abbey had been thrown open without restriction several days after each of the two recent coronations so that the public might see the decorations, the police had had some difficulty, but only "on account of the numbers, none on account of the disposition of the people".[27]

[. . .]

This was the sort of thing Hume and his liberal colleagues wanted to hear, backed up as it was by a substantial amount of testimony to the same effect from other well-chosen witnesses. The great problem they faced was to reassure the respectable public at large, particularly in view of such an embarrassment as the smashing of the Portland vase. Throughout the 1840s influential portions of the London press strove to allay any doubts that a general reformation of manners had indeed occurred. Papers like *The Times* and the *Illustrated London News* regularly added to their reports of the holiday attendance at public monuments such statements as "perfect order was maintained" and "there was no single instance of misbehaviour".

The mere prospect of these parliamentary inquiries caused a few reforms to be effected at the institutions due to be scrutinized, and several others followed the hearings and the respective committees' recommendations. Among the reforms which anticipated the inquiries was the long overdue retirement in 1839 of the ragged regiment, the scandalous epitome of the Abbey's catchpenny atmosphere. As we have seen, in grudging compliance with one or two recommendations, the British Museum was opened on holidays, and the trustees, accepting a suggestion from Sir Robert Peel, decided to issue cheap guides to the contents of the four main departments open to visitors.

[. . .]

Once the committees' reports had been issued and such action taken as the authorities at the various monuments thought desirable, plenty of room for complaint remained. The near-completion of the building program at the British Museum had provided several large new exhibition halls, but the collections

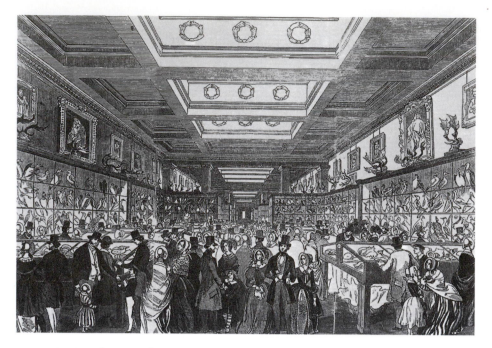

Figure 11.2 The British Museum: Easter Monday crowd in the Great
Zoological Gallery, 1845: from the *Illustrated London News*, 29
March 1845

continued to outgrow the available space. Ralph Waldo Emerson, visiting the
museum in 1848, dismissed it in a few tart words: "The arrangement of the antique
remains is surprisingly imperfect and careless, without order, or skilful disposi-
tion, or names or numbers. A warehouse of old marbles".[28] [. . .] But at least
there was no question of multiple fees or intrusive attendants, and it was these
stumbling-blocks to enjoyment, which the inquiries had done nothing to eliminate,
that placed the other monuments under more severe criticism than ever during
the 1840s.

At St. Paul's, where the twopenny entrance fee was stubbornly retained, it
was, according to an incensed writer in *Blackwood's*, but the prelude to a process
of continuous extortion once the visitor was inside:

> There is a fee for the body of the church, a fee for the choir, a fee for
> the whispering gallery, a fee for the library, a fee for the clock-work, a
> fee for the great bell, a fee for the little bell, a fee for the ball at the top,
> and a fee for the vaults at the bottom; wherever an Englishman would
> put his nose, in any corner of his own National Church, built by the con-
> tributions of his ancestors, he is met by a mob of money-takers, cheque-
> takers, and the like, vociferating fees – fees – fees! . . . The demands of
> the money-takers are studiously regulated so as to extort the greatest
> possible amount of money from the visitors.[29]

[. . .]

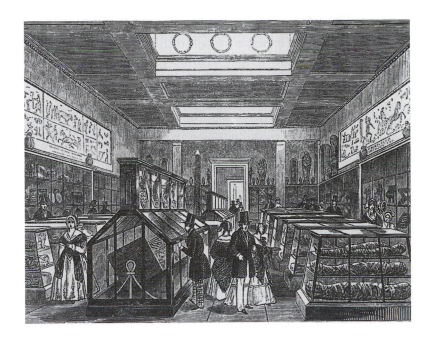

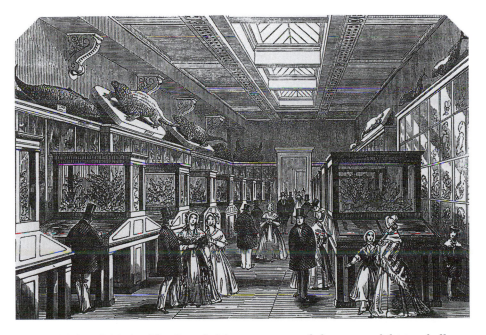

Figures 11.3 and 11.4 The British Museum: two of the new exhibition halls, the Egyptian Room above and the Coral Room below: from the *Illustrated London News*, 13 February 1847 and 3 April 1847

At the Abbey, the chief cause of complaint was no longer the admission charge *per se*. Following the unpleasantness between Parliament and the dean and chapter in the mid-1820s, an arrangement was eventually arrived at whereby the canons and singing men renounced their claim on the money collected from visitors in exchange for a collective annual stipend of £1,400.[30] The fees, now earmarked for cleaning and maintenance, were gradually lowered, until by the mid-1840s the public was admitted gratis to the south transept, including the Poets' Corner, threepence being charged to see the monuments in the nave and threepence more to see all the rest. Subsequently, the whole nave was liberated. Two disadvantages of the old enclosure system, however, remained: the offense to the eye and the bothersomeness of the now salaried (a guinea a week) corps of "tomb-showers". Describing in his novel *Sybil* (1845) Egremont's first visit to the building, Disraeli wrote of his disenchantment by "the boards and spikes with which he seemed to be environed, as if the Abbey were in a state of siege; iron gates shutting him out from the solemn nave and the shadowy isles; scarcely a glimpse to be caught of a single window; while on a dirty form, some noisy vergers sat like ticket-porters or babbled like tapsters at their ease".[31]

And so the young, impudent, *Punch* had plenty of ammunition when it picked up the campaign where the committees of Commons had left off. Between 1844 and 1851 it persistently sniped at the "clerical showmen" of both the Abbey and St. Paul's. In one satiric paragraph and cartoon after another it recommended that the dean and chapter advertise in the newspapers and on placards, as did the Colosseum; that the Poets' Corner accept Byron's body as a counter-attraction to the giraffe and chimpanzee at the Zoo; that a circuslike platform be erected on the west porch of St. Paul's, complete with garish posters, band, and barker; that children be admitted to both buildings at half-price, as was done at Madame Tussaud's; that there should be refreshment stalls at both places; that handbills be distributed at Sunday services advertising the weekday attractions; and that the dome of St. Paul's be fitted up as a camera obscura show.[32]

[. . .]

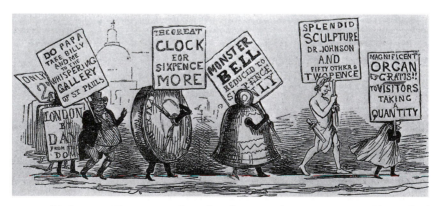

Figure 11.5 *Punch*'s vision of sandwich men advertising St Paul's Cathedral: from *Punch*, 17 April 1847

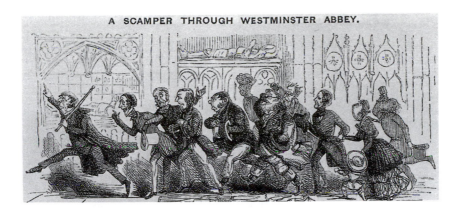

A SCAMPER THROUGH WESTMINSTER ABBEY.

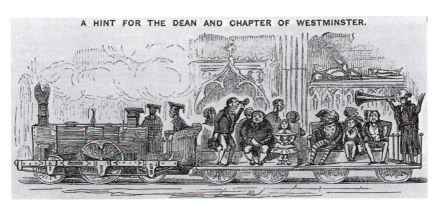

A HINT FOR THE DEAN AND CHAPTER OF WESTMINSTER.

Figure 11.6 Whirlwind tours of Westminster Abbey, two fancies from *Punch*:
25 October 1845 and 5 September 1846

One thing, however, is certain. By the time the dust settled in 1851 (the cliché has the sanction of history, because no visitor ever wrote of St. Paul's in those years without deploring its dirt) these famous London sights now attracted crowds unthought of a mere decade earlier. Comparative annual attendance figures tell the story. In 1827–8 the British Museum had 81,228 visitors; in 1838, 266,000; in 1848, 897,985.[33] In 1837–8 the Tower armory alone (there seem to be no figures on the total number who entered the precincts) had 11,104 paying customers; only four years later, there were 95,231.[34] The National Gallery had the same experience: 397,649 persons entered it during its first year at Trafalgar Square (1838); in 1845 the total attendance was almost 700,000.[35] On one day alone, Boxing Day 1847, 24,191 persons entered the British Museum.[36]

[. . .]

Almost accidentally, both directly and by way of the pressure it exerted upon the Church, Parliament had come to participate in the London exhibition business. By more or less cleansing the Abbey and St Paul's of the grounds for the

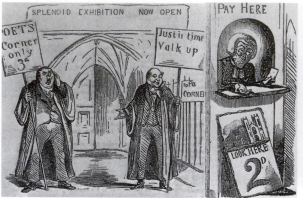

Figure 11.7 *Punch*'s comments on 'Ecclesiastical Exhibitions': *Punch*, 11 May 1844, 28 February 1846 and 31 May 1846

frequent reproach that they were managed like Madame Tussaud's, it had made them the most popular attractions in London – true rivals of the Baker Street waxworks. It had forced the British Museum to be made accessible to the same public that the Polytechnic had had it in mind to serve. Public monuments now competed with commercial enterprise for the leisure-time custom of the multitude.

Equally important, in the course of the protracted discussion in Parliament and press that had attended these developments, the hopes and fears centering on the people's right to the enjoyment of national monuments had been extensively canvassed. For the first time, also, the broad educational potentialities of exhibitions and the social and cultural implications of certain aspects of show-going had been recognized, although more questions were raised than there were decisive answers supplied. When, at the end of the 1840s, the idea of a great national exhibition to be held in London was broached, all that had been said, proposed, and accomplished in the preceding fifteen years turned out to have been an instructive prologue.

Notes

1 Frederick von Raumer, *England in 1835*, trans. Sarah Austin and H. E. Lloyd (Philadelphia: 1836), p. 141.

2 J. Mordaunt Crook, *The British Museum* (London: 1972), pp. 109–10; [Richard Ford], 'The British Museum', *Quarterly Review* 88 (1850): 139–54.

3 Benjamin Silliman, *A Journal of Travels . . . in the Years 1805 and 1806* (New York, 1807), I.

4 Crook, p. 66.

5 Robert Cowtan, *Memories of the British Museum* (London: 1872), p. 305.

6 [J. F. Murray], 'The world of London', *Blackwood's Magazine* 51 (1842): 419.

7 *National Monuments Committee*, q. 2146. The witness quoted was John Britton.

8 *Hansard's Parliamentary Debates*, 3rd ser. 57 (1841), col. 952.

9 *National Monuments Committee*, p. vi.

10 James Fenimore Cooper, *Gleanings in Europe*, Vol. II, *England*, ed. Robert E. Spiller (New York: 1930), pp. 38–9.

11 *Hansard*, 3rd ser. 16 (1833), col. 1003.

12 *Hansard*, 3rd ser. 20 (1833), col. 618.

13 *Report from the Select Committee on the British Museum* (1835), qq. 1320–30.

14 *The Times*, 30 May 1837.

15 *National Monuments Committee*, qq. 2957–8, 3092, 3158.

16 *Report from the Select Committee on the British Museum* (1836), qq. 3408–10.

17 This may or may not have been overidealistic, but there can be no such doubt in respect to a proposal that employed workingmen be encouraged to pay weekday visits to St. Paul's and the Abbey. Two witnesses before the 1841 National Monuments Committee readily assented to the proposition that if those buildings "were known to be open for a few hours every day . . . parties from the different workshops and factories in the town [would] be formed to go and visit them in succession, instead of, as now, going to a public-house". (*Report from the Select Committee on National Monuments*, 1841, q. 1347.)

18 *National Monuments Committee*, q. 2961.

19 *Report from the Select Committee on the British Museum* (1835), qq. 3916–22.

20 *National Monuments Committee*, qq. 16–34.

21 *National Monuments Committee*, qq. 43, 340.

22 Robert Southey, *Letters from London* (London, 1951 [1807]), pp. 132–3.

23 *Penny Magazine* 6 (1837): 46–7.

24 *Athenaeum*, 27 January 1844, p. 88; *The Times*, 24 and 25 January 1844.

25 *Athenaeum*, 20 April 1844, p. 360.

26 *National Monuments Committee*, q. 615.

27 ibid., qq. 1359–1430 passim.

28 *The Journals and Miscellaneous Notebooks of Ralph Waldo Emerson* (Cambridge, MA: 1960–), X. 239.

29 *Blackwood's Magazine* 51 (1842): 422.

30 *Art Journal*, n.s., 6 (1860): 21.

31 *Sybil*, Book IV, Ch. vi (Bradenham edition, London: 1927, p. 269).

32 *Punch* 6 (1844): 206–7; 9 (1845): 156; 10 (1846): 34, 248.

33 Cowtan, p. 305.

34 *ILN*, 22 April 1848, pp. 266–8.

35 *Art-Union* 3 (1841): 186; 8 (1846): 313.

36 *Athenaeum*, 1 January 1848, p. 15.

David Goodman

FEAR OF CIRCUSES
Founding the National Museum of Victoria

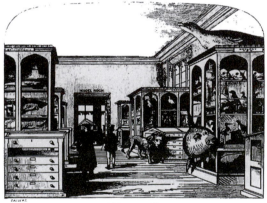

VICTORIAN MUSEUM.

THE Victorian Museum of Natural History has, after some vicissitudes, found its home in the University, where it is disposed in spacious apartments, over the lecture theatres, in the north wing, now the transept. It contains a fair collection of specimens illustrating the natural productions of the country, with models of mining appliances, and other objects of interest, native and imported.

Figure 12.1 The Victorian Museum of Natural History: from the *Illustrated Journal of Australasia*, 1857 (LaTrobe University Library, Melbourne)

WHAT WOULD A 'CULTURAL' APPROACH to the history of the National Museum of Victoria in Melbourne be like? The stance to take at the beginning is that of David Schneider, when he writes that 'Culture is man's adaption to nature . . . but it is more. Nature, as a wholly independent "thing" does not exist, except as man formulates it.'[1] Or of Claude Lévi-Strauss, telling an interviewer in 1967 that the nature–culture opposition is 'not an objective one;

men need to invent it. Perhaps it is a precondition for the birth of culture.'[2] The neat distinction has to be blurred for the culturalist, not because of the discovery that chimps can talk, but because of the realisation that 'nature' is just as cultural as anything else — defined, even constructed, socially. The cultural construction of the 'natural' has been a recurrent concern of contemporary cultural analysis. Roland Barthes summarised, in one of his last books, a constant theme of his work: 'The natural is never an attribute of physical Nature; it is the alibi paraded by a social majority: the natural is a legality.'[3]

The natural science museum, in this context, is of interest in that it is, and was even more especially in the nineteenth century, a privileged, legitimated constructor of the natural world. Those within the museum were licensed to speak of the nature — to name it, classify it, construct it — they produced as valorised discourse. In Melbourne in the 1850s, this effect was heightened by two factors: the scientific community was isolated and very small; and the Australian environment — animal, vegetable and mineral — was incompletely known and much speculated upon. Both accentuated the role of the museum as, not just a store-house of objects, but a privileged maker and disseminator of knowledge.

But there is another aspect to adopting a cultural approach to the history of the National Museum. The history of our museum has a place in the history of museums in general. And the historiography of museums is beset with a prevailing Whig/progressivist interpretation of the rise of the scientific museum, based on sound classifactory principles, out of the mire of the confused collections of curiosities that passed for museums in earlier times. The modern historiography of museums begins with David Murray's seminal 1904 work, *Museums — Their History and Their Use*. In a chapter entitled 'The non-scientific character of early museums' Murray argued that early museums had 'a tendency to represent the abnormal rather the normal, what was rare rather than what was common', to display 'curiosities'. The object in view', he explained censoriously, 'was to create surprise rather than to afford instruction.'[4] In the sixteenth century, museums were devoted to magic objects — unicorns' horns, giants' bones, elks' antlers, and Egyptian mummies. By the seventeenth century, there was classification of a sort. But Murray's judgement on the arrangement of these, exemplified by Ole Worm's Danish museum, is stern: 'It is obvious that to lump all archaeological objects in one division under the general title "artificial curiosities", could convey no real idea of their nature, nor was the arrangement helped by subdividing them into articles of wood, of metal, of glass, and so on,'[5]

For Murray, the modernity of a museum was expressed in its specialisation, and in its careful and accurate classification.[6] The museum's presentation, he argued, should reflect its serious function — the promiscuous decorations and catholic accession policies of the old museums were but signs of their pre-scientific status. That, then, is the conventional story of the history of the museum — the banishment of unicorns. As Sir John Forsdyke, then director of the British Museum, confidently told the London Royal Society of Arts in 1949, 'the first duty of the museum is to preserve realities, that is to say, to demonstrate the truth of things'.[7] Without labouring the point further, one of the duties of a cultural approach to the history of the museum is to question this triumphalist view of a rise from magic to science and 'the truth of things'. As Mary Douglas has

argued, 'it is part of our culture to recognise at last our cognitive precariousness. It is part of our culture to be sophisticated about fundamentalist claims to secure knowledge.'[8] But if we are no longer to view the history of the museum as the tale of closer and closer approximations of displays to natural reality, what are we to do?

Michael Foucault, in his *The Order of Things*, offers a typically suggestive yet cryptic account of the archaeology of natural history. Typically again, his account revolves around a sharply drawn distinction between the Renaissance and the Classical Age. 'To the Renaissance', he writes,

> The strangeness of animals was a spectacle: it was featured in fairs, in tournaments, in fictitious or real combats, in reconstructions of legends in which the bestiary displayed its ageless fables. The natural history room and the garden, as created in the Classical period, replace the circular procession of the 'show' with the arrangement of things in a 'table'. What came surreptitiously into being between the age of the theatre and that of the catalogue was not the desire for knowledge, but a new way of connecting things both to the eye and to discourse. A new way of making history.[9]

As Foucault describes this new way, natural history from the Classical age on seeks to reduce the gap between things and language, to bring 'the things observed as close as possible to words'. This results in a privileging of the observing gaze as the instrument of classification – 'hearsay is excluded, that goes without saying,' Foucault writes, 'but so are taste and smell, because their lack of certainty and their variability render impossible any analysis into distinct elements that could be universally acceptable'.[10] For Foucault, then, the scientific natural history museum is marked, not by its close approach to truth, but by its subordination of other senses to sight, by its attachment to the classificatory table, and by its rejection of theatre and 'show'. In looking at the beginnings of the Melbourne museum we can see an institution struggling to define itself in just these terms. The establishment of a museum in a very new, unformed colonial society provides a special chance to see articulated this conception of what a museum was, and to see the museum's interpretation and display of the natural differentiating itself from other modes of display and interpretation – for a useful self-consciousness pervades the beginnings of institutions.

To begin, then, we should look diachronically at the sequence of events which led to the formation of a museum in the fledgling scientific community in Melbourne in the mid-1850s. It was on 23 September 1853 that Mr Mark Nicholson, a lawyer by training, rose in the Victorian Legislative Council to move that funds be set aside from the colony's newfound wealth (the riches accruing from the gold fields having been for two years now accumulating in the treasury) for the establishment of a Museum of Natural History. Nicholson (later honoured by having a very rare species of almond-breasted pelican named after him, *Pelicanus Nicholsonus*) told the House that 'the object he had in view was to increase the public knowledge on a question in which the whole civilised world was interested, by collecting together facts and illustrations connected with the natural history of this colony'. There had

already been a small museum set up inside the Mechanics' Institute, but Nicholson argued that this was hardly adequate, and pointed out that it had anyway been boxed up to make way for a Fine Arts Exhibition. 'The fine arts are well enough in their way', he argued, 'but they should not be put before nature.' His motion was carried with only two dissenting votes, and in the government estimates for 1854 there appeared a sum of £2,000 for a Museum of Natural History.[11]

It had been felt by some of those who took part in the debate in Parliament that a society needed to be set up to take on the management of the museum. The *Argus*, the city's leading newspaper, editorially set the need for such a society firmly in the context of public improvement. 'One of the most effectual ways of counteracting habits of dissipation', it argued:

> is to provide inducements and facilities for the formation of higher tastes, and the promotion of more rational enjoyments. Intemperance is to be combated not only by the Press, the Pulpit, the Police, or the Legislature, but also by the genius of institutional organisation.

The paper felt that much was at stake:

> unless the educated classes are content to fall behind in the march of civilisation, and forgo the advantages which organisation would confer upon scientific pursuits, they should now be turning their attention to the establishment of a Victorian Institute, devoted to Art, Literature, and Philosophy.[12]

Within a month, at the instigation of a Melbourne pharmacist, such a society had been brought into formal existence.

The room, the *Argus* reported, was 'tastefully decorated' for the occasion with the flags of the various nations. Messrs Tuck and Co., the confectioners of Elizabeth Street, provided refreshments for the two hundred ladies and gentlemen present, which the *Argus* correspondent considered 'worthy of the occasion'. An excellent German band, known as the 'Lady Jocelyn Band', was reported to have contributed greatly to the pleasures of the evening. After the refreshments had been consumed, Redmond Barry, judge and patriarch of the cultural institutions of the city, took the podium and announced to the gathering: 'We assemble in the vestibule of the temple of science.'[13] This was the inaugural *conversazione* of the Victorian Institute for the Advancement of Science.

Surrounding the guests in the hall of the Collins Street Mechanics' Institute, that Friday evening in the spring of 1854, 'were ranged contributions illustrative of the objects of the Institute'.[14] Michel Foucault, again, has directed attention to the importance of understanding how a culture 'experiences the propinquity of things'.[15] What important principles, then, what determining modes of perception or classification lent an order and a similitude to the objects arranged here for their exemplary and illustrative effects, beneath the flags of all nations, and between the tables of refreshments? Listed on a page, the catholicity of the endorsement seems bizarre – here there were gold ingots, fire-arms, a microscope, some curiosities from the Cape of Good Hope, a stuffed kangaroo, a metronome, a map of

the goldfields, the skull of an Australian half-caste, a model of a steam ferry, Aboriginal implements and drawings, views of New Zealand, plans of a proposed Government House, some limestone from Mount Eliza, surgical implements, a model locomotive, fossils, skulls, plans for a ships' canal, a statuette 'Dorothea', views of the Holy Land, a galvanic battery, parakeet skins, pathological specimens of comparative anatomy, Chinese coins and medicines, a stuffed platypus, a collection of gilt picture frames covered with glass (a 'new and very useful discovery'), some arrowroot grown at Prahran, a map of the world, plants and flowers from the goldfields, and some engravings by Albrecht Dürer.[16] It was in this confusion of the exotic and the useful, the curious and the improving, that the first Victorian scientific society opened for business.

Gibbons, the pharmacist, had seen the objects of the Institute as

> the establishment of a means of communication between persons engaged in the pursuit of science, and of cultivating a refined taste among the people of Victoria; a centre for the collection of observations and specimens from all sources, and the gradual formation of a museum; a source to which the community generally may look for information on scientific subjects; and an agency for the development of the resources of the colony.

The Institute thus encouraged its members to present their papers 'in a popular style', to extend their utility and enhance the communicative role.[17]

Barry's conception of the Institute's role was vaguer, as befitted one of his belief that high culture could be recognised by its detachment from the sphere of the practical and the useful. Barry saw the Institute as a machine for validating knowledge – 'it affords', he said:

> an opportunity to those who become members, of collecting materials and interesting facts respecting the multitudinous subjects which form topics for the rational enquirer, and to which careful and well regulated observation will attach an accredited worth; of arranging and collating them so as to facilitate investigation and attract the attention of those competent to exercise thereon an enlightened judgement . . .

As Barry warmed to his subject, his eye wandering over the assembled objects which, in their contiguity, spoke of the aims of the new Institute, he articulated his fondest wish – that such knowledge should belong to all men, that science itself should no longer be reserved for an elite. Such, he argued, was the spirit of the age, for

> this is not an era which will tolerate the acroatic or exoteric learning, or recognise barriers within which the initiated are not permitted to encroach; men are no longer content that the search for knowledge should be delegated to the exclusive charge of any particular body, involved in the frivolous niceties of alchemical empiricism; clouding in allegory or shrouding in mystic symbols the steps by which they, as

they supposed, approached the secret of philosopher's stone, the elixir
of life, or the universal solvent – no longer amused with the accumu-
lated subtleties of metaphysical disquisitions, dogmatic theology, or
philological dissertations.[18]

The irony of this, of course, as of most of Barry's equalitarian sentiments, is
that of form belying content, the contorted, display-of-learning style confuting the
populist message. Yet Barry's hope seemed sincere, that some village Newton
might arise from this yet unformed society:

is it presumptuous to imagine that this genial southern sun may hasten
into birth some unrevealed combination of forces, the rudiment of
which as yet lies in the brain of one amongst us hitherto unsmiled on
by the favour of his own compatriots, ungladdened by the approving
voice of his own countrymen?[19]

As a popularising scientific body, the Victorian Institute encouraged useful
science. In its year of existence, it heard papers on sanitary conditions in the
working-class suburb of Collingwood, on Victorian botany, Melbourne's water
supply, possible sources of brick and building stone near the city, the need for an
observatory, a scheme to check the rolling of ships, and the virtues of phonetic
spelling. In line with its principles, the members of the Institute were encouraged
to discuss the papers presented at the meetings.

No such equality prevailed at the Philosophical Society of Victoria, founded
shortly after the Institute. Modelled on the London Royal Society, the Philosophical
Society forbade the discussion of papers at its meetings. Its president, Captain
Clarke, the Surveyor General, stressed in his inaugural address, a less utilitarian
and popular science – 'correct and minute observation' was to be the basis of
research; it was 'vain to attempt to measure' the advantages which arose from the
pursuit of knowledge and the study of the natural sciences.[20]

When in March 1855 it was beginning to be said that two such institutions
were unnecessary and inefficient for a young colony, it was the more austere
Society that was wary of compromise. The Secretary of the Institute reported to
his General Meeting on 8 March that 'the project for amalgamation has been
received somewhat coldly by our sister society'.[21] When the union came in July
1855, the objectives of the Society were adopted as those of the new body, the
Philosophical Institute.[22] The Philosophical Institute was, in name as in program,
a compromise, a blend on the professional and the gentlemanly, the useful and
the abstract. The dialogue it tried to set up between the handful of professional
men of science in the colony, and the educated classes of civil servants, clergymen,
doctors, lawyers, architects, engineers, bankers and merchants, could not last, and
each, by the end of the century, had gone its separate way. But it was this compro-
mised group that provided a focus for the early research into the Australian
environment, and the beginnings of the National Museum of Victoria.

By 1855, then, the Philosophical Institute had a small museum. It also
had its eye upon, and some hopes of acquiring, the small government museum
kept in two rooms above some government offices by the Colonial Zoologist,

Blandowski. But the opening that year of the Melbourne University had brought three fêted new men of learning into the colony: most significantly for this story, the Professor of Natural Science, Frederick McCoy. McCoy, a bearded Irishman, was one of the foremost palaeontologists of his day, and every bit as covetous of the government collection as the gentlemen of the Philosophical Institute. He carried with him, moreover, all the professional authority and prestige associated with a university chair. Thus when the colonial economy faltered in 1855, and the government withdrew all financial support from its museum, the 5,600 specimens of the government collection (760 birds, 2,180 mineralogical specimens, 1,000 insects, 274 reptiles and fishes) found their way to a large room at the new university.[23] The Philosophical Institute led the attack on McCoy (Dr Eades told one meeting that 'his own experience in the mother country taught him that such collections were not easily got back once any University had its paw on them'), but large public meetings and letters to the paper failed to alter the situation of *fait accompli*.[24] A great deal of anti-university feeling was expressed, especially by the scientific gentlemen of the Institute. The local version of *Punch* complained that:

> . . . it don't become professors,
> When they become possessors,
> Of property by methods contraband, band, band.[25]

But McCoy was officially appointed director of the Museum, displacing the unaffiliated men of science who had preceded him in the colony. For forty-two years, the museum would be subject to his close personal direction. During all this time, McCoy was professor of science at the University as well as Museum director, both full-time jobs. He explained his situation in a letter to Redmond Barry, who by this time was also the Chancellor of the University – 'as my business is my pleasure also, I devote much time to the arrangement of the Museum and to the naming and classification of the specimens, but this I have always explained I do because I liked . . . my successor might wish to take exercise in the open air, or practice music, or please himself otherwise in the disposal of his time after lectures, as is the case with the other professors'.[26]

One of the basic assumptions of structuralist analyses is that the units in any cultural system gain meaning only from their relation to the other units, just as the words in a language gain meaning only from their opposition to other words. In our case, then, the museum as an institution is to be defined by its differences from other institutions in the same cultural system. We have already seen, in the brief history of the founding of the museum, that its birth was marked by attempts to articulate the differences between a museum and a university, and between amateur and professional science. We need now to abandon the sequence of events, in order to examine synchronically how it was that the museum thus established set about differentiating itself from the other institutions in Melbourne in the 1850s concerned with the presentation of the natural.

How did McCoy see the museum? Something of his aims can be understood from two documents – the paper 'Museums in Victoria' which he delivered to the philosophical Institute in 1856, and an undated memorandum in his hand-

writing, 'On the organisation of the National Museum of Melbourne'. The original conception of the museum, McCoy wrote, was to exhibit well-classified collections in zoology and palaeontology, which would exhibit the relations of all the members of the animal kingdom.[27]

McCoy subscribed to the idea of the museum as an improving force, and as an instrument for communicating knowledge of natural resources to those that needed it. Museums, he wrote, have within the last few years been discovered to be 'the most ready and effectual means of communicating the knowledge and practical experience of the experienced few to the many'.[28] The communication would be inherent in the whole display of the museum – 'the eye of the unlearned could be familiarised with natural objects, with the principles of classification applied to them by scientific men, to place their peculiar characters and mutual relations in a striking light'.[29] McCoy's plan for the botanical garden at the University was even more subliminal. There he imagined:

> Each **Class** having a large bed to itself, with a label bearing its name in the centre, of such a size, that it can be read from any part of the margin: this bed is divided by small fences into smaller divisions, containing each one of the subordinate **Orders** of the **Class**, these again being subdivided into **Families**, and these into compartments for the **Genera**; each subordinate division in the classification being marked by a conspicuous, but progressively smaller, label, until finally the **Species** placed in each generic compartment have ordinary sized labels, setting forth the **Genus, Species, Locality**, and common name of each. A garden well labelled in this manner will teach the principles of botanical classification, even if but poorly furnished with plants, and the eye of the visitor will familiarise him insensibly with the natural alliances and affinities of the various groups of plants, and suggest the relations which the scientific botanists have detected and used for their classification . . .[30]

In the museum itself, zoological specimens were also to be 'labelled with the family, genus, species, locality and popular name, and a Roman numeral indicating the order by reference to lists painted on the walls giving the orders of all the classes of animals in full'. Each mineralogical specimen was labelled, 'not only with its name and locality, but with the crystalline system and the chemical formula of its partial composition set forth in symbols explained by adjoining painted tables and lists'. In the Palaeontology section, the specimens were

> first divided into geological groups or periods according to the distribution in time and analogous to the distribution in space indicated by the arrangement of the collections of specimens of the living species. The fossils of each formation are then arranged in zoological systematic order, and fully named with genus, species, locality and formation.[31]

McCoy's museum was a house of classification, and the whole intent of its display was to elucidate and communicate classification and its rationale. It was,

as we have seen, this systematic attempt at naming and classifying that defined the scientific museum – the museum that eschewed the interest of its predecessors in the merely unusual or exotic. McCoy, speaking of the role of zoological museums, argued that

> in this, as in other departments of science, the showy and the useless has received more attention than the apparently insignificant creatures that for good or evil most concern mankind. The natural history of birds has usurped a most undue share of attention.

A museum, he sternly warned, would need to be concerned as much with the 'small and ugly creatures' as with the 'showy' ones.[32] This was a concern that even the amateur and utilitarian Captain Clarke, President of the Philosophical Institute, could endorse. He wrote in 1857 that the museum should not be 'a mere collection of curiosities, serving rather to bewilder than to instruct. It is not to contain specimens that are interesting only because they are beautiful. I hope to see in that museum a complete collection of all the ores that are useful, of all the woods that are suitable for shipbuilding, for roads, and for tramways . . . I desire to see the museum filled with all those objects that are peculiarly valuable in a new country, to the exclusion of merely ornamental specimens'.[33] What was it that caused this anxiety about avoiding the merely decorative and showy, when surely the precedence given to classification would ensure that every type was equal on the great classificatory grids of science? It was, I am arguing, partly a knowledge of the history of the museum, a knowledge that in Europe a sign of that institution's coming of age was seen to be its abandonment of the presentation of curiosities for the scientific classification of the natural world. But it was also the need to define, right there in Melbourne, what it was that set the museum's presentation of the natural apart from other, more theatrical, presentations.

Melbourne in the 1850s was regularly visited by circuses, which usually contained a menagerie of sorts. There was still enough vacant land in the centre of the city for lions and tigers to be set up in the main thoroughfares, Bourke and Collins Streets.[34] The problem was that such animals usually suffered on the long ship voyage to Australia, and public disappointment arose if they looked too mangy. Caged lions were still meant to appear proud and ferocious – that was their theatre.

When in 1853 Melbourne acquired its first permanent menagerie, the animals took their place in a context of spectacular entertainment. James Ellis's Cremorne Gardens, on the northern bank of the River Yarra in the suburb of Richmond, displayed foreign and native animals in an amusement park filled with wonders of all sorts, thrown indiscriminately together. The garden's heyday was between 1856 and 1863, when it was owned and run by the great actor and entrepreneur, George Coppin. Ten acres of land were laid out in the manner of a botanical garden, dotted with attractions – the large 'Parisian' dancing platform on which, in 1853, instruction was being given nightly 'on that last new and very exciting dance "Pop Goes the Weasel"'; the walks 'brilliantly illuminated' by gaslight; the landing stage conveying guests to and from Princes Bridge in gondolas; two hotels

and a bar; a maze; a theatre for presenting concerts from the resident orchestra and vaudeville; an open-air theatre for summer entertainment, including trapeze artists, foreign gymnasts and performing animals; a collection of side-shows, Juan Fernandez, who nightly put his head into a lion's mouth, a Fat Boy, a Bearded Woman, some Ethiopians, Wizards, as well as Billiards, Shooting Galleries, Punch and Judy shows and Bowling Saloons; a lake with hire boats; a kiosk selling refreshments; a fine collection of statues; a 25,000 square-foot panorama of Naples, the work of four artists, later replaced by scenes of Canton and Sebastopol; nightly displays of fireworks, which re-enacted such spectacular events as the eruption of Mount Vesuvius; provision for the holding of 'monster' lotteries; a balloon platform from which the first ascent in Australia was made by two especially imported English aeronauts, Captain Deane and Professor Brown; Mr Higgins's pantechnicon, and the menagerie containing emus, wallabies, kangaroos and possums, as well as lions, elephants, monkeys and parrots.[35] The *Argus* described the atmosphere as 'Ellisian'.[36] The gardens were said to be patronised by all classes, and admittance was free; though occasionally a night was set aside for the 'fashionable and wealthy' to experience the pleasures on their own.[37] On New Year's Day 1854, 5,236 people were at Cremorne. The gardens were both popular and respectable – but they were clearly entertainment. What gave a unity to the assortment of objects and activities within their walls was a shared novel, curious, or spectacular quality. 'I like to see things because they are novel, or because they are unusual, as well as on the ground of their being attractive or important,' wrote the approving reporter for *My Note Book*.[38] Coppin promised 'rare and astonishing novelties'. His menagerie was subsumed into the theatre of the place – his animals were not there to be labelled, but to excite. It was in part the aesthetic of the circus, then, the presentation of the novel and curious parts of the natural world in a theatrical mode, that gave definition to the museum. McCoy's museum was not to be a circus, but a classifying house; its displays aimed not to impress or excite, but to teach. It was not merely that his animals were dead and could not roar – the whole arrangement of the museum, as we have seen, stressed system rather than event. The tables and names painted on the museum walls were McCoy's attempt to dictate unequivocally the context in which his display of the natural would be seen, to provide a frame within which the reading of the museum objects would be controlled.[39]

So perhaps, like his contemporary, Mr Gradgrind (Dickens's *Hard Times* was published in 1854), McCoy feared the circus. Perhaps he was aware that one of the largest and best-arranged natural history museums of the time was the American Museum on Broadway in New York, run by circus entrepreneur P. T. Barnum.[40] Travelling circuses and menageries had played an important part in popularising natural history in the United States in the 1840s and 1850s, and it was only after the Civil War that permanent natural history museums were established in the major cities. Dead circus animals remained an important source of supply for the museums. When Barnum's museum burned down, he took his animals on the road again – his 'Great Museum, Menagerie, Circus and Travelling World's Fair' illustrated the confusion of categories that was still possible. Barnum also described his show variously as a 'Zoological Garden', a 'Polytechnic Institute', and a

'Colloseum of Natural History and Art'. His animals were set alongside human exhibits – Fijian cannibals, Indians, Chinese, Japanese, Aztecs and Eskimos. The confusion of categories could only promote anxiety among those concerned to assert and maintain professional and disciplinary boundaries.

Two other societies in Melbourne in the 1850s and early 1860s were concerned with presenting the natural. In October 1857 a Zoological Society was founded, with the aims of collecting and exhibiting zoological species, and domesticating the indigenous animals and birds of the colony. By May 1858 the Society had twenty-four native animals and two monkeys, and had been granted by the government £3,000 and a 30-acre paddock at Richmond, opposite the Botanical Gardens. When the Richmond Paddock turned out to be too small and swampy for the animals, they were moved over the river into von Mueller's Botanical Gardens. In 1860 the Society was given land for a depot in Royal Park, where it kept larger animals, such as camels. In 1862 the Zoological Gardens were officially opened at Royal Park; some of the animals, including two lions, were from an insolvent circus in Bourke Street.[41] Thus commerce existed between the different animal presenters. In February 1858 a gazelle imported for the zoo at the Botanical Gardens died shortly after arrival, and was promptly sent by von Mueller to his friend McCoy for stuffing and inclusion in the museum – a relationship that was to continue.[42] The zoo lay uneasily between the circus and the museum: the principles of zoology were evidenced in its displays, but elephant rides were offered to get the public through the gates.

In 1861 there began a society that would soon merge with the Zoological Society – the Acclimatisation Society of Victoria.[43] It too kept its stock at Royal Park. By the end of 1862 most of the birds and nearly all the quadrupeds of the two societies had been moved from the Botanic Gardens. The societies' largest early venture was a government-sponsored importation of llamas and alpacas. But the plans were broader. The 1862 Annual Report recorded that 'measures are now underway for the speedy introduction and acclimatisation of Roedeer, Partridges, Rooks, Hares, Sparrows, and Songbirds from England; Deer, Cashmere Goats, and Black Partridge from India; Ostriches, Pheasants and Partridges and Antelopes from the Cape of Good Hope'. Actually on hand at Royal Park were porcupines, turtles, tortoises, goats, deer, ducks, pigeons, albatrosses, owls, pelicans, monkeys, sheep, and skylarks.[44] The acclimatisers had a pre-ecological sense that nature's designs needed completing and perfecting. The silence troubled them in Australia, and they liberated thrushes, blackbirds, larks, starlings, and canaries in large numbers, hoping to fill the skies with melodious reminders of home. They saw few indigenous animal sources of food in the new continent (though some speculated about the tastiness of the wombat), and wanted to stock the bush with their favourite foods. Colonial gentry wanted hunting and fishing like that to which they had become used at home – the introduction of salmon into colonial streams was a high priority. The Society looked forward to enriching Victoria by 'stocking its broad territory with the choicest products of the animal kingdom borrowed from every temperate region on the face of the earth' to achieving the 'aggrandisement of the colony'.[45] McCoy, an early friend of acclimatisation, felt it a good thing that this finishing of nature's work had fallen to Englishmen.[46] He told the Society, in an Anniversary Address, that

while Nature has so abundantly furnished forth the natural larder of every other similarly situated country on the face of the earth with a great variety, and a profusion of individuals of ruminants good for food, **not one single creature of the kind inhabits Australia!** If Australia had been colonised by any of the lazy nations of the earth, this nakedness of the land would have been indeed an oppressive misfortune, but Englishmen love a good piece of voluntary hard work, and you will all, I am sure, rejoice with me that this great piece of nature's work has been left to us to do.[47]

The Acclimatisation Society, then, had a distinctive attitude to the natural order, which distinguished its depot at Royal Park from the zoo, the museum, and the circus menageries. The differences were spelled out by the Victorian Governor, Sir Henry Barkly, in his inaugural address to the Society. 'I don't think it is generally borne in mind by the public', he said, 'or even by the press, that the design of this Society is to stock the country with useful animals, rather than to form a Zoological Garden.' The wrong expectations led people to be disappointed when they visited Royal Park, 'forgetful all the while that we do not aim at setting up a wild beast show, or even at elucidating the natural history of the Australian continent'.[48] So, in a country originally settled by convicted poachers, victims of the English game laws, efforts were made to acclimatise English game, and the animals connected with the most delicious, luxurious and elite aspects of English consumption – partridge, quail and grouse, ostriches for feathers, bees for honey, cochineal insects for colouring, silk-worms for silk, trout, salmon, lobster and crab for the table. Such a selective and indulgent treatment of nature was far indeed from the typologising interest of the museum.

In the 1850s, then, the museum had to be set apart by its classification and its austere presentation, its rejection of the theatre and the circus.[49] The boundaries that were being set up at that time were those of professional science and its methods – epitomised in the Museum, and symbolised by the victory of McCoy over the gentlemen of the Institute. By the 1970s and 1980s, the distinct relationship of science to the natural world no longer needed to be forcefully articulated – the boundaries of professional science were institutionalised, the products of that science were all around. The value of the typical museum's exhibits as curiosities – the theatre of the stuffed gorilla – had been considerably eroded by television, the cinema and the picture book. The rhetoric of the contemporary museum director now came to be based on a rejection of exactly the visual, classificatory emphasis Foucault spoke of – the gaze is out of date.

'Interpretation relies heavily on sensory perception,' writes Edward P. Alexander in *Museums in Motion*, 'sight, hearing, smell, taste, touch and the kinetic muscle sense to enable the museum-goer emotionally to experience objects.'[50] Since the discovery of 'museum fatigue', a Marshall McLuhan's 1969 attack on the linear, sequential, logical, book-like presentation of most museums, the emphasis has been on the museum as a total experience.[51] McLuhan wanted to bombard the viewer's senses – he advocated a museum communication that would be 'random, shared, instantaneous'.[52] A 1969 exhibition at the American Museum of Natural History featured narrow, claustrophobic passages and floors that tilted

slightly to induce a feeling of physical unrest and unease.[53] Dillon Ripley, secretary of the Smithsonian Institution, wrote in 1970 that 'I am constantly surprised . . . by the difficulty of obtaining truth from the printed word, or the television screen . . . an object to be touched, seen, felt, smelled, is true'.[54]

Today's experimental museum embraces the theatre its nineteenth century predecessor felt obliged to renounce. Where the nineteenth century museum defined itself against the circus and the zoo, today's museum is defined by its difference from the book, the cinema and television. It is thus now emphasising, not classification, but the experience of the real object. On International Museum Day in Melbourne recently, the National Museum brought out old exhibits on carts, so that visitors could touch them. What would Frederick McCoy have thought of these busloads of school children in his museum, being encouraged to find out what a stuffed kangaroo really feels like? The tactile museum is seeking its own kind of authenticity.

Notes

1 David Schnieder, 'Notes towards a theory of culture', in K. Basso and H. Selby (eds) *Meaning in Anthropology* (Albuquerque: 1976), p. 203.
2 Quoted in Miriam Glucksmann, *Structural Analysis in Contemporary Social Thought* (London: 1974), p. 69.
3 Roland Barthes, *Roland Barthes* (New York: 1977), p. 130.
4 David Murray, *Museums — Their History and Their Use* (Glasgow: 1904), p. 208.
5 ibid., p. 211.
6 ibid., p. 231.
7 Sir John Forsdyke, 'The functions of a national museum', in *Museums in Modern Life*, Royal Society of Arts (London: 1949), p. 2.
8 Mary Douglas, *Implicit Meanings — Essays in Anthropology* (London: 1975), p. xvii.
9 Michel Foucault, *The Order of Things* (New York: 1973), p. 131.
10 ibid., p. 132.
11 *Argus*, 24 September 1853. Report on pelican, *Argus*, 24 April 1855.
12 *Argus*, 31 May 1854.
13 *Argus*, 25 September 1854.
14 *Transactions and Proceedings of the Victorian Institute for the Advancement of Science for the Sessions 1854–1855* (Melbourne: 1855), p. ix.
15 Foucault, p. xxiv.
16 *Transactions and Proceedings*, p. ix.
17 ibid., p. iii. Gibbons was speaking at the public meeting on 15 June 1854 which endorsed the plan to found an institute. The meeting was presided over by the Mayor of Melbourne who 'declared that he felt it a privilege to have assisted at the inauguration of an Institute of so noble a character'.
18 ibid., p. 2
19 ibid., p. 5.
20 Philosophical Society of Victoria, *Transactions*, Vol. I, *1854–5* (Melbourne: 1855), pp. 3–4.
21 *Transactions and Proceedings*, p. xv.
22 Philosophical Society of Victoria, *Transactions*, p. xvii. Discussion of papers,

however, was to be allowed at the meetings of the Philosophical Institute.

23 *Argus*, 29 June 1855.

24 *Argus*, 20 June 1856; 29 July 1856.

25 *Melbourne Punch*, 14 August 1856, p. 12.

26 F. McCoy to R. Barry, 25 October 1856. McCoy Letter Book, Vol. I, Museum of Victoria.

27 F. McCoy, 'Memorandum by Prof. McCoy on the organisation of the National Museum of Melbourne', n.d., Museum of Victoria archive.

28 F. McCoy, 'Museums in Victoria', *Transactions of the Philosophical Institute of Victoria* (Melbourne: 1857), p. 127.

29 ibid., p. 128.

30 ibid., pp. 131–2.

31 McCoy, 'Memorandum'.

32 McCoy, 'Museums in Victoria', p. 133.

33 Captain A. Clarke, 'Anniversary address', *Transactions of the Philosophical Institute of Victoria*, Vol. I, p. 9.

34 Garry Owen, *The Chronicles of Early Melbourne* (Melbourne: 1888), p. 849, records the brief existence of a 'wild beast exhibition' in Bourke Street opposite the Post Office in 1847.

35 J. Alexander Allan, 'Coppin's Cremorne', *Argus*, 8 April 1933; Alec Bagot, *Coppin the Great – Father of the Australian Theatre* (Melbourne: 1965), pp. 212–13.

36 *Argus*, 12 December 1853.

37 On the first such night, in 1858, *My Note book* recorded the presence of 'a thousand to twelve hundred ladies and gentlemen enjoying the entertainments'. *My Note Book*, 30 Jan. 1858, p. 463.

38 *My Note Book*, 6 Feb. 1858, p. 471.

39 Disciplined knowledge (the science of zoology) required disciplined comprehension.

40 On Barnum, see John Rickards Betts, 'P. T. Barnum and the popularization of natural history', *Journal of the History of Ideas* XX(3) (June–Sept. 1959): 343–68, and Neil Harris, *Humbug – The Art of P. T. Barnum* (Chicago: 1973).

41 J. Cecil Le Souef, 'The development of a zoological garden at Royal Park', *Victorian Historical Magazine* 36(1) (Feb. 1965).

42 'I have been instructed by the office of public work, to send the Gazelle which died last night, to the Museum for preservation, with which request I immediately comply.' von Mueller to McCoy, 5 Feb. 1958 – Inward Correspondence, Museum of Victoria archive.

43 See J. Cecil Le Souef, 'Acclimatization in Victoria', *Victorian Historical Magazine* 36(1) (Feb. 1965).

44 *First Annual Report of the Acclimatisation Society of Victoria* (Melbourne: 1862), p. 8, 14.

45 ibid., p. 9.

46 Awkward beliefs, surely, for an Irish creationist.

47 *First Annual Report*, p. 39.

48 ibid., p. 26.

49 Compare Neil Harris's argument for a later period, about museums, World's Fairs, and department stores: 'Before World War I, then, if one examines institutional influences on what Americans knew about art and style in objects, one has a giant triptych: museums in the centre, flanked by fairs on one side and

great retail establishments on the other.' Neil Harris, 'Museums, merchandising, and popular taste: the struggle for influence', in Ian M. G. Quimby (ed.), *Material Culture and the Study of American Life* (New York: 1978), p. 154.

50 Edward P. Alexander, *Museums in Motion – An Introduction to the History and Functions of Museums* (Nashville: 1979), p. 12.

51 'The viewer who must stand while reading quickly experiences museum fatigue and will skip long labels entirely' (ibid., p. 183.). The context is no longer defined by a discipline, but by patterns of consumer behaviour – Harris's argument about the behavioural relevance of the department store seems even more applicable as we approach the present.

52 ibid., pp. 186–7.

53 ibid., p. 188.

54 Dillon Ripley, 'Foreword', to Alma S. Wittlin, *Museums: In Search of a Useable Future* (Cambridge, MA: 1970).

Robert W. Rydell

THE CHICAGO WORLD'S COLUMBIAN EXPOSITION OF 1893
"And was Jerusalem builded here?"

The long lines of white buildings were ablaze with countless lights; the music from the bands scattered over the grounds floated softly out upon the water; all else was silent and dark. In that lovely hour, soft and gentle as was ever a summer night, the toil and trouble of men, the fear that was gripping men's hearts in the markets, fell away from men and in its place came Faith. The people who could dream this vision and make it real, those people . . . would press on to greater victories than this triumph of beauty – victories greater than the world had yet witnessed.

(Robert Herrick, *Memoirs of an American Citizen*, 1905[1])

THE DIRECTORS OF THE CENTENNIAL EXHIBITION began the task of providing industrialized America with a cultural synthesis through the medium of the international exposition. This effort by America's leaders to define social reality reached a new level of sophistication with the Chicago World's Columbian Exposition of 1893.[2]

In the midst of the Mauve Decade, five years after the outbreak of class violence at Haymarket Square in Chicago, a neoclassical wonderland, an imposing White City suddenly appeared on the desolate marshlands of the Lake Michigan shore, seven miles south of the downtown Loop. To a country on the brink of yet another financial panic, the fair seemed "a little ideal world, a realization of Utopia . . . [foreshadowing] some far away time when the earth should be as pure, as beautiful, and as joyous as the White City itself". For Meg and Robin Macleod, two orphans with "elflocks and pink cheeks" in a Frances Hodgson Burnett novel, the fair took on similar importance. "I've been reading the *Pilgrim's Progress*," Meg said to her brother, "and I do *wish* – I do so wish there *was* a City Beautiful." The two waifs, upon hearing about the ivory palaces, amethystine lakes, and enormous crowds,

adopted the role of Christian and made a pilgrimage to the City Beautiful rein-carnate in Jackson Park.[3]

They were not alone. In February 1892 Harlow N. Higinbotham, a partner in Marshall Field's mercantile empire and chairman of the exposition's committee on ways and means, appeared before the House Appropriations Committee. He estimated that 20 million people would visit the fair once and that nearly half of them would make a second visit. His estimate proved to be only slightly inflated. Admissions totaled 27,529,400 adults and children. Pilgrims all, many visitors, like the twins, were lifted into ecstasy at the spectacle. "Everything is buzz and clatter and confusion, an unending, everlasting labyrinth of grandeur," wrote Horace G. Benson, a Denver attorney. "I am dazzled, captivated and bewildered, and return to my room, tired in my mind, eyes, ears and body, so much to think about, so much to entice you on from place to place, until your knees clatter and you fall into a chair completely exhausted." "However," he concluded, "it is very pleasant to lay here and think of it all." Other visitors, like the fictitious Uncle Jeremiah, a midwestern farmer, found reassurance and justification: "I used to be afraid that the government was all a goin' to pieces and that my fighting for Uncle Sam at Gettysburg was of no use, but I ain't any more afraid of the world bustin' up. People that made the machinery that I've seen and all that have too much sense."[4]

William Dean Howells, at the peak of his career, again journeyed to a world's fair and like many of his middle-class contemporaries looked upon the White City as a manifestation of what was good in American life and as an ennobling vision Americans should strive to effectuate. In *Letters of an Altrurian Traveller*, orig-inally serialized for the *Cosmopolitan*, Howells, through the character of Homos, sought to direct Americans toward building a commonwealth based on the New Testament. To the dismayed Homos, Chicago, the burgeoning metropolis of the West, with its corruption and filth, seemed a "Newer York, an ultimated Manhattan, the realized ideal of largeness, loudness, and fastness, which New York has persuaded the American is metropolitan". After seeing the fair, however, Homos found cause for optimism that in the future of America urban problems "shall seem as impossible as they would seem to any Altrurian now". The "Fair City", Howells proclaimed, "is a bit of Altruria: it is as if the Capitol of one of our Regions has set sail and landed on the shores of the vast inland sea where the Fair City lifts its domes and columns".[5]

In actuality, the utopian vision projected by the exposition directors had a dual foundation: the monumental White City and the Midway Plaisance. The Midway, the honky-tonk sector of the fair, was officially classified under the auspices of the exposition's Department of Ethnology. Hailed as a "great object lesson" in anthro-pology by leading anthropologists, the Midway provided visitors with ethnological, scientific sanction for the American view of the non-white world as barbaric and childlike and gave a scientific basis to the racial blueprint for building a utopia. The Chicago world's fair, generally recognized for its contributions to urban plan-ning, beaux-arts architecture, and institutions of the arts and sciences, just as importantly introduced millions of fairgoers to evolutionary ideas about race — ideas that were presented in a utopian context and often conveyed by exhibits that were ostensibly amusing. On the Midway at the World's Columbian Exposition,

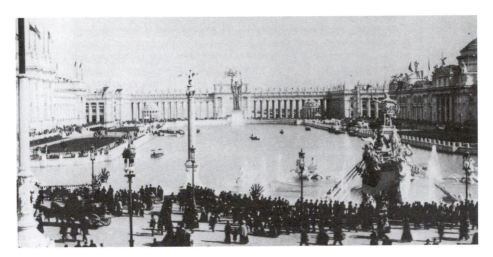

Figure 13.1 Court of Honor at the Chicago World's Columbian Exposition, 1893: courtesy of the Smithsonian Institution Archives, Record Unit 95, Photograph Collection

evolution, ethnology, and popular amusements interlocked as active agents and bulwarks of hegemonic assertion of ruling-class authority. In addition to its ethnological underpinnings, the cultural force of the fair was further augmented by a series of international congresses. Organized by the exposition directors, these public conferences brought together the world's leading authorities to discuss religion, labor, women, and other important concerns of the day. George Alfred Townsend, columnist for the *Chicago Tribune*, described the heart of the fair when he wrote: "The motives and facts around this exposition are the confessions of faith of a new dispensation." This new dispensation gave to the creed of American progress a new tenet: evolution.[6]

One of the sidelights of the persisting tensions and uncertainties about industrialization that characterized American life in the 1880s and early 1890s was the tug-of-war between urban elites over the site for the international exposition that would commemorate the four hundredth anniversary of the landfall of Columbus. Minneapolis, Washington, DC, and Saint Louis had their staunch supporters, but the leading contenders were the businessmen and financiers of New York and Chicago. There was something ridiculous about either New York, with its obvious Dutch and English beginnings, or Chicago, situated a thousand miles from the Atlantic seaboard, proposing to commemorate Columbus's landing in the West Indies, but the urgency of the country's social and economic situation as well as the prospects for profit rendered such objections trivial. Leading businessmen in both cities undoubtedly were familiar with the United States Centennial Commission's final report, which estimated that each visitor to the Centennial had contributed $4.50 to Philadelphia's economy. Many businesses in the city chosen for the next fair clearly stood to reap enormous benefits. Proponents of the Columbian celebration, however, included not only businessmen, but the financial titans of the respective cities. In New York, Chauncey Depew (president of the New York Central

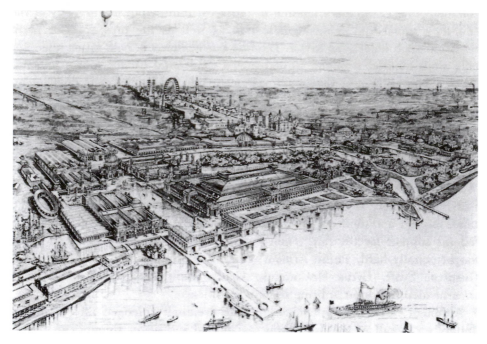

Figure 13.2 Bird's-eye view of the Chicago World's Columbian Exposition, 1893: engraving from Prints and Photographs Division, Library of Congress

Railroad) was in the forefront of the exposition effort. William Waldorf Astor, J. P. Morgan, Cornelius Vanderbilt, Grover Cleveland, William Rockefeller, Jay Gould, Elihu Root, and August Belmont contributed time, money, and their not inconsiderable political influence to gain state and federal support for the fair. Their counterparts in Chicago's financial world fought equally hard. Philip Armour, Charles B. Holmes, Charles T. Yerkes, Gustavus Swift, Cyrus McCormick, George Pullman, and Marshall Field spearheaded the drive to bring the fair to Chicago.[7]

Although New York financial interests eventually pledged 15 million dollars on behalf of the exposition, a political schism in Republican ranks, complicated by conflicts with Tammany Hall, eroded the efforts of New York's backers. While their plans hovered uncertainly in the state legislature, the Chicago boosters organized an effective corporation and began lobbying in Congress five weeks before the New York delegation arrived. Even before President Harrison formally approved the congressional Act that sanctioned a commemorative exposition, nearly 30,000 subscriptions to $5,407,350 of exposition stock had been gathered. The number of subscriptions was as impressive as the distribution was consolidated: 948 people purchased 70 per cent of the stock, and of those individuals 16 controlled 18 per cent of the stock. The consolidation of control was confirmed when, before the election of the first board of directors, a decision was made to count each share as one vote rather than give one vote to each stockholder. At the first meeting Lyman Gage, president of the First National Bank, was elected first president of the board of directors and became part of the congressional

lobbying effort. His acumen proved decisive, for at the last minute the congressional committee balked at the Chicago offer and seemed ready to award the exposition prize to New York. The committee gave Gage 24 hours to raise an additional $5 million as a guarantee. He immediately approached the exposition's financial backers in Chicago to obtain the necessary pledges. As he later recalled, "we received a fully supporting telegram signed by thirty or more citizens whose aggregate wealth was known to be more than a hundred millions of dollars". In the succeeding months, as the country's financial condition worsened and the size of the exposition increased, additional funding became necessary. More stock was issued, and the federal government appropriated $2.5 million in the form of souvenir half-dollars – which the exposition directors sold for one dollar apiece, thereby doubling in effect the amount of the appropriation. In April 1893, a month before the opening of the fair, the exposition's finance committee voted $5 million of bonds at 6 per cent interest. Chicago banks purchased $2.3 million, and "leading capitalists" throughout the country absorbed $1.5 million.[8]

If these investors sought a return on their capital outlay, they also had broader cultural goals. Two years before the fair opened, Gage rhapsodized on what a visitor could expect to see from the "dizzy height" of the Proctor Tower, an abortive plan to imitate the Eiffel Tower erected in Paris for the 1889 exposition. The fairgoer, Gage promised, "will see beautiful buildings radiate with color and flashing the sunlight from their gilded pinnacles and domes". "And beyond all," Gage suggested, visitors "will behold the boundless waters of Lake Michigan, linking the beautiful with the sublime, the present with the past, the finite with the infinite."[9]

As was the case in 1876, the Smithsonian Institution again contributed materially and conceptually to the organic whole of the exposition. Following the Centennial, the Smithsonian participated in many local, national, and international fairs. Exhibits traveled to the International Fisheries Exhibitions in Berlin and London (1880 and 1883), to Boston's Foreign Exhibition (1883), and to the Chicago Railway Exhibition (1883). Over the next two years exhibits went to the International Electrical Exhibition in Philadelphia (1884), the Southern Exposition in Louisville (1884), Cincinnati's Industrial Exposition (1884), and the World's Industrial and Cotton Exposition at New Orleans (1885). Between 1887 and 1893 the Smithsonian also provided displays for the Minneapolis Industrial Exposition (1887), the Centennial Exposition of the Ohio Valley (1888), the Marietta, Ohio, Exposition, the Paris International Exposition (1889), the Patent Centennial (1891), and the Columbian Historical Exposition in Madrid (1892). By 1893 the Smithsonian had earned a well-deserved reputation "as the one bureau of Government whose special function is that of exhibition".[10]

With its experience in exposition matters, the Smithsonian was the place the directors of the Chicago fair naturally turned to for assistance in classifying exhibits. The institution assigned the task to its assistant secretary, G. Brown Goode.

Goode, highly regarded as an ichthyologist and museum administrator, had studied under Louis Agassiz at Harvard. He was also knowledgable in physics, astronomy, and comparative philology, versed in anthropology and American history, and an authority on genealogy. Samuel Pierpont Langley, Baird's successor

as secretary of the Smithsonian, explained how this latter interest related to science: "Doctor Goode was a strong believer in heredity, and he was profoundly impressed with the idea that man's capabilities and tendencies were to be explained by the characteristics of the men and women whose blood flowed through their veins." Goode, however, devoted himself primarily to museum work, which he considered intimately related to expositions. International fairs and museums, Goode felt, both possessed great educational value as well as vast potential for creating the good citizenship necessary for advancing civilization.[11]

Goode's exposition experience had started at age 25 when Baird appointed him to arrange the Smithsonian's exhibit of animal resources of the United States at the Philadelphia Centennial. He subsequently served as a federal commissioner to the Fisheries Exhibitions in London and Berlin and represented the Smithsonian at every major United States exposition between 1884 and 1895. At the Madrid exposition, just before the Chicago world's fair, Goode briefly held the post as commissioner-general. His exposition experience in the 1880s and his organizational efforts within the National Museum formed the backdrop for his seminal address "The museums of the future", delivered at the Brooklyn Institute in early 1889.[12]

"There is an Oriental saying," Good told his audience, "that the distance between ear and eye is small, but the difference between hearing and seeing is very great." He was referring to the growing importance of visual arts in the late nineteenth century, perhaps best typified by the separate building that had been provided for photographic exhibits at the Centennial. The increasing prominence of the visual arts, according to Goode, marked a fundamental cognitive shift. He put it bluntly: "To see is to know." In this context, he urged that the museum ought to become a major influence, "for it is the most powerful and useful auxiliary of all systems of teaching by means of object lessons." The problem was that museums were too few and generally were antiquated in their display techniques. "This can not long continue," he warned. "The museum of the past must be set aside, reconstructed, transformed from a cemetery of bric-á-brac into a nursery of living thoughts. The museum of the future must stand side by side with the library and the laboratory, as part of the teaching equipment of the college and university, and in the great cities cooperate with the public library as one of the principal agencies for the enlightenment of the people." Above all, Goode stressed, future museums "in this democratic land should be adapted to the needs of the mechanic, the factory operator, the day laborer, the salesman, and the clerk, as much as to those of the professional man and the man of leisure". They should give adults the opportunity to continue the learning process begun in the schools. "[T]he people's museum should be much more than a house full of specimens in glass cases. It should be a house full of ideas, arranged with the strictest attention to system."[13]

The exposition directors gave Goode the opportunity to arrange their "house full of ideas". In his "First draft of a system of classification for the World's Columbian Exposition", he reiterated the central theme of his Brooklyn Institute lecture. "*The exhibition of the future will be an exhibition of ideas rather than of objects, and nothing will be deemed worthy of admission to its halls which has not some living, inspiring thought behind it, and which is not capable of teaching some valuable lesson.*"

The guiding thought he had in mind for the World's Columbian Exposition was progress. The fair, he wrote, would illustrate "the steps of progress of civilization and its arts in successive centuries, and in all lands up to the present time". It would become, "in fact, an *illustrated encyclopedia of civilization*".[14]

Once he had completed the classification for the fair, Goode returned to Washington to supervise the Smithsonian's plans for an exhibition of scientific progress at Chicago. Goode's ideas about the specific role of science at the exposition can be inferred from his 1894 address "America's Relation to the Advance of Science". "Is it not possible", he asked his audience at the Philosophical Society of Washington, "that [science in America] may hereafter become the chief of the conservative forces in civilization rather than, as in the past, be exerted mainly in the direction of change and reform?" After informing the audience that "the Renascence of today is leading men to think not only with personal freedom, but accurately and rightly", Goode concluded with a quotation from Whitman's *Leaves of Grass*:

> Brain of the New World, what a task is thine,
> To formulate the Modern – out of the peerless grandeur
> of the Modern,
> Out of thyself . . .
> Thou mental orb, thou new, indeed new, spiritual world,
> The President holds thee not – for such vast growth as thine,
> For such unparalleled flight as thine, such brood as
> thine,
> The Future only holds thee and can hold thee.

Goode's definition of science as the guarantor of civilization into the future also pinpointed the function of science at the Chicago exposition – an exposition that in its very essence was an effort to educate and "to formulate the Modern".[15]

At the public dedication, held 12 October 1892, Potter Palmer, Gage's successor as president of the World's Columbian Commission and owner of Chicago's most fashionable hotel, expressed the enthusiasm he and the other directors felt for the educational value of the exposition: "May we not hope that lessons here learned, transmitted to the future, will be potent forces long after the multitudes which will throng these aisles shall have measured their span and faded away?" Francis J. Bellamy, an editor of *Youth's Companion*, substantially aided the realization of these hopes when he devised a plan whereby schoolchildren across the country could feel themselves a part of the exposition's quadricentennial liturgy. He urged that the dedication day of the fair be set aside as a national holiday and that children congregate in their schools and churches to celebrate Columbus's achievement and the fair designed to commemorate it. To make the event truly national in character, Bellamy drafted the Pledge of Allegiance to the flag of the United States. The Federal Bureau of Education circulated copies to teachers throughout the country. Presidential candidates Harrison and Cleveland endorsed the operation, as did the exposition directors. At the ceremonies themselves schoolgirls dressed in red, white, and blue formed a living flag. The result was that while well over

100,000 people witnessed the dedication of the fair, millions of children around the country pledged "allegiance to my flag and the Republic for which it stands, one Nation indivisible with Liberty and Justice for all." And as Annie Randall White, author of a children's history of Columbus and the fair, reminded her young readers, the fair "involved more than an exhibit of wonderful productions. It means a new era in the onward march of civilization."[16]

The fair, which opened seven months after the dedication proceedings, served as an exercise in educating the nation on the concept of progress as a *willed* national activity toward a determined, utopian goal. The interplay of progress and human will was constantly repeated in the contemporary literature on the fair. But will was not enough. The pathway to the future could be constructed only out of fibers of human will rightly informed. "Education", as Henry Adams ruefully observed, "ran riot" at the World's Columbian Exposition of 1893.[17]

Because the central message of the fair emphasized American progress through time and space since 1492, it was appropriate that Frederick Jackson Turner chose the American Historical Association's meeting, held in conjunction with the exposition that summer, for the presentation of his frontier thesis. He informed his colleagues that the individual "would be a rash prophet who should assert that the expansive character of American life has now entirely ceased". Turner's admonition found support in an exposition that strongly suggested that America's past achievements were indicative of the future direction of society. Pilgrims to the various shrines in the White City caught glimpses of such sacred articles as a lock of Thomas Jefferson's red hair and Miles Standish's pipe. Relics abounded that traced the road already traveled; yet Americans were asking where the country was headed.[18]

That such fundamental questions were thought relevant to the Columbian Exposition was indicated by the title of a sonnet in the Chicago *Daily Inter Ocean*: "The perfection of society in Columbia's future". To arrive at this perfected state, visitors were told they first needed to absorb the spirit of the fair. Mariana G. van Rensselaer, art critic for *Century Magazine*, urged her readers to go to the fair "wholly conscienceless – not like a painstaking draftsman, but like a human kodak, caring only for as many pleasing impressions as possible, not for analyzing their worth". Thus, lying back in Venetian gondolas or electric motor launches, drifting idly about ethereal fountains, they could imbibe what Potter Palmer termed "a vision snatched from dreams whose lines have been brought out and well-defined by the iodine of art". How was the vision to be actualized? Youthful Meg Macleod explained to her brother that although the idea of the fair had originated with a great magician who was the ruler of all the genii in the world, the fair was designed to make people "know what *they* are like themselves, because the wonders will be made by hands and feet and brains just like their own. And so they will understand how strong they are – if they only knew it – and it will give them courage and fill them with thoughts." Courageous human will, inspired by the vision of America's future triumph, could begin the task of restructuring America.[19]

In the light of such visions it was also essential to ask who would be the builders of the "New Jerusalem" and, more important, to determine who would be included in

The city so holy and clean,
No sorrow can breathe in the air;
No gloom of affliction or sin,
No shadow of evil is there.

As explained in a Fourth of July oration published in the Chicago *Tribune*, the "far-off divine event" would be accomplished "by the average citizen – that plain, sturdy, self-reliant, ambitious man, who is known as the typical American". The *Cosmopolitan* assured its readers that the fair was for "the Average People . . . and not for the few at the top or for the helpless lot in the gutter, but for the Average". Rightly instructed by Daniel Burnham's neoclassical exposition forms, average Americans were told they could at long last fulfill their destiny as "the solvent the alchemists of politics groped for". Their task, however, was enormous, for the exposition made clear that not only the national, but also the international, body politic needed much racial purification before the dream of perfection could be realized. The White City was a utopian construct built upon racist assumptions. Yet this did not mean that all non-whites were perceived uniformly.[20]

When invitations were sent to foreign governments, Japan was among the first to respond, and it eventually invested more than $630,000, one of the largest sums spent by any foreign country, in setting up its exhibits. Japan, moreover, was given what many considered the choicest location on the fairgrounds, the Wooded Isle, for its official building. Whereas American workers built the other foreign structures, Japanese workers were sent from Japan to build the Ho-o-den Palace. The building was designed by a Japanese architect, the interior decorated by members of the Tokyo Art Academy. Gozo Tateno, Japanese minister to Washington, explained because of Japan's interest in furthering commercial ties with America as well as proving "that Japan is a country worthy of full fellowship in the family of nations". American officials welcomed the Japanese, apparently with few reservations.[21]

The situation with respect to China provided a contrast. Earlier ambivalence about the Chinese in 1876 had given way to hostility. Because of the Geary Law, which renewed the restrictions placed on Chinese immigration by the Exclusion Act of 1882, China declined to send a commissioner to Chicago. More important, China refused to set up an official exhibit at the fair. But since it seemed essential that China be represented in some capacity in an exposition supposedly international in character, the Chinese exhibit was leased to "patriotic and commercially interested Chinese" in America and was placed on the Midway Plaisance, with its theater set next to the Captive Balloon concession and its teahouse adjoining the Ice Railway. Sandwiched between entertainment facilities, both Chinese displays became a source of amusement, not respect.[22]

The disparities in the reception and treatment of China and Japan were reminiscent of the situation at the Centennial; but at Chicago, American attitudes more explicitly revolved around the cultural and racial capacities attributed to the two nations to attain and carry forward the banner of Anglo-Saxon civilization. Although the Japanese seemed to be more highly regarded than the Chinese, on closer examination the esteem shown them was not without qualification.

In the opinion of most observers, Japan had the potential for reconciling its preindustrial culture with the example of American industrial growth. "The astonishing progress of Japan in arts and civilization", reported the *Inter Ocean*, "is one of the wonders of the age." Not only was Japan rapidly progressing, it was doing so without moral decadence. *The Popular Science Monthly* attested to the purity and decency of Japanese life: "Filial piety, connubial affection, parental tenderness, fraternal fondness . . . and above all this is that ardent spirit of patriotism and love for home that so preserves the unity of the Japanese people." Nowhere was the morality of the Japanese and the belief that they could even influence American culture given more pointed expression than in an anecdote related by Charles Stevens, author of the popular novel *Uncle Jeremiah and Family Go to the Fair*. Uncle Jeremiah, perpetually awestruck at the sights and sounds in the Manufacturer's Building, saw two elderly ladies sit down in the Japanese section to admire a display of pottery and managed to overhear their conversation. "I don't see the use of sending missionaries to Japan," said the first. Nodding her head in agreement, the other replied: "I don't believe they are so very bad after all. I can't believe that anyone who could make such lovely things could be a very wicked heathen. I should think the Japanese would almost feel like sending missionaries over here." At first glance, the American posture toward the Japanese conveyed the same goodwill as this conversation. Yet, notwithstanding the pronouncement of one souvenir publication that "because of their intelligence and ingenuity not a race prejudice exists against them", the Japanese were central to the racial economics of the fair.[23]

Japan, because of its moral and industrial progress, was portrayed as on the verge of leaping "at one bound to those things for which the Caucasians battled during succeeding centuries". "If the modern civilization of Japan stands," a newspaper predicted, "the cradle of humanity will become worthy of its children, the races of civilized men." An early historian of the fair offered another version of the same theme: "Japan, the Great Britain of Asia, . . . with every day is making some new stride toward the Western spirit of enterprise and civilization." Japan, in short, was expected to have an uplifting – that is, Americanizing – influence on an otherwise backward Asian continent.[24]

The subordinate status accorded the Japanese in hastening the realization of the vision of the White City was clear in the same souvenir folio that denied the existence of any race prejudice against the Japanese. "Everybody wanted to know, and knowing, liked the Japs. They were so quiet, and so good-natured," asserted the author. As long as Japan remained a "Children's Paradise," and the Japanese, as "Yankees of the East", showed deference to the desires of the United States, there was every reason to believe that the Japanese people could be accommodated after a fashion in the future utopia. But once the Japanese began striking out on their own, once they began to loom large as an actual Great Britain of Asia over the next decade, they could no longer be seen in the same perspective, much less be permitted to send "missionaries" to this country.[25]

In 1893 Americans' positive attitude toward the Japanese was also demeaning and patronizing. The nuance at the Columbian Exposition became explicit at the San Francisco Midwinter Exposition of 1893–4 – brainchild of M. H. De Young and largely imitative of the Chicago fair – where Japanese were portrayed as

"cousins" of the Chinese and visitors to the Japanese Village were invited to view "part and parcel of the home life of the little brown men". The possibility that the Japanese might become full citizens of the City Beautiful of the future was increasingly problematic.[26]

If, however, the Japanese were given at least a semblance of respect in 1893, the Chinese were seen as replicas of the old stereotype of the shrewd, cunning, and threatening "John Chinaman". The *Chicago Tribune*, in an article titled "Freaks of Chinese fancy at the fair", reported that, despite their inability to speak English fluently, the Chinese never made a mistake against themselves in giving change. On the apparent slowness of the Chinese fortuneteller, the *Tribune* commented: "hustle" is something to which Professor Hin has hereditary objection." References to "almond-eyed" and "saffron-colored mongolians" abounded. Hubert Howe Bancroft, who in the 1830s had written that "as a progressive people we reveal a race prejudice intolerable to civilization", looked disdainfully upon the Chinese theater for the "oddity of the performance and for the nature of its themes". Comparing theatrical themes to those of Chinese literature and denigrating both, Bancroft found "the pervading tone is morbid and ultra pessimistic, virtue in woman and honor in man being conceded only to a few". China, he continued, "is a country where the seat of honor is the stomach; where the roses have no fragrance and women no petticoats; where the laborer has no sabbath and the magistrate no sense of integrity".[27]

Charles Stevens, author of *Uncle Jeremiah*, expressed pleasure that a few "decent-looking Chinamen" who did not "look like rats and whose fluent English proclaims their long stay in "Flisco" were serving tea at the entrance to the theater", but he also stated his suspicion that the joss house contained the opium bunks of the Chinese actors. *Harper's Weekly*, in an article on the Fourth of July parade staged by the villagers of the Midway Plaisance, wrote of the Chinese: "[They] are a meek people, but seem anxious to apologize and make atonement for their humility by the extraordinarily aggressive dragons and devils which they contrived. The dragon did much to raise the standing of the Midway Chinese among other more savage and not half so ingenious races." Viewed as a race, the timid but cunning, immoral, and uncivilized Chinese were considered to be closer to the lower orders of mankind than to visions of future possibilities and perfections.[28]

If, to white Americans, the fair was a reaffirmation of the nation's unity, self-confidence, and triumphant progress, despite a devastating Civil War and mounting social-industrial turmoil, its impact on American blacks was quite different. A black newspaper in Cleveland described it as "the great American white elephant". Earlier anticipations by blacks that the fair might serve as a forum for displaying their achievements since emancipation quickly disappeared as it became apparent that no black representative would be appointed to positions of authority on any of the various commissions governing the fair. When the Board of Lady Managers refused to appoint a black woman to its committee, the *New York Age* reported bitterly: "We object. We carry our objection so far that if the matter was left to our determination we would advise the race to have nothing whatever to do with the Columbian Exposition or the management of it. . . . The glory and the profit of the whole thing, is in the hands of white "gentlemen" and "ladies" and in all charity

they should be allowed to share all the glory or failure of the undertaking." As a result of such protests, a Saint Louis school principal, Hale G. Parker, who considered himself "above" other blacks by virtue of his professional status, was finally appointed to the National Commission, but he served only as an alternate.[29]

Controversy divided the black community. Frederick Douglass and Ida Wells, longtime advocates of black political and economic rights, wanted to publish a pamphlet in foreign languages informing the rest of the world of the travails of black Americans in both North and South. Many editors of black newspapers, however, argued that such an action would increase white hostility and disgrace blacks before foreign visitors. Lack of funds eventually compelled Wells and Douglass to publish only an English edition of their pamphlet, with prefaces in French and German that referred to the exposition as a "white sepulcher". Discussion also developed over the idea of an Afro-American exhibit, which proponents argued would encourage black participation in the fair. Blacks laid plans to rely on the Southern Exposition in Raleigh, North Carolina, in 1891 as a gathering-point for black exhibits to be sent to the world's fair two years later. But the idea of a separate exhibit aroused opposition as de facto surrender to segregation. The issue in many respects became moot when the directors ruled against racially separate exhibits. Instead, they encouraged blacks to participate in existing state displays but tempered their encouragement by the requirement that black exhibits be submitted to and approved by all-white committees in the various states. Few black exhibits made their way through the screening apparatus.[30]

A further source of contention was the exposition management's decision to grant demands some blacks made for a special day of their own – "Jubilee" or "Colored People's Day" as it was variously called. Since there had been other days set aside for specific ethnic groups, Douglass favored the proposal. Ida Wells, conversely, saw the gesture as condescending and urged blacks to avoid the fair. The black community again divided. The *Indianapolis Freeman*, the nation's most widely circulated black newspaper, argued that the day, "if carried out . . . will only serve to attract invidious and patronizing attention to the race, unattended with practical recompense or reward". As Jubilee Day, 25 August, drew nearer, the *Freeman* became increasingly sarcastic: "The Board of Directors have furnished the day, some members of the race have pledged to furnish the "niggers," (in our presence Negroes), and if some thoughtful and philanthropic white man is willing to furnish water melons, why should he be gibbeted?" A revealing cartoon in *Puck* suggests why all but one thousand blacks stayed away from the fair on the day set aside for them. Frederick Douglass, however, availed himself of the opportunity to address those white Americans who branded the black "a moral monster". Douglass, United States minister to Haiti, had been appointed by the Haitian government as its delegate and delivered his message from the Haitian Building: "Men talk of the Negro Problem. There is no Negro Problem. The problem is whether the American people have honesty enough, loyalty enough, honor enough, patriotism enough to live up to their own Constitution." "We have come out of Dahomey into this," he declared. "Measure the Negro," he urged. "But not by the standard of the splendid civilization of the Caucasian. Bend down and measure him – from the depths out of which he has risen."[31]

Whites were only too happy to measure blacks. Shortly after the close of the fair, a souvenir book of photographs appeared. The caption to one of the illustrations read: "Perhaps one of the most striking lessons which the Columbian Exposition taught was the fact that African slavery in America had not, after all, been an unmixed evil, for of a truth, the advanced social conditions of American Africans over that of their barbarous countrymen is most encouraging and wonderful."[32]

Black visitors apparently experienced little overt discrimination in public facilities at the fair, since only one instance was reported. The case involved a black woman who was refused admission to the entertainment program in the Kentucky Pavilion. Racism, however, existed in other forms. Popular attitudes embracing the spectrum of racist notions were articulated in a series of cartoons that appeared in *Harper's Weekly*, depicting the adventures of a black family at the fair. The first of the series ridiculed blacks' aspirations to advance in American society as well as their intellectual ability to comprehend the lessons of the fair. Mr Johnson, wide-eyed and viscid-lipped, exclaimed to his wife as they first caught sight of the buildings from the Peristyle entrance: "Great Lan' Gloriah! I'd a given dat spotted mule ob mine for the contrac' of whitewashing dis yer place." Another cartoon found Johnson in agitated dialogue with a South Sea Islander: "Does you speak Inglish?" With the crowd chortling in the background, the Samoan responded: "Yes, does you?" Another caricature followed in which Johnson paused at the Dahomeyan Village to shake hands with one of the villagers. His wife, menacing him with her parasol, shouted: "Ezwell Johnson, stop shakin' hands wid dat heathen! You want de hull fair ter t'ink you's found a poo' relation!" The most suggestive illustration, however, placed the Johnson family in the Kentucky exhibit. There Johnson met his former master, who asked him what he was doing at the fair. Johnson, with a trace of deference, answered, "Well, sah, I's lak a noble shoe dat's been blacked — 'bout time I's gettin' some polish!"[33]

The fair did not merely reflect American racial attitudes, it grounded them on ethnological bedrock. So pervasive was the opportunity to study anthropology at the World's Columbian Exposition that Otis T. Mason, curator of the Smithsonian's Bureau of American Ethnology since 1884, exclaimed: "Indeed, it would not be too much to say that the World's Columbian Exposition was one vast anthropological revelation. Not all mankind were there, but either in persons or pictures their representatives were." Anthropological exhibits — including "representatives of living races in native garb and activities", photographs and drawings, books, and "objects connected with every phase of human life" — seemed to be everywhere. The exposition directors hired Frederic Ward Putnam, head of Harvard's Peabody Museum of American Archaeology and Ethnology, to take charge of the exposition's Department M, which included the anthropological exhibits. The National Museum and the Bureau of American Ethnology of the Smithsonian contributed a separate and sizable ethnological display. Foreign governments and concessionaires also contributed ethnological materials. According to William H. Dall, a naturalist and scientific correspondent for the *Nation*, America's leading and soon-to-be leading anthropologists, including Franz Boas, Alice Fletcher, George A. Dorsey, John Wesley Powell, Elizabeth Coxe Stevenson, and James Mooney, "brought

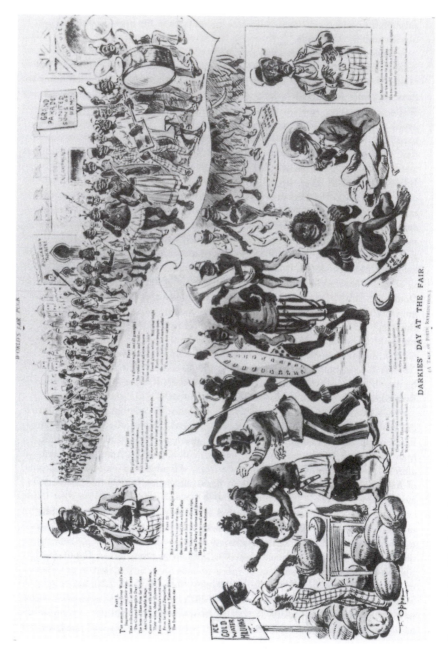

Figure 13.3 'Darkies' day at the fair', cartoon from *World's Fair Puck*: from Prints and Photographs Division, Library of Congress

together . . . an anthropological collection hitherto unequalled and hereafter not likely to be surpassed".[34]

The immediate starting-point for the ethnological ventures at the Chicago fair was the tenth Congrès Internationale d'Anthropologie et d'Archéologie Préhistoriques held in conjunction with the Paris Exposition of 1889. The two members of the United States delegation to this meeting of the world's foremost anthropologists were from the Smithsonian – Otis Mason and Thomas Wilson, Rau's successor as curator of prehistoric anthropology in the USNM. Delegates listened to presentations of scholarly papers and, under the guidance of renowned French anthropologists, toured the exposition and the museums of Paris. Mason was particularly impressed by the Paris fair: "to the eye of the anthropologist the whole Exposition seemed to have been arranged for his special pleasure and profit by his colleagues there."[35]

Much of Mason's enthusiasm centered on the colonial city, where 182 Asians and Africans had been installed in simulated native villages, presumably to quell French anxieties over the government's policies of empire. In late summer the congress met on the esplanade for a special all-day tour of exhibits with anthropological content. M. G. Dumotier, minister of education in the Tonkin Bureau, delivered the welcoming address. Dumotier and E. T. Hamy, curator of the Paris Musée d'Ethnographie, conducted the visitors on a guided tour through the colonial city. When they arrived at the Okanda and Adouma villages, the lieutenant governor of Gabon introduced the inhabitants of the villages as examples of two different races, "*en insistant sur les différences de leurs caractères extérieurs, taille, indices céphaliques, etc.*". Mason, impressed by the colonial city, was especially pleased by the History of Human Habitations display fronting the Eiffel Tower, which demonstrated the evolution of human dwellings from prehistoric to present times. "[A] most interesting series of structures illustrative of human habitations in all grades of culture," Mason declared. To his way of thinking the Paris exposition had triumphed precisely because it had demonstrated "this living connection between men and things".[36]

Mason would try to surpass the achievements of the Paris exposition at the World's Columbian celebration. His account of the Paris exhibits laid the basis for the plans Langley and Goode first proposed to the United States Congress in 1890 for the Smithsonian's ethnological display at Chicago. Its purpose would be "to show the physical and other characteristics of the principal races of men and the very early stages of the history of civilization as shown by the evolution of certain selected primitive arts and industries". The Paris exposition, they noted, had accomplished this task in "a popular and effective" manner. These plans, moreover, were wholly compatible with Goode's intent to classify exhibits at the fair so as to illustrate the progress of civilization.[37]

The exposition management, always concerned about the escalating costs of the project, was well aware that the ethnological villages at Paris had been one of the main attractions for over 30 million visitors. Thomas W. Palmer, president of the National Commission, was particularly interested in an ethnological display and advocated placing living villages on the narrow strip of land known as the Midway Plaisance.[38]

The efforts of Goode and Palmer to mount an ethnological display at least on par with that at Paris were further supported by Putnam. Putnam, like Goode a former student of Agassiz, had developed while at Harvard an expertise in museum work for which he became nationally famous. An "institutional entrepreneur in an age of organizing genius", he regarded the Chicago fair as a tremendous opportunity to introduce the science of anthropology to the American public and to build a collection that would lead to the establishment of a great ethnological museum in Chicago. He explained his ideas for the fair in a letter to the *Tribune* in May 1890. So impressive were his plans for a detailed exhibit of "the stages of the development of man on the American continent" that in early 1891 the directors appointed him chief of the Department of Ethnology and Archaeology.[39]

In the course of planning their exhibits, the scientists in the Smithsonian and Department M sought to avoid duplication. Putnam and his assistants concentrated on a living ethnological display of American Indians and on collecting and organizing ethnological artifacts from around the world. The vast amount of material they acquired led the directors of the fair, after repeated prodding by Putnam, to establish a separate Anthropology Building on the fairgrounds. This building, one of Putnam's major achievements in trying to popularize anthropology and to prove the worth of building a permanent ethnological museum, contained archaeological exhibits, laboratories, a library, and a large collection on religion and folklore. Visitors to this building could be examined and measured by physical anthropologists under the direction of Putnam's assistants, Franz Boas and Joseph Jastrow. For fairgoers who harbored doubts about the ideal types they were to conform to, statues of a male and female student from Harvard and Radcliffe stood nearby. The overriding aim of the department was stated by an ethnologist and one of Putnam's assistants, Harlan Ingersoll Smith: "From the first to the last," he declared, "the exhibits of this department will be arranged and grouped to teach a lesson; to show the advancement of evolution of man."[40]

The Smithsonian's display in the Government Building was smaller than Putnam's but equally significant. Thomas Wilson arranged an exhibit of prehistoric people between the stone ages, while William Henry Holmes organized an exhibit based on his own archaeological research. The most important ethnological display by the Smithsonian was planned by Mason, who, after consulting with Putnam, agreed to avoid duplicating Putnam's efforts and to organize an Indian exhibit that would reflect life in America at the time Columbus landed. In the wake of the exposition directors' decision to set up an ethnological department, Mason determined to create a display that would demonstrate the value of John Wesley Powell's recently completed linguistic map of Native American speech patterns. "The Chicago Exposition", Mason wrote in his annual report for 1892, "furnishes an excellent opportunity for testing the question – how far language coordinated itself with industries and activities as a mark of kinship and race, and how far climate and the resources of the earth control the arts and industries of mankind in the sphere of language and race." Often described as a striking departure from Baird and Rau's arrangement of the ethnological display at the Centennial, Mason's exhibit was a variation on the theme of racial progress. Life-size statues of Indian adults and children of a given language grouping were dressed in char-

acteristic clothing and shown working at typical tasks in their natural environments. The emphasis on culture areas, occupational groups, and environment would have a significant impact on twentieth-century anthropology. Yet, if the exhibit technique was a milepost in the development of the science of anthropology, the concept of culture areas fit snugly with a view of Native Americans as "lower races in costume", living an outmoded life. The Smithsonian display at the World's Columbian Exposition presented Indians as culturally distinct from one another and racially inferior to other "types" of humanity, especially when viewed against the backdrop of the White City.[41]

At a meeting of the International Congress of Anthropology, which met from 28 August to 2 September at Chicago's Art Institute and on the exposition grounds, Mason described the Smithsonian exhibit for his colleagues. In the course of his presentation he suggested that the idea of culture areas might resolve the ongoing dispute between Daniel G. Brinton, America's foremost ethnologist, and Putnam whether Indians in North America constituted one race or two. Mason argued that Indians had not been in North America long enough "to breed races with differential and hereditable characteristics". Rather than viewing Indians as plural races, Mason counseled anthropologists to study Indians from the standpoint of different cultural regions in which they lived. That different cultural areas existed, however, was not at all incompatible with understanding Indian Life in racial terms. "Among the civilized communities," Mason noted, "there has grown up a reverence for the government, called patriotism, and from this, combined with the love of one's native land, comes a strong motive in holding the people of a nation together." "Not so in savagery," he added. "Among the American tribes of Indians, indeed, the strongest civilized bond is that of kinship, which, after all, is a racial characteristic."[42]

That the concept of culture areas was compatible with a belief in cultural/racial grades became further apparent in Mason's plans to round out the Smithsonian's ethnological collection with a presentation of American and Afro-American types. To understand what America "has done and undone" to blacks, Mason urged that a display of the industries of western Africans and Afro-Americans be established at the fair so visitors could compare their respective levels of culture. Anthropologists, Mason felt, should be encouraged to make forays into Africa to gather artifacts because, as was the case with the Indians, it was only a matter of time until their "rude arts" would be supplanted by those of Western nations. The exhibit would have immense scholarly importance and enable ethnologists "to comprehend many things observable in the present condition of the United States and to trace them to their true source".[43]

Funding for this plan was not forthcoming, but the ethnological display in the Woman's Building gave Mason the opportunity to locate for visitors the "source" of contemporary Afro-American difficulties in adjusting to the demands of white society. To illustrate women's role in peacemaking through the ages, Mason synoptically arranged twelve groups of objects in such a way that "in each group a certain art is traced in its manifestation among the three modern types of savagery, namely: the American, the Negroid and the Malayo-Polynesian". Within this framework, the political and economic situation of American blacks would easily be explained as an outgrowth of their "savage" heritage. He allowed that blacks, Indians, and

Malaysians might have distinct cultures, but his presentation of different peoples and cultures formed a crucial link in the chain of human progress along racial lines that the fair presented.[44]

Shortly after the fair concluded, Mason mentioned that he had been deeply affected by a bas-relief of a "forlorn savage woman depicted on the doorway of the Transportation Building at one end of a series of weary burden bearers", who "was in strange contrast with the spirituelle painting of angels on the walls above her head". The contrast became even more dramatic on the Midway Plaisance, where the "savages" frozen in art and in the Smithsonian's lay figures seemed to come alive.[45]

The Midway Plaisance was a strip of land a mile long and nearly 600 feet wide, formerly a wooded drive connecting Jackson Park with Washington Park. By opening day of the fair, its serenity had been transformed into what the *Tribune* labeled the "Royal Road of Gaiety". On either side of the street the visitor could find restaurants, entertainment facilities, ethnic villages, and above all enormous crowds. Historian Hubert Howe Bancroft described it as follows:

> Entering the avenue a little to the west of the Woman's Building [the visitor] would pass between the walls of mediaeval villages, between mosques and pagodas, past the dwellings of colonial days, past the cabins of South Seas islanders, of Javanese, Egyptians, Bedouins, Indians, among them huts of bark and straw that tell of yet ruder environment. They would be met on their way by German and Hungarian bands, by the discord of . . . camel drivers and donkey-boys, dancing girls from Cairo and Algiers, from Samoa and Brazil, with men and women of all nationalities, some lounging in oriental indifference, some shrieking in unison or striving to outshriek each other, in the hope of transferring his superfluous change from the pocket of the unwary pilgrim. Then, as taste and length of purse determined, for fees were demanded from those who would penetrate the hidden mysteries of the plaisance, they might enter the Congress of Beauty with its plump and piquant damsels, might pass an hour in one of the theatres or villages, or partake of harmless beverages served by native waiters. Finally they would betake themselves to the Ferris Wheel, on which they were conveyed with smooth, gliding motion to a height of 260 feet, affording a transient and kaleidoscopic view of the park and all it contains.

Rao Telang, a visitor from India, outlined the scene in the center of the Midway: "the mania for buying tickets, the anxiety to get there first to secure the best seat, the excitement of the orator assisted by the salesman . . . the distant roar of the lions from the show of wild beasts . . . make the place unbearable for a quiet sort of person." The *New York Times* put the matter succinctly: "The late P. T. Barnum should have lived to see this day."[46]

Several visitors to the fair denied the ethnological value of the Midway, believing it was "a sideshow pure and simple". To others it appeared the Midway had strayed far from its ethnological origins. An early history of the fair suggested that the Midway exhibits were grouped under Department M solely for classification and

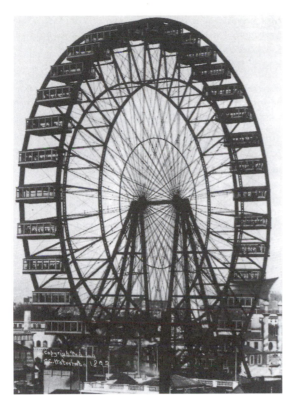

Figure 13.4 Ferris wheel: from Prints and Photographs Division, Library of Congress

were not directly connected with it. Putnam, however, made the most of the situation and attested to the anthropological value of the Javanese, Samoan, and Dahomeyan villages and others. Significantly, the Rand-McNally guidebook to the fair suggested that people visit the Midway and view the exhibits – none of which were national displays, though several had government approval from the countries represented – only after having seen the edifices of modern civilization in the White City. There was a lesson to be learned from the apparent contrast.[47]

The Midway's didactic function was related to its history. From the time Thomas Palmer first proposed confining villages of people within its bounds, there existed strong sentiment that no cheap entertainment be permitted to clutter the magnificence of the White City. That as late as spring 1892 no firm plans had been made for the exhibits to be located on Midway suggests the ambivalence felt by many exposition backers, harking back to the precedent of the Philadelphia Centennial, about making popular entertainments part of the spectacle. But once again the example of the Paris fair loomed large. Concessionaires had contributed over $700,000 to the coffers of the 1889 exposition. Furthermore, the decision by the Committee on Ways and Means that most of the attractions proposed for the Midway had certain "ethnological and historical significance" and therefore should be located in the Department of Ethnology and Archaeology gave the Midway an aura of scientific respectability. As it became apparent that instruction and entertainment could complement one another, the fairgoer became more than welcome to ride the Ferris wheel or to sip a glass of Dr Welch's grape juice while waiting in line to see Fatima perform her titillating hootchy-kootchy dance.[48]

The installation of Midway exhibits was put in the hands of a 21-year-old San-Franciscan, Sol Bloom, who would later build a name for himself in real estate and national politics as well as help draft the United Nations charter. Bloom had visited the 1889 exposition and recorded that "of all the exhibits at the fair I had found those of the French colonies most fascinating". He had discovered as he walked among the exhibits that "a kind of natural selection (though not precisely the theory enunciated by Darwin) was governing my movements". He noted "that the spiritual intensity of the performance presented by a troupe of Bedouin acrobats exceeded the emotional power of a pre-Renaissance tapestry" and that "a tall, skinny chap from Arabia with a talent for swallowing swords expressed a culture which to me was on a higher plane than one demonstrated by a group of earnest Swiss peasants who passed their days making cheese and milk chocolate". Before leaving Paris, Bloom signed a contract to bring the Algerian Village to the United States for a tour. Arrival of the Algerians was delayed until shortly before the Chicago fair opened, but Bloom busied himself superintending the installation of other Midway exhibits from his position in Burnham's Division of Works. He was astonished to find that the Midway was part of Frederic Putnam's domain. While Bloom had no quarrel with Putnam's scientific capabilities, he felt, as he later recalled, that placing him in charge of the Midway was tantamount to making Albert Einstein manager of Barnum and Bailey's Circus. Although Bloom and Putnam worked separately, the net result of their efforts was an alliance between entertainment and anthropology replicated in subsequent fairs.[49]

Putnam's major contribution to the ethnological display was organizing living representatives of various Indian tribes into an exhibit. To persuade Indians to participate, he relied primarily on Indian agents and on a young Apache, Antonio, who had been captured and "civilized". When various displays of Indian life and handicrafts were being considered, Putnam wrote that he intended "the presentation of native life [to] be in every way satisfactory and creditable to the native peoples, and no exhibition of a degrading or derogatory character will be permitted". Putnam believed that "this gathering of different natives of this continent at such a time and place can but be beneficial, as it will afford them a grand opportunity to see and understand the relations of different nations and the material advantages which civilization brings to mankind". A fundamental flaw in Putnam's scheme was that several of the exhibits of Dakota Sioux, Navajos, Apaches, and various north-western tribes were on or near the Midway Plaisance, which immediately degraded them as has happened with the Chinese exhibits.[50]

Emma Sickles, one of Putnam's staff members, raised the only objection to the treatment of Indians that was heard throughout the duration of the exposition, and she was summarily dismissed from her position. In a letter of protest to the *New York Times*, she charged that every effort had been made to use the Indian exhibits to mislead the American people. The display, she wrote, "has been used to work up sentiment against the Indian by showing that he is either savage or can be educated only by Government agencies. . . . Every means was used to keep the self-civilized Indians out of the Fair." Putnam dismissed the charges against the Department of Ethnology as "simply a tissue of misrepresentations and false statements". Yet if the Sickles indictment needed qualification, so did Putnam's claim to be "a true friend to [the Indian] race".[51]

The Native Americans who participated in the exhibits did not benefit from the exposition. Rather, they were the victims of a torrent of abuse and ridicule. With Wounded Knee only three years removed, the Indians were regarded as apocalyptic threats to the values embodied in the White City who had to be tamed – an idea already captured and put into effect in Wild Bill's Congress of Rough Riders, which was performing on Sixty-third Street, several blocks from the fair.[52]

To illustrate the inevitable triumph of white civilization over the Indian nations, the exposition management had invited several Sioux chiefs to the opening ceremonies and permitted them to view the proceedings from the highest point of the Administration Building. The Indians appeared at the climax of the ceremony, just as the chorus began singing "My country 'tis of thee". As one newspaper correspondent later reported the effect of the scene: "Nothing in the day's occurrences appealed to sympathetic patriotism so much as this fallen majesty slowly filing out of sight as the flags of all nations swept satin kisses through the air, waving congratulations to cultured achievement and submissive admiration to a new world."[53]

The significance of the Midway as a bulwark of the utopian dream projected by the White City cannot be underestimated. "The Midway Plaisance", explained correspondent Amy Leslie, "seems to be a magnet of deepest and most lasting significance." Its greatest importance lay simply in the vivid illustrations of evolutionary principles provided by ethnological villages.[54]

Since Putnam was a student and colleague of Agassiz, one might suspect that he was somewhat unreceptive to the evolutionary ideas of Darwin. But as early as 1880, *Popular Science Monthly* pointed out that Agassiz was becoming increasingly isolated in academic circles: "Of all the younger brood of working naturalists who Agassiz educated, every one – Morse, Shaler, Verrill, Niles, Hyatt, Schudder, Putnam, even his own son – has accepted evolution." While Putnam was "more interested in institutional development than in evolutionary theory", he nevertheless did intend the exhibits in his department to portray the stages of development of man from prehistoric times to the present. As with his chief assistant at the fair, Franz Boas, who had not yet moved into the camp of cultural relativism, Putnam's thoughts were in flux concerning the wisdom of conventional racial attitudes. Putnam clearly hoped American civilization could accommodate different races. Yet he was so eager to popularize anthropology that he acquiesced in the amalgamation of honky-tonk concessions and living ethnological displays on the Midway Plaisance. The results were devastating not only for Africans, Native Americans, and Chinese, but also for other non-white people of the world. For Putnam, it was sufficient to believe that "there was much of instruction as well as of joy on the Merry Midway".[55]

Nathaniel Hawthorne's son Julian revealed the educational thrust of the Midway: "Roughly speaking, you have before you the civilized, the half civilized, and the savage worlds to choose from – or rather to take one after the other." Department M, he decided, could be better titled "The world as plaything". On the Midway, presented as being under the control of the well-meaning professor from Harvard, the world became a bauble with which Americans might amuse themselves and a standard against which they might measure their achievements.

Alternating between specimens and toys in the eyes of observers, the non-white people living in villages along the Midway not only were seen through the lens of America's material and presumed racial progress leading to future utopia, but were neatly categorized into the niches of a racial hierarchy.[56]

A strong possibility exists that such racial compartmentalization reflected the intended organization of the Midway Plaisance. Denton J. Snider, a contemporary literary critic, suggested that the Midway consisted of a "sliding scale of humanity". Nearest to the White City were the Teutonic and Celtic races as represented by the two German and two Irish villages. The center of the Midway contained the Mohammedan world, West Asia, and East Asia. Then, "we descend to the savage races, the African of Dahomey and the North American Indian, each of which has its place" at the opposite end of the Plaisance. For Snider, there was only one way to understand this "living museum of humanity". "Undoubtedly," he declared, "the best way of looking at these races is to behold them in the ascending scale, in the progressive movement; thus we can march forward with them starting with the lowest specimens of humanity, and reaching continually upward to the highest stage." "In that way," he suggested, "we move in harmony with the thought of evolution, and not with that of the lapse or fall." The *Chicago Tribune* also hinted that the Midway was organized along evolutionary lines. In retrospect, the *Tribune* recalled that the "reconvening of Babel" on the Midway Plaisance afforded the American people an unequaled opportunity to compare themselves scientifically with others: "What an opportunity was here afforded to the scientific mind to descend the spiral of evolution," the newspaper affirmed, "tracing humanity in its highest phases down almost to its animalistic origins."[57]

Among white visitors there seems to have been nearly unanimous consent about which people belonged at the respective extremes of the racial spectrum. With the Anglo-Saxons at one end, "the negro types at the fair," according to one publication, "represented very fairly the barbarous or half-civilized state of a people who are a numerous and rapidly increasing class of American citizens". White observers generally agreed that, of the blacks, the Dahomeyans were the most savage and threatening. "Sixty-nine of them are here in all their barbaric ugliness," a correspondent wrote for *Frank Leslie's Popular Monthly*, "blacker than buried midnight and as degraded as the animals which prowl the jungles of their dark land. . . . In these wild people we easily detect many characteristics of the American negro." A woman from Boston expressed regret at having seen the Africans when she considered "the gulf between them and Emerson". By contrast to the Dahomeyans, with their war dances and rumoured cannibalism, the American Indian became, according to a souvenir publication, "a thing of beauty and joy forever".[58]

Climbing the rungs of the evolutionary ladder, a Midway tourist moved from the "savagery" of the Dahomeyans to the delightful and engaging Javanese – the "Brownies". "About the shade of a well-done sweet potato," the *Popular Monthly* reported, "the Javanese holds the position closest to the American heart of all the semi-civilized races." Javanese men were described as industrious workers, the women as untiring in their domestic duties. Described as cute and frisky, mild and inoffensive, but childlike above all else, the Javanese seemingly could be accommodated in America's commercial empire as long as they remained in their evolutionary niche.[59]

Like the Javanese, the Samoans, popularized in the writings of Robert Louis Stevenson, were well received. Yet an incident reported in the *Inter Ocean* revealed the limits within which such hospitality was contained. The prospect of coming to the United States, according to the *Inter Ocean*, had sparked in the Samoans an ambition to reform. Upon arriving in Chicago, much to their manager's horror, they had given one another haircuts and begun dressing in American garb. The manager had put a halt to the "civilizing process", and the *Inter Ocean* reported that "the Samoans [were] making a heroic and laudable effort to resume their natural state of barbarism". In an exhibit portraying the tiers of mankind, every race had its own permanent racial position.[60]

The Midway Plaisance, a place where Americans regardless of class could "study ethnography practically", linked equality to race. In blurring class lines and providing a quasi-scientific basis for the American image of the non-white world as barbaric and childlike, the Midway fed directly into the utopian vision of the White City. For Miss Berry, a character in a contemporary novel titled *Sweet Clover*, the relation between the two sides of the fair was crystal clear:

> That Midway is just a representation of matter, and this great White City is an emblem of mind. In the Midway it's some dirty and all barbaric. It deafens you with noise; the worst folks in there are avaricious and bad; and the best are just children in their ignorance, and when you're feelin' bewildered with the smells and sounds and sights, always changin' like one o' these kaleidoscopes, and when you come out o' that mile-long babel where you've elbowed and cheated, you pass under a bridge – and all of a sudden you are in a great, beautiful silence. The angels on the Woman's Buildin' smile down and bless you, and you know that in what seemed like one step, you've passed out o' darkness and into light.

The Midway made the dream of the future seem all the brighter and the present civilization all the more progressive.[61]

With the forces of mind and light counterposed to ignorance, dirt, smells, and matter, the White City and the Midway were truly symbolic, but not antithetical, constructs. Rather, the vision of the future and the depiction of the non-white world as savage were two sides of the same coin – a coin minted in the tradition of American racism, in which the forbidden desires of whites were projected onto dark-skinned peoples, who consequently had to be degraded so white purity could be maintained.[62] The Midway, with its half-naked "savages" and hootchy-kootchy dancers, provided white Americans with a grand opportunity for a subliminal journey into the recesses of their own repressed desires. Like Miss Berry, however, Americans were expected to leave what was filthy behind them and accept what was pure of mind and vision. Miss Berry's escort, Aunt Love, remarked: "It's come to me, Mr Gorham, that perhaps dyin' is goin' to be somethin' like crossin' the dividin' line that separates the Midway from the White City." On the downhill side of the dividing line were designated displays of various racial types that the *Chicago Tribune* had described as a "Sort of Universal Stew / A Pot Pie of the Earth". On the other side rose the antiseptic structures of the White City.[63]

The evolutionary steps in human progress presented by the spectrum of human "types" along the Midway leading up to the White City were further explained in September by the Congress on Evolution, a part of the World's Parliament of Religion. This conference was one of several sponsored by the World's Congress Auxiliary, which had been organized by Charles C. Bonney, Thomas B. Bryan, Lyman Gage, and Benjamin Butterworth. These men had been concerned that the overwhelming number of exhibits at the fair might obscure the fair's larger lessons about progress. To prevent fairgoers from losing sight of the whole, the World's Congress Auxiliary was formed as the "Intellectual and Moral Exposition of the Progress of Mankind" that would bring "all the departments of human progress into harmonious relations with each other". The Congress on Evolution, specifically intended to reconcile the teachings of evolution with Christianity, also attempted, as Herbert Spencer noted, "to advance ethics and politics by diffusing evolutionary ideas". Spencer provided the starting-point for this congress with a short paper in which he asserted that the "highest social type and production of the greatest general happiness" would result only when a balance was struck between egoism and altruism. Other contributors to the conference included John Fiske, T. H. Huxley, and a number of lesser-known scientists and religious leaders. One of these, James A. Skilton, called Spencer the "Columbus of the new epoch", because he had "discovered the unity of the universe and taught us how to make that discovery plain to others". It was left to the Reverend James T. Bixby to express the central lesson of the congress: "Evolution from lower to the higher, from the carnal to the spiritual, is not merely the path of man's past pilgrimage, but the destiny to which the future calls him, for it is the path that brings his spirit into closest resemblance and most intimate union with the divine essence itself." The congress, in short, synthesized and validated the theory of racial and material progress along evolutionary lines that the exposition itself presented in visible form. "Chicago", Henry Adams confirmed in retrospect, "was the first expression of American thought as a unity; one must start there."[64]

The fair lasted only six months. But through the City Beautiful Movement, popular novels, pulp fiction, souvenir albums, theatrical performances, and even a scale model of the White City built by George Ferris, which traveled to subsequent fairs, the World's Columbian Exposition left a lasting imprint on the American cultural landscape. Louis Sullivan, contemptuous though he was of the artistic quality of the White City, nonetheless testified to its importance: "The damage wrought by the World's Fair will last for half a century from its date, if not longer. It has penetrated deep into the constitution of the American mind, effecting there lesions significant of dementia." Thirty years later George F. Babbitt, Sinclair Lewis's prototypical businessman and urban booster, nervously awaited the arrival of his paramour while thumbing through a photograph book of the world's fair. "Fifty times", Lewis wrote, Babbitt "looked at the picture of the Court of Honor." The irony was not lost on the millions who had either been to the fair or read about it in the multitude of literary accounts. A decade after the close of the fair, Joe Mitchell Chapple, editor of *National Magazine*, made a nostalgic return to Jackson Park and reported that "a permanent uplifting of the people" had resulted from the fair and that this moral elevation of the people had

been perpetuated in the beauty of the park itself and in the Field Columbian Museum.[65]

The museum, a modified version of Putnam's original idea for a grand ethnological institution, was established by Marshall Field and other cultural barons of Chicago who had been responsible for the fair to institutionalize selected exhibits from the exposition and continue its didactic mission. Under the direction of Frederick J. V. Skiff, a Colorado mining investor and Denver newspaper editor, who had been chief of the Department of Mines at the fair, the Field Museum became "in the widest sense an educational institution". Its early collections included industrial and commercial displays from the fair, but after these were returned to their donors the emphasis shifted to natural history. From the beginning the museum had a department of anthropology established by Putnam and Boas, who were followed in succession by William Henry Holmes and George Dorsey. Under the latter's guidance, anthropological exhibits illustrated "the stages of culture and the physical characteristics" of Native Americans. The museum, moreover, became a repository of exposition ideas. In succeeding years, Skiff became active in promoting and classifying exhibits for subsequent fairs. By 1915 he was considered the world's foremost authority on expositions. Skiff's tie both to a major museum and to world's fairs would provide continuity to the attempts by other political and industrial leaders in other sections of the country to present Americans with visions of progress and cultural unity.[66]

[. . .]

Notes

1 Robert Herrick, *The Memoirs of an American Citizen* (Cambridge MA: Belknap Press of Harvard University Press, 1963), P. 147. Originally published 1905.

2 Useful histories of the fair include David F. Burg, *Chicago's White City of 1893* (Lexington: University of Kentucky Press, 1976); Rodney Reid Badger, *The Great American Fair: The World's Columbian Exposition and American Culture* (Chicago: Nelson-Hall, 1979). [. . .] See also Justus D. Doenecke, "Myths, machines, and markets: the Columbian Exposition of 1893", *Journal of Popular Culture* 6 (1972): 535–44; Larzer Ziff, *The American 1890s: The Life and Times of a Lost Generation* (New York: Viking Press, 1966); John Cawelti, "America on display, 1876, 1893, 1933", in *America in the Age of Industrialism*, ed. Frederic C. Jaher (New York: Free Press, 1968), pp. 317–63; Alan Trachtenberg, *The Incorporation of America* (New York: Hill & Wang, 1982), pp. 208–34: and Robert W. Rydell, "The World's Columbian Exposition of 1893: racist underpinnings of a utopian artifact", *Journal of American Culture* 1 (1978): 253–75.

3 Quoted from "Goodbye to the fair", *Chicago Tribune*, 1 November 1893, p. 4, in Harold M. Mayer and Richard C. Wade, *Chicago: Growth of a Metropolis* (Chicago: University of Chicago Press, 1969), p. 196. Frances Hodgson Burnett, *Two Little Pilgrims' Progress: A Story of the City Beautiful* (New York: Charles Scribner's Sons, 1895), p. 9.

4 "Testimony of H[arlow] N. Higinbotham", in *The Reports of Committees of the House of Representatives for the First Session of the Fifty Second Congress, 1891–1892*, no.

3047 (Washington, DC: Government Printing Office, 1892), p. 363 (hereafter cited as *Reports of Committees*); Horace G. Benson diary, 7, University of Colorado, Boulder, Western Historical Collections, Horace G. Benson Papers; Charles M. Stevens [Quondam], *The Adventures of Uncle Jeremiah and Family at the Great Fair* (Chicago: Laird & Lee, 1893), p. 46.

5 William Dean Howells, "Letters from an Altrurian traveller", *Cosmopolitan Magazine* 16 (1893): 219–312. See also Howells, *Letters of an Altrurian Traveler*, ed. Clara M. Kirk and Rudolf King (Gainseville, Fla: Scholar's Facsimiles and Reprints, 1961), pp. v–xii, 13–34.

6 Frederick Starr, "Anthropology at the World's Fair", *Popular Science Monthly* 43 (1893): 621. Architectural dimensions of the fair are discussed by Thomas S. Hines, *Burnham of Chicago: Architect and Planner* (New York: Oxford University Press, 1974); [. . .] George Alfred Townsend, "People and impressions of the World's Fair", MS, in the Chicago Historical Society Manuscript Division, George Alfred Townsend Papers.

7 Francis L. Lederer, II, "Competition for the World's Columbian Exposition: the Chicago campaign", *Journal of the Illinois State Historical Society* 45 (1972): 365–81; Robert D. Parmet, "Competition for the World's Columbian Exposition: the New York campaign", *Journal of the Illinois State Historical Society* 45 (1972): 382–94; Badger, 86–195; Robert Knutson, "The White City – the World's Columbian Exposition of 1893" (PhD dissertation, Columbia University, 1956), pp. 8–15; and the *United States Centennial Commission Reports* as cited by John Clarke Lathrop, "The Philadelphia Exhibition of 1876: a study of social and cultural implications" (MA thesis, Rutgers University, 1936), pp. 9–16.

8 [William E. Cameron, Thomas W. Palmer, and Frances E. Willard], *The World's Fair: Being a Pictorial History of the Columbian Exposition* (Philadelphia: National Publishing Company, 1893), pp. 132, 232; Knutson, 14–15; telegram to Lyman Gage, 8 March 1890, in Chicago Historical Society, Manuscripts Division, Samuel Waters Allerton Collection; Lyman Gage, *Memoirs of Lyman J. Gage* (New York: House of Field, 1937), p. 80; Parmet, 381; and Charles H. Baker, *Life and Character of William Taylor Baker* (New York: Premier Press, 1908), p. 157.

9 Lyman Gage, *The World's Columbian Exposition: First Annual Report of the President* (Chicago: Knight & Leonard, 1891), p. 22.

10 [Richard Rathbun?], "Expositions in general", Smithsonian Institution Archives (cited hereafter as SIA), Record Unit (cited hereafter as RU) 55, Assistant Secretary in Charge of USNM (Rathbun), 1897–1916, box 19; Robert Earll to Edwin Willits, 26 March 1892, SIA, RU 70, Exposition Records of the Smithsonian Institution and the USNM, 1875–1916, box 10 (cited hereafter as SIA, RU 70).

11 Samuel Pierpont Langley, "Memoir of George Brown Goode", in *Annual Report of the United States National Museum: Year Ending June 30, 1897* (Washington, DC: Government Printing Office, 1898), p. 58; G. Brown Goode, "Museums and good citizenship", *Public Opinion* 17 (1894): 758.

12 Langley, "Memoir of George Brown Goode", 41–61; "George Brown Goode", *National Academy of Science*, clipping, SIA, RU 7098, Biographical Information File E–G; Curtis M. Hinsley, Jr, *Savages and Scientists: the Smithsonian Institution and the Development of American Anthropology, 1846–1910* (Washington, DC: Smithsonian Institution Press, 1981), pp. 91–4.

13 George Brown Goode, "The museums of the future", in *Annual Report of the*

United States National Museum: Year Ending June 30, 1897 (Washington, DC: Government Printing Office, 1898), pp. 243–62.

14 George Brown Goode, "First draft of a system of classification for the World's Columbian Exposition", 656, 650–52, SIA, RU 70, box 37; Badger, 187; "Professor Goode in the city", *Chicago Post*, 1 October 1890, *Chicago Herald*, 3 October 1890, clippings, SIA, RU 7050, George Brown Goode Collection, 1798–1896, box 27 (cited hereafter as SIA, RU 7050); "Called on Professor Goode", *Chicago Tribune*, 1 October 1890, "Professor Goode in the city", *Chicago News*, 1 October 1890, *Chicago Post*, 2 October 1890, *Chicago Herald*, 3 October 1890, clippings in SIA, RU 7050, box 27. See also William H. Dall, "Science", *Nation* 57 (14 September 1893): 186–7; "Science at the Columbian Exposition", *Popular Science Monthly* 44 (1893): 124; "Department of Organization", *World's Columbian Exposition Illustrated* 1 (June 1891): 20.

15 G. Brown Goode, "America's relation to the advance of science", *Science*, n.s., 1 (4 January 1895): 8–9.

16 Thomas W. Palmer, "Presentation of the buildings", in *Memorial Volume: Dedicatory and Opening Ceremonies of the World's Columbian Exposition* (Chicago: A. L. Stone, 1893), p. 159; Knutson, 55–6; "National school celebration of Columbus Day: the official program", *Youth's Companion* 65 (8 September 1892): 446–7; Annie Randall White, *The Story of Columbus and the World's Columbian Exposition . . . Designed for Young Folks* (Chicago: Monarch Books, [1892]), pp. 288, 355–6.

17 Henry Adams, *The Education of Henry Adams* (Boston: Houghton Mifflin, 1961), p. 342. Originally published 1907.

18 Knutson, 246; and Frederick Jackson Turner, "The significance of the frontier in American history", in *The Significance of the Frontier in American History*, ed. Harold P. Simonson (NewYork: Frederick Ungar Publishing, 1963), p. 1.

19 Clarence A. Buskirk, "The pageant of the centuries from the dawn of the new light to the triumph of the full day: A vision of strong manhood and perfection of society in Columbia's future", *Chicago Daily Inter Ocean*, 26 April 1893, supplement; Mariana G. van Rensselaer, "At the fair", *Century Magazine* 46 (1893): 12–13; Potter Palmer in the *Chicago Tribune*, 21 October 1892, clipping, UCLA, Department of Special Collections, Expositions and Fairs Collection, 344/2, box 2 (cited hereafter as UCLA, 344/2); and Burnett, 98.

20 *Daily Inter Ocean*, 27 September 1893, supplement; J. S. Norton, "Blessings of American liberty", *Chicago Tribune*, 5 July 1893, p. 2; Walter Besant, "A first impression", *Cosmopolitan Magazine* 15 (1893): 536–7; *Chicago Tribune*, 2 May 1893, clipping, UCLA, 344/2, box 2; "The people opened the fair", *Chicago Tribune*, 12 May 1893, p. 2.

21 *A Week at the Fair Illustrating Exhibits and Wonders of the World's Columbian Exposition* (Chicago: Rand McNally, 1893), pp. 162, 168, 239; Ben C. Truman, *History of the World's Fair* (Philadelphia: Mammoth Publishing, 1893), pp. 427–37; Hubert Howe Bancroft, *The Book of the Fair*, 2 vols (New York: Bancroft Books, 1894), II, pp. 679–85; Gozo Tateno, "Japan", *North American Review* 156 (1893): 42. A recent account is Neil Harris's "All the world a melting pot? Japan at American fairs, 1876–1904", in *Mutual Images: Essays in American Japanese Relations*, ed. Akira Iriye (Cambridge, MA: Harvard University Press, 1975), pp. 24–54.

22 "Freaks of Chinese fancy at the fair", *Chicago Tribune*, 24 September 1893, p. 33; and *Oriental and Occidental: Northern and Southern Portraits. Types of*

the Midway Plaisance (Saint Louis: N. D. Thompson Publishing, 1894). For an account of anti-Chinese feelings in the United States see Richard A. Thompson, "Yellow peril, 1890–1924" (PhD dissertation, University of Wisconsin, 1957).

23 Harris, 24–54, offers a provocative interpretation of America's fascination with Japan. Quotations are from *Daily Inter Ocean*, 20 September 1893, supplement; Delano W. Eastlake, "Moral life of the Japanese", *Popular Science Monthly* 43 (1893): 348; Stevens, 100; and *Midway Types: A Book of Illustrated Lessons about the People of the Midway Plaisance* (Chicago: American Engraving, 1894).

24 *Daily Inter Ocean*, 20 September 1893, supplement; Truman, 201.

25 *Midway Types; Chicago Tribune*, 23 July 1893, reprints Eastlake's article. See also Truman, 566.

26 *Sunset City and Sunset Scenes, no. 2, May 14, 1894* (San Francisco: H. S. Crocker, 1894); and *Official History of the California Midwinter International Exposition* (San Francisco: Press of H. S. Crocker Company, 1894).

27 "Freaks of Chinese fancy at the Fair", *Chicago Tribune*, 24 September 1893, 33; Bancroft quoted in Jacobus tenBroek, Edward N. Barnhart, and Floyd W. Matson, *Prejudice, War, and the Constitution* (Berkeley and Los Angeles: University of California Press, 1954), p. 11; Bancroft, *Book of the Fair*, II, p. 873.

28 Stevens, 163–4; and *Harper's Weekly: A Journal of Civilization* 37 (7 July 1893): 629.

29 The *Cleveland Gazette*, quoted in Elliot Rudwick and August Meier, "Black Man in the "White City", Negroes and the Columbian Exposition, 1893", *Phylon* 26 (1965): 354. My discussion of Afro-Americans and the fair owes much to this article. See also Ann Massa, "Black women in the White City", *Journal of American Studies* 8 (1974): 319–37; "The women and the World's Fair", editorial, *New York Age*, 24 October 1891, p. 4; M. W. Caldwell, "World's Fair commissioner", *New York Age*, 14 February 1891.

30 Frederick Douglass and Ida Wells, *The Reason Why the Coloured American Is Not in the World's Columbian Exposition* (no imprint, 1893), p. 4; Alfreda M. Duster (ed.), *Crusade for Justice: The Autobiography of Ida B. Wells* (Chicago: University of Chicago Press, 1970); Frederick Douglass, "Inauguration of the World's Columbian Exposition", *World's Columbian Exposition Illustrated* 3 (March 1893): 300; Badger, 248–51; *New York Age*, 27 June 1891; and "Testimony of George R. Davis", in *Reports of Committees*, 476.

31 "The Jubilee Day folly", *Indianapolis Freeman*, 2 September 1893; "The world in miniature", *Indianapolis Freeman*, 2 September 1893.

32 *Oriental and Occidental*.

33 Rudwick and Meier, 357; and *Harper's Weekly* 37 (15 July 1893): 681; (23 September 1893): 914; (19 August 1893): 797; (4 November 1893): 1059.

34 Otis T. Mason, "Summary of progress in anthropology", in *Annual Reports of the Smithsonian Institution for the Year Ending July 1893* (Washington, DC: Government Printing Office, 1894), p. 605; Judy Braun, "The North American Indian exhibits at the 1876 and 1893 World Expositions: the influence of scientific thought on popular attitudes" (MA thesis, George Washington University, 1975), pp. 53–80; William H. Dall, "Anthropology", *Nation* 57 (28 September 1893): 226.

35 Mason, "Report of the Department of Ethnology in the U.S. National Museum, 1890", MS, p. 10, SIA, RU 158, Curators' Annual Reports, 1881–1904, box 3, folder 10.

36 Debora L. Silverman, "The 1889 Exhibition: the crisis of bourgeois individu-
 alism", *Oppositions* 8 (1978): 77–80; *Congrès Internatioinale d'Anthropologie et
 d'Archéologie Préhistoriques: Compte rendu de la dixiéme session à Paris, 1889* (Paris:
 Ernest Lerous, 1891), pp. 33–5; Mason, "Report of the Department of Ethnology
 in the U.S. National Museum, 1890"; and Mason [notes for Chicago exhibit],
 in Anthropology Correspondence, 1891–2, in National Anthropology Archives,
 USNM Division of Ethnology, Manuscript and Pamphlet files, box 2, folder 20
 (cited hereafter as Mason, [notes for Chicago exhibit]).

37 Samuel P. Langley and G. Brown Goode to Secretary of the Treasury, 12 March
 1890, 10, SIA, RU 70, box 27.

38 Badger, 188.

39 George W. Stocking, *Race, Culture, and Evolution: Essays in the History of
 Anthropology* (New York: Free Press, 1968), p. 278; *Chicago Tribune*, 31 May
 1890, quoted by Ralph W. Dexter, "Putnam's problems popularizing anthro-
 pology", *American Scientist* 54 (1966): 316; "Suggested attractions for the
 Exposition", *World's Columbian Exposition Illustrated* 1 (February 1891): 18; and
 "Ethnology and archaeology at the Exposition", ibid., 1 (June 1891): 9. Dexter's
 article is the best account of Putnam's activities at the fair.

40 Dall, "Anthropology", 225–6; Harlan Ingersoll Smith, "Man and his works: the
 Anthropology Building at the World's Columbian Exposition", *American
 Antiquarian* 15 (March 1893): 115–17, quoted by Joan Lester, "A museum's eye
 view", *Indian Historian* 5 (Summer 1972): 31.

41 Mason, "Report on the Department of Ethnology in the U.S. National Museum,
 1892", SIA, RU 158, box 3, folder 12; "Testimony of O.G. [sic], Mason", in
 Report of Committees, 639–40, 643–4; Mason, [notes for Chicago exhibit].

42 Mason, "Ethnological exhibit of the Smithsonian Institution", in *Memoirs of the
 International Congress of Anthropology*, ed. C. Staniland Wake (Chicago: Schute
 Publishing, 1894), p. 210.

43 Mason, [notes for Chicago exhibit]; Mason to Goode, 8 July 1890, attached to
 Goode to Mason, 11 July 1890, SIA, RU 70, box 33.

44 Braun, 75–7; Mason, "Ethnological exhibit of the Smithsonian Institution",
 211–12; Hinsley, 316–20.

45 Mason, "Summary of Progress in Anthropology", 606. Dall was one scientist
 who easily made this transition between lay figures and the living villagers of
 the Midway. See Dall, "Anthropology", 225. Mason followed suit in
 "Anthropology", in *Report of the Committee on Awards of the World's Columbian
 Commission: Special Reports upon Special Subjects or Groups (1901–1902)*. House
 Report no. 4373, 154: 319–22.

46 "Is a new paradise", *Chicago Tribune*, 30 April 1893, supplement; Bancroft, *Book
 of the Fair*, quoted in Edward Wagenknecht, *Chicago* (Norman: University of
 Oklahoma Press, 1964), pp. 14–15; Rao Telang, *A World's Fair Souvenir:
 Impressions of the World's Fair and America in General* (San Francisco: Pacific Press
 Publishing, 1893); and "Wonderful place for fun", *New York Times*, 19 June 1893,
 p. 9.

47 "Within the Midway Plaisance", *The World's Fair Special Number: Illustrated
 American*, n.d., 59, Chicago Historical Society; *Report of the President to the Board
 of Directors of the World's Columbian Exposition* (Chicago: Rand, McNally, 1893),
 pp. 85–6, cited by Helen Lefkowitz Horowitz, *Culture and the City: Cultural
 Philanthropy in Chicago from the 1880s to 1917* (Lexington: University of Kentucky

Press, 1976), p. 99; Rossiter Johnson (ed.), *A History of the World's Columbian Exposition*, 4 vols (New York: D. Appleton, 1898), II, pp. 315–57; and *A Week at the Fair*, 230. See also Putnam to George R. Davis, 17 October 1893, in Harvard University Archives, Frederic Ward Putnam Papers, World's Columbian Exposition Correspondence, A–D, box 31, folder D (cited hereafter as Putnam Papers). Putnam did try at first to keep the North American Indian display off the Midway. See "Indian Office Exhibit . . .", transcript, 1 February 1892, ibid., box 34. I wish to express my thanks to Ralph W. Dexter and the authorities of the Harvard University Archives for permission to consult this collection.

48 Horowitz, 99; John F. Kasson, *Amusing the Millions* (New York: Hill & Wang, 1978), pp. 11–28; Badger, 188–90; Sol Bloom, *The Autobiography of Sol Bloom* (New York: G. P. Putnam, 1948), pp. 107–40; Johnson, II, 316. See also John A. Kouwenhoven, "The Eiffel Tower and the Ferris wheel", *Arts Magazine* 54 (1980): 170–3; and Barbara Rubin, "Aesthetic ideology and urban design", *Annals of the Association of American Geographers* 69 (1979): 339–61.

49 Bloom, 106, as cited in Badger, 189.

50 Frederic Ward Putnam, in *World's Columbian Exposition: Plan and Classification* (Chicago: Chicago World's Columbian Exposition, Department of Publicity and Promotion, 1892), pp. 8–9.

51 *New York Times*, 8 October 1893, quoted by Dexter, 327; Frederic Ward Putnam to the Commissioner of Indian Affairs, 29 September 1893, 2, in Putnam Papers, box 34, Indians folder; and duplicate of undated Putnam memorandum in ibid., box 33, folder T. Some years later R. H. Pratt, head of the Carlisle Indian School, wrote of the Chicago and Saint Louis fairs: "In some cases the ethnologists who managed had to show the Indians how to build and dress because none of the present generation in such tribes knew." See Pratt to Franklin K. Lane, 21 August 1913, National Archives, Record Group 75, Records of the Indian Office, Indians for Show and Exhibition Purposes, folder 5–70.

52 *Midway Types*.

53 *Chicago Tribune*, 21 October 1892, clipping, UCLA, 344/2, box 2; and Amy Leslie, *Amy Leslie at the Fair* (Chicago: W. B. Conkey, 1893), p. 13.

54 Leslie, 99.

55 "Scientific teaching in the colleges", *Popular Science Monthly* 16 (1880): 558, cited by Richard Hofstadter, *Social Darwinism in American Thought* (Boston: Beacon Press, 1955), p. 5; Stocking, 278; Ralph W. Dexter, "The impact of evolutionary theories on the Salem Group of Agassiz zoologists", *Essex Institute Historical Collections* 115 (1979): 144–71; and Putnam, in *Oriental and Occidental*. Putnam wrote the introduction for this volume, apparently before seeing the pictures or captions. On the back cover he was connected with the editorial work, but such was not the case. See N. D. Thompson to Putnam, 19 June 1894, in Putnam Papers, box 33, folder T.

56 Julian Hawthorne, "Foreign folk at the fair", *Cosmopolitan Magazine* 15 (1893): 568, 570.

57 Denton J. Snider, *World's Fair Studies* (Chicago: Sigma Publishing, 1895), pp. 237, 255–7; "Through the looking glass", *Chicago Tribune*, 1 November 1893, p. 9.

58 *Oriental and Occidental*; Edward B. McDowell, "The World's Fair cosmopolis", *Frank Leslie's Popular Monthly* 36 (October 1893): 415; John C. Eastman, "Village

life at the World's Fair", *Chautauquan* 17 (1893): 602–4; Dall, 225; and *Midway Types*.

59 McDowell, 412–14. "The American public", according to a promotional pamphlet, "are now able to judge of the Javanese art and industry in this village and the syndicate that brought it over expects . . . that American capital and commerce may combine to develop commercial relations between Java and the Great Republic." See *The Javanese Theatre, the Java Village, Midway Plaisance: World's Columbian Exposition, Chicago, 1893* ([Chicago]: Java Chicago Exhibition Syndicate, n.d.).

60 *Daily Inter Ocean*, 14 June 1893, supplement. E. E. Packer, *The White City, Being an Account of a Trip to the World's Columbian Exposition at Chicago in 1893* (San Diego: n.p., 1933), p. 54, notes that South Sea Islanders concluded their shows by singing "America".

61 Staff, 619; and Clara Louisa Burnham, *Sweet Clover* (Chicago: Laird & Lee, 1893), p. 201.

62 This aspect of American racism has been discussed by Winthrop D. Jordan, *White over Black: American Attitudes towards the Negro, 1550–1812* (Baltimore: Penguin Books, 1968); Joel Kovel, *White Racism: A Psychohistory* (New York: Vintage Books, 1971); Michael P. Rogin, *Fathers and Children: Andrew Jackson and the Subjugation of the American Indian* (New York: Alfred A. Knopf, 1975); and Peter Loewenberg, "The psychology of racism", in *The Great Fear: Race in the Mind of America,* ed. Gary B. Nash and Richard Weiss (New York: Holt, Rinehart & Winston, 1970), pp. 186–202.

63 Burnham, 201–2; and "Captain Jack at the Fair", *Chicago Tribune*, 10 September 1893, supplement.

64 Kenten Druyvesteyn, "The world's parliament of religions" (Ph.D. dissertation, University of Chicago, 1976). See also Maurice F. Neufeld, "The contribution of the World's Columbian Exposition of 1893 to the idea of a planned society in the United States" (PhD dissertation, University of Wisconsin, 1935), pp. 260–79; Johnson, 414–15, 444, 480–4; and Adams, 343.

65 Hines, *Burnham of Chicago*; Carl S. Smith, "Fearsome fiction and the Windy City; or, Chicago in the dime novel", *Chicago History* 7 (1978): 2–11; Imre Kiralfy, "America", in California State University, Fresno, Department of Special Collections, vertical files. For an account of the scale model of the White City constructed by Ferris, designer of the Ferris wheel, consult "Exposition notes", SIA, RU 70, box 40, folder 1. For other reactions, see Louis H. Sullivan, *The Autobiography of an Idea* (New York: W. W. Norton, 1926), p. 325; Sinclair Lewis, *Babbitt* (New York: Harcourt, Brace, 1922), p. 305; and Joe Mitchell Chapple, "Affairs at Washington", *National Magazine* 21 (1904): 4. [. . .]

66 "Testimony of F. J. V. Skiff ", in *Reports of Committees*, 299; and Frederick J. V. Skiff *et al.*, *An Historical Account and Descriptive Account of the Field Columbian Museum*, Field Columbian Museum Publication no. 1 (Chicago: 1894), quoted by Regna Diebold Darnell, "The development of American anthropology, 1879–1920. From the Bureau of American Ethnology to Frank Boas" (Ph.D. dissertation, University of Pennsylvania, 1969), p. 199; Dorsey, quoted by Darnell, 205; Ralph W. Dexter, "The role of F. W. Putnam in founding the Field Museum", *Curator* 13 (1970): 21–6; and Phyllis Rabineau, "North American anthropology at the Field Museum of Natural History", *American Indian Arts Magazine* 6 (1981): 30–7. [. . .]

Carol Duncan

FROM THE PRINCELY GALLERY
TO THE PUBLIC ART MUSEUM
The Louvre Museum and the National Gallery, London

THE LOUVRE WAS THE PROTOTYPICAL public art museum. It first offered the civic ritual that other nations would emulate.[1] It was also with the Louvre that public art museums became signs of politically virtuous states. By the end of the nineteenth century, every Western nation would boast at least one important public art museum. In the twentieth century, their popularity would spread even to the Third World, where traditional monarchs and military despots create Western-style art museums to demonstrate their respect for Western values, and — consequently — their worthiness as recipients of western military and economic aid.[2] Meanwhile in the West, museum fever continues unabated. Clearly, from the start, having a public art museum brought with it political advantages.

This chapter will look at two of the most important public art museums in Europe, the Louvre Museum in Paris and the National Gallery in London. However different their histories and collections, both of these institutions stand as monuments to the new bourgeois state as it was emerging in the age of democratic revolutions. If the Louvre, whose very establishment was a revolutionary act, states the central theme of public art museums, the story of the National Gallery in London elaborates its ideological meanings. Its details were spelled out in the political discourse that surrounded its founding and early years, a discourse in which bourgeois and aristocratic modes of culture, including the new art-historical culture, were clearly pitted against each other. The larger question here is what made the Louvre and the other museums it inspired so politically attractive, and how did they differ from older displays of art? Or, to rephrase the question in terms of the theme of this book, what kind of ritual does the public art museum stage, and what was (and is) its ideological usefulness to modern states?

I

Ceremonial displays of accumulated treasure go back to the most ancient of times. Indeed, it is tempting to extend our notion of "the museum" backwards into earlier eras and discover museum-like functions in the treasuries of ancient temples or medieval cathedrals or in the family chapels of Italian Baroque churches. Some of these older types of display come surprisingly close to modern museum situations.[3] Yet, however they may resemble today's public art museums, historically, the modern institution of the museum grew most directly out of sixteenth-, seventeenth-, and eighteenth-century princely collections. These collections, which were often displayed in impressive halls or galleries built especially for them, set certain precedents for later museums.[4]

Typically, princely galleries functioned as reception rooms, providing sumptuous settings for official ceremonies and framing the figure of the prince. By the eighteenth century, it was standard practice everywhere in Europe for princes to install their collections in lavishly decorated galleries and halls, often fitting individual works into elaborate wall schemes of carved and gilt panelling. The point of such show was to dazzle and overwhelm both foreign visitors and local dignitaries with the magnificence, luxury, and might of the sovereign, and, often – through special iconographies – the rightness or legitimacy of his rule. Palace rooms and galleries might also be decorated with iconographic programs that drew flattering analogies to the ruler – galleries of portrait busts of legendary emperors or depictions of the deeds of great monarchs of the past. A ruler might also surround himself with sculptures, paintings, and tapestries of a favorite classical god to add luster to his image – Louis XIV's appropriation of the sun-god Apollo is the most famous, in Madrid it was Hercules, celebrated in a series of paintings by Rubens, whose exploits were linked to the throne. In one way or another, these various displays of objects and paintings demonstrated something about the prince – his splendor, his legitimacy, or the wisdom of his rule.[5] As we shall see, public art museums both perpetuated and transformed the function of these princely reception halls wherein the state idealized and presented itself to the public.

The Louvre was not the first royal collection to be turned into a public art museum, but its transformation was the most politically significant and influential. In 1793 the French revolutionary government, seizing an opportunity to dramatize the creation of the new Republican state, nationalized the king's art collection and declared the Louvre a public institution.[6] The Louvre, once the palace of kings, was now reorganized as a museum for the people, to be open to everyone free of charge. It thus became a lucid symbol of the fall of the Old Regime and the rise of a new order. The new meaning that the Revolution gave to the old palace was literally inscribed in the heart of the seventeenth-century palace, the Apollo Gallery, built by Louis XIV as a princely gallery and reception hall. Over its entrance is the revolutionary decree that called into existence the Museum of the French Republic and ordered its opening on 10 August, to commemorate "the anniversary of the fall of tyranny" (Figure 14.1). Inside the gallery, a case holds crowns from the royal and imperial past, now displayed as public property.[7]

The new museum proved to be a producer of potent symbolic meanings. The transformation of the palace into a public space accessible to everyone made the museum an especially pointed demonstration of the state's commitment to the principle of equality. As a public space, the museum also made manifest the public it claimed to serve: it could produce it as a visible entity by literally providing it with a defining frame and giving it something to do. In the museum, even the rights of citizenship could be discerned as art appreciation and spiritual enrichment. To be sure, equality of access to the museum in no way gave everyone the relevant education to understand the works of art inside, let alone equal political rights and privileges; in fact, only propertied males were full citizens. But in the museum, everyone was equal in principle, and if the uneducated could not use the cultural goods the museum proffered, they could (and still can) be awed by the sheer magnitude of the treasure.

As a new kind of public ceremonial space, the Louvre not only redefined the political identity of its visitors, it also assigned new meanings to the objects it displayed, and qualified, obscured, or distorted old ones. Now presented as public property, they became the means through which a new relationship between the individual as citizen and the state as benefactor could be symbolically enacted. But to accomplish their new task, they had to be presented in a new way. In a relatively short time, the Louvre's directors (drawing partly on German and Italian precedents) worked out a whole set of practices that came to characterize art museums everywhere. In short, the museum organized its collections into art-historical schools and installed them so as to make visible the development and achievement of each school. Certainly, it did not effect this change overnight. It first had to sort out the various, and in some ways, contradictory, installation models available at the time, and the different notions of artistic "schools" that each entailed.[8]

Probably the most fashionable way of hanging a collection in the later eighteenth century was what might be called the connoisseur's or gentlemanly hang. This installation model was practiced internationally and corresponded rather precisely to the art education of European aristocrats. In the eighteenth and early nineteenth centuries, there was widespread agreement among cultivated men (and those few women who could claim such knowledge) that, aside from the sculpture of classical antiquity, the masters most worth collecting were sixteenth- and seventeenth-century Italian, Flemish, Dutch, and French. Men of taste and breeding, whatever their nationality, were expected to have learned key critical terms and concepts that distinguished the particular artistic virtues of the most popular masters. Indeed, such knowledge was taken as a sign of aristocratic breeding, and in the course of the eighteenth century it became the fashion to hang collections, including royal collections, in a way that highlighted the formal qualities of the various masters – that is, in a way that displayed one's knowledge of current critical fashions. A gentlemanly hang, be it in England, Italy, or France, might group together on one wall contrasting examples from opposing schools. For example, an Italian *Venus* or martyrdom on the right might be balanced by a Flemish *Venus* or martyrdom on the left, the better to show off their particular qualities of drawing, color, and composition; alternatively, works by various masters from the same school might be grouped together to complement each other.[9]

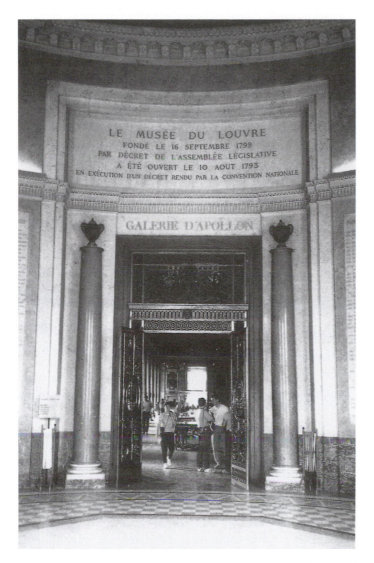

Figure 14.1 Louvre Museum, Paris, entrance to the Apollo Gallery: photograph by Carol Duncan

In the later eighteenth century, this gentlemanly type of installation was given increasing competition by newer, art-historical arrangements, versions of which were being introduced into certain private and princely collections.[10] In these new arrangements, more was made of the progress demonstrated by each school and its principal masters. By and large, this progress was measured in terms of a single, universal ideal of beauty, an ideal toward which all societies presumably evolved, but one that, according to experts, ancient sculpture and Italian High Renaissance painting most fully realized. As the administrators of the Louvre Museum put it in 1794, the new museum's goal was to show visitors "the progress of art and the degrees of perfection to which it was brought by all those peoples who have successively cultivated it".[11] And when, some years later, the noted German art expert

Gustav Waagen toured English art collections, he could, in the same spirit, pronounce the National Gallery's *Resurrection of Lazarus* by Sebastiano del Piombo the star of the collection and indeed of all English collections combined, since, in his eyes, it was the one work that most embodied the genius of the Italian High Renaissance and therefore most achieved the universal ideal.[12]

These kinds of judgments concerned more than the merits of individual artists. Progress in art could be taken as an indicator of how far a people or an epoch evolved toward civilization in general. That is, the art-historical approach gave works of art a new cultural-historical importance and a new cognitive value. As such, they required new, more appropriate kinds of settings. Whereas older displays, princely and gentlemanly alike, commonly subordinated individual works to larger decorative schemes, often surrounding them with luxurious furnishings and ornaments, the new approach called for settings that would not compete with the art. At the same time, new wall arrangements were evolved so that viewers could literally retrace, work by work, the historical lines of development of both individual artists and their schools. In the course of the nineteenth century, the conviction that art must be valued and ranked according to a single ideal of beauty would be gradually modified; educated opinion would appreciate an ever greater range of schools – especially fifteenth-century Italian art – each for its own unique qualities, and would increasingly demand their representation in public collections.[13] In all of this, the concept of high art was being rethought. Rather than a rare attainment, it was coming to be seen as a necessary component of every society, an organic expression of one or another particular national spirit.[14] However, the language associated with the evolutionary approach and the habit of extolling ancient sculpture and High Renaissance art above all else, would hang on for a long time. Malraux noted how long this change took in the museum market: only late in the nineteenth century would different schools be treated fully as equals, and only toward the end of the century could a Piero della Francesca be rated as equal or superior to Raphael.[15]

Historians of museums often see the new art-historical hang as the triumph of an advanced, Enlightenment thinking that sought to replace earlier systems of classification with a more rational one. To be sure, the new construct was more in keeping with Enlightenment rationality. But more significant to the concerns of this study was its ideological usefulness to emerging bourgeois states, all of which, in the course of the nineteenth century, adopted it for their public art museums. Although still pitched to an educated elite and still built on a universal and international standard, the new system, by giving special emphasis to the "genius" of national schools, could both acknowledge and promote the growth of state power and national identity.

The differences in these models of display amount to very different ritual structures. Just as the public art museum redefined the content of its displays, so it reconceptualized the identity of its visitors and their business in the museum. That is, as a new kind of dramatic field, the art museum prompted its visitors to assume a new ritual identity and perform a new ritual role. The earlier, aristocratic installation addressed the visitor as a gentleman and reinforced this identity by enabling him to engage in and re-enact the kind of discerning judgments that gentlemanly culture called "good taste". By asking him to recognize – without the help of labels

– the identities and distinctive artistic qualities of canonized masters – Guido Reni, Claude, Murillo, and other favorites – the visitor-cum-connoisseur could experience himself as possessing a culture that was both exclusive and international, a culture that marked its possessor as a member of the elite.[16] In contrast, the public art museum addressed its visitor as a bourgeois citizen who enters the museum in search of enlightenment and rationally understood pleasures. In the museum, this citizen finds a culture that unites him with other French citizens regardless of their individual social position. He also encounters there the state itself, embodied in the very form of the museum. Acting on behalf of the public, it stands revealed as keeper of the nation's spiritual life and guardian of the most evolved and civilized culture of which the human spirit is capable. All this it presents to every citizen, rationally organized and clearly labeled. Thus does the art museum enable the citizen–state relationship to appear as realized in all its potential.

Almost from the beginning, the Louvre's directors began organizing its galleries by national school.[17] Admittedly, some very early displays presented works of art as confiscated treasure or spoils of a victorious army (this was the era in which French armies systematically packed up art treasures from churches and palaces all over Europe and sent them to the Louvre[18]). But by its 1810 reopening as the Musée Napoléon, the museum, now under the direction of Vivant Denon, was completely organized by school, and within the schools, works of important masters were grouped together. The conversion of the old palace into a public art museum had taken some doing architecturally, but in certain ways the old building was well equipped for its new symbolic assignment. It was, after all, already full of sixteenth- and seventeenth-century spaces originally designed to accommodate public ritual and ceremonial display (Figure 14.2). Its halls and galleries tended to develop along marked axes so that (especially in the rooms occupied by the early museum) visitors were naturally drawn from room to room or down long vistas. The setting was well suited to the kind of narrative iconographic program it now contained.

Thus ordered, the treasures, trophies, and icons of the past became objects of art history, embodiments of a new form of cultural-historical wealth. The museum environment was structured precisely to bring out this new meaning and suppress or downplay old ones. In this sense, the museum was a powerful transformer, able to convert signs of luxury, status, or splendor into repositories of spiritual treasure – the heritage and pride of the whole nation. Organized chronologically and in national categories along the museum's corridors, works of art now became witnesses to the presence of "genius", cultural products marking the course of civilization in nations and individuals.[19] The ritual task of the Louvre visitor was to re-enact that history of genius, re-live its progress step by step and, thus enlightened, know himself as a citizen of history's most civilized and advanced nation-state.

Throughout the nineteenth century, the Louvre explained its ritual program in its ceiling decorations. An instance of this is still visible in what was originally the vestibule of the Musée Napoléon (the Rotunda of Mars), dedicated in 1810. Four medallions in the ceiling represent the principal art-historical schools, each personified by a female figure who holds a famous example of its sculpture: Egypt a cult statue, Greece the *Apollo Belvedere*, Italy Michelangelo's *Moses*, and France

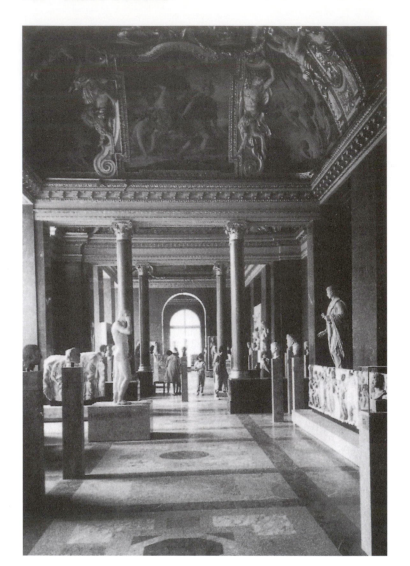

Figure 14.2 The old Louvre Palace, a former royal apartment, converted to museum use in the nineteenth century: photograph by Carol Duncan

Puget's *Milo of Crotona*. The message reads clearly: France is the fourth and final term in a narrative sequence that comprises the greatest moments of art history. Simultaneously, the history of art has become no less than the history of Western civilization itself: its origins in Egypt and Greece, its reawakening in the Renaissance, and its present flowering in modern France. The same program was elaborated later in the century in mosaic decorations for the five domed spaces above the Daru Stairway (Figure 14.3) (subsequently removed).

Other ceilings further expound the symbolic meanings of the museum's program. Throughout the nineteenth century, museum authorities used the ceilings

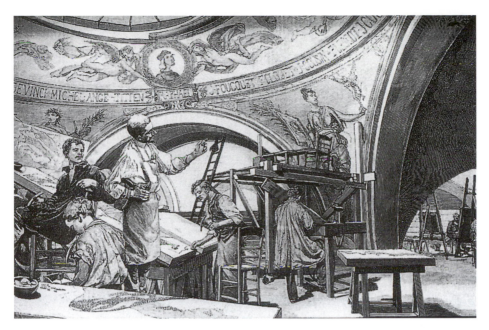

Figure 14.3 Creating a genius ceiling in the central dome of the Louvre's Daru
Staircase; the decorations were later removed: from *L'Illustration*,
27 August 1887, photograph by Carol Duncan

to spell them out, lecturing visitors from above. They especially hammered home
the idea of the state as protector of the arts. Often resorting to traditional princely
iconography, images and insignia repeatedly identified this or that government or
monarch as the nation's cultural benefactor. One ceiling, for example, decorating
the museum's 1812 grand stairway (the stair is gone but the ceiling remains),
represents *France in the Guise of Minerva Protecting the Arts* (by Maynier, 1819). The
napoleonic insignia that originally surrounded it were later removed. Successive
regimes, monarchical or republican, often removed the insignia of their pre-
decessors in order to inscribe their own on the museum's walls and ceilings.

Increasingly the iconography of the museum centered on artists. For example,
in the Musée Charles X (the series of rooms opened to the public in the 1820s),
ceilings still celebrate great patron-princes of the past; but artists are also abun-
dantly present. As in later decorations, sequences of their names or portraits,
arranged into national schools, grace the entablatures. Indeed, ever greater expanses
of overhead space would be devoted to them as the century wore on. If anything,
the nineteenth century was a great age of genius iconography,[20] and nowhere are
genius ceilings more ostentatious than in the Louvre (Figure 14.4). Predictably,
after every coup or revolution, new governments would vote funds for at least
one such ceiling, prominently inscribing its own insignia among the names or
profiles of the great artists so honored. Thus in 1848, the newly constituted
Second Republic renovated and decorated the Salon Carré and the nearby Hall of
Seven Chimneys, devoting the first masters of the foreign schools, and the second
to French geniuses, profiles of whom were alphabetically arranged in the frieze

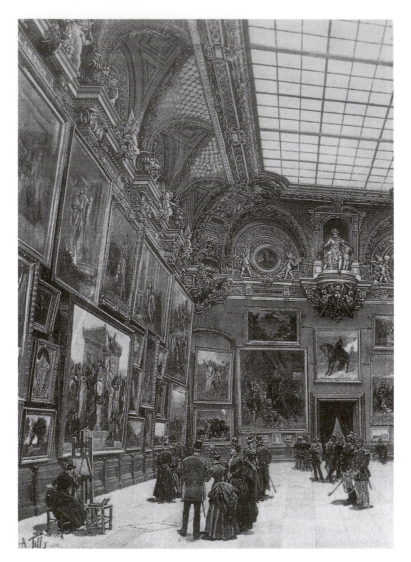

Figure 14.4 The Louvre Museum, the newly decorated Salle des Etats 1886:
from *L'Illustration*, 30 October 1886, photograph by Carol Duncan

(Figure 14.5). It is relevant to recall that from the early nineteenth century on, most artists were very aware of themselves as candidates for the category of great artist so lavishly celebrated on the ceiling and plotted their artistic strategies accordingly.

It should be obvious that the demand for great artists, once the type was developed as an historical category, was enormous – they were, after all, the means by which, on the one hand, the state could demonstrate the highest kind of civic virtue, and on the other, citizens could know themselves to be civilized. Not surprisingly, quantities of great artists were now duly discovered and, in time, furnished with properly archetypal biographies by the burgeoning discipline of art history.[21] These

Figure 14.5 The Louvre Museum, detail of a genius ceiling in the Hall of
 Seven Chimneys, commissioned in 1848 by the French Republic:
 photograph by Carol Duncan

conditions are perpetuated today in the institution of the giant retrospective. A vora-
cious demand for great artists, living or dead, is obligingly supplied by legions of art
historians and curators trained for just this task. Inevitably some of the great artists
inducted into this role fill it out with less success than others. Even so, a fair or just
good great artist is still a serviceable item in today's museum business.

The importance of the Louvre Museum as a model for other national galleries and
as an international training ground for the first community of professional museum
men is everywhere recognized. After the example of the Louvre, there was a flurry
of national gallery founding throughout Europe, whose heads of state often simply

designated an existing royal or imperial collection as a public art museum. Conversions of this kind had been made before the Revolution, in Dresden and Vienna, for example, but would continue now with greater speed. Under Napoleon's occupying armies, numerous public art museums were created in, among other places, Madrid, Naples, Milan, and Amsterdam. Of course, some of the new "national galleries" were more like traditional princely reception halls than modern public spaces – more out to dazzle than enlighten – and one usually entered them as a privilege rather than by right.[22] Whatever form they took, by 1825, almost every Western capital, monarchical or Republican, had one.

The influence of the Louvre continued in the later nineteenth and twentieth centuries in the many public art museums founded in European provincial cities[23] and in other places under the sway of European culture. In New York, Boston, Chicago, Cleveland, and other American cities, museums were carefully laid out around the Louvre's organizing theme of the great civilizations, with Egypt, Greece, and Rome leading to a centrally placed Renaissance. When no Greek or Roman originals were on hand, as they were not in many American cities, the idea was conveyed by plaster casts of classical sculpture or Greek-looking architecture, the latter often embellished with the names or profiles of great artists from Phidias on; such façades are familiar sights everywhere.

As for the Louvre itself, despite a long history of expansions, reorganizations, and reinstallations, the museum maintained until very recently its nineteenth-century bias for the great epochs of civilization. Classical and Italian Renaissance art always occupied its most monumental, centrally located spaces and made the museum's opening statements.[24] In the course of the nineteenth century, it expanded its history of civilization to include the art of ancient Egypt, the Near East, Asia, and other designated culture areas. Just as these episodes could be added, so others could be subtracted without damaging the museum's central program: in the years after the Second World War, Impressionist painting and Far Eastern art were moved out of the Louvre altogether, the one to the Jeu de Paume, the other to the Musée Guimet. In terms of the museum's traditional program, neither collection – however valued as a collection – was essential, and, as one museum official affirmed, their subtraction actually clarified the museum's primary program:

> It may be said that the Louvre collections form today a coherent whole, grouping around our western civilization all those which, directly or indirectly, had a share in its birth. . . . At the threshold of history there stand the mother civilizations: Egyptian, Sumerian, Aegean. Then, coming down through Athens, Rome, Byzantium, towards the first centuries of our Christian era, there are the full blossomings of Medieval, Renaissance and Modern art. At the Louvre, then, we are on our own home territory, the other inhabited parts of the earth being dealt with elsewhere.[25]

The museum's commitment to lead visitors through the course of Western civilization continues to this day, even though a new entrance, new access routes and a major reinstallation allow visitors to map their own paths through a somewhat revised history of art. As I write this (in 1993), the museum is getting ready

to unveil its latest expansion, the newly installed Richelieu Wing, in which, for the first time, northern European art will be given the kind of grand ceremonial spaces that, up until now, were usually reserved for French and Italian art. It appears that, in today's Louvre, French civilization will look more broadly European in its sources than before, more like a leading European Community state. Whatever the political implications of the new arrangement, the Louvre continues its existence as a public state ritual.

But 1993 is a long way from 1793. Of the legions of people who daily stream through the Louvre, most, whether French or foreign, are tourists. Which is to say that, as a prime tourist attraction, the museum is crucial to the city's economy. If it still constructs its visitors as enlightenment-seeking citizens, it must also cater to crowds of hungry, credit-card-bearing consumers in search of souvenirs and gifts. Besides a revised art-historical tour, therefore, the Louvre of 1993 also includes spacious new restaurants and a monumental shopping mall.[26] Such developments, however, belong to the Louvre's later years. We have still to consider more of the public art museum's significance in the nineteenth and early twentieth centuries, first in Britain.

[. . .]

II

Let us turn now to the National Gallery in London. If the Louvre is the prototype of the public art museum – and that is its status in the literature[27] – how are we to understand the National Gallery? The dramatic and revolutionary origins of the French museum, including its very site in what was once the royal palace, is unparalleled in the British example, whose founding, next to the Louvre's, seems sorely lacking in political and historical fullness. The decisive events and powerful symbolic ingredients that made the French example so much the archetype of the European public art museum are simply not present.

The first missing ingredient is a significant royal art collection of the kind that seventeenth- and eighteenth-century monarchs had often assembled and which then became the core of a national gallery. Certainly, England had once known such royal treasure: Charles I's famous and much admired collection of paintings. Broken up when Charles fell, the story of this collection – its destruction as much as its creation – must figure as the beginning of the story of public art museums in England.

Charles came to the English throne in 1625, bringing with him ideas about monarchy that were shaped by continental models and continental theories of the divine right of kings. Especially impressed by the haughty formality and splendor of the Spanish court, he sought to create on English soil similar spectacles of radiant but aloof power. Accordingly, he commissioned Inigo Jones to design a properly regal palace complete with a great hall decorated by Rubens (in 1635). A show of power in the seventeenth century also demanded a magnificent picture collection; elsewhere in Europe, church and state princes – Cardinal Mazarin and the Archduke Leopold William are outstanding examples – paid fortunes for the requisite Titians, Correggios, and other favourites of the day. Charles understood fully

the meaning of such ceremonial display. So did his Puritan executioners, who pointedly auctioned off a large part of the king's collection. Not only did they feel a Puritan discomfort with such sensually pleasing objects; they also wished to dismantle a quintessential sign of regal absolutism.[28] The absence of a significant royal collection in England is as much a monument, albeit a negative one, to the end of English absolutism as the Louvre Museum is to the end of French absolutism.

This is only to say that the process of British state building was English, not French, as was the development of the symbols and public spaces which culturally articulated that process. In the England after Charles I, monarchs might collect art, but political realities discouraged them from displaying it in ways that recalled too much the regal shows and absolutist ambitions of the past. In fact, after Charles and a very few other grand seventeenth-century art collectors – in particular the Earl of Arundel and the Duke of Buckingham – there would be no significant English collections for several decades.[29] It was only after the Restoration that large-scale English picture-collecting would be resumed, most notably by the powerful aristocratic oligarchs to whom state power now passed. Meanwhile, British monarchs kept rather low public profiles as art collectors and art patrons.

Kensington Palace is a telling reminder of the modesty in which monarchy was expected to live, at least in the later seventeenth century. The residence of King William III and Queen Mary (installed on the throne in 1689), the building began as an unpretentious dwelling, certainly comfortable and dignified enough for its noble occupants – as seen in its two "long galleries" filled with art objects – but not in any way palatial. It lacked the ceremonial spaces of an empowered royalty, spaces that would appear only later under Kings George I and II. William's picture gallery held a fine collection, but it remained a source of private pleasure, not regal display. In fact, various royal residences would end up with considerable holdings, but these were never institutionalized as "the British Royal Collection." Even now, they remain largely private; indeed, when displayed in the new Sainsbury Wing of the National Gallery in 1991–2, they attracted attention precisely because so much of the collection has been unfamiliar to the art-viewing public.[30]

Besides the want of a royal collection properly deployed as such, British eighteenth-century history lacks a potent political event that could have dramatically turned that collection into public property – in short, an eighteenth- or nineteenth-century type of democratic revolution Of course, another way to get a public art museum (short of being occupied by a French army) was through the liberalizing monarchical gesture as seen on the continent, in which a royal collection was opened up as a public space in symbolic (if not direct political) recognition of the bourgeois presence. The French crown had been planning just such a move at the time of the Revolution. The Revolution took over that museum project but also redefined it, making what would have been a privileged and restricted space into something truly open and public. The revolutionary state thus appropriated the legacy of absolutist symbols and ceremonies and put them to new ideological use, making them stand for the Republic and its ideal of equality. The English ruling class, on the other hand, had rejected the use of a royal art collection as a national symbol just as deliberately as it had blocked the development of

an absolutist monarchy. There was political room neither for the kind of art collection that the people could meaningfully nationalize nor for the kind of monarch who could meaningfully nationalize it himself.

By the late eighteenth century, however, the absence of a ceremonially important royal collection was more than made up for by those of the aristocracy. In fact, the British art market actually became the most active in the eighteenth-century Europe as both the landed aristocracy and a newly arrived commercial class sought the distinctive signs of gentlemanly status. Whether defending older class boundaries or attempting to breach them, men of wealth deemed it socially expedient to collect and display art, especially paintings. Italian, Flemish, and other old-master works of the kind prescribed by the current canons of good taste poured into their collections. As Iain Pears has argued, art collecting, by providing a unifying cultural field, helped the upper ranks of English society form a common class identity.

> They increasingly saw themselves as the cultural, social and political core of the nation, "citizens" in the Greek sense with the other ranks of society scarcely figuring in their understanding of the "nation."[31]

In short, here were the social elements of the "civil society" of seventeenth- and eighteenth-century political philosophy, that community of propertied citizens whose interests and education made them, in their view, most fit to rule.[32]

To modern eyes, the social and political space of an eighteenth-century English art collection falls somewhere between the public and private realms. Our notion of the "public" dates from a later time, when, almost everywhere in the West, the advent of bourgeois democracy opened up the category of citizenship to ever broader segments of the population and redefined the realm of the public as ever more accessible and inclusive. What today looks like a private, socially exclusive space could have seemed in the eighteenth century much more open. Indeed, an eighteenth-century picture collection (and an occasional sculpture collection) was contiguous with a series of like spaces (including, not incidentally, the newly founded British Museum[33]) that together mapped out the social circuit of a class. Certainly access to these collections was difficult if one did not belong to the elite.[34] But from the point of view of their owners, these spaces were accessible to everyone who counted, the

> finite group of personal friends, rivals, acquaintances and enemies who made up the comparatively small informal aristocracy of landed gentlemen, peers or commoners, in whom the chains of patronage, "friendship" or connection converged.[35]

Displayed in galleries or reception rooms of town or country houses, picture collections were seen by numerous visitors, who often toured the countryside expressly to visit the big landowners' showy houses and landscape gardens.[36] Art galleries were thus "public" spaces in that they could unequivocally frame the only "public" that was admissible: well-born, educated men of taste, and, more marginally (if at all), well-born women.

Art galleries signified social distinction precisely because they were seen as more than simple signs of wealth and power. Art was understood to be a source of valuable moral and spiritual experience. In this sense, it was cultural property, something to be shared by a whole community. Eighteenth-century Englishmen as well as Frenchmen had the idea that an art collection could belong to a nation, however they understood that term. The French pamphleteers who called for the nationalization of the royal collection and the creation of a national art museum had British counterparts who criticized rich collectors for excluding from their galleries a large public, especially artists and writers.

Joshua Reynolds, Benjamin West, and Thomas Lawrence, the first three presidents of the Royal Academy, were among those who called for the creation of a national gallery or, at least, the opening up of private collections. Even before the creation of the Louvre, in 1777, the radical politician John Wilkes proposed that Parliament purchase the fabulous collection of Sir Robert Walpole and make it the beginning of a national gallery. The proposal was not taken up and the collection was sold to Catherine the Great. A few years later, the creation of the Louvre Museum intensified the wish for an English national collection, at least among some. Thus in 1799, the art dealer Noel Joseph Desenfans offered the state a brilliant, ready-made national collection of old masters, assembled for King Stanislas Augustus of Poland just before he abdicated. Desenfans, determined to keep the collection intact and in England, offered it to the state on the condition that a proper building be provided for it. According to the German art expert J. D. Passavant, the offer "was coolly received and ultimately rejected". Desenfans's collection was finally bequeathed to Dulwich College [. . .] and was, for another decade or so, the only public picture collection in the vicinity of London.

Why was Parliament so resistant to establishing a national gallery? In the years between the founding of the Louvre in 1793 and the fall of Napoleon in 1815, almost every leading European state acquired a national art museum, if not by an act of the reigning monarch then through the efforts of French occupiers, who began museum building on the Louvre model in several places. Why did the ruling oligarchs of Great Britain resist what was so alluring in Berlin, Madrid, and Amsterdam? The answer to this question, I believe, lies in the meaning of the art gallery within the context of eighteenth-century patrician culture.

Eighteenth-century Britain was ruled by an oligarchy of great landowners who presided over a highly ranked and strictly hierarchical society. Landed property, mainly in the form of rents, was the basic source of wealth and the key to political power and social prestige. Although landowners also engaged in commercial and industrial capitalist ventures, profits were normally turned into more land or land improvement, since that form of property was considered the only gentlemanly source of wealth. Living off rents was taken to be the only appropriate way of achieving the leisure and freedom necessary to cultivate one's higher moral and intellectual capacities. Apologists for the landowners argued that ownership of land was a precondition for developing the wisdom, independence, and civic-mindedness necessary for the responsible exercise of political power. They maintained that holdings in land rooted one in the larger community and made one's private interests identical with the general interest and well-being of the whole of

society. Landowners, both old and newly arrived, thereby justified their monopoly of political rights on the basis of their land holdings.

In fact – and contrary to the claims of their apologists – the great landowners exercised power according to narrow self-interest. The business of government was largely a matter of buying and selling influence and positioning oneself for important government appointments, lucrative sinecures, and advantageous marriages for one's children. The more land one owned, the more patronage, influence, and wealth one was likely to command and the better one's chances to buy, bribe, and negotiate one's way to yet more wealth and social luster.[37] To be even a small player in this system required a great show of wealth, mediated, of course, by current codes of good taste and breeding. A properly appointed country house with a fashionably landscaped garden was a minimum requirement. If few landowners could compete with Sir Robert Walpole's Houghton, the Duke of Marlborough's Blenheim, or the Duke of Bedford's Woburn Abbey, they could nevertheless assemble the essentials of the spectacle. As Mark Girouard has described it,

> Trophies in the hall, coats of arms over the chimney-pieces, books in the library and temples in the park could suggest that one was discriminating, intelligent, bred to rule and brave.[38]

Art collections, too, betokened gentlemanly attainments, and marked their owners as veterans of the grand tour (mandatory for any gentleman). Whether installed in purpose-built galleries or in other kinds of rooms (Figure 14.6), they provided a display of wealth and breeding that helped give point and meaning to the receptions and entertainments they adorned. Compared to today's academic discourse, the critical vocabulary one needed to master was decidedly brief and the number of canonized old masters few: the Carracci, Guidi Reni, Van Dyck, and Claude were among those most admired.[39] However shallow one's understanding of them, to display them in one's house and produce before them the right clichés served as proof that one was cultivated and discerning and fit to hold power. Whatever else they might have been, art collections were prominent artifacts in a ritual that marked the boundary between polite and vulgar society, which is to say, the boundary of legitimated power.[40]

Given the structure of the British oligarchy, the notorious self-interest of its ranking magnates, and the social uses of art displays, the unwillingness to create a national gallery until 1824 is not surprising.[41] Absorbed in a closed circle of power, patronage, and display, the ruling oligarchy had no compelling reason to form a national collection. Indeed, at this historical moment – an era of democratic revolutions – it had been good reason *not* to want one, since national galleries tended either to signal the advent of Republicanism or to give a liberalized face to surviving monarchies attempting to renew their waning prestige.[42] The men who dominated Parliament had no reason to send either of these signals. Their existing practices of collection and display already marked out boundaries of viable power and reinforced the authority of state offices.[43]

Parliament's claim to represent the interest of the whole society, when in fact self-enrichment had become the central operating principle of its members, was a

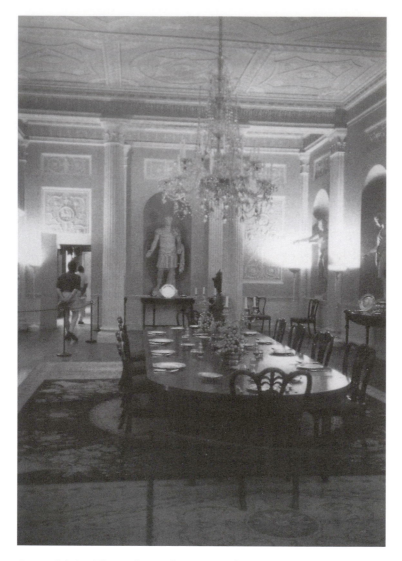

Figure 14.6 The eighteenth-century dining room from Lansdowne House,
London, as installed in the Metropolitan Museum of Art, New
York: photograph by Carol Duncan

contradiction that became ever more glaring and ever less tolerable to growing
segments of the population. Over the first few decades of the nineteenth century,
groups of industrialists, merchants, professionals, disgruntled gentry locked out of
power, and religious dissenters mounted well-organized attacks on both the struc-
ture and policies of the government. They not only pressed the question of what
class should rule, they also challenged aristocratic culture, contested its authority,
and discredited some of its more prestigious symbols. Their most scathing and
effective attacks on the culture of privilege would come in the 1820s and 1830s,
when radicals and reformers, the Benthamites prominent among them, gave voice
to widely felt resentments.[44] (The Benthamites were followers of the social

reformer and utilitarian philosopher Jeremy Bentham, 1748–1832.) From those decades date proposals for public art galleries and campaigns to increase access to existing public museums and monuments. In the context of early nineteenth-century Britain, these efforts were highly political in nature and directly furthered a larger project to expand the conventional boundaries of citizenship. The cultural strategy involved opening up traditionally restricted ritual spaces and redefining their content – this as a means of advancing the claims of "the nation". The effort to define and control these spaces would build as the nineteenth century wore on.

This concern to defend and advance the rights of the political nation easily shaded into feelings of a broader nationalism, appearing elsewhere in western Europe in the early nineteenth century, as well as patriotic sentiments, which the wars with France intensified. The creation of the Louvre Museum and its spectacular expansion under Napoleon sharpened these feelings of English–French rivalry and gave them a cultural focus. The marvels of the Louvre caused acute museum envy not only among English artists and writers like Hazlitt, Lawrence, and West, but also among some of the gentleman collectors who sat in Parliament and felt the lack of a public art collection as an insult to British national pride. Both during and after the wars, however, the state was diffident about projects that might have fostered national pride. As the historian Linda Colley has argued, in late eighteenth- and early nineteenth-century England, to encourage nationalism was to encourage an inclusive principle of identity that could too easily become the basis of a political demand to broaden the franchise. It is thus no surprise that the expression of nationalist feeling came from outside the circles of official power. Typically, it took the form of proposals for cultural and patriotic monuments, as well as charitable institutions and philanthropic gestures.[45]

In 1802 the wealthy and self-made John Julius Angerstein, the creator of Lloyds of London, set up a patriotic fund for dependants of British war dead and contributed to it handsomely. He also published the names of everyone who contributed and exactly what each gave. The tactic exposed the landed aristocracy as selfish – their donations were generally meager – while publicizing commercial City men like Angerstein as patriotic, generous, and more responsive to the true needs of the nation. Angerstein clearly saw himself as the equal if not the better of any lord of the realm, and he lived accordingly. With his immense fortune and help of artist friends like Thomas Lawrence, he amassed a princely art collection of outstanding quality, installed it in magnificently decorated rooms in his house in Pall Mall, and – in pointed contrast to many aristocratic collectors – opened his doors wide to interested artists and writers. But not all doors were open to Angerstein. As a Russian-born Jew who lacked formal education – and was reputedly illegitimate to boot – he was never allowed to shake the appellation "vulgar'"and could never fully enter the highest ranks of society.

Nevertheless, after his death in 1823, Angerstein's art collection became the nucleus of the British National Gallery. With the help of Lawrence, the state was allowed to purchase the best of his collection – thirty-eight paintings – at a cost below their market value.[46] By now, sentiment in Parliament had shifted in favor of such a gallery; both Lord Liverpool, the Prime Minister, and his Home Secretary Sir Robert Peel backed the move. However, while the motion passed with relative ease, working out just where it would be and who would oversee it occasioned

considerable political skirmishing. The trustees of the British Museum clearly expected to take it in hand, but had to give up that idea in the face of fierce parliamentary opposition. The problem was solved when the government was allowed to buy the remainder of the lease on Angerstein's house in Pall Mall, and the new National Gallery opened there in May, 1824. Thus, intentionally or not, Angerstein posthumously provided both the substance and site for a prestigious new symbol of the nation. There is every indication that he would have heartily approved and supported this transformation of his property. Both his son and executors thought so.[47] Indeed Angerstein's son believed that had it been proposed to his father that he contribute to a National Gallery, "he might have given a part or the whole [of his collection] for such a purpose".[48]

Which brings me back to the larger, historical issue with which I began this section. Although the story of the founding of the National Gallery lacks a clear-cut revolutionary moment, it nevertheless points to a growing acceptance of a new concept of the nation in Britain. Because the issue of nationalism looms so large in today's political news, and because the terms nation and nationalism are now so much in currency, we must take care not to read modern meanings into early nineteenth-century political discourse when it speaks of "the nation". In the eighteenth and early nineteenth centuries, one spoke of patriotism, not nationalism. Later ideas of the nation as a people defined and unified by unique spiritual yearnings or "racial" characteristics, are foreign to the early nineteenth-century political discourse I am describing. Although there was great concern and interest in the uniqueness of national cultures, nations were generally understood and described in social, political, and economic terms, and the term "nation" was normally used as a universal category designating "society". The word "nation" was often used in the context of a middle-class campaign to dispute the claim of the privileged few to be the whole of the polity. In British political discourse, the nation could even be a code word for the middle class itself, one that highlighted the fact that British society consisted of more people than those presently enfranchised.[49] The founding of the National Gallery did not change the distribution of real political power – it did not give more people the vote – but it did remove a portion of prestigious symbolism from the exclusive control of the elite class and gave it to the nation as a whole. An impressive art gallery, a type of ceremonial space deeply associated with social privilege and exclusivity, became national property and was opened to all. The transference of the property as well as the shift in its symbolic meaning came about through the mediation of bourgeois wealth and enterprise and was legitimated by a state that had begun to recognize the advantages of such symbolic space.

The story, far from ending, was only at its beginning when the National Gallery opened in 1824. The struggle between the "nation" and its ruling class was still heating up politically. Years of resentment against the aristocracy, long held in by the wars, had already erupted in the five years following the Battle of Waterloo (1815). If the violence had subsided, the political pressures had not. Throughout the 1820s, a strong opposition, often Benthamite in tone and backed by a vigorous press, demanded middle-class access to political power and the creation of new cultural and educational institutions. This opposition ferociously attacked hereditary

privilege, protesting the incompetency of the aristocratic mind to grasp the needs of the nation, including its cultural and educational needs, and the absurdity of a system that gave aristocrats the exclusive right to dominate the whole. After the passage of the Reform Bill in 1832, elections sent a number of radicals to Parliament, where, among other things, they soon took on the cause of the National Gallery.

Debate was immediately occasioned by the urgent need to find a new space for the collection, since the lease on Angerstein's old house in Pall Mall would soon end and the building was slated for demolition. In April, 1832, Sir Robert Peel proposed to the House of Commons that the problem be solved by the erection of a new building on Trafalgar Square. He had in mind a dignified, monumental structure ("ornamental" was the term he used), designed expressly for viewing pictures. The proposal passed easily, but not before it sparked a lively discussion, with many members suggesting alternatives to it. A few members even toyed with the possibility of a British Louvre: instead of spending public money on a new building, they argued, why not put the collection in one of those royal buildings already maintained at public expense? Indeed, as one speaker noted, Buckingham Palace would make a splendid art gallery – it already had suitable space and, as a public art museum, it would be bigger and better than the Louvre! It was Joseph Hume who took the idea to its logical and radical conclusion. Since the nation needed a new art gallery, and since the government spent huge sums to maintain royal palaces which royalty rarely or never occupied, why not pull down a palace and build an art gallery in its place? In Hume's view, Hampton Court, Kensington Palace, or Windsor Castle would all make fine sites for a new public space.[50] Hume's proposal could hardly have been serious. But it does expose, if only for an instant, an impulse in the very heart of Parliament to dramatically displace vulnerable symbols of British royalty and claim their sites for the public.

As the new building on Trafalgar Square progressed, radical and reforming members of Parliament again concerned themselves with the National Gallery. In 1835, they created a select committee of the House of Commons and charged it to study the government's involvement with art education and its management of public collections.[51] The committee was full of well-known radicals and reformers, including William Ewart, Thomas Wyse, and John Bowring, long an editor of the influential Benthamite organ, the *Westminster Review*. The committee's immediate purpose was to discover ways to improve the taste of English artisans and designers and thereby improve the design and competitiveness of British manufactured goods. Its members, however, were equally intent on uncovering the ineptitude of the privileged gentlemen to whom the nation's cultural institutions were entrusted.

To the committee, the management of the National Gallery was a matter of significant political import. Most of its members were convinced that art galleries, museums, and art schools, if properly organized, could be instruments of social change capable of strengthening the social order. The numerous experts called in to testify to this truth repeatedly confirmed the committee's already unshakable belief that the very sight of art could improve the morals and deportment of even the lowest social ranks. Not surprisingly, the committee found the nation's improving monuments to be seriously mismanaged by their inept aristocratic overseers, who allowed entry fees and other obstacles to keep out most of the people.

These issues were aired not only in the Select Committee *Report* of 1836 and its published proceedings, but also in subsequent parliamentary proceedings, in other public meetings, and in the press at large.

Reforming politicians were not only concerned with the utilitarian benefits of art. They also believed that culture and the fine arts could improve and enrich the quality of national life. To foster and promote a love of art in the nation at large was political work of the highest order. Thomas Wyse, a member of the Select Committee of 1836 and well known as an Irish reformer, addressed these concerns at some length in his public speeches. In 1837, he spoke at a gathering called for the purpose of promoting free admission to all places in which the public could see works of artistic and historical importance. The real issue in the question of free admission, argued Wyse, was the conflict between the needs of the nation and the interests of a single class. The outcome was important because art, far from being a mere luxury, is essential for a civilized life. Art is "a language as universal as it is powerful", said Wyse; through it, artists leave "an immediate and direct transcript" of moral and intellectual experience that embodies the full nature of man. The broad benefits of art therefore belong by natural right to everyone – the nation as a whole – and not just to the privileged few.[52] As Wyse argued elsewhere, however great English commercial achievements, no nation is whole without the arts.

> Rich we may be, strong we may be; but without our share in the literary and artistic as well as scientific progress of the age, our civilization is incomplete.[53]

For Wyse, as for many other reformers of his day, progress toward this goal could be brought about only by removing from power a selfish and dull-witted aristocracy and replacing it with enlightened middle-class leadership. These ideas run through the Select Committee hearings of 1835 and its *Report* of the following year. Radical committee members pounced on anything that could demonstrate the ill effects of oligarchic rule, anything that, as one member put it, showed the "spirit of exclusion in this country", a spirit that had allowed art-collecting gentlemen to monopolize the enriching products of moral and intellectual life.[54]

It was just now that the National Gallery, having lost its house in Pall Mall, was on the point of moving into its new building on Trafalgar Square.[55] The coming move provided an excellent opportunity to ask whether or not the National Gallery could be called a truly *national* institution. Here, certainly, was an entity purporting to serve the cultural needs of the nation. But did its planners and managers understand those needs? Alas, as so many testified, prompted and prodded by Ewart and the others, the National Gallery was a sorry thing compared to the Louvre, to Berlin's Royal Gallery, and to Munich's Pinakothek, the new picture gallery built as a complement to the Glyptothek. As the eminent picture dealer Samuel Woodburn said, "from the limited number of pictures we at present possess, I can hardly call ours a national gallery".[56] But it was not merely the size of the collection that was wrong. As the Select Committee made plain, it was not enough to take a gentleman's collection and simply open it up to the public. In order to serve the nation, a public collection had to be formed on principles different from a gentleman's collection. It had to be selected and hung in a different way. And

that was the crux of the problem. So testified Edward Solly, a former timber merchant whose famous picture collection, recently sold to Berlin's Royal gallery, had been formed around advanced art-historical principles. Solly noted that whereas other nations gave purchasing decisions to qualified experts, in England the "gentlemen of taste" who made them – creatures of fashion with no deep knowledge of art – were hardly up to the serious mental task of planning an acquisition program for a national collection worthy of the name. Solly's opinion was inadvertently backed by the testimony of William Seguier, the first keeper of the National Gallery.[57] Grilled at length, his ignorance of current museological practices was of great political value to the Committee. No, admitted Seguier, there was no plan for the historical arrangement of pictures according to schools. No, nothing was labeled (although he agreed it was a good idea), and no, he had never visited Italy, even though, as everyone now knew, Italy was the supreme source for a proper, publicly minded art collection. Nor was there any rationalized acquisitions policy, so that, as keeper, Seguier had been helpless to watch the build-up of Murillos and other things inappropriate to a national collection while nothing whatsoever by Raphael was acquired.

And what should a national collection look like? The Committee was well informed about continental museums and frequently cited the Louvre as a model of museum arrangement and management.[58] Although no one from the Louvre testified at the hearings, the Committee did have two renowned museum experts on hand. One was Baron von Klenze, director of Munich's new museum. His descriptions of its art-historical arrangements and labeling, not to mention its fireproofing, air-heating, scientifically researched lighting and color schemes, inspired much admiration and envy. The other star witness was Dr Gustav Friedrich Waagen, a leading art-historical authority and director of the Royal Gallery at Berlin. He told the Committee that a public collection had to be historically arranged so that visitors could follow "the spirit of the times and the genius of the artists". Only then would they experience art's harmonious influence upon the mind. Dr Waagen also insisted that early Renaissance art was necessary to a good collection, as were representative works from even earlier times. The point to be made (and the Committee made it repeatedly) was that the traditional favorites among gentleman collectors, what still passed among them as "good taste", would no longer do. The Committee therefore recommended that the National Gallery change its course and focus its efforts on building up the collection around works from the era of Raphael and his predecessors, "such works being of purer and more elevated style than the eminent works of the Carracci".[59] A taste for Carracci was now disparaged as evidence of class misrule.

The Committee published its report in 1836, but the objectives for which it struggled were far from won. It would in fact require decades of political pressuring and Select Committee probings before the National Gallery would conform to the type developed on the continent. Although it would always be a picture gallery (and never a universal survey museum like the Louvre), it would eventually become one of Europe's outstanding public art museums, complete with elaborate genius ceilings and sumptuous galleries (Figure 14.7) in which the history of art unfolds with the greatest possible quality and abundance. It is significant, however, that it

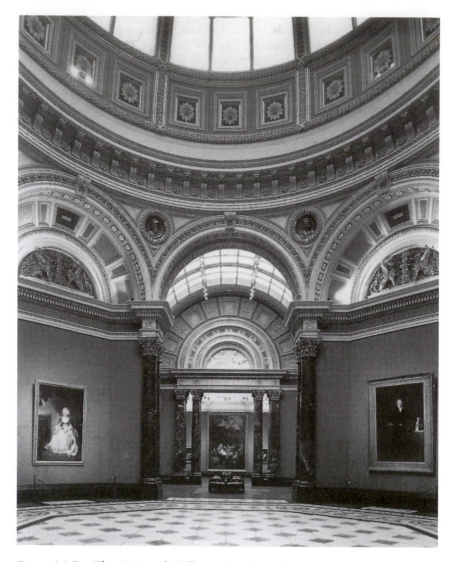

Figure 14.7 The National Gallery, London, the Barry Rooms: reproduced by
courtesy of the Trustees, the National Gallery, London

would become a fully realized civic ritual only in the third quarter of the nine-
teenth century, the same era that brought universal male suffrage to much, if not
all, of Britain. That is to say, the National Gallery came to rival the Louvre only
when political developments forced the British state to recognize the advantages
of a prestigious monument that could symbolize a nation united under presum-
ably universal values. As the historian E. P. Thompson has noted, it is a peculiarity
of British history that the formation of the bourgeois state – and of its supporting
culture – evolved slowly and organically out of a complex of older forms.[60] So,
too, the evolution of its National Gallery. However protracted, piecemeal and
partial the process, eventually, in Britain as in France, the princely gallery gave
way to the public art museum.

Notes

1 Much of what follows draws from Carol Duncan and Alan Wallach, "The Universal Survey Museum", *Art History* 3 (December 1980): 447–69.

2 For example, in 1975, Imelda Marcos, wife of the Philippine dictator, put together a museum of modern art in a matter of weeks. The rush was occasioned by the meeting in Manila of the International Monetary Fund. The new Metropolitan Museum of Manila, specializing in American and European art, was clearly meant to impress the conference's many illustrious visitors, who included some of the world's most powerful bankers. Not surprisingly, the new museum re-enacted on a cultural level the same relations that bound the Philippines to the United States economically and militarily. It opened with dozens of loans from the Brooklyn Museum, the Los Angeles County Museum of Art and the private collections of Armand Hammer and Nathan Cummings. Given Washington's massive contribution to the Philippine military, it is fair to assume that the museum building itself, a hastily converted unused army building, was virtually an American donation. (See "How to put together a museum in 29 days", *ArtNews* (December 1976): 19–22).

The Shah of Iran also needed Western-style museums to complete the façade of modernity he constructed for Western eyes. The Museum of Contemporary Art in Teheran opened in 1977 shortly before the regime's fall. Costing over $7 million, the multi-leveled modernist structure was filled with mostly American post-Second World War art – reputedly $30 million worth – and staffed by mostly American or American-trained museum personnel. According to Robert Hobbs, who was the museum's chief curator, the royal family viewed the museum and its collection as simply one of many instruments of political propaganda. See Sarah McFadden, "Teheran report", and Robert Hobbs, "Museum under siege", *Art in America* (October 1981): 9–16 and 17–25.

3 For ancient ceremonial display, see Joseph Alsop, *The Rare Art Traditions* (New York: Harper and Row, 1982), p. 197 (on temple treasures); Ranuccio B. Bandinelli, *Rome: The Center of Power, 500 BC to AD 200*, trans. P. Green (New York: Braziller, 1970), pp. 38, 43, 100 (on museum-like displays in temples, houses, and palaces); [. . .] Germain Bazin, *The Museum Age*, trans. J. van Nuis Cahill (New York: Universe Books, 1967), Ch. 1 (on the ancient world); and Francis Haskell, *Patrons and Painters: Art and Society in Baroque Italy* (New York and London: Harper and Row, 1971), Ch. 3 and *passim* (for displays in Italian Baroque churches and seventeenth-century palaces).

4 The princely gallery I am discussing is less the "cabinet of curiosities", which mixed together found objects, like shells and minerals, with man-made things, and more the large, ceremonial reception hall, like the Louvre's Apollo Gallery. For a discussion of the differences, see Bazin, op. cit. (note 3), pp. 129–36; and Giuseppe Olmi, "Science-honour-metaphor: Italian cabinets of the sixteenth and seventeenth centuries", in O. Impey and A. MacGregor (eds), *The Origins of Museums: The Cabinet of Curiosities in Sixteenth- and Seventeenth-Century Europe* (Oxford: Clarendon Press, 1985), pp. 10–11.[. . .]

5 For princely galleries see Bazin, op. cit. (note 3), pp. 129–39; Niels von Holst, *Creators, Collectors and Connoisseurs*, trans. B. Battershaw (London: G. P. Putnam's Sons, 1967), pp. 95–139 and *passim*.

[. . .]

6 More exactly, it established an art museum in a section of the old Louvre palace. In the two hundred years since the museum opened, the building itself has been greatly expanded, especially in the 1850s, when Louis-Napoléon added a series of new pavilions. Until recently, the museum shared the building with government offices, the last of which moved out in 1993, finally leaving the entire building to the museum.

7 For Louvre Museum history, see Andrew McClellan, *Inventing the Louvre: Art, Politics, and the Origins of the Modern Museum in Eighteenth-century Paris* (Cambridge: Cambridge University Press, 1994). [. . .]

8 McClellan, op. cit. (previous note), gives a full account of the ideas that guided the installation of the very early Louvre Museum and of the difference between it and earlier installation models.

9 For some detailed descriptions of gentlemanly hangs, see ibid., pp. 30–9. [. . .]

10 For example, in the Uffizi in Florence, the Museum at Naples and in Vienna in the Schloss Belvedere, the latter installed chronologically and by school by Christian von Mechel (von Holst, op. cit. [note 5], pp. 206–8; and Bazin, op. cit. [note 3], pp. 159–63). See [. . .] André Malraux's *Museum without Walls*, trans. S. Gilbert and F. Price (Garden City, NY: Doubleday, 1967), for an extensive treatment of the museum as an art-historical construct.

11 Quoted in Yveline Cantarel-Besson (ed.), *La Naissance du Musée du Louvre*, Vol. 1 (Paris: Ministry of Culture, Editions de la Réunion des Musées Nationaux, 1981), p. xxv.

12 Gustav Friedrich Waagen, *Treasures of Art in Great Britain (1838)*, trans. Lady Eastlake (London: 1854–7), Vol. 1, p. 320.

13 For a good example of this, see William Dyce, *The National Gallery, Its Formation and Management, Considered in a Letter to Prince Albert* (London: 1853).

14 Raymond Williams, in *Culture and Society, 1780–1950* (New York: Harper & Row, 1966), Part I; and *Keywords* (New York: Oxford University Press, 1976), pp. 48–50 and 76–82, treats the changing meaning of such key critical terms as "art" and "culture".

15 Malraux, op. cit. (note 10), gives an overview of this development in art-historical thinking.

16 See Iain Pears, *The Discovery of Painting: The Growth of Interest in the Arts in England, 1680–1768* (New Haven, CT and London: Yale University Press, 1988), for an excellent treatment of this.

17 For Louvre installations, see McClellan, op. cit. (note 7).

18 For accounts of this looting, see McClellan, op. cit. (note 7).

19 Genius is another of those terms that, by the early nineteenth century, already had a complex history and would continue to evolve. See Williams, *Culture and Society*, pp. xiv and 30–48, or Malraux, op. cit. (note 10), pp. 26–7 and *passim*, for some of the changing and complex meanings of the term. At this point, genius was most likely to be associated with the capacity to realize a lasting ideal of beauty. But, new definitions were also in use or in formation – for example, the notion that genius does not imitate (and cannot be imitated), but rather expresses the unique spirit of its time and place (seen, for example, in statements by Fuseli, Runge, and Goya).

20 See Francis Haskell, *Rediscoveries in Art: Some Aspects of Taste, Fashion and Collecting in England and France* (Ithaca, NY: Cornell University Press, 1976), pp. 8–19. [. . .]

21 See Nicholas Green, "Dealing in temperaments: economic transformation of the artistic field in France during the second half of the nineteenth century", *Art History* 10 (March 1987): 59–78, for an early phase of the literature of art-historical genius.

22 See von Holst, op. cit. (note 5), pp. 169–71, 204–5, 228–9; and Brazin, op. cit. (note 3), p. 214. The ornately decorated Hermitage Museum in St Petersburg was probably the most princely of these nineteenth-century creations in both its traditional installations and its visiting policy. Until 1866, full dress was required of all its visitors. Entrance to the Altes Museum in Berlin, the national gallery of the Prussian state, was also restricted, although in form it was a model of the new art-historical gallery. [. . .]

23 See Daniel J. Sherman, *Worthy Monuments: Art Museums and the Politics of Culture in Nineteenth-Century France* (Cambridge, MA and London: Harvard University Press, 1989).

24 See Duncan and Wallach, op. cit. (note 1), for a tour of the Louvre as it existed in 1978.

25 Georges Salles, director of the Museums of France in "The Museums of France", *Museum* 1–2 (1948–9): 92.

26 For the new Louvre, see Emile Biasini, Jean Lebrat, Dominique Bezombes, and Jean-Michel Vincent, *Le Grand Louvre: A Museum Transfigured, 1981–1993* (Milan and Paris: Electra France, 1989).

27 See, for example, Nathanial Burt, *Palaces for the People: A Social History of the American Art Museum* (Boston and Toronto: Little Brown, 1977), p. 23; Alma Wittlin, *The Museum: Its History and Its Tasks in Education* (London: Routledge & Kegan Paul, 1949), pp. 132–4; and Francis H. Taylor, *Babel's Tower: The Dilemma of the Modern Museum* (New York: Columbia University Press, 1945), p. 17. I cite here only three of the many writers who have understood public art museums in terms of the Louvre.

28 Peter W. Thomas, "Charles I of England: a tragedy of absolutism", in *The Courts of Europe: Politics, Patronage and Royalty, 1400–1800*, ed. A. G. Dickens (London: Thames & Hudson, 1977), pp. 191–201; Francis Haskell, *Patrons and Painters: Art and Society in Baroque Italy* (New York and London: Harper & Row, 1971), p. 175; and Pears, op. cit. (note 16), pp. 134–6. [. . .]

29 Pears, op. cit. (note 16), pp. 106 and 133–6; and Janet Minihan, *The Nationalization of Culture* (New York: New York University Press, 1977), p. 10. [. . .]

30 As Tim Hilton wrote of this exhibition in the *Guardian* (2 October 1991), p. 36, "something seems not to be right" when people must pay £4 to view works that "seem to be national rather than private treasures" and "seem so obviously to belong . . . in the permanent and free collections of the National Gallery upstairs". As Hilton noted, the Queen's Gallery, a small, recently established exhibition space next to Buckingham Palace has made selected portions of this collection available to the public; it does not, however, change the status of the collection as private property.

31 Pears, op. cit. (note 16), p. 3.

32 See J. G. A. Pocock, *Politics, Language and Time: Essays on Political Thought and History* (London: Methuen, 1972), especially Ch. 3, "Civic humanism and its role in Anglo-American thought".

33 The British Museum, founded in 1753 by St Hans Sloane, president of the Royal

Society, is sometimes described as the nation's first public museum (see, for example, Margorie Caygill, *The Story of the British Museum* [London: British Museum Publications, 1981], p. 4). However, it began its life as a highly restricted gentlemanly space and was democratized only gradually in the course of the nineteenth century. The state did not appropriate public funds for its purchase, but rather allowed a lottery to be held for that purpose. Nor was it conceived as an art collection. Although today it contains several aesthetically installed galleries of objects now classified as "art" (including the famed Elgin Marbles), it originated as an Enlightenment cabinet of curiosities – the museo-logical category from which both science and history museums descend. See Caygill, ibid., and David M. Wilson, *The British Museum: Purpose and Politics* (London: British Museum Publications, 1989).

34 Pears, op. cit. (note 16), pp. 176–8; and Peter Fullerton, "Patronage and peda-gogy: the British Institution in the early nineteenth century". *Art History* 5(1) (1982): 60.

35 Harold James Perkin, *The Origins of Modern English Society, 1780–1880*, (London: Routledge & Kegan Paul, 1969), p. 51.

36 Mark Girouard, *Life in the English Country House: A Social and Architectural History* (New Haven, CT and London: Yale University Press, 1978), p. 191.

37 For the social and political workings of eighteenth-century society, I consulted Asa Briggs, *The Making of Modern England, 1783–1867: The Age of Improvement* (New York: Harper & Row, 1965); Perkin, op. cit. (note 35); Philip Corrigan and Derek Sayer, *The Great Arch: English State Formation as Cultural Revolution* (Oxford and New York: Basil Blackwell, 1985); Edward P. Thompson, "The peculiarities of the English", in *The Poverty of Theory and Other Essays* (New York and London: Monthly Review Press, 1978), pp. 245–301; and Raymond Williams, *The Country and the City* (New York: Oxford University Press, 1973).

38 Girouard, op. cit. (note 36), p. 3.

39 John Rigby Hale, *England and the Italian Renaissance: The Growth of Interest in Its History and Art* (London: Arrow Books, 1963), pp. 68–82.

40 Pears, op. cit. (note 16), explores this meaning of eighteenth-century collec-tions in depth, especially in Chs 1 and 2. See also Corrigan and Sayer, op. cit. (note 37), Ch. 5.

41 For Parliament's neglect of the National Gallery after 1824, see Minihan, op. cit. (note 29), pp. 19–25.

42 For a good example of the latter see Steven Moyano's study of the founding of the Altes Museum in Berlin, "Quality vs. history. Schinkel's Altes Museum and Prussian arts policy", *Arts Bulletin* 72 (1990): 585–608.

43 In any case, there was nothing in the eighteenth-century British concept of the state that would call for spending public money on art galleries (see John S. Harris, *Government Patronage of the Arts in Great Britain*, Chicago and London: University of Chicago Press, 1970, pp. 13–14). [. . .]

44 George L. Nesbitt, *Benthamite Reviewing: The First Twelve Years of the Westminster Review, 1824–1836* (New York: Columbia University Press, 1934); Briggs, op. cit. (note 37) Chs 4 and 5; and Perkin, op. cit. (note 35), pp. 287–91, 302.

45 Linda Colley, "Whose nation? Class and national consciousness in Britain, 1750–1830", *Past and Present* (November 1986): 97–117.

46 The Prince of Orange had been willing to pay more, and the fear of losing the collection to a foreigner was a factor in prompting Parliament's approval of the

purchase. At the same time, Sir George Beaumont, a prominent amateur and patron of the arts, made known his intention to give the nation paintings from his collection, on condition that the state provide suitable housing for them. Beaumont's offer, combined with the prestige of the Angerstein Collection, tilted the balance in favor of a national collection. For a blow-by-blow account of the legal and legislative history of the founding of the National Gallery, see Gregory Martin, "The National Gallery in London", *Connoisseur* 185 (April 1974): 280–7; (May 1974): 24–31; and 187 (June 1974): 124–8. See also William T. Whitley, *Art in England, 1821–1837* (Cambridge: Cambridge University Press, 1930), pp. 64–74. [. . .]

47 As the latter wrote to a representative of the government: "Well knowing the great satisfaction it would have given our late Friend that the Collection should form part of a National Gallery, we shall feel much gratified by His Majesty's Government becoming the purchasers of the whole for such a purpose. Christopher Lloyd, "John Julius Angerstein, 1732–1823" *History Today* 16 (June 1966): 373–9.

48 ibid., p. 68.

49 See Benedict Anderson, *Imagined Communities: Reflections on the Origin and Spread of Nationalism* (London and New York: Verso, 1991), p. 4; and Eric J. Hobsbawm, *Nations and Nationalism* (Cambridge and New York: Cambridge University Press, 1990), Ch. 1, especially p. 18. [. . .]

50 *Parliamentary Debates (Commons)*, 13 April 1832, new ser., vol. 12, pp. 467–70; and 23 July 1832, new ser., vol. 14, pp. 643–5.

51 The committee was to discover "the best means of extending a knowledge of the Arts and of the Principles of Design among the People . . . (and) also to inquire into the Constitution, Management, and Effects of Institutions connected with the Arts" (*Report from the Select Committee on Arts, and Their Connection with Manufacturers*, in House of Commons, *Reports*, 1836, vol. IX.1, p. iii).

52 In George Foggo, *Report of the Proceedings at a Public Meeting Held at the Freemason's Hall on the 29th of May, 1837* (London: 1837), pp. 20–3. [. . .]

53 In a speech delivered at the Freemason's Tavern on 17 December 1842, reproduced in John Pye, *Patronage of British Art* (London: 1845), pp. 176–85.

54 William Ewart, in House of Commons, op. cit. (note 51), p. 108.

55 Paid for by the government, the building would have to be shared with the Royal Academy, a situation, in the opinion of the Committee, that amounted to government support for a body that was the very soul of oligarchic patronage and actually retarded the cultivation of the arts in England. Much of its proceedings were devoted to an investigation of the R.A.

56 ibid., p. 138.

57 Seguier was a successful art expert and restorer who had guided several high-ranking gentlemen in the formation of conventional aristocratic collections. Both George IV and Sir Robert Peel had availed themselves of his services (*Dictionary of National Biography*).

58 House of Commons, op. cit. (note 51), p. 137.

59 ibid., p. x.

60 Thompson, op. cit. (note 37), *passim*.

Tony Bennett

THE EXHIBITIONARY COMPLEX

I N REVIEWING FOUCAULT on the asylum, the clinic, and the prison as institutional articulations of power and knowledge relations, Douglas Crimp suggests that there 'is another such institution of confinement ripe for analysis in Foucault's terms – the museum – and another discipline – art history'.[1] Crimp is no doubt right, although the terms of his proposal are misleadingly restrictive. For the emergence of the art museum was closely related to that of a wider range of institutions – history and natural science museums, dioramas and panoramas, national, and later, international exhibitions, arcades and department stores – which served as linked sites for the development and circulation of new disciplines (history, biology, art history, anthropology) and their discursive formations (the past, evolution, aesthetics, man) as well as for the development of new technologies of vision. Furthermore, while these comprised an intersecting set of institutional and disciplinary relations which might be productively analysed as particular articulations of power and knowledge, the suggestion that they should be construed as institutions of confinement is curious. It seems to imply that works of art had previously wandered through the streets of Europe like the Ships of Fools in Foucault's *Madness and Civilisation*; or that geological and natural history specimens had been displayed before the world, like the condemned on the scaffold, rather than being withheld from public gaze, secreted in the *studiolo* of princes, or made accessible only to the limited gaze of high society in the *cabinets des curieux* of the aristocracy. Museums may have enclosed objects within walls, but the nineteenth century saw their doors opened to the general public – witnesses whose presence was just as essential to a display of power as had been that of the people before the spectacle of punishment in the eighteenth century.

Institutions, then, not of confinement but of exhibition, forming a complex of disciplinary and power relations whose development might more fruitfully be juxtaposed to, rather than aligned with, the formation of Foucault's 'carceral

archipelago'. For the movement Foucault traces in *Discipline and Punish* (1977) is one in which objects and bodies – the scaffold and the body of the condemned – which had previously formed a part of the public display of power were withdrawn from the public gaze as punishment increasingly took the form of incarceration. No longer inscribed within a public dramaturgy of power, the body of the condemned comes to be caught up within an inward-looking web of power relations. Subjected to omnipresent forms of surveillance through which the message of power was carried directly to it so as to render it docile, the body no longer served as the surface on which, through the system of retaliatory marks inflicted on it in the name of the sovereign, the lessons of power were written for others to read:

> The scaffold, where the body of the tortured criminal had been exposed to the ritually manifest force of the sovereign, the punitive theatre in which the representation of punishment was permanently available to the social body, was replaced by a great enclosed, complex and hier-archised structure that was integrated into the very body of the state apparatus.[2]

The institutions comprising 'the exhibitionary complex', by contrast, were involved in the transfer of objects and bodies from the enclosed and private domains in which they had previously been displayed (but to a restricted public) into progressively more open and public arenas where, through the representations to which they were subjected, they formed vehicles for inscribing and broadcasting the messages of power (but of a different type) throughout society.

Two different sets of institutions and their accompanying knowledge/power relations, then, whose histories, in these respects, run in opposing directions. Yet they are also parallel histories. The exhibitionary complex and the carceral archipelago develop over roughly the same period – the late eighteenth to the mid-nineteenth century – and achieve developed articulations of the new principles they embodied within a decade or so of one another. Foucault regards the opening of the new prison at Mettray in 1840 as a key moment in the development of the carceral system. Why Mettray? Because, Foucault argues, 'it is the disciplinary form at its most extreme, the model in which are concentrated all the coercive technologies of behaviour previously found in the cloister, prison, school or regiment and which, in being brought together in one place, served as a guide for the future development of carceral institutions' (p. 293). In Britain, the opening of Pentonville Model Prison in 1842 is often viewed in a similar light. Less than a decade later the Great Exhibition of 1851 brought together an ensemble of disciplines and techniques of display that had been developed within the previous histories of museums, panoramas, Mechanics' Institute exhibitions, art galleries, and arcades. In doing so, it translated these into exhibitionary forms which, in simultaneously ordering objects for public inspection and ordering the public that inspected, were to have a profound and lasting influence on the subsequent development of museums, art galleries, expositions, and department stores.

Nor are these entirely separate histories. At certain points they overlap, often with a transfer of meanings and effects between them. To understand their inter-relations, however, it will be necessary, in borrowing from Foucault, to qualify

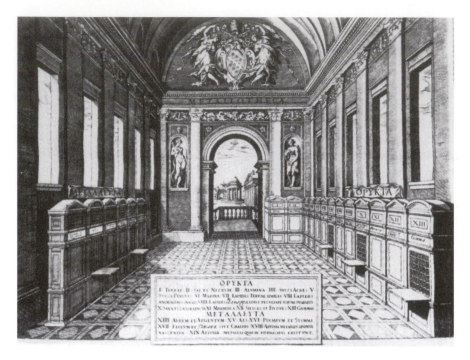

Figure 15.1 The cabinet of curiosities: the *Metallotheca* of Michele Mercati in the Vatican, 1719

the terms he proposes for investigating the development of power/knowledge relations during the formation of the modern period. For the set of such relations associated with the development of the exhibitionary complex serves as a check to the generalizing conclusions Foucault derives from his examination of the carceral system. In particular, it calls into question his suggestion that the penitentiary merely perfected the individualizing and normalizing technologies associated with a veritable swarming of forms of surveillance and disciplinary mechanisms which came to suffuse society with a new – and all-pervasive – political economy of power. This is not to suggest that technologies of surveillance had no place in the exhibitionary complex but rather that their intrication with new forms of spectacle produced a more complex and nuanced set of relations through which power was exercised and relayed to – and, in part, through and by – the populace than the Foucauldian account allows.

Foucault's primary concern, of course, is with the problem of order. He conceives the development of new forms of discipline and surveillance, as Jeffrey Minson puts it, as an 'attempt to reduce an ungovernable *populace* to a multiply differentiated *population*', parts of 'an historical movement aimed at transforming highly disruptive economic conflicts and political forms of disorder into quasi-technical or moral problems for social administration'. These mechanisms assumed, Minson continues, 'that the key to the populace's social and political unruliness and also the means of combating it lies in the "opacity" of the populace to the forces of order'.[3] The exhibitionary complex was also a response to the problem

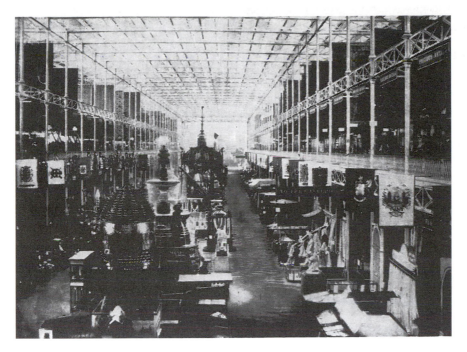

Figure 15.2 The Great Exhibition, 1851: the Western, or British, Nave, looking east: plate by H. Owen and M. Ferrier

of order, but one which worked differently in seeking to transform that problem into one of culture – a question of winning hearts and minds as well as the disciplining and training of bodies. As such, its constituent institutions reversed the orientations of the disciplinary apparatuses in seeking to render the forces and principles of order visible to the populace – transformed here, into a people, a citizenry – rather than vice versa. They sought not to map the social body in order to know the populace by rendering it visible to power. Instead, through the provision of object lessons in power – the power to command and arrange things and bodies for public display – they sought to allow the people, and *en masse* rather than individually, to know rather than be known, to become the subjects rather than the objects of knowledge. Yet, ideally, they sought also to allow the people to know and thence to regulate themselves; to become, in seeing themselves from the side of power, both the subjects and the objects of knowledge, knowing power and what power knows, and knowing themselves as (ideally) known by power, interiorizing its gaze as a principle of self-surveillance and, hence, self-regulation.

It is, then, as a set of cultural technologies concerned to organize a voluntarily self-regulating citizenry that I propose to examine the formation of the exhibitionary complex. In doing so, I shall draw on the Gramscian perspective of the ethical and educative function of the modern state to account for the relations of this complex to the development of the bourgeois democratic polity. Yet, while wishing to resist a tendency in Foucault towards misplaced generalizations, it is to Foucault's work that I shall look to unravel the relations between knowledge and

power effected by the technologies of vision embodied in the architectural forms of the exhibitionary complex.

Discipline, surveillance, spectacle

In discussing the proposals of late-eighteenth-century penal reformers, Foucault remarks that punishment, while remaining a 'legible lesson' organized in relation to the body of the offended, was envisioned as 'a school rather than a festival; an ever-open book rather than a ceremony' (p. III). Hence, in schemes to use convict labour in public contexts, it was envisaged that the convict would repay society twice: once by the labour he provided, and a second time by the signs he produced, a focus of both profit and signification in serving as an ever-present reminder of the connection between crime and punishment:

> Children should be allowed to come to the places where the penalty is being carried out; there they will attend their classes in civics. And grown men will periodically relearn the laws. Let us conceive of places of punishment as a Garden of the Laws that families would visit on Sundays. (p. III)

In the event, punishment took a different path with the development of the carceral system. Under both the *ancien régime* and the projects of the late-eighteenth-century reformers, punishment had formed part of a public system of representation. Both regimes obeyed a logic according to which 'secret punishment is a punishment half-wasted' (p. III). With the development of the carceral system, by contrast, punishment was removed from the public gaze in being enacted behind the closed walls of the penitentiary, and had in view not the production of signs for society but the correction of the offender. No longer an art of public effects, punishment aimed at a calculated transformation in the behaviour of the convicted. The body of the offended, no longer a medium for the relay of signs of power, was zoned as the target for disciplinary technologies which sought to modify behviour through repetition.

> The body and the soul, as principles of behaviour, form the element that is now proposed for punitive intervention. Rather than on an art of representation, this punitive intervention must rest on a studied manipulation of the individual. . . . As for the instruments used, these are no longer complexes of representation, reinforced and circulated, but forms of coercion, schemata of restraint, applied and repeated. Exercises, not signs . . . (p. 128)

It is not this account itself that is in question here but some of the more general claims Foucault elaborates on its basis. In his discussion of 'the swarming of disciplinary mechanisms', Foucault argues that the disciplinary technologies and forms of observation developed in the carceral system – and especially the principle of panopticism, rendering everything visible to the eye of power – display a

tendency 'to become "de-institutionalised", to emerge from the closed fortresses in which they once functioned and to circulate in a "free" state' (p. 211). These new systems of surveillance, mapping the social body so as to render it knowable and amenable to social regulation, mean, Foucault argues, that 'one can speak of the formation of a disciplinary society . . . that stretches from the enclosed disciplines, a sort of social "quarantine", to an indefinitely generalisable mechanism of "panopticism"' (p. 216). A society, according to Foucault in his approving quotation of Julius, that 'is one not of spectacle, but of surveillance':

> Antiquity had been a civilisation of spectacle. 'To render accessible to a multitude of men the inspection of a small number of objects': this was the problem to which the architecture of temples, theatres and circuses responded. . . . In a society in which the principal elements are no longer the community and public life, but, on the one hand, private individuals and, on the other, the state, relations can be regulated only in a form that is the exact reverse of the spectacle. It was to the modern age, to the ever-growing influence of the state, to its ever more profound intervention in all the details and all the relations of social life, that was reserved the task of increasing and perfecting its guarantees, by using and directing towards that great aim the building and distribution of buildings intended to observe a great multitude of men at the same time. (pp. 216–17)

A disciplinary society: this general characterization of the modality of power in modern societies has proved one of the more influential aspects of Foucault's work. Yet it is an incautious generalization and one produced by a peculiar kind of misattention. For it by no means follows from the fact that punishment had ceased to be a spectacle that the function of displaying power – of making it visible for all to see – had itself fallen into abeyance.[4] Indeed, as Graeme Davison suggests, the Crystal Palace might serve as the emblem of an architectural series which could be ranged against that of the asylum, school, and prison in its continuing concern with the display of objects to a great multitude:

> The Crystal Palace reversed the panoptical principle by fixing the eyes of the multitude upon an assemblage of glamorous commodities. The Panopticon was designed so that everyone could be seen; the Crystal Palace was designed so that everybody could see.[5]

This opposition is a little overstated in that one of the architectural innovations of the Crystal Palace consisted in the arrangement of relations between the public and exhibits so that, while everyone could see, there were also vantage points from which everyone could be seen, thus combining the functions of spectacle and surveillance. None the less, the shift of emphasis is worth preserving for the moment, particularly as its force is by no means limited to the Great Exhibition. Even a cursory glance through Richard Altick's *The Shows of London* convinces that the nineteenth century was quite unprecedented in the social effort it devoted to the organization of spectacles arranged for increasingly large and

undifferentiated publics.[6] Several aspects of these developments merit a preliminary consideration.

First: the tendency for society itself – in its constituent parts and as a whole – to be rendered as a spectacle. This was especially clear in attempts to render the city visible, and hence knowable, as a totality. While the depths of city life were penetrated by developing networks of surveillance, cities increasingly opened up their processes to public inspection, laying their secrets open not merely to the gaze of power but, in principle, to that of everyone; indeed, making the specular dominance of the eye of power available to all. By the turn of the century, Dean MacCannell notes, sightseers in Paris 'were given tours of the sewers, the morgue, a slaughterhouse, a tobacco factory, the government printing office, a tapestry works, the mint, the stock exchange and the supreme court in session'.[7] No doubt such tours conferred only an imaginary dominance over the city, an illusory rather than substantive controlling vision, as Dana Brand suggests was the case with earlier panoramas.[8] Yet the principle they embodied was real enough and, in seeking to render cities knowable in exhibiting the workings of their organizing institutions, they are without parallel in the spectacles of earlier regimes where the view of power was always 'from below'. This ambition towards a specular dominance over a totality was even more evident in the conception of international exhibitions which, in their heyday, sought to make the whole world, past and present, metonymically available in the assemblages of objects and peoples they brought together and, from their towers, to lay it before a controlling vision.

Second: the increasing involvement of the state in the provision of such spectacles. In the British case, and even more so the American, such involvement was typically indirect.[9] Nicholas Pearson notes that while the sphere of culture fell increasingly under governmental regulation in the second half of the nineteenth century, the preferred form of administration for museums, art galleries, and exhibitions was (and remains) via boards of trustees. Through these, the state could retain effective direction over policy by virtue of its control over appointments but without involving itself in the day-to-day conduct of affairs and so, seemingly, violating the Kantian imperative in subordinating culture to practical requirements.[10] Although the state was initially prodded only reluctantly into this sphere of activity, there should be no doubt of the importance it eventually assumed. Museums, galleries, and, more intermittently, exhibitions played a pivotal role in the formation of the modern state and are fundamental to its conception as, among other things, a set of educative and civilizing agencies. Since the late nineteenth century, they have been ranked highly in the funding priorities of all developed nation-states and have proved remarkably influential cultural technologies in the degree to which they have recruited the interest and participation of their citizenries.

Finally: the exhibitionary complex provided a context for the *permanent* display of power/knowledge. In his discussion of the display of power in the *ancien régime*, Foucault stresses its episodic quality. The spectacle of the scaffold formed part of a system of power which 'in the absence of continual supervision, sought a renewal of its effect in the spectacle of its individual manifestations; of a power that was recharged in the ritual display of its reality as "super-power"' (p. 57). It is not that the nineteenth century dispensed entirely with the need for the

periodic magnification of power through its excessive display, for the expositions played this role. They did so, however, in relation to a network of institutions which provided mechanisms for the permanent display of power. And for a power which was not reduced to periodic effects but which, to the contrary, manifested itself precisely in continually displaying its ability to command, order, and control objects and bodies, living or dead.

There is, then, another series from the one Foucault examines in tracing the shift from the ceremony of the scaffold to the disciplinary rigours of the penitentiary. Yet it is a series which has its echo and, in some respects, model in another section of the socio-juridical apparatus: the trial. The scene of the trial and that of punishment traversed one another as they moved in opposite directions during the early modern period. As punishment was withdrawn from the public gaze and transferred to the enclosed space of the penitentiary, so the procedures of trial and sentencing – which, except for England, had hitherto been mostly conducted in secret, 'opaque not only to the public but also to the accused himself' (p. 35) – were made public as part of a new system of judicial truth which, in order to function as truth, needed to be made known to all. If the asymmetry of these movements is compelling, it is no more so than the symmetry of the movement traced by the trial and the museum in the transition they make from closed and restricted to open and public contexts. And, as a part of a profound transformation in their social functioning, it was ultimately to these institutions – and not by witnessing punishment enacted in the streets nor, as Bentham had envisaged, by making the penitentiaries open to public inspection – that children, and their parents, were invited to attend their lessons in civics.

Moreover such lessons consisted not in a display of power which, in seeking to terrorize, positioned the people on the other side of power as its potential recipients but sought rather to place the people – conceived as a nationalized citizenry – on this side of power, both its subject and its beneficiary. To identify with power, to see it as, if not directly theirs, then indirectly so, a force regulated and channelled by society's ruling groups but for the good of all: this was the rhetoric of power embodied in the exhibitionary complex – a power made manifest not in its ability to inflict pain but by its ability to organize and co-ordinate an order of things and to produce a place for the people in relation to that order. Detailed studies of nineteenth-century expositions thus consistently highlight the ideological economy of their organizing principles, transforming displays of machinery and industrial processes, of finished products and *objets d'art*, into material signifiers of progress – but of progress as a collective national achievement with capital as the great co-ordinator.[11] This power thus subjugated by flattery, placing itself on the side of the people by affording them a place within its workings; a power which placed the people behind it, inveigled into complicity with it rather than cowed into submission before it. And this power marked out the distinction between the subjects and the objects of power not within the national body but, as organized by the many rhetorics of imperialism, between that body and other, 'non-civilized' peoples upon whose bodies the effects of power were unleashed with as much force and theatricality as had been manifest on the scaffold. This was, in other words, a power which aimed at a rhetorical effect through its representation of otherness rather than at any disciplinary effects.

Yet it is not merely in terms of its ideological economy that the exhibitionary complex must be assessed. While museums and expositions may have set out to win the hearts and minds of their visitors, these also brought their bodies with them creating architectural problems as vexed as any posed by the development of the carceral archipelago. The birth of the latter, Foucault argues, required a new architectural problematic:

> that of an architecture that is no longer built simply to be seen (as with the ostentation of palaces), or to observe the external space (cf. the geometry of fortresses), but to permit an internal, articulated and detailed control — to render visible those who are inside it; in more general terms, an architecture that would operate to transform individuals: to act on those it shelters, to provide a hold on their conduct, to carry the effects of power right to them, to make it possible to know them, to alter them. (p. 172)

As Davison notes, the development of the exhibitionary complex also posed a new demand: that everyone should see, and not just the ostentation of imposing façades but their contents too. This, too, created a series of architectural problems which were ultimately resolved only through a 'political economy of detail' similar to that applied to the regulation of the relations between bodies, space, and time within the penitentiary. In Britain, France, and Germany, the late eighteenth and early nineteenth centuries witnessed a spate of state-sponsored architectural competitions for the design of museums in which the emphasis shifted progressively away from organizing spaces of display for the private pleasure of the prince or aristocrat and towards an organization of space and vision that would enable museums to function as organs of public instruction.[12] Yet, as I have already suggested, it is misleading to view the architectural problematics of the exhibitionary complex as simply reversing the principles of panopticism. The effect of these principles, Foucault argues, was to abolish the crowd conceived as 'a compact mass, a locus of multiple exchanges, individualities merging together, a collective effect' and to replace it with 'a collection of separated individualities' (p. 201). However, as John MacArthur notes, the Panopticon is simply a technique, not itself a disciplinary regime or essentially a part of one, and, like all techniques, its potential effects are not exhausted by its deployment within any of the regimes in which it happens to be used.[13] The peculiarity of the exhibitionary complex is not to be found in its reversal of the principles of the Panopticon. Rather, it consists in its incorporation of aspects of those principles together with those of the panorama, forming a technology of vision which served not to atomize and disperse the crowd but to regulate it, and to do so by rendering it visible to itself, by making the crowd itself the ultimate spectacle.

An instruction from a 'Short Sermon to Sightseers' at the 1901 Pan-American Exposition enjoined: 'Please remember when you get inside the gates you are part of the show.'[14] This was also true of museums and department stores which, like many of the main exhibition halls of expositions, frequently contained galleries affording a superior vantage point from which the lay-out of the whole and the activities of other visitors could also be observed.[15] It was, however, the expositions

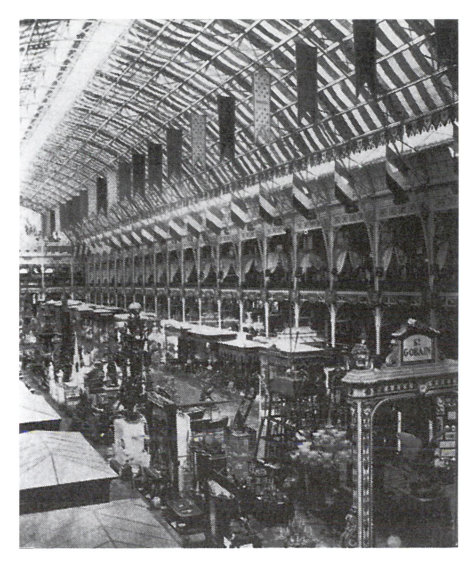

Figure 15.3 The Paris Exhibition, 1855

which developed this characteristic furthest in constructing viewing positions from which they could be surveyed as totalities: the function of the Eiffel Tower at the 1889 Paris exposition, for example. To see and be seen, to survey yet always be under surveillance, the object of an unknown but controlling look: in these ways, as micro-worlds rendered constantly visible to themselves, expositions realized some of the ideals of panopticism in transforming the crowd into a constantly surveyed, self-watching, self-regulating, and, as the historical record suggests, consistently orderly public – a society watching over itself.

Within the hierarchically organized systems of looks of the penitentiary in which each level of looking is monitored by a higher one, the inmate constitutes

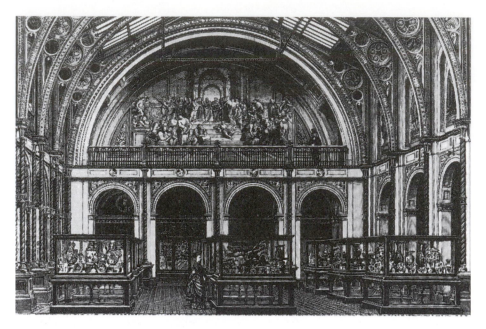

Figure 15.4 The South Kensington Museum (later the Victoria and Albert): interior of the South Court, eastern portion, from the south, circa 1876: drawing by John Watkins

the point at which all these looks culminate but he is unable to return a look of his own or move to a higher level of vision. The exhibitionary complex, by contrast, perfected a self-monitoring system of looks in which the subject and object positions can be exchanged, in which the crowd comes to commune with and regulate itself through interiorizing the ideal and ordered view of itself as seen from the controlling vision of power – a site of sight accessible to all. It was in thus democratizing the eye of power that the expositions realized Bentham's aspiration for a system of looks within which the central position would be available to the public at all times, a model lesson in civics in which a society regulated itself through self-observation. But, of course, of self-observation from a certain perspective. As Manfredo Tafuri puts it:

> The arcades and the department stores of Paris, like the great exposi-
> tions, were certainly the places in which the crowd, itself become a
> spectacle, found the spatial and visual means for a self-education from
> the point of view of capital.[16]

However, this was not an achievement of architecture alone. Account must also be taken of the forces which, in shaping the exhibitionary complex, formed both its publics and its rhetorics.

Seeing things

It seems unlikely, come the revolution, that it will occur to anyone to storm the British Museum. Perhaps it always was. Yet, in the early days of its history, the fear that it might incite the vengeance of the mob was real enough. In 1780 in the midst of the Gordon Riots, troops were housed in the gardens and building and, in 1848, when the Chartists marched to present the People's Charter to Parliament, the authorities prepared to defend the museum as vigilantly as if it had been a penitentiary. The museum staff were sworn in as special constables; fortifications were constructed around the perimeter; a garrison of museum staff, regular troops, and Chelsea pensioners, armed with muskets, pikes, and cutlasses, and with provisions for a three-day siege, occupied the buildings; stones were carried to the roof to be hurled down on the Chartists should they succeed in breaching the outer defences.[17]

This fear of the crowd haunted debates on the museum's policy for over a century. Acknowledged as one of the first public museums, its conception of the public was a limited one. Visitors were admitted only in groups of fifteen and were obliged to submit their credentials for inspection prior to admission which was granted only if they were found to be 'not exceptionable'.[18] When changes to this policy were proposed, they were resisted by both the museum's trustees and its curators, apprehensive that the unruliness of the mob would mar the ordered display of culture and knowledge. When, shortly after the museum's establishment, it was proposed that there be public days on which unrestricted access would be allowed, the proposal was scuttled on the grounds, as one trustee puts it, that some of the visitors from the streets would inevitably be, 'in liquor' and 'will never be kept in order'. And if public days should be allowed, Dr Ward continued:

> then it will be necessary for the Trustees to have a presence of a Committee of themselves attending, with at least two Justices of the Peace and the constables of the division of Bloomsbury . . . supported by a guard such as one as usually attends at the Play-House, and even after all this, Accidents must and will happen.[19]

Similar objections were raised when, in 1835, a select committee was appointed to inquire into the management of the museum and suggested that it might be opened over Easter to facilitate attendance by the labouring classes. A few decades later, however, the issue had been finally resolved in favour of the reformers. The most significant shift in the state's attitude towards museums was marked by the opening of the South Kensington Museum in 1857. Administered, eventually, under the auspices of the Board of Education, the museum was officially dedicated to the service of an extended and undifferentiated public with opening hours and an admissions policy designed to maximize its accessibility to the working classes. It proved remarkably successful, too, attracting over 15 million visits between 1857 and 1883, over 6.5 million of which were recorded in the evenings, the most popular time for working-class visitors who, it seems, remained largely sober. Henry Cole, the first director of the museum and an ardent advocate of the role museums should play in the formation of a rational public culture, pointedly

rebutted the conceptions of the unruly mob which had informed earlier objections to open admissions policies. Informing a House of Commons committee in
1860 that only one person had had to be excluded for not being able to walk
steadily, he went on to note that the sale of alcohol in the refreshment rooms had
averaged out, as Altick summarizes it, as 'two and a half drops of wine, fourteen-
fifteenths of a drop of brandy, and ten and half drops of bottled ale per capita'.[20]
As the evidence of the orderliness of the newly extended museum public mounted,
even the British Museum relented and, in 1883, embarked on a programme of
electrification to permit evening opening.

The South Kensington Museum thus marked a significant turning-point in the
development of British museum policy in clearly enunciating the principles of
the modern museum conceived as an instrument of public education. It provided
the axis around which London's museum complex was to develop throughout the
rest of the century and exerted a strong influence on the development of museums
in the provincial cities and towns. These now rapidly took advantage of the Museum
Bill of 1845 (hitherto used relatively sparingly) which empowered local authorities
to establish museums and art galleries: the number of public museums in Britain
increased from 50 in 1860 to 200 in 1900.[21] In its turn, however, the South
Kensington Museum had derived its primary impetus from the Great Exhibition
which, in developing a new pedagogic relation between state and people, had also
subdued the spectre of the crowd. This spectre had been raised again in the debates
set in motion by the proposal that admission to the exhibition should be free. It could
only be expected, one correspondent to *The Times* argued, that both the rules of
decorum and the rights of property would be violated if entry were made free to
'his majesty the mob'. These fears were exacerbated by the revolutionary upheavals
of 1848, occasioning several European monarchs to petition that the public be
banned from the opening ceremony (planned for May Day) for fear that this might
spark off an insurrection which, in turn, might give rise to a general European conflagration.[22] And then there was the fear of social contagion should the labouring
classes be allowed to rub shoulders with the upper classes.

In the event, the Great Exhibition proved a transitional form. While open to
all, it also stratified its public in providing different days for different classes of
visitors regulated by varying prices of admission. In spite of this limitation, the
exhibition proved a major spur to the development of open-door policies.
Attracting over 6 million visitors itself, it also vastly stimulated the attendance at
London's main historic sites and museums: visits to the British Museum, for
example, increased from 720,643 in 1850 to 2,230,242 in 1851.[23] Perhaps more
important, though, was the orderliness of the public which in spite of the thousand extra constables and ten thousand troops kept on stand-by, proved duly
appreciative, decorous in its bearing and entirely a-political. More than that, the
exhibition transformed the many-headed mob into an ordered crowd, a part of
the spectacle and a sight of pleasure in itself. Victoria, in recording her impressions of the opening ceremony, dwelt particularly on her pleasure in seeing so
large, so orderly, and so peaceable a crowd assembled in one place:

> The Green Park and Hyde Park were one mass of densely crowded
> human beings, in the highest good humour and most enthusiastic.

I never saw Hyde Park look as it did, being filled with crowds as far
as the eye could see.[24]

Nor was this entirely unprepared for. The working-class public the exhibition
attracted was one whose conduct had been regulated into appropriate forms in
the earlier history of the Mechanics' Institute exhibitions. Devoted largely to the
display of industrial objects and processes, these exhibitions pioneered policies of
low admission prices and late opening hours to encourage working-class atten-
dance long before these were adopted within the official museum complex. In
doing so, moreover, they sought to tutor their visitors on the modes of deport-
ment required if they were to be admitted. Instruction booklets advised
working-class visitors how to present themselves, placing particular stress on the
need to change out of their working clothes – partly so as not to soil the exhibits,
but also so as not to detract from the pleasures of the overall spectacle; indeed,
to become parts of it:

> Here is a visitor of another sort; the mechanic has resolved to treat
> himself with a few hours holiday and recreation; he leaves the 'grimy
> shop', the dirty bench, and donning his Saturday night suit he appears
> before us – an honourable and worthy object.[25]

In brief, the Great Exhibition and, subsequently, the public museums developed
in its wake found themselves heirs to a public which had already been formed by
a set of pedagogic relations which, developed initially by voluntary organizations
– in what Gramsci would call the realm of civil society – were henceforward to
be more thoroughgoingly promoted within the social body in being subjected to
the direction of the state.

Not, then, a history of confinement but one of the opening up of objects to
more public contexts of inspection and visibility: this is the direction of move-
ment embodied in the formation of the exhibitionary complex. A movement which
simultaneously helped to form a new public and inscribe it in new relations of
sight and vision. Of course, the precise trajectory of these developments in Britain
was not followed elsewhere in Europe. None the less, the general direction of
development was the same. While earlier collections (whether of scientific objects,
curiosities, or works of art) had gone under a variety of names (museums, *studiolo*,
cabinets des curieux, *Wunderkammer*, *Kunstkammer*) and fulfilled a variety of functions
(the storing and dissemination of knowledge, the display of princely and aristo-
cratic power, the advancement of reputations and careers), they had mostly shared
two principles: that of private ownership and that of restricted access.[26] The forma-
tion of the exhibitionary complex involved a break with both in effecting the
transfer of significant quantities of cultural and scientific property from private into
public ownership where they were housed within institutions administered by the
state for the benefit of an extended general public.

The significance of the formation of the exhibitionary complex, viewed in this
perspective, was that of providing new instruments for the moral and cultural
regulation of the working classes. Museums and expositions, in drawing on the
techniques and rhetorics of display and pedagogic relations developed in earlier

nineteenth-century exhibitionary forms, provided a context in which the working-
and middle-class publics could be brought together and the former – having been
tutored into forms of behaviour to suit them for the occasion – could be exposed
to the improving influence of the latter. A history, then, of the formation of a
new public and its inscription in new relations of power and knowledge. But a
history accompanied by a parallel one aimed at the destruction of earlier traditions
of popular exhibition and the publics they implied and produced. In Britain, this
took the form, *inter alia*, of a concerted attack on popular fairs owing to their
association with riot, carnival, and, in their side-shows, the display of monstrosi-
ties and curiosities which, no longer enjoying elite patronage, were now perceived
as impediments to the rationalizing influence of the restructured exhibitionary
complex.

Yet, by the end of the century, fairs were to be actively promoted as an aid
rather than a threat to public order. This was partly because the mechanization of
fairs meant that their entertainments were increasingly brought into line with the
values of industrial civilization, a testimony to the virtues of progress.[27] But it was
also a consequence of changes in the conduct of fairgoers. By the end of the
century, Hugh Cunningham argues, 'fairgoing had become a relatively routine
ingredient in the accepted world of leisure' as 'fairs became tolerated, safe, and
in due course a subject for nostalgia and revival'.[28] The primary site for this trans-
formation of fairs and the conduct of their publics – although never quite so
complete as Cunningham suggests – was supplied by the fair zones of the late-
nineteenth-century expositions. It was here that two cultures abutted on to one
another, the fair zones forming a kind of buffer region between the official and
the popular culture with the former seeking to reach into the latter and moderate
it. Initially, these fair zones established themselves independently of the official
expositions and their organizing committees. The product of the initiative of
popular showmen and private traders eager to exploit the market the expositions
supplied, they consisted largely of an *ad hoc* melange of both new (mechanical
rides) and traditional popular entertainments (freak shows, etc.) which frequently
mocked the pretensions of the expositions they adjoined. Burton Benedict
summarizes the relations between expositions and their amusement zones in late-
nineteenth-century America as follows:

> Many of the display techniques used in the amusement zone seemed to
> parody those of the main fair. Gigantism became enormous toys or gro-
> tesque monsters. Impressive high structures became collapsing or
> whirling amusement 'rides'. The solemn female allegorical figures that
> symbolised nations (Miss Liberty, Britannia) were replaced by comic male
> figures (Uncle Sam, John Bull). At the Chicago fair of 1893 the gilded
> female statue of the Republic on the Court of Honour contrasted with a
> large mechanical Uncle Sam on the Midway that delivered forty thousand
> speeches on the virtues of Hub Gore shoe elastics. Serious propagandists
> for manufacturers and governments in the main fair gave way to barkers
> and pitch men. The public no longer had to play the role of impressed
> spectators. They were invited to become frivolous participants. Order
> was replaced by jumble, and instruction by entertainment.[29]

Figure 15.5 The Crystal Palace: model of one of the colossi of Abu Simbel, 1852/3: plate by Philip Henry Delamotte

As Benedict goes on to note, the resulting tension between unofficial fair and official exposition led to 'exposition organisers frequently attempting to turn the amusement zone into an educational enterprise or at least to regulate the type of exhibit shown'. In this, they were never entirely successful. Into the twentieth century, the amusement zones remained sites of illicit pleasures – of burlesque shows and prostitution – and of ones which the expositions themselves aimed to render archaic. Altick's 'monster-mongers and retailers of other strange sights' seem to have been as much in evidence at the Panama Pacific Exhibition of 1915 as they had been, a century earlier, at St Bartholomew's Fair, Wordsworth's Parliament of Monsters.[30] None the less, what was evident was a significant restructuring in the ideological economy of such amusement zones as a consequence of the degree to which, in subjecting them to more stringent forms of control and direction, exposition authorities were able to align their thematics to those of the

official expositions themselves and, thence, to those of the rest of the exhibitionary complex. Museums, the evidence suggests, appealed largely to the middle classes and the skilled and respectable working classes and it seems likely that the same was true of expositions. The link between expositions and their adjoining fair zones, however, provided a route through which the exhibitionary complex and the disciplines and knowledges which shaped its rhetorics acquired a far wider and more extensive social influence.

The exhibitionary disciplines

The space of representation constituted by the exhibitionary complex was shaped by the relations between an array of new disciplines: history, art history, archaeology, geology, biology, and anthropology. Whereas the disciplines associated with the carceral archipelago were concerned to reduce aggregates to individualities, rendering the latter visible to power and so amenable to control, the orientation of these disciplines – as deployed in the exhibitionary complex – might best be summarized as that of 'show and tell'. They tended also to be generalizing in their focus. Each discipline, in its museological deployment, aimed at the representation of a type and its insertion in a developmental sequence for display to a public.

Such principles of classification and display were alien to the eighteenth century. Thus, in Sir Hans Soane's Museum, architectural styles are displayed in order to demonstrate their essential permanence rather than their change and development.[31] The emergence of a historicized framework for the display of human artefacts in early-nineteenth-century museums was thus a significant innovation. But not an isolated one. As Stephen Bann shows, the emergence of a 'historical frame' for the display of museum exhibits was concurrent with the development of an array of disciplinary and other practices which aimed at the life-like reproduction of an authenticated past and its representation as a series of stages leading to the present – the new practices of history-writing associated with the historical novel and the development of history as an empirical discipline, for example.[32] Between them, these constituted a new space of representation concerned to depict the development of peoples, states, and civilizations through time conceived as a progressive series of developmental stages.

The French Revolution, Germain Bazin suggests, played a key role in opening up this space of representation by breaking the chain of dynastic succession that had previously vouchsafed a unity to the flow and organization of time.[33] Certainly, it was in France that historicized principles of museum display were first developed. Bazin stresses the formative influence of the Museum des monuments français (1795) in exhibiting works of art in galleries devoted to different periods, the visitors route leading from earlier to later periods, with a view to demonstrating both the painterly conventions peculiar to each epoch and their historical development. He accords a similar significance to Alexandre du Sommerard's collection at the Hôtel de Cluny which, as Bann shows, aimed at 'an integrative construction of historical totalities', creating the impression of a historically authentic milieu by suggesting an essential and organic connection between artefacts displayed in rooms classified by period.[34]

Bann argues that these two principles – the *galleria progressiva* and the period room, sometimes employed singly, at others in combination – constitute the distinctive poetics of the modern historical museum. It is important to add, though, that this poetics displayed a marked tendency to be nationalized. If, as Bazin suggests, the museum became 'one of the fundamental institutions of the modern state',[35] that state was also increasingly a nation-state. The significance of this was manifested in the relations between two new historical times – national and universal – which resulted from an increase in the vertical depth of historical time as it was both pushed further and further back into the past and brought increasingly up to date. Under the impetus of the rivalry between France and Britain for dominion in the Middle East, museums, in close association with archaeological excavations of progressively deeper pasts, extended their time horizons beyond the medieval period and the classical antiquities of Greece and Rome to encompass the remnants of the Egyptian and Mesopotamian civilizations. At the same time, the recent past was historicized as the newly emerging nation-states sought to preserve and immemorialize their own formation as a part of that process of 'nationing' their populations that was essential to their further development. It was as a consequence of the first of these developments that the prospect of a universal history of civilization was opened up to thought and materialized in the archaeological collections of the great nineteenth-century museums. The second development, however, led to these universal histories being annexed to national histories as, within the rhetorics of each national museum complex, collections of national materials were represented as the outcome and culmination of the universal story of civilization's development.

Nor had displays of natural or geological specimens been organized historically in the various precursors of nineteenth-century public museums. Throughout the greater part of the eighteenth century, principles of scientific classification testified to a mixture of theocratic, rationalist, and proto-evolutionist systems of thought. Translated into principles of museological display, the result was the table, not the series, with species being arranged in terms of culturally codified similarities/dissimilarities in their external appearances rather than being ordered into temporally organized relations of precession/succession. The crucial challenges to such conceptions came from developments within geology and biology, particularly where their researches overlapped in the stratigraphical study of fossil remains.[36] However, the details of these developments need not concern us here. So far as their implications for museums were concerned, their main significance was that of allowing for organic life to be conceived and represented as a temporally ordered succession of different forms of life where the transitions between them were accounted for not as a result of external shocks (as had been the case in the eighteenth century) but as the consequence of an inner momentum inscribed within the concept of life itself.[37]

If developments within history and archaeology thus allowed for the emergence of new forms of classification and display through which the stories of nations could be told and related to the longer story of western civilization's development, the discursive formations of nineteenth-century geology and biology allowed these cultural series to be inserted within the longer developmental series of geological and natural time. Museums of science and technology, heirs to the rhetorics

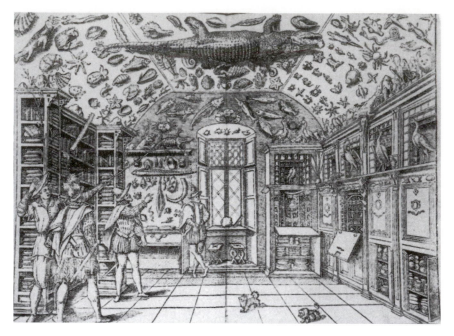

Figure 15.6 The cabinet of curiosities: Ferrante Imperato's museum in Naples, 1599

of progress developed in national and international exhibitions, completed the evolutionary picture in representing the history of industry and manufacture as a series of progressive innovations leading up to the contemporary triumphs of industrial capitalism.

Yet, in the context of late-nineteenth-century imperialism, it was arguably the employment of anthropology within the exhibitionary complex which proved most central to its ideological functioning. For it played the crucial role of connecting the histories of Western nations and civilizations to those of other peoples, but only by separating the two in providing for an interrupted continuity in the order of peoples and races – one in which 'primitive peoples' dropped out of history altogether in order to occupy a twilight zone between nature and culture. This function had been fulfilled earlier in the century by the museological display of anatomical peculiarities which seemed to confirm polygenetic conceptions of mankind's origins. The most celebrated instance was that of Saartjie Baartman, the 'Hottentot Venus', whose protruding buttocks – interpreted as a sign of separate development – occasioned a flurry of scientific speculation when she was displayed in Paris and London. On her death in 1815, an autopsy revealed alleged peculiarities in her genitalia which, likened to those of the orang-utan, were cited as proof positive of the claim that black peoples were the product of a separate – and, of course, inferior, more primitive, and bestial – line of descent. No less an authority than Cuvier lent his support to this conception in circulating a report of Baartman's autopsy and presenting her genital organs – 'prepared in a way so as

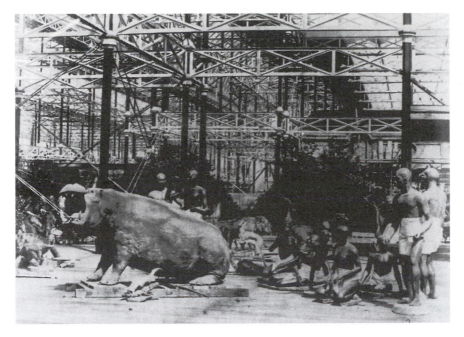

Figure 15.7 The Crystal Palace: stuffed animals and ethnographic figures: plate by Philip Henry Delamotte

to allow one to see the nature of the labia'[38] — to the French Academy which arranged for their display in the Musée d'Ethnographie de Paris (now the Musée de l'homme).

Darwin's rebuttal of theories of polygenesis entailed that different means be found for establishing and representing the fractured unity of the human species. By and large, this was achieved by the representation of 'primitive peoples' as instances of arrested development, as examples of an earlier stage of species development which Western civilizations had long ago surpassed. Indeed, such peoples were typically represented as the still-living examples of *the* earliest stage in human development, the point of transition between nature and culture, between ape and man, the missing link necessary to account for the transition between animal and human history. Denied any history of their own, it was the fate of 'primitive peoples' to be dropped out of the bottom of human history in order that they might serve, representationally, as its support — underlining the rhetoric of progress by serving as its counterpoints, representing the point at which human history emerges from nature but has not yet properly begun its course.

So far as the museological display of artefacts from such cultures was concerned, this resulted in their arrangement and display — as at the Pitt-Rivers Museum — in accordance with the genetic or typological system which grouped together all objects of a similar nature, irrespective of their ethnographic groupings, in an evolutionary series leading from the simple to the complex.[39] However, it was with regard to the display of human remains that the consequences of these principles of classification were most dramatically manifested. In eighteenth-century

museums, such displays had placed the accent on anatomical peculiarities, viewed primarily as a testimony to the rich diversity of the chain of universal being. By the late-nineteenth-century, however, human remains were most typically displayed as parts of evolutionary series with the remains of still extant peoples being allocated the earliest position within them. This was particularly true for the remains of Australian Aborigines. In the early years of Australian settlement, the colony's museums had displayed little or no interest in Aboriginal remains.[40] The triumph of evolutionary theory transformed this situation, leading to a systematic rape of Aboriginal sacred sites – by the representatives of British, European, and American as well as Australian museums – for materials to provide a representational foundation for the story of evolution within, tellingly enough, natural history displays.[41]

The space of representation constituted in the relations between the disciplinary knowledges deployed within the exhibitionary complex thus permitted the construction of a temporally organized order of things and peoples. Moreover, that order was a totalizing one, metonymically encompassing all things and all peoples in their interactions through time. And an order which organized the implied public – the white citizenries of the imperialist powers – into a unity, representationally effacing divisions within the body politic in constructing a 'we' conceived as the realization, and therefore just beneficiaries, of the processes of evolution and identified as a unity in opposition to the primitive otherness of conquered peoples. This was not entirely new. As Peter Stallybrass and Allon White note, the popular fairs of the late eighteenth and early nineteenth centuries had exoticized the grotesque imagery of the carnival tradition by projecting it on to the representatives of alien cultures. In thus providing a normalizing function via the construction of a radically different Other, the exhibition of other peoples served as a vehicle for 'the edification of a national public and the confirmation of its imperial superiority'.[42] If, in its subsequent development, the exhibitionary complex latched on to this pre-existing representational space, what it added to it was a historical dimension.

The exhibitionary apparatuses

The space of representation constituted by the exhibitionary disciplines, while conferring a degree of unity on the exhibitionary complex, was also somewhat differently occupied – and to different effect – by the institutions comprising that complex. If museums gave this space a solidity and permanence, this was achieved at the price of a lack of ideological flexibility. Public museums instituted an order of things that was meant to last. In doing so, they provided the modern state with a deep and continuous ideological backdrop but one which, if it was to play this role, could not be adjusted to respond to shorter-term ideological requirements. Exhibitions met this need, injecting new life into the exhibitionary complex and rendering its ideological configurations more pliable in bending them to serve the conjuncturally specific hegemonic strategies of different national bourgeoisies. They made the order of things dynamic, mobilizing it strategically in relation to the more immediate ideological and political exigencies of the particular moment.

This was partly an effect of the secondary discourses which accompanied exhibitions. Ranging from the state pageantry of their opening and closing ceremonies through newspaper reports to the veritable swarming of pedagogic initiatives organized by religious, philanthropic, and scientific associations to take advantage of the publics which exhibitions produced, these often forged very direct and specific connections between the exhibitionary rhetoric of progress and the claims to leadership of particular social and political forces. The distinctive influence of the exhibitions themselves, however, consisted in their articulation of the rhetoric of progress to the rhetorics of nationalism and imperialism and in producing, via their control over their adjoining popular fairs, an expanded cultural sphere for the deployment of the exhibitionary disciplines.

The basic signifying currency of the exhibitions, of course, consisted in their arrangement of displays of manufacturing processes and products. Prior to the Great Exhibition, the message of progress had been carried by the arrangement of exhibits in, as Davison puts it, 'a series of classes and sub-classes ascending from raw products of nature, through various manufactured goods and mechanical devices, to the "highest" forms of applied and fine art'.[43] As such, the class articulations of this rhetoric were subject to some variation. Mechanics Institutes' exhibitions placed considerable stress on the centrality of labour's contributions to the processes of production which, at times, allowed a radical appropriation of their message. 'The machinery of wealth, here displayed,' the *Leeds Times* noted in reporting an 1839 exhibition, 'has been created by the men of hammers and papercaps; more honourable than all the sceptres and coronets in the world.'[44] The Great Exhibition introduced two changes which decisively influenced the future development of the form.

First, the stress was shifted from the *processes* to the *products* of production, divested of the marks of their making and ushered forth as signs of the productive and co-ordinating power of capital and the state. After 1851, world fairs were to function less as vehicles for the technical education of the working classes than as instruments for their stupefaction before the reified products of their own labour, 'places of pilgrimage', as Benjamin put it, 'to the fetish Commodity'.[45]

Second, while not entirely abandoned, the earlier progressivist taxonomy based on stages of production was subordinated to the dominating influence of principles of classification based on nations and the supra-national constructs of empires and races. Embodied, at the Crystal Palace, in the form of national courts or display areas, this principle was subsequently developed into that of separate pavilions for each participating country. Moreover, following an innovation of the Centennial Exhibition held at Philadelphia in 1876, these pavilions were typically zoned into racial groups: the Latin, Teutonic, Anglo-Saxon, American, and Oriental being the most favoured classifications, with black peoples and the aboriginal populations of conquered territories, denied any space of their own, being represented as subordinate adjuncts to the imperial displays of the major powers. The effect of these developments was to transfer the rhetoric of progress from the relations between stages of production to the relations between races and nations by superimposing the associations of the former on to the latter. In the context of imperial displays, subject peoples were thus represented as occupying the lowest levels of manufacturing civilization. Reduced to displays of 'primitive' handicrafts and the

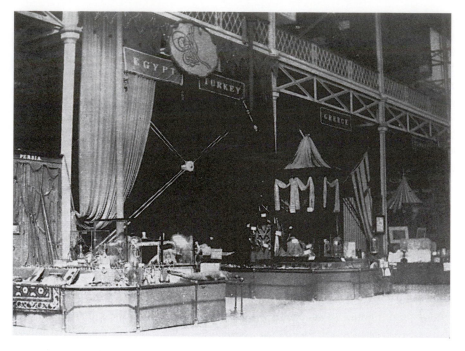

Figure 15.8 The Great Exhibition, 1851: stands of Egypt, Turkey and Greece:
plate by H. Owen and M. Ferrier

like, they were represented as cultures without momentum except for that benignly
bestowed on them from without through the improving mission of the imperialist
powers. Oriental civilizations were allotted an intermediate position in being repre-
sented either as having at one time been subject to development but subsequently
degenerating into stasis or as embodying achievements of civilization which, while
developed by their own lights, were judged inferior to the standards set by
Europe.[46] In brief, a progressivist taxonomy for the classification of goods and
manufacturing processes was laminated on to a crudely racist teleological concep-
tion of the relations between peoples and races which culminated in the
achievements of the metropolitan powers, invariably most impressively displayed
in the pavilions of the host country.

 Exhibitions thus located their preferred audiences at the very pinnacle of the
exhibitionary order of things they constructed. They also installed them at the
threshold of greater things to come. Here, too, the Great Exhibition led the way
in sponsoring a display of architectural projects for the amelioration of working-
class housing conditions. This principle was to be developed, in subsequent
exhibitions, into displays of elaborate projects for the improvement of social condi-
tions in the areas of health, sanitation, education, and welfare – promissory notes
that the engines of progress would be harnessed for the general good. Indeed,
exhibitions came to function as promissory notes in their totalities, embodying, if
just for a season, utopian principles of social organization which, when the time
came for the notes to be redeemed, would eventually be realized in perpetuity.
As world fairs fell increasingly under the influence of modernism, the rhetoric of

progress tended, as Rydell puts it, to be 'translated into a utopian statement about the future', promising the imminent dissipation of social tensions once progress had reached the point where its benefits might be generalized.[47]

Iain Chambers has argued that working- and middle-class cultures became sharply distinct in late-nineteenth-century Britain as an urban commercial popular culture developed beyond the reach of the moral economy of religion and respectability. As a consequence, he argues, 'official culture was publicly limited to the rhetoric of monuments in the centre of town: the university, the museum, the theatre, the concert hall; otherwise it was reserved for the "private" space of the Victorian residence'.[48] While not disputing the general terms of this argument, it does omit any consideration of the role of exhibitions in providing official culture with powerful bridgeheads into the newly developing popular culture. Most obviously, the official zones of exhibitions offered a context for the deployment of the exhibitionary disciplines which reached a more extended public than that ordinarily reached by the public museum system. The exchange of both staff and exhibits between museums and exhibitions was a regular and recurrent aspect of their relations, furnishing an institutional axis for the extended social deployment of a distinctively new ensemble of disciplines. Even within the official zones of exhibitions, the exhibitionary disciplines thus achieved an exposure to publics as large as any to which even the most commercialized forms of popular culture could lay claim: 32 million people attended the Paris Exposition of 1889; 27.5 million went to Chicago's Columbian Exposition in 1893 and nearly 49 million to Chicago's 1933/4 Century of Progress Exposition; the Glasgow Empire Exhibition of 1938 attracted 12 million visitors, and over 27 million attended the Empire Exhibition at Wembley in 1924/5.[49] However, the ideological reach of exhibitions often extended significantly further as they established their influence over the popular entertainment zones which, while initially deplored by exhibition authorities, were subsequently to be managed as planned adjuncts to the official exhibition zones and, sometimes, incorporated into the latter. It was through this network of relations that the official public culture of museums reached into the developing urban popular culture, shaping and directing its development in subjecting the ideological thematics of popular entertainments to the rhetoric of progress.

The most critical development in this respect consisted in the extension of anthropology's disciplinary ambit into the entertainment zones, for it was here that the crucial work of transforming non-white peoples themselves – and not just their remains or artefacts – into object lessons of evolutionary theory was accomplished. Paris led the way here in the colonial city it constructed as part of its 1889 Exposition. Populated by Asian and African peoples in simulated 'native' villages, the colonial city functioned as the showpiece of French anthropology and, through its influence on delegates to the tenth Congrès Internationale d'Anthropologie et d'Archéologie Préhistorique held in association with the exposition, had a decisive bearing on the future modes of the discipline's social deployment. While this was true internationally, Rydell's study of American world fairs provides the most detailed demonstration of the active role played by museum anthropologists in transforming the Midways into living demonstrations of evolutionary theory by arranging non-white peoples into a 'sliding-scale of humanity', from the barbaric to the nearly civilized, thus underlining the exhibitionary rhetoric

of progress by serving as visible counterpoints to its triumphal achievements. It was here that relations of knowledge and power continued to be invested in the public display of bodies, colonizing the space of earlier freak and monstrosity shows in order to personify the truths of a new regime of representation.

In their interrelations, then, the expositions and their fair zones constituted an order of things and of peoples which, reaching back into the depths of prehistoric time as well as encompassing all corners of the globe, rendered the whole world metonymically present, subordinated to the dominating gaze of the white, bourgeois, and (although this is another story) male eye of the metropolitan powers. But an eye of power which, through the development of the technology of vision associated with exposition towers and the positions for seeing these produced in relation to the miniature ideal cities of the expositions themselves, was democratized in being made available to all. Earlier attempts to establish a specular dominance over the city had, of course, been legion – the camera obscura, the panorama – and often fantastic in their technological imaginings. Moreover, the ambition to render the whole world, as represented in assemblages of commodities, subordinate to the controlling vision of the spectator was present in world exhibitions from the outset. This was represented synecdochically at the Great Exhibition by Wylde's Great Globe, a brick rotunda which the visitor entered to see plaster casts of the world's continents and oceans. The principles embodied in the Eiffel Tower, built for the 1889 Paris Exposition and repeated in countless subsequent expositions, brought these two series together, rendering the project of specular dominance feasible in affording an elevated vantage point over a micro-world which claimed to be representative of a larger totality.

Barthes has aptly summarized the effects of the technology of vision embodied in the Eiffel Tower. Remarking that the tower overcomes 'the habitual divorce between *seeing* and *being seen*', Barthes argues that it acquires a distinctive power from its ability to circulate between these two functions of sight:

> An object when we look at it, it becomes a lookout in its turn when we visit it, and now constitutes as an object, simultaneously extended and collected beneath it, that Paris which just now was looking at it.[50]

A sight itself, it becomes the site for a sight; a place both to see and be seen from, which allows the individual to circulate between the object- and subject-positions of the dominating vision it affords over the city and its inhabitants. In this, its distancing effect, Barthes argues, 'the Tower makes the city into a kind of nature; it constitutes the swarming of men into a landscape, it adds to the frequently grim urban myth a romantic dimension, a harmony, a mitigation', offering 'an immediate consumption of a humanity made natural by that glance which transforms it into space'.[51] It is because of the dominating vision it affords, Barthes continues, that, for the visitor, 'the Tower is the first obligatory monument; it is a Gateway, it marks the transition to a knowledge'.[52] And to the power associated with that knowledge: the power to order objects and persons into a world to be known and to lay it out before a vision capable of encompassing it as a totality.

In *The Prelude*, Wordsworth, seeking a vantage point from which to quell the tumultuousness of the city, invites his reader to ascend with him 'Above the press

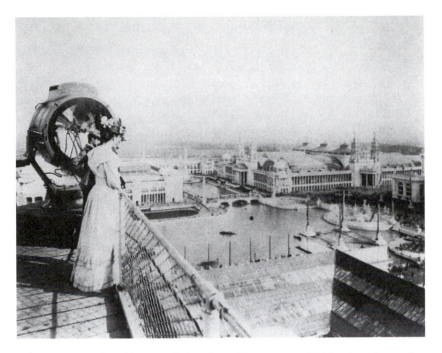

Figure 15.9 The Chicago Columbian Exposition, 1893: view from the roof of
the Manufactures and Liberal Arts Building

and danger of the crowd/Upon some showman's platform' at St Bartholomew's
Fair, likened to mobs, riotings, and executions as occasions when the passions of
the city's populace break forth into unbridled expression. The vantage point,
however, affords no control:

> All moveables of wonder, from all parts,
> Are here – Albinos, painted Indians, Dwarfs,
> The Horse of knowledge, and the learned Pig,
> The Stone-eater, the man that swallows fire,
> Giants, Ventriloquists, the Invisible Girl,
> The Bust that speaks and moves its goggling eyes,
> The Wax-work, Clock-work, all the marvellous craft
> Of modern Merlins, Wild Beasts, Puppet-shows,
> All out-o'-the-way, far-fetched, perverted things,
> All freaks of nature, all Promethean thoughts
> Of man, his dullness, madness, and their feats
> All jumbled up together, to compose
> A Parliament of Monsters.[53]

Stallybrass and White argue that this Wordsworthian perspective was typical
of the early-nineteenth-century tendency for the educated public, in withdrawing
from participation in popular fairs, also to distance itself from, and seek some
ideological control over, the fair by the literary production of elevated vantage

points from which it might be observed. By the end of the century, the imaginary dominance over the city afforded by the showman's platform had been transformed into a cast-iron reality while the fair, no longer a symbol of chaos, had become the ultimate spectacle of an ordered totality. And the substitution of observation for participation was a possibility open to all. The principle of spectacle – that, as Foucault summarizes it, of rendering a small number of objects accessible to the inspection of a multitude of men – did not fall into abeyance in the nineteenth century: it was surpassed through the development of technologies of vision which rendered the multitude accessible to its own inspection.

Conclusion

I have sought, in this article, to tread a delicate line between Foucault's and Gramsci's perspective on the state, but without attempting to efface their differences so as to forge a synthesis between them. Nor is there a compelling need for such a synthesis. The concept of the state is merely a convenient shorthand for an array of governmental agencies which – as Gramsci was among the first to argue in distinguishing between the coercive apparatuses of the state and those engaged in the organization of consent – need not be conceived as unitary with regard to either their functioning or the modalities of power they embody.

That said, however, my argument has been mainly with (but not against) Foucault. In the study already referred to, Pearson distinguishes between the 'hard' and the 'soft' approaches to the nineteenth-century state's role in the promotion of art and culture. The former consisted of 'a systematic body of knowledge and skills promulgated in a systematic way to specified audiences'. Its field was comprised by those institutions of schooling which exercised a forcible hold or some measure of constraint over their members and to which the technologies of self-monitoring developed in the carceral system undoubtedly migrated. The 'soft' approach, by contrast, worked 'by example rather than by pedagogy; by entertainment rather than by disciplined schooling; and by subtlety and encouragement'.[54] Its field of application consisted of those institutions whose hold over their publics depended on their voluntary participation.

There seems no reason to deny the different sets of knowledge/power relations embodied in these contrasting approaches, or to seek their reconciliation in some common principle. For the needs to which they responded were different. The problem to which the 'swarming of disciplinary mechanisms' responded was that of making extended populations governable. However, the development of bourgeois democratic polities required not merely that the populace be governable but that it assent to its governance, thereby creating a need to enlist active popular support for the values and objectives enshrined in the state. Foucault knows well enough the symbolic power of the penitentiary:

> The high wall, no longer the wall that surrounds and protects, no longer the wall that stands for power and wealth, but the meticulously sealed wall, uncrossable in either direction, closed in upon the now mysterious work of punishment, will become, near at hand, sometimes even

at the very centre of the cities of the nineteenth century, the monot-
onous figure, at once material and symbolic, of the power to punish.
(p. 116)

Museums were also typically located at the centre of cities where they stood
as embodiments, both material and symbolic, of a power to 'show and tell' which,
in being deployed in a newly constituted open and public space, sought rhetori-
cally to incorporate the people within the processes of the state. If the museum
and the penitentiary thus represented the Janus face of power, there was none the
less — at least symbolically — an economy of effort between them. For those who
failed to adopt the tutelary relation to the self promoted by popular schooling or
whose hearts and minds failed to be won in the new pedagogic relations between
state and people symbolized by the open doors of the museum, the closed walls
of the penitentiary threatened a sterner instruction in the lessons of power. Where
instruction and rhetoric failed, punishment began.

Notes

1 Douglas Crimp, 'On the museum's ruins', in Hal Foster (ed.), *The Anti-Aesthetic:
 Essays on Postmodern Culture* (Washington: Bay Press, 1985), p. 45.
2 Michel Foucault, *Discipline and Punish: The Birth of the Prison*, trans. A. Sheridan
 (London: Allen Lane, 1977), pp. 115–16; further page references will be given
 in the text.
3 Jeffrey Minson, *Genealogies of Morals: Nietzche, Foucault, Donzelot and the Eccentricity
 of Ethics* (London: Macmillan, 1985), p. 24.
4 This point is well made by MacArthur who sees this aspect of Foucault's argu-
 ment as inimical to the overall spirit of his work in suggesting a 'historical
 division which places theatre and spectacle as past'. John MacArthur, 'Foucault,
 Tafuri, Utopia: essays in the history and theory of architecture' (unpublished
 MPhil thesis, University of Queensland, 1983), p. 192.
5 Graeme Davison, 'Exhibitions', *Australian Cultural History* 2 (1982/3), Canberra:
 Australian Academy of the Humanities and the History of Ideas Unit, A.N.U.,
 7.
6 See Richard D. Altick, *The Shows of London* (Cambridge, MA and London: Belknap
 Press of Harvard University Press, 1978).
7 Dean MacCannell, *The Tourist: A New Theory of the Leisure Class* (New York:
 Schocken Books, 1976), p. 57.
8 See Dana Aron Brand, *The Spectator and the City: Fantasies of Urban Legibility in
 Nineteenth-Century England and America* (Ann Arbor, MI: University Microfilms
 International, 1986).
9 For discussions of the role of the American state in relation to museums and expo-
 sitions, see, respectively, K. E. Meyer, *The Art Museum: Power, Money, Ethics* (New
 York: William Morrow, 1979), and Reid Badger, *The Great American Fair: The
 World's Columbian Exposition and American Culture* (Chicago: Nelson Hall, 1979).
10 Nicholas Pearson, *The State and the Visual Arts: a discussion of state intervention in
 the visual arts in Britain, 1780–1981* (Milton Keynes: Open University Press,
 1982), pp. 8–13, 46–7.

11 See Debora Silverman, 'The 1889 exhibition: the crisis of bourgeois indivi-
dualism', *Oppositions: A Journal of Ideas and Criticism in Architecture* (spring
1977), and Robert W. Rydell, *All the World's a Fair: Visions of Empire at Amer-
ican International Expositions, 1876–1916* (Chicago: University of Chicago Press,
1984).

12 See H. Seling, 'The genesis of the Museum', *Architectural Review* 131 (1967).

13 MacArthur, op. cit., 192–3.

14 Cited in Neil Harris, 'Museums, merchandising and popular taste: the struggle
for influence', in I. M. G. Quimby (ed.), *Material Culture and the Study of American
Life* (New York: W. W. Norton, 1978), p. 144.

15 For details of the use of rotunda and galleries to this effect in department stores,
see John William Ferry, *A History of the Department Store* (New York: Macmillan,
1960).

16 Manfredo Tafuri, *Architecture and Utopia: Design and Capitalist Development*
(Cambridge, MA: MIT Press, 1976), p. 83.

17 For further details, see Edward Millar, *That Noble Cabinet: A History of the British
Museum* (Athens, OH: Ohio University Press, 1974).

18 A. S. Wittlin, *The Museum: Its History and Its Tasks in Education* (London: Routledge
& Kegan Paul, 1949), p. 113.

19 Cited in Millar, op. cit., 62.

20 Altick, op. cit., 500.

21 See David White, 'Is Britain becoming one big museum?', *New Society* (20
October 1983).

22 See Audrey Shorter, 'Workers under glass in 1851', *Victorian Studies* 10(2)
(1966).

23 See Altick, op. cit., 467.

24 Cited in C. H. Gibbs-Smith, *The Great Exhibition of 1851* (London: HMSO, 1981),
p. 18.

25 Cited in Toshio Kusamitsu, 'Great exhibitions before 1851', *History Workshop* 9
(1980): 77.

26 A comprehensive introduction to these earlier forms is offered by Olive Impey
and Arthur MacGregor (eds), *The Origins of Museums: The Cabinet of Curiosities in
Sixteenth- and Seventeenth-Century Europe* (Oxford: Clarendon Press, 1985). See
also Bazin, note 33.

27 I have touched on these matters elsewhere. See Tony Bennett, 'A thousand and
one troubles: Blackpool Pleasure Beach', *Formations of Pleasure* (London:
Routledge & Kegan Paul, 1983) and 'Hegemony, ideology, pleasure: Blackpool',
in Tony Bennett, Colin Mercer and Janet Woollacott (eds), *Popular Culture and
Social Relations* (Milton Keynes: Open University Press, 1986).

28 Hugh Cunningham, *Leisure in the Industrial Revolution* (London: Croom Helm,
1980). As excerpted in Bernard Waites, Tony Bennett and Graham Martin (eds),
Popular Culture: Past and Present (London: Croom Helm, 1982), p. 163.

29 Burton Benedict, 'The anthropology of world's fairs', in Burton Benedict (ed.),
The Anthropology of World's Fairs: San Francisco's Panama Pacific Exposition of 1915
(New York: Scolar Press, 1983), pp. 53–4.

30 For details, see McCullough, *World's Fair Midways: An Affectionate Account of
American Amusement Areas* (New York: Exposition Press, 1966), p. 76.

31 See Colin Davies, 'Architecture and remembrance', *Architectural Review* (February
1984), p. 54.

32 See Stephen Bann, *The Clothing of Clio: a study of the representation of history in nineteenth-century Britain and France* (Cambridge: Cambridge University Press, 1984).

33 G. Bazin, *The Museum Age* (New York: Universal Press, 1967), p. 218.

34 Bann, op. cit., 85.

35 Bazin, op. cit., 169.

36 For details of these interactions, see Martin J. S. Rudwick, *The Meaning of Fossils: Episodes in the History of Palaeontology* (Chicago: University of Chicago Press, 1985).

37 I draw here on Michel Foucault, *The Order of Things: An Archaeology of the Human Sciences* (London: Tavistock, 1970).

38 Cuvier, cited in Sander L. Gilman, 'Black bodies, white bodies: toward an iconography of female sexuality in late nineteenth-century art, medicine and literature', *Critical Inquiry* 21(1) (autumn 1985): 214–15.

39 See David K. van Keuren, 'Museums and ideology: Augustus Pitt-Rivers, anthropological museums, and social change in later Victorian Britain', *Victorian Studies* 28(1) (autumn 1984).

40 See S. G. Kohlstedt, 'Australian museums of natural history: public practices and scientific initiatives in the 19th century', *Historical Records of Australian Science* 5 (1983).

41 For the most thorough account, see D. J. Mulvaney, 'The Australian Aborigines 1606–1929: opinion and fieldwork', *Historical Studies* 8(30–1) (1958).

42 Peter Stallybrass and Allon White, *The Politics and Poetics of Transgression* (London: Methuen, 1986), p. 42.

43 Davison, op. cit., 8.

44 Cited in Kusamitsu, op. cit., 79.

45 Walter Benjamin, *Charles Baudelaire: A Lyric Poet in the Era of High Capitalism* (London: New Left Books, 1973), p. 165.

46 See Neil Harris, 'All the world a melting pot? Japan at American fairs, 1876–1904' in Ireye Akira (ed.), *Mutual Images: Essays in American-Japanese Relations* (Cambridge, MA: Harvard University Press, 1975).

47 Rydell, op cit., 4.

48 Iain Chambers, 'The obscured metropolis', *Australian Journal of Cultural Studies* 3(2) (December 1985): 9.

49 John M. MacKenzie, *Propaganda and Empire: the manipulation of British public opinion, 1880–1960* (Manchester: Manchester University Press, 1984), p. 101.

50 Roland Barthes, *The Eiffel Tower, and Other Mythologies* (New York: Hill & Wang, 1979), p. 4.

51 ibid., 8.

52 ibid., 14.

53 VII, 684–5; 706–18.

54 Pearson, op. cit., 35.

Museums and cultural management

Introduction to part four

■ Jessica Evans

T HERE ARE TWO BROAD THEMES that account for the selection of the readings in this section. The first three readings provide some theoretical arguments for the importance of thinking about the museum as an arena of government; that is, as involving a complex interaction between cultural institutions and the forms of policy discourse which they develop, aimed at guiding and shaping forms of conduct amongst the broader population. The other readings outline some of the contemporary issues in museum curatorship, in different national contexts, as they bear upon issues of management and policy development in an era in which the modern paradigm governing museum culture is coming under considerable pressure.

In the first reading, by Kenneth Hudson, sets out a context for thinking about the problem of defining a mueum in the first place. In 'Attempts to define ''museum''', Hudson's report for UNESCO, he reviews the ways in which the concept of a museum has been developed in recent years, as well as how the International Council of Museums has adjusted its definition of a museum accordingly. He indicates nicely how even innocuous-sounding concepts often incorporated into the mission statement or constitution documents of museums, such as 'object', as well as the more obviously contested concepts, such as 'cultural value' and 'public interest', cannot be defined conclusively but are entirely relative to their specific national and local contexts of use.

In the next two readings, Tony Bennett and Colin Mercer outline a particular theoretical apparatus for understanding how the museum, amongst many other cultural institutions, can be seen to function as a 'governmental technology'. Following Foucault, they understand governmentality as a distinctive form of modern social regulation involving the management of populations and modes of citizenship by means of specialist knowledges, techniques and practices. As Bennett indicates in his article 'Useful culture', this notion of government departs

radically from that of traditional political theory. Traditional social democratic accounts – which are mirrored to a great extent in Marxist theory with its conception of base, superstructure and the ideological 'reflections' of these which hold society together – had at their heart a conceptualization of power as emanating from a single, centralized source. In contrast, the 'governmentality' model which informs Bennett and Mercer's discussion of cultural policy considers the 'material operations of power' embedded in a specific practices and locales. Whereas models of state and ideology centre on the operations of power over consciousness, with all the epistemological baggage of false, true and imaginary consciousness that comes with it, the Foucauldian model is concerned with modes of conduct and the regulation of habitual norms and manners (see Bennett, in this volume, p. 384). Colin Mercer succinctly puts it thus, 'Our concern is not simply with what culture represents but with what it actually *does* in both exceptional and everyday terms' (Mercer, in this volume, p. 397). Bennett and Mercer are united in their critique of what they consider to be a tendency within cultural studies toward an overly textual conception of culture. In particular, they are concerned with the widening gap between the forms of cultural critique characteristic of recent cultural studies and cultural policy; the former being charged with adopting an intellectual-outsider position in which, in the words of Stuart Cunningham, 'the search for positive markers of the intrinsic subversiveness of everyday life' becomes the central prerogative (Cunningham, 1993: 136). Furthermore, it is argued, there is a predisposition by cultural critics to see policy-making as inevitably compromised, and instrumentally short-termist. Textual analysis, or at least an emphasis on the internal symbolic arrangements of museum displays, is limited, it is argued, if it is not related to an analysis of the social apparatus that provides the conditions for the production and reception of such cultural forms and representations, and to the communities of interest that seek to develop policy.

In 'Useful culture' Bennett argues for a 'style of intellectual work' that is more concerned with 'tinkering with practical arrangements rather than . . . an epic struggle for consciousness' (Bennett, in this volume, p. 390). Both Bennett and Mercer argue that the opposition of textual analysis and policy analysis is homologous with that of the distinction between humanities and social sciences; both arise from a specific construction of the differentiated relationship required of intellectuals to government as 'pedagogues' or 'technicians'. The first, typical of humanities education, deals with the population as an agglomeration of distinct individuals (hence its humanist bent); the second, typical, of the social sciences, conceives of a society administratable through techniques of collective management (hence its quantitative bent). Mercer observes how the idea that the worlds of 'policy' and of 'culture' are diametrically opposed is of quite recent invention, specifically arising from the ethical separation of spheres of government and culture in the post-Romantic period. For example, if we follow Hall's line of argument in 'Culture, community, nation' (Chapter 2 in this volume) one can see how Raymond Williams prefers to separate the process by which communities derive their identity from the modes of regional and national regulation – both legal and informal – that are bound up with the formation of a community. Williams therefore retreats

into a view that culture and government are mutually exclusive entities and processes. This separation mystifies in an important sense the routine and significant relationships between the two spheres. For the purposes of thinking about museum culture, the aestheticization of high culture is itself the product of practices of government (ranging from arts-funding to humanities education) which have produced 'high culture' as a means of assessing the level of the 'cultural development' of the population – as we have seen in Part Three. As Bennett shows in 'Useful culture', the nineteenth-century advocates of rational recreation argued that the exposure of the working classes to the museum and art gallery environment would give rise to a self-activating desire for betterment via the pursuit of knowledge. This was a process of improvement which, it was envisaged, would act as an 'antidote to less civilizing habits'. The point here is that the effects of this technology were tangible only in the changes in the fields of habitual norms and modes of conduct. This requires, at a methodological level, some careful attention to the small, concrete and apparently banal mechanisms through which these transformations can take place.

The theoretical framework developed in these readings concerning the way that culture is instrumentalized and hitched to governmental programmes can provide a useful focus for considering the next set of readings. Though mostly not Foucauldian in their mode of analysis they are concerned with the pragmatics of managing collections and museums in the context of both desirable and undesirable pressures on and within the museum sector. What dilemmas do museums encounter when grappling with the often conflicting interests they seek to serve – from public funding bodies, visitors, tourists, local or ethnically specific communities, academic and research communities, and so on? These readings allow us to think more clearly about issues of access, equity and cultural authority within the museum, as well as the ways in which 'heritage' defines and constitutes a domain that is seen as needing to be managed.

In recent years museums have had to face up to processes of decolonization, the presence and demands of multi-ethnic national populations, the internal critiques of disciplines such as anthropology and art history, the increasing commercialization of the domain of public culture, and the broader revolution with the social sciences and humanities, which have questioned the absolute distinctions dominant in the modern age between subject and object, knower and known. Although these pressures impact diversely upon the policies of the museum sector, the net result in general terms is that the whole idea of the institutions of culture as universalizing, civilizing edifices, has shattered. A central contributor to these transformations is the diffusion of display culture into popular cultural markets – from theme parks to heritage trails – in which spectacle, accessibility and brute experience are the over-riding concerns (see Rojek, in this volume). At the same time as the rise of heritage culture, museums in most of the industrial economies have had their funding cut as part of a drive to control public expenditure. One upshot of this concatenation of pressures is that curators now seek to be accountable to those they represent and are chary of making scientistic claims backed up by the paternalistic authority and objective connotations of the museum.

The cultural and national relativity of the museum form is indicated in Arjun Appadurai and Carol A. Breckenridge's 'Museums are good to think: heritage on view in India'. For they place Indian museums in the context of a national culture in which heritage is not institutionalized as a bygone past. It is, rather, a 'live component of the human environment' (Appadurai and Breckenridge, in this volume, p. 405). There is a concern to locate museum and collection practices firmly within what the authors call 'the public sphere'. This does not simply mean that they are public institutions, it also means that they play an important role in regulating the definition of that which is public, and, by extension, of 'the people'. In India, the argument goes on, this relationship is not marked, as in many Western societies, by a separation of the past from the present, the sacred from the secular, the commercial from the non-commercial. There is a 'grey zone where display, retailing and festivity shade into one another' (ibid., p. 405). If the cultural specificity of India requires a positive 'interocular' approach in which the management of museums embraces the principles of interaction, diversity and 'inter-textuality', Sharon Macdonald and Roger Silverstone, writing about the Science Museum in London, sound a note of warning about the collapse of some of the old boundaries in a museum culture increasingly having to operate under the pressures of a market-led economy. David Goodman's prescient remarks at the end of his 'Fear of circuses' provide an historical context for their article. Goodman suggests that whilst the museum of the mid-nineteenth century had to be set apart by its austere presentation, scientific classification systems and rejection of popular experience, today's museum sets itself against the mass-mediating forms of the television and the cinema (in this volume, p. 270). The 'experience of the real object' as a kind of simulated authenticity and the return to tactile and immediate sensation is, he suggests, what constitutes the regime of the museum in the last decades of this century. However, his remark that museums now maintain their 'distinctiveness' by *not* using the mass-reproduced, electronically mediated forms of popular culture is perhaps somewhat overstated. The hybrid combination of mass media forms *and* direct sensation in displays is surely what characterizes museums at the end of the twentieth century. We can see this as representative of a shift in which museums rethink the competencies of their audiences, move towards market segmentation and conceptualize their communities as domains of active participation — all this in a retreat from the promise of a total and inclusive account which has, in the modern period, underwritten the museum exhibition.

In 'Rewriting the museums' fictions: taxonomies, stories and readers' Macdonald and Silverstone examine a gallery in the London Science Museum — *Food for Thought: the Sainsbury Gallery* — at a time when this museum was being pressured to shift its priorities. At the beginning of the 1990s, public museums were beginning to apply charges for entry; the visiting public, a founding principle of the fully accessible national museum, was being inexorably reinvented as the individualized unit of the customer. The effect of these changes, Macdonald and Silverstone show, 'is not only upon what museums do, but on the definition of museums themselves' (p. 427). Museum displays are no longer defined by their collections, but by the stories they tell, woven around artefacts or locations. They

indicate how the chosen theme of the exhibition, as well as the lack of specialist knowledge possessed on the subject by the team who devised it, manifested a desire to structure the exhibits around a lay or common level of understanding in which accessibility prevailed as a key aim. Visitors are asked to identify with the narrative as consumers first, and sensory experience is encouraged; judgements or prescriptions about good or bad diets are suspended in order to present visitors with open-ended questions. They conclude that the visitor has become not only a consumer but also a curator, since the museum's withdrawal from the traditional, modernist modes of authorial and authoritative curatorship means that the job of being responsible for the overall meaning of the exhibition is passed on to the visitor.

A different argument is made by the social anthropologist, James Clifford, in our final reading. 'Museums as contact zones' continues the critique of modernist forms of knowledge – in which the anthropologist/curator is singularly endowed with authoritative knowledge and interpretation – with which so much of Clifford's work has been occupied. Thus his work is positioned within those discourses of empowerment of the community with which some of those belonging to the progressive ethnographic and art gallery sector have become preoccupied, and which have displaced formerly held allegiances to nation-states and a unified, singular national culture. In this reading he opens up quite directly the issue of the interaction between an ethnographic museum and the communities it seeks to represent or nurture. One way in which curators have sought to redress the power relations inaugurated in the era of colonial anthropology is by demonstrating awareness of the partiality of their own knowledges in the construction of museum displays, a development that we have just seen in the different setting of the Science Museum (see Clifford and Marcus, 1986). He argues that the facts of colonial exploitation and the consequent construction of the colonized 'other', now well established in cultural history and critical anthropology, represent only a partial account of the colonial encounter. For the purposes of this argument he employs Mary Louise Pratt's metaphor of 'contact zones' in order to think about the twentieth-century museum as a space of intercultural encounter between colonized and colonizer, so that the museum becomes a site for the negotiation of meanings and values in which reciprocity can ideally be achieved (see Pratt, 1992). It may well be that, as Tony Bennett has recently argued, Clifford's account represents a continuation of the romantic attitude in which the community survives and resists dominant cultural programmes, and in which 'realms of government or of the state stand condemned as external and impositional forms which are either indifferent or antagonistic to the creative cultural life of communities' (1998: 201). If this is the case, it might be better to think about how communities are themselves the by-product of policies and interventionist practices. None the less, Clifford's article is useful in highlighting the complexities of achieving a meaningfully equitable museum practice, a practice that will be demanded of museums for as long as they continue to represent nations, cultures and communities.

References

Bennett, Tony (1998) *Culture: a reformer's science*, London: Sage.

Clifford, James and Marcus, George (1986) *Writing Culture: the poetics and politics of ethnography*, Berkeley: University of California Press.

Cunningham, Stuart (1993) 'Cultural Studies from the viewpoint of cultural policy', in Graeme Turner (ed.), *National Culture, Text: Australian cultural and media studies*, London and New York: Routledge.

Pratt, Mary Louise (1992) *Imperial Eyes: travel writing and transculturation*, London: Routledge.

Kenneth Hudson

ATTEMPTS TO DEFINE 'MUSEUM'

AT THE TENTH GENERAL CONFERENCE of the International Council of Museums (ICOM), held in Copenhagen in 1974, it was made clear that museums throughout the world are coming to regard themselves less and less as self-contained professional units and more and more as cultural centres for the communities within which they operate. One could summarise the change by saying that museums are no longer considered to be merely storehouses or agents for the preservation of a country's cultural and natural heritage, but powerful instruments of education in the broadest sense. What a museum is attempting to achieve has become more important than what it is. This trend, which is unmistakable, makes the definition of a museum increasingly difficult and perhaps increasingly pointless. The rapid increase in new types of museum – technical, scientific, agricultural, ecological, ethnographical – throughout the world has strained the traditional definitions to breaking point. For many years ICOM has tried hard and progressively to define a museum in a way which might be found reasonably satisfactory from Canada to the Congo. It is an unenviable task and, inevitably, the definition has had to be modified from time to time, with a diplomatic phrase added here and an explosive word removed there.

The 1971 version embodies the wisdom developed over many years of argument, conferences and international battles. 'The museum', ICOM suggested, 'is an institution which serves the community. It acquires, preserves, makes intelligible and, as an essential part of its function, presents to the public the material evidence concerning man and nature. It does this in such a way as to provide opportunities for study, education and enjoyment.'

But who, one may reasonably ask, is to decide whether a museum is serving the community or not? What proportion of the community does it have to serve in order to justify its existence? What limits are to be set to such a vague concept as 'the community'? What level of intelligence and education is assumed when the museum attempts to make its collections intelligible?

The museum, as Richard Grove has pointed out, 'is a nearly unique peculiarity. A hospital is a hospital. A library is a library. A rose is a rose. But a museum is Colonial Williamsburg, Mrs. Wilkerson's Figure Bottle Museum, the Museum of Modern Art, the Sea Lion Caves, the American Museum of Natural History, the Barton Museum of Whiskey History, the Cloisters, and Noell's Ark Chimpanzee Farm and Gorilla Show.'[1]

If the word 'museum' is required to cover both the American Museum of Natural History and Mrs Wilkerson's Figure Bottle Museum, it could conceivably have outlived its usefulness. Both institutions might well claim that they were providing 'opportunities for study, education and enjoyment', yet a discriminating observer would almost certainly sense some essential difference between the two. Pressed to say what this difference was, he would probably answer that the American Museum of Natural History was not primarily aiming to make money from the public, whereas Mrs Wilkerson certainly was. He might also add that in the case of Mrs Wilkerson the balance between study, education and enjoyment was unsatisfactory. But who is to say where enjoyment ends and education begins? How can one possibly judge what is going through a museum visitor's mind as he stands gazing at a Giotto or a giraffe?

By 1974 the ICOM definition had been completely overhauled and rebuilt and a number of previous ambiguities removed. According to the Statutes adopted at the 10th General Assembly in that year, a museum is 'a non-profit-making, permanent institution in the service of society and of its development, and open to the public, which acquires, conserves, researches, communicates, and exhibits, for purposes of study, education and enjoyment, material evidence of man and his environment'.

The following are considered to comply with this definition, in addition to museums designated as such:

(a) conservation institutes and exhibition galleries permanently maintained by libraries and archive centres;

(b) natural, archaeological, and ethnographic monuments and sites and historical monuments and sites of a museum nature, for their acquisition, conservation and communication activities;

(c) institutions displaying live specimens, such as botanical and zoological gardens, aquaria, vivaria, etc.;

(d) nature reserves;

(e) science centres and planetaria.

It is clear from this that a much greater range of institutions now has the right to the name 'museum' than was the case only twenty years ago, but not every museum appears to have the same liberal views as ICOM itself. In 1974–5, while this very wide definition was in the process of being absorbed and accepted by the museum profession as a whole, the author of the present work invited people throughout the world who were professionally involved in museum work to write down their own brief definition of the word 'museum'. A few avoided the problem by saying that they found the ICOM definition perfectly satisfactory[2] and that they had no modifications to suggest, and others[3] were able to content themselves with their countries' legal definition of a museum. 'In Japan,' we were informed, 'the

definition given in Article 2 of Museum Law (Law No. 285 of 1951, revised several times) is used most widely. Some museologists prefer a somewhat different wording, but the import is substantially the same. Therefore, you can safely judge that the word "museum" is defined in Japan according to the above-mentioned Law, as cited below:

> "Museums" as used in this Law shall mean such organs (excluding citizens' public halls under the Social Education Law and the libraries under the Library Law), which have the purpose of collecting, keeping in custody inclusive of fostering, and exhibiting materials concerning history, fine art, ethnic customs, industries, natural science, etc., so that they are offered for public use under educational care, and of conducting necessary business to serve for people's cultural attainments, research, survey, recreation, etc., and of making research and survey pertaining to such materials.'

A number of respondents put the instructional function of the museum first. According to the director of the Museum of Archaeology in Barcelona, a museum is 'a didactic institution which carries out its task of cultural dissemination by audio-visual techniques which are employed in display areas of various kinds'. The Museum of Folklore and Ethnology at Thessaloniki, Greece, considered a museum to be 'a place where one displays, scientifically and didactically, objects or works of art which produce for the visitor conditions in which he is likely to add to his knowledge'. In Cologne, the Römisch-Germanisches Museum saw its function as 'providing material with which our citizens can educate themselves', and in Nicosia the Cyprus Museum believed its duty was 'to give the museum an educational aspect and make it a research centre'.

The words 'culture' and 'cultural' are much used outside the English-speaking countries in connection with museums and very little within them. The Institution of Conservation and Methodology of Museums in Budapest believes that 'a museum is a cultural institution, performing tasks of collection, research and education'. The Executive of the Association of Museum Curators in Madrid saw a museum as having 'purely cultural aims', and the Bardo National Museum in Tunisia regards itself as 'a cultural and educational centre, reflecting civilisations which have existed in Tunisia'.

The developing countries of the world frequently stress the importance of museums as a means of spreading and reinforcing the national consciousness or, as they often express it, the national culture. In such new states as Ghana or Tanzania, the word 'culture' has a powerful emotive force. To be independent is to assert the vigour and autonomy of one's own culture and it is unthinkable that museums, schools, newspapers, or any other means of public enlightenment would think or act differently. 'Culture', in such a context, is both the accumulated traditions of the national territory and the basis of all government policy and planning.

The Anglo-Saxon countries tend to avoid the word 'culture', except in a scientific or ethnological sense, and to be somewhat embarrassed by it. Most of the rest of the world, however, uses the term easily and naturally enough, although not always with a great deal of precision. 'Culture' undoubtedly varies in meaning

from country to country and for that reason it is a word to be used with great caution. ICOM has acted prudently in omitting it from its current definition of a museum. It was, however, still in use in 1951, when the Executive Committee decided that ICOM would recognise as a museum 'any permanent institution which conserves and displays, for purposes of study, education and enjoyment, collections of objects of cultural or scientific significance'. Nowadays, the definition very wisely plays down 'culture' which can and often does have elitist, political-theological and nationalistic overtones, and emphasises instead 'community'.

The aim of 'serving the community' brings problems of its own. Any institution which consciously and deliberately sets out to do this will necessarily find itself compelled to find some means of measuring its success. It will have to discover, as a continuous process, what its customers think about the goods being offered to them. The community museum is unavoidably involved in market research. The old-style autocratic museum, of which many still survive, was under no such obligation. But merely to monitor the results of what one has already done is inadequate and uncreative. The true skill of any form of market research, and that practised in museums is no exception, lies first in asking the right questions and second in using one's findings to produce something which is closer to what the customer really wants. Monitoring by itself is of no great value.

During the past twenty-five years especially, the museum-going public has changed a great deal, and it is still changing. Its range of interests has widened, it is far less reverent and respectful in its attitudes, it expects to find electronic and other modern technical facilities adequately used, it distinguishes less and less between a museum and an exhibition, it considers the intellect to be no more prestigious or respectable than the emotions, and it sees no reason to pay attention to the subject-division and specialisms which are so dear to academics. This is a reflection of a fundamental change in thought and behaviour throughout the world, and in all fields of activity. People are no longer content to have their lives run for them dictatorially by a few powerful and privileged people. They are increasingly demanding a say in the planning and the organisation.

It remains true, however, that a museum is essentially an institution in which objects – a better phrase, perhaps, is 'real things' – are the principal means of communication. Dr Alma S. Wittlin uses this fact in order to arrive at what one might call a negative definition of museums.[4]

> Establishments [she says] in which objects are not used at all, or are not used as main carriers of messages, are not museums, whatever their qualities may be otherwise. A place in which people are exposed to changing lights or to a galaxy of light and sound unrelated to objects may offer a new kind of symphony or a carnival, according to its quality, but it is not a museum. If a few objects provided by a museum or by any source are used in a club or a recreation centre among other items on the programme, such as dancing or discussions of current problems and of vocational opportunities, the place still retains its identity. The term museum is neither better nor worse than the term club or centre. We dim the outlook on our goals if we instil terms with connotations of borrowed status. . . .

> There is considerable scope for a combination of objects with other media, with brief motion pictures illustrating a single concept or with appropriately designed (and not overdesigned) suitably sized and placed graphics, but objects have to remain the stars of the cast.

Few museologists would disagree with this, but in order to accept Dr Wittlin's theory completely one has to define 'object' in a wider sense than many people feel to be reasonable. Can a living plant or fish or animal be reasonably termed an object, without straining the ordinary use of language? Is it carrying empire-building too far to call a botanical garden, a zoo or an aquarium or, for that matter, a library a museum? A library certainly contains objects and it might well be described as a museum of books, but it somehow seems more sensible to continue to call it a library.

Zoos and aquaria are, perhaps, borderline cases, but ICOM and Dr Wittlin might find themselves in greater difficulties with the San Francisco Museum of Conceptual Art, which describes itself as functioning on two levels, 'as a storehouse and library for documentation of events and happenings and conceptual projects from all over the world, but primarily as a place where these may take place and be witnessed'. There are, either fortunately or regrettably, no patent rights attached to the word 'museum'. The most unworthy and incongruous institution is free to describe itself as a museum, despite the attempts made in many countries to establish some kind of official criterion. In the United States, for instance, the American Museums Association has set up a system of accreditation. In order to be approved in this way a museum has to meet three requirements – it must have a permanent collection, it must have a professional staff and it must take proper pains to display its material to the public. Yet, ironically, it is perfectly possible for a dull museum to receive accreditation and a lively one to be denied it.

In a period of rapid and fundamental social change it is natural and highly desirable that those in charge of museums should ask themselves with some frequency such questions as 'Why does this museum exist? How relevant is it to the needs and conditions of the society in which it exists? What, things being as they are, is its main task? How do I measure its success?' The public answers to these questions are not, of course, always the same as the private answers and many of the statements made by museologists in published articles and at international conferences need to be interpreted with some skill, and with considerable knowledge of the countries in which these experts operate.

There is some pressure within American society and increasingly elsewhere, too, which makes it difficult to make a public statement in simple, straightforward language. Museologists are all too likely to produce such unhelpful sentences as 'The affectable changes in attitude and involvement by museum visitors, as a result of integrated museum experience, is observable within the museum environment'. The urge to grade-up one's utterances by weaving in sociological jargon is difficult to resist, and the result is often a totally misleading impression of the person or institution concerned. No museum could be less pompous or academic than the Brooklyn Children's Museum in New York, yet a member of its staff found it possible to define a museum as 'a facility devoted to the preservation and promotion of the cultural arts and sciences through the use of specific resources that generally are not maintained in the course of daily events or used within the context

of daily routine', phrases which do not suggest the lively, original Brooklyn Children's Museum at all.

Many museums see their prime function as that of preserving the relics of the past. The National Museum of Denmark, for instance, considers itself to be 'an institution for assembling material evidence of the past for display to the present and conservation in the future'. The Vatican Museums believe that a museum is 'a place intended for the preservation and display of unwritten testimonies of the past'. Few museums nowadays would find it either possible or politic to place such a strong emphasis on preserving the achievements of the past. In India, on the other hand, there is a widespread feeling that the museums of that country are far too concerned with ancient history and that the generation which has grown up since Independence is much more anxious to be informed about what has been happening in more recent years. The Ministry of Education has devoted much money and thought to producing well-written school textbooks on social studies and modern history and it would like to see this new kind of teaching, which has started in the classrooms, reflected and continued in museums. In its campaign to divert attention from the past, the Ministry is giving all the support it can to the teaching of science and technology, and it considers that museums have an important part to play in this.

The official Chinese attitude to history, whether inside or outside museums, has not always been easy to understand. At one point there was a strongly marked tendency to decry and even to reject the traditional culture, and western visitors were surprised by such experiences as being taken round a pottery which had been operating for more than six hundred years and being told that it had produced nothing of any value or interest before 1949. This appeared particularly strange to one visitor, who felt that the current output of the pottery was in no way to be compared with what had been made there previously.

It is not easy for a developing country, which must always be conscious that time is not on its side, to show the regard for history and tradition which, ideally, one might hope to see. If, for political reasons, the past is viewed in a selective fashion or if certain features in the country's history are exaggerated to an unjustified extent, the task of some museum curators may become difficult or even impossible. The problem is a complicated one, especially in the case of museums which are concerned with history and ethnography. There may, for instance, be no agreed or acceptable guidelines as to the history of the country as a whole, but there can, within the same country, be a strong consensus of opinion on the history of a particular region or a particular period.

The National Museum in Ghana takes a view which one hopes will work out satisfactorily in practice. 'A museum', it says, 'is an institution which acquires, preserves and presents material to the public, not for profit, but for their information and enjoyment. The museum should take the interest of all sections of its community into consideration; it should highlight some of the current topical subjects in the community, such as agriculture, health and politics. It should not acquire everything, but should encourage the community to cherish its culture.'

'Current topical subjects' are not easy to handle within a museum context, often because of philosophical and political disagreements within the local or national community. In many, perhaps most, countries there is no problem. Certain

subjects are known to be of public importance and there is general acceptance of the broad lines of presentation. Elsewhere, however – and this is true of most western countries – highly topical and socially important matters can be so controversial that museum directors can be excused from fighting shy of them. This can show itself in curious ways. In East Berlin, for instance, there is the excellent Museum of German History. Such a museum is possible, because the German Democratic Republic has an agreed philosophy of history. Contemporary events can therefore be reflected in temporary exhibitions, in the sure knowledge that the past and the present will not find themselves in conflict. There is, however, no really comparable national Museum of German History in the Federal Republic, or for that matter in France, England or the United States, because in these countries there is no common agreement on the interpretation of the nation's history.

A Chinese museum finds no difficulty whatever in arranging a special exhibition on the necessity and methods of birth control. An American or Belgium museum would almost certainly find itself unable to do so. On the other hand, the Museum of the City of New York experienced no serious problems in devoting part of its space, in the spring of 1974, to an exhibition illustrating the dangers and treatment of venereal disease, since no citizens and taxpayers in New York would be likely to come forward to state that venereal disease was a desirable feature of society, which should be officially encouraged.

One can sense throughout the world, however, two developments of great importance to museums. One is a growing feeling that the past and the present shade off into one another and that a sensitivity to the achievements of the past can be a great help towards understanding the present. The second notable change, compared with twenty or thirty years ago, is a willingness to accept the fact that museums can be appreciated emotionally and sensually as well as intellectually. This is, as yet, best understood, perhaps, in art museums. 'Today's museum', says the Museum of Fine Art in Rio de Janeiro, 'is a place in which visitors acquire experiences and receive impressions which stimulate their powers of thought and their creative ability.' The Royal Scottish Museum, in Edinburgh, speaks of 'using objects made by man or produced by nature' to 'enrich the human experience'. 'Experience', nevertheless, is a word that should be used with considerable care. It can easily degenerate into a jargon term, behind which it is all too easy for the lazy or woolly-minded curator to shelter.

The changing concept of a museum's function

To emphasise 'experience' can, however, lead a museum a very long way from traditional methods of display, and force it to realise, however unwillingly, that it is in the communication business. It is dangerous and ridiculous, even so, to become enthusiastic about 'communication' without having a clear idea as to what one is trying to communicate or why or to whom. Merely to 'communicate' is as absurd a concept as to 'love' or to 'believe'. Another fashionable museum word, 'participation', is often used in the same loose and largely meaningless way.

There were examples of this regrettable modern tendency to allow the heart to conquer the head at a seminar held in 1967 at the Museum of the City of New

York. In the course of the proceedings, Dr Marshall McLuhan expressed a characteristically exaggerated and provocative view, when he attacked what he described as 'the story-line approach' – using artifacts to illustrate a story or theme. He praised Expo 67 on the grounds that it was the first world's fair to have no storyline whatever. It was, he said, 'just a mosaic of discontinuous items in which people took an immense satisfaction precisely *because* they weren't being told anything about the overall pattern or shape of it, but they were free to discover and participate and involve themselves in the total overall thing. The result was that they never got fatigued.'[5]

During the seminar, the general outline of the 'participating' museum emerged. It would ask the visitor questions, rather than give him answers. It would encourage visitors to touch objects. It would give equal value to understanding through the ear and understanding through the eye. It would assume that communication was both complex and untidy, that the person 'who lives in an oral world, that is where the primary method of communication is by mouth to ear, lives at the centre of a sphere where communication comes into him simultaneously from all sides, banging at him'.

Dr McLuhan's ideas of what a museum can and should do are clearly very different from those current in the museum world thirty or forty years ago. They are possible only as a result of new electronic tools and they illustrate how museums need to be continually redefined, within the context of new technical resources and new social demands.

Museums were a product of the Renaissance, a product of an aristocratic and hierarchical society which believed that art and scholarship were for a closed circle. In Europe and in most colonial territories, museums and art galleries began at a time when the people who controlled them had a contempt for the masses. Collections were formed by men who wished to display them to others with the same tastes and the same level of knowledge as themselves, to connoisseurs and scholars. Any idea that there might be a duty to make this material interesting or intelligible to a wider range of visitors would have seemed ludicrous.

In the seventeenth century only distinguished travellers and foreign scholars were, as a rule, permitted to see the collections belonging to the European princes, which were often housed in the palaces themselves. A similar attitude controlled visits to the botanical gardens. After 1700 the general public was admitted to the Imperial Gallery in Vienna on payment of a fee and there were similar opportunities in Rome, at the Quirinal Palace, and in Madrid, at the Escorial. On the other hand, the pictures belonging to the French monarchy remained inaccessible to the public until half-way through the eighteenth century when, as a result of petitions, about a hundred paintings were hung in the Luxembourg Palace, where the public would see them on two days a week. At one time England had a particularly bad name for the secrecy and possessiveness of her collectors. The wealthy English, who bought widely in Italy and other continental countries throughout the seventeenth and eighteenth centuries, had little feeling that their collections might, as cultural assets, belong to the nation or to Europe as a whole and that it was irresponsible to prevent other people from enjoying them. Some, at least, of the German courts took a more generous and progressive view. The gallery at Dresden, for example, could be viewed without difficulty from 1746 onwards.

When public museums, such as the British Museum, were established in Europe at the end of the century, they carried on the traditions of the private collections. They might belong to the state, or to a body of trustees, but they were as exclusive and elitist as their predecessors. They were run by autocrats, who asked for nobody's advice as to how the collections should be presented or organised. Visitors were admitted as a privilege, not as a right, and consequently gratitude and admiration, not criticism, were required of them.

But, in any case, the language in which criticism could be expressed took a long time to develop. To bring together into, say, Arundel House in London works of art from Italy, Germany, the Netherlands, Greece and the Middle East was to transform them into something artificial and different. The museum, an entirely European development, removes the picture or sculpture from its original, meaningful context and compels the visitor to see it as an isolated abstraction, a work of art. To analyse and describe it in terms of this new concept demanded a fresh attitude, a different kind of expertise and a specialised phraseology. [. . .]

Notes

1 'Some problems in museum education', in *Museums and Education*, ed. Eric Larrabee (Washington: 1968), p. 79.
2 Musée Royal, Mariemont, Belgium; Museo del Prado, Madrid; Musées d'Archéologie et des Arts Décoratifs, Liège; Ethnographical Museum, Antwerp.
3 Notably Bernice P. Bishop Museum, Honolulu; National Science Museum, Tokyo.
4 *Museums in Search of a Usable Future* 1970, pp. 203–4.
5 *Exploration of the Ways, Means and Value of Museum Communication with the Viewing Public* (New York: Museum of the City of New York, 1969), p. 3.

Tony Bennett

USEFUL CULTURE

To work with a government implies neither subjection nor global acceptance. One can simultaneously work and be restive. I even think that the two go together.

(Foucault)

IT IS USEFUL, in the context of the so-called 'policy debate' in cultural studies, to call to mind Foucault's contention that – as Colin Gordon summarizes it – a governmental logic of and for the left ought to be possible, 'involving a way for the governed to work with government, without any assumption of compliance or complicity, on actual and common problems' (1991: 48). For, predictably enough, the mere mention of terms like 'government' and 'policy' in connection with cultural studies sparks off in some a yearning for a moment of pure politics – a return to 1968 – in whose name any traffic with the domain of government can be written off as a sell-out. Something of this was evident in Helen Grace's (1991) review of the Australian cultural studies conference held at the University of Western Sydney in December 1990, and especially in the oppositions which organize the discursive strategy of that review in, on the one hand linking the turn to policy with pragmatically driven research and a yearning for money and power while, on the other, ranging against these an uncontaminated holy trinity of theory, scholarship and textual analysis.

My principal concern here, then, is to suggest that viewing 'the policy debate' through the prism of such oppositions runs the risk of distorting the issues that are at stake in that debate.[1] These, I want to argue, do not take the form of a generalized choice between theory on the one hand and policy on the other, or between textual analysis and pragmatically oriented research. Rather, they take the form of a choice between *different* bodies and styles of theory, between *different* ways of construing the relations between theoretical and pragmatic concerns, and

between *different* kinds of textual analysis and their associated estimations of the issues at stake in the conduct of such analysis.

This is not intended, however, as a way of pulling the policy punch, or of seeking to legitimize policy work by claiming that it, too, can lay claim to a stock of theoretical credentials of its own. Nor is it intended as a pluralist argument for relations of peaceful coexistence with other styles, paradigms or tendencies within cultural studies. This is not to suggest that all work within cultural studies (however we might want to define it) should or need be directly concerned with policy matters. What it is to suggest is that all such work is indirectly affected by policy issues and horizons. This being so, my contention is that recognition of this would, and should, make a considerable difference to the manner in which the concerns of cultural studies are broached and conceptualized as well as to the political styles and dispositions governing the ways in which work in the field is conducted and the constituencies to which it is addressed.

In these respects, my presentation takes its bearings from Stuart Cunningham's (1991) contention that the incorporation of an adequate and thorough-going policy orientation into cultural studies would see a shift in its 'command metaphors away from rhetorics of resistance, progressiveness, and anti-commercialism on the one hand, and populism on the other, toward those of access, equity, empowerment and the divination of opportunities to exercise appropriate cultural leadership'.[2] Such a project, Cunningham argues, enjoins a far-reaching theoretical revisionism that 'would necessitate rethinking the component parts of the field from the ground up'. It is to this task that I wish to contribute here by reviewing – and suggesting alternatives to – the concepts of culture which have subtended the cultural studies enterprise.[3]

Histories of culture

This is a timely undertaking. In *Politics and Letters*, Williams claimed that his motives in writing *Culture and Society* were mainly oppositional. His aim, he wrote, was 'to counter the appropriation of a long line of thinking about culture to what were by now decisively reactionary positions' rather than 'to found a new position' (1979: 97–8). There can be little doubt that this work proved to be decisively enabling for the subsequent development of cultural studies in the new views and definitions of culture it helped establish. The limitations of the new definitional horizons Williams thus opened up, however, are becoming increasingly apparent.

The respects in which Williams's concept of culture as a 'whole way of life' is connected to a Romantic conception of historical process as one destined to restore us to the communal ways of living from which it has allegedly rent us asunder have already been commented on (see Hunter, 1988). So, too, have the respects in which his enthusiasm for the historical restitution of community rests on an over-sentimental attachment to the patriarchal forms of Welsh working-class culture (see Jardine and Swindells, 1989). Here, then, I shall seek to add to these perspectives by focusing on the limitations of the kind of historical account Williams offers of the evolution of the range of meanings associated with 'culture' in its modern usage.

These limitations are not ones of error; rather, they are ones of implication. I do not, that is to say, wish to question Williams's reading of the line of descent from Coleridge and Newman to Arnold and thence to Leavis. What I do want to question, however, is the assumption – largely taken on trust within cultural studies – that an adequate definition of culture can be derived from such an analysis. In tracing the emergence of the selective definition of culture, understood as a standard of achieved perfection, Williams offers an account of its functioning as a key term in modern forms of social critique and commentary. Important though this is, there are limits to the conclusions that can be derived from such a history. In particular, there are no good reasons to suppose that such semantic shifts can be regarded as anything but symptomatic of the concurrent changes affecting the organization and social functioning of those practices which fall within the category of culture so defined. Or, to put this another way: the changing definitional contours of 'culture' comprise merely a part of the changing set of relations in which, in the period since the late eighteenth century, cultural forms and activities have come to be implicated. Viewed in this light, I want to suggest, the transformations we should take most note of concern less the changing semantic fortunes of 'culture', particularly as manifested in its development into a standard of achieved perfection, than the role which such developments played in relation to the emergence of the wider domain of 'the cultural' as a field of social management. This, then, is the nature of the revisionism I wish to propose, one in which the distinctiveness of culture – in its modern forms – is sought less in the specificity of its practices than in the specificity of the governmental tasks and programmes in which those practices come to be inscribed. By 'governmental' here, I should stress, I do not mean 'of or pertaining to the state'. Rather, I have in mind the much broader conception of the governmentalization of social relations – that is, the management of populations by means of specific knowledges, programmes and technologies – which, according to Foucault, most clearly distinguishes modern forms of social regulation from their predecessors. An adequate genealogy of modern culture, I want to suggest, needs to take more account of culture's practical deployment within such governmental processes than previous accounts have been wont to.

The perspectives I shall draw on in support of this argument are derived from work-in-progress on the early history of the public museum and, in the British context, the rational recreations movement. These provide some rough and ready co-ordinates for a history of culture which focuses on the manner in which the practices that are so described have come to be rendered useful by being harnessed to governmental programmes aimed at transforming the attributes – mental and behavioural – of extended populations. Such a history would, of course, be quite different from the more familiar ones within cultural studies in that it would take its bearings from the changing forms and contexts of culture's governmental and administrative utilization rather than from its shifting semantic horizons. It is a history, moreover, written in the institutional arrangements and programmes developed by cultural administrators like Henry Cole – the architect of the Great Exhibition and of London's South Kensington museum complex – rather than, as Williams proposed, one contained in the texts of cultural critics. And it is a history, finally, in which policy – which, in its broad sense, I define as the governmental

utilization of culture for specific ends — would appear not as an optional add-on but as central to the definition and constitution of culture and so also, therefore, equally central to the concerns of cultural studies.

There is no space, here, to do more than sketch the contours of such a history. In doing so, however, I shall try to demonstrate how the arguments advanced so far undermine the intelligibility of a polarity between, on the one hand, theory, politics and textual analysis and, on the other, an unprincipled, policy-oriented pragmatism. I shall do so by means of three provocations. First, I shall seek to show how a stress on the governmental utilization of culture can suggest new approaches to some of the perennial theoretical problems and concerns of cultural studies. My contention in this regard will be that the emergence of the modern relations between high and popular culture can be viewed as an artefact of govern-ment in view of the degree to which the former was — and still is — subjected to a governmental technologization or instrumentalization in order to render it useful as a means of social management. Second, I shall endeavour to show how acknow-ledging the intrinsically governmental constitution of modern culture undermines the logic of a cultural politics of resistance or opposition to some generalized source of cultural domination. I shall suggest that, to the contrary, modern forms of cultural politics often have their origins and *raison d'être* in the governmentaliza-tion of culture: that is, that the objectives to which they are committed are a by-product of the governmental uses to which specific forms of culture have been put just as those objectives can only be met via modifications to existing govern-mental programmes or the development of new ones. My third provocation will be to suggest that the ends toward which textual analysis is directed, the means by which such analysis is conducted and the political issues which hinge on its pursuit are an effect of the ways in which specific regions of culture (literature, art) have been instrumentalized via their inscription within particular governmental cultural technologies or apparatuses.

Culture and power

As good a way as any of broaching these various issues is to suggest that cultural studies might usefully review its understanding of the relations between culture and power in the light of Foucault's critique of juridico-discursive conceptions of power. The main burden of Foucault's critique, it will be recalled, is that western political thought, up to and including Marxist theories of the state, has proved incapable of recognizing the capillary network of power relations associated with the development of modern forms of government because it still envisages power, on the model of its monarchical form, as emanating from a single source. The primary concern of political theory has accordingly been to specify how limits might be placed on the exercise of such power or to identify sources external to it from which it might be opposed. To cut off the king's head in political theory, Foucault argues, means 'that we should direct our researches on the nature of power not towards the juridical edifice of sovereignty, the state apparatuses and the ideologies which accompany them, but towards domination and the material operators of power, towards forms of subjection and the inflections and utilizations

of their localized systems, and towards strategic apparatuses' (1980: 102). It also means, he argues, that we should forsake looking for a source outside power from which it might be opposed and seek instead to identify the differentiated forms of resistance which the exercise of power – through multiple and dispersed networks of relations – itself generates.

Many of the views regarding the relations between culture and power still current within cultural studies suggest that an equivalent cutting off of the king's head has yet to take place. While the dominant ideology thesis has few remaining supporters, the perspective of cultural hegemony which – by and large – has replaced that thesis remains committed to a juridico-discursive conception of power in its deployment of what Foucault calls a descending analysis of power which, in positing a centre of and for power, then aims to trace the means by which that power percolates down through the social structure so as to reproduce itself in its molecular elements. It is true that, in its more sophisticated variants, this perspective stresses the negotiated nature of this process: that is, that power is never exercised without encountering sources of opposition to which it is obliged to make concessions so that what is consented to is always a power that has been modified in the course of its exercise. None the less, it remains the case that the field of culture is thought of as structured by the descending flows of hegemonic ideologies, transmitted from the centres of bourgeois cultural power, as they reach into and reorganize the everyday culture of the subordinate classes. As a consequence, analysis is then often concerned to ascertain how far and how deeply such ideologies have reached into the lives of the subordinate classes or, *per contra*, to determine the extent to which their downward transmission has been successfully resisted. It is thus that studies of the mid-nineteenth-century advocacy of rational recreations are usually preoccupied with assessing the degree to which bourgeois cultural and ideological values succeeded in reorganizing working-class thought and feeling, and especially with determining how far down the class structure their influence reached: only so far as the upper reaches of the labour aristocracy or more deeply into the 'respectable' sections of the working class (see, e.g., Bailey, 1987; Gray, 1976)?

While not wishing to gainsay the importance of such concerns, the focus they embody is, at best, one-eyed. For the assumption that the advocacy of rational recreations was premised on their anticipated success in transforming working-class ideology and consciousness is a questionable one, and especially so if it is supposed that such a transformation was expected to result from the working-class's simple exposure to the purely mental influence of such recreations. Rather, cultural reformers were often less concerned with questions of consciousness than with the field of habits and manners. Moreover, in so far as they did anticipate any changes in the former, it was thought that this would only come about as a result of transformations in habitual norms and codes of conduct that contact with rational recreations would effect.

Such contact, however, was not envisaged as exclusively or even mainly mental in form. Rather, if access to the world of rational recreations was expected to result in changed forms of behaviour and habits of conduct, this was because that contact was planned to take place in a technologized environment – the museum or the concert hall, for example – in which the desired behavioural effect was to

result not from contact with 'culture' in itself but rather from the deployment of cultural objects within a specific field of social and technological relations. Thomas Greenwood's staunch advocacy of the civilizing virtues of science museums thus rested less on the intrinsic properties of the objects displayed than on the manner of their display within the specialized classificatory environment of the museum.

> The working man or agricultural labourer who spends his holiday in a walk through any well-arranged Museum cannot fail to come away with a deeply-rooted and reverential sense of the extent of knowledge possessed by his fellow-men. It is not the objects themselves that he sees there, and wonders at, that cause this impression, so much as the order and evident science which he cannot but recognise in the manner in which they are grouped and arranged. He learns that there is a meaning and value in every object, however insignificant, and that there is a way of looking, at things common and rare, distinct from regarding them as useless, or merely curious.
>
> (1888: 26)

Similarly, the specific knowledge acquired in the course of such a visit is less important than the new habits to which it gives rise – ideally, a self-activating desire for the pursuit of knowledge that will serve as an antidote to less civilizing habits. Greenwood thus continues:

> After a holiday spent in a Museum the working man goes home and cons over what he has seen at his leisure, and very probably on the next summer holiday, or a Sunday afternoon walk with his wife and little ones, he discovers that he has acquired a new interest in the common things he sees around him. He begins to discover that the stones, the flowers, the creatures of all kinds that throng around him are not, after all, so very commonplace as he had previously thought them. He looks at them with a pleasure not before experienced, and talks of them to his children with sundry references to things like them which he saw in the Museum. He has gained a new sense, a craving for natural knowledge, and such a craving may, possibly, in course of time, quench another and lower craving which may at one time have held him bondage – that for intoxicants or vicious excitement of one description or another.
>
> (1888: 26–7)

The behavioural changes which might result from the working class's exposure to art in art galleries were similarly often expected to derive from the opportunities for commingling with middle-class exemplars which visiting art galleries afforded as much as from the qualities of the art displayed.[4] Indeed, the quality of the art displayed was often viewed as quite incidental to the prospective technological effects of art galleries in these regards. When quizzed before the 1867 Select Committee on the Paris Exhibition, for example, Henry Cole could not be budged from the view that, once placed in the environment of a museum, *any* art was imbued with a civilizing potential which made it preferable to no art at all:

Q . . . and I understand you to state that you consider that the gift of indifferent pictures to the museum would be productive of unmitigated good; is that your opinion?

A Certainly; but it is a vague term to say indifferent pictures. I could go through the National Gallery where there are many pictures which in one sense are indifferent pictures; there they are, and people go there to see them; you cannot say it is evil and not good. I say it is an unmitigated good . . .

Q Do you think it is desirable that the standard of taste should be maintained in this country at its present level, at which you say that a picture like the 'Derby Day' would beat any Raphael hollow?

A I presume to say I do not know what is the standard of taste.

Q I understand you to say, that if the 'Derby Day', by Mr Frith, and a Raphael were exhibited in this country, the 'Derby Day' would beat the Raphael hollow in its appreciation by the people of this country; do you think that that state of things is desirable?

A No; but I think it is desirable that people should be taught to look at the pictures, and to take pleasure in them.

Q Either good or bad?

A Either good or bad, unless they are indecent or bloodthirsty; but I think a picture which is harmless in its morality is a work of art; and I think if it attracts anybody to look at it, that is something gained to the cause of civilisation. I had much sooner that a man looked at an inferior picture than that he went to the public-house.

Q Why do we try to purchase good works of art, if it is desirable to have bad ones?

A Just in the same sense that a glass of table beer is better than nothing, but you would prefer sherry, perhaps, if you could get it.

('Select', 1971: 920–4)

In the nineteenth-century advocacy of rational recreations, then, as well as in the development of public art galleries, museums and concert halls, we can see the development of a new orientation *vis-à-vis* culture, one in which specific forms and arrangements of culture are judged capable of being harnessed to governmental programmes aimed at the transformation of popular morals and manners. This envisaged effect, however, is anticipated in view of the way in which specific forms of culture are instrumentalized – fashioned into useful vehicles for governing – rather than from their intrinsic properties even though, as I shall argue shortly, this inscription of culture into governmental programmes both supplies the conditions for and is assisted by the development of essentializing aesthetic discourses.

I am suggesting, then, that an understanding of the relations between culture and power in modern societies needs to take account of the instrumentalization of culture which accompanies its enlistment for governmental purposes. For the culture/power articulation which results from these developments is quite distinct from the organization of such relations in earlier societies. Within the absolutist regimes of early modern Europe, for example, culture certainly formed part of the strategies of

rule and statecraft. It thus formed part of a sphere of élite display through which, in pre-revolutionary France, the aristocracy could be bound to, and rendered dependent on, the world of the court. Equally, so far as the relations between state and people were concerned, it formed part of a politics of spectacle through which the might and majesty of royal power was dramatized via its symbolic display.[5]

Of course, there remains a symbolic aspect to the relations between culture and power in modern societies; the 'politics of spectacle' did not die out with the *ancien régime* or Old Corruption.[6] However, this aspect no longer exhausts such relations or even accounts for their most distinctive qualities. Rather, these are to be found in the respects in which culture comes to be imbricated within governmental programmes directed at transforming the mental, spiritual and behavioural attributes of the population. If culture is the servant of power within absolutist regimes, the power it serves is – if not a singular one – certainly a power which augments its own effects in being *represented* as singular just as it is a power whose interest in the generality of the population is limited to the need to impress it into obedience. In the early nineteenth century, by contrast, we see the sphere of culture being, quite literally, refashioned – retooled for a new task – as it comes to be inscribed within governmental strategies which aim less at exacting popular obedience to a sovereign authority than at producing in a population a capacity for new forms of thought, feeling and behaviour.

Both relations of culture and power, of course, are productive; but their productiveness belongs to different modalities. They aim at producing different kinds of persons, organized in different relations to power, and they proceed by means of different mechanisms for distributing the effects of culture through the social body: the representational and symbolic versus the governmental and technological. If we are to write an adequate history of culture in the modern period, it is to the changing contours of its instrumental refashioning in the context of new and developing cultural and governmental technologies that we must look. This is not to say that the changing co-ordinates of 'culture's' semantic destinies are unimportant. However, it is to suggest that these derive their significance from their relations to culture's governmental and technological refashioning. Some pointers as to the directions which such a revisionist history might take can be indicated by briefly developing the three provocations I mentioned earlier.

Culture and its discontents

The differences between high and popular culture, Geoffrey Nowell-Smith has argued, are becoming increasingly blurred in view of two considerations. First, the fact that virtually all forms of modern culture are capitalist means that different realms of culture can no longer easily be distinguished in terms of their relations of production while, second, modern culture tends increasingly to comprise a 'single, intertextual field whose signifying elements are perpetually being recombined and played off against each other' (1987: 87). There is, however, a third reason. For it is also true that virtually all forms of culture are now capable of being fashioned into vehicles for governmental programmes of one sort or another – for AIDS education programmes, for example, or, as popular literary texts come

to be incorporated into the literature lesson, as textual props for ethical or civic trainings of various kinds. It is, indeed, precisely these kinds of changes which form part of the material and institutional conditions of existence which have supported the development of cultural studies.

In these various ways, then, the co-ordinates of the discursive field in which the modern concept of culture first emerged – a field characterized by the antimony between the high and the popular – are being weakened. Yet these discursive co-ordinates were also practical ones in that it was precisely the production of a vertical relation between the high and the popular which established the gradient down which the 'improving' force of culture could flow in order to help 'lift' the general cultural level of the population. The point I'm after here is that it was precisely the aestheticization of high culture which provided the enabling conditions for the production of such a gradient. There is not, that is to say, any opposition between culture's aestheticization and its being rendered useful as an instrument for governmental programmes of social and cultural management. To the contrary, it was only the development of aesthetic conceptions of culture which allowed the establishment of those discursive co-ordinates in which elite cultural practices could be detached from their earlier functions – of dazzling spectacle, for example – and then come to be connected to civilizing programmes in which they could function as instruments of cultural 'improvement' directed toward the population at large.

If, today, the discursive co-ordinates which supported such conceptions and strategies are mutating, this is partly because of a tendency toward self-undoing that is inherent within them. An important characteristic of the relations between culture and power developed in the nineteenth century consisted in the degree to which forms of culture needed to be valorized as embodiments of universal norms of civilization or humanity in order to be rendered governmentally useful. Yet this process has also served to generate alternative demands and oppositions from the zones of exclusion and margins which it itself establishes. It is in this respect, to come to my second provocation, that many modern forms of cultural politics can be viewed as by-products of culture's governmentalization rather than as arising autochthonously out of relations of repression. Foucault has argued that the government of sexuality has given rise to a new sphere of biopolitics in which new kinds of counter-politics have been generated in view of the 'strategic reversibility of power relations' through which, as Colin Gordon put it, 'the terms of governmental practices can be turned around into focuses of resistance' (1991: 5). We need also to be alert to the ways in which the utilization of culture as an instrument of government has exhibited a similar capacity to generate its own fields of counter-politics.

Demands that representational parity be given to women's art in art galleries or to the histories of subordinate social strata in history museums are thus ones which are generated out of, and fuelled by, the norms of universal representativity embodied in the rhetorics of public art galleries and museums. Earlier collections of valued objects seem not to have given rise to any similar demands – partly, no doubt, because of the limited influence of democratic and egalitarian philosophies but also because the principles of curiosity and wonder which governed the constitution of such collections meant that no general political value could be attached to the question of what was included within, or excluded from, such collections.

For, where objects were collected for their curiosity value, it was their singularity that mattered, not their representativeness.[7] Only the refashioning of the semiotic frames of reference of collecting institutions such that cultural objects came to be displayed and classified in terms of their representativeness of general norms of humanity lent any cogency or purpose to the view that the histories and cultures of different social groups should be accorded equal representational rights and weight. The first organized campaigns for more attention to be paid to women's history and culture in collecting institutions thus took the form of a demand that such matters be accorded representational parity within the universalizing project of modernity as exemplified by the international exposition.[8]

Many aspects of modern cultural politics, then, are effects of the ways in which specific fields of cultural practice have been governmentally deployed. The same is true of many aspects and forms of cultural analysis. Moreover, this is so in ways which render the opposition between textual analysis and policy analysis quite disabling. For the text which analysis encounters and which must be engaged with, theoretically and politically, is never simply given to analysis. Rather, what a text is, and what is at stake in its analysis, depends on the specific uses for which it has been instrumentalized in particular institutional and discursive contexts – some of which, of course, will be governmentally constructed and organized. This being so, the development of politically self-reflexive forms of textual analysis depends precisely on adopting a policy perspective – that is, on recognizing how the textual regime in question functions as part of a technological apparatus with a view to considering the kinds of reading activities and relations through which that regime might be redeployed for new purposes.

Take the modern art museum. Clearly, many forms of textual analysis – art history, for example, in its commitment to tracing intertextual relations within the archive of the museum text – are dependent on the assemblage of art within museums and on the systems that have been developed for recording, collating and exchanging information between museums. However, it can also be argued that, in view of its functioning as an institution of social differentiation, the modern art museum has fashioned a distinctive textuality for the modern art object, one which organizes social relations of inclusion – which, of course, are also always ones of exclusion – by producing an invisible depth within the art-work (the depth, precisely, of its intertextuality) such that a line can be drawn between those who can, and those who cannot, see its 'hidden' significances. Questions of textual analysis – and of how to approach them – thus cannot, on this view, be posed independently of their implications for the positions and practices they make available in relation to this specific, socially and historically produced form of textuality. Indeed, political debates within the art museum are, in essence, debates about how (if at all) this distinctive textuality of the art object might be retechnologized and for what purpose – questions whose axes are simultaneously policy and textual ones.

From critics to technicians

Government, then, is not the *vis-à-vis* of cultural politics. It is an abstraction to be opposed in the name of a cultural politics which imaginarily draws its nourishment

from a ground outside the governmental domain: the purely economic conditions of existence of a class, say, or the somatic resistances of the body. Rather, the relations between government and modern forms of cultural politics are ones of mutual dependency. How cultural forms and activities are politicized and the manner in which their politicization is expressed and pursued: these are matters which emerge from, and have their conditions of existence within, the ways in which those forms and activities have been instrumentally fashioned as a consequence of their governmental deployment for specific social, cultural or political ends.

Clearly, perspectives of this kind sit ill at ease with what have come to be regarded as the central paradigms of cultural studies. For if cultural studies is defined by its concerns – theoretical and practical – with the relations between culture and power, it has largely envisaged such relations negatively in its critiques of dominant cultures as instruments of an oppressive power. The position argued here, by contrast, attributes a certain productivity to power in contending that the modern forms of culture's politicization are historical outcomes of the specific relations between culture and power that have been embodied in culture's fashioning as an instrument of government. This theoretical dissonance, moreover, has far-reaching practical consequences in suggesting that cultural studies needs to devise different ways of intervening within the fields of cultural politics it identifies as relevant to its concerns.

The issues that are at stake in many fields of modern cultural politics, I have thus argued, are a historical result of the ways in which cultural forms have been technologically adapted in order to be rendered governmentally useful. However, if this is so, then it follows that making a difference to how culture works – altering the fields of uses and effects within which specific forms of culture are inscribed and which they help to support – is also a technological matter requiring that close attention be paid to the nuts-and-bolts mechanisms which condition the governmental uses of specific cultural practices in the framework of particular cultural technologies or apparatuses. Take the manifold political issues associated with the relations between nation, culture and identity. It is clear that this nexus of relations has been shaped into being by the activities of modern governments concerned to endow their citizens with specific sets of nationalized traits and attributes. It is also equally clear that, whatever their present configuration, there can be no reorganization of the relations between nation, culture and identity without intruding policy – and so a shift in culture's governmental deployment – into that trinity. Such an intrusion might take different forms: the regulation of broadcast content by bodies like the Australian Broadcasting Tribunal, for example, or the monitoring of the cultural resources available to minority ethnic groups of the kind undertaken by the Office for Multicultural Affairs. It might equally take the form of new protocols of reading which, in allowing literary or film texts to be technologized in new ways by providing readers with different exercises to undertake in relation to them, allow those texts to play a role in the refashioning of national identities.

Cultural change – or, perhaps better, changing what culture does – thus emerges as a largely technical matter, not, however, in the sense that it is something to be left to specialists but rather in the sense (the good Brechtian sense) that it results from tinkering with practical arrangements rather than from an epic struggle for consciousness. For cultural studies this would mean not merely a shift

in its command metaphors of the kind proposed by Cunningham (away from rhetorics of resistance, progressiveness, etc., and toward those of access, equity, and empowerment). It would also entail a shift in its conception of the kind of enterprise it envisages itself as committed to and of the means by which that enterprise might be realized.

The style of intellectual work – and the associated rhetorics, modes of address, styles of pedagogy and forms of training – cultural studies sees itself as concerned to promote is of crucial significance in this respect. The model of the cultural critic – of the intellectual engaged in the struggle for consciousness by means of techniques of cultural commentary – has not been the only model of the intellectual informing the history of cultural studies. It has, however, been an influential one, and it is one that is deeply written into the tradition – at least in its British versions – given its historical affiliations with literary criticism. It is, moreover, a model of the intellectual that is now being significantly reinscribed into cultural studies as – in one of the more influential of the many guises in which it now appears within the academy – it is increasingly cast in the role of heir and successor to English. This unfortunately means that it also often takes on the moral mantle of English in supplying an institutional and discursive context in which the trainee cultural critic can become adept in using a range of moralized enunciative positions. As an alternative, then, cultural studies might envisage its role as consisting in the training of cultural technicians: that is, for changing consciousness than to modifying the functioning of culture by means of technical adjustments to its governmental deployment.

Notes

1 Especially as there are signs that this version of 'the policy debate' will prove an influential one within Australian cultural studies. Grace's antinomial constructions are thus echoed by Deborah Chambers in her editorial for the June/July 1991 issue of the Australian Cultural Studies Association Newsletter.

2 Cunningham's use of the term 'leadership' here is, perhaps, misleading. My sense, from the context of his discussion, is that the concept of 'cultural facilitation' would have better suited his purposes given, on the one hand, the elitist associations of traditional conceptions of cultural leadership or, on the other, their association with Gramsci's conception of the role of intellectuals in providing moral and cultural leadership for social classes and allied social movements. Clearly, neither of these meanings accords well with Cunningham's sense that intellectuals should play more of a technical and co-ordinating role in enhancing the range of available cultural resources and facilitating more equitable patterns of access to those resources.

3 For a complementary discussion of related issues, see Bennett (1992).

4 For a fascinating discussion of the influence of such views in the development of art galleries and exhibitions in mid- to late-nineteenth-century Leeds, see Arscott (1988).

5 Even though the text (and not just the reception) of such spectacles was often more ambiguous than has usually been supposed. See Laqueur (1989).

6 However, the rhetorical strategies of the politics of spectacle were significantly transformed in the nineteenth century. For a discussion of these transformations in the case of museums and exhibitions, see Bennett (1988).

7 For an excellent discussion of the contrast between the focus on the singularity of objects in pre-modern collecting institutions and the concern with the representativeness of objects evinced by modern public museums and exhibitions, see Breckenridge (1989). For a detailed example of the pre-modern concern with the singularity of objects, see MacGregor (1983).

8 For a full account of the most influential of these campaigns and its influence on American feminism, see Weimann (1981).

References

Arscott, Caroline (1988) ' "Without distinction of party": the polytechnic exhibitions in Leeds, 1839–45', in Janet Wolff and John Seed (eds), *The Culture of Capital: Art, Power and the Nineteenth Century Middle Class*, Manchester: Manchester University Press.

Bailey, Peter (1987) *Leisure and Class in Victorian England: Rational Recreation and the Contest for Control, 1830–1885*, London: Methuen.

Bennett, Tony (1988) 'The exhibitionary complex', *New Formations* 4.

Bennett, Tony (1992) 'Putting policy into cultural studies', in Lawrence Grossberg, Cary Nelson and Paula Treichler (eds) *Cultural Studies*, Routledge: New York.

Breckenridge, Carol (1989) 'The aesthetics and politics of colonial collecting: India at world fairs', *Comparative Studies in Society and History* 31(2).

Cunningham, Stuart (1991) 'A policy calculus for media studies', paper presented to the *Fourth International Television Studies Conference*, London.

Foucault, Michel (1980) 'Two lectures', in Colin Gordon (ed.), *Power/Knowledge: Selected Interviews and Other Writings 1972–1977*, New York: Pantheon Books.

Gordon, Colin (1991) 'Governmental rationality: an introduction', in Graham Burchell, Colin Gordon and Peter Miller (eds), *The Foucault Effect: Studies in Governmentality*, London: Harvester Wheatsheaf.

Grace, Helen (1991) 'Eating the curate's egg: cultural studies for the nineties', *West* 3(1).

Gray, Robert (1976) *The Labour Aristocracy in Victorian Edinburgh*, Oxford: Clarendon Press.

Greenwood, T. (1888) *Museums and Art Galleries*, London: Simpkin, Marshall.

Hunter, Ian (1988) *Culture and Government: The Emergence of Literary Education*, London: Macmillan.

Jardine, Lisa and Swindells, Julia (1989) 'Homage to Orwell: the dream of a common culture, and other minefields', in Terry Eagleton (ed.), *Raymond Williams: Critical Perspectives*, Cambridge: Polity Press.

Laqueur, Thomas W. (1989) 'Crowds, carnival and the state in English executions, 1604–1868', in A. L. Beier, D. Cannadine and M. R. James (eds), *The First Modern Society: Essays in English History in Honour of Lawrence Stone*, Cambridge: Cambridge University Press.

MacGregor, A. (1983) *Tradescant's Rarities: Essays on the Foundation of the Ashmolean Museum, 1683, with a Catalogue of the Early Collection*, Oxford: Clarendon Press.

Nowell-Smith, Geoffrey (1987) 'Popular culture', *New Formations* 2.

'Select Parliamentary Committee Report on the Paris Exhibition, 1867' (1971) *British Parliamentary Papers*, Shannon: Irish University Press, pp. 920–4.

Weimann, Jeanne (1981) *The Fair Women*, Chicago: Academy Press.

Williams, Raymond (1979) *Politics and Letters*, London: New Left Books.

Colin Mercer

CULTURAL POLICY
Research and the governmental imperative

BEFORE DISCUSSING THE WORK of the Institute for Cultural Policy Studies (ICPS), I would like to situate my comments by reflecting on the nature of the relations between culture and government. The first reflection is on the theme and orientation of the seminar – Cultural Policy Studies: Questions of Method – and the peculiarity of the context to which it responds. This context consists of:

- the growth of cultural policy studies in Australia;
- the increased engagement of academics with bureaucracies;
- the need for more debate about the place of policy analysis in the broad field of governmentality and culture; and, finally,
- the relationship between these developments and the determination of research agendas and the circulation of information.

These are welcome and timely questions, issues and emphases, but I want to suggest that they are given a certain 'peculiarity' precisely because of the domain in which they operate and the object, both theoretical and practical, with which they are concerned. This domain and this object are one: *culture*. Culture is peculiar in so far as it is a field of training and research which has an historically resilient set of defence mechanisms to protect it from analytical intrusion by forces and agencies which are not, so to speak, culturally sanctioned. 'You may enter and analyse' culture is able to say, 'but only if you are endowed with certain capacities'. These capacities are provided in a number of ways but essentially through an *aesthetic* paradigm which is provided by a range of disciplines – aesthetics itself, but also literary studies, art history and cultural studies. In the latter case, the aesthetic is subsumed but not displaced by a larger paradigm allowing one to talk of politics, power and ideology: the paradigm of *representation*. None the less, the

capacities and criteria of entry into the domain of culture remain those essentially of the original aesthetic model – cultivated and critically informed reading, watching, exegesis, decipherment and decoding.

The fact that such a seminar has taken place is something of a testament to the resilience of this defence against unwelcome intrusion in the cultural domain. We have to ask ourselves if there would be a problem or any peculiarity attached to similar events in other areas of inquiry where policy is an issue and where there is an established teaching and research agenda to accompany and respond to those issues. Would there be a problem in discussing environmental policy in the con-text of a well-established teaching and research agenda in environmental studies? Would there be a problem in discussing women's policy in the context of a well-established teaching and research agenda in women's studies? Would there be a problem in discussing economic policy, social policy, urban policy and so on? The answer would be no.

The second reflection, then, is what it is about cultural policy that makes us falter, that provokes sometimes fierce debates in national and international forums. I want to suggest that this is in many ways a peculiarly Anglo-Saxon problem and issue and is closely related to the semantic and cultural history of the two words 'culture' and 'policy' in those social and cultural formations which have an Anglo-Saxon heritage and comparable polity.

'Culture' has been predominantly understood and received in the Romantic Anglo-Saxon tradition as a representational and aesthetic domain of personal fulfilment, liberation, transcendence and critique – of the 'machine age', of industrialism, of the dominant order and so on. You can critique the 'dominant culture' but it is none the less through other cultures – working-class, sub- and post-colonial – that you will find the path to transcendence. The gesture of 'flying' presented by this model is not conducive to the apparently pedestrian requirements of policy.

'Policy' has been predominantly understood in the Anglo-Saxon tradition as existing in a rather 'grey', indeterminate and bureaucratic semantic zone. It is a very 'English' word and it is instructive to compare its usage, for example, in French and Italian. In French, the word for 'policy' is either *politique*, which means the same as 'politics', or the more elaborate *lignes de conduite*, meaning 'lines or forms of conduct'. The same is true of Italian where there are the comparable words *politica* and *linea de condotta*. This more elaborate formulation of lines of conduct offers a clue to the relevance of cultural *policy* studies in so far as culture can be understood very productively in terms of the generation and reproduction of forms of conduct – for individuals, citizens, communities and nations – and this is a point to which I will return below in discussion of the 'governmental' aspects of culture.

I think that there are sound historical reasons for the Romantic 'ethical' separation of the domains of government and culture in the Anglo-Saxon tradition and the different forms of their relationship in, for example, France, Germany and Italy. These are, quite simply, that in those three countries, which also had Romantic traditions, Romanticism formed an essential component of nation-building and the elaboration, *de novo*, of new systems of education, the reconstruction of a viable national past with a clear line of folk heritage and the elaboration of various other 'national popular memories'. Romanticism, in these

contexts, was necessarily imbricated with the governmental, pedagogic and ethno-graphic imperatives necessary to the training of new citizens and populations. The English Romantic tradition, on the other hand, came too late in the history of nation-building to be a partner in this process and had to confine its role largely to the critique of the governmental from a clearly demarcated ethical sideline.

It is no accident, I think, that it is precisely in the Anglo-Saxon polities that we have witnessed the emergence of national governmental mechanisms such as the Australia Council, the Arts Council of Great Britain, the Canada Council for the Arts, the National Endowment for the Arts in the USA and the QEII Council for the Arts in New Zealand, whose paradoxical task is precisely to keep govern-ment and culture, policy and culture at arm's length by defining their primary responsibilities for resource allocation as the maintenance of clearly demarcated and aesthetically defined 'art forms'.

The ICPS

This background offers some context, admittedly with the benefit of a good deal of hindsight, for the establishment of the ICPS at Griffith University in 1987. Those of us responsible for bidding for and securing its establishment were conscious of the fact that there had been a failure, quite simply, to properly historicise and specify the cultural domain. We had all been formed in and through cultural studies of one sort or another and yet recognised that there had been few attempts to critically investigate the ground on which we – as academics and erstwhile cultural critics – actually stood.

If one were to look for a theoretical manifesto of the ways in which we began to examine and turn over this ground, it surely has to be Issue 4 of the London-based journal *New Formations*, devoted to the theme of 'Cultural Technologies', which was edited from the ICPS and published in 1988. 'Technologies' in this context was an explicit reference to a certain debt to the work of Michel Foucault – the Foucault of genealogy, of governmentality and of techniques of the self. Technologies referred to the work of culture in areas such as self, person and population formation and management. Thus Tony Bennett's article on museums and exhibitions, 'The exhibitionary complex', developed a Foucauldian analysis of the role of museums and exhibitions in the nineteenth century as distinctive tech-nologies for 'cultural resource management' in the context of the wider pedagogic imperatives of population management. My own article on forms of urban popular fiction and related reading practices developed a similar line of argument about the place of popular entertainment in 'conduct formation' or, in Eugène Suë's terms, the 'policing of virtue'. David Saunders's article on the much neglected effect of law and juridical intervention on the nature and form of literature demon-strated a necessarily 'governmental' presence in the very practice of writing. Finally, Ian Hunter's article 'The limits of culture' argued cogently for a detailed attention to the genealogies of the technical, conduct- and person-forming effects of cultural technologies in educational and social policy: details which had been so studiously ignored in the grand sweeps and foundational principles of even the most sophisticated (Gramscian) Marxist and critical cultural theory.

The concern with policy not only as a focus on 'government and bureaucracy' but also as a methodological emphasis on questions of conduct – 'lines of conduct' – becomes clearer in this context. It does not signal, in other words, simply a concession to or complicity with 'government' in traditional terms but, rather, argues for a systematic inclusion and recognition of the necessarily 'governmental' role of the management of cultural resources, in historical terms, since at least the mid-eighteenth century as 'populations' and 'citizens' became new objects of political calculation.

This is another way of saying that the relationship between our continuing concerns with cultural history and the operational focus on contemporary policy is not a contingent one. This relationship is governed by a concern with the precise nature of both the theoretical and the policy object: culture. 'Cultural Policy Studies' could be translated, in other words, into 'Studies in the Relations of Government and Culture' and, in our teaching programs as well as our research this is, indeed, the case. There is, in other words, a close connection between our attention to the 'technologies' and minutiae of culture – culture as resources, culture as techniques, uses, tactics and strategies – and the ways in which we operate in both 'pure' and 'applied' research. Our concern is not simply with what culture represents but with what it actually *does* in both exceptional and every-day terms. This is not culture as consciousness or ideology or text to be deciphered by decoding the rules, structures and conventions but culture as what Pierre Bourdieu calls practical orientation (*sens pratique*). This is, clearly, much more of an 'anthropological' than an aesthetic approach to the analysis and management of culture but it is also one which enables us to maintain a so far productive relationship between 'pure' research into, for example, the history of museums, popular entertainment, tourism, education, copyright and urban history, and 'applied' research both *of* and *for* their contemporary and operational equivalents. More of this below.

ICPS research and impacts

So much for the theoretical and methodological rationales which led to the establishment of and still contribute to the current research profile of the ICPS. Let me now move on to the sorts of work we do, its possible impacts and the nature of the bureaucracy–researcher relationship.

This is best done by outlining our current triennial research management plan which is called Cultural Planning, Research and Development. This plan has three broad research schedules.

Cultural planning

This is the work we do in research, policy analysis and development in urban, regional and community contexts. It is targeted at providing the necessary frameworks and tools for the 'mapping' and planning of cultural resources. These resources normally include, and frequently start from, 'the arts' as traditionally

defined and specified in government funding and service frameworks. But the work also includes a necessary conceptual broadening of the meaning of culture and of what counts as culture. The move from an aesthetic to an anthropological definition of culture — and its implications for resource management, funding, service delivery and general policy purview — is crucial here. Shopping centres, churches and temples are often much more vibrant and effective 'cultural centres' than those officially blessed with that name but they are not normally recognised in extant policy frameworks. Streets and buildings are cultural resources as are the forms of intangible cultural heritage of festivals and local traditions. Again, these resources are frequently not recognised. In urban and regional planning frameworks the question of culture is usually reduced to issues of embellishment and beautification — an aesthetic definition rather than the more effective operational and anthropological definition of how people use, relate to, celebrate or desecrate their living environments. The process of 'cultural mapping' which needs to be integrated with broader processes of planning provides ways, both qualitative and quantitative, of, on the one hand, conceptually recasting the boundaries of culture and, on the other hand, forcing policy and planning frameworks to redefine their own operational and resource allocation parameters.

This is resolutely workaday and technical work. It involves consultation and negotiation with local government officials, librarians, architects, planners, traffic engineers and community organisations in order to recognise, map and strategically plan and manage cultural resources. You cannot easily do that if you are guided by an aesthetic approach to culture. You cannot do it either, in my view, if you are not familiar with some of the best theoretical work in the area of urban history, cultural and otherwise. The work of Sharon Zukin and Anthony Vidler has been invaluable in identifying the limitations and implications of some forms of 'cultural development' in the urban context. That is not to say that one carries these weighty tomes around on site with a hard hat to point or refer to for guidance. It is simply that this body of work in its concentration on the history of the 'little tactics of the habitat' provides an invaluable basis for understanding, in the contemporary context, the possible implications of policy and planning decisions in which one is currently involved.

Citizenship and cultural identity

This is the research schedule which covers the work, pure and applied, that we do in explicit equity areas such as gender, multiculturalism, youth and, slowly and falteringly now, also in relation to indigenous cultures. It also covers the more general investigations into the relationship between citizenship and cultural resources in areas such as heritage, education, film and media policy, and copyright and moral right. This is a research schedule which is concerned explicitly or implicitly with the role of cultural resources in the construction of identity, or, more technically and theoretically, with 'techniques of the self' and, further, 'techniques of community and population' formation and management. It is not — and this is important — a celebratory agenda. From a 'governmental' point of view, it is important to recognise that 'cultural identity' is not by any means a benign

repository of human values and aspirations. What is happening in the former Yugoslavia is a matter of cultural identity. The attempt at an Afrikaans *Volkstaat* in South Africa is a matter of cultural identity. Clearly, therefore, any concern with cultural identity has to negotiate its way through a series of complex questions and issues such as identity on whose terms and to what ends and in what balance between rights and obligations? This is why the more 'governmental' concept of citizenship rather than the more free-wheeling (and often aesthetically determined) concept of 'subjectivity' shapes the agenda.

This is the 'constraint' side of the equation. On the 'potential' side it is clear that a lot of work needs to be done in this area to account for and redress, for example, the inadequacy of current cultural policy frameworks and resource allocation mechanisms, to recognise, let alone address, the needs and expectations of women, non-English-speaking background communities, indigenous communities and youth in strategies for the development of the cultural industries in Australia. Again, this is not merely a question of giving more resources to identified equity groups. It is also a conceptual issue of recognising and managing the resources which count as cultural to those groups. An aesthetically determined arts policy framework, for example, is not well positioned to address the needs of non-European and indigenous communities who recognise neither the European concept of art, nor the aesthetic hierarchy of discrimination and evaluation which govern resource allocation in that area.

Cultural indicators

This is the research schedule which is ostensibly more 'quantitative' in response to the sheer dearth of cultural statistics and indicators in Australia. In fact, while based on statistical work and various forms of body-counting, it is the blindingly obvious qualitative outputs which are probably more important. The facts on who is visiting our museums and art galleries, and who is not, and what the major patterns and forms of cultural consumption and participation are by ethnicity, gender, age and location provide some fascinating government- and industry-relevant data and show clearly, furthermore, the need for sustained research (and research-funding) in this area. Apart from any pure research objectives it is hard not to notice the significant mismatch between current policy frameworks and the actual patterns of cultural activity in Australia. As Tony Bennett has argued recently, based on research that he and his colleagues have undertaken for a joint University of Queensland/ICPS research project, *Australian Cultural Consumption:*

> The causes of inequality of cultural opportunity are so deeply rooted in the fabric of Australian social life they cannot be simply conjured out of existence by the mere wave of a policy wand. Yet, if the problem is to be tackled effectively, it must be properly defined; and if we are to find out where, when and how progress is made, many aspects of the operations of our public cultural institutions need to be more precisely, more regularly and more pointedly measured than is at present the case.
>
> (Bennett, 1994: 23)

Like social statistics and indicators in the nineteenth century, cultural statistics and indicators in the twentieth century provide not simply a 'picture' of activity but also a set of indicators whose aim is, indeed, 'governmental'. And while government can always be construed as on the side of the 'coercive', we would be in no position to stake our own governmental claims if we were not in possession of these indicators.

ICPS performance

I come now to the question of the effects of our work; this is probably the most difficult question to answer because we do not really have any real 'performance indicators'. What indicators we do have, however, I will attempt to outline in the three domains of policy change, academic research, and teaching and training.

In the area of policy change it is, by definition, very difficult to evaluate effects simply because of the wide gap between policy development and implementation. I can point to examples at local and state government levels where our research, policy development, recommendations, etc., have had effects in written policy statements. I can point to new budget programs and sub-programs, to policy statements, recommendations and action plans adopted by government agencies. I can even point to organisational restructuring and new appointments resulting from our work in this area, especially at local government level. Possibly more important, though less tangible, is our contribution to the redefinition of cultural policy agendas at various levels. At local government level I think that these changes – or simply getting cultural policy onto the agenda in the first place – are measurable. The higher up the three levels of government you go, the more difficult it is to measure. I think I can ascertain some effects at the level of the Queensland State Government but I have no idea about possible effects at the Commonwealth level except that we have good relations with them and they usually come to our conferences. We make submissions, we lobby, we publish our research but who knows what the effects are? All I can say there is a wistful 'perhaps' and leave it to the clients to respond!

In the academic research domain, there are some demonstrable effects both in terms of our own published research outputs (now more than forty publications, large and small) and in terms of the generation of debate at national and international levels. Boris Frankel's castigation of Tony Bennett, Ian Hunter and myself as 'left technocrats' in his book *From Prophets Deserts Come* (1992) is, I suppose, a performance indicator in this context. There have been others in a similar mood and there was, for a while, the 'critique versus policy' or 'cultural studies versus cultural policy' debate at a number of national and international conferences and in a number of journals. This has, thankfully, now died down and was, in effect, a clearing of the throat before a more reasoned and continuing dialogue as the ethos of cultural policy studies becomes more embedded as another legitimate domain in the study of culture. I suppose that one can also measure effects in this domain by performance indicators such as publications, sales and reviews. These are healthy and continuing and our capacity to attract both internal and external grant-funding and, more recently, 'quality money' from the recent lottery, is strong and growing.

In the area of teaching and training there have been definite effects both inter-
nally and externally. The ICPS is a research not a teaching centre but its research
profile has had definite effects on teaching and postgraduate research. Cultural
policy studies, while not enshrined as such, is an increasingly important component
of the undergraduate profile in the Faculty of Humanities. We have a new Masters
program in Cultural Policy Studies which commenced in 1992 and, as from this
year, a Masters in Cultural Policy offered nationally through the Open Learning
Agency of Australia. In the postgraduate research area we have a rapidly growing
number of MPhil and PhD students from Australia and overseas working at the
culture and policy or culture and government coalface. These are 'effects' which
testify to very productive relations between research and teaching profiles and
objectives. The fact that they were largely unforeseen in 1987 makes them more
of a pleasure.

Contradiction and constraints of consulting work

The bureaucracy–researcher relationship is a difficult area which is strewn with
bodies and the walking wounded. It is no more difficult, in my view, in cultural
policy than in social, economic, environmental or women's policy but it is none
the less difficult. There are ethics and protocols of consultancy work or research
commissions concerning disclosure of information, intellectual property and
disputes over outcomes and implications. I don't think, however, that these
constraints should be posed in dichotomous opposition to the free and indepen-
dent work which takes place outside of the consultancy domain. Non-consultancy
work in areas such as working with indigenous communities, or in genetic engi-
neering or any other form of human experimentation, can have as many if not
more constraints attached.

We need to recognise that consultancy work or research commissions in the
area of cultural policy do not take place in the Republic of Letters. Nor should
we assume that by virtue of its being 'cultural' it therefore exists in a domain of
transcendence, critique and liberation. Knowledge, after all, has always been
power. The free flow of information and ideas and the virility of the public sphere
can by no means be assumed. This principle is increasingly being enshrined by
Commonwealth and State governments in moves to claim total intellectual property
rights on the outcomes of research commissions. In our experience this is frequently
negotiable. With the exception of commercial-in-confidence and other sensitive
information it is frequently possible to negotiate either joint copyright or, at least,
the rights to publish in another form and for non-commercial purposes the results
or the account of results of your research in more scholarly forums. In the end,
however, you are selling product to a purchaser and this brings contractual oblig-
ations with it that are not implied in the grant-assisted research situation. If the
law affects cultural product like any other we should not be surprised and what-
ever is the opposite to *caveat emptor* applies: *seller beware*. In the first and last
instances, however, we need to treat this as a legal and contractual matter guided
by ethical guidelines and protocols and not as a Faustian drama. Let's remember
that when we express concern at the 'increased engagement of academics with

bureaucracies as consultants' we are really concerned with the place of *cultural* academics as consultants. The rest have been doing it for years without the shadow of Dr Faust beckoning them to an ethical hell.

Research of and research for cultural policy

Finally, I come to the question of the relationship between research *of* cultural policy and research *for* cultural policy. This is an interesting distinction and the question is tricky to respond to. It clearly relates to the issue of the equilibrium which is established between non-commissioned and commissioned research. The former would be deemed to be the area of research *of* policy and the latter the area of research *for* policy. In this context I can say that as a research centre we have our own internal policy which requires an effective equilibrium between the two areas of research. In terms of the output measured in numbers of words, non-commissioned research wins easily. In terms of outputs measured by revenue generation or 'value-added' research, the latter area wins. Aside from policy requirements, this also sets up an effective cross-subsidisation relationship between commissioned and non-commissioned research and, not least for a minimally funded centre, pays the wages of the administrative staff.

Beyond that matter of equilibrium, however, the distinction is a difficult one to maintain for a number of reasons. First, because of the origins of the ICPS as a focal centre to build on previously consolidated theoretical and historical work there has always been a fairly measured relationship between research *of* and research *for* policy. Any research *of* policy has the potential, since it is in the public domain, of being research *for* policy. When Tim Rowse wrote *Arguing the Arts* (1985), which was research *of* policy, he probably had it in mind that it was also research *for* policy even before it was taken up by the Committee of Inquiry into the Arts and cited in *Patronage, Power and the Muse*, the report of that committee. Similarly, it is difficult to undertake, say, the history of museums, of tourism or of urban cultures and do research *of* policy without it being taken up as research *for* policy either explicitly or implicitly.

And then, any research *for* policy, if it does its work properly, must be cognisant of what went before. Part of its methodology must be an 'information trawl' which includes a 'policy audit' of prior and extant policy frameworks and assumptions whether documented or not. There are tacit but not explicit policy frameworks – including non-existent policies – which none the less can have definite policy implications.

Following this circle round it is the case, of course, that the findings of research *for* policy – the absence, for example, of a recognition of or funding framework for 'traditional' or 'folkloric' cultural forms which are not European in origin – can productively feed back – or forward – into research *of* policy. The trick, I guess, is to make sure that this wheel keeps turning – of, for, of, for, of, for – and does not stop at any one point. This brings me to a final comment.

This wheel not only needs to keep turning but needs to be considerably speeded up. The connections and feedback mechanisms between research *of* and research *for* cultural policy seem to me to be increasingly important in the context of the

new needs of a mass education system in largely post-industrial Australia. We know so little about the current configurations of our cultural behaviour that we cannot hope, without a significant boost in research effort and funding, to know not only about the cultural industries about which we have been ignorant – at least in our policy frameworks – for so long, but also about the implications and effects of communications and information technologies which are steadily and radically transforming the cultural landscape. In the context of an explicit commitment to 'cultural development' at the national level and the proliferation of cultural policies and investments at other levels, I think we would be mistaken to construe the relations between culture and government as those of antagonism or bad faith. If the concept of governmentality means anything in this context, then it means recognising our 'complicity' with the processes and cultural technologies that shape and form our identities and capacities as citizens and populations and taking *that* position and not some Archimedean position of externality as the necessary starting-point for negotiation.

References

Bennett, Tony (1994) 'Research and cultural development', in *Enhancing Cultural Value: Narrowcasting, Community Media and Cultural Development*, ed. M Breen, Melbourne: CIRCIT.

Frankel, Boris (1992) *From Prophets Deserts Come*, North Carlton: Arena Publishing.

Rowse, Tim (1985) *Arguing the Arts*, Melbourne: Penguin.

Chapter 19

Arjun Appadurai and
Carol A. Breckenridge

MUSEUMS ARE GOOD TO THINK
Heritage on view in India

ONE OF THE STRIKING FACTS about complex societies such as India is that they have not surrendered learning principally to the formal institutions of schooling. In this type of complex society, urban groups tend to monopolize postsecondary schooling and the upper middle class tends to control the colleges and universities. In such societies, therefore, learning is more often tied to practical apprenticeship and informal socialization. Also, and not coincidentally, these are societies in which history and heritage are not yet parts of a bygone past that is institutionalized in history books and museums. Rather, heritage is a live component of the human environment and thus a critical part of the learning process. These observations are particularly worth noting since societies such as India are often criticized for having created educational institutions where learning does not thrive and where credentialism has become a mechanical mode for selection in an extremely difficult economic context. Informal means of learning in societies such as India are not, therefore, mere ethnographic curiosities. They are real cultural resources that (properly understood and used) may well relieve the many artificial pressures placed upon the formal educational structure. Museums are an emergent component of this world of informal education, and what we learn about museums in India will tell us much of value about learning, seeing, and objects, which in turn should encourage creative and critical approaches to museums (and informal learning arrangements in general) elsewhere.

Museums in India look simultaneously in two directions. They are a part of a transnational order of cultural forms that has emerged in the last two centuries and now unites much of the world, especially its urban areas.[1] Museums also belong to the alternative forms of modern life and thought that are emerging in nations and societies throughout the world. These alternative forms tend to be associated with media, leisure, and spectacle, are often associated with self-conscious national approaches to heritage, and are tied up with transnational

ideologies of development, citizenship, and cosmopolitanism. Conducting an investigation of museums, therefore, entails being sensitive to a shared transnational idiom for the handling of heritage while simultaneously being aware that this heritage can take very different national forms.

Museums and heritage

Although there is a growing literature (largely by scholars outside the museum world) that concentrates on museums, collecting, objects, and heritage, these discussions do not generally extend to museums in India. Our concern is to build on a few recent efforts in this direction as well as some earlier ones,[2] so that comparative evidence from non-western, postcolonial societies can be brought into the mainstream of theory and method in this area.

In anthropology, there is a renewed interest in objects, consumption, and collection more generally.[3] What emerges from the literature on this topic is that objects in collections create a complex dialogue between the classificatory concerns of connoisseurs and the self-reflective politics of communities; that the presence of objects in museums represents one stage in the objects' cultural biographies;[4] and that such classified objects can be critical parts of the "marketing of heritage".[5] Here we are reminded that objects' meanings have always reflected a negotiated settlement between long-standing cultural significations and more volatile group interests and objectives.

A related set of discussions explicitly links museums to material culture in a consciously historical way.[6] We are reminded that archaeological and ethnographical collections emerged out of a specific set of political and pedagogical aims in the history of anthropology;[7] that collections and exhibitions cannot be divorced from the larger cultural contexts of philanthropy and ethnic or national identity formation; that anthropologists and "natives" are increasingly engaged in a dialogue out of which cultural identity emerges; and that museums contribute to the larger process by which popular culture is formed. As far as India is concerned, museums seem less a product of philanthropy and more a product of the conscious agenda of India's British rulers, which led them to excavate, classify, catalogue, and display India's artifactual past to itself. This difference affects the ethos of Indian museums today, and also affects the cultural dynamics of viewing and learning.

Another relevant body of literature emphasizes the relationship between museums and their publics as well as their educational mission.[8] For the most part, these studies lack a sense of the historical and cultural specificity of the different publics that museums serve. While the public sphere has been most richly discussed in terms of the last three hundred years in Europe,[9] there are now a host of non-western nations that are elaborating their public spheres – not necessarily ones that emerge in relation to civil society, but often ones that are the result of state policies in tandem with consumerist interests. Thus, there is a tendency in these discussions for the idea of "the public" to become tacitly universalized (through some of these studies are concerned with sociological variations within visitor populations). What is needed is the identification of a specific historical and cultural public, one which does not so much *respond* to museums but is rather *created*, in

part, through museums and other related institutions. In India, museums need not worry so much about finding their publics as about making them.

There is, of course, a vast body of literature that is about art in relation to museums. This literature is not very relevant to the Indian situation because, except for a small minority in India and for a very short period of its history, and in very few museums there, art in the current western sense is not a meaningful category. Art continues to struggle to find a (bourgeois) landscape it can be comfortable in.[10] In place of art, other categories for objects dominate, such as handicraft, technology, history, and heritage. Of these, the one on which we focus is the category of heritage.

History becomes heritage in various ways.[11] Artifacts become appropriated by particular historical agendas, by particular ideologies of preservation, by specific versions of public history, and by particular values about exhibition, design and display. Tony Bennett's concept of "the exhibitionary complex"[12] and Donna Haraway's argument that natural history has the effect of naturalizing particular histories[13] both remind us that museums are deeply located *in* cultural history, on the one hand, and are therefore also critical places for the politics *of* history, on the other. Ideologies of preservation might frequently conceal implications for transformation.[14] For example, the effort to present vignettes of life from other societies often involves the decontextualization of objects from their everyday contexts, with the unintended result of creating aesthetic and stylistic effects that do not fit the original context. In other cases, objects that were parts of living dramas of warfare, exchange, or marriage become mechanical indicators of culture or custom. In yet other cases, the politics of cultural patrimony and political conquest are concealed in the technical language of ethnographic signage. All of these examples reveal a tension between the dynamic contexts from which objects were originally derived and the static tendencies inherent to museum environments. This is a valuable tension to bear in mind as we explore the context of museums in India, where the politics of heritage is often intense, even violent.

Among anthropologists, folklorists, and historians, there has recently been a spate of writing about the politics of heritage.[15] Much of this work suggests (in some cases using non-Euro-American examples) that the appropriation of the past by actors in the present is subject to a variety of dynamics. These range from the problems associated with ethnicity and social identity, nostalgia, and the search for 'museumized' authenticity, to the tension between the interests states have in fixing local identities and the pressures localities exert in seeking to transform such identities. The result is a number of contradictory pressures, some toward fixing and stabilizing group identities through museums (and the potential of their artifacts to be used to emblematize existing or emergent group identities), and others that attempt to free and destabilize these identities through different ways of displaying and viewing objects.

This body of literature is a reminder that heritage is increasingly a profoundly political issue and one in which localities and states are often at odds, and that museums and their collections are in the midst of this particular storm. Focusing on the politics of heritage in India brings out the place of Indian museums in these politics, and problematizes the cultural modes of viewing, traveling, experiencing, and learning in which heritage is negotiated.

The cultural and conceptual background

The public sphere in contemporary India, as in the rest of the world, has emerged as part of the political, intellectual, and commercial interests of its middle classes. In India in the last century, this public sphere has involved new forms of democratic politics, new modes of communication and transport, and new ways in which class, caste, and livelihood are articulated. We are concerned with one dimension of this evolving public sphere, which we call public culture. By public culture we mean a new cosmopolitan arena that is a "zone of contestation".[16] and different classes and groups formulate, represent, and debate what culture is (and should be). Public culture is articulated and revealed in an interactive set of cosmopolitan experiences and structures, of which museums and exhibitions are a crucial part.

On the surface, museums as modern institutions have only a short history and appear to emerge largely out of the colonial period:

> The museums started under British rule had been intended mainly for the preservation of the vestiges of a dying past, and only subsidiarily as a preparation for the future. Museums were the last haven of refuge for interesting architectual fragments, sculptures and inscriptions which saved them from the hands of an ignorant and indifferent public or from unscrupulous contractors who would have burned them to lime, sunk them into foundations or melted them down. Into the museums the products of the declining indigenous industries were accumulated, in the vain hope that they might serve as models for the inspiration of artisans and the public. Mineralogical, botanical, zoological and ethnological collections were likewise started, though rarely developed systematically: often they did not grow beyond sets of hunting trophies.[17]

As a consequence, until recently most museums in India have been moribund and have not been a vibrant part of the public cultural life of its people. One early analysis of this "failure" of museums in India comes from Hermann Goetz. The factors he identifies as reasons for this failure include the fragmentary nature of many collections, the failure of industrial art to inspire capitalist production, and the lack of response to natural-history collections by a public "still living in the world of myths".[18]

The ambiguous place of museums in India is partly a result of long-standing cultural and historical factors: first, India still has a living past found especially in its sacred places and spaces, so there is little need for "artificial" conservation of the Indian heritage; second, the separation of sacred objects (whether of art, history, or religion) from the objects of everyday life had not really occurred; and third, the separation of human beings from the overall biological, zoological, and cosmological environment in which they lead their ordinary lives had barely began.

More recently, museums have begun to play a more vigorous role in Indian public life. In part this is because of a renewed concern with education as one element of social and economic development; in part because private commercial enterprises have begun to use an exhibition format for displaying their wares; and in part because

museums have become plugged into a circuit of travel, tourism, pilgrimage, and leisure that has its own distinctive history and value in Indian society.

Here it may be useful to make a historical contrast. Museums in Europe and the United States have been linked to department stores through a common genealogy in the great nineteenth-century world's fairs. But in the last century, a separation of art and science and of festivity and commerce has taken place in these societies, with the objects and activities in each category fairly sharply distinguished in terms of audience, curatorial expertise, and visual ideology. In India, such a specialization and separation are not a part of either the past or the present.

This is not to say that there are not department and chain stores in contemporary India. There are, and they are clearly distinguishable from public festivities as well as from permanent exhibits in museums. Rather, there is a gray zone where display, retailing, and festivity shade into one another. It is precisely because of this gray zone that museums have taken on fresh life; objects in India seem to flow constantly through the membranes that separate commerce, pageantry, and display. The two major forms that characterize the public world of special objects in contemporary India are the exhibition-cum-sale and the ethnic-national festival. The exhibition-cum-sale is a major mode of retailing textiles, ready-to-wear clothing, books, and home appliances. These merchandizing spectacles (which recall the fairs

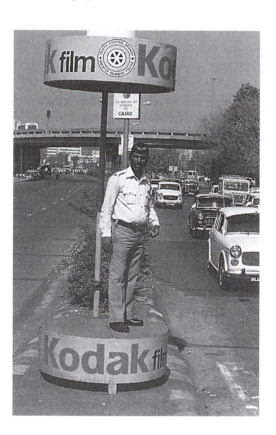

Figure 19.1
The visual promise of Kodak film frames the disciplinary gaze of a traffic policeman; Bombay, 1989: photograph by Arjun Appadurai and Carol A. Breckenridge

of medieval Europe) are transient, low-overhead, mobile modes for transporting, displaying, and selling a variety of goods. In them, in contrast to department stores, ordinary consumers have a chance to combine gazing, longing, and buying. This combination of activities, which is at the core of the informal schooling of the modern Indian consumer, is bracketed between two other, more permanent poles. One pole is the modern museum – whether of art, craft, science, or archaeology – in which the Indian viewer's visual literacy is harnessed to explicitly cultural and nationalist purposes. The other pole is the newly emergent, western-style department store, where gazing and viewing also go on but buying is the normative goal. In our usage, *gazing* implies an open-ended visual and sensory engagement tired up with fantasy and desire for the objects on display, while *viewing* implies a more narrowly framed, signage-guided visual orientation.

Framing these three display forms and contributing most actively to the regeneration of the museum experience is the festival form, especially as it has been harnessed by the Indian state in its effort to define national, regional, and ethnic identity. Such festivals are on the increase throughout the world[19] and everywhere represent ongoing debates concerning emergent group identities and group artifacts.

In India, the museum-oriented Festival of India, first constructed in 1985 as a vehicle for the cultural display of India in foreign nations and cities, quickly became indigenized into a massive internal festival called Apna Utsav (Our Festival), which began in 1986 and now has an elaborate national and regional administrative structure. Part of a vast state-sponsored network for local and interregional displays of art, craft, folklore, and clothing, these spectacles of ethnicity are also influencing the cultural literacy and visual curiosity of ordinary Indians in a manner that gives further support to the reinvigoration of museums, on the one hand, and the vitality of exhibition-cum-sales, on the other. What is thus emerging in India, and seems to be a relatively specialized cultural complex, is a world of objects and experiences that ties together visual pleasure, ethnic and national display, and consumer appetite. Museums, marginal in the eyes of the wider Indian public in the last century, have taken on a new role in the last decade as part of this emergent constellation of phenomena.

This constellation, which may be called the "exhibition complex" (museum-festival-sale), is further energized by new technologies of leisure, information, and movement in contemporary India. Cinema and television (and the landscapes and stars that they display), packaged pilgrimages and tours (which take thousands of ordinary Indians outside their normal locales as part of "vacation" experiences), and the growing spectacularization of political and sports events (especially through television), all conduce to a new cosmopolitan receptivity to the museum, which would otherwise have become a dusty relic of colonial rule. It is these new contexts of public culture that are now transforming the Indian museum experience.

The photographs in this essay constitute a narrative parallel to the text. They provide a representative visual sample of the archive of visual experiences that Indian visitors bring to museums. They are meant to convey the points of contact between different segments of Indian visual reality, which range from film and television images to mythic and political scenarios, and constitute the "interocular field" within which the museum experience operates and to which we refer in the conclusion.

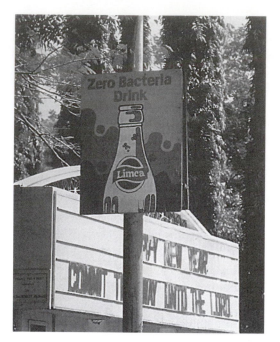

Figure 19.2
The discourses of health, leisure and thirst form a consumption vignette; Madras, 1989: photograph by Arjun Appadurai and Carol A. Breckenridge

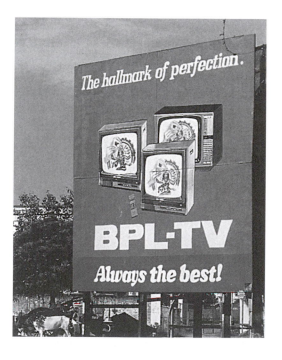

Figure 19.3
Classical images underwrite the mechanical excitement of television and lend archaism to the space of the billboard; Madras, 1989: photograph by Arjun Appadurai and Carol A. Breckenridge

Museums in India have to be seen in tandem with exhibitions of several sorts, and as parts of a larger cosmopolitan world of leisure, recreation, and self-education for wide sectors of the Indian population. Nothing of this emergent cosmopolitanism can be grasped without also understanding the impact that modern modes of communication have had on Indian public life. Print media, especially newspapers and magazines, have a history going back over a century in India (as in the West) but the last decade has seen an explosion of magazines and newspapers (both in English and in the vernacular languages), which suggests both a quantum leap in Indian readers' thirst for news, views, and opinion and the eagerness of cultural producers to satisfy this thirst profitably. Film (both documentary and commercial) has a history in India that clearly parallels its history in the West, and remains today the dominant medium through which large numbers of Indians expend time and money allotted to entertainment. Television and its sister technology, video recordings, have entered India in a big way and constitute a new threat to the cultural hegemony of cinema, while at the same time they extend the reach of cinematic forms to the smaller towns and poorer citizens of India.

Though Indian television programming is controlled by the state (just as radio programming is), it already has a very large component of privately produced soap operas, docudramas, and other forms of televised entertainment. This is, of course, in addition to a fairly large amount of state-sponsored and state-controlled programming, which ranges from news programs (which are still largely state-controlled) to live sports programs, "cultural performances," and informational programs on everything from birth control to new farming techniques. In general, though a number of the most popular serials on Indian television are variations of the Hindi film formula, many television programs have a historical, cultural, or documentary dimension. In television above all, it is the Indian heritage that is turned into spectacle. The most striking examples of this process are the three most popular trials and tribulations of the partition of India as experienced by a large Punjabi extended family, and the television serializations of the two great Indian epics, the *Ramayana* and the *Mahabharata*, for the weekly broadcast of which the whole television-watching audience of India apparently dropped everything. Thus, museums are part of a generalized, mass-media-provoked preoccupation with heritage and with a richly visual approach to spectacles.

Museums and public culture

In countries such as India, the challenge of training skilled teachers, the rudimentary resources available for primary and secondary education, and the bureaucratization and politicization of higher education, all mean that education outside formal settings has continued to be crucial to the formation of the modern citizen. Such education – which involves learning the habits, values, and skills of the contemporary world – happens through a variety of processes and frameworks, including those of the family, the workplace, friendship networks, leisure activities, and media exposure. Museums and the exhibition complex in general form an increasingly important part of this non-formal educational process, the logic of which has been insufficiently studied, especially outside the West.

Museums are also a very complex part of the story of western expansion since the sixteenth century, although they are now part of the cultural apparatus of most emergent nations. Museums have complex roots in such phenomena as cabinets of curiosities, collections of regalia, and dioramas of public spectacle.[20] Today, museums reflect complex mixtures of state and private motivation and patronage, and tricky transnational problems of ownership, identity, and the politics of heritage. Thus museums, which frequently represent national identities both at home and abroad, are also nodes of transnational representation and repositories for subnational flows of objects and images. Museums, in concert with media and travel, serve as ways in which national and international publics learn about them-selves and others.

Museums provide an interesting contrast with travel, for in museums people travel short distances in order to experience cultural, geographical, and temporal distance, whereas contemporary tourists often travel great distances in short spaces of time to experience "otherness" in a more intense and dramatic manner. But both are organized ways to explore the worlds and things of the "other." In the public cultures of nations such as India, both museums and tourism have an impor-tant domestic dimension, since they provide ways in which national populations can conceptualize their own diversity and reflect (in an objectified way) on their diverse cultural practices and histories. Such reflexivity, of course, has its roots in the colonial experience, during which Indians were subject to a thoroughgoing classification, museumification, and aestheticization in the museums, fairs, and exhi-bitions of the nineteenth and early twentieth centuries.[21] Finally, both museums and travel in India today would be hard to imagine apart from a fairly elaborate media infrastructure, as has been suggested already.

The media are relevant to museums and exhibitions in specific ways. For example, verbal literacy affects the ways in which people who come to museums and exhibitions are able to understand the objects (and signage) that are at the center of them. Thus, the issue of the ability to read is critical. Media are also important in the form of advertising, particularly through billboards, newspaper advertisements, and television coverage, which in many cases inform people about exhibitions (especially those associated with national and regional cultural repre-sentations). Literacy (both verbal and visual) is also relevant to the ways in which pamphlets, photographs, and posters associated with museums are read by various publics as they travel through different regions, visit various sites, and purchase inexpensive printed publicity materials associated with museums, monuments, and religious centers. Exposure to the media affects as well the ways in which partic-ular groups and individuals frame their readings of particular sites and objects, since media exposure often provides the master narratives within which the mini-narratives of particular exhibitions and museums are interpreted. Thus, for example, the National Museum in Delhi and its various counterparts in the other major cities of India offer specific narratives of the colonial, precolonial, and post-colonial periods (for example, the classification of the tribal as 'primitive').

Viewers do not come to these museums as cultural blanks. They come as persons who have seen movies with nationalist themes, television serials with nationalist and mythological narratives and images, and newspapers and magazines that also construct and visualize the heroes and grand events of Indian history and mythology.

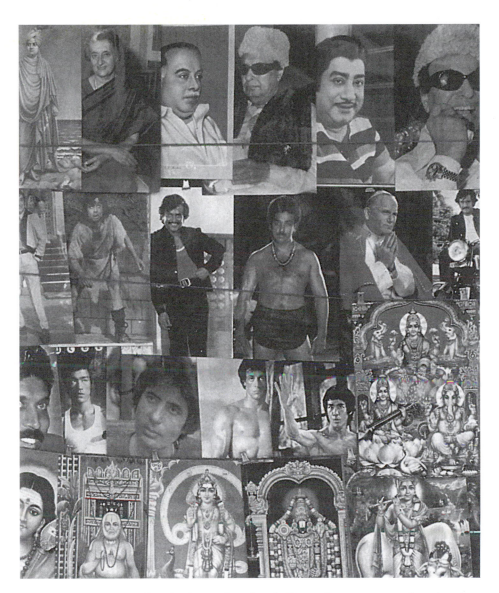

Figure 19.4 A street hawker's gendered anthology of cinematic, political and religious images of stardom; Madras, 1989: photograph by Arjun Appadurai and Carol A. Breckenridge

Figure 19.5 Old tech and new gloss in the world of the kitchen; Madras, 1989: photograph by Arjun Appadurai and Carol A. Breckenridge

Figure 19.6 Epic horizons, superstars and the seduction of the theater; Madras, 1989: photograph by Arjun Appadurai and Carol A. Breckenridge

Figure 19.7 Coffee and the wish-fulfilling cow in a mythic Hindu landscape; Madurai, 1989: photograph by Arjun Appadurai and Carol A. Breckenridge

Figure 19.8 Cinematic superdramas frame the microtraffic of the street; Madras, 1989: photograph by Arjun Appadurai and Carol A. Breckenridge

In addition, it is important to reiterate that the museum experience is part and parcel of learning to be cosmopolitan and "modern." This learning process has a consumption (as well as a media) dimension. Whether for city dwellers or for villagers, the experience of visiting museums is always implicitly connected to the consumption of leisure and pleasure. As regimented as many groups visiting Indian museums may seem, visits to museums and exhibitions are part of the pleasures of seeing, and visual pleasure has a very deep and special logic in the Indian context. In the annual traveling commercial exhibition known as the Ideal Home Exhibition, for example, the mastery of modern modes of domestic technology and lifestyle is the key to the exhibition experience, even for those who do not actually buy anything.

There is a complex dialectic among the experiences that Indians have in the ethnic-national museums (that is, museums where national heritage and ethnic identity are key concerns), in art museums, and in commercial exhibitions. In each case, they are being educated in different forms of cultural literacy: in the first case, they are being educated in the objectified narratives of nationality and ethnicity; in the second case, in the experience of cosmopolitan aesthetics; and in the third case, in the habits and values of the modern, high-tech householder. These three forms of cultural literacy play a central role in the construction of the modern Indian, who is drawn into the visual and auditory narratives of modern citizenship by his or her experiences in museums and exhibitions. The outstanding question is, how does the museum and exhibition experience help create such cultural literacy?

A major theoretical cue comes from what has been called "reception theory,"[22] a body of ideas developed largely out of postwar German neo-Marxism, but now modified by interaction with reader-response theory and associated approaches to problems of audience analysis in mass-media studies. From this rather diffuse and developing body of theory, four hypotheses can be suggested as especially relevant to those postcolonial societies outside the Euro-American axis, such as India, in which nationalism, consumerism, and leisure have become simultaneous features of contemporary life for important segments of the population. We see these hypotheses as particularly applicable to societies such as India, since in them the connoisseurship of "art" as a distinct category is relatively undeveloped, the visiting of museums is not sharply separated from other forms of leisure and learning, and the idea of expert documentation and credentials in the interpretation of objects has not displaced the sense that viewer groups are entitled to formulate their own interpretations.

The first hypothesis is that sacralized objects and spaces generate specialized modes of viewing and interaction, which are likely to be rooted in historically deeper modalities of seeing as a cultural practice. In the Indian case, there is a considerable literature showing that the mutual gaze (*darsan*) of sacred persons or objects and their audiences creates bonds of intimacy and allegiance that transcend the specifics of what is displayed or narrativized in any given context.[23] The faculty of sight creates special bonds between seer and seen. Museum-viewing may be expected, therefore, to display some transformation of this long-standing cultural convention.

The second is that the reception of specialized sites and spaces is a profoundly communal experience, and the objects and landscapes of museums are viewed by "communities of interpretation"[24] in which the isolated viewer or connoisseur is a virtually absent type. Thus, in any museum or exhibition in India (with the possible exception of certain museums devoted to "modern" art) the lonely and private gaze that we can often observe at places such as the Museum of Modern Art in New York is absent. Viewing and interpretation are profoundly communal acts.

The third hypothesis is that viewers are not likely to be passive and empty receivers of the cultural information contained in exhibitions and museums. Rather, as in all societies, they come with complex ideas of what is likely to be seen, and share this knowledge in highly interactive ways among themselves and with those few "experts" who are cast in the role of explainers. Thus museums and exhibitions are frequently characterized not by silent observation and internal reflection, but by a good deal of dialogue and interaction among the viewers, as well as between them and whoever is playing the role of guide. Here the museum experience is not only visual and interactional, it is also profoundly dialogic; that is to say, it is an experience in which cultural literacy emerges out of dialogues in which knowledge, taste, and response are publicly negotiated among persons with very diverse backgrounds and expertise. In many cases, the near-absence in Indian museums of docents and the underdevelopment of the idea that exhibited objects need to be explained (either by signage or by guides or docents) create a much wider space for discourse and negotiation among viewers: viewers are left free to assimilate new objects and arrangements into their own prior repertoires of knowledge, taste, and fantasy. Such freedom characterizes a great many Indian museums, even those in which there is a strong effort to determine viewer interpretations, but is true only of smaller, less intensively curated, less well-funded museums in the contemporary United States and Europe. There is thus a profound tension between the museum or exhibition as a site of defamiliarization, where things are made to look strange, and the viewer-dominated process of dialogue and interpretation, which familiarizes cosmopolitan forms and narratives into larger master narratives from other arenas of public life, such as travel, sport, and cinema. Thus, the museum experience has to be understood as a dialogue moment in a larger process of creating cultural literacy, in which other media-influenced narratives play a massive role.

Fourth, the responses of viewers, gazers, and buyers vary significantly, along at least two axes: (1) the type of exhibition or museum to which they are exposed; and (2) personal characteristics, such as the class, ethnic group, and age group to which they belong. These differences create significant variations within a larger common structure that is predictable from the previous three theoretical assumptions. Since the study of reception is in a general way not highly developed and is especially poorly developed for the study of readerships outside Europe and the United States (and even less so for reception in contexts such as museums), further examination of the exhibition complex could make a significant contribution to more general methodological debates.

Much of the structure, organization, taxonomy, and signage strategy of Indian museums is colonial in origin. Thus while the *contexts* of current museum-viewing may require new applications of reception theory, the *texts* contained in many

museums (that is, the collections and their associated signage) require the analysis of colonial modes of knowledge and classification.

Conclusions

Like many other phenomena of the contemporary world, museums in contemporary India have both internal and external logics. As far as the rest of the world is concerned, there is no denying that museums constitute part of an "exhibitionary complex"[25] in which spectacle, discipline, and state power become interlinked with questions of entertainment, education, and control. It is also true that museums everywhere seem to be increasingly caught up with mass-media experiences.[26] Finally, museums everywhere seem to be booming as the "heritage industry"[27] takes off.

In India, each of these global impulses has crosscut a particular colonial and post-colonial trajectory in which new visual formations link heritage politics to spectacle, tourism, and entertainment. In making this link, it seems that older Indian modes of seeing and viewing are being gradually transformed and spectacularized. While the investigation of the museum experience in India is only in its infancy, we would like to suggest that it will need to focus especially on the deep interdependence of various sites and modes of seeing, including those involved in television, cinema, sport, and tourism. Each of these sites and modes offers new settings for the development of a contemporary public gaze in Indian life. The gaze of Indian viewers in museums is certainly caught up in what we would call this interocular field (the allusion here, of course, is to intertextuality, as the concept is used by the Russian literary theorist Mikhail Bakhtin). This interocular field is structured so that each site or setting for the disciplining of the public gaze is to some degree affected by viewers' experiences of the other sites. This interweaving of ocular experiences, which also subsumes the substantive transfer of meanings, scripts, and symbols from one site to another in surprising ways, is the critical feature of the cultural field within which museum-viewing in contemporary India needs to be located. Our effort in this paper has been to argue for the importance of such an interocular approach to museums in India, and perhaps everywhere else in the contemporary world where museums are enjoying a fresh, postcolonial revival.

Notes

1 See, for example, Arjun Appadurai, "The global ethnoscape: notes and queries for a transnational anthropology," in R. G. Fox (ed.), *Recapturing Anthropology: Working in the Present* (Santa Fe, NM: School of American Research, 1991).

2 For a more recent work, see Carol A. Breckenridge, "The aesthetics and politics of colonial collecting: India at world fairs," *Comparative Studies in Society and History* 31(2) (1989): 195–216. Earlier efforts include Ray Desmond, *The India Museum, 1801–1809* (London: Her Majesty's Stationery Office, 1982); Hermann Goetz, "The Baroda Museum and Picture Gallery," *Museum* 7(1) (1954): 15–19; and Grace Morley, "Museums in India," *Museum* 18(4) (1965): 220–60.

3 Arjun Appadurai (ed.), *The Social Life of Things: Commodities in Cultural Perspective* (Cambridge: Cambridge University Press, 1986); Burton Benedict (ed.), *The Anthropology of World's Fairs: San Francisco's Panama Pacific International Exposition of 1915* (Berkeley: Scolar, 1983); James Clifford, *The Predicament of Culture: Twentieth-Century Ethnography, Literature, and Art* (Cambridge, MA: Harvard University Press, 1988); Virginia R. Dominguez, "The marketing of heritage," *American Ethnologist* 13(3) (1986); 546–66; Nelson H. H. Graburn, (ed.), *Ethnic and Tourist Arts: Cultural Expressions from the Fourth World* (Berkeley: University of California Press, 1976).

4 Igor Kopytoff, "The cultural biography of things: commoditization as process," in Arjun Appadurai (ed.), *The Social Life of Things: Commodities in Cultural Perspective* (Cambridge: Cambridge University Press, 1986).

5 Dominguez, "The marketing of heritage," *American Ethnologist* 13(3) (1986): 54–66.

6 Michael Ames, *Museums, the Public, and Anthropology: A Study in the Anthropology of Anthropology* (Vancouver: University of British Columbia Press, 1986); Douglas Cole, *Captured Heritage: The Scramble for Northwest Coast Artifacts* (Vancouver: Douglas & McIntyre, 1985); Neil Harris, "Museums, merchandising, and popular taste: the struggle for influence," in Ian M. G. Quimby (ed.), *Material Culture and the Study of American Life* (New York: Norton, 1978); Masatoshi Konishi, "The museum and Japanese studies," *Current Anthropology* 28(4) (1987): S96–S101; Mark P. Leone Parker B. Potter, Jr, and Paul A. Shackel, "Toward a Critical Archaeology," *Current Anthropology* 28(3) (1987): 283–302; Ian M. G. Quinby (ed.), *Material Culture and the Study of American Life* (New York: Norton, 1978); George W. Stocking, Jr, *Objects and Others: Essays on Museums and Material Culture*, History of Anthropology, Vol. 3 (Madison: University of Wisconsin Press, 1985).

7 Leone, Potter, and Shackel, "Toward a Critical Archaeology," *Current Anthropology* 28(3) (1987): 283–302.

8 W. S. Hendon, F. Costa, and R. A. Rosenberg, "The general public and the art museum: case studies of visitors to several institutions identify characteristics of their publics," *American Journal of Economics and Sociology* 48(2) (1989): 231–43; Kenneth Hudson, *Museums of Influence* (Cambridge: Cambridge University Press, 1987); Leone, Potter, and Shackel, "Toward a critical archaeology"; Michael H. Frisch and Dwight Pitchaithley, "Audience expectations as resource and challenge: Ellis Island as case study," in Jo Blatti (ed.), *Past Meets Present: Essays about Historic Interpretation and Public Audiences* (Washington, DC: Smithsonian Institution Press, 1987); Elliot W. Eisner and Stephen M. Dobbs, "Museum education in twenty American art museums," *Museum News* 64(2) (1986): 42–9; Danielle Rice, 'On the ethics of Museum education', *Museum News* 65(5) (1987): 13–19; Sheldon Annis, "The museum as staging ground for symbolic action," *Museum* 38(3) (1986): 168–71.

9 Jürgen Habermas, *The Structural Transformation of the Public Sphere: An Inquiry into a Category of Bourgeois Society*, trans. Thomas Burger with the assistance of Frederick Lawrence (Cambridge, MA: MIT Press, 1989).

10 Cf. Pierre Bourdieu, *Distinction: A Social Critique of the Judgement of Taste*, trans. Richard Nice (Cambridge, MA: Harvard University Press, 1984).

11 Robert Lumley (ed.), *The Museum Time-Machine: Putting Cultures on Display*, (New York: Routledge, 1988); Jo Blatti (ed.), *Past Meets Present: Essays about Historic*

Interpretation and Public Audiences (Washington, DC: Smithsonian Institution Press, 1987); Robert Hewison, *The Heritage Industry: Britain in a Climate of Decline* (London: Methuen, 1987); Donald Horne, *The Great Museum: The Re-Presentation of History* (London: Pluto, 1984).

12 Tony Bennett, "The exhibitionary complex," *New Formations* 4 (1988): 73–102.

13 Donna Haraway, "Teddy bear patriarchy: taxidermy in the Garden of Eden, 1908–1936," *Social Text* 11 (Winter 1984–5): 20–64.

14 See Blatti, *Past Meets Present*, especially the following essays therein: Michael J. Ettema, 'History museums and the culture of materialism'; Jane Greengold, 'What might have been and what has been – fictional public art about the real past'; and Michael Wallace, 'The politics of public history'.

15 Shelly Errington, "Fragile traditions and contested meaning," *Public Culture* 1(2) (1989): 49–59; Richard Handler, *Nationalism and the Politics of Culture in Quebec* (Madison: University of Wisconsin Press, 1988); Michael Herzfeld, *Ours Once More: Folklore, Ideology, and the Making of Modern Greece* (Austin: University of Texas Press, 1982); Eric Hobsbawm and Terence Ranger (eds), *The Invention of Tradition* (Cambridge: Cambridge University Press, 1983); Richard Johnson *et al.* (eds), *Making Histories: Studies in History-Writing and Politics* (London: Hutchinson, 1982); William W. Kelly, "Rationalization and nostalgia: cultural dynamics of new middle class Japan," *American Ethnologist* 13(4) (1986): 603–18; Jocelyn S. Linnekin, "Defining tradition: variations on the Hawaiian identity," *American Ethnologist* 10(2) (1983): 241–52; David Whisnant, *All That Is Native & Fine: The Politics of Culture in an American Region* (Chapel Hill: University of North Carolina Press, 1983).

16 Arjun Appadurai and Carol A. Breckenridge, "Why public culture?", *Public Culture* 1(1) (1988): 5–9.

17 Hermann Goetz, "The Baroda Museum and Picture Gallery," *Museum* 7(1) (1954): 15.

18 ibid.

19 For example, see Richard Handler, *Nationalism and the Politics of Culture in Quebec* (Madison University of Wisconsin Press, 1988).

20 See Richard Altick, *The Shows of London* (Cambridge, MA: Harvard University Press, 1978) for descriptions of these dioramas in the development of museums in England.

21 C.A. Breckenridge, "The aesthetics and politics of colonial collecting."

22 For example, Jane Feuer, "Reading *Dynasty*: television and reception theory," *South Atlantic Quarterly* 88(2) (1989): 443–60.

23 For example, Diana L. Eck, *Darshan: Seeing the Divine Image in India*, 2nd edn (Chambersburg, PA: Anima, 1985); J. Gonda, *Eye and Gaze in the Veda* (Amsterdam: North Holland, 1969).

24 Stanley Fish, *Is There a Text in This Class? The Authority of Interpretive Communities* (Cambridge, MA: Harvard University Press, 1980).

25 Bennett, "The exhibitionary complex."

26 Lumley, *The Museum Time-Machine*.

27 Hewison, *The Heritage Industry*.

Sharon Macdonald and Roger Silverstone

REWRITING THE MUSEUM'S FICTIONS:
Taxonomies, stories and readers

> The set of objects the Museum displays is sustained only by the fiction
> that they somehow constitute a coherent representation universe . . .
> Should the fiction disappear, there is nothing left of the *Museum* but
> ('bric-a-brac'), a heap of meaningless and valueless fragments of objects
> which are incapable of substituting themselves either metonymically for
> the original objects or metaphorically for their representations.
>
> (Donato, 1979: 223)

IN CURRENT DEBATES AROUND the changing nature of contemporary
culture, many of the defining fictions of our everyday world have been identi-
fied as under threat: the legitimacy of the 'grand narratives' of science and reason
are in decline; there is a fragmentation of taste and style; representation and classi-
fication have become unprecedently problematic; and what were once called
'truths' are increasingly being dubbed 'fictions'. The museum has not occupied a
particularly strategic position in these debates. Indeed, in our own everyday sense
of the key institutions of the modern world, the museum would probably take its
place a long way down the list. Yet recent discussions of the museum both from
within the profession and from outside it have begun to focus on the museum as
a potentially interesting and important site for the examination of cultural change
(Lumley, 1988; Vergo, 1989), and recent reports in the nation's press have focused
on the major structural changes that seem to be affecting – and affecting in a very
public way – the present status of, in particular, the national museums in British
society.

Something is happening in the world of the museum which from inside is often
seen as a crisis, above all a crisis of funding and identity,[1] but which from outside
(and increasingly from inside too) appears to be expressive of a wider set of
concerns. These concerns – with problems of authenticity, representation and the

active demanding reader/viewer/visitor – are central to current discussions in the analysis of other cultural industries. Yet the museum should not be regarded simply as a somewhat specialized, or even esoteric, refraction of the issues raised by those other cultural industries. By dealing with the legacy of past or declining fictions, and in their attempts to write new ones, museums' concerns lie at the centre of the issues surrounding contemporary cultural change.

There is in the museum world itself a sense of profound change underway. Recent years have seen numerous signs of this change. The acrimonious debates waged over restructuring at the Victoria and Albert Museum provide just one example of dilemmas facing all of the national museums; and the museum's 'Ace Caff' advertising campaign has become symbolic of some of the cultural transformations in progress. The advertisement, which reads 'An Ace Caff with rather a nice museum attached', gave clear – if amusing – priority to a consumerist culture which some in the museum world consider to threaten the very identity of Britain's great museums.

Yet, whilst there is talk of a crisis of identity facing the national museums, and the *Museums Journal* can ask 'Is it Armageddon?' (July 1989), local and independent museums and heritage sites are springing up at a rate of about one a fortnight (Tait, 1989; Lumley, 1988: 1; Hewison, 1987: 9). The same forces which are constraining the established museums seem to be enabling the new. In this paper, we argue that this paradox is symptomatic of a series of interrelated shifts and uncertainties in classification expressed through the nature of museums' collections, of their modes of presentation, of the visitors – the readers and consumers – whom they serve, and above all of the identity of the museums themselves. These are all now matters for critical self-examination and re-evaluation in the museum world. The crises and uncertainties that museums are experiencing today may have been thrown into sharp relief by the urgent problems of funding but they have not been created by them. Their source lies much deeper and it goes back much further; indeed, it goes to the heart of the museums' own ethnographic project of collection, classification and display (Clifford, 1988). The museums are engaged in a struggle for a new legitimacy: for the high ground of public display, and for the rights of representation of objects, ideas and narratives.

Our argument here is conducted through a discussion of the present situation of one national museum, the Science Museum (National Museum of Science and Industry), where we have been undertaking ethnographic fieldwork since October 1988. In particular, we examine a recently completed major gallery in the Science Museum – *Food for Thought: The Sainsbury Gallery* which, in so far as it is one resolution of the problems facing museums at this point in time, can be regarded, we suggest, as one expression of the museum's changing identity. At a time when the old dominant fictions of museum display are losing their authority, the writing of a new gallery inevitably plays its part in inscribing the new fictions on which museums' future identities will be based. Our ethnographic case-study illuminates the ways in which one particular exhibition has come to terms with a set of dilemmas which face all exhibitions. It is, of course, only one of an infinite number of possible resolutions which museums might make. One feature of the present time is that there is no clearly defined and fully accepted approach for museums to take in their creation of new exhibitions: this is a period of pluralism and fragmentation.

Signs of change: the Science Museum

The period of our research has been one of marked change in the Science Museum, so much so that the comment, 'The Science Museum is in the grip of a cultural revolution' (Swade, 1989: 50), could be included in the Science Museum's *Annual Review*. On 3 October 1988, the day on which our ethnography began in the Science Museum, the museum began charging an entry fee for visitors, and there were protests at the doors. The museum was already in the midst of a wholesale reorientation, with a new emphasis on 'customer care' and 'marketing'. A major facelift of the museum was underway, the main entrance area, the East Hall, having been refurbished and opened in June 1988 (see Cannon-Brookes, 1989). The Science Museum's attendants had changed from their old guards' uniforms to 'informal', tennis-club style outfits during the summer of 1988, and over the following year advertising banners appeared along Exhibition Road and in the museum's foyer; the museum adopted a new designer logo; a large bookshop and gift shop were opened; an extensive poster-advertising campaign was begun; the museum showed its first ever television advertisement; 'visitor research' was given a new emphasis; the first Professor of the Public Understanding of Science was appointed; and plans were made for a new Head of Interpretation post.

If much of this was 'front-of-house' change, according to the new terminology, it was matched by structural change behind the scenes. The Science Museum, like all of the nationals, now has a 'corporate plan' which lists 'priorities' and means of achieving them. 'Accountability', 'rationalization' and 'performance indicators' are part of the new cultural milieu. The museum appointed its present director, Dr Neil Cossons, in April 1986 and his 'initial management plan' – a scheme to reorganize the museum's managerial structure – was adopted in October of that year and is still being put into effect. The scheme reflects more widespread changes in the museum world. Instead of the curatorial functions of the museum accounting for all but one of the museum's departments,[2] these are now concentrated in just one of five new divisions, and have taken on the new title of Collections Management. A key shift of function is that in the new scheme exhibitions are managed not by curators but by a Public Services Division: the institutional links between the collections and display have, therefore, been diminished relative to the connection between display and 'the public'.

In addition to Public Services, Marketing and Resource Management have also become divisions in their own right.[3] The changes are oriented around providing a more 'efficient', and more 'marketable', service to the museum's visitors, or 'customers' as they are increasingly being called. The shift is sometimes talked about within the museum as an introduction of the mores of the City, a move into enterprise culture, an adoption of the new realism. Whether this 'cultural revolution' is seen within the Science Museum as challenging or decadent, it is clearly perceived to raise many questions about the museum's identity, and indeed there have been discussions held within the museum during the period of our field-work on just these issues.

The new exhibition, *Food for Thought*, which we look at in more detail below, will be the first exhibition to be completed within the new cultural framework. The problems which have faced the exhibition team working on this project, whose

progress we have watched, are in many ways those which face museums as a whole, and, therefore, just as the Science Museum's response to the prevailing climate in which museums are operating can be seen as one of many possible responses, so too, at a more detailed level, is that of the exhibition itself. These problems are generated by a shifting of cultural categories, and include such dilemmas as those between entertainment and education, the real thing and the reconstruction ,the truth and stories, and specialist and lay information (cf. Silverstone, 1988: 231–2; see also Bud, 1988, 1989).

The Science Museum is not unusual among Britain's established museums in experiencing such changes: the sources of the present crises apply in varying degrees to, though are refracted in different ways in, all of the nationals. There are two features of science museums, however, which focus the dilemmas more keenly. The first is that a science museum is expected to have 'up-to-date' collections, therefore it must continue collecting, and expanding its storage space and effort on conservation, indefinitely. The second is that science museums often have more narrowly defined educational aims than the general cultural enrichment that art museums and galleries offer. The effect of these is that science and technology museums are called upon to justify their 'contribution to society' to an extent that their arts counterparts are not.

Changing fictions

At one level the present problems that the national museums face are due to falling income in real terms from the state. This, of itself, pushes museums into the market place where they must compete for both corporate sponsorship and, if they charge, 'heads through the door'. But the emphasis on marketing is not simply a function of economic pressure, it is also a function of the fact that the world in which museums now operate is populated by 'consumers'. As the director of the Science Museum put it 'We are in a period of deregulation when traditional professions are under threat from the consumers' (*Museums 2000*)[4] The shift underway seems to be away from the old idea that the national museums served a community, in their case the nation, towards the more individualistic notion of the consumer. Charging for entry of the national museums, anathema to the community perspective, becomes almost *de rigeur* once visitors are not citizens but customers.[5]

The 'threat from the consumers' is a very real one for institutions which have historically taken for granted their right and ability to define their own relationships with their visitors. Indeed the issue of consumption is increasingly becoming the *leitmotif* of discussions amongst theorists of, and policy-makers within, the cultural industries. And although such a preoccupation disguises the still continuing capacity of those industries to occupy the strategic high ground of cultural definition, as well as the profound inequalities in the abilities of consumers to consume (evidence of which can be seen in the decreased proportion of visitors from among the less well off as a result of the introduction of charges), it faithfully expresses a real and significant change in the balance of power within contemporary culture. As such it is indeed a threat to those institutions which have little choice but to adjust their practices to it.

Also aggravating traditional museums' financial problems is the expenditure needed to store and conserve their ever-growing collections. Over time, collections have outgrown the available display space, and so, inevitably, the proportion of the collections actually in the showcase as opposed to the vault has declined. One recent estimate reckons that 80 per cent of museums' collections in this country are in storage (Lord, Lord and Nicks, 1989). Unless there is major change made to either collecting or display policies, or unless the museum acquires a vast amount of extra display space, then the proportion of the collections on display will continue to decrease. For national museums, which are increasingly called upon to legitimate their practices in terms of the public, collections which are not publicly accessible necessarily constitute a problem.

The problem is exacerbated by many of the currently fashionable display techniques which often use fewer artefacts in a given space than did the more traditional well-filled showcase method. The increased use of reconstructed scenarios, interactive exhibits, and audio-visual technology, and often a more spartan aesthetic, have all led to what are known by curators as less 'object-dense' exhibitions. The impetus for 'interpretative' and 'contextual' means of display has come, in part, from the consumers, and from competition with other media such as television and theme parks.

But there is another, and in some ways more fundamental, problem which faces museums today, and that is the growing sense of the changing and subjective nature of the principles on which museum objects are selected. Early museum collections were motivated primarily by the rare and exotic (Hudson, 1975; Impey and MacGregor, 1985): the key feature of the objects they collected was their singularity, and it was in this that that 'special magic of museums' (Horne, 1984) – authenticity – lay. The Great Exhibition, however, from which the Science Museum was born, was concerned with objects as signs of progress, and thus 'the latest' developments became collectable (Greenhalgh, 1989). Objects selected in this way still laid claims to authenticity, though they did so not through their specificity but as icons, as representatives of classes.

Of course, in practice collections were often not so neat or complete as their curators might have wished because of the uncertainty introduced by chance salvagings and donations. However, where active selection was possible, the Science Museum used two main criteria in determining its collections. These were that the collections should illustrate general scientific principles and the progressive history of science and industry (Follett, 1978: 12–14; Lawrence, 1989: 9–12). These taxonomic and evolutionistic ideas, and the object-centred series displays they typically produced, are, however, no longer so easily accepted within museums. The growing sense of disquiet about them has come on the one hand from an intellectual critique of the nature of knowledge, and, in particular, scientific knowledge; and on the other from competing discourses of representation. Within the history and philosophy of science, as in many other disciplines, absolutist positions have been displaced by relativist ones (Lyotard, 1984; for a recent review of the science literature see Woolgar, 1988), so rendering any system of classification arbitrary.

The consequence of this for museums is a shift from displaying *the* taxonomy to telling 'stories' or transmitting 'messages', and very often the appropriate

methods for doing this are less the showcase than the new interpretative media such as videos and reconstructions. 'Stories' and 'messages', rather than taxonomies, then, are the museums' new fictions. This is not to say that taxonomic displays will necessarily disappear from museums, nor even that new exhibitions will inevitably avoid taxonomic modes of display. There are several reasons for this. One is that the old taxonomic legacy will not easily be forgone: it was, and still is, a persuasive fiction. Taxonomic modes of display also have an advantage where accessibility to the public has become a criterion of the legitimacy of holding collections at all, in that, on the whole, they are more object-dense and so succeed in offering up more objects to public scrutiny than might a more contextualist presentation. However, when taxonomic displays are used in museums today they are necessarily recontextualized: museum professionals cannot assume that they will be read as unproblematically, or as passively, as they once were, and may even have to consider taxonomies themselves in terms of 'messages' or 'stories'.

Collecting must, of course, take place within some system of classification. As the authority of those systems has weakened, however, so too has their defining power over other categories, particularly in this case over categories of display. Collections can no longer be so easily accepted as unproblematic 'rational' or even 'natural' taxonomies, taxonomies which would previously have been wholly appropriate to the showcase (cf. Donato, 1979; Haraway, 1984–5). In a movement which has gathered pace over recent years, collections are seen to require not just display but interpretation. The task of interpretation, then, which is fast becoming professionalized in museums, is to rewrite the fictions inherent in the collections.

The transition towards interpretative media has also been spurred on by other modes of representation, especially television, which have, in effect, issued a challenge to museums' claims as proprietors of authenticity and immediacy. Museums may well hold 'the real thing', but one function of a relativist epistemology is that authenticity becomes a feature not only of the object itself, but of the subject's experience of it. The question that a museum must address is whether an object is more 'real' for a visitor when it is displayed with taxonomically related artefacts in a showcase than when it is represented in the context of its production or use, as it may be, for example, on television. What counts as context is, of course, itself a culturally defined matter, and it is significant that the taxonomic mode of presentation is not generally deemed by museum professionals to count as contextualized at all (see, for example, Swade, 1989). The contexts which count as context these days are predominantly social and experiential.

While television offers a mode of representation which suggests authenticity through 'natural context' (however contrived that might in fact be), other areas of the 'leisure industry', notably theme parks, such as Disneyland in the United States and Alton Towers in Britain, offer a fuller sensory representation than the predominantly visual experience that museums have typically presented. The 'reality' that theme parks present, though often not 'real' in the senses of authenticity on which museums traditionally relied, is often superlatively real in experiential terms, or 'hyperreal' as Umberto Eco terms it (1987). It is not surprising then that museums are making their claims to authenticity through new notions of immediacy and reality; for example by creating exhibits which museum-

goers can enter, touch, hear and even smell. Museums are, then, we would suggest, exceptionally rich sites for the examination of changing and postmodern formulations of the notion of authenticity.

The effect of these challenges is not only upon what museums do, but on the definition of museums themselves. As we have said, some museum professionals feel the very identity of museums to be under threat, and small wonder given that museums are ceasing to have a special prerogative on the categories on which they have, largely unselfconsciously, been based. One speaker at a major museums conference in 1989 could state, without contradiction, 'The truth is, we do not know any more what a museum institution is' (Tomislav Sola, *Museums 2000*). Museums deal more and more not in taxonomies but in stories or messages (Silverstone, 1988, 1989): display is ceasing to be so intimately bound up with collections. One consequence of this is that these stories, woven around artefacts or locations, can be told by institutions other than the established museums. The undermining of categories which gives rise to a sense of crisis in the traditional, collection-based museums simultaneously provides a semantic space which can be colonized by new variations on the museum theme.

If, as we have argued, the category 'museum' is in the process of being recast, and its fictions rewritten, this makes the creation of any new museum or exhibition itself part of the ongoing redefinition. The loosening of constraints on the category provides the possibility to develop many different sorts of museums and of exhibitions: the museum world as a whole, and individual museums, are likely to become more pluralist. For any established museum, a new exhibition or gallery is necessarily the outcome of a debate or struggle between different possible definitions of museums: it is at once a resolution of competing semantic claims, and an experiment tested out, literally and metaphorically, on the floor of the museum.

Food for Thought: a text for consumption

Food for Thought, a permanent gallery which opened in the Science Museum in October 1989, is consciously seen within the museum to be breaking with traditional museum practices in a number of respects. It is the first major gallery to be begun and completed under the museum's present director and within the new managerial and cultural milieu. As such it has both helped to establish, and placed itself within, the discourse generated by the current uncertainties of classification. While we do not wish to deny the creative input of the exhibition's makers, nor the great complexity of the processes and negotiations involved in exhibition creation (which we are in the process of analysing and will report upon later), we want to show here how the gallery has, in part, been articulated around certain oppositions, or even dilemmas, which are particularly timely.

We have suggested that collections no longer have the same defining power over categories of display that they once had. This is a consequence of material and epistemological developments: too extensive collections to display on the one hand, and a growing sense of the arbitrary nature of categories of collection on the other. 'Food' is an example of a category that was not defined by a

collection: there was no pre-existing food collection, and the objects incorporated in the gallery have been drawn from various collections both within and outside the museum. The 'non-specialist', 'public' and even 'domestic' dimension of the category – and its openness to the sort of social and contextural interpretation which is becoming increasingly dominant in museums – was regarded as a virtue by those devising (and those approving) the exhibition.[6] In the rhetoric of the construction of this gallery the emphasis has been on the users, the public, the consumers (in both senses of the word).

This user-friendliness has made itself felt on a number of levels, and various oppositions and forms of reasoning have been employed in the formulation of this gallery as a 'determinedly populist' one. None of the museum staff appointed to devise this exhibition – the 'project team' had particular specialist knowledge of the subject – a state of affairs promoted by exhibitions being organized within a public services – rather than a collections or research-based division of the museum – and the team members themselves stressed the value of beginning with a lay or common level of understanding. The idea was that by themselves being consumers rather than producers of any technical or scientific knowledge they would be better able to represent this knowledge in a publicly accessible form. The attempt to make the exhibition accessible to 'everybody' (a term frequently used in presentations of the gallery during its planning phase) was also formalized in a number of ways, such as by doing various tests on the vocabulary and syntax used in the text for the gallery to ensure that, technically at least, it would not presuppose more than the most elementary – or everyday – understanding.[7] In this way the food gallery has claimed to be concerned with 'public under-standing' by opposing this to 'specialist' or 'expert' constructions of knowledge. The audience, then, has been constructed as widely as possible without postulating a composite public (made up not just of the 'ordinary person' but also, say, of enthusiasts or specialists).

This is not to say that there is an expectation that all visitors will come away from their visit to this exhibition having read it or experienced it in the same way. In keeping with the shift towards visitors as consumers, the gallery has been designed to allow, and even promote, visitors to make *choices* both with relation to their experience in the gallery itself, and, at another level, to the topics of the gallery – food and diet. *Food for Thought* does not have a single determining narra-tive or story, though it does have a stated overall aim to 'show the impact of science and technology on our food'. This is interpreted through a series of 'messages' which address the visitor through the familiar (in the first place at least) rather than the more technical or scientific.

For example, the technological developments which have played a part in changing shopping are represented initially from the vantage point of the shopper (there are actual reconstructions of shops) rather than, say, by beginning with a focus on production methods. In the theory of this gallery the unfamiliar is intro-duced via the everyday: processes like 'aseptic packaging' are represented in conjunction with the reminder that packaged fruit juice has 'become a common item on our dinner tables'; factory processing is counterbalanced with domestic kitchen scenes where, it is suggested, many of the same processes go on, though on a different scale; nutritional principles are illustrated in the first place by piles

of food. This is a gallery in which consumption is literally at the forefront: it begins with the everyday activities of eating and shopping, and only later (in both the conceptual structure of the gallery and its physical layout) does it move into production.[8]

The offer to the consumers to make choices is also effected by the design and multi-media presentation of the subject. There are various routes which a visitor might make through this gallery, and in all areas a variety of media is used, so a visitor's reading of the gallery is not determined by, say, just one or two modes of presentation. As well as using objects and the written word, the gallery also incorporates videos, recordings, and a great range of interactive exhibits which, it might be argued, are of themselves open to greater choice in the ways in which they are experienced. Certainly more of the senses can be involved in a visit to the *Food for Thought* gallery than is generally the case in the Science Museum's other galleries: there are spices and foods to be sniffed; exhibits to be touched, shaken, entered, stood on, or listened to; and only health and safety regulations prevented there being exhibits to actually taste – or literally consume. All of this is not only to do with choice, of course, it is also part of the related phenomenon of the museum entering the world of entertainment. *Food for Thought* is 'determinedly populist' not only in its catering to the non-specialist but also in its attempts to attract and engage an audience through modes of presentation which once were the preserve of television, the theme park and the funfair.

Consumers of *Food for Thought* are also offered choices over their consumption of food itself. The gallery is not narrowly prescriptive over food or diet: in several places, for example, the visitor is presented with competing notions of what constitutes a 'healthy diet' and asked 'What do you think?' In talking about the gallery the project team have repeatedly stressed that they are 'not making judgements' and that buying and eating foods are relative matters: 'what is right for one person is not going to be right for another' (Project Manager, October 1989). In doing this, they highlight two things relatively unusual within a science museum: the subjective nature of individual experience and the uncertainty of some areas of contemporary science.

The responses which *Food for Thought* has made to the uncertainties of classification in museums have not, however, been made without debate and sometimes misgivings. There was often a tension, for example, between 'getting a message across' and showing historic objects; there were dilemmas over whether to show 'real' things or to use reconstructions, and whether to use interactive or static exhibits. Marrying the everyday and familiar with the more technical was often difficult, as was steering the line between 'factual accuracy' and 'public accessibility', and balancing entertainment and information. Nor was the extent to which the gallery would attempt to 'avoid making value judgements' easily resolved. In coming to the final resolution – the finished gallery itself – the project team had to find a way of dealing with these dilemmas which would be acceptable both to themselves and to the institution at this point in time. How 'successful' the gallery is, and indeed in what terms such an assessment should be made, is, and will remain, open to question. What is clear, however, is that this is a gallery which has addressed some of the contemporary issues surrounding museums in a particularly direct way.

New fictions and their readers

Food for Thought provides ample evidence, then, of one way in which museums are responding to the uncertainties which they face. This emphasis on the reader, or visitor, which has the capacity to pervade every aspect of an exhibition, is one which many other museums and exhibitions are making. And indeed the further museums go along the route which takes them closer and closer to the heartland of the cultural industries, where the terms 'competition', 'choice', 'entertainment', 'enterprise', 'sponsorship' become both realities and slogans, then the more central the visitor becomes (cf. Vergo, *Museums Journal*, October 1989: 22). But the visitor is a problematic entity for a number of reasons. The first is that he or she is perceived increasingly as a consumer rather than the isolated scholar or the education-hungry layperson or the seeker after truth, prepared to accept the authority of the museum, the integrity of its classification, the authenticity of its display. The museum visitor seems to be being perceived more and more as a pleasure seeker, consuming images, ideas, experiences, and restlessly requiring to be entertained in a world of competing distractions.

The second follows. The visitor has to be taken into account – numerically and economically as well as in terms of content and approach – in the design of new galleries, in the remodelling of old galleries, and in the creation of new heritage sites and museums. In the past, the main space for catering to the visitor was on object labels. But now the visitor is increasingly, and consciously, the focus of the display as a whole, as the museum creates – through the use of interactive exhibits and familiar communication technologies – spaces and opportunities for the visitor to become involved on his or her own terms. But then what are these terms? Once the visitor is granted status as consumer or reader, and once consumption and reading are seen as active rather than passive, individual rather than collective, activities, then it is the visitor who requires classification. And in a world of fragmenting tastes and pleasures this is no easy matter.

Who, then, is the visitor? Evaluative research can discover, once an exhibition is open, who comes to it and what they say about it. Formative research can test the effectiveness of individual exhibits. But such research rarely goes very deeply into the socially defined nature of the relationship between the visitor and the objects, exhibits and texts of an exhibition, and it is this relationship which is the crucial one. It is presumed in the design of galleries, and as such the experience of the visitor provides not an end point in the museum's communication, but the point at which a loop is made back to its creation. The visitor is at once the reader of the museum's fictions, and their hero. If we can (and must) read the visitor in the texts of the museum, we can (and must) also read the texts of the museum through the visitor's experience.

Recent discussions of the changing nature of contemporary culture – the shift from modernity to postmodernity – have discussed the increasing fragmentation of style and taste, the result of a shift in production practices which both creates and responds to the consumer, and which lays increasing stress on consumption as the driving cultural and economic force in contemporary society (e.g. Harvey, 1989). Recent discussions of consumption, both literally in terms of the consumption of goods, and metaphorically in terms of the consumption of meanings (the

two, of course, are not separable), have laid great stress both on the individual-
izing and cultural variability of consumption, but also on consumption as active
(e.g. Miller, 1987).

Visitors are consumers. And the goods and meanings which they consume are
not absorbed but appropriated, and in the act of appropriation they are trans-
formed from public to private, from collective to individual, from the relatively
open to the relatively closed (ibid.). The visitor-consumer is active, but active
within the bounds set by the objects, the collection, or the display: in some cases
and at some times the visitor is offered a great deal; in other cases and at other
times text and context will deny the visitor the space and opportunity for much
in the way of appropriation. The clarity of the labels, the tightness of the phys-
ical layout of the gallery, the quality of the designed environment are all elements
in the textual bid for control at the same time as they may appear (or are designed)
to release the visitor to discover his or her own meanings. Contemporary display,
no less, but often much more than the displays of old, steers a precarious balance
between offering and insisting, between constructing the visitor-consumer as active
or as passive.

Increasingly, of course, it is the active, creative, released visitor who is
constructed for the museum text, and in active consumption the consumer – the
visitor, the viewer, the reader – is assumed to bring to the involvement with the
texts and objects of consumption his or her own socially defined experiences and
interests, which provide both the context of, and the control for, the meanings
which emerge and become significant in the interaction between body and text
(de Certeau, 1984). The visitor in the museum is more and more inscribed in the
text as active, as a contributor to, if not a creator of, his or her own experience
of the museum. While this may seem at one level to be unproblematically self-
evident to curators and interpreters as they go about their business in the museum
world, it has profound implications for the new identity and cultural significance
of the museum as an institution of collection, classification and display. The dilemma
can be very simply expressed through a question. In the new museum world of
active visitor-consumers, who is doing the collecting and the classifying, who is
constructing the display?

Historically, the museum has presented a set of objects, and in that set has
made a number of statements both about its own practices and its legitimacy but
also about the significance of the objects included as representatives of the world
from which they have come. Objects are metaphorically related to a past or to
another culture: they stand for that other and otherwise inaccessible world synec-
dochally, as the part stands for the whole (Seznec, quoted in Donato, 1979: 225).
But the displacement of attention and concern away from the curatorial achieve-
ment – the authority and the coherence of the collection – to the visitor's
experience – the authority and coherence of the person – transforms the context
of representation and interpretation. Objects become meaningful not so much in
terms of outside reality – physics, palaeontology, Chinese civilization – but in
terms of an experiential reality, one which is based in the visitor's own individual
or cultural biography. Presented with a series of objects or experiences in the new
gallery, the visitor is being invited to become curator: the collection, in its fictional
coherence, which is an albeit recontextualized statement about the coherence of

the world, becomes instead a display of separate objects and experiences which invite the visitor to choose those elements which are already meaningful in terms of his or her own reality. The collection becomes, in Susan Stewart's terms, a series of potential or actual souvenirs (Stewart, 1984): objects that are domesticated and appropriated not just because they signify the time and place of their consumption but because they signify something of the already experienced. The visitor recognizes himself or herself in the objects and displays of a gallery, and in those acts of recognition appropriates curatorial power.

The visitor, then, is the significantly new focus, and even writer, of the museum's fictions. This is far from being a purely literary or ideological point. The financial crisis currently afflicting museums is real and pressing enough. Without substantial changes of government policy the museum visitor will increasingly become a vital source of revenue, vital even for the national museums as they seek to maintain their institutional and cultural viability. The construction of the visitor as consumer is a cultural as well as a financial matter. It is not just bodies which pass through the turnstiles every day. Passing through too are those forces unleashed within contemporary culture which threaten the museums' fictions as well as our own.

Notes

1 A recent report on the national museums and galleries by the Museums and Galleries Commission discusses some of the dilemmas which face the nationals (1988). One of the immediate causes of the present crisis is the transfer of responsibility for museum buildings away from the government's Property Services Agency to museums themselves, a move which has left most national museums and galleries with serious financial problems. [. . .] For a more general account of museums' changing relationship with government see Cossons, 1989, and for an earlier discussion of the changes underway in museums see Cossons, 1985.

2 By 'curatorial functions of the museum' we mean those centred around the collections: these include the acquisition of new 'objects', conservation and cataloguing. In the old system, exhibitions were also managed within curatorial departments. 'Objects' is the word used by curators to designate the artefacts which are part of the museum's collections.

3 In the later 1970s there were eight departments, of which one – Museum Services – was non-curatorial. In addition there was the Administration and the library. By the time of the implementation of the new management plan seven curatorial departments had been amalgamated into four. Museum Services was broadly analogous to the new Public Services, Administration to Resource Management, and the library is now incorporated into the Research and Information Services Division.

4 Museums 2000 was a conference, held in May 1989, organized by the Museums Association to discuss the future of museums. Proceedings were published as *Museums 2000*, ed. Patrick Boylan (London: Routledge, 1991).

5 So a museum director can today argue that charging is not a denial of the right of entry to a museum but that it offers potential customers the opportunity

properly to exercise, and so value, that right (Patrick Green, interview with author, July 1989).

6 Another relevant issue in the choice of food as a subject for exhibition was that it provided the opportunity for sponsorship, an important consideration in the present financial climate. We will be exploring the complex issue of sponsorship elsewhere.

7 The lengths that the project team went to in order to ensure that their text would not be 'difficult' were unprecedented in the museum (which is not to say, of course, that there has been no attempt previously to cater for the non-specialist). In addition to the devising of careful guidelines on the length of text to be permitted on labels and so on, and in addition to the sending of the text to other non-specialists to be read for 'comprehensibility' (as well as to 'experts' to check for 'factual accuracy'), the text was all submitted to a computer 'readability' program.

8 To say that this gallery has been constructed around a notion of the consumer is not to say that it gives the 'consumer angle' as this is understood with regard to the politics of food. The degree to which the gallery does in fact, or even could in theory, offer the opportunity to make genuine choices is a complex matter beyond the scope of the present paper. Our concern here is with the ways in which the consumer or visitor has become central to the rhetoric of exhibition construction.

References

Bud, Robert (1988) 'The myth and the machine: seeing science through museum eyes', in Gordon Fyfe and John Law (eds), *Picturing Power: Visual Depiction and Social Relations*, Sociological Review Monography 35, London: Routledge.

Bud, Robert (1989) 'Chemistry in the museum. Reflections on a mythic form', unpublished MS.

Cannon-Brookes, Peter (1989) 'Refurbishing the East Hall of the Science Museum, London', International Journal of Museum Management and Curatorship 8: 69–76.

Clifford, James (1988) *The Predicament of Culture: Twentieth Century Ethnography, Literature, and Art*, (Cambridge, MA: Harvard University Press).

Cossons, Neil (ed.) (1985) *The Management of Change in Museums*, (London: National Maritime Museum).

Cossons, Neil (1989) 'Plural finding and the heritage', in David Uzzell (ed.), *Heritage Interpretation*, *The Visitor Experience*, Volume 2, London: Bellhaven Press, pp. 16–22.

de Certeau Michel (1984) *The Practice of Everyday Life*, Berkeley: University of California Press.

Donato, Eugenio (1979) 'The museum's furnace: notes toward a contextual reading of *Bouvard and Pecuchet*', in Josue V. Harari (ed.) *Textual Strategies: Perspectives in Post-Structuralist Criticism*, London: Methuen, pp. 213–38.

Eco, Umberto (1987) 'Travels in hyperreality', in Umberto Eco, *Travels in Hyperreality*, London: Pan, pp. 1–58.

Follett, David (1978) *The Rise of the Science Museum under Henry Lyons*, London: Science Museum.

Greenhalgh, Paul (1989) 'Education, entertainment and politics: lessons from the great international exhibitions', in Peter Vergo (ed.), *The New Museology*, London: Reaktion Books, pp. 74–98.

Haraway, Donna (1984–5) 'Teddy bear patriarchy: taxidermy in the Garden of Eden, New York City, 1908–1936', *Social Text* 11: 20–64.

Harvey, David (1989) *The Condition of Post-Modernity*, Oxford: Blackwell.

Hewison, Robert (1987) *The Heritage Industry*, London: Methuen.

Horne, Donald (1984) *The Great Museum*, London: Pluto.

Hudson, Kenneth (1975) *A Social History of Museums: What the Visitors Thought*, London and Basingstoke: Macmillan.

Impey, Oliver and MacGregor, Arthur (1985) *The Origins of Museums: The Cabinet of Curosities in Sixteenth- and Seventeeth-Century Europe*, Oxford: Clardendon.

Lawrence, Ghislaine (1989) 'Object lessons in the museum medium', unpublished MS.

Lord Barry, Lord, Gail Dexter, and Nicks, John (1989) *The Cost of Collecting*, London: HMSO.

Lumley, Robert (ed.) (1988) *The Museum Time-Machine: Putting Cultures on Display*, London: Routledge/Comedia.

Lyotard, Jean-François (1984) *The Postmodern Condition: A Report on Knowledge*, trans. Geoff Bennington and Brian Massumi, Minneapolis: University of Minnesota Press.

Miller, Daniel (1987) *Mass Consumption and Material Culture*, Oxford: Blackwell.

Museums and Galleries Commission (1988) *The National Museums: The National Museums and Galleries of the United Kingdom*, London: HMSO.

Silverstone, Roger (1988) 'Museums and the media: a theoretical and methodological exploration', *International Journal of Museum Management and Curatorship* 7: 231–41.

Silverstone, Roger (1989) 'Heritage as media: some implications for research', in David Uzzell (ed.) *Heritage Interpretation*, *The Visitor Experience*, London: Belhaven Press, pp. 138–48.

Stewart, Susan (1984) *On Longing: Narratives of the Miniature, the Gigantic, the Souvenir, the Collection*, Baltimore and London: John Hopkins University Press.

Swade, Doron (1989) 'Mouseproof pedals and the curator's dilemma', *Science Museum Review*; 50–2, London: Science Museum.

Tait, Simon (1989) *Palaces of Discovery: The Changing World of Britain's Museums'*, London: Quiller Press.

Vergo, Peter (ed.) (1989) *The New Museology*, London: Reaktion Books.

Woolgar, Steve (1988) *Science: The Very Idea*, Chichester: Ellis Horwood, and London and New York: Tavistock.

James Clifford

MUSEUMS AS CONTACT ZONES

IN EARLY 1989 I FOUND MYSELF sitting around a table in the basement of the
Portland Museum of Art, Portland, Oregon. About twenty people had gathered
to discuss the museum's Northwest Coast Indian collection. The group included
museum staff, several well-known anthropologists and experts on Northwest Coast
art, and a group of Tlingit elders, accompanied by a couple of younger Tlingit trans-
lators. I was present as a "consultant", part of a grant supporting the proceedings.

The museum's Rasmussen Collection was amassed in the 1920s in southern
Alaska and along the coast of Canada. Long displayed in a drab, somewhat "ethno-
graphic" manner, it was overdue for reinstallation. The director of the Portland
Art Institute, Dan Monroe, who had worked with native tribes in Alaska, took
the unusual step of inviting a representative group of Tlingit authorities, promi-
nent elders from important clans, to participate in planning discussions.

In the museum basement, objects from the collection were brought out, one
by one, and presented to the elders for comment: a raven mask, an abalone-inlaid
headdress, a carved rattle. . . . What transpired was a series of complicated, moving
performances, by turns serious and light-hearted.

The curatorial staff seems to have expected the discussions to focus on the
objects of the collection. I, at any rate, anticipated that the elders would comment
on them in a detailed way, telling us, for example: this is how the mask was used;
it was made by so-and-so; this is its power in terms of the clan, our traditions,
and so forth. In fact, the objects were not the subject of much direct commen-
tary but the elders, who had their own agenda for the meeting. They referred to
the regalia with appreciation and respect, but they seemed to use them as *aides-
mémoires*, occasions for the telling of stories and the singing of songs.

The songs were sung and stories told in accordance with clear protocols
governing the authority of particular individuals and clans, rules establishing perfor-
mance rights. An elder representing one clan would offer his or her songs and

stories; then an elder from another clan would offer thanks and reciprocate. The whole event had a ceremonial dimension, punctuated by intense emotion, silences, and laughter. The objects in the Rasmussen Collection, focus for the consultation, were left – or so it seemed to me – at the margin. For long periods no one paid any attention to them. Stories and songs took centre stage.

Amy Marvin says of the prayers she sings that they "balance" her, "as in a boat," so that she can tell stories. She begins haltingly, seeming to search for points in a familiar landscape, places "over there . . ." She tells the "Glacier Bay story" about a village covered with ice: a sense of great loss. She sings a memorial song. "Where is my land?" "I'm not going to see my village again . . ." She refers to the previous day, when a killer-whale drum was brought out – a drum the clan did not know had been preserved. A very heavy moment, she says. Jimmy George, an elder nearly 90 years old, had offered the killer-whale story, which belongs to his clan . . . a story he once told at San Diego Sea World. She thanks him.

The Glacier Bay recitation concerns her present homeland around Hoonah, Alaska. This becomes explicit when Amy Marvin connects the loss of tribal lands in the story with current Forest Service policies regulating their use.

A headdress representing an octopus is brought out. So she tells an octopus story about an enormous monster that blocks the whole bay with its tentacles and keeps the salmon from coming in. (All the stories are told in Tlingit with translation and explanation by the younger participants – elaborate performances, sometimes interrupted by dialogue.) The Tlingit hero has to fight and kill the octopus to let the salmon come into the bay. Salmon which are the livelihood of the group. The hero opens the bay so the group can live. And by the end of the story the octopus has metamorphosed into state federal agencies currently restricting the rights of Tlingit to take salmon according to tradition.

As performed in the museum basement, "traditional" stories and myths suggested by the old clan objects end up specific histories with pointed meanings in current political struggles.

One of the younger Tlingit says: There will be a day when we're back fishing there. And an older man, Austin Hammond, speaking for the Raven House in Haines, Alaska, supports Amy Marvin, saying he could feel her emotions as she spoke. He is weeping. The Glacier Bay story reminds him, he says, of how he used to fish and trap there. Now the same monster is coming underneath our canoe again. The land's being taken from us, and that's why I'm telling this. We're sharpening our knives, so to speak. Words are that strong, he says.

She thanks him for his words: words need to be caught, she says. Then Austin Hammond tells about the octopus blanket made for his father (not in the museum collection), about its power. We're telling you these things, he says to the white people assembled. We hope you'll back us up.

Lydia George, a city councilwoman, fills in details about current land claims. She stresses that different clans and places come together in these struggles. She avoids generalizations about the "Tlingit."

Austin Hammond tells a long Raven story; his father's blanket spread in front of him. He goes into great detail about different kinds of fish, the specific times of their entry into the bay and rivers. He tells how the Raven determined these things – all the species of salmon, the rules of their behavior, and of our fishing.

Why am I telling this? he asks. Four people from Washington, DC came to our convention. They told us we were taking up all our salmon. I told them the story – how the Raven worked on the salmon for everyone here on our land.

A beaded jacket is laid on the table. Austin Hammond tells a "Bible story" – a Raven tale reminiscent of Jonah and the Whale. We have no writing, he says, so we make copies in our jackets, blankets. He thanks another elder for permission to tell the story. In it, the Raven flies down the whale's blowhole, sets up a little stove, and cooks the salmon the whale swallows. But he can't get out. The humorous tale turns tragic. To our white brothers here, Hammond says, our prayers are like the Raven's. Who will cut open the whale, so we can come out? We're in need of all our ancestors, our land is being taken. Our children . . . Who will look after them? Maybe you can help us, help cut open the whale. That's how I feel.

Sadly, he tells of being alone in his clan house. He invokes his grandfathers and ancestors, then sings a song composed by his uncle, Joe Wright, weaving a portion of it into his urgent speech. We're losing our grounds, he says, so I hold onto this song.

More speeches, stories, and explications follows – formal responses to the speakers. After lunch, the mood is lighter: love songs are sung, spiced with off-color humor and innuendo. Anyone can sing along with these. A younger Tlingit explains that at memorials and parties there is a heavy part – with loss, the ancestors, name-giving – and a lighter side: humor and expressions of love for one another.

As the process continues over three days, objects from the Rasmussen Collection lie on the museum tables or in storage boxes.

Reciprocities

The experience of "consultation" left the Portland Art Museum staff with difficult dilemmas It was clear that from the elders' viewpoint the collected objects were not primarily "art." They were referred to as "records," "history," and "law," inseparable from myths and stories expressing ongoing moral lessons with current political force. The museum was clearly informed that the elders' voices should be presented to the public when the objects were displayed. This demand presupposed a real degree of trust, since many of the stories and songs were proprietary. Specific permissions were needed. Indeed, a prior agreement stipulated that any information revealed at the consultation would be jointly controlled by the museum and the elders. On more than one occasion during the proceedings, the museum was directly admonished: Were taking the risk of confiding important things to you. It's important that these be recorded for posterity What will you do with what we give you? We'll be paying attention.

Staff at the Portland Museum were genuinely concerned that their stewardship of the Rasmussen Collection include reciprocal communication with the communities whose art, culture, and history were at stake. But could they reconcile the kinds of meanings evoked by the Tlingit elders with those imposed in the context of a museum of "art"? How much could they decenter the physical objects

in favor of narrative, history, and politics? Are there strategies that can display a mask as simultaneously a formal composition, an object with specific traditional functions in clan/tribe life, and as something that evokes an ongoing history of struggle? Which meanings should be highlighted? And which community has the power to determine what emphasis the museum will choose? Should the museum now search out individuals with clan authority connected to other tribal objects in the collection – Kwagiulth, Haida, Tsimshian? Could it establish relations of trust with all the relevant groups and individuals? To what extent was the whole process dependent on specific personal contacts? How could the relationship deal with conflicts within contemporary tribal communities? (The Tlingit elders who came to Portland did not represent all the clans connected to the objects.) How much discussion and negotiation is enough? And how many grants could a single museum expect to receive in support of such activities? I cannot go into the personal, institutional, and funding contingencies that have delayed reinstallation of the Rasmussen Collection. Suffice it to say that the choices posed by the elders remain unresolved, their gift (and challenge) unanswered.[1]

As the meeting progressed, the basement of the Portland Art Museum became something more than a place of consultation or research; it became a *contact zone*. I borrow the term from Mary Louise Pratt. In her book *Imperial Eyes: travel and translation* (1992: 6–7) she defines "contact zone" as "the space of colonial encounters, the space in which peoples geographically and historically separated come into contact with each other and establish ongoing relations, usually involving conditions of coercion, radical inequality, and intractable conflict." Unlike the term "frontier," which is "grounded within a European expansionist perspective the frontier is a frontier only with respect to Europe)," the expression "contact zone"

> is an attempt to invoke the spatial and temporal copresence of subjects previously separated by geographic and historical disjunctures, and whose trajectories now intersect. By using the term 'contact' I aim to foreground the interactive, improvisational dimensions of colonial encounters so easily ignored or suppressed by diffusionist accounts of conquest and domination. A 'contact' perspective emphasizes how subjects are constituted in and by their relations to each other. [It stresses] copresence, interaction, interlocking understandings and practices, often within radically asymmetrical relations of power.

When museums are seen as contact zones, their organizing structure as a *collection* becomes an ongoing historical, political, moral *relationship* – a power-charged set of exchanges, of push and pull. The organizing structure of the museum-as-collection functions like Pratt's frontier. A center and a periphery are assumed: the center a point of gathering, the periphery in an area of discovery The museum, usually located in a metropolitan city; is the historical destination for the cultural productions it lovingly and authoritatively salvages, cares for, and interprets.

What transpired in the Portland Museum's basement was not reducible to a process of *collecting* advice or information. And something in excess of consultation was going on. A message was delivered, performed, within an ongoing contact

history. As evoked in the museum's basement, Tlingit history did not primarily illuminate or contextualize the objects of the Rasmussen Collection. Rather, the objects provoked (called forth, brought to voice) ongoing stories of struggle. From the position of the collecting museum and the consulting curator, this was a disruptive history which could not be confined to providing past tribal *context* for the objects. The museum was called to a sense of its responsibility, its steward-ship of the clan objects. (Repatriation was not, at this time, an explicit issue.) The museum was asked to be accountable in a way that went beyond mere preserva-tion. It was urged to act on behalf of Tlingit communities, not simply to represent the history of tribal objects completely or accurately. A kind of reciprocity was claimed, but not a give-and-take that could lead to a final meeting of minds, a coming together that would erase the discrepancies, the ongoing power imbalances of contact relations.

Before we explore this uneven reciprocity; it is important to realize the limits of the contact perspective I am developing here. For example, some of what went on in Portland was certainly not primarily contact zone work. Some of the songs, speeches, stories, and conversations were performances among Tlingit, not directed to the museum and its cameras but interclan work — that had to be done if the objects were to be addressed at all. (This dimension was largely obscure to me in my marginal location.) Moreover, although one cannot separate a history of loss, displacement, and reconnection from the meanings these masks, drums, and garments hold for clan elders, it would be wrong to reduce the objects' tradi-tional meanings, the deep feelings they still evoke, to "contact" responses. If a mask recalls a grandfather or an old story this must include feelings of loss and struggle; but it must also include access to powerful continuity and connection. To say that (given a destructive colonial experience) all indigenous memories must be affected by contact histories is not to say that such histories determine or exhaust them. The "tribal" present is a fabric of whose strands extend before (and after) the encounter with white societies — an encounter that may appear endless but is actually discontinuous and, in some respects, terminable. The old objects certainly invoked these other histories (memories, hopes, oral traditions, attachments to land). But in the contact zone of the Portland Museum's basement, the meanings addressed to white interlocutors were primarily relational: "This is what the objects inspire us to say in response to our shared history, the goals of ongoing respon-sibility and reciprocity we differently embrace."

While *reciprocity* is a crucial stake, it will not be understood in the same way by people from different cultures in asymmetrical power relationships. Reciprocity in the Tlingit's demands for help was not, as in a commercial transaction, the goal of being paid up, quit. Rather, the intent was to challenge and rework a rela-tionship. The objects of the Rasmussen Collection, however fairly or freely bought and sold, could never be entirely possessed by the museum. They were sites of a historical negotiation, occasions for an ongoing contact.

[. . .]

"Reciprocity," a standard for fair dealings, is a translation term, whose mean-ings will depend on specific contact situations. Thus, the term's different contexts and meanings, the locations of power from which it is asserted, must always be

kept in view. These differences of location and meaning were at issue in the Portland Museum's basement.

In contact zones, Pratt tells us, geographically and historically separated groups establish ongoing relations. These are not relations of equality, even though processes of *mutual* exploitation and appropriation may be at work. As we have seen, fundamental assumptions about relationship itself – notions of exchange, justice, reciprocity – may be topics of struggle and negotiation. Moreover, contact zones are constituted through reciprocal movements of people, not just of objects, messages, commodities, and money. Highland New Guinea is distant from London, yet the Wahgi who cooperated with the ethnographer and curator Michael O'Hanlon to amass a collection of "material culture" for the Museum of Mankind in 1993 felt connected, indeed entitled to visit. Their expectation was that a London tour would be arranged, similar to one several years before by a group of their neighbors, a Mount Hagenance troupe. Certain Wahgi, at least, were ready to "work" this London–Highlands contact zone for their own purposes. O'Hanlon had to explain that his mandate from the museum did not include funds for their travel. Differences of power, control, and design of budgets determined who would be the collectors and who the collected.

Stanford University in California is also far from Highland New Guinea. It has recently been the site of a rather different set of contact relations. A dozen or so sculptors from the Highlands recently traveled to Palo Alto to carve and install a sculpture garden on the university's campus. The project was organized on a shoe-string by Jim Mason, a student in anthropology, with small grants and contributions. Once at Stanford, the sculptors occupied a wooded corner of the central campus and set to work. Throughout the summer of 1994 they transformed tree trunks brought from New Guinea and soft stone from Nevada into human figures entwined with animals, fantastic designs. Their workplace was open to everyone passing by and on Friday evenings it turned into a party; with barbecues, face-painting, drumming, and dancing. The New Guinea artists taught their designs to interested Palo Altoans. Growing numbers turned up every week to hang out, make art, and celebrate.

When I visited in the autumn of 1994, the artists had returned to the Highlands and the "New Guinea Sculpture Garden" consisted of several dozen carved trunks and stones scattered among the trees. The former were secured by cables (one had recently been stolen) and protected from the rain by sheets of transparent plastic. People wandered in and pulled back the plastic shrouding crocodiles and long-beaked birds. A leaflet informed visitors that the project still needed to raise $40,000 for site installation and landscaping. Suggested contributions ranged from $10,000 for travel from New Guinea, to $250 for a fern, to $100 for a spotlight, to $25 for artists' spending money. As of this writing, a year later, the garden is taking shape. Volunteers have set the poles in cement and installed the stone carvings. Mounds of earth and plants follow New Guinea landscaping styles. The tallest poles form a "spirit house," and other brightly painted, or elaborately carved, twisting wooden poles and slit gongs are scattered throughout the grove.

At the New Guinea Sculpture Garden, interactive process was as important as the production and collection of "art" or "culture." Although there is a long tradition of bringing exotic people to western museums, zoos, and world fairs,

the sculptors at Stanford were not offered as specimens on display. They were presented as practising "artists," not as "natives." People could, of course, view them as exotica, but this went against the spirit of the project, which invited people to participate, financially and personally, in the making of the garden. The travelling artists pursued their own adventures, collecting prestige, information, and fun, while staying in touch with the Highlands by phone. They made friends with the various communities around Stanford. They were taken to Disneyland and the Esalen Institute, entertained by local firefighters and the WO'SE African Community Church in Oakland. Hundreds of people were at the airport to see them off. Return visits, in both directions, have been planned. A regular visitor to the campus grove: "It is like a miracle dropping here from outer space, in a very lily-white, upper-class community." A carver: "All the people who come are good. People are happy to see us, and they bring us food" (Koh, 1994: 2B).

[. . .]

Exploitations

It is important to keep the possibilities for subversion and reciprocity (or relatively benign mutual exploitation) in tension with the long history of "exotic" displays in the West. This history provides a context of enduring power imbalance within and against which the contact work of travel, exhibition, and interpretation occurs. An ongoing ideological matrix governs the understanding of "primitive" people in "civilized" places. As Coco Fusco and Guillermo Gómez-Peña discovered when they performed a broad satire in which "undiscovered" Amerindians were confined in a golden cage, more than a few visitors took them literally. Fusco (1995) discerns an "other history" of intercultural performance, which runs from Columbus's kidnapped Arawacs and Montaignes's "cannibals," to populated "villages" and "streets" at world exhibitions, to Ishi at the University of California Anthropological Museum. She extrapolates the history to include all more or less coerced performances of identity: the spectacularization of "natives" in documentary films or the collection of "authentic" Third World art (and artists) for exhibitions such as "Les Magiciens de la Terre" in Paris. A growing body of writing has begun to provide details of this quite extensive and continuous history of exhibitory contacts (Rydell, in this volume; Bradford and Blume, 1992; Corbey, 1993; Fusco, 1995). It reveals the racism, or at best the paternalist condescension, of spectacles which offered up mute, exoticized specimens for curious and titillated crowds. The degradation was physical as well as moral, not infrequently resulting in the travelers' untimely deaths. Exhibitions were contact zones where germs made their own connections.

A wholly appropriate emphasis on coercion, exploitation, and miscomprehension does not, however, exhaust the complexities of travel and encounter. Montaigne, for example, derived something more than an ethnocentric *frisson* from his meeting with Tupinamba in Rouen. Even encounters that are ethnocentric – which they all are to a degree – can produce reflection and cultural critique. The critical reflections and agency of the exotic "travelers" are most difficult to discover, given limited records and a tendency, in what records exist, to accord such travelers *behavior* rather than independent *expression*. Since they were generally treated

as passive specimens (or victims), their views seldom entered the historical record. Their "captivity narratives" remain to be discovered or pieced together, inferred, from historical shreds. Some of those displayed in European courts, museums, fairs, and zoos were kidnapped, their travel anything but voluntary. In many cases, a mix of force and choice was at work. People lent themselves to the projects of explorers and entrepreneurs for a range of reasons, including fear, economic need, curiosity, a desire for adventure, a quest for power.

"One of my colleagues," writes Raymond Corbey, "who grew up in postwar Berlin told me of his astonishment when, as a boy, he came across an African man whom he had seen only hours before in native attire in Castan's Panoptikum, now in European clothes on a tramcar, smoking a cigarette" (Corbey, 1993: 344). Astonishment, mixed perhaps with a sense of betrayal, was an appropriate response for someone accustomed to a carefully staged primitivity. But what was the African's attitude to the movement between racial/ethnic spectacle and common streetcar? Was acting the "African" an ordeal? A satire? A source of pride? Just a job? All of these? And more? An adequate answer depends on knowing about individual histories and specific power relations. In most cases the details are unavailable. But documentation does exist for a revealing experience in which native culture was made into a spectacle – an experience which, though far from typical, can help clarify the social relationships and different investments at stake.

In 1914 Edward Curtis, the elegiac photographer of North American Indians, made a feature-length movie called *In the Land of the Headhunters*. Working on northern Vancouver Island, Curtis hired a large contingent of Kwakiutl Indians to act in a tale of precontact Northwest Coast life, complete with boy meets girl romance, evil sorcerers masks, war canoes, and severed heads. With the help of local authorities – notably George Hunt, Franz Boas's principal assistant – a serious attempt was made to recreate authentic traditional settings, artefacts, dances, and ceremonies. T. C. McLuhan, in her film *The Shadow Catcher*, (1975), records the reminiscences of three elderly people who participated in Curtis's re-creation. They recall that it was a lot of fun, dressing up and doing things the old way. Everybody had a good time. Bill Holm's conversations with other surviving participants at screenings of the restored film in 1967 confirm their point (Holm and Quimby, 1980).

In an important sense, the Kwakiutl were exploited by Curtis, made to act out a stereotype of themselves for white consumption. The sensational title featuring "headhunters" is indicative of what Fusco argues is the inescapable violence of such projects. And one wonders: Had the film been a commercial success, how much of the profit would have found its way back to northern Vancouver Island? In other important senses, however, relations were not exploitative. The participants in *Headhunters* earned good money and enjoyed themselves. They willingly donned wigs, shaved their mustaches, and endured the tickle of abalone nose-rings. They knew that Curtis's portrayal of their traditions, while sensational, was respectful. Spectacle was, after all, very much a part of Kwakiutl culture, and Curtis tapped a rich tradition of acting. Moreover, George Hunt played a crucial role in the process interpreting tradition, recruiting actors, and gathering costumes and props. Surviving snapshots of the filming show Curtis behind the camera, with Hunt beside him, holding a megaphone and directing the action (Holm and Quimby,

1980: 57–61). By local standards, in the context of prior trade and ethnographic contacts, Curtis dealt fairly with the communities he mobilized. His interest in a "vanishing" culture seems to have overlapped productively with their own interest in a way of life which some knew through their parents and grandparents and with which they felt a strong continuity through changing times.

The staging of cultural spectacles can thus be a complex contact process with different scripts negotiated by impresarios, intermediaries, and actors. Of course Curtis's film, made on native grounds with the assistance of local authorities, was quite different from the traveling shows and exhibitions, which tended to be more domineering and exploitative. The most famous of all the purveyors of stereotypes, Buffalo Bill's Wild West Show, was generally sustained by respectful personal relations with its Native American participants. But the conditions of travel were hard, and few stayed for more than a season or two. Some joined the show for the wages it offered (low but there was no way to make money on the new reservations); others wanted to escape the inaction imposed by "pacification"; occasionally "troublemakers" were sent by the government as an alternative to imprisonment; others wanted to travel and to observe the world of whites (Blackstone, 1986: 85–8). Black Elk, an Oglala Sioux, joined Buffalo Bill for the last-mentioned reason, and his memories of Chicago, New York, London, and Paris provide a precious glimpse of travel and cultural criticism from a native viewpoint (Black Elk, 1979; DeMallie, 1984; see also Standing Bear, 1928). It is critical to recognize that the cultural performances in such spectacles were scripted and their actors frequently exploited. But it is also important to recognize a range of experiences and not to close off dimensions of agency (and irony) in their participation. The crucial issue of power often appears differently at different levels of interaction, and it cannot simply be read off from ascribed geopolitical locations. Power and reciprocity are articulated together in specific ways. Who calls which shots? When? Do structural and interpersonal power relations reinforce or complicate each other? How are differing agendas accommodated in the same project?

On the contemporary scene, the performance of culture and tradition may include empowerment and participation in a wider public sphere *as well as* commodification in an increasingly hegemonic game of identity. Why would tribal people be eager to dance in New York or London? Why come to Stanford? Why play the game of self-representation? Such visitors, their hosts, and impresarios are not free of colonial legacies of exoticism and neocolonial processes of commodification. Nor are they entirely confined by these repressive structures. It is important to recognize this complexity. For what exceeds the apparatus of coercion and stereotype in contact relations may perhaps be reclaimed for current practice in movements to expand and democratize what can happen in museums and related sites of ethnomimesis. The historical possibilities of contact relations – negative and positive – need to be confronted.

[. . .]

Africa and Europe have been thrown together by destructive and creative histories of empire, commerce, and travel; each uses the other's traditions to remake its own. Pratt (1992: 6), following Fernando Ortiz and Angel Rama, calls such processes "transculturations." Until recently in the West, transculturation has been

understood hierarchically, in ways that naturalize a power imbalance and the claim of one group to define history and authenticity. For example, Africans using Europe's heritage were seen to be imitating, losing their traditions in a zero-sum game of acculturation; Europeans using African cultural resources appeared to be creative, progressive, inclusive modernists. [. . .]

Contact history is evoked in two titles – "Africa explorers" and "Digesting the West" – from Susan Vogel's innovative exhibition and catalogue on twentieth-century African art (Vogel, 1991). In this instance a contemporary museum, the Center for African Art in New York, collects work that has, for more than a century itself been collecting the West through transcultural processes ranging from infatuation and forced feeding to satire, syncretic conversion, and critical selection. The New York museum operates in long-established circuits of travel and transculturation. On the one hand, it replays, in new forms, established practices of discovering, gathering, and valuing art and culture – a restless curatorial exploration and construction of Africa. In this practice it brings peripheral work to an established center, for appreciation and commodification. On the other hand, the Center for African Art increasingly operates in an awareness of Africa as not simply "out there" (or "back then") but as part of a network, a series of relays forming a diaspora that includes New York City. This diaspora has well-established, branching routes and roots in slavery, in migration from Caribbean, South American, and rural North American places, and in current circuits of commerce and immigration from the African continent. In this context, the museum's contact work takes on local, regional, hemispheric, and global dimensions. In the center's recent exhibition of African and African American altars, "Face of the Gods," it grappled explicitly with the challenge of exhibiting (in) diaspora. This project brought artist/practitioners of African-based religions into the museum work, both in New York and in the altars' successive gatherings, and changes, on the road.

Africa 95 offers a more extensive example of a contact approach. This extraordinary ensemble of art exhibits, music and dance performances, films, conferences, workshops, residencies, TV and radio shows, and children's events was provoked by a planned exhibition at London's Royal Academy of Arts, "Africa: The Art of a Continent." The Royal Academy project, a major "comprehensive" selection, was conceived according to a classic model: a single European curator gathered what he considered the finest and most representative work, while limiting the exhibition to "art" produced before 1900. The organizers of *Africa 95* in effect folded this project into a more heterogeneous and future-oriented vision. Without rejecting its historical/aesthetic agenda, they surrounded and decentered it. Instead of bringing art from Africa, *Africa 95* brought artists. It recognized that African artists had long been in contact with Europe and were currently working both within and beyond the African continent, moving in and out of the "West."

The first *Africa 95* event, "Teng/Articulations," was an artist-led workshop in Senegal. It was followed by an "international sculpture workshop" at the Yorkshire Sculpture Park, where for three months artists from a dozen African countries joined with artists from the United States and the United Kingdom to create on-site works. More than twenty exhibitions of contemporary African art and

photography took place throughout the autumn of 1995 in London and other British cities. These were coordinated with colloquia and extensive film, music, dance, and literature programs. There was a consistent policy of involving Africans as authorities and curators. At the Whitechapel Art Gallery, a counterpoint to the Royal Academy show was titled "Seven Stories about Modern Art in Africa." Five of the seven curators were leading African artists and art historians, and their personal visions of modern African art effectively complicated assumptions of a unified continental aesthetic.

Clémentine Deliss, artistic director of *Africa 95*, stressed that the project was conceived not merely as a site of exhibitions, but also of meetings among artists, an occasion for developing ongoing contacts (Deliss, 1995: 5). That the contact zones of *Africa 95* were not political or economic free-spaces is signaled by prominent advertisements for transnational corporate sponsors, notably banks, in the program brochure and by recurring complaints that the event was being held in Britain rather than in Africa (Riding, 1995). Europe still enjoyed the power to collect and exhibit Africa on its own terms and terrain. However, for many of the artists and musicians Europe and America were already sites of work, and the event was an opportunity to expand their audiences and sources of inspiration.

Africa 95, working in and out of museums and galleries, had something in common with the current spate of national festivals (Festival of India, of Indonesia, and so on) in which Third World regions display their arts in First World places with the aim of increasing global legitimacy and attracting investors. But there were major differences. Although corporate sponsors such as CitiBank used the event to portray themselves as good transnational "African" citizens, *Africa 95* did not directly represent any major commercial interest or national polity and its diverse occasions and participants, its stress on cross-national exchanges, were not easily channeled. It did, of course, help produce a modern, hybrid "Africa" as a marketable commodity for international art markets. But this product was, significantly, the contact work of Africans who may profit from it. *Africa 95* used, and was used by transnational circuits tied to colonial and neocolonial relations – making spaces for contacts that exceed those relations.

Contestations

The notion of a contact zone, articulated by Pratt in contexts of European expansion and transculturation, can be extended to include cultural relations within the same state, region, or city – in the centers rather than the frontiers of nations and empires. The distances at issue here are more social than geographic. For most inhabitants of a poor neighborhood, located perhaps just blocks or a short bus ride from a fine-arts museum, the museum might as well be on another continent. Contact perspectives recognize that "natural" social distances and segregations are historical/political products: apartheid was a relationship. In many cities, moreover, contact zones result from a different kind of "travel": the arrival of new immigrant populations. As in the colonial examples evoked by Pratt, negotiations of borders and centers are historically structured in dominance. To the extent that museums understand themselves to be interacting with specific communities across

such borders, rather than simply educating or edifying a public, they begin to operate – consciously and at times self-critically – in contact histories.

We have seen some of the ways that museum practices of collecting and display look different in a contact perspective. Centers become borders crossed by objects and makers. Such crossings are never "free" and indeed are routinely blocked by budgets and curatorial control, by restrictive definitions of art and culture, by community hostility and miscomprehension. The examples I have chosen so far suggest ways these borders can be more democratically negotiated, a choice reflecting the reformist tenor of my analysis. I could have begun, however, not with border crossings, but with border *wars*. Two recent disputes have sent shock waves through the museum world in Canada and to a lesser degree the United States: the Lubicon Cree boycott of the "Spirit Sings" exhibition in Calgary and the widely publicized conflict over "into the Heat of Africa" at the Royal Ontario Museum, Toronto, during 1989 and 1990. In both cases, communities whose cultures and histories were at stake in prominent exhibits mobilized to seriously trouble the museum.

"The Spirit Sings: Artistic Traditions of Canada's First Peoples" was organized by the Glenbow Museum in Calgary to coincide with the 1988 Winter Olympics. It brought together a large number of artefacts from collections in Canada and abroad, with the goal of presenting a detailed and diverse picture of Native Canadian cultures at the time of early contact with Europeans. The exhibition further explored the distinctive world view shared by these cultures and their resilience in the face of outside influence and domination (Harrison, 1988). For many, including some Native Canadian groups, the exhibit was successful, though it was criticized for its relative lack of attention to contemporary manifestations of its guiding themes. But the content of "The Spirit Sings" was not, primarily, what provoked a widely supported boycott. The Lubicon Lake Cree of Northern Alberta, to dramatize their pending land-claim, called a boycott of the Winter Olympics, a highly visible political stage. The action focused on the Glenbow Museum because the exhibition's chief sponsor, Shell Oil (which provided $1.1 million of the exhibition's total budget of $2.6 million), was drilling on land claimed by the Lubicon. To a growing number of Lubicon supporters, native and non-native, it was hypocritical for "The Spirit Sings" to celebrate the beauty and continuity of cultures whose current survival was threatened by the exhibit's own corporate sponsor. Supporters of the exhibit pointed out that no museum of any size can survive without corporate or government sponsors, whose hands are never perfectly clean. The museum was being unfairly targeted, dragged without warning into the Lubicons' struggle.

Whatever the different perceptions of fairness and exploitation, the affair raised questions of broad importance. Should museums be able to assemble exhibits of Indian artifacts (including loans from other institutions) without permission from relevant tribal communities? What is involved in control over "cultural property"? What kind of consultation and involvement in planning is proper? (Glenbow had consulted with nearby tribes but not with the Lubicon, who did not respond to a blanket invitation. Curatorial control of the show was, in any event, undiluted.) Must some attention to current issues and struggles be part of any exhibition on native art, culture, or history? Can museums claim political neutrality? How

accountable are they for the activities of their public or private sponsors? In response to these questions, the Canadian Museums Association and the Assembly of First Nations commissioned a Task Force on Museums and First Nations, whose report gained wide acceptance and which established guidelines for collaboration between native representatives and museum staff (Hill and Nicks, 1994). Serious collaboration is now the norm in Canadian exhibitions of First Nations art and culture.

"Into the Heart of Africa," at the Royal Ontario Museum, was inspired in part by recent critical writings on the history of collecting and museum display. "Studying the museum as an artifact, reading collections as cultural texts, and discovering life histories of objects," it sought to "understand something of the complexities of cross-cultural encounters" (Canizzo, 1989: 92). The exhibition's approach was reflexive, relying strongly on juxtaposition and irony. Statements by missionaries and imperial authorities were presented without comment beside African artifacts. The exhibit clearly did not condone the sometimes racist images and words it displayed, nor did it maintain a consistently critical perspective. Objects and images were often left to "speak for themselves." But the attempt to complicate curatorial didacticism backfired. Colonialist perspectives were all too clear in the nineteenth-century quotations and images; African responses remained implicit. People absorbed quite different messages from the presentation. While some visitors found the exhibit provocative, if somewhat confusing in its presentation, others were offended by what they took to be a suspension of criticism that bordered on indifference. Many – though not all – African Canadians who visited the museum were shocked by glorified colonialist images and condescending statements about Africans prominently and apparently uncritically displayed. They were not seduced by an ironic treatment of the violent destruction and appropriation of African cultures. The museum and its guest curator, anthropologist Jeanne Cannizzo, had misjudged the exhibit's discrepant audiences.

A bitter controversy ensued in the media. There were clashes between picketers at the Royal Ontario Museum and the police; all of the museums that were scheduled to host the exhibit during its traveling phase canceled. This is not the place (nor am I well placed) to survey the controversy and adjudicate the extremes of mutual suspicion and miscomprehension that emerged. (See, among others, Ottenberg, 1991; Cannizzo, 1991; Hutcheon, 1994; and Mackey 1995.) "Into the Heart of Africa" was denounced as racist colonization by other means, part of an ongoing suppression of African achievements and African Canadian experiences. The exhibit's critics were dismissed as narrow ideologues and censors, unable to grasp irony or a complex historical account. The controversy has since rippled through museum contexts, and as Enid Schildkraut, in a sensitive critique, confesses: "It made many of working in the field of ethnographic exhibitions, particularly African exhibitions, tremble with a sense of 'There but for the grace of God go I.' How could an exhibition have gone so wrong? How could it have offended so many people from different sides of the political spectrum?" (Schildkraut, 1991: 16).

The museum became an inescapable contact (conflict) zone. Distinct audiences brought differently attuned historical experiences to "Into the Heart of Africa." M. Nourbese Philip makes this point trenchantly, chastizing the museum for missing an opportunity in the controversy to confront its publicly stated goals: to

understand the "museum as an artifact" and the "complexities of cross-cultural encounters." The exhibition was clearly not sensitive to African Canadians' stake in the history of white Canadians and the African colonial enterprise. Its story was understood to be continuous with ongoing racist structures in offically "multi-cultural" Canadian life. African history could not be distanced in time and space. The museum learned, the hard way, about the risks (and Philip insists: the opportunities) of working in relation to an African diaspora within a fissured Canadian public sphere. The exhibit was a "cultural text" that could not be read from a stable location. "The same text resulted in contradictory readings determined by the different life histories and experiences. One reading saw these artifacts as being frozen in time and telling a story *about* white Canadian exploration of Africa; the other inserted the reader – the African Canadian reader – actively into the text, who then read those artifacts as the painful detritus of salvage exploration and attempted genocide of their own people" (Philip, 1992: 105).

Would fuller "consultation" with the relevant "communities" (including the white Canadians whose family histories were at issue) have prevented polarization? Would more explicit narration of an African "side" to the story in the exhibit have helped, as Schildkraut argues? Surely. But Philip sees – as do some museum professionals thinking in the wake of "The Spirit Sings" and "Into the Heart of Africa – that structures of power are fundamentally at stake (Ames, 1991: 12–14). Until museums do more than consult (often after the curatorial vision is firmly in place), until they bring a wider range of historical experiences and political agendas into the actual actual planning of exhibits and the control of museum collections, they will be perceived as merely paternalistic by people whose contact history with museums has been one of exclusion and condescension. It may, indeed, be utopian to imagine museums as public spaces of collaboration, shared control, complex translation, and honest disagreement. Indeed, the current proliferation of museums may reflect the fact that, as historically evolved, such institutions tend to reflect unified community visions rather than overlapping, discrepant histories. But few communities, even the most "local," are homogeneous. In practice, different groups may come together around a specific issue or antagonism (as many African Canadians did in response to the Royal Ontario Museum), yet divide on others. The tribal response to "The Spirit Sings" was not uniform. And on certain issues, black Canadians whose families have been in Canada for two centuries may differ from people with close connections to places in the Caribbean or from Africans who have recently arrived. On the general issue of Africa and colonial history they may share a common outrage. But when practical problems of interpretation and emphasis, issues of repatriation and compensation, are raised, the unanimity can dissolve.

Who, after all, is best qualified by "experience" (what kinds?), by depth and breadth of knowledge (what knowledges?), to control and interpret an African collection? African Canadians who have never been to Africa and who may hold an idealized vision of its cultures? White anthropologists and curators who have spent considerable time on the continent and have studied its history in depth, but have never viscerally known racism or colonization? Contemporary Africans? (From which ethnicity, nation, or region? Living in Africa? In Canada?) Sometimes, as in the case of the Tlingit at the Portland Museum of Art, the connection of current

community members to old objects is very direct. In other cases, what is at issue is "cultural property" or a more distant "historical" relationship. Since communities and collections are seldom unified, museums may have to address sharply discrepant publics.

Clearly there is no easy solution to these problems, no formula based on unassailable principle. Neither community "experience" nor curatorial "authority" has an automatic right to the contextualization of collections or to the narration of contact histories. The solution is inevitably contingent and political: a matter of mobilized power, of negotiation, of representation constrained by specific audiences. To evade this reality – resisting "outside" pressures in the name of aesthetic quality or scientific neutrality, raiding the specter of "censorship" – is self-serving as well as historically uniformed. Community pressures have always been part of institutional, public life. Museums routinely adapt to the tastes of an assumed audience – in major metropolitan institutions, largely an educated, bourgeois, white audience. National sensibilities are respected, the exploits and connoisseurship of dominant groups celebrated. Donors and trustees exercise very real "oversight" (a more polite word than "censorship") on what kinds of exhibits a museum can mount.

[. . .]

Ownership and control of collections have never been absolute; individual donors routinely attach conditions to their gifts. But now communities that are socially distant from the museum world can effectively constrain the display and interpretation of objects representing their cultures. In contemporary Canada and the United States, at least, there are strong, overtly political limits on how Native American, Latino, or African American art can be displayed and interpreted. Emerging notions of "cultural property" impinge on abstract assumptions about freedom of ownership. Of course, major museums have never owned their artworks in quite the same way that an individual does. Their collections are held in trust for a wider community – defined as a city, class, caste or elite, nation or projected global community of high culture. The objects in a museum are often treated as a patrimony, someone's cultural property. But whose? Which communities (defined by class, nationality, race) have a stake in them? Carol Duncan's research on the history of the Louvre, an institution that has served as a model for major museums throughout the world, shows how its transition from palace to museum was linked to the creation of a "public" in post-revolutionary France, the development of a secular, national community (Duncan, 1991, 1995 and see this volume). The homogeneity of such a public is currently at issue in struggles over multiculturalism and equality of representation. Borders traverse the dominant national of cultural spaces, and museums that once articulated the cultural core or high ground now appear as sites of passage and contestation.

[. . .]

The fact that an altar or a tribal mask can mean quite different things in different locations makes inescapable the recognition and display of multiple contexts for works of art or culture. Innovative museum professionals have long been interested in ways to put objects in a fresh light, to make them new. Explicit

contact relations now place this kind of search in a different conjuncture, imposing new collaborations and alliances. Thus, the multiplication of contexts becomes less about discovery and more about negotiation, less a matter of creative curators having good ideas, doing research, consulting indigenous experts, and more a matter of responding to actual pressures and calls for representation in a culturally complex civil society.

[. . .]

One of the most difficult areas of negotiation around tribal objects and colonial histories concerns repatriation. In a contact perspective, the movement of objects out of tribal places into metropolitan museums would be an expected outcome of colonial dominance. Such movements would not be confused with progress or with preservation (a kind of immobility/immortality) in a cultural "center." In contact zones, cultural appropriations are always political and contestable, cross-cut by other appropriations, actual or potential. Museums and the market manage the travel of art objects between different places. Objects of value cross from a tribal world to a museum world as a result of political, economic, and intercultural relations that are not permanent. For example, a powerful tradition of collecting in the salvage mode has long been justified by the idea that authentic tribal productions are doomed: their future can only be either local destruction or preservation in the hands of knowing collectors, conservators, and scientists. But it is harder now to see the destiny of collections as a linear teleology of this sort (Clifford, 1987). By positing the disappearance of tribal worlds, salvage collecting presumed (and to an extent created) the rarity of "authentic" tribal art. Some tribal communities did indeed disappear, often violently. Others hung on, against terrible pressures. Sometimes this meant putting on camouflage, coming out of hiding when the situation was less repressive. Others changed, finding new ways to be different. In light of these diverse histories, the notion that indigenous artworks somehow *belong* in majority (scientific or fine-art) museums is no longer self-evident. Objects in museums can still go elsewhere.

Repatriation of tribal works is not the only proper response to contact histories, relations which cannot always be reduced to colonial oppression and appropriation. But it is a possible, appropriate route. And although the return of objects may be a fortunate homecoming, it is not always obvious where home is for collected objects. The situation can be complicated and ambiguous.[2] Indeed, some native groups do not want physical possession of traditional objects; they simply want ongoing connection and control. In practice, the notion of cultural property can mean that a metropolitan or state museum holds collections in trust for specific communities. Indeed, some museums may come to resemble a depository and lending library, circulating art and culture beyond their walls — with varying constraints — to local museums or community centers and even for use in current ritual life (Blundell and Grant, 1989). This is relatively easy to imagine between national and tribal or ethnic museums. But can a museum allow art and artifact to travel in and out of the "world of museums" (an emerging network considerably larger than what is usually called the "museum world")? Movement of collections in and out of the world of museums is still quite difficult for curators and boards of directors to accept, given the traditional economy and mission

of the western museum. It would require breaking with strong traditions of conservationism. For example, shudders were surely felt by many museum professionals over the recent repatriations of Zuni war-god figures, *Ahauutas*, which are now rotting on secret mesa tops, completing their interrupted traditional life journey.

[. . .]

"Museums" increasingly work the borderlands between different worlds, histories, and cosmologies. Is the Kwagiulth U'mista Cultural Centre a museum? Yes and no. An art museum? Yes and no. Is the San Franciso Galeria de la Raza a museum? Yes and no. Contact zones – places of hybrid possibility and political negotiation, sites of exclusion and struggle – are clear enough when we consider tribal or minority institutions, but what would it take (and why would it matter?) to treat the Metropolitan Museum of Art in Manhattan as a contact zone rather than a center? Or the Louvre? To give marginal, "between" places a tactical centrality is ultimately to undermine the very notion of a center. All sites of collection begin to seem like places of encounter and passage. Seen way objects currently in the great museums are travelers, crossers – some strongly "diasporic" with powerful, still very meaningful, ties elsewhere. Moreover, the "major" museums increasingly organize themselves according to the dictates of tourism, national and international. This rethinking of collections and displays as unfinished historical processes of travel, of crossing and recrossing, changes one's conception of patrimony and public. What would be different if major regional or national museums loosened their sense of centrality and saw themselves as specific places of transit, intercultural borders, contexts of struggle and communication between discrepant communities? What does it mean to work within these entanglements rather than striving to transcend them?

Such questions evoke some of the conflicting demands currently felt by museums in multicultural and multiracial societies. By thinking of their mission as contact work – decentered and traversed by cultural and political negotiations that are out of any imagined community's control – museums may begin to grapple with the real difficulties of dialogue, alliance, inequality, and translation.

In the world of museums

My account of museums as contact zones is both descriptive and prescriptive. I have argued that it is inadequate to portray museums as collections of universal culture, repositories of uncontested value, sites of progress, discovery and the accumulation of human, scientific, or national patrimonies. A contact perspective views all culture-collecting strategies as responses to particular histories of dominance, hierarchy resistance, and mobilization. And it helps us see how claims to both universalism and to specificity are related to concrete social locations. As Raymond Williams showed in *Culture and Society* (1966), nineteenth-century bourgeois articulations of a high/universal "culture" were responses to industrial change and social threat. Conversely "minority" and "tribal" articulations of a discrete culture and history respond to histories of exclusion and silencing. They claim a locally controlled place in the broader public culture, while speaking both within

particular communities and to a wider array of audiences. Museums/cultural centers can provide sites for such articulations.

My account argues for a democratic politics that would challenge the hierarchical valuing of different places of crossing. It argues for a decentralization and circulation of collections in a multiplex public sphere, an expansion of the range of things that can happen in museums and museum-like settings. It sees the inclusion of more diverse arts, cultures, and traditions in large, established institutions as necessary but not as the only or primary point of intervention. Indeed, any pluralist vision of inclusivity at privileged sites (such as the Mall in Washington, DC – a national museum of museums) is questioned. A contact perspective argues for the local/global specificity of struggles and choices concerning inclusion integrity dialogue, translation, quality and control. And it argues for a distribution of resources (media attention, public and private funding) that recognizes diverse audiences and multiply centered histories of encounter. Given the history of museums in the Euro-American bourgeois state and indeed in national contexts everywhere, this view may seem utopian. It is utopia in a minor key, a vision of uneven emergence and local encounter rather than of global transformation. It makes a place for strong, if precarious, initiatives that pull against established hierarchical legacies.

These legacies have recently been subjected to searching critical and historical analysis. The growth of public museums in nineteenth-century Europe and America was part of a general attempt to purvey and organize "culture" from the top down. Museums accumulated the "symbolic capital" of tradition and emergent elites (Bourdieu, 1984). They institutionalized a hardening distinction between "highbrow" and "lowbrow" activities (Levine, 1988). The "publics" whom they addressed and whose "patrimonies" they collected were constituted by bourgeois nationalist projects (Duncan, 1991). In the nineteenth century, a series of important "legislative and administrative reforms . . . transformed museums from semi-private institutions restricted largely to the ruling professional classes into major organs of the state dedicated to the instruction and edification of the general public" (Bennett, 1988: 63). In the twentieth century, museums have been central to the production and consumption of "heritage" in a dizzying range of local, national, and transnational contexts (Walsh, 1992), integral elements in expansive tourist industries (MacCannell, 1976; Horne, 1984; Urry 1990). As an institution that emerged with the national, bourgeois state and with industrial and commercial capitalism, the museum's destiny is linked to their global diffusion and local adaptations.

The link with capitalist marketing and commodification has been traced by Neil Harris (1990) in his provocative comparison of museums and department stores in nineteenth- and twentieth-century North America. By the 1940s, he argues, museums had been widely eclipsed by commerical emporia as sites for the display of art and objects and for the edification of popular taste. But recently many major museums have become more consumer-oriented, with a concomitant change of image.

> If attractiveness and public appeal become the museum's objectives,
> how in effect does it differ from any commercial institution which exists

chiefly for the purpose of selling? . . . Has the museum, a new enter-
tainment palace, become merely another asylum, an asylum not for
objects and art but for special kinds of memory baths and gallery-going
rituals, a quantified, certified, collective encounter that may shape
purchase patterns but hardly improve them? At one time, museums
were charged with paying too little attention to the wants and needs
of millions of laymen. Now, in another era, they are taxed with
pandering to delight in relevance, drama, and popularity.

<div align="right">(Harris, 1990: 81)</div>

However these developments are evaluated, and whatever possibilities of
cultural/political advocacy are opened up by the increasingly frank abandonment
of older ideals of aesthetic and scientific neutrality (1990: 95), Harris concludes
that "the changing fortunes of the museum as a public influence suggest capacities
that are great, growing, and endowed with almost infinite variation" (ibid.: 81).[3]

The "museum" Harris refers to is a western, largely metropolitan institution.
But his vision of a dynamic, consumer-oriented machine for gathering and display-
ing objects of artistic, cultural, and commercial value has evident global ramifica-
tions. The "flexible accumulation" (Harvey, 1989) of traditions, identities, arts, and
styles associated with contemporary capitalist expansion supports the proliferation
of museums in what might cynically be called a global department store of cultures.
Kevin Walsh (1992) develops this general perspective in a trenchant critique of
"museums and heritage in a postmodern world." Walsh extends David Harvey's view
of globalizing capitalist culture: a relentless erosion of "place," of local and contin-
uous senses of collective time, and the substitution of shallow, spectacular, and
merely nostalgic conceptions of the past. Heritage history, contributing to a hege-
monic articulation of national and class interests. Building on Robert Hewison's *The
Heritage Industry* (1987), Walsh grounds the recent rapid growth of museums in
Britain in a period of industrial/imperial decline and Thatcherite retrenchment. He
finds similar neoliberal hegemonies at work wherever changing societies, engaged
with expansive capitalism, represent and consume their past as heritage. The com-
modification of local pasts is part of a global process of cultural "de-differentiation."

Walsh and Harvey's analysis of the "postmodern" marketing of heritage is a
necessary, but not a sufficient, account of the many activities happening in and
through museums. A contact perspective, as Pratt argues, complicates diffusionist
models, whether they be celebratory (the march of civilization and western explo-
ration) or critical (the relentless spread of capitalist commodity systems). Walsh
recognizes, at times, that his approach oversimplifies, and he cites Mike
Featherstone's caution: "The binary logic which seeks to comprehend culture via
the mutually exclusive terms of homogeneity/heterogeneity, integration/disinte-
gration, unity/diversity, must be discarded. At best, these conceptual pairs work
on one face only of the complex prism which is culture" (Featherstone, 1990: 2).
The burden of Walsh's account falls, however, on the first terms of the series.

<div align="center">[. . .]</div>

Why have museum practices proved so mobile, so productive in different loca-
tions? Several interlocking factors are at work. The ability to articulate identity,

power, and tradition is critical, linking the institution's aristocratic origins with its modern nationalist and "culturalist" disseminations. Museums also resonate with a broad range of vernacular activities of collecting, display, and entertainment. Accumulating and displaying valued things is, arguably, a very widespread human activity not limited to any class or cultural group. Within broad limits, a museum can accommodate different systems of accumulation and circulation, secrecy and communication, aesthetic, spiritual, and economic value. How its "public" or "community" is defined, what individual, group, vision, or ideology it celebrates, how it interprets the phenomena it presents, how long it remains in place, how rapidly it changes – all these are negotiable. Gathering an individual's or a group's treasures and history in a museum overlaps with practices such as collecting memorabilia, making a photo album, or maintaining an altar. In some cases, museums are sustained with relatively few resources: the energy of a local collector/enthusiast and some volunteers. Communities or individuals who might have traditionally expressed their sense of identity and power by holding a festival or building a shrine or church may now (also) support a museum.

In a global context where collective identity is increasingly represented by having a culture (a distinctive way of life, tradition, form of art, or craft), museums make sense. They presume an external audience (national and international connoisseurs, tourists, scholars, curators, "sophisticated" travelers, journalists, and the like). These may not be the sole or even the primary audience for cultural displays and performances, but they are never entirely absent. When a community displays itself through spectacular collections and ceremonies, it constitutes an "inside" and an "outside." The message of identity is directed differently to members and to outsiders – the former invited to share in the symbolic wealth, the latter maintained as onlookers, or partially integrated, whether connoisseurs or tourists. From their emergence as public institutions in nineteenth-century Europe, museums have been useful for polities gathering and valuing an "us." This articulation – whether its scope is national, regional, ethnic, or tribal – collects, celebrates, memorializes, values, and sells (directly and indirectly) a way of life. In the process of maintaining an imagined community, it also confronts "others" and excludes the "inauthentic." This is the stuff of contemporary cultural politics, creative and virulent, enacted in the overlapping historical contexts of colonization/decolonization, nation formation/minority assertions, capitalist marketing expansion/consumer strategies.

The "world of museums" is diverse and dynamic. To varying degrees, the different contact zones I have been tracking partake of a postmodern marketing of heritage, the display of identity as culture or art. And there is no doubt that the museum-structure of culture – objectified tradition, construed as moral/aesthetic value and marketable commodity – is increasingly widespread. Aspirations of both dominant and subaltern populations can be articulated through this structure, along with the material interests of national and transnational tourism. To "have" a culture, Richard Handler has argued (1985a, 1985b, 1993a, 1993b), is to be a collector, caught up in the game of possessing and selectively valuing ways of life. But how completely caught? What *else* goes on in tribal and other local articulations of culture? How unified is the constellation of cultural/economic formations we call the postmodern? . . . The world system? . . . Late capitalism?

Let us not foreclose too soon. Museums, those symbols of elitism and staid immobility, are proliferating at a remarkable rate: from new national capitals to Melanesian villages, from abandoned coal-pits in Britain, to ethnic neighborhoods in global cities. Local/global contact zones, sites of identity-making and transculturation, of containment and excess, these institutions epitomize the ambiguous future of "cultural" difference.

Notes

1 For another encounter of native elders, traditional objects, and curators in a museum storage space, see Jonaitis (1991: 66–9).

2 Intensive discussions of repatriation are ongoing in a wide range of museums and government agencies. For a sense of the issues, see the differing positions of the National Museum of the American Indian (1991) and Sturtevant (1991); also Blundell and Grant (1989).

3 Museums' current commercial competitors and alter egos are theme parks and shopping malls. In an effort to provide safe meeting-places and edifying middle-class entertainments, some large urban museums have developed their own shops, upscale cafés, and restaurants.

References

Ames, Michael, (1991) "Biculturalism in exhibitions", *Museum Anthropology* 15(2) 7–15.

Bennett, Tony (1988) "Museums and 'the People' ", in *The Museum Time Machine: Putting Cultures on Display*, ed. Robert Lumley, London: Routledge.

Black Elk (1979) *Black Elk Speaks*, as told through John G. Neihardt, Lincoln: University of Nebraska Press.

Blackstone, Sarah (1986) *Buckskins, Bullets, and Business: A History of Buffalo Bill's Wild West*, New York: Greenwood Press.

Blundell, Valda and Grant, Laurence (1989) "Preserving our heritage: getting beyond boycotts and demonstrations", *Inuit Art Quarterly* (Winter): 12–16.

Bourdieu, Pierre (1977) *Outline of a Theory of Practice*, Cambridge: Cambridge University Press.

Bourdieu, Pierre (1984) *Distinction*, London: Routledge & Kegan Paul.

Bradford, Phillips Verner, and Blume, Harvey (1992) *Ota Benga: The Pygmy in the Zoo*, New York: St Martin's Press.

Cannizzo, Jeanne (1989) *Into the Heart of Africa*, Ontario: Royal Ontario Museum.

Cannizzo, Jeanne (1991) "Exhibiting cultures: 'Into the Heart of Africa' ", *Visual Anthropology Review* 7(1): 150–60.

Clifford, James (1987) "Of other peoples: beyond the 'Salvage' paradigm", in *Discussions in Contemporary Culture*, ed. Hal Foster, Seattle: Bay Press, pp. 121–30.

Corbey, Raymond (1993) "Ethnographic Showcases, 1870–1930", *Cultural Anthropology* 8(3): 338–69.

Deliss, Clémentine (1995) "The visual programme", in *Africa 95: A Season Celebrating the Arts of Africa*, London: Richard House.

DeMallie, Raymond (ed.) (1984) *The Sixth Grandfather: Black Elk's Teachings Given to John G. Neihardt*, Lincoln: University of Nebraska Press.

Duncan, Carol (1991) "Art museums and the ritual of citizenship", in *Exhibiting Cultures: the Poetics and Politics of Museum Display*, ed. Ivan Karp and Steven Lavine, Washington, DC: Smithsonian Institution Press, pp. 88–103.

Duncan, Carol (1995) *Civilising Rituals: Inside Public Art Museums*, London: Routledge.

Featherstone, Mike, (1990) "Global Culture: an introduction", *Global Culture: Nationalism Globalization and Modernity*, ed. Mike Featherstone, London: Sage.

Fusco, Coco (1995) *English is Broken Here: Notes on Cultural Fusion in the Americas*, New York: The New Press.

Handler, Richard (1985a) "On dialogue and destructive analysis: problems in narrating nationalism and ethnicity", *Journal of Anthropological Research* 41(2): 171–82.

Handler, Richard (1985b) "On having a culture: nationalism and the preservation of Quebec's *Patrimoine*", *History of Anthropology* 3: 192–217.

Handler, Richard (1987) *Nationalism and the Politics of Culture in Quebec*, Madison: University of Wisconsin Press.

Handler, Richard (1993a) "An anthropological definition of the museum and its purpose", *Museum Anthropology* 17(1): 33–6.

Handler, Richard (1993b) "Anthropology is dead! Long live anthropology!" *American Anthropologist* 95(4): 991–9.

Harris, Neil (1990) *Cultural Excursions: Marketing Appetites and Cultural Tastes in Modern America*, Chicago: University of Chicago Press.

Harrison, Julia (1988) "Museums and politics: *The Spirit Sings* and the Lubicon Boycott: co-ordinating curator's statement", in *Muse VI* (3): 12–13.

Harvey, David (1989) *The Condition of Postmodernity: An Inquiry into the Origins of Cultural Change*, Oxford: Blackwell.

Hewison, R. (1987) *The Heritage Industry: Britain in a Climate of Decline*, London: Methuen.

Hill, Tom and Nicks, Trudy (eds) (1994) "Turning the page: forging new partnerships between museums and first peoples", report of the Task Force on Museums and First Peoples, Ottawa: Assembly of First Nations and Canadian Museums Association.

Holm, Bill and Quimby, George Irving (1980) *Edward S. Curtis in the Land of the War Canoes: A Pioneer Cinematographer in the Pacific Northwest*, Seattle: University of Washington Press.

Horne, Donald (1984) *The Great Museum: The Re-presentation of History*, London: Pluto Press.

Hutcheon, Linda (1994) "The post always rings twice: the postmodern and the post-colonial", *Textual Practice* 8(2): 205–38.

Jonaitis, Aldona (1991) "Chiefly Feasts: the creation of an exhibition", in *Chiefly Feasts: The Enduring Kwakiutl Potlatch*, ed. Aldona Jonaitis, Seattle: University of Washington Press, pp. 21–69.

Koh, Barbara (1994) "In the magic grove", *San Jose Mercury News*, 16 September: 1B–2B.

Levine, Lawrence (1988) *Highbrow/Lowbrow: The Emergence of Cultural Hierarchy in America*, Cambridge, MA: Harvard University Press.

MacCannell, Dean (1976) *The Tourist: A New Theory of the Leisure Class*, New York: Schocken.

Mackey, Eva (1995) "Postmodernism and cultural politics in a multicultural nation: contests over truth in the *Into the Heart of Africa* controversy", *Public Culture* 7 (2): 403–32.

National Museum of the American Indian (1991) "National Museum of the American

Indian policy statement on Native American human remains and cultural materials," *Museum Anthropology* 15(2): 25–8.

Ottenberg, Simon (1991) "Into the heart of Africa", *African Arts* 24(3): 79–82.

Philip, Marlene Nourbese (1992) *Frontiers: Essays and Writings on Racism and Culure*, Stratford, Ontario: Mercury Press.

Pratt, Mary Louise (1992) *Imperial Eyes: Travel Writing and Transculturation*, London: Routledge.

Riding, Alan (1995) "African creativity on Europe's stage", *New York Times* (4 October): B1, B4.

Schildkraut, Enid (1991) "Ambiguous messages and ironic twists: *Into the Heart of Africa* and *The Other Museum*," *Museum Anthropology* 15(2): 16–23.

Standing Bear, Luther (1928) *My People the Sioux*, Lincoln: University of Nebraska Press.

Sturtevant, William (1991) "New National Museum of the American Indian collections policy statement: a critical analysis," *Museum Anthropology* 15(2): 29–30.

Urry, John (1990) *The Tourist Gaze: Leisure and Travel in Contemporary Societies*, London: Sage.

Vogel, Susan (1987) *Perspectives: Angles on African Art*, New York: Center for African Art and Harry F. Abrams.

Vogel, Susan (1991) *Africa Explores: Twentieth Century African Art*, New York: Center for African Art.

Walsh, Kevin (1992) *The Representation of the Past: Museums and Heritage in the Post-Modern World*, London: Routledge.

Williams, Raymond (1966) *Culture and Society, 1780–1950*, New York: Harper & Row.

INDEX